Pre-Columbian ART HISTORY

Selected Readings

Alana Cordy-Collins
Jean Stern

San Diego Mesa College
San Diego, California

Peek Publications • Box 11065 • Palo Alto, California 94306

ISBN 0-917962-41-9

Manufactured in the United States of America

Preface

Pre-Columbian Art signifies the art of a particular place, time, and people. The place is the New World—the Americas. The time extends from the fourth millenium B.C. through the early sixteenth century A.D. The people—the artists and craftsmen who created the art—were the indigenous inhabitants of the New World, representatives of myriad cultures on both continents. Some of these cultures influenced others artistically. Others developed autonomously.

Pre-Columbian art ceased, not with the landing of Columbus in 1492 as the term pre-Columbian implies, but with the arrival of the Spanish on the mainland some years later. Although Cortez conquered Mexico in 1521 and Pizarro conquered Peru in 1532, many areas of the New World were untouched by Spanish influence for years thereafter. Therefore, the term "pre-Hispanic" is actually more accurate than "pre-Columbian." For this reason many researchers prefer the term pre-Hispanic Art to pre-Columbian Art. However, "pre-Columbian" is the more widely used of the two terms; and it is, therefore, for the sake of consistency that the editors here use the term "pre-Columbian."

Within the pre-Columbian world, two main cultural areas are recognized. The more northerly is Mesoamerica, an area which encompasses Mexico, Guatemala, Honduras, British Honduras, and part of El Salvador. The Andean Area is the more southerly and includes southern Ecuador, Peru, western Bolivia, and the northern part of Chile and Argentina. Between these two main culture zones lies another which is usually termed the "Intermediate Area," formed by Costa Rica, Nicaragua, Panama, Colombia, and northern Ecuador.

In arranging the articles in this volume, we have followed a southward progression, beginning with Mesoamerica, followed by the Intermediate Area, and ending with the Andean Area. Within the three areas, we have followed a general chronologic order, beginning with the oldest cultures in a specific area and moving forward in time.

Over the past several years, the field of pre-Columbian studies has expanded tremendously, and an ever-increasing number of pre-Columbian art courses are being offered in colleges and universities. An unfortunate side effect of this burgeoning field and expanding research is that it is extremely difficult for instructional material to be kept current. The problem in writing survey books in pre-Columbian Art is the same as in any rapidly developing field: by the time a book is finally published, much of the

material is outdated. A book of readings, by contrast, can be produced while its contents are still fresh, because it is composed of recently published journal articles.

The articles in this volume were selected with two main criteria in mind: the first was that the articles be basically art historical; i.e., that they dealt with form and meaning as subject matter, as well as exhibiting sound art historical methods and theories. The second criterion was that the articles be timely. While a few of the articles in this volume are several years old, this in no way detracts from their timeliness. Because the older articles were initiatory in their specific areas and have not been superceded by more recent research, they are indeed timely.

The majority of the articles contained herein were first published within the last few years. In addition, the editors were fortunate to be able to secure several entirely new articles that were written expressly for this volume and are published here for the first time.

While this book is primarily intended for use in pre-Columbian Art History survey courses and seminars, it will also serve as a valuable supplement to pre-Columbian Anthropology courses. Indeed, several of the contributors hold appointments in departments of anthropology rather than art.

The editors extend their sincere gratitude to the authors for allowing their articles to be included in this volume. Appreciation is also extended to Jack L. Riesland for his help in the style and organization of several articles.

Alana Cordy-Collins
Jean Stern

Contents

Olmec Art or the Art of La Venta

By Miguel Covarrubias
Translated by Robert Thomas Pirazzini*

In the state of Guerrero, there in the times before the highways and tourism, in a "pulqueria" of Iguala, where the farmers of the region used to exchange their idols for mezcal, I acquired some very strange archaeological objects: small idols of fat personages, of extraordinarily mongoloid traits and with thick unpleasant-looking mouths. There was among them a fat, round little body without a head, carved in black, polished serpentine with astonishing realism and skill. Other objects were of translucent jade, blue or gray-green, and were marvelously carved and polished. Eight years afterwards, the painter Diego Rivera, another fanatic collector, gave me a little black serpentine head that miraculously turned out to be the head which was missing from the little body from Iguala. It was rounded in the form of an avocado, with swollen eyes, inflated cheeks and with an extremely strange mouth, the mouth of a monster, of a child or dwarf born without a lower jaw, showing the trachea carved in realistic form (Fig. 9). Later I found another little statue of the same style in the State of Veracruz that seemed to represent a deaf person (Fig. 10). With time, I came across other similar little figurines from Oaxaca, from Guatemala, Tabasco, etc.

At that time, the term *Olmec* was not yet employed, and this new art, so simple but skillful, was for me a revelation and a novelty within pre-Hispanic art, generally subordinated to religious ideas and frequently limited by its traditional stylizations. Here one was confronted with an art of enormous plastic force, with mysterious archaic traits that contrasted with the astonishing skill in the difficult art of carving and polishing hard stones. I began to interest myself from then on in this strange culture about which there had been almost nothing written and which had come to be called *Olmec* after the legendary Olmec Zone—the Gulf Coast—where the style predominated, although the pieces that I had collected came for the most part from the state of Guerrero.[1]

My interest for the *Olmec* gradually became a true mania and I began to collect photographs and drawings of any *Olmec* pieces found in museums, private collections and archaeological monographs. The matter came to acquire pathological character-

*The editors wish to thank Hasso von Winning and Jack L. Riesland who read this translation and made several significant comments and suggestions.

Reprinted from *Cuandernos Americanos*, Vol. 28, No. 4, 1946.

2

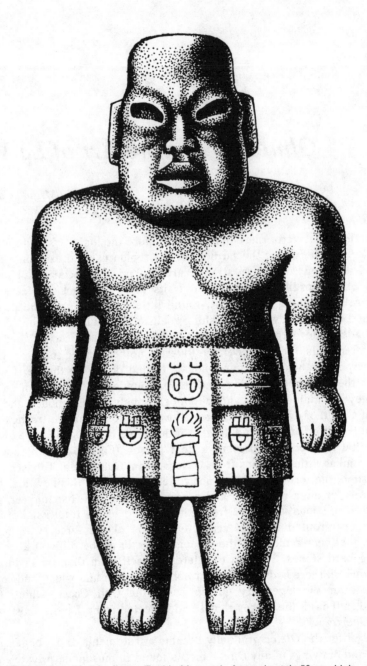

Plate 1. Large jadeite figure (Puebla Museum). Approximately 50 cm. high.

istics. Now, whenever anyone praises the artistic skill of the *Olmecs*, I am accused of thanking him on behalf of the *Olmecs*.

There had not yet been any objects of this style found under scientific conditions and there were few pieces that had an authentic provenience. As if to deepen the mystery that surrounded them, many of these objects appeared intentionally broken or mistreated. It was obvious that the study of an important culture with its own great style and with a very special psychology had been overlooked; a culture that did not fit within known molds, that could be neither Maya, nor Toltec, Totonac nor Zapotec. Little by little, new concrete data about it were being unearthed in Oaxaca, Morelos, Puebla, etc., until the great apotheosis of *Olmec* archaeology, when in 1939 Mathew W. Stirling began his excavations in the Gulf Coast at Tres Zapotes, Cerro de la Mesas, and San Lorenzo Tenochtitlan, and especially at La Venta, Tabasco. Sensational discoveries were made there of gigantic monuments of basalt, colossal heads, sculptures of a negroid type, a stela dated to a period before the Christian era, tombs, stone sarcophagi, mosaic floors of green serpentine, and especially great quantities of jade objects, extraordinary for their artistic quality and their color. In Cerro de las Mesas alone, there was a cache of jade that consisted of 780 pieces, among them some of which are counted among the masterworks of pre-Hispanic art.

The known geographic distribution of this culture is already known to be great and it does not permit us to establish its identity, for it includes almost all of Southern Mexico and parts of Central America[2]—that is to say, the zone called by archaeologists Mesoamerica, seat of the most advanced indigenous cultures of the continent.

The discoveries of Stirling, Caso, Vaillant, etc., made the *Olmec* complex a true problem so that the Mexican Society of Anthropology took the initiative and called a Round Table meeting in Tuxtla, Chiapas, in which the principal archaeologists of the continent participated. Perhaps the most important results of the discussion were the establishment of five successive cultural horizons for Mesoamerica, and the classification of the *Olmec* complex, or the La Venta complex as it has been called since then, in the First Horizon, the so-called Archaic.[3]

From the artistic point of view the *Olmec* sculptures are counted among the best in pre-Hispanic art, technically they were not surpassed and archaeologically they continue to be a profound mystery since they only show connections with the oldest cultures, the so-called archaic ones, of periods prior to the Christian era. Thus we are faced with the paradox of a very complex culture, with a technical and artistic development of great knowledge and refinement, that already appears in the most ancient archaeological horizons known.

These *gatos pardos* of Mexican archaeology (as they were called by Spinden) will continue to disturb the sleep of archaeologists until the problem is studied in depth and an attempt is made to clarify what is represented by the jaguar-babies, the monstrous dwarfs, the fat bearded men, and who were their creators, from where and when did they come, and what was their influence on other Mesoamerican cultures? The growing complexity of the culture of La Venta and the natural desire for better understanding the artistic psychology of the creators of these marvelous sculptures will explain the reason why a painter interests himself with problems essentially archaeological. Perhaps by studying the artistic style of these mysterious peoples, one will be able to add new data to the scarce knowledge we possess of the culture of La Venta.

The *Olmec* fluidity is the antithesis of the stylized and rather rigid art of the great era of the Central Plateau or of the flamboyant Baroque of the tropical lowlands, both of which are overburdened by religious symbolism and ritual details. On the contrary, the *Olmec* esthetic has much in common with the archaic cultures: simplicity and sensual realism in its forms, and force and spontaneity in its concepts. The *Olmec* artists delighted in representing human beings in massive forms, solid and chubby in keeping with the physical type of the Indians of southern Mexico, handling these forms with discipline and sensibility. They liked the smooth and highly polished surfaces, barely interrupted at times by fine incised lines in order to indicate additional characteristics like tattooing, details of dress, adornments or glyphs. These lines are clean and precise, with an almost geometric style: smooth curves and rounded rectangles reminiscent of Maya glyphs or of the decorative style of the Indians of the northwest coast of Alaska and Canada.

Besides basalt and jadeite, which were the preferred materials *par excellence*, they carved various serpentines and all the *chalchihuites*, the hard green stones that looked like jade. I know of *Olmec* objects of steatite, aventurine quartz, hematite, obsidian, and at La Venta there have been found beads of amethyst and rock crystal. I have never seen objects of bone or shell, but there does exist a marvelous wooden mask of the purest *Olmec* style found in a cave in El Cañon de la Mano, near El Naranjo, in Guerrero. Of course, there are not any *Olmec* metal objects.

The *Olmecs* modeled clay with the same skill and sensibility with which they carved jade, and it is very curious that they had not developed techniques for treating the two materials distinctly. Contrary to the lapidary techniques of later times, in which the hardness of the stone and the mechanical methods used determined the style and dictated the forms, the *Olmec* artist was master of the material and so imposed upon it the form he desired, carving it with the same facility with which he modeled clay. This highly advanced technique used forcefully all the imaginable methods: cuts and abrasions with scrapers, perforations with solid and tubular drills, percussion flaking, as well as a notable unknown technique for obtaining the splendid polish of the pieces. They made marvelous perforations in the jade pieces, through their length as well as through their diameter. There are some so fine that they are barely able to be strung with a slender thread. A masterpiece of this technique is the little jade lizard from Guerrero (Fig. 19), formed by three links carved from one single piece: the center forming the body, the front part the head and forelegs, and the back part the tail and hindlegs. It is strange that a people ignorant of metal had the concept of chains and links. In the adjacent illustration I have tried to explain an hypothesis of the technical sequence in the carving of an *Olmec* face, defining first basic masses for establishing the forms, then with drill holes strategically located in order to join them afterwards by means of cuts and incisions, and then finishing the final details by means of abrasion. Later the Indian stoneworkers, especially the Mixtecs, developed or rather they mechanized this technique in order to mass produce objects.

The *Olmec* artists represented almost exclusively *man*, that is to say, themselves, or at least their esthetic ideal: short and fat beings, with wide jaws, a prominent chin, short and flat noses with the septum perforated, mongoloid eyes with swollen eyelids, and with artificially deformed heads in the shape of a pear, or as Caso says, in the shape of an avocado, elongated towards the top and with the back of the neck

Hypothetical technique used in carving an *Olmec* face.

enlarged. Perhaps its most characteristic trait is the form of the mouth, which is called the *Olmec Mouth*. It has a trapezoidal form, with thick lips and the corners of the mouth strongly drawn downwards which gives them a fierce and evil-looking appearance, with a bold and protruding upper lip like that of a growling jaguar.

The curious *Olmec* physical type does not exist just in Mexico, rather it is fairly frequent in all ethnic groups and all social classes. I would dare to say that it is one of the most ancient ethnic archetype that perhaps has been disseminated or blended in other indigenous types. Nevertheless it is the predominant *Olmecoid* type among the peoples of the southern part of the country, especially among the speakers of the Macro-Otomangue languages. According to the engineer Weitlaner, the type is very frequent among the Mazatecs and the Chinantecs, and I have frequently seen it among the Mixtecs, Zapotecs, Totonacs, Popolucas, etc. W. Jiménez Moreno has suggested the hypothesis that the originators of the La Venta culture were Maya speakers, probably Huastecs, with the participation of peoples of other linguistic affiliation. Nevertheless it is probable that as in the case of the archaic cultures, various peoples who spoke different languages may have participated in the same culture. I am inclined to believe that, in view of the continuity of certain traits such as the geographic distribution, the apparent monopoly of jade carving, certain stylistic concepts, etc., that perhaps the originators of the style may have belonged to some Oaxacan group, perhaps the Mixtecs or archaic Zapotecs.

In the majority of the cases the personages of the *Olmec* sculptures appear completely nude, devoid of any adornment, with the head totally shaved, and without any characteristic that might indicate their sex. Other pieces on the other hand, show loincloths, helmets, chin straps, thick belts with great buckles, kilts, capes, bracelets, and anklets. Some seem to wear a form of footwear different from the typical Mexican sandal. It is curious that in the monuments of La Venta, Tres Zapotes and San Lorenzo, the personages wear large earplugs,[4] necklaces, pectorals, frontal adornments, and fantastic headdresses almost as tall as the figure wearing them. The wealth of material of dress and adornment which the explorations of these places have produced perhaps can provide us with some data about their wearers. For example, the typical helmet of La Venta, very similar to that of modern football players, is characteristic of the archaic cultures (Vaillant's figurine types D) of the Valley of Mexico and of Monte Albán in the culture of the "danzantes." The jaguar helmet already appears in Period I of Monte Albán, on stelae and on ceramics, and later in very evolved forms in all the high cultures. Nevertheless, the great crests and fans of quetzal feathers that tipped the helmets, so typical of cultures like Mayan, Teotihua-

6

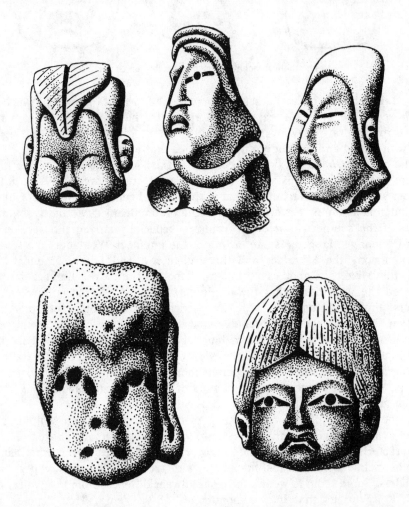

Plate 2. Ceramic heads. Above: from La Venta. Below: from La Mixtequilla, Veracruz.

cán, Toltec, etc., are totally absent in the art of La Venta. The custom of totally shaving the head bare or leaving eccentric tufts of hair is also an archaic trait that lasted until Teotihuacán III. In the *Olmec* figures, we see at times personages with half of the head shaved, others with long hair loose in the back with short bangs in the front, and others with a crest of hair at the center of the head as the Algonquin Indians were accustomed to wearing it. Short beards but without a mustache appear frequently in the *Olmec* sculptures. An *Olmec* clay figure coming from Tlaxcala shows the teeth filed and painted red.

Very important in the art of La Venta is the representation by fine incised lines, of motifs by tattooing or facial painting on the cheeks, above the eyes, on the forehead, lips, legs, and arms, drawn with that characteristic style of secondary lines described previously and that appear to represent glyphs (Pl. 3, I and II). These motifs appear in designs engraved on ceramics of the Middle Archaic Period, of Monte Albán I, and on other ceramics of very ancient periods. They all recall the general style of the Maya glyphs and especially of their basic components. All of which leads us to believe that these *Olmec* designs, at least from their stylistic point of view, could well be the forerunners of Mayan glyphs. The presence of marks or motifs that seem to be glyphs in La Venta art is another problem, since inscriptions or dates have not been found at La Venta. Nevertheless, the latter are frequently on *Olmec* monuments from the Tuxtla and Mixtequilla Veracruz zones, just as in the period Monte Albán I, one of the oldest that we know of. A thorough study of *Olmec* writing will perhaps clarify somewhat the profound problem of Mayan epigraphy.

Frequently the heads of *Olmec* sculptures appear cleaved by a notch in the form of a *V* at times very deep, resembling the claw end of hammers. This mysterious cleft has been explained by Saville[5] as related to the cult of Tezcatlipoca in commemoration of the episode in which Quetzalcoatl gives him a tremendous blow, with a stick, crushing his head. This explanation is too simple, and it is possible that this notch represents either some form of sacrifice or some method of cranial deformation, possibly for imitating the natural furrow of jaguar skulls with which the art of La Venta is so intimately related. The cleft appears also in the little clay heads from Teotihuacán II and might well have been motivated by a magical belief of the priesthood, which aspired to modify the faculties of an individual by means of certain cranial deformations. This concept could have been based on mystical machinations, perhaps suggested by the soft area on a baby's head. The *Olmec* cleft could be a symbol of contact between divinity and man by way of the crown or pineal gland, perhaps with a symbolism similar to that of the cleaved mitres of Catholic Bishops and the shaving of the priests, protected by the skull cap. In many regions of the world the occipital lobe is considered to be the seat of divinity.

Besides the artificial deformations that have been mentioned, there appear in the *Olmec* figurines some traits of a pathological nature admirably expressed. They almost always show a type of abnormal obesity that gives them the appearance of eunuchs. This type of obesity, as well as the other traits that characterize the *Olmec* type (swollen eyes, thick and flabby cheeks, the corners of the mouth with dimples or marked depressions, the thick neck, the thick thighs and arms with small and feminine hands and feet) are all typical of a hyperpituitaristic condition (Dystrophia Adiposo-Genitalis), abnormalities in the growing pattern caused by irregularities in

Plate 3. [I and II] Motifs or glyphs in the art of La Venta.

oreja decorada.

decoración alrededor de los ojos

glifo atrás
de la cabeza

the functioning of the endocrine glands, especially the hypophysis and pituitary. Other pathological traits common in La Venta art are dwarfism, acromegalia, achondroplasia, hunchbacks, etc. These deformed beings seemed to have concerned the peoples of the La Venta culture to the point that they must have worshipped them as supernatural beings, especially the dwarfs—men perpetually children.

Among the most characteristic objects of the *Olmec* style are the figurines of serpentine or basalt of children or dwarfs with big heads, bloated bellies, legs flexed, enormous feet, and generally with hands clenched on the chest. The sculptural style of these figurines is amazingly realistic and so uniform that they appear made by the same hand. In spite of their dynamic and naturalistic postures and expressions, they are conceived with disciplined form, predominantly ovoid and admirably coordinated. These mysterious figurines appear to represent infant-like elves or dwarfs with all kinds of physical abnormalities, perhaps jungle spirits that call to mind the impish *chaneques* that inhabit Guerrero and coastal Veracruz. The chaneques are mischievous, lovesick dwarfs who dedicate themselves to playing practical jokes on human beings. The idea of the chaneques seems to have its origin in the concept, very common among the peoples of Southern Mexico, of very old dwarfs with the face of children, who bring rain and are also the patrons of hunting and fishing. For example, the Mazatecs believe in elves like the *la'a* who cause sicknesses, and the *chikushi* who make rain when offerings are made to them.[6] The Zoques of Chiapas have their *mo yo,* old men of small stature with the faces of children who hide treasures in the caves where the best corn is stored and who carry in their hands thunderbolts in the form of serpents.[7] The Popolucas of Veracruz have their *chanis*, small black elves, and they fear the *hunchuts*, whistling dwarfs without a brain and with feet turned backwards. These live behind the great waterfalls and are nourished with the brains of human beings.[8] These elves and dwarfs who produce the rains and who are the owners of the best corn and other treasures which they hide in caves, remind us of their probable ancestors: the old gods of the rain and their helpers, the Maya *chacs* and the Mexican *tlaloques*, whose function was to water the earth with pitchers that they broke with a stick in order to produce lightning. In an even more ancient era these had their prototype in the dwarfs with the jaguar mouth from the art of La Venta.

The jaguar-deities predominate in the art of La Venta and the traits of the jaguar are its basic motifs. There are big and small sculptures, of basalt or jade, that represent all types of jaguars, some with large canine teeth and marked animal appearance, or else anthropomorphic jaguars in half-human attitudes, half feline, with the adornments and ceremonial vestments of men. Even in the clearly human figurines there are unmistakeable feline traits in the face and in the expression. This feline obsession must have had an essentially religious motive, even totemic, related to the cult of the god-jaguars of the rain and the earth. One of these types of *Olmec* jaguars has its eyebrows or superciliary arches in the form of plates frequently crenelated and with a stern frown. It has hollow, empty eyes, the flat feline nose, and the open toothless mouth with the gums showing. It is curious that this toothless mouth is devoid of the most characteristic aspect of the jaguar: his fangs. This can be interpreted in two ways: either it can be considered as the face of a flayed jaguar in order to use it as a mask, or it is the representation of a jaguar cub. Here it is worth mentioning the relationship of the toothless mouth with the mouth of a child that

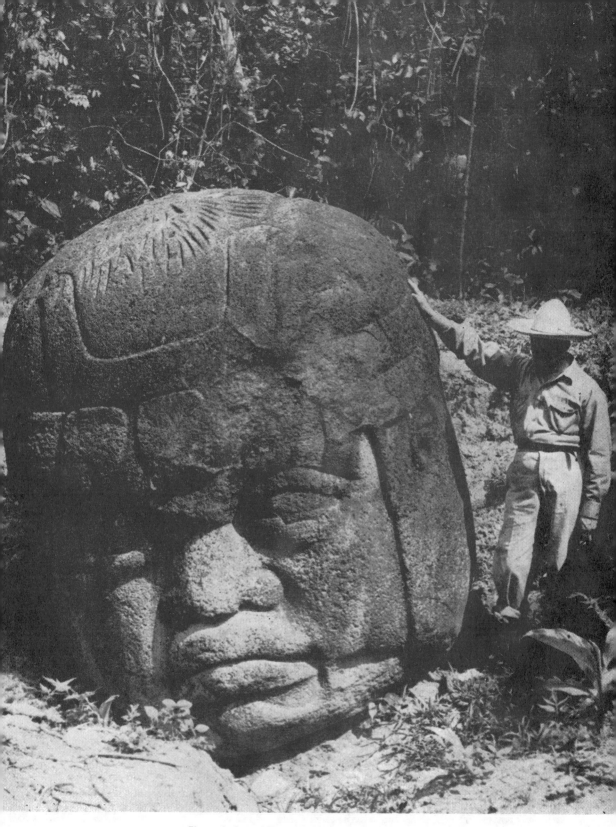

Figure 1. One of the colossal heads at La Venta, Tabasco.

12

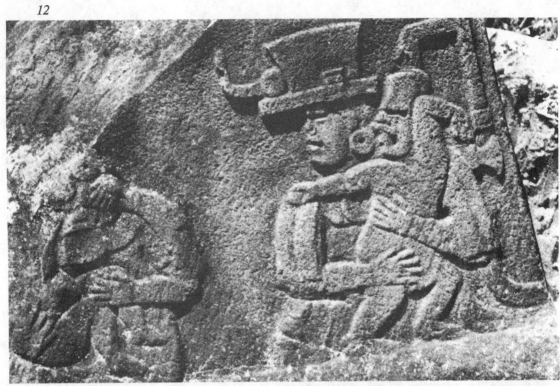

Figure 2. Side of an altar at La Venta, Tabasco.

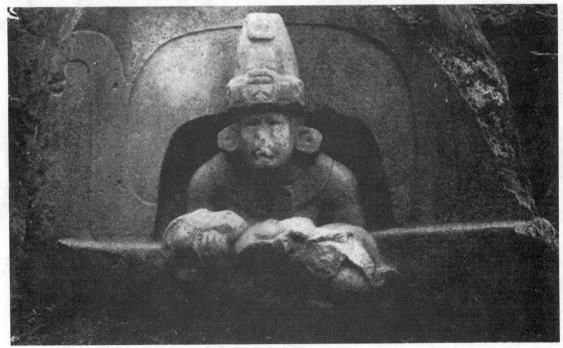

Figure 3. Front of the same altar.

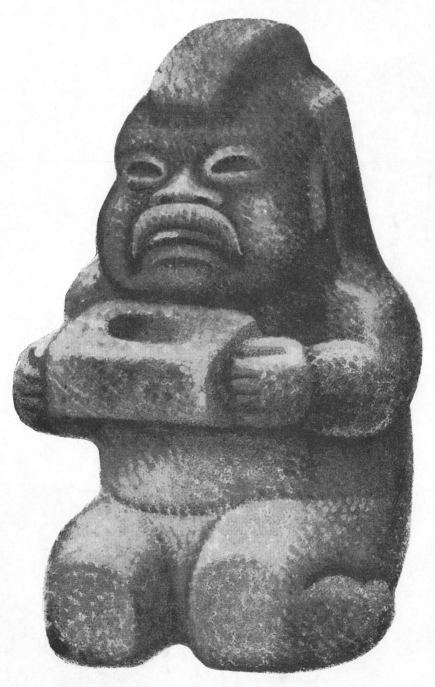

Figure 4. ''La Abuelita,'' La Venta, Tabasco. Basalt, 1.37 meters high.

14

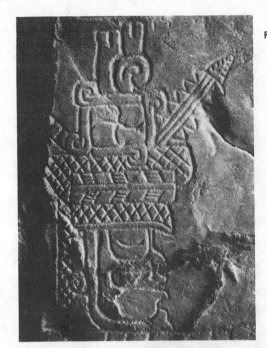

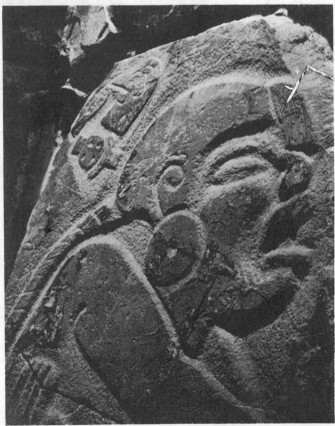

Figure 5. Detail from a stone on Mound J, Monte Alban II.

Figure 6. Detail of a "danzante," Monte Alban.

Figure 7. Fragment of a serpentine mask, Apoala, Oaxaca. (National Museum of Anthropology, Mexico).

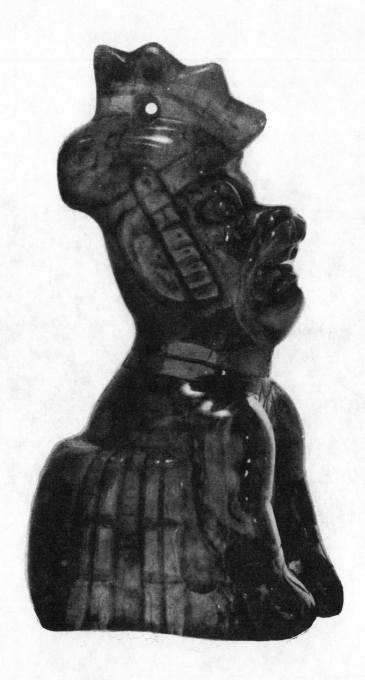

Figure 8. Jaguar of greenish-blue jade, Necaxa, Puebla. (American Museum of Natural History, New York).

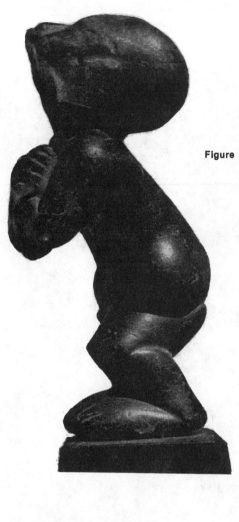

Figure 9. Statue of black serpentine, Iguala District, Guerrero (M. Covarrubias Collection).

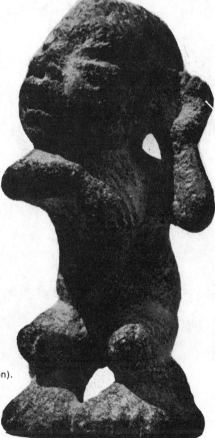

Figure 10. Statue of basalt, Veracruz (M. Covarrubias Collection).

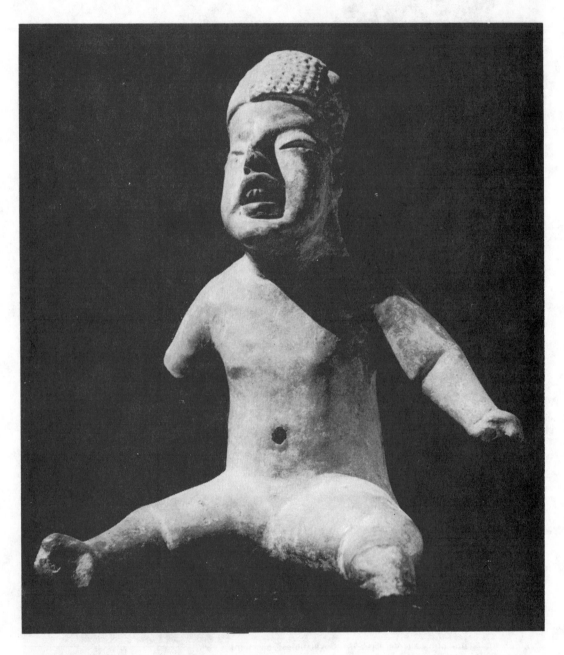

Figure 11. Archaic hollow ceramic figurine, Gualupita style, from the State of Puebla (M. Covarrubias Collection).

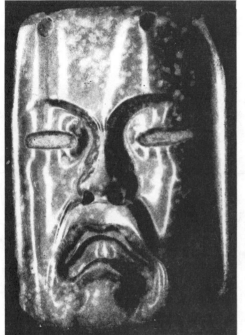

Figure 12. Jadeite mask, unknown provenience.

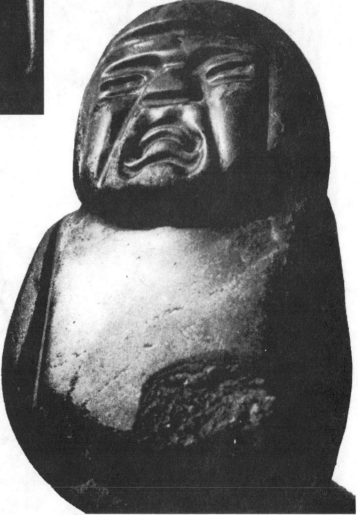

Figure 13. Carved jadeite pebble, Niltepec, Oaxaca (M. Covarrubias Collection).

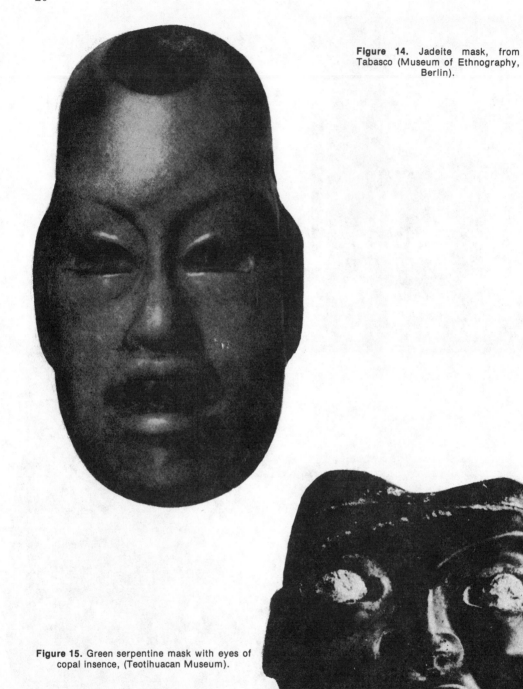

Figure 14. Jadeite mask, from Tabasco (Museum of Ethnography, Berlin).

Figure 15. Green serpentine mask with eyes of copal insence, (Teotihuacan Museum).

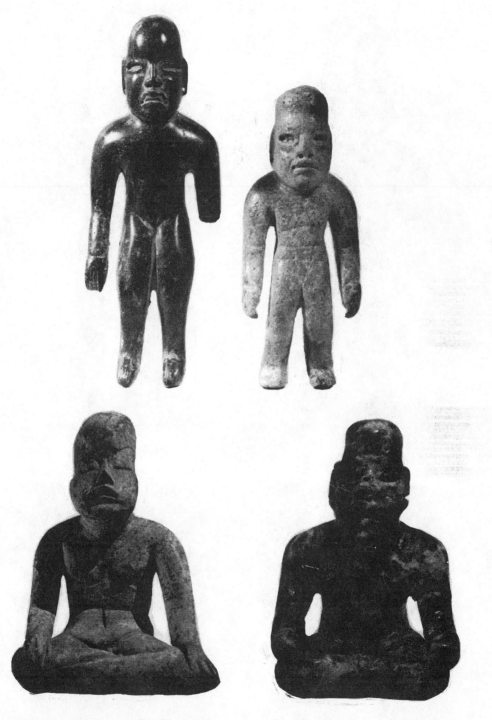

Figure 16. (above) Serpentine figurines, right: from a tomb at La Venta, lef: from Tlatilco, Mexico D.F. (below) right: green jadeite figurine from La Venta, left: ceramic figurine from Tlatilco, Mexico D.F.

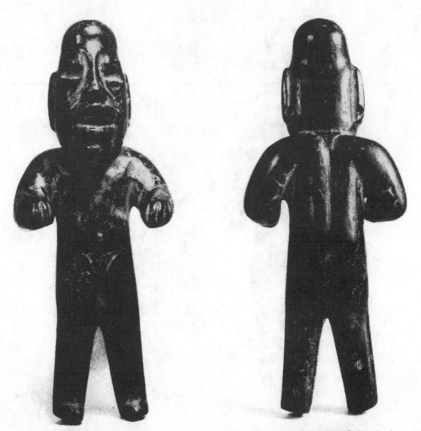

Figure 17. Black serpentine figurine of a bearded person (J. Encisco Collection).

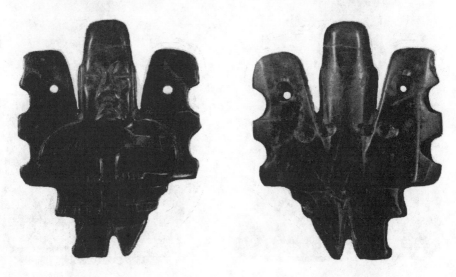

Figure 18. Blue jadeite figurine representing a winged person, Province of Guanacaste, Costa Rica (Jorge Lines Collection).

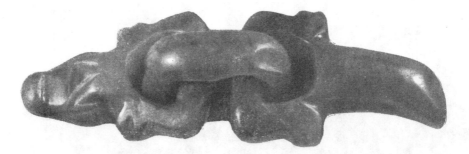

Figure 19. Jadeite lizard, formed by three links carved from one piece of stone, 5 cm. long (M. Covarrubias Collection).

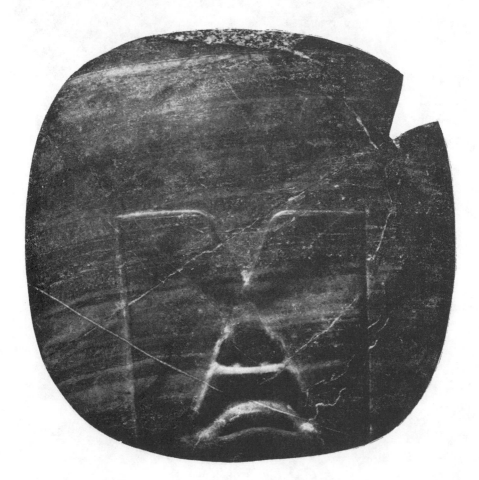

Figure 20. Jadeite disk with *Olmec* face, unknown provenience (Pierre Matisse Collection).

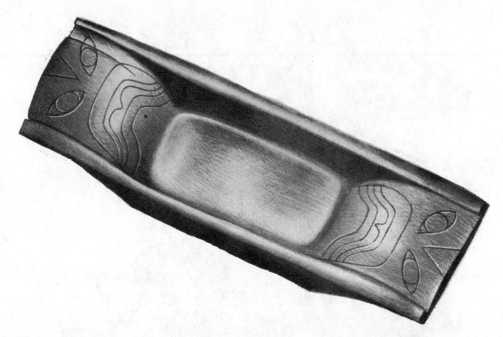

Figure 21. Jade canoe, one of the 78 objects in a cache from Cerro de las Mesas, Veracruz (National Museum of Anthropology, Mexico).

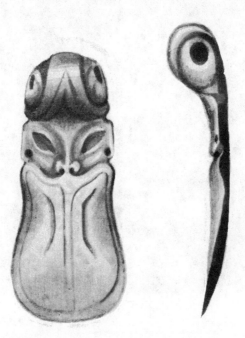

Figure 22. Jade pendant representing a human face wearing a mask in the form of a duck's bill, Balsas District, Guerrero.

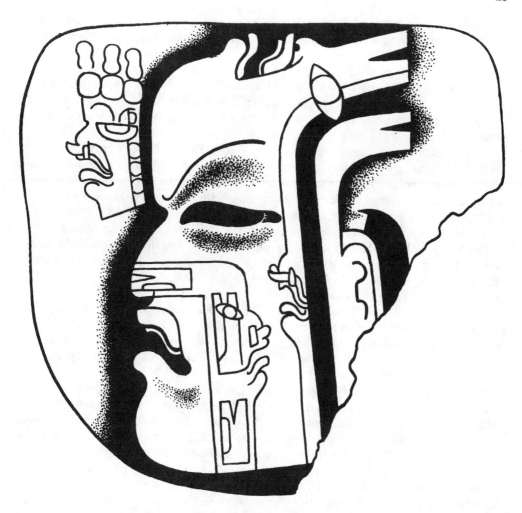

Figure 23. Design on a pectoral plaque of dark green nephrite (National Museum of Anthropology, Mexico).

Figure 24. *Cucharita* (spoon) of jade, 11 cm. long, Balsas District, Guerrero (Private Collection).

shows the upper gum while crying. Children when they cry, especially Indian children, depress the corners of their lips showing the gums, thus producing a classic *Olmec* mouth.

The flayed face might have signified a relationship with Xipe, god of spring and vegetation. Xipe was the lord of the coast (Anahuatliteca) of Southern Mexico who had wide open eyes cast downward as eyes appear in *Olmec* art.[9] I do not claim that Xipe is represented in these sculptures, and I am only pointing out these curious coincidences.

The southern god-jaguar was also Tepeyollotl, Heart of the World, god of the earth, that according to Burgoa was the Atlas that held it up on his shoulders, and thus was the echo of the mountain and god of earthquakes. He was worshipped in the land of the Mixtecs, in a cave of Achiutla, and in Tehuantepec, where he had a sanctuary in another cave on the Huave island of Monopoxtiac. Deities that seem to be Tepeyollotl appear on the coast of Veracruz (on stelae at Cerro de las Mesas and on a yoke in the National Museum), in Monte Albán (the Bazán Slab), in Teotihuacán (Tetitla Fresco), in Yucatán (stucco reliefs of Acankeh), and they are particularly abundant in the jungles of the Gulf Coast which are infested with jaguars, not just of stone but also of flesh and blood.

In the Codex Borgia (pp. 14 and 63) Tepeyollotl appears in two forms: as an animal, a jaguar with a feathered headdress seated above a cave, and in human form, bearded, with thick eyebrows in the form of plates and a pattern of jaguar skin around the mouth in order to indicate the mouth of a jaguar. He is dressed with the costume of the god of rain and only lacks the blue mask to be identical to Tlaloc. Xipe as well as Tepeyollotl are related to the great Tezcatlipoca, who also was a jaguar. All these god-jaguars—Xipe, Tezcatlipoca, Tepeyollotl, Tlaloc—present a very interesting development of a very ancient concept: perhaps the *Olmec* were-jaguars, in various deities acquire individual characteristics due to a long and varied adoption by different peoples. It is fitting here to point out the Nahual concept of the Aztec secret societies, whose emblem was the jaguar and whose members wore disguises and jaguar amulets. In our times, notwithstanding that more than 400 years have gone by since the Conquest and perhaps two thousand since the *Olmec* Period, dances with jaguar masks are still performed in Guerrero, Veracruz, and Oaxaca.

In Plate 4, I have tried to show the influence of the art of La Venta on the evolution of the jaguar mask through the various pre-Hispanic gods of rain: the Maya Chac, the Tajín of Veracruz, Tlaloc of the Central Plateau, and Cocijo of Oaxaca; as well as the evolution of the characteristic rain god vase through the cultures of Monte Albán I and II, Teotihuacán, and finally to the Aztec. One can easily follow the transformation of the lip band of the jaguar becoming the notched nosebar of Tlaloc, and of the crenelated eyebrows, that perhaps represent clouds, forming the goggles of Tlaloc. These variations in concepts that have so much influence on style may be due to a lack of understanding of the original significance of certain elements by artists of later periods. For example, the thick and protruding upper lip of the jaguar is extraordinarily extended to form the kind of trunk or snout of the Maya Chac; the toothless gum with its central appendage evolves in various forms in order to be furnished with teeth and fangs, ending up by producing very elaborate mouths.

In spite of the limitations in subject matter, the art of La Venta is extremely rich

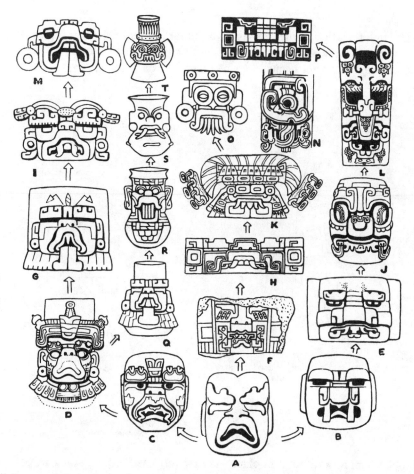

Plate 4. Influence of the La Venta style in the evolution of the mask of the rain god:

A—Stone mask, Central Veracruz, of the purest *Olmec* style. American Museum of Natural History, New York

B—Green stone mask, Cárdenas, Tabasco. American Museum of Natural History, New York

C—Hard green stone mask, Oaxaca. Peabody Museum, Cambridge

D—Ceramic urn from Monte Albán I, Oaxaca. National Museum of Anthropology, Mexico

E—Stucco mask motif on pyramid E-VII Sub in Uaxactún, Petén, Guatemale. Chicanel Period

F—Stela C of Tres Zapotes, Veracruz, dated from Bactún 7. National Museum of Anthropology, Mexico

G—Mask on a ceramic box from Monte Albán II, National Museum of Anthropology, Mexico

H—Jaguar mask from Stela 8, Cerro de las Mesas, Veracruz

I—Mask on the headdress of a ceramic figurine from Tomb 109, Monte Albán. Loma Larga Period (transition between II and III). National Museum of Anthropology, Mexico

J—Mask of Chac, Maya rain god, from the base of an altar, Piedras Negras, Guatemala. University Museum, Philadelphia.

K—Tlaloc with jaguar's jaws from a Teotihuacán III vessel. National Museum of Anthropology, Mexico

L—Mask on the reverse of Stela B, Copán, Honduras

M—Mask of Cocijo, the Zapotec Rain god, Monte Albán III, Private Collection

N—Profile of Tajín, the Veracruz rain god, detail of a palmate stone. Private Collection

O—Tlaloc mask of the Mixteca-Puebla Period, on a ceramic tube from Tehuantepec, Oaxaca. National Museum of Anthropology, Mexico

P—Stone mask from Tzibilnocac, Yucatán (after Seler).

Series demonstrating the evolution of rain god vessels:

Q—Ceramic vessel from Monte Albán I, Private Collection

R—Large jade vase from the Plancarte Collection, Oaxaca. National Museum of Anthropology, Mexico

S—Ceramic vessel of Teotihuacán Style, Monte Albán. National Institute of Anthropology and History, Mexico

T—Ceramic Tlaloc vessel of Aztec style. Museum of Ethnography, Berlin (after Seler)

in artistic manifestations and possesses a great variety of types of sculpture. Its monumental works, made almost invariably of hard basalt (generally in regions where this kind of stone does not occur), can be classified as follows:

Rock-carving at San Isidro Piedra Parada, near Quetzaltenango, Guatemala.

Rock-carving of figure with mask, Chalcatzingo, near Jonacatepec, Morelos.

1) Reliefs on rocks, found in places as disparate as Piedra Parada in Guatemala,* and in Chalcatzingo near Jonacatepec, Morelos (see accompanying drawing).

2) Colossal heads, at Tres Zapotes, La Venta (Fig. 1), San Lorenzo Tenochtitlán, and the gopher and jaguar heads in the park of San Andres Tuxtla.

3) Very generalized, colossal statues like that of a child with a stone box in his hands (Fig. 4), known popularly in La Venta as "La Abuelita" (Granny).

4) Enormous sculpted altars from La Venta and San Lorenzo.

5) Stelae with figures in bas relief, at La Venta, Tres Zapotes, Roca Partida, El Mesón, Alvarado, Tepatlaxco, etc., all places in Tabasco and Veracruz.

6) Stone sarcophogi with cover and jaguar mask (one example at La Venta was reportedly destroyed).

7) Great boxes of carved stone in Tres Zapotes and San Lorenzo.

In objects of jadeite, serpentine, hematite and other fine stones, the variety is even greater, for example:

8) Figurines of personages, perhaps ancestors, standing, crouching, bearded and

*Editors' Note: The monuments of San Isidro Piedra Parada and Santa Magarita are now known by the name of Abaj Takalik ("Standing Stones"). See S.W. Miles, "Sculpture of Guatemala—Chiapas Highlands and Pacific Slopes—and Associated Hieroglyphs," in *Handbook of Middle American Indians*, vol. 2, 1965, p. 246 ff.

hairless, reclining, etc. Little figures of dwarfs or monstrous children, of jaguars or were-jaguars, as well as personages with heads of animals or bird disguises, with wings and the mask of a duck or an eagle.

9) Large and small masks of human types or of jaguar-deities. They are generally hollow in back with fine perforations. There are small convex masks in jadeite, surrounded by small perforations that seem to have been used sewn to a band as a frontal decoration.

10) Celts of all forms and sizes: very large celts with a notch, in the form of were-jaguars. They measure 25 or 30 centimeters in length and must have had very important ceremonial value (Pl. 5). There are celts incised with ceremonial motifs, and some have a strange form with facets that resemble the form of a duck's beak. A variety of colossal anthropomorphic celts are the great jadeite plaques with the representation of the dwarf-jaguar.

11) Articles of personal adornment: rounded or rectangular earplugs, with or without engraved decorations; spherical beads for necklaces, in the form of cala-bashes, and tubular beads in the form of bamboo sections, some made of the finest translucent emerald green jade. Pendants in the form of jaguar teeth and claws, a duck's head, the head of a monkey, links of jade (one in the form of a lizard), parts of the human body: hands, feet, a thumb, arms and legs, a human ear, a skull, a pair of deer jaws, frogs, a large hook, etc. Most interesting is the necklace found by Stirling in a La Venta tomb, or manta ray spines incrusted with small rectangles of crystaline hematite. There was also found a facsimile of a manta ray spine made of blue jade.

12) Another group of objects that could have ritual significance are: large disks of smooth jadeite or with incised motifs, large needles, spatulas, augers, concave tablets, reproductions of clam shells, the so-called *cucharitas* (spoons) of very special form (Fig. 24), that could also be reproductions of shells, the splendid canoe of Cerro de las Mesas (Fig. 21), bulb-form objects with a handle, a large hook and an object in the form of a spear-thrower. All these objects are made of jadeite of the finest variety and must have been of enormous value to their owners. All are of unknown usage and only in the case of the disks do we know that they were used as pectorals. A large mirror of crystalline hematite was found at La Venta, so brilliant as if it had just been made, and later appeared a figurine of a smiling woman of painted jadeite with a thick coating of red cinnabar, with a miniature replica of an identical mirror of hematite hanging from the neck.

Other objects which can be classified as belonging to this artistic complex are the little stone yokes from Guerrero (collections Salo Hale and M. Covarrubias), another from Tehuantepec and another of unknown provenience in the collection of Diego Rivera. These little yokes (Yuguitos) could well be an antecedent of the stone yokes from Veracruz.

Jade being the material *par excellence* at La Venta, it is pertinent to make some comments on where it is found on this continent. Jade objects have been found in abundance in Southern Mexico and in Central America; and the question of whether the material itself is indigenous to Mexico, where it most frequently appears, has always preoccupied those that believe in the importation of cultural elements from Asia to America. Both in China and Mexico, there are many similarities among the use, the methods of carving and polishing the jade, the artistic style, and the beliefs

Plate 5. Types of very large celts and hand-axes. (Upper row, left to right) Aventurine quartz, (British Museum); Jadeite, (American Museum of National History); Grey stone, from Guerrero, (M. Covarrubias Collection); (lower row, left to right) Basalt, (Museum of the American Indian); Jadeite, Mixteca region of Oaxaca, (National Museum of Anthropology, Mexico); Green stone, (U.S. National Museum, Washington).

about its magical powers; it is difficult to totally deny the possibility of such importation. Nevertheless, spectroscopic analysis[10] has clearly demonstrated that the American and Asiatic jades are two distinct varieties of the same stone.*

The Chinese as well as the Mexicans attributed magical powers to jade, and they considered it to be the most precious substances. Both people carved it exquisitely, they wore it as an amulet, they used to make their offerings with it, and they buried their dead with it. For the Chinese of the Archaic Period, 2,500 years ago, jade had the property of impeding decomposition and it was the custom to seal the openings of the body of the deceased with jade objects, putting a locust made of this material, symbol of reincarnation, in the mouth. The ancient Mexicans also had the custom of placing a jade bead in the mouth of their dead. Both peoples painted their funerary jade with a coating of red cinnabar. As if to complicate the problem, the style and ornamentation of certain jades, Chinese as well as Mexican, look very much alike: combinations of meandering rectangles that represent or are derived from stylizations of felines, dragons, or clouds. Jade was for the Mexicans as well as for the Chinese, something more than a simple jewel; they worshiped it as a symbol of divinity and worth, perhaps because it was the color of water, sky, and vegetation. The name *chalchihuitl* and the glyph for jade was synonymous with *jewel* and *precious*. They also supposed jade to have medicinal properties, a belief shared by sixteenth century Spaniards. Certainly the modern name for jade, as well as one of its technical names, *nephrite*, has its origin in the word for the kidneys or of pains of the side that jade was thought to cure. The jade beads which were taken from Mexico were called *stone of the loin* or *of the flank* (in Spanish: *piedra de ijada*).

The question always comes up why jade deposits have not been found in Mexico. The answer is simply that the jade is not found in veins, but rather in isolated pebbles in rivers and gorges where perhaps no one has looked for it. Besides, only an expert would know how to distinguish between an ordinary pebble and one with a jade core. In China there are professional jade prospectors who look for the round stones in the most remote and deepest gorges and whose knowledge of identifying the round stones that contain jade are family secrets. Fray Bernardino de Sahagún tells us a legend that his Aztec informants, who perhaps had only hearsay information, told him:

> There are people who know where the precious stones were created and the fact is that any precious stone, wherever it may be, is casting off from itself vapors or exhalations, like a delicate smoke, and this smoke appears at sunset or sunrise, and the persons who look for these stones and know them, they place themselves in a convenient spot when the sun is rising, and look towards the rising sun; and where they see a delicate smoke rising, then they know that there are precious stones there, or that have been born there, or that have been hidden there; and they go then to that place, and if they find some stone from where that little smoke came out they understand that within it there is some precious stone, and they break it in order to look for it; and if there is no stone where that smoke

*Editor's Note: For an excellent comprehensive study on jade carvings and native sources of jade see Tatiana Proskouriakoff, "Jades from the Cenote of Sacrifice, Chichén Itzá, Yucatán," *Memoirs of the Peabody Museum of Archaeology and Ethnology*, Harvard University, vol. 10, no. 1, Cambridge, 1974.

comes out, they dig in the earth and find some stone box, where there are hidden some precious stones, or perhaps they are hidden or lost in the earth itself.

Also there is another sign, where precious stones are located, especially the ones that are called *chalchihuites*, in the place where they are created, grass which is born there is always green; and it is because these stones give off a fresh and humid exhalation; and where this is they dig and find the stones in which these *chalchihuites* are created.[11]

This reference, fantastic as it may be, suggests the secret methods of the Chinese prospectors for identifying the native jade and points out the existence of professional prospectors of jade among the ancient Mexicans. Jade is found in many parts of the world; besides their traditional places of origin in Asia, Sinkiang and Burma (it is rare in China itself), it is common in Siberia, India, Central Europe, New Zealand, New Caledonia, and New Guinea, and on this continent in Alaska, Mexico, Central America, and Colombia. I have seen several pebbles of jade in the rough in the State of Guerrero and the archaeologist Juan Valenzuela has picked some up in the Tesechoacán River in Veracruz, probably carried down river from the mountains of Chinantla.

The jades of the *Olmec* Period are predominantly the translucent blue-green, spinach-green, or bluish-gray varieties, carved with absolute sureness and skill. The shapes are simple and the surfaces are sensually modeled and polished, with the peculiarity mentioned earlier, of fine and precise incised lines. This style, undoubtedly the most ancient, contrasts notably with those of subsequent epochs: in the Classic Horizon, especially in the Maya zones, and in Oaxaca and Veracruz, the preferred material is opaque grass-green jade. Instead of the fat and nude personages with mongoloid eyes and lips and thick and wide noses, we find tablets of emerald-green jade carved in bas relief with richly dressed personages, with thin and well-proportioned bodies, large oblique eyes, prominent noses, and fleshy but small mouths. They wear monumental headdresses, adorned with plumes and with long quetzal feathers, as well as necklaces, pectorals, jeweled belts, anklets, and decorative sandals. During this period there was a radical change in the indigenous cultures of Southern Mexico: great cities of carved stone and stucco were erected, with monuments of an exuberant and flamboyant style that were the antithesis of the serene simplicity of the previous cultures. There appeared then all kinds of new elements, absent in the culture of La Venta, most characteristic are: serpents, motifs of spirals and plumes of quetzal feathers that pervade the monuments, carved jades, and ceramics. These elements seem to mark the dividing line that separates the Archaic cultures from the so-called Classic, which are more Baroque than Classic. Still later, by the 10th century of our era, there was a Renaissance-like resurgence in the indigenous art that also marks a change in the lapidary technique and the materials in use; in these periods appear white jade, white with green stains, and green with ocre stains. The technique is more conventional and mechanized; methods of mass production were invented which consisted of simple cuts, circles, half circles, and curves made with tubular drills to indicate features. The carving of jade and hard stones became an occupation of expert artisans who were not yet true artists. The inevitable conclusion is that the art of jade carving in the oldest periods was of greater artistic quality because it had not yet been converted into an industry.

The conclusions at which we have arrived in this brief and hasty study of the great culture of La Venta are: that it concerns an art that is not at all primitive, and that it is not just one of so many local styles, but rather a very ancient mother-culture which exerted a definitive influence on the arts of the Archaic Horizon and of the period of transition to the era of the Classic cultures as, for example, the periods of Oaxaca called Monte Albán I and II; the Chicanel Period of the Maya zone that preceded the so-called Old Empire; the Teotihuacán II period; and especially the cultures of the Gulf Coast: Tres Zapotes, Cerro de las Mesas, and El Tajín.

The culture of La Venta seems to have had a long duration and perhaps it may have survived in places like La Venta until the beginnings of the Classic Period. This site seems to be its most magnificent and last stand, until its conservative and aristocratic chiefs had to yield to the growing pressure of the Mayas and Olmecs that surrounded it.

The pre-Hispanic chronology is even more unstable, especially in referring to the earliest periods, and it is not possible to establish the interval of time of *Olmec* duration, although its florescent period seems to be placed around the end of the first millennium B.C. or at least the beginning of the Christian Era.

Neither can one define who were their creators and where their origin was. Their known distribution occupies almost all of the zone of the high Mexican cultures, and we do not know if their creators were ancient Mayas, Archaic Zapotecs or Mixtecs, or Totonacs, Zoques or Popolucas, or whether the culture was shared by several of these peoples which seem to be the most ancient. The physical type of their art survives in Mexico, but it is so widely spread that its existence does not enlighten us on this point. Their religious or ceremonial ideas are of great complexity and present some unique traits in Mexico, like the use of stone sarcophagi, tombs made with natural columns of prismatic basalt, the use of colossal stone heads perhaps as commemorative monuments, very large anthropomorphic celts, tools and adornments especially of jadeite, etc.

Their ideology is equally impenetrable; they represented almost exclusively deities or mythological beings that seem simultaneously to be jaguars and children, or humanized jaguar cubs, as well as dwarf hunchbacks and other deformed beings. The esthetic ideal of their artists was undoubtedly based on their own physical type modified by certain aspects of pathological character and imbued with feline traits.

In summary, the art of La Venta is strong and simple, but wise and vehement, free from the Baroque decoration of the most recent pre-hispanic cultures. It is interesting that while other cultural complexes have *Olmec* characteristics, this style does not possess traits or elements of other cultures, except of the so-called Archaic. The *Olmec* style does not have anything of the terrifying necrophilia of the Aztecs, nor of the complicated symbolism of the Mayas, nor of the orderly and flowery art of Teotihuacán at the end of its period. Nor does it resemble the arts of West Mexico, so vigorous and brutal. On the other hand, it is definitely related to Archaic art, and in a form more remote yet discernible with the more ancient art of Teotihuacán, and to the so-called Totonac style, to the oldest forms of Mayan art, and to Zapotec objects, which themselves become more *Olmec*-like the older they are.

Notes

[1]At the end of the last century and basing himself on the Indian tradition, Del Paso y Troncoso had already classified as *Olmec* the little clay figurines that until then were not called Archaic. Later, Hermann Beyer classified a green stone idol of this style as *Olmec*. Following this classification, Saville and Vaillant wrote the first study of the *Olmec* style. At the Mesa Redonda of Tuxtla in Chiapas, Jiménez Moreno established as Olmecs the inhabitants of the *rubber region*, i.e., the coast of Veracruz. As these are made up of five distinct periods and cultures not precisely related to the creators of the *Olmec* sculptures, it was agreed to change the name of this culture to the "culture of La Venta," a place in the Tabascan jungle where its most important monuments were found; but the custom of calling them *Olmecs* had already been rooted and they will undoubtedly be continued to be called by that name. (See W. Jiménez Moreno, "El Enigma Olmeca," in *Cuadernos Americanos*, vol. 5, 1942).*

[2]Objects of *Olmec* style persistently appear in the States of Guerrero (the Rio Balsas basin and the Costa Grande), Oaxaca, Puebla, Morelos, and especially in Tabasco, southern and central Veracruz, Chiapas, Guatemala, and Honduras. Nevertheless, the greatest geographic extension where *Olmec* objects are found form a great triangle with apexes in El Opeño, Michoacán, the Papantla region in Veracruz, and from there south to the province of Guanacaste, Costa Rica. Its most important monuments in situ are found at Tres Zapotes, Los Tuxtlas, San Lorenzo Tenochtitlán, all in Veracruz, in La Venta, Tabasco, in Monte Albán, Oaxaca, as well as the reliefs on rocks in Chalcatzingo, near Jonacatepec, Morelos (described by Eulalia Guzmán), Hacienda Miraflores and at Piedra Parada, near Quetzaltenango, in Guatemala.

[3]*Mayas y Olmecas*, Second Meeting of the Mesa Redonda on Anthropological Problems of Mexico and Central America, Tuxtla Gutierrez, 1942.

[4]It is curious that the jade earplugs, an adornment so common among the pre-Hispanic peoples, are absent from the majority of the *Olmec* objects, except on the monuments and some figurines from La Venta. Also in Archaic Art the earplugs do not appear on certain figurine types (D-1 and C-9) that have a great affinity with the *Olmec* type. The perforation of the septum of the nose would serve perhaps for hanging a jade ornament, and in many cases we see representations of personages with a bead hanging from the nose. This adornment is common in the Archaic figurines (types C and B) and could be an antecedent of the noseplugs of later cultures.

[5]Marshall H. Saville, "Votive Axes from Ancient Mexico," in *Indian Notes*, Vol. VI, No. 3, New York, 1929.

[6]Jean Basset Johnson, "Notes on the Mazatecs," in *Revista Mexicana de Estudios Antropologícos*, vol. II, No. 2, Mexico, 1939.

[7]Donald Cordry, *Zoque Notes*, Pasadena Museum, California, 1942.

[8]George M. Foster, *Notes on the Popoluca of Veracruz*, Mexico, 1940.

[9]The tips of the adornments of Xipe, bifurcated in the form of a swallow's tail, are a basic motif of the La Venta style which appear on the jaguar of Necaxa (Fig. 8) on a kind of little skirt of ribbons that end in double tips. The horizontal bands, the head scarf, and the seam or vertical line that crosses both sides of the face of Xipe also are seen in *Olmec* art where they appear as very stylized incised profiles.

[10]Norman and Johnson, "Note on a Spectrographic Study of American and Asiatic Jades," in *Journal of the Optical Society of America*, 1941.

[11]Sahagún, *Historica General de las Cosas de Nueva España*, Book XI, pp. 277-278, Edición Robredo, 1938.

*Editor's Note: The term Olmec is now acceptable usage when referring to the ancient culture and art style that Covarrubias referred to as *Olmec*. The so-called historical Olmecs are now called by their specific local archaeological designation.

The Iconography of
An Engraved Olmec Figurine

Gary W. Pahl

In the winter of 1972 the writer was invited to catalog a private collection of Mesoamerican artifacts in southern California. Among them was the stone Olmec figurine which is the subject of this paper. It seems to be unique because of the iconographic symbols extensively engraved on its torso.

Mr. Hasso von Winning, of the Southwest Museum, informed me that he first authenticated the somewhat restored figurine at the request of the owner. Subsequent to its acquisition the owner permitted the Los Angeles County Museum of Art to display it for an extended period in 1972. In March of the same year a photograph of the figurine was published in a catalog of the collection co-authored by the writer. To date, however, no discussion of the iconographic detail on the piece has been published.

The full-round figurine, with traces of red pigment in its tattoo-like body engravings, represents a nude male individual, perhaps wearing a codpiece as his sole article of clothing. It measures approximately 38 cm. in height, 12 cm. at its widest point, and 6 cm. at its thickest. The material is a type of serpentine, dark green in color with a slightly waxy surface texture. The figurine is carved in a rigidly upright standing position, the arms hanging down from the shoulders and connecting with the hips. The gouging saw-cuts at the back of the shoulders, and the diagonal plane cut from the back of the head are probably the result of the *huaquero's* (pothunter's) attempt to find matching stone material for restoration of the facial region of the head. Drilled holes in the hands of Olmec figurines are not uncommon, but normally each hole is characteristically biconical (i.e., drilled from both sides of the stone so that the hole narrows toward the center) as a result of the usual Precolumbian drilling technique. The restorer may have drilled into existing holes in the hands for restoration material.

Authentication of Precolumbian stone artifacts is usually a very difficult task without positive proof of provenience verified by members of a scientific archaeological team. However, the amount of visible restoration to this figurine, together with those restorations found through radiological examination, bear additional testimony

Reprinted from *The Masterkey*, Vol. 49, No. 3, 1975. Published by the Southwest Museum, Los Angeles.

to its probable authenticity. The figurine was evidently discovered in a very broken state by a *huaquero* who nevertheless recognized its potential economic value because of the extensive engraving. With this in mind the *huaquero* probably tried to restore the object himself, resulting in its current battered and defaced condition. It would seem very unlikely that any self-respecting falsifier of Precolumbian artifacts would so deface a figurine if he was constructing the artifact from "scratch." Scars, like the saw-cuts in the back of the arms and the cut on the back of the head, would reflect adversely on his ability as a craftsman. Contemporary Precolumbian forgers are much too sophisticated for such shoddy craftsmanship.

Radiological analysis of the figurine revealed that it was broken in several places and subsequently repaired. Both of the legs were broken off and replaced, as was suggested by the numerous cracks which appeared across them just below the base of the trunk. Side-view X-rays reveal a great deal of restoration to the head. It appears that the face was so badly damaged when discovered that the finder sawed it off and replaced it with an unbroken and more marketable piece of stone cut from the back of the head, hence the diagonal plane seen there. The newly carved face was attached to the remaining material of the head with ground stone and an undetermined type of glue base. The effect given in the X-rays is sandwich-like, with the face of the figurine and the back of the remaining head material separated by a thick layer of the groundstone compound.

While the figurine in general is not in the best of condition, the remarkable engraved detail of iconographic symbols remains perceptible for the most part.

The panoply of iconographic symbolism which dominates this figurine is the feature which makes it worth studying. The number of such objects which carry as much engraved detail is limited, and almost all such finds have been made by *huaqueros*.[1]

The engraving on the present figurine runs in a network of related symbols from the front of the torso to the back, and is characterized by a great deal of punning with line. The pattern on the chest and right leg is dominated by the side view of a seated individual who holds up an offering. He is seated on a dais marked by a Kan-cross symbol. Extending down from the dais, and onto the leg of the figurine, hangs a mantle which ends in a tassle device which is punned as the head and legs of a saurian monster. The whole pattern on the front of the torso, extending from the right arm of the figurine to the middle of the right leg, appears to represent a fully extended serpent. The headdress of the seated individual serves as the three-tiered rattles of the serpent's tail.

The lines of the engraving on the front of the figurine are intended to lead under its right arm to the related engravings on the back; however, the lines fade out under the right arm. The engraved lines begin again on the back of the figurine, giving the impression of extending around from the front. The whole engraved pattern on the back represents the arm and leg of an anthropomorphic individual, possibly that of the individual shown seated on the front of the figurine since no other anatomical features of the engraved character on the back are visible (Fig. 1).

In examining the iconography of the engraving in detail the seated individual on the front of the figurine will be dealt with first. Sitting in a cross-legged pose, he wears an ornate headdress, a loin-cloth, and possibly a pectoral. The individual is

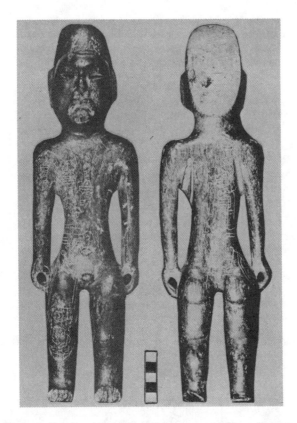

Figure 1. Front and back sides of the engraved Olmec figurine.

undoubtedly male, judging from his brief costume. His facial features are all but obliterated by weathering, but raking-light photographs and close observation aided in making a composite drawing of the seated individual (Fig. 2). The eye is a pendant or "trough-shaped eye" (PDJ-6B). There is a remote possibility that an eye-stripe extends through the eye, but the almost imperceptible lines may be attributed to the grain of the stone or its highly eroded surface. The hair is plaited in a criss-cross fashion, and is bound at the end by a band indicated by four lines with two ornamental dots between the central two lines. The ear and the pendant ear ornament do not appear in the Joralemon classification.[2] The loin-cloth is depicted briefly by two horizontal lines with perpendicular lines representing stripes; a knotted back flap for the loin-cloth is indicated by a simple geometric pattern. A faint arm-band and two bracelets decorate the uplifted arm.

The three-tiered headdress is the dominant article of the individual's costume. The three-tiered portion has been identified by Joralemon (PDJ-50) as "rattlesnake buttons," but some additional lines and dots occur in this example. The foundation appears to be a tightly wrapped turban decorated by three dot ornaments. The object protruding from the rear of the headdress probably represents the stalk of a maize plant, if the dangling piece at the end of the stalk is correctly interpreted as a type of maize symbol (PDJ 88, 91, 95, 96). The three ornamental dots of the turban may also

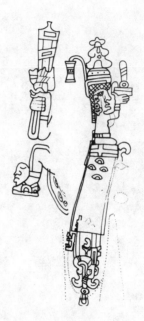

Figure 2. Drawings of the engravings on front and back sides of the Olmec figurine.

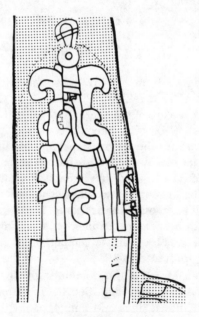

Figure 3. Enlarged drawing of detail from the saurian monster's head.

symbolize maize (PDJ 91 or 95). The importance of the maize is emphasized again in the symbolic offering held aloft by the individual—clearly a banded maize glyph (PDJ 88) emerging from a maize seed (PDJ 91). Judging from the repetition of maize symbols in association with the seated individual, it might be safe to assume that he represents a priest of a maize or fertility cult. The previously mentioned Kan-cross symbol upon which he is seated is also easily recognizable as a maize symbol.

The curling device in front of the Kan-cross symbol seems purely ornamental, but the extension of lines beneath it can be doubly interpreted as a mantle or cloth and the trunk of the saurian monster which the whole design on the front of the figurine represents. Just beneath the Kan-cross glyph appears a diamond-shaped arrangement of four inverted "trough-shaped eyes" (PDJ-6B). The significance of these eye symbols, if they represent nothing else, is difficult to determine.

At the terminal end of the extended lines a saurian monster is depicted in detail (Fig. 3). Hasso von Winning has suggested (personal communication) that the monster is reminiscent of Kidder's Serpent X (Kidder, *et al.* 1946: 223-225). Enough of the characteristic elements of Serpent X are present to make von Winning's suggestion quite acceptable.

Serpent X Elements

Kidder's Serpent X elements [1946:223-225]:
1. long snout curved downward at the end.
2. snout crossed midway to the end by one or more lines.
3. rod-like antenna devices in nostril area.
4. sharp hook element parallel and below snout.
5. lower jaw not always present.
6. hook for eye.
7. supra-orbital plaque often with flattened U-shaped element inside.

Serpent X elements on the monster:
1. long snout curving upward and downward at the end.
2. extension from mouth crossed midway by double lines; lips also striped in same way.
3. nostril represented but not extended.
4. hooked lower lip.
5. supra-orbital plaque with flame-eyebrow motif (PDJ-5).

In addition to these Serpent X elements the saurian monster has further distinct elements. At the distal end of the striped projection, listed above as "Serpent X elements on the monster, 2", the "banded-maize" symbol is repeated. A peculiar element, not recognizable in Joralemon's catalog, is positioned in the ear area. To the right of this inverted U-shaped element are two designs similar to the previously mentioned " rattlesnake buttons" (PDJ-50). Although these two designs are associated with a reptile, here their function does not logically serve as "rattlesnake buttons." Beneath the trunk of the saurian monster the artist depicts two geometric claw projections which do not occur in the Joralemon catalog. More geometric patterns were once present to the left of the ear and the claw area but have since been defaced beyond recognition.

Summarizing the elements of the saurian monster in relation to the seated individual depicted above him on the figurine's torso, and the abundance of Serpent X elements, it is tempting to suggest that the saurian monster engraved here may have been antecedent, or perhaps an early form, of the Serpent X motif. The dominance of

the maize theme in connection with the Olmec saurian monster, if we can extend the theory that this monster is an early form of Serpent X of Izapan and Maya cultures, strongly suggests that Olmec saurian monsters, and possibly Serpent X, had very close association with matters of fertility and maize in early Precolumbian beliefs. This, in turn, leads to the speculation that the Serpent X concept may have developed in the Olmec Heartland rather than the Pacific coast of Guatemala, as Quirarte has so ably discussed (Quirarte 1973:11-30).

Passing to the engraved character on the back of the figurine, the impression is given that the seated individual on the front is stretching an arm and a leg around the right side of the figurine in a straddling posture (Fig. 4). The hand of the character on the back extends a scepter, or torch-like object, the handle of which extends downward parallel to the forearm. The portion of the torch-like object directly above the hand is a beaked avian head sprouting a maize symbol variants of PDJ-81, 88 and 96) from its cleft and striped head. Another maize symbol rests on the forehead and beak of the avian head (variant of PDJ-81, 88, or 96). The composite picture of this

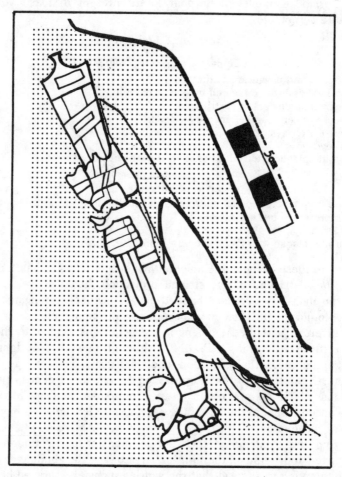

Figure 4. Enlarged drawing of engraved arm and leg from back of Olmec figurine.

character with avian and maize motifs is an amalgamation of Joralemon's Gods II and III, respectively, the maize god and the god with dominant avian characteristics (Joralemon 1971:170-205).

The leg of this same character on the back of the figurine bends around its right hip and bears a frontal stripe which extends down to an anklet. A head with closed eye (presumed to be a death's head) is attached to the anklet and the sandal.

A curious liquid emission, bearing three "trough-shaped eyes" (PDJ-6B) like those found beneath the seated individual on the front of the figurine, passes from the anal region of the engraved leg. A similar disgorgement theme is to be found in Maya art and iconography. Maya earth monsters (*Cipactli*) are closely associated with water and fertility (Thompson 1970:220). Alta T from Copan carries a sprawled earth monster which is disgorging liquid from its bowels. In Codex Madrid (page 31a) the rain god (Chac) is shown with water gushing from between its legs (Thompson 1970:258). The same disgorgement theme shown engraved here on an Olmec figurine, although not directly associated with an earth monster, indicates that this theme is quite probably a mythological "survival" handed down from the Olmec to the Maya.*

The saurian monster from the engravings on the front of the figurine, which carries the "trough-shaped eyes" on its trunk, may be another method of expressing fertility. In this case the saurian monster may act as an early form of the earth monster in close association with maize symbols.

The dominant theme of the engraved symbols on the figurine is clearly related to fertility, and especially maize. A total of six maize symbols are readily discernible on the figurine: (1) the maize offering of the seated individual, (2) the maize stalk and symbol which arise from the back of the seated individual's headdress, (3) the maize symbol emerging from the mouth of the saurian monster, (4) the Kan-cross symbol for maize and the color yellow (Maya), (5) the stylized maize symbol which emerges from the cleft of the avian head, and (6) the maize symbol attached to the beak and forehead of the avian head. These six maize elements, combined with the death's head ornament, the disgorgement theme, and the probable saurian monster, suggest the natural life-cycle and the notion of regeneration in death. Based on these suppositions and identifiable symbols, one might speculate that the figurine served as a cult object with important significance for matters of fertility, but only further archaeological research with the good fortune of locating more figurines *in situ* will be able to bear out this hypothetical observation.

*Editor's Note: Upon reviewing Lathrap's article on Chavin art (this volume), the author is willing to entertain the possibility that the eyes of this motif may be indicative of manioc, a typical lowland cultigen.

Notes

[1]Other figures with a considerable amount of engraved iconographic symbolism which can be consulted for comparison are: Las Limas figurine (Coe 1968:115); El Baul figurine (Shook 1956); Idolo de San Martin Pajapan (Clewlow 1970: Fig. 1-3).

[2]All references to iconographic symbolism are based on the compilation of Olmec iconographic symbols published by P.D Joralemon (1971). Anatomical terms and articles of costume follow the terminology developed by C.W. Clewlow (1974:11-14).

Bibliography

Clewlow, C.W.
 1970 Comparison of Two Unusual Monuments. *Contributions*, No. 8: 35-40. Archaeological Research Facility, University of California. Berkeley.

 1974 A Stylistic and Chronological Study of Olmec Monumental Sculpture. *Contributions*, No. 19: Archaeological Research Facility. University of California. Berkeley.

Coe, M.
 1968 *America's First Civilization*. American Heritage. New York.

Joralemon, P.
 1971 A Study of Olmec Iconography. *In* Studies in Pre-Columbian Art and Archaeology, No. 7. Dumbarton Oaks. Washington.

Kidder, A.V., *et al*
 1946 Examinations at Kaminaljuyu, Guatemala. *Publication No. 561*. Carnegie Institution of Washington. Washington.

Quirarte, J.
 1973 Izapan and Maya Traits in Teotihuacan III Pottery. *Contributions*, No. 18: 11-30. Archaeological Research Facility. University of California. Berkeley.

Shook, E.
 1956 An Olmec Sculpture from Guatemala. *Archaeology*, Vol. 9, No. 4: 260-262. Brattleboro.

Thompson, J.E.S.
 1870 *Maya History and Religion*. University of Oklahoma Press. Norman.

Olmec Felines in Highland Central Mexico

David C. Grove
University of Illinois

Although it has been noted that purely zoomorphic jaguar representations are rare in Olmec art (Furst 1968:148), they are present in the monumental art, including that of Mexico's central highlands. Here, in addition to purely zoomorphic forms, the feline is also shown in varying degrees of stylization. In this the highland Olmec art differs little from its Gulf Coast counterpart. Although we tend to identify the felines in Olmec monumental art as jaguars, it is only in the painted art that typical jaguar markings such as spot motifs occur. Since the great majority of felines in Olmec art occur in carvings lacking identifying characteristics, their jaguar identification is hypothetical. However, there is good reason to suspect that many Olmec carvings were painted. Stirling (1943:58) found traces of paint on a colossal Olmec head, and it seems possible that jaguar-spot motifs as well as other iconographic devices were once painted on the carved feline representations.

Chalcatzingo, Oxtotitlan, and Juxtlahuaca are the three highland sites known today to have major monumental Olmec art. These have all been reported upon previously (e.g., Gay 1967, Grove 1968a, 1970) and need not be discussed completely here. This paper will discuss feline representations at these sites, and particularly at Chalcatzingo, but a few general comments appear appropriate first.

While the general consensus today is that highland Olmec art is derived from a Gulf Coast Olmec source, there are some who for a variety of reasons still believe in the highland origin of Olmec culture. Simply from the standpoint of the art style (and not considering the archaeological data which currently confirms Gulf Coast priorities), a highland origin for Olmec culture seems incorrect. The jaguar of feline motif is popular in highland Olmec monumental art, but there is little if any data to indicate that jaguars were native to the highlands during the past three thousand years. However, the jaguar abounds along the Gulf Coast, and so too do the major Olmec

Reprinted from *The Cult of the Feline: A Conference in Pre-Columbian Iconography*, Elizabeth P. Benson, editor. Published by Dumbarton Oaks Research Library and Collections, Trustees for Havard University, 1972.

ceremonial centers. The presence of Olmec art in the highlands can best be explained at this time by diffusion from a Gulf Coast center or centers.

The manner of the diffusion from the Gulf Coast to the highlands is important to a proper interpretation of the highland feline motifs, for the mechanism by which they arrive in the highland locale may determine to a large degree the iconographic significance placed upon them there. The basic question is, was the art brought to the highlands by Gulf Coast culture carriers, or did it diffuse independently of actual contact? The latter situation would suggest that different iconographic values and roles might be placed upon the art. The similarities between the highland and Gulf Coast Olmec styles are so close as to suggest not only actual contact diffusion, but also that the persons executing the art were quite familiar with the style and iconography, and were in all probability themselves from the Gulf Coast. The manner through which such contacts could have occurred has been explored in other articles (Coe 1965:123; Flannery 1968; Grove 1968b, 1970; Grove and Paradis 1971) and need not concern us here.

Does the jaguar in Olmec iconography represent one or a manifold concept? Miguel Covarrubias (1957:57-60, Fig. 22) stressed the Olmec jaguar as a rain deity which eventually evolved into the rain gods of later Mesoamerican civilizations. Peter Furst, on the other hand, suggested that Olmec jaguar symbolism is related to shamanistic transformations (1968:150). Ignacio Bernal (1969:103) and others feel that no particular deities were present in Olmec religion, a conclusion not supported by the recent investigations of Michael Coe (1968, this volume) and David Joralemon (1971). It appears obvious to me that the jaguar enjoyed a number of iconographic roles including some related to rain or to transformation, and others just now becoming apparent. Regarding the rain-deity aspect, to be discussed further below, this concept may have been deeply rooted in Gulf Coast Olmec mythology, and during the zenith of Olmec culture overpowered in the art by more dominant jaguar themes. However, the evolution of the were-jaguar face into the goggle-eyed rain deities of the Classic and Post-Classic (e.g., Covarrubias 1957:Fig. 22) seems doubtful. Painting A-3 from Oxtotitlan (Grove 1970:Fig. 27) and a recently discovered and yet unpublished Chalcatzingo carving both exhibit the goggle-eye motif. Both are apparently Olmec and Early Formative. The goggle-eyed deity is unknown on the Gulf Coast at this time period, and its early presence in the highlands suggests that it may be a highland innovation.

The Chalcatzingo bas-reliefs contain a number of feline representations, including one purely zoomorphic and several stylized only in the head region. Several highly stylized jaguar-monster faces also occur. These carvings are discussed individually below.

Relief III (Figure I)

The feline in this large boulder bas-relief is purely zoomorphic, with no apparent stylistic embellishments. In general form it is unlike most jaguars shown in highland Olmec art. As with all carved felines, it lacks the jaguar-spot motifs, but is depicted with a line along its side. It is possible that this feline represents a puma rather than a jaguar, for the puma has much lighter coloration on its undersides—if this is what the line along its side is actually depicting. This feline is shown in a prone position, quite similar to the felines of Rio Chiquito Monument 2 (Stirling 1955:8, Pl. 3) and

Figure 1. Relief III, Chalcatzingo

Monument 7 from San Lorenzo (Stirling 1955:13, Pl. 17). However, the Relief III feline is depicted with its tongue touching or licking an unusual plant. In comparing this plant to the current flora of the Chalcatzingo region, the closest similarity appears to be with the cardon cactus, *Lemaireocerus weberi*. The fruits of this tree cactus were gathered for food in Pre-Hispanic times. Of course, this identification is extremely tenuous, for it is equally probable that the plant illustrated is highly stylized or even mythical. The act of the feline's tongue licking the plant could perhaps symbolically represent ingestion of something from the plant. Furst's (1968) suggestion concerning shamanistic transformations could be employed in interpreting this carving; the animal might be ingesting a psychoactive alkaloid from the cactus, while the feline would represent the transformed state. Furst recently has noted (personal communication) that the cardon cactus is currently sold in the "curing" sections of some Mexican market places and that at least one species in Peru contains mescaline. An argument against an interpretation of transformation in this scene would be Furst's own observation (1968:148-9) that his "transformed shamans" are not zoomorphic but are shown as were-jaguars.

Relief IV (Figure 2)

This relief is the only monumental Olmec art known today which depicts two felines or jaguars together. With the exception of their stylized heads, these jaguars can be considered zoomorphic. There is general similarity in the manner in which each jaguar is represented. They have similar body postures and elaborate head ornamentation, both lack ears, and each has a cartouche containing a St. Andrew's cross over its eye. Both in addition are depicted with unsheathed claws, crouching over or leaping upon prone human figures. However, these jaguars also exhibit several significant differences between them. The face of the upper jaguar is shown

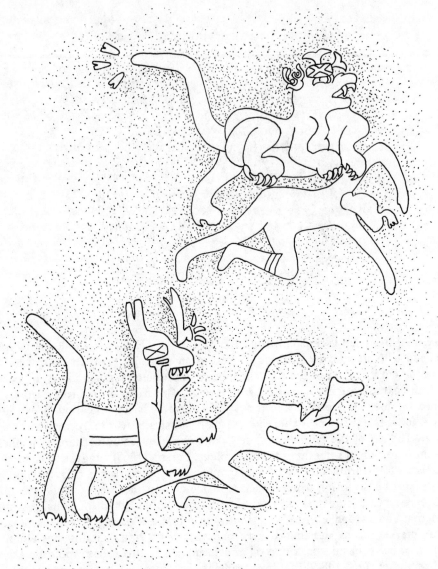

Figure 2. Relief IV, Chalcatzingo.

with a snarling mouth with upper gums exposed, and the animal's eye is represent
represented. Its head ornamentation includes the motif which Coe (this volume) has
connected with the corn deity. In the area where the ear should be represented there
is a symbol or glyph which is difficult to discern on the carving today, but which
appears similar to Maya glyphs for Venus (e.g., Thompson 1960:Fig. 22.51) and to the
Olmec capital-U element which is often shown with stylized plant motifs within it. In
this case it shows similarities to stylized plant motifs on Chalcatzingo Relief IX (Fig.

4c). The tail of this jaguar has three "notched" elements radiating from its tip. These are similar in shape to many small Olmec jade "axes" and to the Olmec notched-fang motif. The ornamentation of the lower jaguar is contrastingly different. Its eye is a narrow, vacant slit; its fanged mouth lacks the snarling, exposed gums; and in addition this animal has a stripe running along its side and up to its eye. The vacant eye and stripe are reminiscent of Xipe symbolism. Of particular importance is the head ornamentation of this jaguar, with the long plumes at the forehead and the long notched piece at the rear. This is identical in form to the headdress worn by one of the standing masked Olmec figures of nearby Relief II (Fig. 3).

The St. Andrew's cross above the eye of each jaguar is probably significant to their proper identification, as few Olmec jaguars have this iconographic device. To the Maya it appears to have represented sky, heaven, or divinity, and in Olmec art it may, when enclosed in the cartouche, be a symbol indicating a deity. It suggests that these jaguars are jaguar deities. The plumed forehead of the lower jaguar and the "corn motif" of the upper jaguar suggest they are in some manner fertility deities. The figure in Relief II (Fig. 3) is probably a priest representing the same deity as the lower jaguar. Within the headdress of the standing figure is a motif which I have earlier suggested (1970:9) was an Olmec glyph for water, which in my opinion tends to support the fertility aspects in both these reliefs.

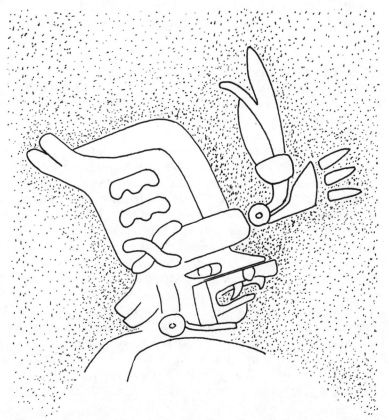

Figure 3. The masked face of a standing Olmec figure in Chalcatzingo Relief II.

Because the jaguars are ornamented differently, are they different deities or simply different aspects of the same jaguar deity? This is a difficult question to answer, for the dividing line between separate deities and separate aspects is often quite vague. The fact that they are different may indicate that in Levi-Straussian terms they are an opposition of deities, such as life and death, day and night, or sky and underworld. The fact that they are depicted together on the same relief may imply a concept of duality. Thompson (1970:293) has pointed out the duality in the Maya jaguar god who reigns both in the sky and under the earth. The concept of duality was particularly strongly associated with Mesoamerican creator gods who in turn were strongly associated with fertility concepts and symbolism (Caso 1958:9-10). The normal association of the jaguar in Mesoamerican religions was with caves, the night sky, and the underworld. The mythical origins of Mesoamerican foodstuffs were often also attributed to caves and the underworld (Nicholson, n.d.:6).

It would be unrealistic at the moment to attempt a definite interpretation of this relief, other than mentioning its fertility aspects. Using various types of ethnographic and ethnohistoric data a number of analogies, none of them completely satisfactory, can be offered. For example, the depiction of the jaguars leaping upon human figures is quite similar to the idea of domination discussed by Gerardo Reichel-Dolmatoff (this volume). He also spoke of a culture group thinking of themselves as jaguars, and of neighboring groups fearing them because they too believed them to be jaguars. If we were to ignore the deific aspects of our two jaguars, we could hypothesize that they represent Jaguar-People (the Olmecs) dominating or "conquering" non-Olmecs: the Gulf Coast "conquest" of the highlands. In this case the stylistic differences in the jaguars would have to be interpreted as designating different clans or possibly different Olmec centers. While this idea may appeal to those who hypothesize militarism as an explanation for Olmec art in the highlands, it is probably incorrect.

It would be difficult to ascribe a theme of shamanistic transformations (e.g., Furst 1968) to this relief. While the jaguars could represent visions, alter egos, or *naguales* of the prone human figures, the positioning of the jaguars and their overall ferocity make such an interpretation improbable. They appear to be attacking the humans. There are a number of mythical accounts in Mesoamerica concerning jaguars attaching humans, etc. I would like to briefly mention two, both dealing with the destruction of the world. The present-day Lacandón Indians believe that the world will end with jaguars devouring the sun and the moon (Cline 1944:111). Could the human figures in Relief IV represent these celestial bodies? In the Pre-Hispanic creation myth of the five Suns, the initial Sun is presided over by the jaguar. At the end of this Sun, jaguars devour the giants inhabiting the earth. I occasionally wonder if a trace of historical reality lies behind this legend. The chronicles discussing this myth present actual time spans which place the beginning of the Jaguar Sun at 1050 or 955 B.C., dates which fall within our archaeological time span for Olmec culture. I infer no accuracy to mythical time spans, and the similarity to Formative chronology may be purely coincidental, but it is interesting that jaguar symbolism is strong in Olmec culture. Does the myth faintly remember the dominance of Jaguar-People (Olmec) during a date far in the past? A Lacandón myth (Cline 1944:108, 110) states that one of the first groups of people created on the earth were named the Jaguar-People.

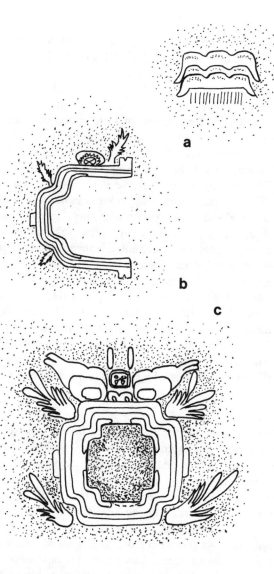

Figure 4. A: Rain-cloud motif from Chalcatzingo Relief I.

B: Jaguar-monster-mouth motif from Chalcatzingo Relief I, representing a cave.

C: Relief IX, Chalcatzingo.

Reliefs I and IX (Figures 4b and c)

Because of their similarities, these carvings will be considered together. Both represent stylized jaguar-monster mouths, although this identification is certainly more apparent in Relief IX (Fig. 4c). Relief I (Fig. 4b) shows the jaguar-monster mouth in profile, as a U-shaped niche. Atop this niche is an eye motif with St. Andrew's cross and flame eyebrow which aids in its identification. The connection between earth-monster or jaguar-monster mouths and caves is well documented for Pre-Hispanic Mesoamerica. Above the stylized jaguar-monster-cave mouth of Relief I are three tri-lobed rain-cloud symbols (one shown in Fig. 4a), all similar in execution and shape to the typical were-jaguar or "baby-face" mouth so prominent in Olmec art. Whether this is purposeful symbolism or simply artistic expression is unclear at the moment. Plants are shown sprouting at various places on this relief, including

from the U-shaped niche itself. This relief clearly represents an association of caves, rain, and agricultural fertility. The style and execution of Relief IX are quite similar to that of Relief I. The cruciform mouth of Relief IX in frontal view is the same basic shape and form as the profile mouth of Relief I. Relief IX also has plants shown sprouting from its corners. The plants on Relief I appear to represent maize, but the long double spikes emanating from the Relief IX plants seem to preclude an identification as maize, amaranth, maguey, etc. Of course, these plants may be highly stylized and beyond identification. There is some similarity between these double spikes and the unusual motif on the rear of the head of Relief IV's upper jaguar, which could be interpreted as the Olmec U-element with the double spike growing from it. The association of plant motifs with jaguar-monster mouths is not a phenomenon restricted to highland Olmec art. Stylized plants occur with the jaguar-monster mouth of Altar 4 at La Venta (Drucker, Heizer, and Squier 1959:Pl. 56b), and grow from the U-element. In all these cases the jaguar-monster mouth appears to represent a cave, again reiterating the cave-jaguar-fertility association.

Gordon Ekholm (personal communication) has recently suggested that Relief IX may have been a free-standing slab rather than attached to the Chalcatzingo cliff face (Grove 1968a:489-90). The cruciform mouth is hollow and shows a definite wearing of its lower edge, indicating it probably once served as a passageway. Furst (personal communication) mentions the use of the jaguar mouth symbol in initiation ceremonies of South American tropical forest tribes, with initiates being "re-born" in passing through the jaguar's mouth. Relief IX could have served a similar ceremonial purpose.

Olmec Painted Art

Today our only evidence of the olmec painted art form is preserved in the Guerrero caves of Oxtotitlan and Juxtlahuaca. Both have recently been discussed in detail (Gay 1967; Grove 1970). Three jaguar representations are known from Oxtotitlan and two from Juxtlahuaca. These latter occur deep within the cave in apparent affirmation of Olmec associations between the jaguar and caves. In this case the jaguar paintings probably decorated ceremonial chambers. The relationship between jaguar and cave is also present at Oxtotitlan. Mural 1 at the site (Grove 1970:frontispiece) contains an elaborate jaguar-monster face painted directly over one mouth of the actual cave. Within the cave, painting 1-d (Grove 1970:Fig. 13) shows a human and a jaguar in an apparent act of sexual intercourse. Since representations of this nature also occur in Gulf Coast carvings, this appears to relate to Olmec concepts of mythical origins of the Jaguar-People." I believe that these mythical jaguar-human origins are associated with caves, as at Oxtotitlan, and that the large stone "altars" found at San Lorenzo and La Venta relate in their iconography to this concept. These Gulf Coast altars generally portray a jaguar-monster face above and/or surrounding a concave niche at the base of the altar. Human figures are shown seated in (or emerging from) these niches, often holding were-jaguar infants. The mating of human and jaguar and the birth of infants with jaguar features is strikingly similar to the Paez myths discussed by Reichel-Dolmatoff (this volume). The altar niches beneath the jaguar-monster mouths certainly represent caves, the same association which appears with the jaguar-monster mouth symbolism in the highlands. In at least two cases (San Lorenzo Monument 14 and La Venta Altar 4) the figure emerging from the altar niche-cave grasps a rope which passes along the base of the altar to the wrists of

human figures carved upon the altar's sides. While this may represent captives, the probable interpretation is that the rope represents *tlacamecayotl*, the "human rope" of kinship bonds such as discussed by Carrasco for Post-Classic central Mexico (Carrasco, n.d.:28).

Finally, a number of otherwise human representations in highland Olmec art are shown with the were-jaguar or "baby-face" mouth. Coe (1968:114; this volume) has demonstrated that the were-jaguar face occurs on a number of Olmec deities and thus need not be restricted to the concept of shamanistic transformations. In the highlands these baby-face figures are often shown wearing serpent or bird-serpent masks. This indicates to me that the artistic canon of the baby-face mouth in these cases is something apart from an iconographic symbol. Two plausible explanations I can suggest are that it is an artistic means of denoting priests, or a means of denoting a Gulf Coast (jaguar) person from a "non-Olmec." Ethnic identification with the baby-face mouth has been proposed previously (Covarrubias 1957:58); Soustelle 1966: 35). Quite often the human figures which lack the baby-face mouth are bearded, both in Gulf Coast and highland Olmec art. Perhaps the bearded figures (e.g., Chalcatzingo Relief II, La Venta Stela 3) represent central highlanders.

In summary it seems apparent that there is no one concept involved with the feline motif in Olmec monumental art. The art of the highlands and Gulf Coast appears complementary, as one would expect from a direct and intensive contact situation (at least at the sites discussed). The feline motif appears associated with a complex conglomeration of ideas related to origins, fertility, and probably also rulership. The feline can generally be identified as the jaguar, and its abode, caves and the underworld.

Bibliography

Bernal, Ignacio
 1969 The Olmec World. (Translated by Doris Heyden and Fernando Horcasitas.) University of California Press, Berkeley and Los Angeles.

Carrasco, Pedro
 n.d. The Social Organization of Ancient Mexico. Submitted for *Handbook of Middle American Indians* (in press). Mimeographed copy.

Caso, Alfonso
 1958 El Pueblo del Sol. Fondo de Cultura Economica, Mexico.

Cline, Howard
 1944 Lore and Deities of the Lacandon Indians, Chiapas, Mexico. *Journal of American Folklore*, vol. 57, pp. 107-115. Philadelphia.

Coe, Michael D.
 1965 The Jaguar's Children: Pre-Classic Central Mexico. The Museum of Primitive Art, New York.

 1968 America's First Civilization: Discovering the Olmec. New York.

Covarrubias, Miguel
 1957 Indian Art of Mexico and Central America. New York.

Drucker, Philip, R.F. Heizer, and R.J. Squier
 1959 Excavations at La Venta, 1955. *Bureau of American Ethnology, Bulletin 170.* Washington.

Flannery, Kent V.
 1968 The Olmec and the Valley of Oaxaca: a Model for Inter-regional Interaction in Formative Times. *In* Dumbarton Oaks Conference on the Olmec (Elizabeth P. Benson, ed.), pp. 79-110. Dumbarton Oaks Research Library and Collection. Washington.

Furst, Peter T.
 1968 The Olmec Were-jaguar Motif in the Light of Ethnographic Reality. *In* Dumbarton Oaks Conference on the Olmec (Elizabeth P. Benson, ed.), pp. 143-178. Dumbarton Oaks Research Library and Collection. Washington.

Gay, Carlo T.E.
 1967 Oldest Paintings in the New World. *Natural History*, vol. 76, no. 4, pp. 28-35. New York.

Grove, David C.
 1968a Chalcatzingo, Morelos, Mexico: a Reappraisal of the Olmec Rock Carvings. *American Antiquity*, vol. 33, no. 4, pp. 486-491. Salt Lake City.

 1968b The Pre-Classic Olmec in Central Mexico: Site Distribution and Inferences. *In* Dumbarton Oaks Conference on the Olmec (Elizabeth P. Benson, ed.), pp. 179-185. Dumbarton Oaks Research Library and Collection. Washington.

 1970 The Olmec Paintings of Oxtotitlan Cave, Guerrero, Mexico. *Studies in Pre-Columbian Art and Archaeology*, no. 6. Dumbarton Oaks, Washington.

Grove, David C., and Louise I. Paradis
 1971 An Olmec Stela from San Miguel Amuco, Guerrero. *American Antiquity*, vol. 36, no. 1. Salt Lake City.

Joralemon, Peter David
 1971 A Study of Olmec Iconography. *Studies in Pre-Columbian Art and Archaeology*, no. 7. Dumbarton Oaks, Washington.

Nicholson, H.B.
 1971 Religion in Pre-Hispanic Central Mexico. *In* Handbook of Middle American Indians, vol. 10, part 1, pp. 395-446. University of Texas Press, Austin.

Soustelle, Jacques
 1967 Arts of Ancient Mexico (translated by Elizabeth Carmichael). New York.

Stirling, Matthew W.
 1943 Stone Monuments of Southern Mexico. *Bureau of American Ethnology, Bulletin 138*. Washington.

 1955 Stone Monuments of the Rio Chiquito, Veracruz, Mexico. *Bureau of American Ethnology, Bulletin 157, Anthropological Papers No. 43*, pp. 1-23. Washington.

Thompson, J. Eric S.
 1960 Maya Hieroglyphic Writing: An Introduction. Second edition. University of Oklahoma, Norman.

 1970 Maya History and Religion. University of Oklahoma, Norman.

Terrestrial/Celestial Polymorphs as Narrative Frames in the Art of Izapa and Palenque

Jacinto Quirarte
The University of Texas at San Antonio

Olmec-Izapan-Mayan connections have been established by specialists who have traced the development of formal and thematic programs in all three areas. The broad outlines if not the details of these relationships have been defined. By now it is generally conceded that many images and ideas in Mesoamerican art are Olmec in origin. With regard to the Olmec-Izapan-Mayan relationships most students of this material have postulated a developmental framework that reads in precisely that fashion with the Izapans forming a link in time and space between the Olmec and the Maya. I have tried to show elsewhere that the Izapans were more than mere transmitters of ideas and forms, that they generated a number of uniquely Izapan themes, motifs, and forms as well (Quirarte 1973a).

Downward flying winged figures are Izapan. Downward peering heads in Early Classic Maya stelas found at Tikal may represent similar concepts. The stela-altar complex is also Izapan in origin. Elements such as U-shapes, diagonals and crossed bands in Mayan art demonstrate Izapan antecedents which in turn are traceable to Olmec sources. Compound or polymorphic figures are found in all three areas. Each bears a resemblance to the others.

This is not the place to go into lengthy determinations of what is uniquely Olmec, Izapan, or Mayan in form and meaning. However, I would like to discuss the form and function of several Izapan motifs that do have a direct bearing on later Maya art. I refer to representations of polymorphic creatures symbolizing earth and sky in Izapan style art, which function as frames for narrative scenes. Representations which are similar in terms of function and meaning if not in form are found in Classic Maya art, particularly in the art of Palenque. The profusion of frames comprised of these polymorphs in Palenque invites comparisons to similar arrangements in Izapa. It would be instructive therefore to find out how the Izapan style artist dealt with these problems of articulation, that is, the frame used in the figural reliefs and the manner

Reprinted from *Primera Mesa Redonda de Palenque, Part 1*, Robert Louis Stevenson School, Pebble Beach, California, 1974.

in which this same problem was resolved in Palenque. The study of these frames in formal and spatial terms will help us establish differences as well as similarities in the art of Izapa and Palenque. Iconographical concerns, that is, establishing distinctions between the polymorphs represented in the art of both areas fall outside this study.[1]

The framed niches of Piedras Negras Stelae 6, 11, 14 and 25 although very similar to Palenque arrangements (Maler 1901:Pls. XV, XX, and XXII) demonstrate only one of the several types found at Palenque. Secondly, the Piedras Negras artist/s placed the frame within the narrative scene thus making it part of the theme. This is in contrast to the Palenque artist/s who placed it on the periphery. Its meaning may have been retained but its function is certainly different.[2] It comes closest to operating as a frame.

The frames found in Izapa comprised exclusively of top and base-line designs with or without bands on the sides are different in nature from the Izapa examples considered here and those found in Palenque (Izapa Stelae 2, 4, and 9; Quirarte 1973; Pls. VI, VII and VIII) and therefore fall outside the concerns of the present study. They represent the open mouth of the feline-saurian-serpentine creature used as a stage for the narrative. No such concept survives in Maya figurative art. The only echo of this is found in the Chenes style doorways defined as the open mouth of a polymorphic creature (Temples at Hochob, Dzibilnocac, Uxmal, and Chichén Itzá; see Marquina 1964; fotos. 332, 333, 337, 371, and 416).

The Representation of Earth
And Sky in Pre-Columbian Art

It is well known that the Pre-Columbian artist did not generally represent what he saw but rather what he knew to be true—an approach corresponding to a conceptual as opposed to a perceptual view of the world. The vast corpus of Pre-Columbian art demonstrates that the artists dwelled upon certain natural phenomena while ignoring others. This resulted in the creation of images which are comprised of schematic, abstracted, and naturalistic representations of objects, humans, and mythological beings.

The earth and sky as we know it in Western art was totally alien to the Pre-Columbian mind. The Pre-Columbian artist usually indicated the earth as a simple ground line. The sky was represented with clouds and rain drops in Olmecoid and Izapan style examples (bas-relief at Chalcatzingo and Izapa Stela 21. See Bernal 1969: fig. 21 and Pl. 87). However, the latter examples are an exception. As in Mayan art the earth itself was personified by a great terrestrial dragon head presented in profile and sometimes in frontal view. The sky was usually represented by a celestial serpent. Both of these concepts are found in Izapan style art.

It is not always apparent when we are dealing with a celestial or terrestrial creature in Izapan style art. A creature that is decidedly terrestrial can and does appear within celestial contexts and vice versa. Such equivocation is not generally found in Mayan art. The exhaustive array of figural, symbolic and thematic traits in Izapan style art gives way to a more limited but clearer repertoire of motifs and themes in Maya art.

Polymorphs in Izapan Style Art and Mayan Art

Polymorphic beings represented in Izapan style stelas constitute a most important feature in the works. They either are presented within the narrative register or outside it as a frame for the events depicted on the stelas (Quirarte 1973a). The polymorph's mouth is used to frame the scene above and below. Related beings are shown descending from the sky or emerging from the earth below. Thus numerous manifestations of these creatures constantly move in and outside the narrative scenes rarely staying within their assigned terrestrial or celestial realms. They extend beyond these and in some cases come together to create an entire frame around the central portion of the relief (Stela 7; Norman 1973; Pl. 14). They are ever present and for all intents and purposes always overwhelm and determine what is actually represented within the narrative scene whether it be a confrontation between god impersonators (Izapa Stela 3 and Kaminaljuyú Stela 19) or actual gods descending from the sky (Stelae 2, 4 and 11; Quirarte 1973b; lams. 2, 13, 6, 7, and 3). The back drop itself comprised of these polymorphs is the important feature in these reliefs.

The later Maya solutions elevate the figural portions to such an extent that the same references to polymorphic creatures symbolizing the earth or the sky or both are placed in the background. Let us see how this is done in both areas.

The Polymorph As Frame In Izapa

Izapa Stela 11 shows a frontal representation of a squatting, crocodilian-saurian-serpentine compound creature, or the classic polymorph (Fig. 1a). The crossed bands on the chest and the creature's obesity relate it to the similar figures represented in Olmecoid sculptures (jade tiger from Necaxa, Puebla; see Joralemon, 1971; Fig. 216). In contrast to the predominantly feline cast of most Olmec and Olmecoid heads, this one has a crocodilian head. Another unique feature are the serpent bodies with heads extending to the sides and up to the level of the creature's head.

Figure 1. Terrestrial and Celestial Polymorphs used as Narrative and Frame I. a: Izapa Stela 11; b: Izapa Stela 23; c: Izapa Stela 7; all three after Norman.

The serpent bodies with identical heads are probably attached at the tail of the crocodilian-saurian creature whose body is parallel to the visual surface.[3] The head with gaping jaws is turned 90° to form a profile view which is to the right (the viewer's left) of the body's forward axis and is positioned so as to receive or balance the figure seen directly above (this figure is not included in the drawing).

The only way that the artist can present the tail of this creature is to bring it around and place it on either side of the frontal figure. Evidently it was essential that the tail be duplicated for purposes of clarity. Since the articulation of forms followed strict frontal and profile views of objects and figures, the artist was unable to show the front and back views of a creature simultaneously. A three quarter or angular view of the creature would have made it impossible to do this, for it would have destroyed the strict symmetrical arrangement of parts that consistently echoed the frontal plane.

The inclusion of celestial serpents on Stela 23 creates a more complete frame for the narrative scene (Fig. 1b). The base line scroll-eyed heads attached on either end of the horizontal band face inward and are shown as water suppliers as on Izapa Stelae 1, 22 and 67 (Norman 1973; Pls. 2, 36 and 54). Their profile presentation is in keeping with the similar profile placement of the serpents above.[4] The bifurcated tongue of each serpent head is turned 90° to afford a clearer view of it.[5]

A similar solution comprised of top and bottom portion frames is found on Izapa Stela 7 (Fig. 1c). The intertwined double-headed serpentine-crocodilian creature seen at the bottom, supports one or more human figures on the right side and establishes physical contact with the celestial serpent on the left.[6]

The terrestrial and celestial bodies of these polymorphs, which have heretofore been presented in fashions which indicate that they are parallel to the visual surface with heads facing outward on Stela 11, downward and inward on Stela 23 and a combination of all of these on Stela 7, end up as volumetric units on the latter stela at baseline. The tautly drawn intertwined bodies of the serpent at that level, give very strong three-dimensional effects. This is in contrast to the relatively flat treatment given the others reviewed above.

A move away from these concerns begins to appear in Izapa Stelae 12 and 5 (Fig. 2a and b). The requisite top and base-line designs are included as well as serpentine figures moving from the base-line and invading the narrative scene just under the top line design and then moving inward to encompass the complicated narratives represented within. The basically flat, schematic presentation of the earth monster seen in both stelas gives way to a freer treatment of the heads attached to the long bodies used as frames.

The Polymorph as Frame in Palenque

The distinction between celestial and terrestrial spheres constantly emphasized by the Izapan style artist was ignored by the Palenque artist. The bodies of this serpentine-saurian creature were presented in terms of bands that are more text than image either in segments (Fig. 3a) or as complete rectangular frames (Fig. 3b and c). The celestial aspects of this creature, whether placed at bottom line only or on all sides is established by the inclusion of glyphs symbolizing the moon, Venus, and the celestial creature itself. In the Temple of the Cross and on the piers of the Temple of the Inscriptions a terrestrial head presented in frontal view is shown at the bottom center of the panel (Fig. 3a and b). The reference to this polymorph in the Temple of

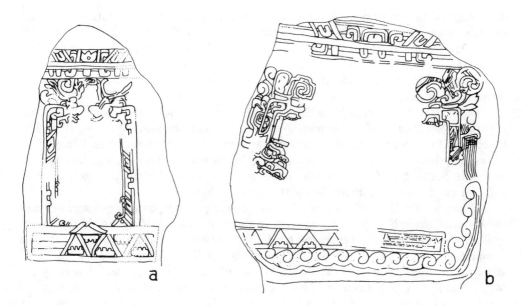

Figure 2. Terrestrial Polymorphs used as Narrative and Frame II. a: Izapa Stela 12; b: Izapa Stela 5; both after Norman.

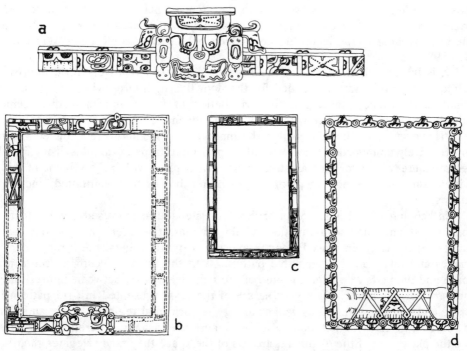

Figure 3. Terrestrial and Celestial Polymorphs (Itzam Na) used as Narrative and Frame III. a. Palenque, Temple of the Cross, Sanctuary Tablet, Center Panel; b. Palenque, Temple of the Inscriptions, pier c facing north; c. Palenque, Palace, House A eastern pier e; d. Palenque, Palace, House D, western pier d; all four after Kubler.

the Cross is abbreviated while on the piers of the Temple of the Inscriptions the body extends upward and continues all along the top thus forming a complete rectangular frame. The head is suppressed while the body remains as a simple frame on all piers of House A in the Palace Group (Fig. 3c). The same is true of the frame seen on the Sarcophagus Lid found inside the pyramid of the Temple of the Inscriptions (Marquina 1964; lam. 6).

The framed stucco reliefs on the piers of House D also in the Palace Group are slightly different in configuration although the concepts remain the same (Fig. 3d). References to serpentine-saurian creatures are made with elements symbolizing shells strung together or by cartouches with crossed bands within them. Except that here as in Izapan Stelae 5 and 12 a further reference to a terrestrial creature is contained within a band depicted directly below the figural reliefs.

Thompson (1973:59-63) identified the Palenque polymorphs as representations of the house of Itzam Na. He further proposed that the Itzam residing within the sky as well as the earth, were represented in this fashion because the Maya had no "isometric" techniques which would have enabled them to give a more complete visual account of this concept. Thus, the ceiling of the Itzam house was shown by the Maya "by joining two Itzam rear-to-rear with tails eliminated thus developing the two-headed monster so common in Maya art . . . In more elaborate representations bodies turn down at right angles to form the sides of the house . . . At times the process is continued, and bodies are bent a second time to include the surface of the earth, this is, the floor of the Itzam house, with the two heads still at the terrestrial ends of the monster. . . However, when they touch, their heads are replaced by a single one shown full-faced. This is that of the Itzam who faces toward the observer. The two touching heads in profile are hidden behind the visible head" (Thompson 1973:59).

It is interesting to note that the Mayans expressed relatively little interest in defining space beyond that needed for the depiction of figures within a two-dimensional surface. They developed the articulation of forms and their displacement laterally on the visual surface with great sensitivity and to a high degree of sophistication. However, the manner in which the omnipresent Itzams were depicted showed how relatively unimportant they were in comparison to Izapan examples. They literally become mere frames for the narrative scenes. Their place within the scheme of things is increasingly represented by glyphic signs rather than by their continued function as images.

In keeping with this set of priorities the Palenque artists used glyphic texts in similar fashion. They also function within the narrative scene and/or outside as frames. Specifically, in most Palenque and Maya figural reliefs, the arrangement of images and texts follow predictable patterns with the images occupying the central space and the texts relegated to some of the negative spaces between figures and to the periphery as frames. The very nature of the texts presented in grid patterns of single and multiple columns as well as along the horizontal registers above and below the scenes, gives these notations a lesser importance visually. Therefore, the nature and the placement of the glyphs regardless of the space they take relegates them to a peripheral position within the schemes of figural reliefs found in Palenque and throughout the Maya area in general.

The Izapan artist did not attain the high degree of sophistication that would have enabled him to present his concerns with the polymorphs within and outside the narratives in such summary fashion. The Izapan artist was still grappling with the enormity of these beings; their over-riding importance was constantly reaffirmed by the artist each time their actual physical presence was depicted. Although the uniquitous elements such as U-shapes, crossed bands, and other combinations of these are included as identifying features in these images they do not stand for the creature nor do they encompass all of the meanings associated with it. The signs and symbols adhere to the image. They do not replace it.

Thus the Izapan artist resorted to numerous formal and spatial solutions in dealing with the celestial/terrestrial polymorphs that differ from later Maya articulations. The polymorphs not only retain their configurations but also move in and out of the narrative scene with the greatest of ease. The celestial serpents on Stela 23 (Fig. 1b) are actually extentions of the polymorph represented by the top- and base-line design so that only the top part of the design is included. The celestial serpents replace the J-shapes of the top-line design. The visual solution is similar to that seen on Stela 11 (Fig. 1a) where the back unit (serpentine polymorph) extends outward and is presented simultaneously with the fat creature.

Under "normal" circumstances the J-shapes correspond to a frontal view of the "head" of the serpent-saurian creature. When the celestial serpents extend downward a profile view of the same creature is presented twice in the same manner as the terrestrial "tail/s" on Stela 11.

The multiplicity of views afforded by these polymorphs depends upon their placement within the visual surface. The directions signalled by the various heads in the Izapan stelas prefigure later Maya practices.

1. The manner in which the frontal figure with serpentine body "tail/s" extending outward and upward is presented on Stela 11 (Fig. 1a) is similar to the procedure followed by the Palenque artist/s at the Temple of the Cross sanctuary tablet (Fig. 3a) and at the Temple of the Inscriptions exterior piers (Fig. 3b). Palace House A relief frames (Fig. 3c) represent a logical extension of this schematization and abstraction process.[7]

2. The terrestrial segments shown in profile at base-line on Stelae 23 (Fig. 1b) 12 and 5 (Figs. 2a and b) are echoed by similar presentations on Palace House D reliefs (Fig. 3d). The serpents with celestial (Stela 23) and terrestrial attributes (Stelae 12 and 5) complete the frame by extending from the bottom or top segment along the sides. The Palenque artist used the shell or crossed band elements strung together to completely enframe the narrative scene and the terrestrial segment. That this is another manifestation of a serpentine polymorph is shown by the serpent draped across the cruciform unit depicted on the Temple of the Cross sanctuary tablet (Quirarte 1973d:8).

3. The complete frame exemplified by the Stela 7 polymorphs is seen in other Maya examples not studied here: the two-headed "monsters" shown directly below the cosmic framed niche on Piedras Negras Stelae 6 and 11. The left profile head looks up or down while the other faces to the right beyond the stela and is represented upside down.

Summary

 The use of polymorphs as frames in Izapan style art is an extremely varied affair in contrast to similar uses of the same creatures in Maya art. The earth monster, discussed elsewhere (Quirarte 1973a) can be the major protagonist as on Stela 11 (Fig. 1a) or he may simply form the stage for activities represented within the narrative panels as a base-line in Izapa Stelae 7, 60 and 4 or as a frame in Stelae 12 and 5. On Stela 7 (Fig. 1c) although represented as a full-bodied serpent the polymorph is relegated to the base-line. On the left the head is physically connected to the downward peering celestial serpent. On Stelae 5 and 12 (Fig. 2a and b) it is a segment of the terrestrial body that is represented in a completely flat manner with the serpent bodies extending up to the top-line design to form a frame for the narrative scene. The same feline-serpentine heads which are undoubtedly the tails of a celestial serpent act as water suppliers on Stela 23 (Fig. 1b).

 In Maya art the polymorph's figural aspects are relegated to representations of a head shown in frontal view. In most cases it is presented as a series of bands segmented at base-line as in the Sanctuary Tablet of the Temple of the Cross (Fig. 3a) or as a complete frame on the exterior piers of the Temple of the Inscriptions (Fig. 3b) and Houses A and D in the Palace Group (Fig. 3c and d).

 The polymorphs in Palenque are moved entirely to the periphery of the narrative scene and therefore function in the true sense of the term as frames. They are text as well as image.[8] They function within the narrative scene spatially in much the same way that glyphic texts do. The artist not only shows but tells what is represented. The polymorphs in Izapa on the other hand start out as protagonists and end up as complete frames in only a few cases (Izapa Stelae 5 and 12). But even here the articulation of the polymorphs as images rather than signs or symbols is sufficiently strong to indicate that these are still a viable part of the narrative even though their placement relegates them to a frame function. The closest thing to the Maya textual concept is found in the Izapan style top and base-line designs. Yet these are not yet glyphic in nature. They still function as images. They signal and "show" rather than merely tell about the polymorphs used as stages for the narrative scenes.

Izapa	
Stelae 11, 23, 7	Late Preclassic 500-350 B.C.
Stelae 12 and 5	Early Protoclassic 100 B.C. - 0 A.D.
Palenque Temple of the Inscriptions exterior piers	Late Classic 610-667 A.D.
Palace House D exterior stuccoes	
Palace House A exterior reliefs	Late Classic 667-692 A.D.
Temple of the Cross sanctuary tablet	

Notes

[1]I have dealt elsewhere with questions of iconography in both areas (Quirarte 1973d and 1973e). References to possible meanings, interpretations, and comparisons of the polymorphs under discussion to others in Izapa and elsewhere will be made in subsequent notes, for they are peripheral to present concerns of form, space, and function.

[2]According to Proskouriakoff (1960:455) the Piedras Negras themes are comprised of "ascension" and "cosmic motifs." The first refers to the ascension of a ruler represented by a seated personage within a niche or doorway reached by a ladder with footprints. The second is the frame itself comprised of a "grotesque" bird above, a "skyband" on the sides and a two-headed monster below. Although the same polymorphs are present in Palenque, the lack of an identifiable "ascension" motif may point to different meanings for these creatures.

[3]That the two polymorphs with serpentine bodies on either side of the central figure are attached to its tail is clearly shown on Izapa Stela 6 (Norman 1973:Pl. 12). The same fat creature presented in profile has a small serpent head with bifurcated tongue attached to the lower part of its back.

[4]The scroll-eyed heads shown at base-line may be the "tails" of these back-to-back celestial serpents. Identical heads are attached to a serpent held aloft by a mythomorphic winged figure on Kaminaljuyú Stela 19 (Quirarte, 1973a:Fig. 11a).

[5]Whenever the celestial serpents are shown in a stela the lower portion of the top-line design—the J-shapes extending downward—are suppressed as on Izapa Stelae 23 and 3 (Quirarte 1973a:Pl. II). The celestial serpent extends downward along the sides of Stela 23 and is part of the theme in Stela 3, where it is shown without a "tail." Its "tail" head shown as "blind" is seen on the left at base-line.

[6]The serpentine-crocodilian creature shown on Izapa Stela 3 is identical to the intertwined polymorph seen in Izapa Stela 7. Perhaps thematically tied are the double-headed polymorphs seen in Piedras Negras Stelae 6 and 11 where the position of each head differs in precisely the same manner as that demonstrated by Izapa Stela 7. The right head is shown upside down on this and the Piedras Negras stelae.

[7]Although not intended to demonstrate a developmental sequence the examples chosen for discussion follow early and late developments at Izapa (Quirarte 1973:Table 1) and Palenque (Fuente 1965:168-170).

[8]Kubler (1969:4-5 and 1973:165) discusses and refers to the differences between images and texts. One shows position in space through "shape, color, texture, and placing" while the other describes "temporal placing" through "name, verb, quality, and date." The interpretation of the Maya celestial serpent bodies as more text than image is mine.

Bibliography

Bernal, Ignacio
 1969 The Olmec World. University of California Press. Berkeley.

de la Fuente, Beatriz
 1965 La Escultura de Palenque. *Instituto de Investigaciones Esteticas.* Universidad Nacional Autonoma de Mexico. Mexico.

Joralemon, Peter D.
 1971 A Study of Olmec Iconography. *Studies in Pre-Columbian Art and Archaeology, no. 7.* Dumbarton Oaks. Washington.

Kubler, George
 1969 Studies in Classic Maya Iconography. *Memoirs of the Connecticut Academy of Arts & Sciences,* vol. XVIII. New Haven.

1973 Science and Humanism among Americanists. *The Iconography of Middle American Sculpture*, pp. 163-167. The Metropolitan Museum of Art. New York.

Maler, Teobert
1901 Researches in the Central Portion of the Usumatsintla Valley. *Memoirs of the Peabody Museum, Harvard University,* vol. II, no. 1. Cambridge.

Marquina, Ignacio
1964 Arquitectura Prehispanica. *Memorias del Instituto Nacional de Historia, num. 1.* Mexico. (1st edition 1950).

Norman, V. Garth
1973 Izapa Sculpture, Part 1: Album. *Papers of the New World Archaeological Foundation,* no. 30. Brigham Young Univesity, Provo.

Prokouriakoff, Tatiana
1950 A Study of Classic Maya Sculpture. *Carnegie Institution of Washington,* Pub. 593. Washington.

1960 Historical Implications of a Pattern of Dates at Piedras Negras, Guatamala. *American Antiquity,* vol. 25, no. 4, pp. 454-475. Salt Lake City.

Quirarte, Jacinto
1973a Izapan-Style Art: A Study of Its Form and Meaning, *Studies in Pre-Columbian Art and Archaeology,* no. 10. Dumbarton Oaks. Washington.

1973b El estilo artistico de Izapa: estudio de su forma y significado. *Cuadernos de historia del arte, num. 3. Instituto de Investigaciones Esteticas.* Universidad Autonoma de Mexico. Mexico.

1973c "The Relationship of Izapan Style Art to Olmec and Maya Art: A Review." A paper presented at the Symposium *Origins of Religious Art and Iconography in Preclassic Mesoamerica.* UCLA. Los Angeles. February 23-25.

1973d "Izapan Style Antecedents for the Maya Serpent in Celestial Dragon and Serpent Bar Contexts." A paper presented at the XXIII *International Congress of the History of Art.* Granada. September 3-8.

1973e "The Representation of Earth and Sky in Izapan Style and Early Classic Maya Art." A paper presented at meetings of the *Mid-America College Art Association.* Albuquerque, New Mexico. November 1-3.

Thompson, J. Eric S.
1973 Maya Rulers of the Classic Period and the Divine Right of Kings. *The Iconography of Middle American Sculpture,* pp. 52-71. The Metropolitan Museum of Art. New York.

Stylistic Evolution of Jaina Figurines

Christopher Corson
University of California, Berkeley.

Ever since the exuberant, sometimes wildly imaginative, explorer Count Frederic de Waldeck published in his *Voyage Pitturesque et Archaeologique dans la Province d'Yucatan* (1838) the first notices of antiquities recovered from a lonely spit of land jutting from the mangrove swamps along the gulf coast of Yucatan an awareness has been dawning that this region of Maya territory "some seven leagues north of the city of Campeche," backwards in many respects, was a forerunner in others. In recent decades the coastal zones of northwestern Yucatan, and above all the island of Jaina, have been increasingly celebrated as the center of one of the New World's most ingratiating traditions of Precolumbian art.

The anthropomorphic ceramic figurines which form so prominent a feature of the burial complex at the island necropolis of Jaina have so far stimulated much rhapsody, which certainly they merit, but little analysis, which they merit equally. As regional examples of Maya art which carry potentially useful information on ethnographic details of dress, adornment, and technology, some notice has already been taken, especially by Alberto Ruz (1969), Roman Piña Chan (1968), and Hasso von Winning. Less critical attention has been paid the light which this remarkable array might cast on the nature of change in styles of art. While typology and seriation, to which Jaina figurines have proved amenable (Piña Chan 1968; Corson *in press*), are fundamental research procedures in archaeology, their intrinsic value lies less in what they achieve than in what they make possible; the result of seriation is a developmental sequence, and this sequence, aside from any other uses to which it might be put, delineates a profile of changing practices and preferences which may span several centuries.

Without braving the hazards of psychological interpretations of the preoccupations of prehistoric artists, it is still possible to identify several of the forces which figured in the evolution of the Jaina style. Field operations by Mexican archaeologists, especially R. Pavon Abreu, A. Ruz, R. Piña Chan, and Carmen Cook de Leonard have accumulated a generous corpus of material (in excess of 500 specimens, held by the Mexican Museum of Anthropology and several regional museums) permitting a

Reprinted from *The Masterkey*, Vol. 49, No. 4, 1975. Published by the Southwest Museum, Los Angeles.

stylistic analysis which may be coordinated with several general features of Maya culture history.

Recent researches have verified a tripartite periodization of the Jaina style, which will be discussed briefly in chronological order:

Jaina Phase I (ca. A.D. 600-800?)

Jaina Phase II (ca. A.D. 800-1000?)

Campeche Phase (ca. A.D. 1000-1200?)

The relative order of phases is derived from stylistic analysis and seriation of the formal characteristics of figurine types. The absolute chronology is more speculative, and is offered tentatively on the basis of grave lot associations and the scheduling of ceramic innovations previously identified on the Campeche coast.

a b

Figure 1. Probable instances of portraiture from Jaina Phase 1. The nude treatment in **a** is very rare.

Jaina Phase I

It is to this earliest phase of artistic developments on Jaina that we may ascribe the best known and most prized treasures of the Jaina tradition. Disconcertingly for some, perhaps, the Jaina artisans appear to have displayed their most consummate mastery early in the practice of their art. At least some of this virtuoso effort owes to social conditions favoring experiment and innovation, though much also is owed some very real, though often overlooked, qualities inherent in the medium which favor the production of unique works. Virtually all of the Jaina I figurines are hand modeled in

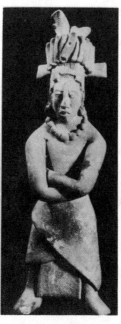

Figure 2. Replicative subjects from Jaina Phase I. **a** depicts the Moon Goddess weaving; **b** a common, though unidentified, male subject.

wet clay, with pigment applied after drying. Since modeling allows nearly endless modification, the artist in clay, provided he keeps his material damp and plastic, need not commit himself as a sculptor must with every chip hammered from the block. The sculptor of stone, to avoid compounding endless error, must pre-visualize to a high degree the eventual form which he desires to see emerge; each false step may require a reorganization of the entire design. The modeler of clay, however, may (though he does not necessarily do so) dispense with previsualization as an element of his technique; he is free at all stages to build up or carve away, to cover blunders, and to try out *on the same piece of work* as many alternate solutions as his patience and imagination will permit. Even painting probably offers fewer opportunities for the artist to change his mind or improve his efforts through reworking and progressive approximation.

Further, non-technical features which may help account for the astonishing diversity of Jaina Phase I figurines must lie in the choice of subjects for depiction and in the function of these pieces as artifacts. So clearly have unique physiognomic types been rendered, and with such careful attention given often highly idiosyncratic details, that we must identify many specimens of at least this first phase as genuine essays in portraiture. This practice seems relatively rare in Mesoamerican art, where more effort is customarily expended on the representation of idealized, if highly symbolic, human characteristics.

If, indeed, the figurines of Jaina Phase I constitute portraits, the problem remains (and it will be a difficult problem for archaeology to resolve) of who is being

depicted. Though we take as given that Jaina figurines, even from the earliest phase, were executed as items of mortuary furniture, it has so far proved impossible to correlate categories of figurine subjects with categories of individuals interred. Figurines of both sexes seem to occur with about equal frequency in both male and female burials, and depiction of adults occurs often in burials of infants. (This impression, admittedly, is based on insufficient data; many Jaina burials have been excavated without adequate recording of either sex or age). We must thus tentatively reject the supposition that the freely modeled Jaina figurines depict the person whose burial they accompany.

Alternate hypotheses which await further testing suggest that they may pertain more directly to survivors of the decedent, or, in some instances, to deities to whom the burial was consecrated. In the latter instance there appear to be good grounds for assuming several female subjects to depict the Yucatecan Moon Goddess (Corson 1973). Other subjects may eventually yield iconographic clues to their identity as deities.

Even in Jaina Phase I not all figurines are unique products. If it is the nature of art to innovate, it is nonetheless in the nature of many artists to exploit avenues of proven success. Before the first Jaina phase closes, thus, we observe the production of specimens which virtually duplicate previous ones. Two forms prevail: (1) a woman, dressed in *huipil* and seated crosslegged, with arms extended and hands on the knees (such specimens are thought to represent the Moon Goddess), and (2) a man, standing or seated crosslegged, with arms folded across the chest. Both types wear the ubiquitous bead necklaces characteristic of most Maya figurines, and male figurines generally wear elaborate headdresses as well. Such duplications of prior effort set the stage, in effect, for developments to transpire in the following phase.

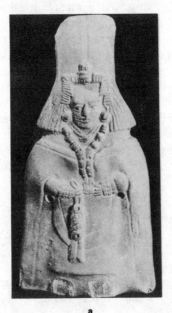

a b

Figure 3. The Moon Goddess in Jaina Phase II. **b** presents a profile showing the Planar presentation typical of mold-cast figurines.

Jaina Phase II

The advent of the second Jaina phase is marked by a technological innovation, the casting of figurines from concave molds. While several of the subjects and ornamental details characteristic of Phase I continue to evolve slowly, the manner of their presentation is profoundly altered. The frequency of complex poses displaying assymetry and body torsion is much reduced in favor of more static frontal views. Further, the high incidence of portraiture which characterized the earlier phase gives way to an increased production of duplicates. Not only does the use of molds allow multiple copies to be produced from a single original creative effort, but also the currency of several distinct "types" seems to have encouraged the Jaina artisans to reproduce, when molds broke or became too worn for further use, prototypes for new molds so like the originals that they are often distinguishable only after minute inspection. Most fascinating, the artistry of the second phase displays much less virtuosity than the earlier artists had commanded. Anatomical details are rendered less precisely, and less effort is expended on the representation of unique human types.

Two factors appear to be involved in this evolution. First, many concessions in format and design were required by the nature of mold casting, which demanded a flatter treatment and the reduction of the narrow projections and appendages seen often on Jaina Phase I specimens. The simplest solution was to draw in the arms and legs, welding them to the body in a solid mass. Headdresses were likewise abbreviated.

A second, and doubtless more fundamental, difference lay in the degree to which mass production, even on this preliminary level, diverted the artist's attention from the practice of his art. The manufacture of copies does not expand the artist's repertoire, and thus does not contribute to his perception of what is feasible or achievable in practice. Clearly, technical brilliance is strongly dependent upon the frequency of the exercise.

Campeche Phase

This phase is signaled by further technological innovations, especially by the introduction of untempered ceramic wares (fine orange) and the use of white pigment to coat the molded surface. Of greater impact on the evolution of the style, however, was a matter of changing emphasis rather than one of changing technique. The subject most profusely explored in this late period, exceeding in numbers all others combined, is a standing woman with hands upraised to the sides of her head. The same theme persists to the final moments of the Jaina style, and it appears along the Campeche coast south of Jaina as well. Its place of origin may lie in Veracruz, or in the great delta of the Usumacinta River where it was adopted enthusiastically in Late or Terminal Classic times at such sites as Jonuta.

The advent of this iconographic theme strongly suggests that late in its history the burial activity on Jaina came under the influence of a new ideology relating to the treatment of the dead. A cult of foreign importation seems not unlikely. These female figurines have been identified variously as representing the central Mexican goddess Xochiquetzal and the Yucatecan moon goddess Ix Chel, though proper identification will await sufficient distributional studies to place accurately the origin of the theme.

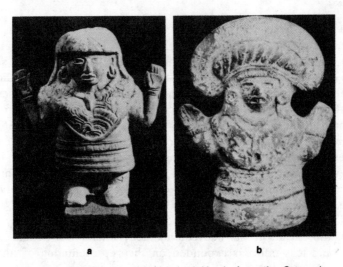

a b

Figure 4. The Woman with Upraised Hands from the Campeche Phase. **a** is an early form, in untempered orange ware; **b** closes the Jaina tradition with a truncated abbreviation of the theme.

The impact which the woman with upraised hands affected on the Jaina artists was not unlike the impact which mold casting techniques had affected earlier. Concentration on one predominant theme further reduced the frequency of innovations, thereby diminishing the artist's repertoire. Throughout this final phase Jaina figurines grow more and more alike, and artistry is replaced by craft. The abundant experimentation which had characterized the earliest phase, and probably all attempts at portraiture, gave way to a much more formal, and perhaps more esoteric, symbolism which emphasized easy recognizability of subject rather than careful detailing of anatomy, dynamic presentations, or unique qualities of face, garment, and ornamentation. Facial characteristics remain abstract and quite similar on female figurines as well as on the few male subjects which occur in the Campeche phase.

The end of the Jaina tradition displays a cursory treatment which is astonishing when we recall the dynamic features which accompanies its beginning. Figurines depicting still the woman with upraised hands are reduced to truncated forms from which the legs are omitted, the torso terminating in a flat-based pedestal. On these specimens even the faces are rendered with desultory technique, though they had always before received the greater portion of the artist's attention. Here eyes are gouged roughly into the face, and mouths rendered often by gashes beneath the nose. I would suggest that it was not only flagging inspiration which resulted in the brusque inelegance of these late specimens, but also the combined, stultifying forces of mass production and a market the demands of which became through time progressively narrower.

Bibliography

Corson, Christopher
 1973 Iconographic survey of some principal figurine subjects from the mortuary complex of Jaina, Campeche. University of California Archaeological Research Facility, *Contributions* 18: 51-75. Berkeley.

 In *Anthropomorphic Maya Figurines from Jaina Island, Campeche.* Ballena Press.
 Press Ramona, Calif.

Piña Chan, Roman
 1968 *Jaina* Instituto Nacional de Antropología e Historia. Mexico.

Ruz, Alberto
 1969 La Costa de Campeche en los Timepos Prehispánicos, *Investigaciones 18*, Instituto Nacional de Antropología e Historia. Mexico.

Waldeck, Frederic de
 1838 *Voyage Pitturesque et Archeologique dans la province d'Yucatan.* Paris.

A Teotihuacán-Style Cache
from the Maya Lowlands

By Joseph W. Ball

When Teotihuacán, one of the great urban centers of ancient Central America, reached the height of its power around A.D. 500, its inhabitants not only controlled the central highlands of Mexico but also had close associations with the principal centers in Oaxaca and the Maya territories. A cache of terracotta and jade figurines, recently unearthed at the site of Becan in the central Maya lowlands, reflects the extensive contacts which existed between the Maya and Teotihuacán civilizations. Consisting of a Maya vase and a number of figurines which bear a striking resemblance of representations of the gods and warriors of Teotihuacán, the treasure raises intriguing questions about the extent of the Teotihuacán Empire and, more specifically, about the nature of its relationship with the Maya.

Excavations at Becan have been conducted since 1969 under the auspices of the National Geographic Society and the Middle American Research Institute of Tulane University. Located in the heart of Mexico's Yucatan Peninsula, the site seems to have been inhabited from about 600 B.C. until A.D. 1400. Massive defense works as well as several other constructions, one building of which contained the cache, appear to belong to the Early Classic period (A.D. 250-500). The building, called Structure XIV, had two periods of construction. The earlier consisted of four vaulted rooms ringing a solid core of rough masonry and dates from the local Chacsik phase (ca. A.D. 250-500). This building apparently remained in use as a residential unit well into Becan's Sabucan phase (ca. A.D. 500-600), during which time it was razed—the outer walls were leveled to about 1.5 meters, and a new structure was built on the rubble. Although a precise identification of the new structure is impossible (it, too, was destroyed), it may have been of crude talud-tablero form—the form of the Mexican stepped pyramids.

The cache was found snuggly nestled in the rubble fill of Structure XIV, midway between the floor and the vaulted ceiling of the lower level. It must have been deposited during the construction of the second building when the walls of the earlier structure were filled with rubble in order to prepare it for reuse. A two-piece, hollow,

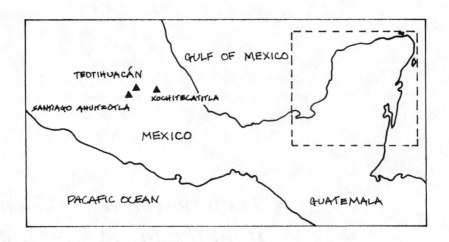

The Maya lowlands.

statuette, executed in the Teotihuacán style, was seated on a low cylindrical vase. The figure had originally contained ten smaller, solid terracotta figurines of deities and warriors, but the pressure of the rubble had broken and crushed the statuette so that we found its front half scattered in fragments in and around the vase. Most of the sculpture's contents had tumbled out into the fill in such a way as to prevent the reconstruction of the original interior arrangement. This disruption deprives us of valuable clues of the significance of the objects. In addition, four jade ornaments and numerous fragments of ceramic applique were recovered from the soil in and around the vase where they had fallen from their places as decorative elements on either the large statuette or its contents.

The cylindrical vase, of typical Maya form and iconography, rests on three legs and measures 16 centimeters in height and 18 centimeters across. Its outer surface is

painted with a highly polished, glossy slip of varying hues ranging from orange to dark brown. On the basal frieze five criss-cross panels alternate with five pairs of modeled cacao beans containing fired clay rattle pellets. Above the frieze, the body of the vase displays two panels of intricate relief work whose excised portions were rubbed with a red pigment, probably cinnabar, after the piece was fired.

Each panel depicts a Maya god seated before the open jaws of a colossal reptilian monster. Both deities resemble God B of the Maya codices, a figure which is assumed to be identical with the rain god Chaac. In each panel, Chaac bears a glyphic "tattoo" on his upper arm and upper leg and wears a beaded necklace with a pendant which also carries a glyphic design. The reptilian monster filling the remaining two-thirds of each panel most probably represents Itzamna, the great creator god and earth monster of the Classic Maya.

The hollow statuette seated within the vessel portrays a young man or god sitting with his left leg crossed over his right and his hands resting on his knees. Traces of a pinkish wash are present on his forehead, and as in the case of the supporting vessel, red cinnabar was applied to the lower half of his face after firing. His slightly flattened heart-shaped and youthful visage is characteristic of Teotihuacán art. Such portraits are not found in Early Classic Maya sculptures or murals, and although some Zapotec and Remojadas terracotta sculptures have affinities to such Teotihuacán portraits, they are found in cultural contexts which had clearly indicated contacts with Teotihuacán. Similar hollow terracottas containing solid miniature figurines are known from Xochitecatitla in Tlaxcala, Teotihuacán and Santiago Ahuitzotla, Azcapotzalco. The Ahuitzotla piece, now in New York's American Museum of Natural History, is especially reminiscent of the Becan terracotta in both its two-piece composition and internal figurines.

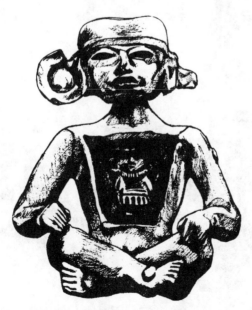

Terracotta statuette from Teotihuacán now in El Museo Nacional de Antropoligia e Historia, Mexico City. Height, 15 cms.

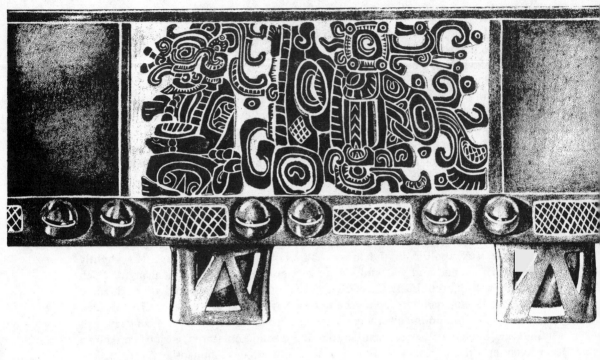

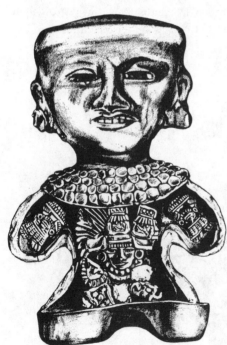

Terracotta statuette from Ahitzotla, now in the
American Museum of Natural History, New York,
Height, 21 cms.

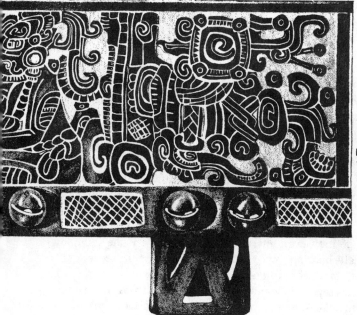

Roll-out illustration of the cylindrical vessel. All drawings by Skaer.

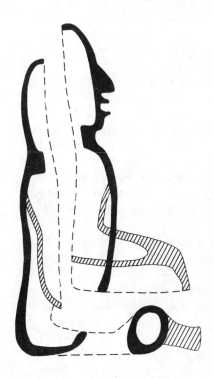

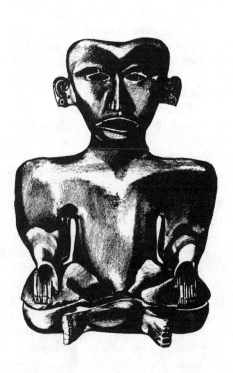

Hollow terracotta statuette from Becan. Height, 22 cm.

The ten solid figurines from within the statuette can be divided by subject into groups of deities and warriors. All were modeled, richly incised and appliquéd before firing, after which their brown to light pink surfaces were decorated with light green, yellow, red, black and/or calcareous white paint. Decoration was confined to the front of the figurines, and their backs were left smooth, an indication that they were meant to be seen from the front. The largest, 7.7 centimeters high, is a representation of the highland Mexican rain god Tlaloc, easily recognized by his goggle eyes and mouth. He is portrayed in human form, wearing quilted armor and a feathered helmet featuring a "cycle of time" glyph—a circular element surmounted by an inverted V. This figure is plano-convex in cross section, that is, the back is flat and the front convex. Tlaloc stood high among the major gods of Teotihuacán; indeed, he may well have been the principal deity of that city. Representations of him abound in Teotihuacán art, and these closely resemble the Becan piece. His presence in the cache would seem to indicate an observance of the rain god's cult or, at least, some relationship to Teotihuacán.

The concave-convex form of the second figurine (it is modeled like a hollow-backed mask), depicting a shield-bearing owl leads us to suspect it served as a pectoral ornament for the larger statuette; although we cannot be certain of this, we do know that in Teotihuacán iconography the owl was associated with warfare. In fact, a figurine fragment from Teotihuacán shows a warrior in quilted armor wearing an owl-emblazoned shield, which is similar to the Becan figurine. The owl may have symbolized the patron deity of Teotihuacán's armies in the fifth century just as the eagle symbolized the patron deity of the elite "Eagle Knights" of eleventh-century Tula and sixteenth-century Tenochtitlán.

A third figurine is a composite showing a goggle-eyed, serpent-tongued individual wearing a feathered, jaguar headdress and quilted armor. This piece has a deeply hollowed back enabling it to fit neatly over the Tlaloc figurine like a mask, covering his face and upper body but leaving his headdress and legs exposed.

If the owl can be interpreted as the patron deity of the warriors' cult and possibly a precursor of the "Eagle Knights" of the Toltecs and Aztecs, perhaps the Jaguar-masked Tlaloc stands in a similar relation to the "Tiger Knights" of these two peoples. Were this hypothesis borne out, it would indicate a long tradition of elite warriors' societies with special patron deities among the peoples of the central Mexican plateau. Teotihuacán has produced a figurine almost identical to the serpent-tongued individual from Becan, and other similar representations are known from both Tula and Chichén Itzá.

The second largest figurine after Tlaloc is a warrior of the Teotihuacán type. Seven centimeters high, he has an elaborately feathered headdress, earspools, yellow face paint, a fringed skirt and a circular shield. A pair of Teotihuacán-type warriors also with earspools, face paint and shields closely resemble the lone warrior but differ primarily in their slightly smaller stature (5.7 centimeters), rectangular helmets and breechcloths.

The remaining four figurines are two matched pairs of warriors seen in profile. They bear no resemblance to Teotihuacán models but wear the black body paint of Maya warriors. One pair has feathered helmets, earspools and fringed skirts. In helmet design, posture and profile view they are virtually copies of the bas-relief warriors carved on the sides of the Maya stele 31 at Tikal. The primary difference

Figurine of the rain god Tlaloc.

Figurine depicting a "Tiger Knight."

Figurine depicting a shield-bearing owl.

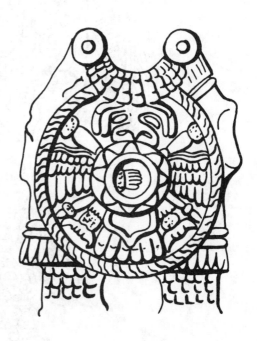

Figurine of a warrior carrying an owl-emblazoned
shield, from Teotihuacán.

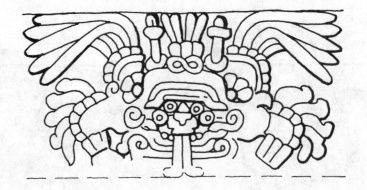

Bas-relief depicting a "Tiger-Knight," from Tula.

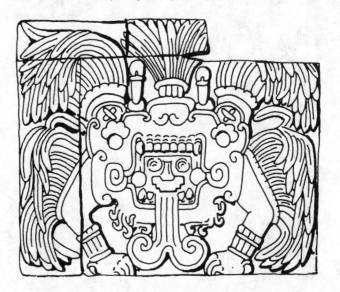

Bas-relief depicting a "Tiger Knight," from Chichén Itzá.

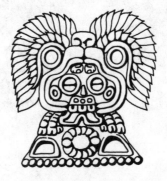

Figurine depicting a "Tiger Knight," from Teotihuacán.

Three Teotihuacán-type warrior figures.

Two non-Teotihuacán-type warrior figurines,
possibly Maya.

Two non-Teotihuacán-type warrior figurines.

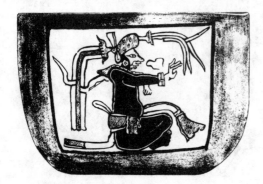

A Late Classic polychrome vase from Nebaj, Guatemala.

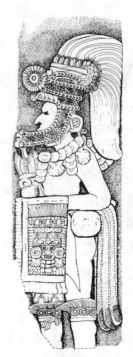

Bas-relief depicting a ''Tlaloc'' shield-bearing warrior from stele 31 at Tikal, Guatemala.

between the warriors at Becan and those at Tikal is that the latter possess rectangular shields bearing full-face portraits of Tlaloc, an indication of some association with Teotihuacán. The other pair of warriors wear turbans instead of feathered helmets, earplugs instead of earspools, and choker-like throat ornaments. Their closest association would seem to be with the Quiché region of highland Guatemala, an area whose people are frequently portrayed in black body paint and turbans on vases of the Late Classic period (A.D. 600-900).

Taken as a whole, then, the assemblage of objects in the Becan cache along with the surrounding defense works suggests a military society having some relationship with Teotihuacán. The relative sizes and different orientations of the figurines may indicate something about the nature of this relationship. It is a generally accepted principle of Teotihuacán iconography that larger figures are more important than smaller ones and that figures shown head on are more important than those shown in profile. This implies a dominant status for Tlaloc and, by extension, for either his cult or his city. The elevated status of the Teotihuacán warriors seem to be confirmed in each case either by their size or by their orientation or both.

What is the significance of this offering to the gods, warriors and city of Teotihuacán, deposited at a fortified site deep in the forests of the central Maya lowlands? Was Becan a northern frontier garrison in an unequal alliance between Teotihuacán and the southern Maya, or was it a stronghold established by the northern Maya to fend off intruders from the south? Who were the residents of Becan who made the offering? What event accompanied the leveling of the building which housed it? These are some of the provocative questions raised, but as yet unanswered, by the discovery of the Becan cache.

The Gods of Teotihuacán: A Synthetic Approach in Teotihuacán Iconography

Esther Pasztory

In the analysis of Teotihuacán iconography one eventually has to face a problem of definition: are the various image clusters the representations of separate gods, or are they unique combinations of a standard motif repertory with no two images being exactly alike? In other words, can one refer to "gods" at Teotihuacán at all?

In the most recent analysis of Teotihuacán iconography, Kubler suggests a linguistic model and interprets the motifs as nouns, adjectives and verbs. He feels that these motifs are combined "with logographic clarity and simplicity" and sees Teotihuacán art as an alternative to writing (1967:5). While this analysis is extremely useful in pointing out an aspect of Teotihuacán iconography not previously defined, the atomistic structure it implies is hard to reconcile with the nature of other, comparable, pre-Columbian religions. Mainly, it is difficult to imagine the organization of cults and priesthood in such a framework. Was there a single group of priests at Teotihuacán who manipulated all these motifs depending on the need of the moment and created new supernatural entities, and if so, could the population "read" these new constructs? Such a group of priests would be an anomaly in Mesoamerica, since information about later periods in Mesoamerica indicates that individual deities generally had separate cults with their own priests.

The deities of Post-Classic Central Mexico are recognizable as separate entities in art by a rather standard iconography, which must have made it possible for the ordinary worshipper to distinguish, for example, the water goddess Chalchiuhtlicue from the maize goddess Chicomecoatl. Nevertheless, several factors complicated Post-Classic iconography. For one, certain deities shared many characteristics with other deities for obvious reasons: the maize and water goddesses were both concerned with the fertility of the crops and thus shared certain insignia characteristic of fertility deities. Since they were both female, they also had certain associations typical of all female as opposed to male deities. These interconnections between various deities and groups of deities were expressed in art by the sharing of certain diagnostic traits of costume, headdress and insignia. While the Post-Classic worshipper may have been as familiar with the image of Chalchiuhtlicue and Chicomecoatl as a Catholic

82

Figure 1. Tlaloc figure, Tepantitla Tlalocan talud border. After Séjourné 1956: fig. 14.

Figure 2. Zacuala Corn-Tlaloc. After Séjourné 1962:fig. 160a.

Figure 3. Tepantitla, Tlaloc figure from doorway border.

Figure 4. Tepantitla, Tlalocan Patio, upper wall scene. Mexico, National Museum of Anthropology, neg. no. XLIX-93.

with Saint Barbara and Saint Catherine, he might have had difficulty with the representation of composite forms in the codices, which are often unique combinations of elements for particular purposes and which may represent one goddess performing the functions of many others. The linguistic model used by Kubler to describe Teotihuacán iconography would be equally useful in the analysis of Post-Classic Central Mexican iconography, but because of the greater amount of available textual information, it has been less necessary to resort to it.

Is the situation at Teotihuacán all that different from Post-Classic Central Mexico? There are fewer motifs in Teotihuacán than in Aztec iconography, but the structure of the composition is in many ways similar. Several investigators (Kubler 1967, Caso 1966) have identified image clusters at Teotihuacán which have some constant and some variable elements quite similar to the iconographic representations of Aztec deities. The constant associations should therefore be interpreted as the traits of individual gods, who had their own cults and priests and were familiar to the population. The presence of a number of variations and composite constructs appears to indicate that the insignia associated with deities were frequently used as metaphors to express new ideas. In the composition of new images the motifs were in fact recombined freely as if they were words in a written text. The first task in the study of Teotihuacán art is to define the constant iconographic clusters, which appear to indicate the presence of individual deities and their cults. The second task is to analyze the exceptions and composite forms in order to be able to account for deviations from the norm.

It has been shown in a previous paper that there is a Teotihuacán deity which corresponds to the Aztec rain god Tlaloc (Pasztory in press). This Teotihuacán Tlaloc is distinguished by concentric eyes, an upper lip turned up at the corners, two long fangs and three to five short ones, a headdress with three to five knots, a water lily in the mouth, and the frequent presence of vessels or lightning symbols in the figure's hands (Fig. 1). The deity is usually painted blue, green or black, all colors indicative of rain. There are, however, two representations of the figure at Teotihuacán which deviate from the iconography described above. At Zacuala the figure has all the characteristic facial features but differs in being painted yellow, holding a corn plant in his hand and carrying corn cobs in a pack on his back (Fig 2.) At Tepantitla there are two versions. In one border design there is a typical green Tlaloc (Fig. 1), in another a yellow one (Fig. 3). What explains the presence of the yellow Tlalocs, and why is there both a yellow and a green Tlaloc in one mural?

The Zacuala figure has two unusal traits: the yellow color and the corn cobs, and these characteristics suggest that this Tlaloc is represented as a maize deity. This hypothetical explanation is supported at Tepantitla. As mentioned before, typical green Tlalocs holding effigy vessels are represented in the talud borders. On the doorway border, however, similar Tlaloc heads are painted in yellow. The rest of the border designs are also different: the talud border consists of interlaced bands of water appropriate to Tlaloc, but the doorway border is ornamented with U-shaped plant designs identical with the branches of the tree depicted on the upper wall. That tree emerges from the head of a deity-bust, also painted yellow. The doorway border design at Tepantitla, therefore, shows a composite figure who has the facial features of Tlaloc but is related to a tree-vegetation deity by means of the yellow color. It is suggested that these corn-vegetation aspects of Tlaloc are not separate deities, since

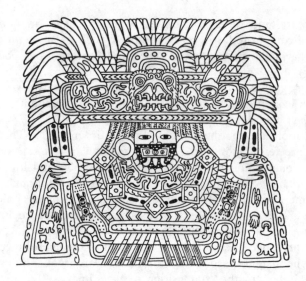

Figure 5. Tetitla ''Jade Tlalocs.'' After Séjourné 1966a:fig. 266.

Figure 6. Tetitla Divine Hands mural. After Villagra 1971:fig. 15.

Figure 7. Design from an incised vessel representing a bird with divine hands. After Séjourné 1966b:fig. 36.

such examples are rare and not standardized in the iconography, but aspects developed for special situations. At Tepantitla, the overriding principle of iconographic organization appears to have been unity and synthesis. A quest for unity explains the design on the doorway border; the border physically frames the lower and upper walls and therefore combines the iconographic themes of both walls into a composite supernatural image, otherwise not known in Teotihuacán iconography (1).

A problem, different from that of the yellow Corn-Tlalocs, presents itself in the iconography of the upper wall deity at Tepantitla (Fig. 4). This deity was identified as Tlaloc by Caso in 1942, and this identification has been accepted by most scholars. This figure, however, lacks several of Tlaloc's most conspicuous features: the concentric eyes, mustache-like upper lip and knotted headdress. Instead, the figure wears a mask, nose pendant, a frame headdress with a bird in the center, and is painted yellow. Since many of these same elements recur in another mural, the so-called Jade Tlalocs of Tetitla (Fig. 5), this personage is most likely a distinct deity and not another aspect of Tlaloc. The Tetitla figures also represent yellow busts with green eye masks or facial paint, jade nose bars with pendants and frame headdresses with a bird in the center.

Unlike the Teotihuacán Tlaloc images, some of which are so close to Post-Classic Tlalocs as to leave little doubt as to their identification as rain gods, the Tetitla and Tepantitla have no distinct visual parallels in later iconography. Their identity can nevertheless be determined by a variety of approaches, none of which would suffice alone but which together reveal a clear picture. These approaches include the contextual analysis of motifs at Teotihuacán, comparison with motifs in other Meso-american cultures, sixteenth-century Aztec and Spanish texts, and modern ethnography. In the absence of written texts, only such a synthetic approach can lead beyond an elementary contextual analysis.

The complex setting of the Tepantitla upper wall deity lends itself to such a synthetic analysis. The figure emerges from a typical Teotihuacán talud-tablero platform, within which there is an upside-down U-shaped enclosure with representations of seeds, jades and water. Since pyramids are generally considered to represent mountains in Mesoamerica (Krickeberg 1950), one may begin with the hypothesis that this platform may represent a mountain with a cave within it. Caves are frequently described as magic places that contain seeds, water and jewels in the sixteenth-century chronicles (Sahagún 1963 vol. II:257) and in modern ethnography (Rands 1955:345). The upside-down U-shape, in fact, is a type of Tlaloc mouth in Teotihuacán iconography, since this deity is the earth monster as well as the rain god (Pasztory in press). The representation of caves as monster mouths goes back to the Pre-Classic period in Mesoamerica. The Tepantitla deity is, therefore, set on a platform that represents a mountain with a cave.

This deity is unusual in having eyes represented by a mask and lips suggested by a nose bar with tooth-like pendants. The lack of clear facial features, other than these ornaments, the placement on a platform and the yellow color suggest that a corn-dough idol may be intended to be represented. Corn-dough idols dressed and adorned were set up by Aztecs during several festivals. At Tepeilhuitl, they represented the mountains and the deceased; at Atemeztli, the mountains; at Uei Tocoztli, the corn goddess Chicomecoatl (2). In all cases among the Aztecs corn-dough images were typical of rituals dealing with agricultural fertility. A further corroboration of the

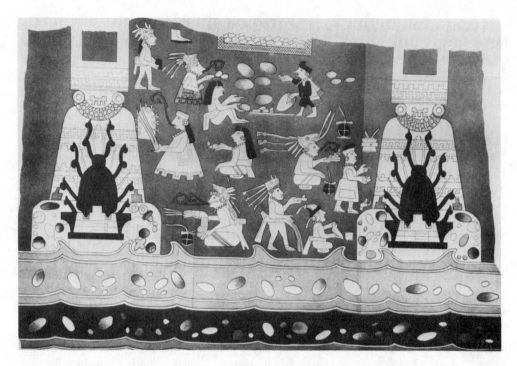

Figure 8. Temple of Agriculture. After Kubler 1967:fig. 46.

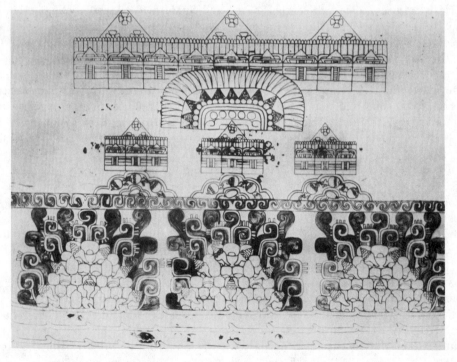

Figure 9. Temple of Agriculture, second layer of mural. After Villagra 1971:fig. 8.

association of busts on platform with maize is found in the Maya area where on Stela 40 at Piedras Negras a maize plant grows out of such an idol (Kubler 1969: Fig. 43).

Besides the seeds within the cave and the yellow color associated with maize, the tree growing behind the Tepantitla figure is the third aspect of this representation referring directly to vegetation. The Tepantitla tree actually represents a cross between a tree and a vine, the vine suggested by the interlacing forms and the water symbols within that may refer to sap (3). Trees in Mesoamerica, besides being symbols of fertility, are generally cosmic symbols referring to the four corners and center of the world and are thought of as having given birth to humanity (Pasztory 1971).

Is this vegetation deity male or female? Again, only a variety of circumstantial evidence can be used to solve this problem. The priests flanking the central deity wear feminine costume, a skirt and shawl, and since in later periods the priests of female deities wore female dress, the female dress of the attendants suggests that the deity may also be female. Since both caves and trees are frequently associated with female deities in later periods, they may have had similar associations at Tepantitla. For example, Sahagun's informants reported that water was believed to emerge from the womb of the water goddess: "This mountain of water, this river, springs from there, the womb of the mountain. For from there Chalchiuhtlicue sends it" (Sahagún 1963 vol. XI:257). Trees are also frequently thought of as feminine since they are shown in the Mixtec codices giving birth to the ancestors of the Mixtec people (Vindobonensis 88), and there is reference in Aztec myth to a cosmic tree with breasts nursing the souls of the unborn. A further feminine association is suggested in the Tepantitla image by the presence of a spider climbing in the branches of the tree and hanging by a thread just above the headdress. The spider is one of the primary symbols of the moon and earth goddesses in Mesoamerica, partly because of its web-making abilities and the parallel to the woman's craft of weaving (Thompson 1939). While none of these traits is decisive by itself, the female dress of the priests, the cave, the tree and the spider together suggest that this deity was intended to be female.

Three other traits help to identify the Tepantitla goddess further. She wears the eye mask of the old fire god, which implies old age, while her counterpart at Tetitla wears a youthful mask. It appears, therefore, that the deity has both old and youthful aspects. Second, she wears a green bird, an owl or quetzal, in her headdress. Both the owl and quetzal may be symbols of water. A similar bird appears in an equally prominent position in the headdress of a contemporary Monte Alban deity, the Goddess IF, who may be the counterpart of the Tepantitla goddess (Boos 1966: pl. XC); this bird has been identified by Caso and Bernal as a quetzal (1952:178). The prominent position of the bird in the headdress suggests that its name may form a part of the name of the goddess. Finally, the open position of the hands pouring liquids containing riches is also characteristic of this deity. At Tetitla, the Jade Tlalocs are represented on the portico walls, while isolated yellow hands pouring such liquids are represented on the walls of the interior rooms (Fig. 6). The bird is directly related to divine hands in an incised design on a ceramic vessel (Fig. 7), a further indication that these are representations of a coherent iconographic cluster.

Would it be possible to relate the Tepantitla personage to a later personage and to ascribe to her a particular name? Of the many Post-Classic creator, vegetation and fertility goddesses, the most versatile is the goddess Xochiquetzal, since she is a

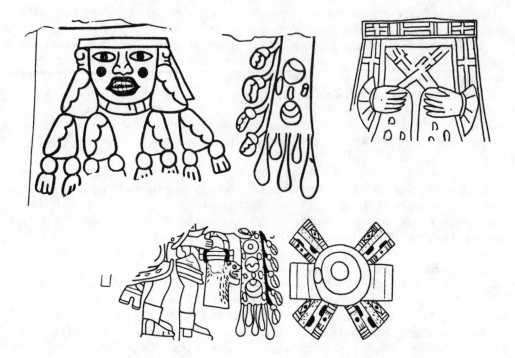

Figure 10. Tetitla Entrance Porch paintings. After Séjourné 1966a:figs. 135, 136.

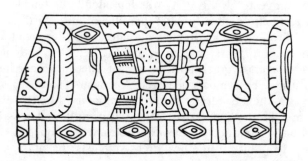

Figure 11. Four-part symbol incised on a vessel. After Kubler
1967:fig. 33.

composite earth-moon goddess, patron of weavers and of sexual love. She is described as the wife of the sun god and the mother of maize. She is nearly indistinguishable, moreover, from the old creator goddess Omecihuatl who with her husband created all things (Nicholson 1971:411, 421). In a hymn she is described as having come from a land of rain and mist, which may be implied by the watery scene at Tepantitla, and her Post-Classic representations in the codices show her wearing flowers and a quetzal in her headdress. The characteristics of the Post-Classic Xochiquetzal correspond so well with the iconography of the Tepantitla image that it appears quite likely this image represents a predecessor of Xochiquetzal.

In order to avoid cumbersome descriptions for Teotihuacán deities whose names are forever lost to us, there is practical value to using the name of a corresponding Aztec deity when such a correspondence can be established, although the reference must be qualified as being to the Teotihuacán version of the deity. Thus, while a general relationship is immediately apparent between the Teotihuacán Xochiquetzal and the Aztec Xochiquetzal, it is also understood that they are not to be thought of as identical.

A number of other representations at Teotihuacán appear to depict a similar deity. In the Temple of Agriculture offering scene, foodstuffs and incense are offered to two unusual images that appear to combine the forms of a mountain and of a human (Fig. 8). Their inverted U shapes suggest a mountain, but the horizontal bands of geometric ornament imply an architectural form such as a pyramid. Their hollow interiors contain seeds and jades as in the Tepantitla image, curling forms that may be smoke and an enigmatic design reminiscent of a platform. The combination while different in form is similar in concept to the Tepantitla platform-mountain-cave. Moreover, the face of the deity is yellow, it has no facial features and wears the characteristic nose bar with several pendants. The Temple of Agriculture idols appear, therefore, to be earlier versions of the Tepantitla Xochiquetzal image.

Another mural in the Temple of Agriculture also has an abbreviated reference to the Teotihuacán Xochiquetzal (Fig. 9). Although there are no human figures, the bands of water with water lillies, the sea shells, sea creatures, seeds and scrolls correspond to the setting of the Tepantitla goddess. In the center of the Temple of Agriculture mural, a headdress emblem consists of the wide feathered frame headdress characteristic of Teotihuacán Xochiquetzal, and within it is the Tlaloc upper lip design which at Tepantitla represents the cave within the mountain platform. This mural, therefore, also appears to have been dedicated to the cult of the same deity as the one shown at Tepantitla.

Another representation of the same goddess appears in the entrance portico of Tetitla (Fig. 10). The portico paintings are unusual in that, contrary to the usual practice, each wall has a different, though related design. On one side of the doorway a frontal yellow face is represented with a flat headdress and tassels hanging from the ears. A priest pouring libations is shown walking toward this image. On the basis of the yellow color and the tassels, Séjourné identifies the figure with the Aztec fire goddess Chantico (1966:252). The corresponding image on the other side of the doorway consists of a pair of yellow hands pouring water. The juxtaposition of yellow face and hands suggests a relationship with the Teotihuacán Xochiquetzal. On the last surviving paintings in this portico a priest is depicted walking toward an emblem consisting of a circle and an X, which upon further analysis appears to be another

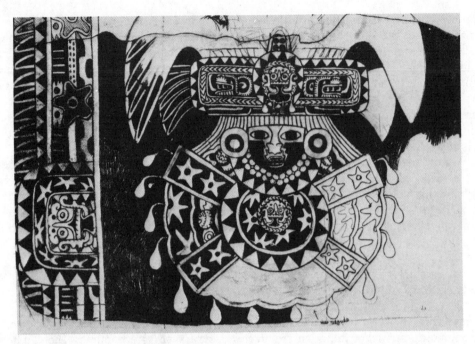

Figure 12. Palace of the Jaguars. Line drawing by Davalos G. Felipe, courtesy of Arthur G. Miller.

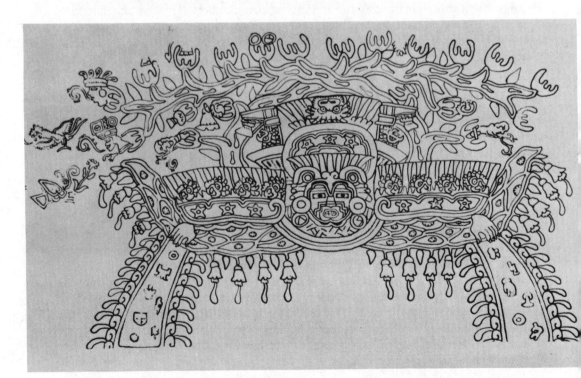

Figure 13. Zone 5A mural of the glyphs. After Gendrop 1971:96.

diagnostic of the same deity. Each panel making up the X design is subdivided into four different ribbons. One of these, the diamond and bar design, is identical to the eye mask of the Tepantitla Xochiquetzal. The four motifs have been interpreted by von Winning (1958) as two fire and two water symbols. This four-part composite symbol often occurs by itself on ceramic vessels and on figurines (Fig. 11). Since its elements represent opposite qualities joined together, it may stand for unity, reconciliation of opposites or completion. In suggesting that the Tapantitla deity represents "Burning Water," Séjourné (1956) may have instinctively touched upon the ambivalent nature of this Teotihuacán goddess.

A clearly dualistic iconography, associated with the X and circle design is found on the chest of a recently found frontal figure from the Palace of the Jaguars (Fig. 12). Here, instead of a four-part symbol, starfish water symbols appear in the X while a skull is placed in the center of the circle. The facial features of the deity, with the mouth open and full of teeth, resemble those of the Tetitla figure, while the rectilinear headdress is reminiscent of Tepantitla. A skull is represented in the center of the headdress flanked by two profile serpent heads. Two serpent heads are similarly found in the headdress emblem of the Tepantitla Xochiquetzal represented in the border (Pasztory 1971: Fig. 18). The border of the Palace of the Jaguars mural consists of the four-part symbol with superimposed skull medallions. The major differences between this deity and the previously discussed images are the skull and its reference to death.

Finally a deity represented on the Zone 5A mural surrounded by glyphs is another version of the Teotihuaçán Xochiquetzal (Miller). The rectangular headdress with the central emblem, which this time is a flower, is comparable to the various headdresses seen before. The mouth with teeth is similar to the mouths of the figures in the Tetitla and Palace of the Jaguars murals. The bust emerges from a container or platform very similar to that of the Tetitla Jade Tlalocs. On the chest of the Zone 5A figure is an X-and-circle emblem, although because of the platform only two upper portions of the X are represented. The designs on the X as well as on the headdress are parts of the four-part symbol. The center of the circle is marked with a reptile-eye (RE) glyph. This RE glyph, which has interested scholars since the 1920's, has so far eluded definite interpretation. It is either seen as a water symbol (von Winning 1961) or a fire symbol (Séjourné 1962). It is closely linked with the four-part symbol since the two are often combined in medallions which suggest a face (Fig. 14). The eyes are formed by the diamond-and-bar motif and the mouth by the RE glyph. Kubler has suggested that four-part-symbol and RE-glyph masks are abbreviations of the Tepantitla deity (1967:10) and that this deity is a construct of antithetical qualities, such as water, air, earth, and fire. This analysis is very probable since these two symbols are very closely related to the Teotihuacán Xochiquetzal, who is very much a deity of opposites.

This paper began with an argument in favor of interpreting some well defined iconographic complexes in Teotihuacán art as individual gods. A goddess, comparable to the Aztec Xochiquetzal, has been described, whose diagnostic traits include the following: the frame headdress with a central emblem, which is a bird, flower or skull in the known examples, a face or eye mask, a nose bar with pendants, a large mouth full of teeth, several types of facial painting, usually a yellow body color, the X-and-circle emblem, the four-part glyph, the RE glyph, divine hands pouring water

Figure 14. Four-part symbol incised on a vessel. After
Kubler 1967:fig. 30.

Figure 15. Stuccoed vessel. Courtesy of the
Brooklyn Museum.

Figure 16. Tetitla mural of the temple. After
Gendrop 1971:fig. 16.

that contains precious items, the mountain cave and temple platform, and the cosmic tree and spider. No one image has all of these traits, but several occur in each image.

It is further possible to define two different aspects of this Teotihuacán Xochiquetzal. The figures related to the platform-mountain-cave also have the eye masks, nose bars, bird emblems and divine hands, and appear to be predominantly associated with fertility. This group of figures includes the Tepantitla deity, the Jade Tlalocs and the Temple of Agriculture figures. The other three representations discussed, the Tetitla Entrance murals, the Palace of the Jaguars and the Zone 5A figures, represent a more destructive aspect of the deity. The figures wear no masks or nose bars with pendants; instead they have human eyes and a voracious set of teeth framed by thick lips. They are associated with skulls, the four-part symbol and RE glyphs, and the X-and-circle designs. Of these only the Tetitla image has the motif of the divine hands. Creative and destructive aspects are characteristic of the Post-Classic female deities in Central Mexico, since, as Nicholson says, the "earth is at one and the same time the great womb and tomb of all life" (1971:422). This concept appears to go back at least as far as Classic Teotihuacán.

While it can be shown that the Tepantitla image is female, and therefore that the very similar Jade Tlalocs are also probably female, it is not equally certain that all the deities described in this cluster are also female. For example, the priests of the Tetitla Entrance paintings wear loin cloths and are definitely masculine. Moreover, a diving figure painted both in polychrome and monochrome red in Zone 5A (Fig. 13) has close parallels with the Tepantitla deity and yet may be masculine. The diving figure wears the disguise of a bird, an interlacing tree grows behind him, and streams of jewels flow from his divine hands. The profusion of flowers and drops of water clearly indicate the concept of fertility, but the features of the face, the human eyes and lips with teeth are more characteristic of the deity in its destructive aspects. Unlike at Tepantitla, the color of this figure is red, not yellow. Diving figures in Mesoamerican iconography are generally masculine and are thought to represent the sun, Venus or other planets at the time of their disappearance from view. Séjourné (1966a) has identified this figure as the sun god Xochipilli, and the Post-Classic Xochipilli is indeed the masculine deity who best fits the iconographic details of the mural. Husband of Xochiquetzal, Xochipilli-Piltzintecuhtli is also a god of fertility, sustenance and creation (Nicholson 1971:table 3).

In the same way that Tlaloc figures are occasionally combined with some traits of the Teotihuacán Xochiquetzal group, some of the Xochipilli-Xochiquetzal have Tlaloc characteristics. A Teotihuacán vessel in the Brooklyn Museum (Fig. 15) depicts essentially the vegetation deity since the figure is painted red, emerges from a platform similar to that of the Jade Tlalocs of Tetitla, wears a rectangular frame headdress with a bird emblem above it, and a nose bar with pendants. The eyes, however, are framed by goggles, a Tlaloc lip is the central motif of the headdress and the hands hold a spear lightning symbol. Since the Tlaloc traits are secondary and fewer, the figure must be an aspect of the Teotihuacán Xochipilli or Xochiquetzal. The combination, however, indicates the conceptual relationship between these earth, water and vegetation deities. This is particularly evident in the jade nose bar with pendants worn by the vegetation gods which appears to be a costume ornament that copies the characteristic Tlaloc mouth. It is certainly not accidental that the destruc-

tive aspects of Xochipilli-Xochiquetzal lack the nose bar with pendants and have instead a mouth treatment typical of some war and death deities.

The open mouth showing a double row of teeth is a separate emblem in its own right in Teotihuacán iconography. It occurs surrounded by flames as the doorway of a temple in a Tetitla mural (Fig. 16), as the mouth of a warrior wearing a net jaguar disguise at Zacuala (Kubler 1967:Fig. 27), and as the mouth of a deity in the border of the North Portico at Atetelco which deals with the themes of war and sacrifice (Kubler 1967:Fig. 13). Like the nose bar with pendants, which appears to echo intentionally the shape of the mouth of Tlaloc, the mouth with teeth is also an emblem with a meaning of its own which exists in other contexts. Signifying fire, death, destruction, war or sacrifice, the mouth symbol functions almost as a word with a precise meaning, as the iconographic model presented by Kubler suggests. However, as has been shown, the contexts in which it occurs are not endlessly variable but form discreet clusters, which can be identified as deities and have parallels in the Post-Classic pantheon. When represented on the Teotihuacán Xochipilli-Xochiquetzal figures, the mouth with the double row of teeth carries the accumulated significance of its representations in other contexts and emphasizes the destructive aspects of these creator deities.

References

[1] A figure similar to the Zacuala Corn-Tlaloc is found on some Monte Alban urns representing the rain god Cocijo. Some urns represent Cocijo with corn cobs in his headdress (Boos 1964:pl. 29), which are otherwise typical of the Monte Alban maize deity of the Glyph L (Boos 1964:pl. 18 and 23).

[2] At Toxcatl, Huitzilopochtli, the war god of the Aztecs, was also represented by a dough image. However, in this case, Huitzilopochtli was the counterpart of the maize and sun god Xochipilli and not exclusively the war god.

[3] Peter Furst (1072:X-XI) feels that the vine represents the morning glory or ololiuhqui plant whose seeds were used as a narcotic in Mexico. Although there is some doubt about this identification of the plant, it would not be inconsistent with the proposed identification of the figure as a female vegetation goddess, since the patrons of the curers using ololiuhqui were often female fertility deities (Soustelle 1970:193-194).

Bibliography

Boos, F.
 1964 *Las urnas zapotecas en el Real Museo de Ontario, Corpus Antiquitatum Americanensium*, INAH, Mexico.
 1966 *Collecciones Leigh y Museo Frissell de arte zapoteca, Corpus Antiquitatum Americanensium*, INAH, Mexico.
Caso, A.
 1942 "El paraíso terrenal en Teotihuacán," *Cuadernos Americanos* 6: pp. 127-136.
 1966 "Dios y signos teotihuancanos," In, *Teotihuacán, onceava mesa redonda*, Sociedad Mexicana de Antropologia, pp. 249-275.

Caso, A. and I. Bernal
1952 *Urnas de Oaxaca*, INAH, Memorias no. 2, Mexico.

Furst, P.T., ed.
1972 *Flesh of the gods, the ritual use of hallucinogens*, New York.

Gendrop, P.
1971 *Murales prehispanicos*, Artes de Mexico no. 144.

Krickeberg, W.
1950 "Bauform und Weltbild im alten Mexico, Mythe, Mensch und Umwelt," *Paideuma* 4: pp. 293-335, Bamberg.

Kubler, G.
1967 *The iconography of the art of Teotihuacán*, Dumbarton Oaks Studies in Pre-Columbian Art and Archaeology, no. 4, Washington, D.C.

1969 *Studies in classic Maya iconography*. Memoirs of the Connecticut Academy of Arts and Sciences, vol. 18, Hamden.

Miller, A.G.
In press *The mural painting of Teotihuacan*

Nicholson, H.B.
"Religion in pre-hispanic Central Mexico,"In, *Handbook of Middle American Indians*, vol. 10, pp. 395-447.

Pasztory, E.
1971 *The murals of Tepantitla, Teotihuacán*, MS, doctoral dissertation, Columbia University.

In press *The iconography of the Teotihuacán Tlaloc*, Dumbarton Oaks Studies in Pre-Columbian Art and Archaeology, Washington, D.C.

Sahagun B. de
1950- *The Florentine Codex, general history of the things of New Spain*. Translated by
1969 A.J.O. Anderson and C.E. Dibble, Santa Fe.

Séjourné, L.
1956 *Burning water: thought and religion in ancient Mexico*, New York.

1962a *El universo de Quetzalcoatl*, Mexico.

1962b "Un jeroglifico teotihuacano," *Cuadernos Americanos* 124: pp. 138-157.

1966a *Arquitectura y pintura en Teotihuacan*, Mexico.

1966b *Arqueologia de Teotihuacan: la ceramica*, Mexico.

Soustelle, J.
1970 *Daily life of the Aztecs on the eve of the Spanish conquest*, Stanford.

Villagra, A.C.
1971 "Mural painting in Central Mexico," *Handbook of Middle American Indians*, vol. 10, pp. 135-156.

Von Winning, H.
1958 "Figurines with movable limbs from ancient Mexico," *Ethnos* 23: pp. 1-60.

1961 "Teotihuacan symbols: the reptile's eye glyph," *Ethnos* 26: pp. 121-166.

Iconographic Aspects
of Architectural Profiles
at Teotihuacán
and in Mesoamerica

George Kubler

The iconography of architecture has been under intense study for several decades both here and in Europe (Lehmann 1945; Bandmann 1951; Smith 1956). The methods of that study can also be made to yield useful results when they are applied to the architecture of ancient Mesoamerica. It is now apparent that no building is without some conventional meaning conveyed by its spatial order as well as by its decorative themes. It is also apparent that such meanings can be recovered even from the designs of peoples who left no written records and whose societies vanished long ago. An example is André Leroi-Gourhan's study of intended meanings that were set out in the distribution of the paleolithic cave paintings of southwestern Europe. In caves like Lascaux, the chambers of the cave are marked out by the animal paintings into ritual divisions corresponding to a liturgical and processional order of ceremony as in a sanctuary (1965, chap. 6).

The main division at Teotihuacán among figural decorations, upon an architectural scale, is between those on the interior walls, with their painted dadoes, and those on the exterior, usually applied to the enframed tableros and their sloping bases. The inner walls bear emblems, processional figures, and narrative scenes. They are generally enframed at the sides and across the top by wide borders containing figures that reflect or echo the sense of the larger figures in the enclosed field. The repertory on the interior walls is far richer than the surviving repertory on the tableros, and it is as though the tableros bore only the most compact designations for the rituals housed within. If so, the tableros may be compared to sign paintings on shops and business concerns in the urban scene today: they designate different ritual activities by using logographic symbols not unlike those in modern advertisements or on road signs portraying an action in pictures rather than words.

At Teotihuacán the ancient architecture built from 300 B.C. to about A.D. 700 included many forms that are suitable for iconographical study. They occupy a period spanning about ten centuries, and they reappear at distant places in Guatemala and Yucatán, signifying at least some continuity of meaning both in time and in space.

The most distinctive and durable physiognomic trait of this Mesoamerican architecture is the terrace profile. It was used to articulate pyramidal platforms. It is often called by its Spanish name—even in English writing—the talud-and-tablero profile, talud meaning talus and tablero signifying the cantilevered vertical panel rising above the slanting talus.

A more detailed analysis of the form distinguishes several parts: the *frame* which is like a molding around a picture; the *panel*, like the plane of the canvas in a painting; the *ledge* of the frame; and the skirt, or *talus*, like a pedestal or base upon which the frame is mounted.

The construction of these terrace profiles (Fig. 1) at Teotihuacán has been described by Jorge Acosta (1964:Fig. 14). At the tableros bordering the square plaza on the north end of the main avenue, the method used about 500 A.D. began with the talus. Upon it an overhanging ledge of slates, called *lajas*, was laid to carry the tablero. The tablero itself began as an angled foundation at the lower shelf projection. At the rear this frame angled up to form the next terrace slope. On the lower shelf the tablero was completed in three stages. First, the frame was added on the cantilevered shelf of lajas. Second, the panel was built within the angled frame foundation. Third, the upper shelf was built on a second cantilever. The stucco sheathing was applied in three stages: on the talus before the laying of the lower cantilever; on the panel and

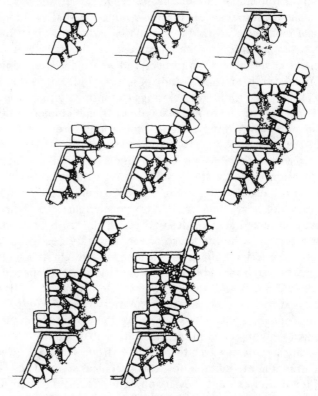

Figure 1. Section of Tableros at structure 5, bordering the Moon Plaza, Teotihuacán. After Acosta 1964, fig. 14.

lower frame before laying the upper cantilever; and on the upper frame and adjoining talus prior to beginning the second-story frame and panel. The overhangs protected the stucco, and the stucco was laid in sheets calculated to shed water and to cover the cleavage planes of the construction.

A further problem with the tablero, beyond protection for the panel and the talus from weathering, was its stability. The projecting frame, resting upon ledges of slate, acted as a cantilevered weight destined sooner or later to collapse. Early frames are wider, deeper, and thicker than late frames. Early frames are made of massive masonry blocks, as at the early "Quetzalcoatl" platform in the Citadel, in contrast to the thin, shallow frames of the later centuries, resting upon slate ledges.

These ledges were a limiting factor. The overhang of the frame could not exceed the available lengths and breaking strength of the slate cantilevers. Thus the frame was unlikely to project more than about 30 centimeters. In fact its sheltering function diminished geometrically with linear increases of size. The result is that few panels exceed the height of a man.[1]

As to the visual effect, the overhanging frame upon a small talus produced a shadow when the angle of the sun was high. This shadow gives an effect of levitation, as of the massive tablero frame resting upon a cushion of darkness, especially evident in the small courtyard dwellings of the last periods.

The main difference between public or religious and secular or private constructions was probably one of size. Large platforms were public; small ones were for dwellings or for household shrines. But within the household, a difference of proportion preserved the difference between divinity and the people of the compound. The shrine rose high upon its slanting base, while the surrounding megaronlike chambers occupied lower pedestals. These domestic tablero profiles may reflect an encroachment by civil authorities upon cults of natural forces.

It has long been accepted that the buried and filled-in lower-level structures at Teotihuacán belong to the earlier history of the city in the Miccaotli period. This was the great urban renewal period in the third century A.D., associated with the overall grid and the laying out of the main north-south avenue.[2] Perhaps two events are indicated: an early "real estate subdivision" about 200 and a later "rash of construction" about 500. The gap defines the boundary between early and late. The buried platforms of the earlier age, however, show the same kinds of proportional schemes, in the relation of the tablero to the talus, as do the surface platforms built over them upon the reticulated grid of blocks 57 meters square. These were imposed about 200 A.D. in the Miccaotli phase, or Teotihuacán II. (René Millon 1960, p. 7). The proportional schemes vary between short tableros on tall bases and high tableros on short bases. Very tall bases were used in the early building history of the site, and the shortest bases appear in the late periods, as shown in the table (Fig. 2), where the height of the base is taken as the unit, and the tablero height is given in relation to this unit. Three groups are defined: ratios below 2:1, from 2:1 through 3.5:1, and 4:1 and larger.

At the Temple of Agriculture, the earliest platform has two terraces with tableros built upon high sloping skirts. The lower talus is two-thirds as high as its tablero, and the upper talus is actually higher than its tablero. The new platform, built to face the avenue, has a tablero fully three times the height of the talus. This three-to-one proportion reappears in the facades surrounding the Moon Plaza. It also appears in

Fig. 2. Ratios Between Tablero and Talus Heights

(1 = talus height; E = early period to A.D. 450; L = late period after A.D. 450*)

.93:1	Temple of Agriculture, first period, upper terrace	E
1.5:1	Temple of Agriculture, first period, lower terrace	E
1.5:1	Tetitla Altar	L
1.66:1	Zacuala Main Cort, southwest side	L
1.9:1	Main avenue, structure 16, jaguar mural	E
1.9:1	Main avenue, structure 15, upper terrace	L
2:1	Temple of Agriculture, third period, upper terrace	L
2.3:1	Main avenue, structure 15, lower terrace	L
3:1	Caracoles emplumados, beneath Quetzalpapalotl	E
3:1	Subterraneos, lower level	E
3:1	Moon Plaza, structure 5	L
3:1	Temple of Agriculture, third period, lower terrace	L
3:1	Yayahuala, northeast corner of court	L
3:1	Yayahuala, altar	L
3.3:1	Subterraneos, Tajín-style tablero	E
3.5:1	Quetzalcoatl Platform, inner terraces	E
3.5:1	Quetzalcoatl Platform, outer terraces	L
4:1	Zacuala, court to south	L
4:1	Moon Plaza, structure 15, third terrace	L
6:1	Atetelco, court, east building	L

the buried platform called the Temple of the Feathered Shells underneath this renewal at its southwest corner. Thus the 3:1 ratio appeared before renewal, and it characterized many elevations both during and after the renewal of that spot.[3] Yet the table suggests that the 3:1 ratio became canonical with the "great renewal," although other ratios could be applied to special situations in renewal design. For instance, at the mural of the giant jaguar on the east side of the avenue, the ratio approaches 2:1 upon a terrace height of about 3 meters. This ratio repeats in adjoining platforms of smaller size. Perhaps designers achieved imposing axial effects along extended facades by using tall bases. But in more inclosed settings like the Citadel court and the Moon Plaza, the 3:1 ratio was preferred, perhaps to give the effect of accessibility. In the intimacy of the residential courts, short bases in ratios of 4:1 to 6:1 were favored.

In its completed appearance about A.D. 600, the main avenue was an extraordinary composition of differing architectural variations. All were held together in a system set by the tablero-and-talus theme. In the region between platforms 15 and 16,

*René Millon (1966 a,b) thinks that the idea of a great grid renewal began about A.D. 200 with major rebuilding occurring after 450 in the Xolalpan and Metepec periods to 750.

for instance, a long section in two tableros of 2:1 ratio was interrupted by platform 15, where two terraces of different ratios (2.2:1 and 5.5:1 above) displaced the larger rhythm with their more abrupt and close intervals.

Here and elsewhere, as at platform 16, the terrace heights were not equal: the upper tablero was raised upon a base higher than that of the lower one, as if to improve its visibility from below. At platform 18, to the east of the Pyramid of the Moon, the four terraces are unsymmetrically divided by the stair. The western terraces are longer than the eastern halves by about half a meter (70 centimeters at the lowest terrace, 60 centimeters on the second, 50 centimeters on the third, and 40 centimeters on the top terrace).[4]

Tablero and talus are omnipresent at Teotihuacán. They dominate all parts of the vast city as the privileged form chosen to distinguish the facades of temples and platforms. No other exterior profile competes, excepting two early versions that will be discussed later on.

The carved and painted decorations on these enframed facade panels bring to mind modern commercial showcases. Their exposure to millennial ruin and leaching has destroyed most of their ornament, but the surviving designs are like those on pottery vessels, reflecting cult practices and foreign styles.

The repertory of the ideas represented is not very large. The Pyramid of Quetzalcoatl (Fig. 3) is unique in having full-round and relief sculpture with painting. These tableros and bases are constructed of blocks of precisely cut stone. Each talus bears in relief carving a feathered serpent set among seashells. The tablero above is decorated with similar feathered serpents whose heads protrude as full-round sculpture, alternating with scaly goggled heads of unidentified nature. Thus talus and tablero both show feathered serpent forms among conch and pecten shells, suggesting watery associations. Another feathered serpent, but lacking water symbols, appears in a large tablero painting at Zacuala (Séjourné 1966b, Fig. 9; pl. 54).[5] A diadem is shown among the feathers.

A second theme of tablero decoration is a water representation of banded designs set with eye forms, as if to suggest the brightness of flowing streams in horizontal layers, or falling rain in vertical bands. These appear at Zacuala and at the Moon Plaza. At Zacuala, in the third patio, there is a tablero with a human mouth flanked by these vertical eye bands. On the main north-south avenue a large red jaguar painted with diagonal stripes appears upon an east side panel: another panel flanking the stair shows remains of a yellow jaguar.

Among such rare examples of tablero decoration, water associations seem to have been significant but not dominant. Feathered serpent and jaguar are common symbols in Teotihuacán iconography. Their exact meaning is not known, despite many efforts to extrapolate by analogy from Aztec sources. The feathered serpent may unite ideas of earth and air. The jaguar may relate to water rites.

At the Subterraneos, farther north near the Moon Plaza, an older buried platform is painted with roundels on the frame and interlocking scrolls resembling those used in Tajín sculpture (Proskouriakoff 1954).[6] The significance of these interlocking scrolls is distinctly foreign at Teotihuacán. They have been interpreted as symbolic of the conflict of opposing forces, being most commonly associated at Tajín with ball-game iconography (Tuggle 1966).

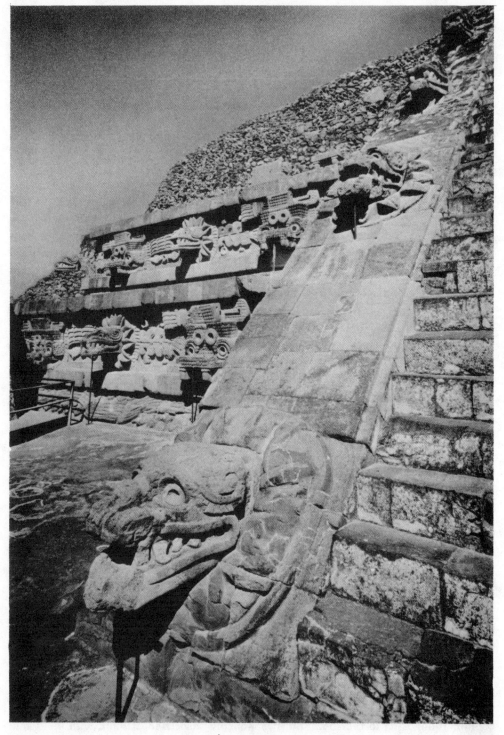

Figure 3. Pyramid of Quetzalcoatl, Teotihuacán. Western front, cut-stone tableros and bases. Photograph Constantino Reyes-Valerio.

Because the preserved representations on tableros are rare, it is profitable to look at those pottery decorations that may portray the tablero and talus. These are molded tripod supports, nose ornaments on human heads, and painted images of temples in murals and on pottery.

Tripod supports representing tableros are common, and they occur late in the seriation of vessel feet. Crossed bands, roundels, conch shell sections, frets, S-curves, and chevrons may appear in the tablero (Fig. 4). Most bases carry a design resembling three downward-pointed feathers; others have inverted trapeze-and-ray signs (Peterson 1952, pp. 13-14).[7]

These all may have served as logographic expressions related to scenes or designs on the cylindrical vessel wall. For example, the crossed-band design on the tablero feet concurs with a warrior wearing a butterfly helmet and geometric butterfly nose-pendant, carrying a butterfly shield device, seated among long-stemmed flowers (Fig. 5). If the butterfly be accepted as the emblem of the soul (Kubler 1967, p. 9),[8] because of its frequent occurrence in the decoration of burial pottery at Teotihuacán, this scene may show funeral rites or beliefs. Another vessel (Fig. 6) shows flayed-skin "Xipe" heads on Maltese crosses separated by drops of water. Here the association of life within the dead skin of the flayed-head image seems to relate death and falling water with crossed bands on the slab feet. This image of crossed bands may be an isolated or singular case of the net designs studied by Hasso von Winning, who interpreted them as ritual devices for bringing rain (1968, pp. 31-46).

Nose ornaments shaped as tablero-and-talus facades frequently hang from the septum on pottery face-masks enshrined inside the temple-like funerary urns of Teotihuacán burials. These nose ornaments also appear on painted vessels among the ornaments of the personages depicted. The decoration often resembles a geometric butterfly, sometimes characterized by wing markings, round eyes, and by a recurved proboscis (Caso 1963, pp. 77-97; Franco 1961). It occasionally decorates tripod-vessel walls, alternating with other logograms like the RE-glyph, or a stylized flower, or a warrior. In general, its contexts resemble those of the vessel foot shaped as a tablero facade. These associations indicate a death-and-rebirth symbolism for butterflies, associated with water and flowers and earth (the RE-glyph) (Kubler 1967, p. 9).

Images of temple platforms, painted or incised on pottery and murals, insofar as they represent only themselves, are perhaps the most revealing of all representations of tablero-and-talus forms at Teotihuacán. One sherd (Fig. 7), published by Von Winning (1947, Fig. 1), shows a temple platform with a stairway flanked by tableros, alternating with goggled rain masks. Leaves sprout from the mouths of the masks. The tableros and their bases, however, are without ornament. This juxtaposition seems to connect ideas of worship with the goggled mask.

In other words, the tablero and its base may have had a meaning like "sacred architecture." The domain of cult and ritual was marked off from secular building by the notched and cantilevered profile of the platform. The tablero may or may not bear indications of a specific cult. Its main purpose is to set sacred edifices apart from dwellings and other secular buildings. If this guess is correct, the tablero and talus are significant without additional information, which, if it had been offered, might even be redundant. In this case, we may suppose that the architectural profile is, in itself and of itself, a major indicator of meaning, specifying both the function of the building and the ethnic identity of the builders.

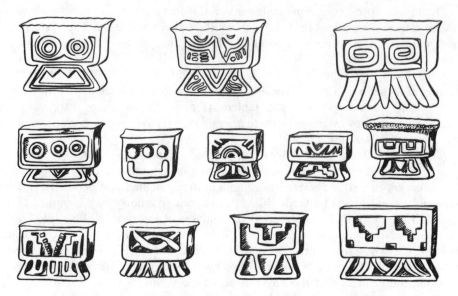

Figure 4. Slab feet from cylindrical tripod vessels. From Séjourné 1966a, fig. 72.

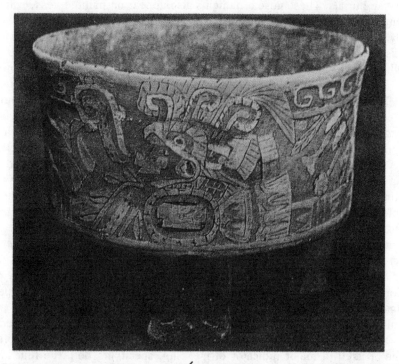

Figure 5. Frescoed tripod vessel. From Artes de México, no. 64/65, p. 153. Museo Diego Rivera, Mexico City.

Figure 6. Frescoed tripod vessel. From Séjourné 1960, fig. 61. Collection Kurt Stavenhagen, Mexico City.

Figure 7. Plano-relief tripod vessel. Black ware. From H. v. Winning 1947, fig. 1. Collection H. v. Winning, purchased at Santiago Ahuzotla.

Figure 8. Red-on-ochre vessel, with painted mountain-form, capped by a tablero-shaped zacuala. From Sejourne 1959, Fig. 146.

The similarity between the geometrized form of the butterfly and the tablero profile at Teotihuacán has already been pointed out. If butterflies represented other worldly life, this geometrical equivalence between butterflies and temple platforms may have provided a metaphorical extention of meaning for both butterflies and temples as to the mystical promises of religion about life after death.

Another poetic extension of the meaning of the tablero-and-talus profile appears in the vase paintings found at Zacuala (Fig. 8). On these vases a mountain is shown with a rectangle at its summit, resembling the cloud caps that frequently envelop the tops of the hills rising from the floor of the Valley of Mexico. The promise of rain, and the architectural facsimile of a mountain implicit in a pyramidal platform, may have been combined metaphorically in the profile we have been discussing to suggest a cloudland where rain is divinely generated, a paradise concealed among clouds where butterflies abound.

The mention of ethnic identity brings us to one more question: how may the terrace profile at Teotihuacán (Fig. 9a) be related to those of the rest of ancient Mesoamerica? The other varieties of profile assembled by Marquina (1951) differ significantly from those of Teotihuacán. Five more kinds are easily recognizable during the 2000-year era from the Late Formative until the sixteenth century (Fig. 9). Each marks out an architectural sphere of influence, and each has a distinct duration. Certain profiles (especially the tablero and talus of Teotihuacán or the dentation of Monte Albán) reappear far away from their origins, both as colonial forms (Kaminaljuyu) and as revival or renascent forms (Tula, Chichén Itzá). Each probably has a distinct meaning in the sense of characterizing different architectural traditions, different cult practices, and different ethnic identities.

The terrace moldings at Monte Albán[9] are often treated as though they were only another variety of the tablero-and-talus profile. But their design and their construction actually differ radically from those of Teotihuacán. The talus is not at the base of the wall. It rests upon a plinth of rectangular profile. Above the talus hang several short brackets opening down and repeating in two or more parallel planes of depth. Above the brackets there may be a short outsloping cornice, or another plinth. The effect in the brackets is of planes and outlines alternating in highlight and deep shadow, giving to the base and the roofline the character of an intermittent or rhythmical system. These separate planes of relief are like a fringed fillet or headband. The molding above the talus is not a tablero. It has no frame and it encloses no panel. In large compositions its profiles slant forward. No supporting ledges cantilever the projecting portions, which are generally corbeled out only enough to cast the desired shadows.

a b c d e f g

Figure 9. Mesoamerican architectural profiles. Adapted by E.G.A. Kubler from Marquina 1951, pls. 287 and 290. (a) the tablero-and-talus, Teotihuacán, (b) The dentated profile of Monte Albán, (c) the slanted and undercut profile of the southern Maya lowlands, (d) the binder molding of the northern Maya provinces, (e,f) the outsloping cornices of Tajín (e), and Xochicalco (f), (g) the double-sloped balustrade of Aztec architecture.

As to a name that would differentiate this profile from the Teotihuacán tablero, the most appropriate seemed to be one that described its dentated character, because of its probable connection with an Olmec symbolism of serpent-jaw teeth. We know little if anything about Olmec architectural profiles, but several figural representations give us a clear idea that sacred places, persons, and acts were designated by borders or frames resembling serpent gullets surrounded by teeth.

Thus a seated figure of clay from Atlihuayan in Morelos wears a feathered serpent-skin mantle with serpent jaws forming a hood bordered by serpent fangs. Monument 19 from La Venta shows a person sheltered within the body curve of such a feather-crested serpent. The altar from Potrero Nuevo shows obese Atlantean dwarfs holding up an altar or throne, the edge of which is carved with brackets defining the intervals between fangs. These elements reappear more than a thousand years later—at Chichén Itzá in the Temple of the Warriors on the dais in the cella, where the leading edge bears a relief carving of an undulant feathered serpent. At Uxmal, in the House of the Magician, the doorway to the temple is enframed by serpent-mouth fangs, as at Copán, Structure 22, or Holmul, Building B. The idea of using serpent teeth or mouths to define sacred places therefore has great antiquity and wide diffusion in Mesoamerica. It seems justified to designate its occurrence at Monte Albán or Mitla as the dentated profile, which was repeated with modifications many generations later at Chichén Itzá in the profiles of the Toltec-Maya Chac Mool Temple as well as at the Castillo.

The southern lowland Maya repertory of profiles is more difficult to define and less easy to interpret. A recognizable group from Uaxactun at E-VII-sub and Tikal at 5D-sub-1st (about 100 B.C.) through to the end of the Initial Series period arises from a coherent system of design. In this system the vaulted building profiles continue those of the platform terraces, and the building is profiled as a topmost terrace. This profile, shared by platform and building alike, can be called a slanted and undercut molding. An architect would recognize it as a chamfered bevel. The chamfer acts as a talus, and it separates the terraces by strong shadows, while the bevel, catching the light, stresses the weight and rise of the terrace it defines.

Northern Maya builders separated the vaulted building from its platform by endowing it with a profiling more characteristic of buildings than of platforms. This profile resembles the binder with which a thatched roof might be gathered or cinched tighter at the eaves and at the peak. It is related to the imitation in stone of that wattled construction with slender saplings used in Maya houses. The binder molding appears in Chenes, Puuc, and East Coast buildings. At the Caracol in Chichén Itzá the binder molding at impost level has five members, expressive of the intricate static and dynamic problems posed by this complicated annular vault system.

Mention should be made of possible prototypes for the binder molding in early examples at Teotihuacán. At the Temple of Agriculture,[10] two buried platforms show a profile resembling the lowland binder molding. It reappears twice more in the Tlamimilolpa ruin at the oldest level, which Linné (1956) has dated by C14 measurements (Burial 1 at A.D. 235 to 265)[11] as being of Miccaotli date. These profiles, like the Tajín scrolls, may have been short-lived foreign fashions, for they had no later issue at Teotihuacán.

The outsloping profiles used at Tajín and Xochicalco may be regarded as a regional variety of the binder molding, rising upon a talus and sloping out above the

construction. Here the binder is like a paneled strip, containing niches or geometric frets. Its early history is unclear: possibly the form reflects contact with Maya peoples.

The last of the six major Mesoamerican terrace moldings appears in Aztec architecture after 1300, sharply distinguished by slopes of different pitch, which appear only in the stairway ramps (Fig. 9). This design is a special variant of the binder molding: the effect is that of the constriction that takes place when a bag of earth is abruptly capped by a confining lid. The suddenly increased pitch of the ramps makes the stairs seem steeper. All the victims of these stairs, ancient or modern, have been intimidated by such visual changes of angle in their ascent and descent of the painfully narrow steps. Aztec influence throughout ancient Mesoamerica was total and no region entirely resisted its terrible appeal. Its architectural symbol was probably the double-sloped stair ramp.

In conclusion, the six major Mesoamerican molding profiles correspond to geographical and ethnic groupings, like those of classical antiquity as codified by Vitruvius (1926, bk. 4, chap. 1, pp. 102f). For Vitruvius, the first-century architect of the Emperor Augustus, the Doric order was the earliest, corresponding to the Peloponnesus in the reign of the Dorian kings of Achaea. The Ionic order arose later when the Athenians colonized Asia Minor. The Corinthian order was invented last by a sculptor wishing to imitate the growth of acanthus leaves. Each order had definite expressive properties: the Doric was manly, Ionic womanly, Corinthian of slighter, maidenly proportions. These expressive intervals have persisted to the present in architectural theory. During the centuries after the Italian Renaissance, architectural fashions recapitulated the earlier history of the orders. In the fifteenth century the Corinthian order was preferred by Italian sculptors; sixteenth-century mannerist architects turned to Doric and Tuscan severity; seventeenth-century Palladians used Ionic details; and baroque architects preferred Corinthian proportions (Forssman 1956, pp. 46f). When the orders were depaganized in the Renaissance, Christ and the saints, both male and female, were assimilated into the Vitruvian intervals. Even the ages of man were equated with Vitruvian orders, in schemes comparing the Tuscan column to old age, and Doric to the prime of manhood, and so on (Forssman, p. 159).

Thinking about the past often takes the form of parallel construction, like Plutarch's *Lives*, or the parallel discussions of Old and New Testament passages whereby prophecies and hidden meanings could be discovered, as in the *Dittochaion* of Prudentius about 400 A.D. This may be the nature of all historical thought, to compare the past to the advantage of the present, to use the past for the justification of an extended present. Plutarch found greater glory for Roman worthies among their Greek prototypes, and Prudentius discovered hidden prefigurations and justification for the New Law in the Old. Today the past is anxiously consulted and restored, less for glory or justification than for confirmation.

In the past quarter-century, the students of American antiquity have become increasingly partial to terms borrowed from Mediterranean archaeology. The Americanist's use of the word "classic," to designate the period ending about A.D. 900, is now part of a terminology having almost unquestioned acceptance. Other suggestions of the "classic" parallel are the following: the presence of a canon of proportions based upon numerical ratios; the prevalence of local-tone coloring without perspective shading; the humanistic emphasis of most Mesoamerican art. All these qualities

reinforce the idea of the "classic" character of American antiquity before A.D. 1000. The existence of an expressive order, shown in the terrace profiles we have examined, similarly confirms the parallels with Greco-Roman antiquity that have long been apparent. The similarities, however, in no way indicate historical connections. The resemblances are as fortuitous as those between people who look or behave alike although born of different races on different continents and in different ages.

Notes

1. The largest may be the painted feline 2 meters long on the east side of the main avenue. Clara Millon (1966, pp. 10-11) ascribed it to phase 3 in her mural chronology (Xolalpan period), although the survival of this painting was due to its temporary obliteration by a renewal-period facade of Xolalpan date. Whether the painting should be ascribed to Tlamimilolpa or to Miccaotli remains uncertain. As a "buried" wall, it may be earlier than Miccaotli.

2. René Millon ascribes the grid and the construction of the platform of "Quetzalcoatl" to the Miccaotli period as about A.D. 200 (1966a, p. 7), and the "urban renewal" to Xolalpan period A.D. 450-650.

3. The dates of the great rebuilding are still in disorder. Although early excavators (Marquina 1922) proposed three periods prior to the building of the main avenue, Armillas placed the rebuilding along the Street of the Dead in the Miccaotli phase (1944, pp. 121-36), though without convincing proof. (See Clara Millon 1962, p. 8). The C14 date for Tlamimilolpa (Linné 1956, p. 191), from beneath the lowest floor, dates its earliest tomb A.D. 236-65, confirming the supposition that the "suburban" enclosures were already then in existence. Michael Coe (1962) has reported C14 dates in Burial 10 (Teotihuacán III, Zacuala) as A.D. 330-80, and in grave 24 at Zacuala as A.D. 290-80.

4. I am obliged to Arthur Miller for the use of measured drawings he gathered at Teotihuacán when working on the murals there.

5. Clara Millon observed in her doctoral dissertation (1962, p. 99) that this mural fragment is of "uncertain provenience," since it was found 4 meters distant from the east platform with which Séjourné associates it.

6. The Subterraneos scrolls are of the rectilinear or earlier type A as discussed by Proskouriakoff (1954).

7. Peterson's examples all are vessel-leg fragments. The vessel's decoration probably reflected or determined the nature of the use of the complete vessel.

8. The vessel, drawn in Séjourné 1960, p. 147, is in the museum at Teotihuacán.

9. Acosta (1965, p. 818) has identified a true Teotihuacán tablero at Monte Albán in period II (300-100 B.C.), but he goes on to speak of a local form of "tablero" (type A) to which he gives the name of *doble escapulario*, "present in 90 percent of the buildings of Monte Albán." He believes it evolved from an "older" type B (p. 827), which we discuss here as the molding used on temple groups and facades. Probable confusion in translation makes this passage difficult to follow. Acosta gives no name other than *tablero* for both types. But the term is best reserved for the Teotihuacán projecting frame (contrast Hartung 1970).

10. Marquina's "period II" platform has been assigned by Armillas to the end of Miccaotli. Clara Millon (1962, p. 170) speaks of it as a "short-lived change . . . a reflection of some foreign influence."

11. It occurs also at Kaminaljuyú, Group A, prior to A.D. 250 (Kidder, Jennings, Shook 1946, p. 18), and preceding the appearance of tablero profiles.

Bibliography

Acosta, Jorge R.
 1964 "El Palacio de Quetzalpapalotl." *Memorias del Instituto Nacional de Antropología e Historia*, 10. Mexico.

 1965 "Preclassic and Classic Architecture of Oaxaca." *Handbook of Middle American Indians, Robert Wauchope*, gen. ed., vol. 3, pt. 2, pp. 814-836. Austin.

Armillas, Pedro
 1944 "Exploraciones recientes en Teotihuacán, México." *Cuadernos Americanos*, año 3, no. 4. Mexico.

Bandmann, Gunter
 1951 *Mittelalterliche Architektur als Bedeutungsträger. Berlin.*

Caso, Alfonso
 1963 "Una urna con el dios mariposa." *Anales del Instituto Nacional de Antropología e Historia*, vol. 16, pp. 77-97. Mexico.

Coe, Michael D.
 1962 *Radiocarbon Dates from Teotihuacán.* Mimeographed. Yale University. New Haven.

Forssmann, Eric
 1956 *Säule und Ornament.* Stockholm.

Franco, José Luis
 1961 "Representaciones de las mariposas en Mesoamérica." *El México Antiguo*, vol. 9. Mexico.

Hartung, Horst
 1970 "Notes on the Oaxaca Tablero." *Bulletin of Oaxaca Studies*, no. 27, pp. 1-8. Mitla.

Kidder, A.V., J.D. Jennings, E.M. Shook
 1946 *Excavations at Kaminaljuyú, Guatemala.* Carnegie Institution of Washington Publication, no. 561. Washington.

Kubler, George
 1967 "The Iconography of the Art of Teotihuacán," *Studies in Pre-Columbian Art and Archaeology*, 4. Washington.

Lehmann, Karl
 1945 "The Dome of Heaven." *Art Bulletin*, 29, pp. 225-248. New York.

Leroi-Gourhan, Andre
 1965 *Prehistoire de l'art occidental.* Paris.

Linné, Sigvald
 1956 "Radiocarbon Dates in Teotihuacán," *Ethnos*, vol. 21, pp. 180-193. Stockholm.

Marquina, Ignacio
 1922 "In La población del valle de Teotihuacán, México." *Manuel Gamio, ed.*, vol. 1, pt. 1, pp. 95-164. Mexico.

 1951 *Arquitectura prehispánica.* Mexico.

Millon, Clara S.H.
 1962 *A Chronological Study of the Mural Art of Teotihuacán.* Ph.D. dissertation, University of California, Berkeley.

 1966 *The History of Mural Art at Teotihuacán. Mesa Redonda.* Mimeographed, Aug. 10, 1966. Paper presented at XI Mesa Redonda of the Sociedad Mexicana de Antropología, Aug. 8-13, 1966. Mexico.

Millon, René
 1960 "The Beginnings of Teotihuacán. *American Antiquity*, 26, no. 1, pp. 1-10. Salt Lake City.

1966a "Cronología y periodificación: datos estratigráficos sobre periodos cerámicos y sus relaciones con la pintura mural." In *Teotihuacán, Onceava Mesa Redonda*, pp. 57-94. Mexico.

Peterson, Frederick A.
1952 "Tlaloc en soportes de vasijas teotihuacanas." *Tlatoani*, 1, pp. 13-14. Mexico.

Proskouriakoff, Tatiana
1954 *Varieties of Classic Central Veracruz Sculpture*. Carnegie Institution of Washington Publication, no. 606, Contributions to American Anthropology and History, no. 58. Washington.

Séjourné, Laurette
1959 *Un palacio en la ciudad de los dioses [Teotihuacán]*. Mexico.
1960 *Burning Water: Thought and Religion in Ancient Mexico*. New York.
1966a *Arqueología de Teotihuacán. La cerámica*. Mexico. Buenos Aires.
1966b *Arquitectura y pintura*. Mexico.

Smith, E. Baldwin
1956 *Architectural Symbolism of Imperial Rome and the Middle Ages*. Princeton.

Tuggle, H. Davis
1966 *Cultural Inferences from the Art of El Tajín, Mexico*. Master's Thesis, University of Arizona. Tucson.

Vitruvius
1926 *Ten Books on Architecture*. M.H. Morgan, transl. Cambridge, Mass.

Von Willing, Hasso
1947 *Representation of Temple Buildings as Decorative Patterns on Teotihuacán Pottery and Figurines*. Notes on Middle American Archaeology and Ethnology, 3, no. 83, pp. 170-177. Cambridge, Mass.
1968 "Der Netzjaguar in Teotihuacán . . . eine ikonographische Untersuchung. *Ethnos*, 16, pp. 31-46. Stockholm.

The Mixteca-Puebla Concept
In Mesoamerican Archaeology:
A Re-Examination

H.B. Nicholson

There is an increasing emphasis in New World archeology on a more precise conceptualization of the vast mass of raw excavational data which has accumulated in recent years. Although a tremendous amount of basic fact-gathering remains to be done, it is recognized that for continuing progress in the field a constant refinement of our methodological and theoretical tools is equally necessary. Occasionally it is also worthwhile to re-examine and, when called for, to reformulate established concepts, particularly where these have been employed somewhat loosely. It is the aim of this brief paper to re-examine and to present suggestions for tightening one such formulation which has had a considerable influence in recent Mesoamerican archeology, the Mixteca-Puebla concept.

Vaillant, in three important studies published between 1938 and 1941 (Vaillant 1938, 1940, 1941) created this construct as a by-product of his attempt to erect a general interpretational scheme for the prehistory of Mesoamerica, with special reference to central Mexico. Boiled down to essentials, Vaillant visualized the development and crystallization of what he variously termed a "culture," "civilization," or "culture complex" in the region of Puebla (especially at Cholula) and the Mixteca of northwestern Oaxaca immediately following the Teotihuacan period, during the "Chichimec" interregnum in the Valley of Mexico. He saw it as diffusing into the Valley, especially at Culhuacan, and providing "the source and inspiration of Aztec civilization" (1941:83). He also believed that elements of this "culture" were carried throughout Mesoamerica, from Sinaloa in the north to Nicaragua in the south, chiefly by actual migratory movements. So important did he view this impact that he labeled his fifth and final major time division of pre-Hispanic Mesoamerica the "Mixteca-Puebla Period" (1941:Chart 1).

Vaillant never presented a systematic exposition of his concept, but in two brief passages he indicated in general terms its major elements: a carefully defined

polytheism, the *tonalpohualli*, 52-year cycle, stylized picture writing, chiefly lineage, formal war, and "characteristic ceremonial practices" (1940:299; 1941:84). As sites, areas, and phases which displayed characteristic Mixteca-Puebla influence, apart from late central and southern Mexico in general, he specifically singled out Guasave in Sinaloa, Xochicalco, the Cerro Montoso phase in Veracruz, "the Mexican occupation of Chichen Itza," Santa Rita in British Honduras, Naco in Honduras, and Guatemala, Salvador, and Nicaragua generally. In addition, he felt that "elements of the religion affected tribal communities as far distant as the southeastern United States" (1941:84).

Applying it to their own findings, Vaillant's Mixteca-Puebla concept was soon accepted by other archeologists. One of the first was Ekholm, who, in his 1942 Guasave report, used it to clarify the source of an important influence in the Aztatlan complex of Sinaloa (Ekholm, 1942:126-131). In the same year the second Mesa Redonda of the Sociedad Mexicana de Antropologia adopted a scheme recognizing four major horizons in Mesoamerica, for the last of which they utilized the label Mixteca-Puebla (Mayas y Olmecas, 1942:76). Since then the term has passed into common terminological currency. Subsequent to its original formulation, however, the concept has not been the subject of any significant re-analysis. This is all the more surprising in view of a major shift in orientation toward the "Toltec problem" which occurred in the very year that Vaillant's final presentation of the concept appeared and which has since led to the rejection of much of that portion of his scheme which concerns the Teotihuacan-"Toltec" and "Chichimec" periods.

I refer to the Instituto Nacional de Antropologia's excavations at Tula, Hidalgo, under the direction of Acosta (beginning in 1940), and the first Mesa Redonda of the Sociedad Mexicana de Antropologia, 1941, where it was almost unanimously agreed, after some spirited debate, to effect a final divorce between Teotihuacan and the Toltecs of the traditions. This re-orientation resulted in a recognition that Vaillant's "Chichimec" period (typified ceramically by Mazapan, Coyotlatelco, and Culhuacan-Aztec I) falls almost wholly within the newly defined Toltec period, during which Tula played a dominant political and cultural role in central Mexico. Since Vaillant had classified "Mexican" Chichen Itza as Mixteca-Puebla, the nearly identical parent style of Tula necessarily also fits within his concept. But the picture revealed by the Tula excavations is quite distinct from that drawn by Vaillant, i.e., of a Mixteca-Puebla movement into the Valley of Mexico during a kind of Chichimec time of troubles. Instead, if his chronology on this diffusion is accepted, it would have occurred some time during the Toltec period, in conjunction with the Development of the "Mixteca-Puebla" Toltec style itself further to the north. Vaillant's hypothesis of a Pueblan origin for "Aztec civilization" is also greatly weakened by this new alignment, for the essentially Toltec background of the latter is constantly receiving more confirmation.

Do these difficulties caused by our somewhat clearer understanding of the period between the end of Teotihuacan and the rise of Tenochtitlan force the conclusion that Vaillant's Mixteca-Puebla notion has lost its conceptual utility? I think not, but I also believe that a certain amount of reformulation is necessary. The remainder of this paper will be devoted to a consideration of the kind of reformulation which seems to be required by the evidence.

As noted above, Vaillant interchangeably employed the terms "culture," "civilization," "culture complex," and "period" for his concept. Later students added the term "horizon." This terminological variance has led to both ambiguity and confusion. The first two labels seem much too broad to be conceptually useful. The third perhaps has more justification but still appears poorly applicable to the type of data out of which Vaillant erected his construct. The last two describe the concept in terms of a temporal framework; a brief comment will be made on this below.

Analysis reveals that what Vaillant and his followers really have in mind when they employ the term Mixteca-Puebla is, above all, a distinct *style*. Thus when Vaillant speaks of "Aztec civilization" entering the Valley of Mexico at Culhuacan, he actually means that a style of ceramic decoration, out of which evolved the later dominant Valley pottery tradition (Aztec II-IV), seemingly first appears at this site (as Aztec I). Vaillant's other elements, listed above, are not particularly useful criteria, being too widespread temporally and spatially. For example, most, conceivably all, of these traits may have been present, at least to some degree, in both the Classic period Teotihuacan and Monte Alban configurations. Phrased in essentially stylistic terms, however, the Mixteca-Puebla concept can still serve a useful purpose, particularly as a chronologic marker.

What are some of the leading features of the style which lend it distinctiveness? Within the brief compass of this paper, a thorough analysis and definition is impossible, but certain diagnostics can be outlined in a very preliminary way. Perhaps the best touchstone for a definition of the developed style is the Codex Borgia, which, considering its iconographic complexity, esthetic sophistication, and stylistic near-identity to the decorative devices of the local polychrome wares, was very likely painted in Cholula itself. Above all, the style at its best, as in this superb *bilderhandschrift*, is characterized by an almost geometric precision in delineation. Symbols are standardized and rarely so highly conventionalized that their original models cannot be ascertained. Colors are numerous, vivid, and play an important symbolic role in themselves. In general, there is much that is akin to modern caricature and cartooning of the Disney type, with bold exaggeration of prominent features.

These generalities, however, are much less important in distinguishing the style from others in Mesoamerica than certain specific ways of representing various symbols. The presence of even one of these symbols or a characteristic grouping is often enough in itself to define the presence of the style. Among the most highly distinctive individual symbols are: solar and lunar disks, celestial and terrestrial bands, the Venus or bright star symbol, skulls and skeletons (with double-outlined bones), jade or *chalchihuitl*, water, fire and flame, heart, war (*atl-tlachinolli*, shield, arrrows, and banner), mountain or place, "downy feather ball," flower (many variants), stylized eyes as stars, stepped fret (*xicalcoliuhqui*), sliced spiral shell (*ehecacozcatl*), and the twenty *tonalpohualli* signs. One of the most frequent and diagnostic symbol groups is the row of alternating skulls and crossed bones (often combined with hearts, severed hands, etc.) Zoomorphic forms are quite distinctive and easily recognizable, particularly serpents (frequently feathered, *quetzalcoatl*, or sectioned, *xiuhcoatl*), jaguars, deer, rabbits, and spiders. The many deities depicted are highly individualized and usually accompanied by special, clearly distinguishable insignia.

The general style can be broken down into a number of regional and temporal variants. The Toltec sub-style is one of the most divergent of these and appears to lack many of the basic elements listed above. Most surviving Toltec relief sculptures and wall paintings (the ceramics rarely display representational or symbolic motifs) seem to deal with predominantly secular themes, although supernaturalistic features are commonly intermixed. If more strictly religious depictions were available, especially pictorial codices, similarities to the general style might well be increased (the rock paintings of Ixtapantongo, State of Mexico (Villagra, 1954), probably provide a fair idea of how a sheet from a Toltec religious manuscript might have appeared). Another notable sub-style is what can be called the Valley of Mexico Aztec style, although its influence extended considerably beyond that range in the wake of the military conquests of the Triple Alliance. It is best typified by the Codex Borbonicus and most of the carved monuments unearthed in Mexico City. Although very close in both spirit and formal detail to the Cholulteca (= Codex Borgia) sub-style, it is marked throughout by greater realism. A third important sub-style is the Mixtec style proper, well-known from the large number of both pre- and post-Conquest codices which have been preserved from this region. It is extremely close to Cholulteca; certain minor but significant differences, however, probably justify its being distinguished. A number of other sub-styles could be delimited, notably that represented by the Codices Fejervary-Mayer and Laud, which perhaps originated in Veracruz (Cuetlaxtlan? The two codices sent by Cortes to Spain?), but space forbids further discussion.

Not only is the Mixteca-Puebla concept best defined in stylistic terms, it is an obvious candidate for one of the most significant recent concepts in New World archaeology, the "horizon style." This useful construct, which originated in Peruvian prehistory, was given its first explicit formulation by Kroeber (1944:108), who defined it as a style ". . . showing definably distinct features some of which extend over a large area, so that its relations with other, more local styles serve to place these in relative time, according as the relations are of priority, consociation, or subsequence." The ideal horizon style is characterized by three principal features: (1) narrow temporal distribution; (2) broad spatial distribution; (3) stylistic complexity and uniqueness. In terms of Willey's "space-time systematics," horizon styles function as ". . . horizontal stringers by which the upright columns of specialized regional development are tied together in the time chart" (Willey, 1945:55).

Does the Mixteca-Puebla style qualify? Although it falls somewhat short of the ideal, it appears to satisfy the requirements well enough to be conceptually utilized as such. Perhaps its weakest aspect is its rather broad temporal range (in some cases apparently throughout most of the Post-Classic). Stylistically, in spite of numerous temporal and regional variants, it certainly possesses enough complexity and uniqueness to qualify. Its strongest aspect is probably its broad, though quite gappy, spatial distribution.

This latter has yet to be worked out in detail, but some of the most obvious and striking occurrences are worth noting. Apart from its heartland in the areas from which it takes its name and the immediately adjacent regions, especially the Valley of Mexico, it has been located: in almost classic form in the Aztatlan complex of Sinaloa; sporadically elsewhere throughout northwestern and western Mexico; in a distinct regional variant in the Huaxteca (particularly in stone sculpture, shell-work, and wall paintings); throughout the Veracruz littoral in styles often very close to Cholulteca

("Cerro Montoso," Cempoala, Isla de Sacrificios, Cerro de las Mesas Upper I-II, etc.); in Yucatan as the Toltec sub-style at Chichen Itza and, in a later variant, as a clearly discernible influence on the wall paintings of Tulum; in the Santa Rita wall paintings, British Honduras (a particularly striking fusion of late Maya and Cholultecoid styles); somewhat weakly and sporadically in the ceramics of Chiapas, Guatemala (where the Cotzumalhuapan or "Pipil" sculptural style also displays certain generalized elements reminiscent of Mixteca-Puebla), and Salvador; and, possibly, as a pale reflection in certain varieties of Nicoya Polychrome in Nicaragua and western Costa Rica. In addition, wherever Plumbate or X Fine Orange is found throughout Mesoamerica, various Mixteca-Puebloid motifs occasionally appear. A thorough check of all Mesoamerican archeological literature would doubtless fill in a number of gaps; further excavation, many more.

The temporal range of the style is bound up with the problem of the time and place of its origin. As of now, Vaillant's hypothesis of earliest appearance in Puebla and/or Mixteca still seems to be supported by the best evidence; certainly, as he justifiably stressed, it reached its greatest elaboration there. Ceramically, one of its earliest occurrences is in the "policroma laca" and black-on-orange wares of Cholulteca I-Altar de los Craneos, falling apparently near the base of the Early Post-Classic (coeval with Mazapan, Coyotlatelco, Culhuacan-Aztec I, etc.; Noguera 1937; 1954). The formative stages through which it passed, however, have not yet been clearly revealed, either at Cholula itself or elsewhere. Sculpturally, some of the motifs of the Xochicalcan style definitely foreshadow the developed Mixteca-Puebla style, particularly calendric symbols (I would hesitate to follow Vaillant, however, in classifying it as a Mixteca-Puebla sub-style). It seems likely that Xochicalco, in this as in other respects, may have served as a bridge between the older Teotihuacan-Monte Alban tradition and the newer Mixteca-Puebla stylistic age.

On the basis of present evidence, the following developmental hypothesis can be suggested: it is probable that, as both the Teotihuacan and Monte Alban traditions were sputtering out, a new stylistic synthesis was taking place (in which Xochicalco may have played an important role) somewhere to the east and south of the Valley of Mexico, possibly centered in Cholula. Meanwhile a parallel process of synthesis was developing further to the north, with Tula as a center. The two evolving traditions must have exerted considerable influence upon each other, particularly the southern upon the northern, which became in a sense a sub-style of it, although preserving a strong individuality. The two traditions seem to have met in the Valley of Mexico, where the Chalco region, particularly, displays striking southern ceramic affiliations. The creators of the southern synthesis, the Mixteca-Puebla style *par excellence*, can perhaps be identified, as Jiménez Moreno has suggested (1942:128-129), with the Olmeca-Xicalanca of the ethno-historic traditions (Historia Tolteca-Chichimeca, Muñoz Camargo, Chimalpahin, Ixtlilxochitl, *el al.*), who may have been the masters of a political empire rivaling and contending with that of Tula. With the break-up of this latter center, an outpouring of migrants, "civilized" Toltecs as well as "barbaric" Chichimeca, evidently overran the southern region. Far from obliterating its stylistic traditions, however, these newcomers appear to have readily accepted them, the Toltec groups probably fusing their own well-developed and similar stylistic canons with those they encountered. The southern tradition, therefore, continued with little basic change, as evolved Cholulteca and Mixtec, eventually strongly influencing the

formation of a new Valley of Mexico synthesis, Aztec. All three were flourishing at the time of the Conquest. During both the Toltec and post-Toltec periods, waves of Mixteca-Puebla stylistic influence spread widely throughout Mesoamerica, some echoes perhaps reaching the southeast United States in the "Southern Cult" efflorescence. Although the extensiveness of this diffusion might seem to justify labeling this final Mesoamerican horizon Mixteca-Puebla, the term now coming strongly into use, Post-Classic, is unquestionably preferable, if for no other reason than the fact that the style had such varying influence in different regions, some apparently being affected little if at all.

This tentative reconstruction is only an attempt to modernize somewhat Vaillant's original stimulating hypothesis and, like his, will undoubtedly be significantly modified by further analysis and excavation. Certainly one of the most important tasks for the future is a more refined sequential breakdown of the basic style into successive stages of development. This would probably eventually result in the formulation of at least two major sub-stages; these might be labeled, respectively, Mixteca-Puebla Horizon Style A (= Toltec period) and Horizon Style B (= post-Toltec period; "evolved Cholulteca"). A promising minor lead in this direction, focusing on a single important stylistic element, the ray device of the solar disk, has already been briefly initiated by both Andrews (1943:75-76) and Caso (1956:173-174). A careful tracing of both the immediate antecedents of the style and its earliest formational stages is another important desideratum.

In summary: Valliant's Mixteca-Puebla concept has been subjected to a brief critical analysis, necessitated particularly by the revision of important parts of the overall scheme in conjunction with which it was formulated. It has been suggested that its reformulation in essentially stylistic terms would best preserve its conceptual utility. An attempt was made to define briefly the salient features of the style and to sketch preliminarily its spatial-temporal distribution. Its candidacy as an horizon style was also put forward, and it was felt that it fitted the specifications well enough to qualify in a broad sense. Lastly, further research designed to clarify its sequential development was urged, which, if successful, would greatly increase its value as a chronologic indicator.

Bibliography

Andrews, E. Wyllys
 1943 The Archaeology of Southwestern Campeche. Carnegie Institution of Washington: *Contributions to American Anthropology and History*, 8: (40) (Publication 546). Washington.

Caso, Alfonso
 1956 La Cruz de Topiltepec, Teposcolula, Oaxaca. In *Estudios antropológicos publicados en homenaje al doctor Manuel Gamio*. Pp. 171-182. Mexico.

Ekholm, Gordon
 1942 Excavations at Guasave, Sinaloa, Mexico. *Anthropological Papers of the American Museum of Natural History*, 38: (2). New York.

Jiménez Moreno, Wigberto
 1942 El Enigma de los Olmecas. *Cuadernos Americanos*, 5: (5) 113-145. Mexico.

Kroeber, Alfred L.
 1944 *Peruvian Archaeology in 1942*. Viking Fund Publications in Anthropology, No. 4. New York.

Mayas y Olmecas
 1942 *Mayas y Olmecas*. Sociedad Mexicana de Antropología, Segunda Reunión de Mesa Redonda sobre Problemas Antropológicos de México y Centro América. Mexico.

Noguera, Eduardo
 1937 *Conclusiones principales obtenidas por el estudio de la cerámica arqueológica de Cholula*. Dirección de Monumentos Prehispanicos (mimeographed). Mexico.

 1954 *La cerámica arqueológica de Cholula*. Mexico.

Vaillant, George C.
 1938 A Correlation of Archaeological and Historical Sequences in the Valley of Mexico. *American Anthropologist*, 40: (4) 535-573. Menasha.

 1940 Patterns in Middle American Archaeology. In *The Maya and Their Neighbors*. Pp. 295-305. New York.

 1941 *Aztecs of Mexico*. New York.

Villagra, Agustin
 1954 *Pinturas Rupestres "Mateo A. Saldaña," Ixtapantongo Edo. de México*. Mexico.

Willey, Gordon R.
 1945 Horizon Styles and Pottery Traditions in Peruvian Archaeology. *American Antiquity*, 11: (1) 49-56. Menasha.

Rituals Depicted On Polychrome Ceramics from Nayarit

Hasso von Winning
Southwest Museum

In the second half of the Early Postclassic period (12th and 13th century A.D.), the potters of west Mexico produced jars with polychrome decoration in the technique of Cholulteca pottery and in the pictorial style of the Mixteca-Puebla religious-ritual complex. This style spread from Cholula, the then dominant center, and is evident in Sinaloa (Guasave, Culiacan and Chametla), in Nayarit (Amapa, Peñitas) and other sites in this area (Bell 1971;Ekholm 1942; Kelly 1938, 1945).

The polychrome ceramics of Amapa, which are far from abundant according to Bell, are distinguished by a variety of zoomorphic, mainly asymmetrical, designs, and they resemble the pottery of the Mixteca-Puebla style and the polychrome wares of Guasave (Bell 1971:707).

The purpose of this study is to analyze the decoration of three remarkably well preserved jars from the Amapa-Peñitas region. These are now in private collections and they represent various narrative scenes and rituals in the style of the Codex Borgia manuscript group.

Technically, the jars can be attributed to the "Iguanas Polychrome" type defined by Grosscup on the basis of small fragments which are distinguished by a black line with white dots (Grosscup 1964:134-138). The decoration extends over the entire surface of the vessel, including the base (cf. Meighan 1976 jar no. 2471). These characteristics also occur on the three jars under discussion which, according to C.W. Meighan (personal information), pertain to the Early Postclassic (12th and 13th century, but not earlier).

General Style Characteristics

The figures are displayed in a horizontal register without vertical divisions. Differences in rank are indicated by size of the figures and the profusion of their attributes, as is customary in Mesoamerican iconography.

The human figure is represented in profile, with some of the ornaments shown frontally, and is composed of separate elements, as in the pictorials of the Borgia group. Colored areas are outlined in black. The head of the human figure is about the

same size as the body. Individuals look to the left of the observer or they face each other when they form a group.

Uncovered body surfaces are painted in hues of yellow or orange with a red line in the middle. Head, arms, and legs are angular. The nose is very large. Women are distinguished by a vertical angular line across the face and their hair is arranged in two separately tied heaps. Arms and hands are larger than legs and feet; the number of fingers varies between two and four. Thumbs and the big toe are distinguished by white paint. With few exceptions, the persons have no footwear and the toes are bent down so that the person actually stands on them. Toes which point downward also occur in the Mixtec codices, and they occupy half the space of the foot. All individuals wear simple wristlets and the men have bands below the knee. A frequent ornament is a rectangular band which projects from the forehead.

Persons who are not standing or kneeling are seated on a stool with crenelated supports, decorated with disks (i.e. inlays). Similar stools occur in Codex Vaticanus B (8, 33, 50, 55, 63) and also in Borgia where they almost always have a back. They are chairs or seats for deities or nobles.

The entire surface of the vessels is utilized to accommodate the figures and designs, leaving little empty space. In making the roll-out drawings, I had to use the largest diameter of the jar for scale which resulted in some minor distortions and empty areas. However, I made every effort to reproduce the details as accurately as possible and in such a manner that the figures are not separated from adjacent attributes and paraphernalia.

VESSEL I (Figs. 1-4)

Tall vase, composite silhouette, with three elongated spherical supports, height 21.5 cm. Painted in variable hues of dark brown, red, and orange over red-orange transparent slip; polished. Residues of white paint applied after firing. After the motifs were painted they were outlined in dark brown with imprecise brush strokes.

Rim design. A series of irregular stepped frets and rectangles in varying color patterns reach to the lip of the jar. These frets differ from the regular toponymical *grecas* in Codex Nuttall and Colombino (cf. Smith 1973).

Description of the four individuals. Four persons, each sitting on a stool are facing to the left and are distinguished by different nose plaques shown frontally. Motion is only indicated by their gestures.

Person A. The great headdress consists of a wide open bird beak topped by various ornaments and a feather crest. The face shows red vertical lines and dots. Attached to the back of the loincloth is an eagle's head, similar to occurrences in Borgia, but less frequent in Vaticanus B (30, 90). In the raised hand is an object topped by white feathers. This is the only individual with an open mouth, which suggests that he is speaking. He is a male and apparently the first of the series.

Person B. In order to avoid tedious repetitions in descriptions I shall only point out significant determinants. Person B is a female and the highest ranking of the four, which is indicated by her large size and her dress and ornaments. Her headdress is similar to that of Person A insofar as it contains the two knot disks on the bands to which the feathers are attached. Instead of a bird she has a feather mosaic pendant in front of her face. She wears a cape with feather fringe and a skirt. Attached to her back is a stylized bird, with elongated beak, whose tail feathers project upwards. She

holds a fan with a feather ornament below the handle. In front of the fan is a wood bundle which is also decorated with feathers.

Person C. His atttributes suggest that he represents Mixcoatl, the Chichimec god of hunting. The following determininatives are evident: 1) a bifurcated object projects from the forehead (as in Person A); This is the god's emblem and it consists of two eagle feathers (*quauhpilolli*), but it is generally worn on top of the head; 2) a design which probably stands for the deer foot worn as an ear ornament by *Mixcoatl,* however, this detail is not too clear; 3) an ornament behind his neck consists of two concentric rings with a volute in the center and three flint knives arranged radially. I do not believe that this emblem represents a solar disk because the "rays" are not painted red but white. It seems more likely that it is "a kind of collar or *quechquemitl* [?], similar in shape and color to a butterfly wing and provided with large flint knives" (Seler 1902, I:136) (Fig. 3,a). This emblem is typical of *Itzpapalotl* who is another aspect of Mixcoatl. The same ornament occurs also on Person 13 on Jar III; 4) An ornament like an inverted U projects from the forearm and possibly represents the net (*metlauacalli*) in which Mixcoatl carried his arrowheads (Fig. 3,b). 5) From the object in his hand emerges a long feather reminiscent of the heron's feather, an attribute of Mixcoatl. Although the identification of this individual as Mixcoatl is tentative, mainly because the attributes differ stylistically from those in the codices, it is highly suggested that Person C is a diety or a priest impersonating a deity.

Person D wears a skirt and a cape fringed with feathers, like female B. Her nose ornament differs from that of the other individuals by being round; I suggest that it is the *yacameztli* of *Tlazolteotl*, goddess of the moon and the earth (cf. Borgia 55). Her headdress also is similar to that of Tlazolteotl who wears it in two spindles. Below her face is her arm which is bent around her neck, so that the second hand is not visible.

Base. On the exterior base is a stylized bird (Fig. 4).

Summary. The scene on Vessel I depicts two men and two women seated on stools in alternating order. All have large headdresses and some have attributes which identify deities in the codices. They carry no weapons. They are probably four deities or their priests and may be related to the four world quarters. The theme appears to have religious rather than secular significance.

VESSEL II (Figs. 5 and 6)

Jar with a long, slighly incurved neck, without supports, 25 cm. high. Decoration in hues of dark brown, red, orange, and white over semi-transparent reddish-yellow slip; glossy surface. Neck and base show alternating geometrical designs. The border below the neck has red and dark brown lines with white dots. A band contains 24 quadriculated disks painted in the following sequence: dark brown, white, red, orange. All designs elements of the scenes below are outlined in dark color.

Description of the Narrative Scenes.

The composition on the body of the jar includes nine individuals in two groups. Four individuals are placed directly upon the base line, the others are slightly higher.

I shall deal first with the group of persons E, F, G, H, I, and A which includes a kneeling woman giving birth. It is significant that her eye is closed which indicates that she died during parturition. She is in an enclosure or a cave, attended by two women (G, I) who wear their hair bound up in two heaps. Attached to the head of the newborn is a serpent's head which also occurs on the skirt of B (twice), and G, and on

the head of C. Two men (F and A), with their heads bowed, pay homage with the typical gesture of placing a hand on the opposite shoulder. The bird in front of Person A is a vulture (*cozcaquauhtli*) which is characterized in the codices, as well as here, by a stiff feather projecting from its head, a white beak, and dark plumage with white down on the underside (painted yellow on the jar). Person E, with a vulture head attached to his forehead, presides the scene, holding a ceremonial staff with feathers and jade beads.

In the second scene a naked individual (C) with his tooth (or tongue?) projecting, is enclosed in a receptacle. Two women (B and D) hold him by the wrists.

In addition, both scenes display some interesting particulars. All the men and the kneeling women (I) wear sandals. The rest are barefoot and their feet are painted like those on Jar I and III. The hands are rendered with two clawlike fingers. The thumb and the big toe is always painted white. The women are distinguished by an angular line on the face, a two-part hairdo, and skirts. The serpent's head (cf. Fig. 3,a) of the newborn, of Person C, and on the skirts of women B and G are probably appelative signs (nahual?) indicating kinship. From the upper rim pend three ornaments decorated with three, five, and four jade beads, respectively.

Interpretation. Both scenes represent mythological-historical events. The birth-giving scene is reminiscent of the myth of the birth of *Quetzalcoatl*, the culture hero of Tula, whose mother *Chimalma* died during parturition according to the *Hystoire du Mechique* (Jimenez Moreno 1941:8). Also the presence of the vulture is significant. It is the sign of the sixteenth day of the *tonalpohualli* and according to Sahagún (Book 4, ch. 29) a sign of good omen for those born on that day. But since Quetzalcoatl was born on a day *ce acatl* (1 Reed) the vulture does not correspond to the newly born but to the mother. The personified form of the vulture is Itzpapalotl, the representative of the *cihuateteo*, the women who died in childbirth (Seler 1923, IV:598).

In the second scene (B, C, D) we note that the individual inside the receptacle wears the same headdress—a serpent head—as the newborn to signify that they are identical persons. A passage in the *Anales de Cuauhtitlán* relates that Quetzalcoatl ordered a stone box made precisely before his departure for Tlillan Tlapallan where he disappeared. "And when it was finished, Quetzalcoatl was laid therein. Only four days did he remain in the stone box. Then he ordered that his jewels (possessions and insignia) be buried and he departed toward the east" (*Códice Chimalpopoca* 1945:11).

If indeed the two scenes refer to Quetzalcoatl, they represent the first episode in his life, his birth, and the last one before his disappearance. Quetzalcoatl had to abandon Tula in A.D. 895 (Jiménez Moreno 1941:8), approximately two centuries before this vase was painted. At that time the legend of Quetzalcoatl must have been vividly remembered, also in western Mexico where it was introduced by the Mixtec immigrants.

VESSEL III (Figs. 7-11)

Jar with straight sided neck, without supports, 33 cm. high. Colors: gray to black, dark red, red, orange, and white on orange semi-transparent slip; glossy. As on the other vessels, the hues vary and all design elements are outlined in black. The white paint was applied after firing and has partially flaked off.

Decoration Around the Neck (Fig. 8)

Four human figures (A, B, E, F) are seated on stools with crenelated supports and face two standing males (C, D). The seated persons A and B wear bird-head

helmets, those on the opposite side (E, F) have a headband with two disks sustaining a round helmet. Furthermore, the seated ones have a nose rod, with the exception of F whose face is a skull. The two standing persons wear similar garments but these differ from those worn by the seated ones. Person C has a nose plaque with stepped design.

I do not think that these individuals represent deities or their impersonators, instead, the scene depicts a confrontation of chieftains, probably an historical event. Although they carry no arms, the standing persons appear more authoritative than those who are seated, the sitting person F bends his arm in sign of submission. Doubtlessly, this narrative scene is related to the rituals depicted below. These will be considered next.

Decoration on the Body of the Jar (Figs. 9 and 10)

There are thirty figures crowded into the space available. However, this seemingly confusing conglomerate is in reality an orderly symmetrical arrangement of twelve pairs on three levels.

Persons and animals 1-5. I begin with the column on the left, which is fringed with cloud elements (cf. Fig. 3,c) and which contains a vertical band of intense dark red color with two eagles (2) descending from the sky upon a habitation. In the latter is a man and a woman, both kneeling, who face an infant lying on his back (3-5). Both adults are old; each one has only a single tooth. The woman holds her hand over the infant (4) who resembles the newborn on Vessel II. The volutes flanking the chamber are extensions of the jaws of the terrestrial monster which occupies most of the base of the vessel (Fig. 11). Altogether, the composition represents the universe—sky, earth and underworld—and probably the primordial pair *Oxomoco* and *Cipactonal*. On the left margin is a stylized figure (1) with a human head and black obsidian knives attached to its spiral body (Itzpapalotl?, cf. Fig. 3,a).

Persons 6-10. A narrow sky band with black (obsidian) arrows pointing down, alternating with "J" signs, encircles the upper part of the body of the jar. Two women (6, 7) in skirts and with the characteristic hair arrangement, are attached to the sky band; one of them wears a pectoral representing a heart. Both have fleshless jaws and they represent the cihuateteo, the women who died in sacrifice or in childbirth and who, therefore, became deified in the sky. The fleshless jaws of these two figures and of 9, 10, 11, 17 and 19 are characterized by the condyloid process of the mandible and a projection on the mandible; these are painted white.

At the second level are two males carrying animals as an offering. No. 8 is not completely preserved but seems to hold a deer. The other individual (9), with mask and fleshless jaw, holds an eagle. Both bearers of offerings are headed toward the column in which the eagles descend. Person 10 is lying on his stomach and also displays a fleshless jaw.

Persons 11-19. On the upper level is a kneeling female with skull head (11) who carries an individual (12) on her back, sustained by a rope. In front of her is a decorated bowl. She approaches a deity or priest (13) seated on a high pillow covered with cloth. This deity resembles Person C on Vessel I, having a similar headdress, nose plaque, and the emblem on the neck, and who has been tentatively identified as Mixcoatl. To his right is a seated woman (14) with one leg extended, the other leg folded (like Person I on Vessel II).

Below, on the second level, are two individuals who are apparently floating in the air and who are distinguished by round eyes with circles (15, 16). One of them (16) wears a conical cap (*yopitzintli*) with long bands. These individuals are probably deities.

On the lower level a woman (17) empties a bowl containing a dark colored liquid over an individual seated on a stool (18). Another woman (19) holds him by the arm and places her hand on his hand (holding him down?, cf. Person 5). Both these females have fleshless mandibles painted white and heart-shaped pectorals, like Person 6. The ritual involving the pouring of a liquid over an individual is shown in *Codex Borgia 31* (lower left) also with two women with skull faces. Seler related the scenes in *Borgia 31* to pulque rites and, by extension, to the concept of sin (Seler 1908, II:15). We shall see, when dealing with Persons 21 and 22, that the allusion to pulque is pertinent. It seems strange, however, that pulque is painted black in *Borgia 31* and here on Vessel III, since pulque has a milky color. Perhaps the dark color was chosen for better contrast against the light background. The occurrence of pulque plants in parts of Nayarit is documented by post-Conquest sources (Bell 1971:697) so that it is conceivable that pulque was known and consumed also before the Spanish Conquest in the region where this vessel originated.

Persons 21 and 22. The central motif of the configuration is a temple with two chambers, one of which has a double conical roof, the other has a single roof. In each chamber a naked individual lies on his back with flexed legs. Representations of persons in such a position are an iconographic convention that occurs elsewhere (Cod. *Vaticanus B32; Borgia 13;* Stela 1, Xochicalco; Stela 31, Yaxhá; Stela 31, Tikal; TI, central panel F6, Palenque; TFC, D2, Palenque) and has been identified by Barthel as a symbol of the "night-drinker" (*Nachttrinker, yohuallahuana;* Barthel 1963:168-169). Later, I was able to obtain additional data that support the association of supine (clay) figures with flexed legs and pulque rituals (von Winning 1972:37-39).

Below the building is the head of a male (23) whose body is shown on the base of the vessel.

Persons 20, and 23-30. A naked Person (20) points to the right but turns his head to the left. He apparently intends to indicate that the scene on the left (11-14) is related to the ritual performed by two aged individuals (24 and 25) on the right. Both have a drooping lower lip as sign of old age. The male (24) is seated on a stool, the female (25) kneels. Both hold pointed objects, one is a maguey (cactus) prickle, the other is a bone. These instruments are inserted in a framework, the upper part of which is identical to the upper part of the composite figure (1) on the left margin. The old man extends his tongue and apparently has extracted blood in an act of self-sacrifice.

On the second level are two floating deities (26, 27) with rings around their eyes. The one on the left has a conical cap. Both deities correspond to the pair 15 and 16.

Below is another scene in which an old woman (28) and an old man (30) each pour the dark contents of a bowl over an individual seated on a stool (29). This scene parallels that of persons 17-19 but, while one couple is identified by mortuary attributes, the other couple is of advanced age.

Exterior base (Fig. 11). The wide open jaws of the earth monster is accompanied by a male figure (23) on a stool, whose head appears below the double-chambered temple. The entire design on the base is an integral part of the overall composition on

the walls of the vessel; the jaws of the earth monster extend upwards and flank the building with Persons 3-5.

Summary. The spatial arrangement of the figures has been carefully planned. Although their placement on the ovoid surface of the jar appears to be at random, a roll-out drawing reveals systematic distribution of the images (Fig. 10). One scene includes eagles descending from the sky upon a house, below which is a terrestrial deity. A sky band which surrounds the entire vase is interrupted only by the eagle column which may indicate different levels in the heavens. The other individuals are distributed around the main motif, a temple with two chambers in which supine individuals represent the concept of "the one who drinks at night" (a reverential name of *Xipe* and his chief priest); this group is related to pulque ceremonies. There are no calendaric inscriptions; day signs of the tonalpohualli and numerals do not occur.

Several individuals represent deities. But there is insufficient evidence for identifying the persons with a banded conical hat as *Quetzalcoatl-Ehecatl,* or those with rings around the eyes as rain gods. Nor can all individuals with fleshless mandible be identified with certainty as death gods. The elderly pairs (3 and 4, 24 and 25, 28 and 30) may personify *Tonacatecutli* and *Tonacacihuatl* of the *Ometeotl* complex, the primordial pair, particularly in the first instance (Pair 3-4).

Around the neck of the vessel is a narrative scene in which two individuals are confronting, or are confronted by, four persons sitting on stools. The two groups are differentiated by their attire and those who are standing are likely to be foreigners. The scene commemorates some important event in the history of the region and provides the historical-geographical setting for the rituals depicted below.

Summary and Conclusions

Three jars with intricate polychome decoration from the Amapa-Peñitas region of Nayarit are analysed iconographically. They are assigned to the end of the Early Postclassic period (12th and 13th century A.D.). The first vessel portrays four deities or priests; the second shows two mythological scenes probably related to *Ce Acatl Topiltzin Quetzalcoatl,* the culture hero of Tula. The third vessel, with the most complex pictorial arrangement, shows a secular narrative scene above a systematic placement of paired figures related to pulque ceremonies in the traditional, vertically divided, space of the universe.

The designs are strongly influenced by the iconographic system of highland central Mexico, expressed in codices of the *Borgia* group and on polychrome Cholulteca phase ceramics, and were adapted to the regional art style of Nayarit. The mixture of styles makes identification of the figures and concepts difficult in view of substitutions and eliminations of diagnostic attributes of highland iconography.

The designs were painted by artists who were thoroughly familiar with Mesoamerican iconographical conventions, probably by painters of pictorial manuscripts who emigrated from Cholula to west Mexico in the wake of the spread of the Mixteca-Puebla culture.

It is suggestive that the scenes might have been copies from codices which at one time existed in Nayarit and which have since long disappeared. The custom of reproducing imagery from pictorial manuscripts on pottery was practiced in the Mixteca, in Sinaloa, and in Veracruz which is evident in the fine polychrome vessels

from Nochistlán, Guasave, and the Mixtequilla. In the Lowie Museum in Berkeley is a cylindrical vase from Yago, Nayarit, painted similarly as Vessel I. The design is not well preserved and remains unpublished.

The commentaries should be considered as a tentative attempt to elucidate sophisticated designs on pottery which merit to be appreciated as replicas of pages from prehispanic pictorial manuscripts.

Acknowledgments. I thank Clement W. Meighan, H.B. Nicholson and Jean Stern for their cooperation in contributing data and photographs.

Note. This paper is a translation of "Escenas Rituales en la Cerámica Polícroma de Nayarit" which I presented at the XLI International Congress of Americanists, Mexico 1974. It appeared in the *Actas del XLI Congreso Internacional de Americanistas,* vol. 2, Mexico 1976, pp. 387-400.

Bibliography

Barthel, Thomas S.
 1963 "Die Stela 31 von Tikal," *Tribus*, 12:159-214. Stuttgart.
Bell, Betty
 1971 "Archaeology of Nayarit, Jalisco, and Colima." *Handbook of Middle American Indians,* 11, 694-753.
Códice Chimalpopoca
 1945 *Anales de Cuauhtitlán*. Instituto de Historia. UN5 M. Mexico.
Ekholm, Gordon F.
 1942 *Excavations at Guasave, Sinaloa, Mexico.* American Museum of Natural History, Anthrop. Papers, vol. 38, pt. 2, 23-129.
Grosscup, Gordon L.
 1964 *The Ceramics of West Mexico*. Ph.D. Diss., UCLA.
Jiménez Moreno, Wigberto
 1941 "Tula y los toltecas según las fuentes históricas." *Revista Mexicana de Estudios Antropológicos*, V:2-3, p. 79-83.
Kelly, Isabel
 1938 *Excavations at Chametla, Sinaloa.* Iberio-Americana, 14, Berkeley.
 1945 *Excavations at Culiacan, Sinaloa.* Ibero-Americana, 25, Berkeley.
Meighan, Clement W.
 1976 *The Archaeology of Amapa, Nayarit.* The Institute of Archaeology, University of California at Los Angeles.
Seler, Eduard
 1902-23 *Gesammelte Abhandlungen*, vols. I, II, IV. Berlin.
Smith, Mary Elizabeth
 1973 *Picture Writing from Ancient Southern Mexico, Mixtec Place Signs and Maps.* Univ. of Oklahoma Press, Norman.
von Winning, Hasso
 1972 "Ritual 'Bed Figures' from Mexico." *Anecdotal Sculpture of Ancient West Mexico.* Ethnic Arts Council of Los Angeles, p. 31-41.

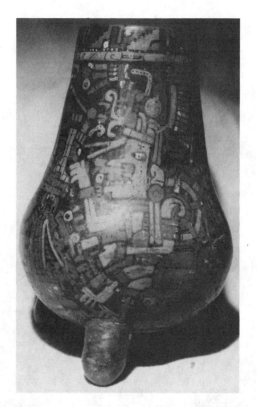

Figure 1. Tripod jar with four individuals (Vessel I). 21.5 cm. high.

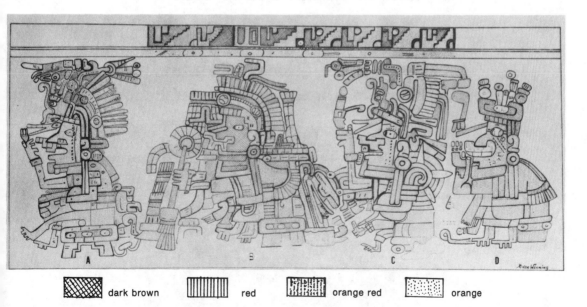

dark brown red orange red orange

Figure 2. Design on Vessel I.

130

Figure 3a. Itzpapalotl (after Seler, GA I:136).

Figure 3b. Mixcoatl (after Sahagun and Codex Magliabecchi).

Figure 3c. Cloud band (Cod. Vaticanus B, 47).

Figure 4.
Underside of Vessel I.

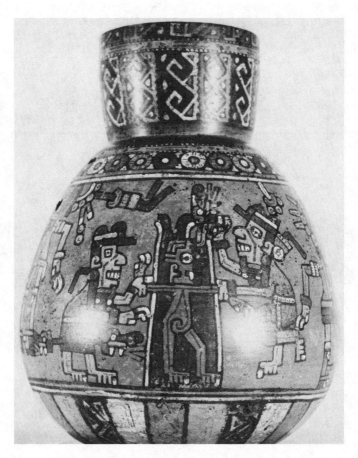

Figure 5. Vessel II (jar with two scenes). 25 cm. high.

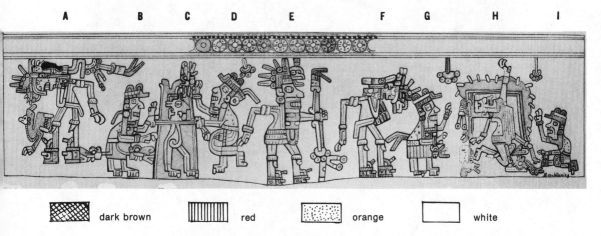

| A | B | C | D | E | F | G | H | I |

dark brown red orange white

Figure 6. Roll-out drawing of the scenes on Vessel II.

Figure 7. Vessel III with 6 figures around the neck and 30 figures on body of jar. 33 cm. high.

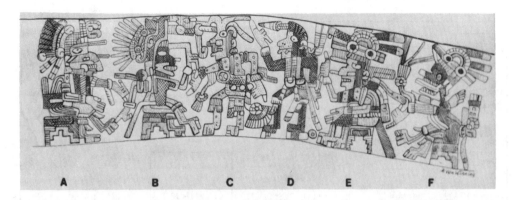

Figure 8. Vessell III, neck design.

grayish black red orange white

Figure 9. Vessel III, design on body of jar.

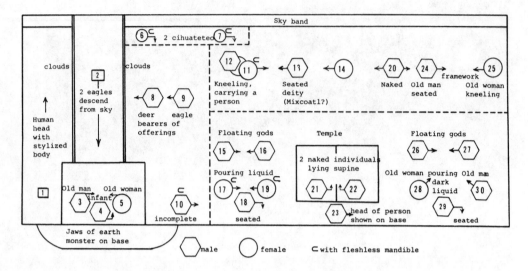

Figure 10. Schematic drawing showing distribution of figures on Vessel III.

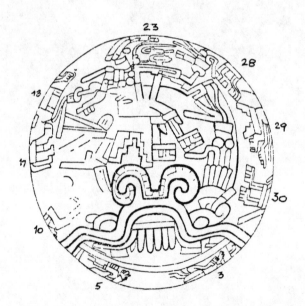

Figure 11. Design on underside of Vessel III.

A Carved Spindle Whorl
From Nayarit

Jean Stern

The finely carved spindle whorl illustrated above is made of green serpentine and measures 24 mm. tall by 36 mm. in diameter. It is said to have been found at the archaeological site of Sentispac, Nayarit, Mexico. This provenience is not secure as it was not found under controlled archaeological conditions; however, the point of origin is supported by the designs carved on its surface. They closely resemble designs found on Amapa pottery and Sentispac is located about 10 km. west of Amapa (Meighan, in prep.).

The carving on the spindle whorl is executed in low-relief over the entire bi-conical surface. Both the top and bottom surfaces are decorated with eight circles arranged around the central hole (see photograph). The design on the body of the spindle whorl is divided into two main panels separated by two smaller, subordinate panels. These subordinate panels exhibit designs largely of a geometric nature, with step-frets, curls and spiral elements. All of these elements are discussed in Bell's study of the Amapa ceramic style (Bell 1960:95ff).

The main panels (see Roll-out #1) are adorned with a highly stylized representation of a feathered serpent. The dominant motif in Panel #1 is a stylized serpent head wearing a feathered headdress. This serpent head (Fig. A) closely resembles those illustrated by Bell (1960:Figs. 25-27). Panel #2 exhibits a mass of elongated forms described by Lister (1949:27) as feather symbols, while Bell (1960:96, 106) cautiously terms them "circular elements" or "rays." In addition there is an element ending in a curled projection, in the lower left hand corner of Panel #2, which has not been discussed in the literature but appears to be the plumed tail of the serpent.

Roll-out #2 is formed by removing the subordinate panels and by joining two roll-out drawings. This procedure graphically reveals the rhythmic continuity of the design composition. By removing the additional repeated heads and other superfluous elements, and by joining several roll-outs, the serpent is shown undulating across the image field (see Roll-out #3). This effect clearly shows that the design of the feathered serpent represents it as winding around the spindle whorl several times, probably two or three times, and terminating in the plumed tail element mentioned above.

Reprinted from *The Masterkey*, Vol. 50, No. 3, 1976. Published by the Southwest Museum, Los Angeles.

Carved green stone spindle whorl.

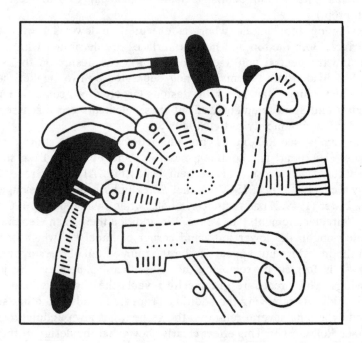

Figure A

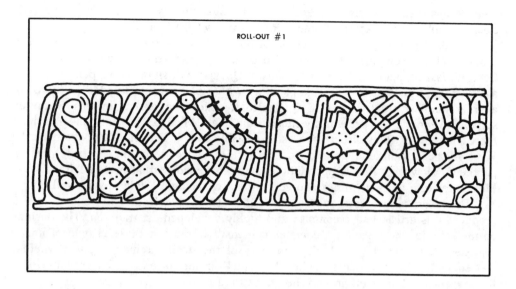

ROLL-OUT #1

The central hole of the spindle whorl is smoothly drilled and wider in diameter on one side than the other, indicating that the drilling action was from one side only. The smooth interior surface of the hole suggests the use of a copper-tipped drill.

The design of the spindle whorl is executed in the Mixteca-Puebla style. The Mixteca-Puebla style is the dominant chronological marker of the Post-Classic horizon in Prehispanic Mexican art. Due to its broad spatial distribution and its stylistic complexity and uniqueness, its presence reliably indicates a temporal locus between the 10th and 14th centuries A.D. (Nicholson 1960:258-263). Representations in the Mixteca-Puebla style are found in archaeological remains throughout Mexico, as far south as El Salvador, Nicaragua and Costa Rica, and as far east as Yucatan in the

ROLL-OUT #2

ROLL-OUT #3

Toltec-Maya cities such as Chichén-Itzá. In the west the style appears in particularly clear examples in the Amapa Complex of Nayarit, where this one originates.

The occurrence of a representation of the feathered serpent on a West Mexican artifact induces comparison to Quetzalcoatl, the great feathered-serpent god of the Central Mexican plateau. Representations of Quetzalcoatl show the serpent as having a rattled tail, whereas this example is shown with a plumed tail. In addition there are a great number of attributes of Quetzalcoatl which are absent in this feathered serpent. Although the present specimen from West Mexico does not appear to be a representation of Quetzalcoatl, it is still possible that it occupied a position in the West Mexican pantheon parallel to that of Quetzalcoatl in the Central Mexican pantheon. However, this is postulation, as we have no textual material from West Mexico relating to its divinities and very little archaeological data to work with.

The historical art data generated by this study reveals that the culture which produced this article had a complex and highly developed art tradition. The designs on the spindle whorl exhibit a complex composition and a multi-level field of image representation. Yet the rhythmic continuity of the design remains active, whether viewed on the single physical level of the actual carving, or on the conceptual level of the serpent winding itself around the image field.

The existence of an art tradition that permits the successful rendition of such a complex image is indicative of a highly advanced culture, not a "village culture" as West Mexico is often referred to. With more research and study of West Mexican material, including the upcoming publication of Meighan's Amapa report and von Winning's figure typology, it is certain that the advanced and complex cultural character of West Mexico will be firmly established.

Bibliography

Bell, Betty B.
 1960 *Analysis of Ceramic Style*. Unpublished Doctoral Dissertation. University of California at Los Angeles.

Lister, Robert H.
 1949 Excavations at Cojumatlan, *University of New Mexico Publications in Anthropology, No. 5*. Albuquerque.

Meighan, Clement W.
 n.d. *Archaeology of Amapa, Nayarit*. In preparation.

Nicholson, H.B.
 1966 The Mixteca-Puebla Concept in Mesoamerican Archaeology: A Re-Examination. *In* Graham, John A., *Ancient Mesoamerica, Selected Readings*. Peek Publications. Palo Alto.

Winning, Hasso von
 n.d. *A Study of the Shaft Tomb Figures of West Mexico*. In Preparation.

Feathered Serpent Motif
On Ceramics From Nayarit

Jean Stern

Iconography is one of the most effective tools of the art historian and archaeologist. By studying the images left by an ancient civilization one can discover important information about cultures that have long disappeared. Such information as details on religious, intellectual and cultural development would normally be obtained from textual sources. When these sources do not exist, this information could be lost forever.

The ancient Prehispanic cultures of western Mexico provide an excellent sphere for the application of iconography as an archaeological tool. In contrast to other areas of Mexico, there are no known surviving texts chronicling the activity of native peoples. Several post-Conquest texts exist, but these were written in connection with military expeditions and concern themselves with cultures which had moved into West Mexico in comparatively recent times (Meighan & Nicholson 1970:22). Whereas there is a definite absence of textual sources in West Mexico, there is, however, an abundance of ceramic artifacts, ranging from the large figures of the shaft tomb period (200 B.C. to 400 A.D.) to the multitude of bowls and vessels representing various Prehispanic cultures. The designs and motifs shown on these ceramic artifacts vary from seemingly repetitive elements to complex and unique images. Therefore, the task of the iconographer is to analyze the various designs and motifs shown on West Mexican ceramics in an attempt to discover symbolic values in the visual representations, and then to interpret the results in conjunction with other data obtained from archaeological inquiry.

In 1959 Clement W. Meighan conducted extensive archaeological investigations at the West Mexican site of Amapa, Nayarit. This collection, which is by far the largest amount of material ever collected in a West Mexican archaeological project, was deposited for study at U.C.L.A., where Bell conducted her study of the Amapa ceramic style (Bell 1960). The collection contains over 600 complete or restorable vessels and spans a period of more than 2,000 years of human occupation (Meighan, in prep.). An iconographical survey of this material by Meighan and this author, as

Reprinted from *The Masterkey*, Vol. 47, No. 4, 1973. Published by the Southwest Museum, Los Angeles.

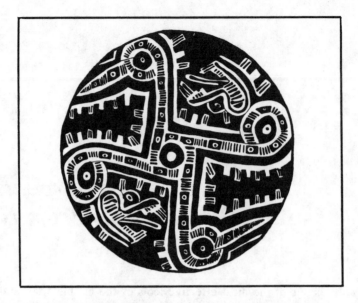

Figure 1. "Ixcuintla Polychrome" bowl, Late Period at Amapa (1000-1300 A.D.), 6¾ in. diam. Amapa collections U.C.L.A.

well as data from several vessels in private collections, produced the material used in this study.

The first group of illustrations show complete representations of the feathered serpent as portrayed on Amapa ceramics. Figure 1 is a drawing of the motif on the exterior of a Late Period white-on-red (with faint black) bowl, designated by Meighan as "Ixcuintla Polychrome" (Meighan, in prep.). The design shows two feathered

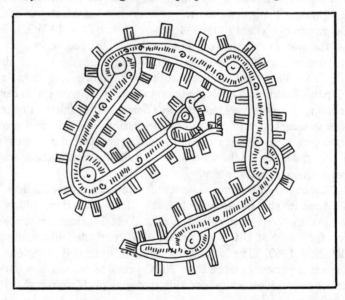

Figure 2. "Tuxpan Engraved" bowl, Middle Period at Amapa (600-1000 A.D.). 10 in. diam. Private collection.

Figure 3. "Ixcuintla Polychrome" bowl, Late Period at Amapa
(1000-1300 A.D.). 5½ in. diam. Amapa collections U.C.L.A.

Figure 4. "Ixcuintla Polychrome" vessel, Late Period at Amapa
(1000-1300 A.D.). 5½ in. high. Private collection.

serpents crossing over each other at the center of the bowl. The serpent heads are distinctive and easily recognizable, and closely resemble those described by Bell in her study (Bell 1960:Figs. 25-27) as well as those discussed in the Cojumatlan report (Lister 1949:27). The serpent bodies are characterized by repeated angular projections depicting feathers. Each serpent loops three times, first immediately after the head, secondly in the center where the two serpents overlap, and thirdly just before terminating at the tail. The looping posture is very common in these representations

and appears to be diagnostic of the Amapa feathered serpent representations on ceramics.

Figure 2 shows the design on the exterior of an engraved bowl of the "Tuxpan Engraved" type, the predominant Middle Period ware at Amapa (Meighan, in prep.) Although not from the Amapa collections at U.C.L.A., this bowl very likely originates from the immediate area of Amapa, if not from the site itself. The design shows a feathered serpent coiled with its head in the center. The body of the snake is shown with the feather projections and is posed in the diagnostic series of loops.

In each of the two above examples, where the serpent is represented with a head and a tail, it is shown with fangs in its mouth and without rattles on its tail.

The next group of illustrations depicts the serpent without head or tail and merely shows the feathered serpent's body used apparently as an abstracted decorative element. The deduction that these motifs represent a *feathered* serpent would not be possible without comparison to the above-described vessels showing complete feathered serpents.

Figure 3 shows another "Ixcuintla Polychrome" vessel with a design closely resembling that of Figure 1; that is, two overlapping feathered serpents, crossing at the center of the bowl. As previously stated, the serpents in this case are shown without head or tail. The resultant motif simply shows two serpent bodies, each highlighted by projections depicting feathers and each portrayed with three loops.

Figure 4 shows an "Ixcuintla Polychrome" vessel. The decorative band is a continuous representation of the feathered serpent, having neither head nor tail and progressing infinitely around the vessel.

Figure 5 presents the design on an "Ixcuintla Polychrome" potsherd (Grosscup 1964). It shows a part of one of the loops in the feathered serpent's body.

Finally, Figure 6 illustrates the design on a Late Period white-on-orange bowl, typed as "Ixcuintla White-on-Orange" (Meighan, in prep.). The scheme of the design is complicated by the extension of the feathers from two opposite sides of the serpent into a series of continuous lines. Otherwise, the serpent is represented in three zigzagging parts, divided by two loops.

Figure 5. "Ixcuintla Polychrome" potsherd, Late Period at Amapa (1000-1300 A.D.). In Grosscup 1964.

In all the examples cited the design motifs exhibit the following characteristics which appear to be diagnostic of the Amapa feathered serpent motif on ceramics:

1. The body of the serpent is patterned in a series of spherical or oval loops.
2. The feathers are depicted by repeated angular projections.
3. The feather band on the outside is separated from the central part by a blank area on each side.
4. The central part of the body is marked with dots and hachures.
5. When the complete serpent is represented it is shown with fangs in its mouth and without rattles on its tail.

The decorative motif discussed in this paper is a common one on Amapa ceramics of the Late Period. The author could have easily listed and illustrated several more examples showing the body of the feathered serpent used as a decorative design. However, the first two vessels (Figs. 1 and 2), showing the representations of the serpent with head and tail, are the only ones that have come to my attention. This comparative rarity between these two variations may be explained by surmising that the representations showing the complete serpent are older than those showing the body only. Thus, of the two vessels having the complete serpent, the one typed as "Tuxpan Engraved" (Fig. 2) dates from the Middle Period at Amapa and is the earliest example used in this study.

Although the other vessel showing the complete serpent is typed as "Ixcuintla Polychrome" (as are the majority of the examples for the serpent's body motif) and therefore dates from the Late Period, it nevertheless displays a more complete image scheme than the remaining examples. This attains significance in view of Meighan's concept that, through time, the ceramic wares at Amapa exhibited a lower degree of

Figure 6. "Ixcuintla White-on-Orange" bowl, Late Period at Amapa (1300-1400? A.D.). Size unknown. Amapa collections U.C.L.A.; also in Bell 1960.

imagery and a tendency to retreat from naturalism as the necessity for simple, more productive methods of ceramic manufacture developed (Meighan, oral comm.).

This concept is demonstrated by a comparison between the earliest vessel in this study and the latest. Figure 2, the "Tuxpan Engraved" bowl, is the earliest and exhibits the most naturalistic representation of the feathered serpent, while Figure 6, the "Ixcuintla White-on-Orange" bowl, is the latest and exhibits the most abstracted representation. As further demonstration, the "Ixcuintla Polychrome" type is characterized by an orange paste ware with a partial red slip onto which a white and black design is painted, whereas the "Ixcuintla White-on-Orange" ware is once removed in time from the "Ixcuintla Polychrome" due to the abandonment of the red slip resulting in an orange ware with white painted designs. This alteration simplifies the manufacture of the bowl and allows for larger production yields.

The identification of this frequent Amapa motif as a feathered serpent accomplishes only half the stated goal of the iconographer. It now remains to interpret the meaning of this pan-Mesoamerican symbol within the ritual and ceremonial context of the Prehispanic people of Amapa. As more material from this little-known area of Mexico becomes available for study, more comparison and correlation will be possible, and perhaps the total picture of the West Mexican ritualistic system will emerge.

Bibliography

Bell, Betty B.
 1960 *Analysis of Ceramic Style.* Doctoral dissertation. University of California at Los Angeles.
Grosscup, Gordon L.
 1964 *The Ceramics of West Mexico.* Doctoral dissertation. University of California at Los Angeles.
Lister, Robert H.
 1949 *Excavations at Cojumatlan.* University of New Mexico Publications in Anthropology, No. 5. Albuquerque.
Meighan, Clement W.
 in prep. *Archaeology of Amapa, Nayarit.*
Meighan, Clement W., & H.B. Nicholson
 1970 The Ceramic Mortuary Offerings of Prehistoric West Mexico. In *Sculpture of Ancient West Mexico.* Los Angeles County Museum of Art. Los Angeles.

An Aztec Stone Image
Of A Fertility Goddess

H.B. Nicholson

Amid the frequently confusing complexities of the intricate religious-ritual system functioning at Contact in central Mexico, one pervasive central theme stands out: fertility. A number of deities embodied various expressions of this concept, particularly a series of goddesses connected with the earth, moisture, and the great staple food plant, maize. Representations of these fertility goddesses are numerous in the ritualistic pictorial books, the codices. They were frequently the subject of the small clay figurines so common in Aztec period sites, which probably served as household gods. Of the many deities portrayed by the surviving stone images, more probably represent the fertility goddess than any other single supernatural in the pantheon. Among these, the maize goddess, known under various names in Nahuatl (Chicome-coatl, "Seven Serpent"; Centeotl, "Maize Deity" (usually male but sometimes female); Xilonen, "She of the Tender Maize Ear"; etc.), was most frequently represented. As was recently stressed by the writer in analyzing another sculpture of a fertility goddess (Nicholson 1961:49), a striking characteristic of the fertility deities as a group is the frequent blending of their ostensibly distinct supernatural personalities through the sharing and exchange of diagnostic insignia[1]. An image labeled a "maize goddess," therefore, often displays the insignia of other fertility deities, especially the water goddess (Chalchiuhtlicue, Matlalcueye)—and vice versa.

The most common form of Aztec style maize goddess stone idol wears the large squarish headdress of *amate* paper, one type of *amacalli* ("coroza de papel," Molina 1944, Pt. 2:4 *recto*; cf. Sahagún in Anderson and Dibble 1950—1961, Pt. II: 4, *passim*), with pleated paper rosettes at the corners (e.g., Seler 1902—1923, III: 416 [Tafel VI,a]). Such a headdress is also occasionally present in the codex versions of the fertility goddess (e.g., Figs. 17, 18, 30). Frequently, in the case of both the stone idols and the codex depictions, she is shown holding pairs of maize cobs, *cemmaitl* ("Maize-hand") (Figs. 14, 15, 17, 30, 31). More rarely she holds in one hand the rattle-staff, *chicahuaztli* (codex versions in Figs. 18, 20, 21). Occasionally her calen-

Reprinted from *Baessler-Archiv, Neue Folge*, Band XI, 1964. Published by Museum Fur Volkerkunde, Berlin.

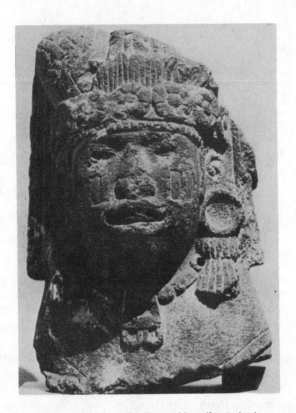

Figure 1. McNear fertility goddess (front view).

dric name, "Seven Coatl," is inscribed in the image. Literally hundreds of these "standard" maize goddess idols are known. The majority are rather crudely carved, obviously mass produced as household deities. A few, however, are excellent examples of the Aztec sculptor's work. Such a piece, of a somewhat different type, will be described in the present article. Aside from its superior esthetic qualities, it exhibits certain iconographic features of special interest.

The piece (Figs. 1-3), of unknown provenience, is in the private collection of Mr. Everett McNear, Chicago, Illinois. It consists of a fragment, a torso, of what may once have been a complete human figure; it now measures slightly over one foot in height. It is carved from dark gray lava stone, probably basalt or andesite. There are traces of gesso and color on the piece, and it was undoubtedly originally painted, as was the case with nearly all Aztec stone idols. It is somewhat battered, particularly on one side of the head, but is, in general, fairly well preserved. Although partly destroyed, the rectangular mantle with the head-slit in the middle and the pointed ends hanging down in front and back, the *quechquemitl*, is clearly delineated. A necklace composed of alternating spherical and tubular beads is worn. From it depends a small pectoral, trapezoidal in shape, with two edging lobe-like elements, similar to the usual manner of depicting feathers or of indicating *chalchihuitl*, "jade, precious" (cf. Fig. 31). Two holes cut into the outermost spherical bead on either side may have served for the insertion of the ends of a real necklace. The usual napkin-ring ear spools are worn.

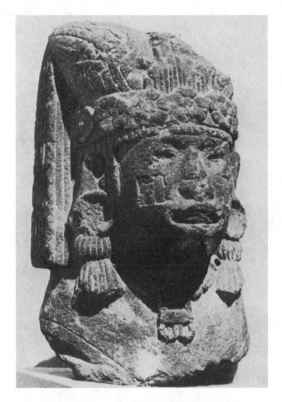

Figure 2. McNear fertility goddess (angle view).

Below these are tassel-like elements; although rather small here, they are often very large and are especially diagnostic of the Chalchiuhtlicue and hybrid Chalchiuhtlicue-Chicomecoatl idols (e.g., Figs. 17, 30). The eye sockets are hollow; they probably originally contained white shell and either pyrites, obsidian, or *chapopote* inlays (to represent the pupil). A similar inlay of white shell to represent the teeth was common, but on this piece the latter appear to have been carved in the stone.

Of particular interest and importance are the two pairs of rectangular slots cut into the cheeks. They probably also originally contained inlays, perhaps of rubber or a dark colored stone. These parallel stripes are a diagnostic insignia of both the water and maize goddesses in various sources, providing another example of the symbol blending so characteristic of the fertility deities. In the Mixteca-Puebla ritualistic codices, *Borgia* and *Cospi*, the water goddess is almost invariably shown with these two parallel stripes on the lower portion of the cheek (Figs. 11, 12). On the other hand, this feature appears to be lacking in the other codices of this group (*Vaticanus B, Fejérváry-Mayer, Laud, Aubin-Goupil #20, Porfirio Díaz Reverse*), with one possible exception (single stripe only) in the *Codex Vaticanus B* (Sheet 42; Seler 1904-09, I:178 [Abb. 474]) and another (two stripes) in the *Codex Porfirio Díaz* (Lam. D'; Seler 1904-09, III: Abb. 1). In the pictorials from the Valley of Mexico and neighboring territory, a single stripe on the cheek is usually assigned to the water goddess in the *Codex Borbonicus* (Fig. 13). In this manuscript there are also two depictions of figures

148

Figure 3. McNear fertility goddess (back view).

with the insignia of both the maize and water goddesses with the two parallel cheek stripes (Fig. 14, 15). On Sheet 27 (Tecuilhuitontli feast), a single stripe also appears to be present on the cheek of a male deity, who is almost certainly Centeotl. In the *Tonalamatl Aubin*, the single stripe is again present on the face of the water goddess (Fig. 16); it is lacking, however, in the principal representation of this deity (sheet 5). It is also assigned in this source to Mayahuel, the goddess of the maguey plant (Sheet 8), while, in one representation, the maize goddess is provided with the double stripe (Fig. 17). The *Codex Magliabecchiano* assigns a single stripe to an obscure fertility goddess connected with the octli cult, Atlacoaya (Fig. 18), but the indubitable maize and water deities in this manuscript lack either the single or double cheek stripes. The same lack is evident in the *Codices Telleriano-Remensis* and *Vaticanus A*. The double stripe is found in Durán's Europeanized drawing of Chicomecoatl (Fig. 19) and seems to be present also in his illustration of another fertility goddess, Iztaccihuatl (Durán 1952, Atlas, Cap. 17 [b]). In the extensive series of fertility goddesses pictured in Sahagún's deity list in his *Primeros Memoriales* (Paso y Troncoso 1905-1907, VI: 23-35; illustrated and quoted *in extenso*, with German translation, in Seler 1902-1923, II: 420-508) this insignia seems to be lacking except, apparently, in the case of a lesser fertility goddess, Tzapotlantenan, credited with the invention of the medicinal turpentine unguent (*oxitl*) (Fig. 20). There it is labeled "*omequipillo*," which is translated by Seler as "zwei herabhängende Tropfen." It may also be present on a fertility

149

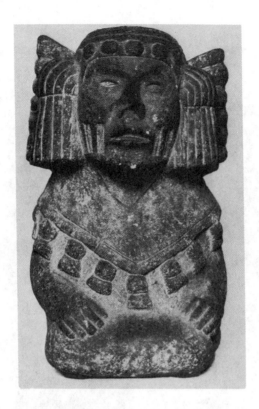

Figure 4. Fertility goddess with double stripe symbol cut as slots into the cheeks. Museum für Völkerkunde, Berlin.

goddess, probably Chalchiuhtlicue, pictured in the Atamalqualiztli feast scene in the same source (Fig. 21). It is also worth mentioning that the female head which serves as the place-glyph for Cihuatlan in the *Codex Mendoza* bears the parallel stripe motif on the cheek (Fig. 22), and Seler (1904a:164) professed to see it also on the female head element in the glyph for Cihuacoatl in the *Humboldt Codex Fragment II*.

The precise symbolic significance of the cheek stripe(s) device is not certain. Two sets of parallel blue stripes were a typical feature of the facades of Tlaloc temples, and sometimes single black stripes were painted on their door jambs and lintels (see, especially, *Codex Borbonicus*, Sheets 24, 25, 32, 35). A thorough analysis of all existing representations of this type would probably further clarify the meanings that were intended in each case.

A well-known example of another stone idol which displays these two pairs of parallel stripes cut into the cheeks, a piece in the Berlin Museum für Völkerkunde, was illustrated and discussed by Seler (1902-1923, II: 907-910). He identified the figure with Chalchiuhtlicue (Fig. 4). A standing female stone idol, which probably also represents Chalchiuhtlicue, in the Albright-Knox Art Gallery, Buffalo, New York, displays single sunken slots on each cheek (Fig. 5). Beyer (1920) published a feminine stone figure, which, because of the presence of the *cemmaitl* and related symbols carved on its back and its serpent head helmet, he identified with Chicomecoatl. In

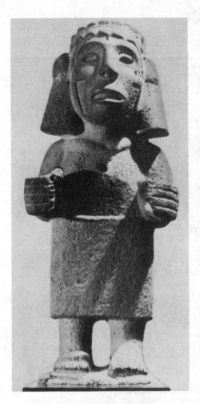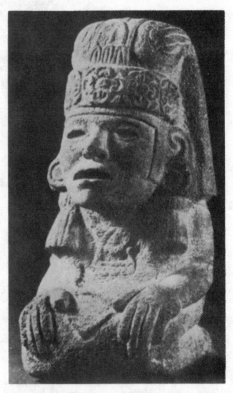

Figure 5. Fertility goddess with cheek stripe symbol cut as slots. Albright-Knox Art Gallery, Buffalo, New York—**Figure 6.** Fertility goddess (Chicomecoatl "Seven Coatl," calendric name, carved on back). Museo Nacional de Antropología, Mexico. (after Museum of Modern Art 1940; three views of this idol are given in Peñafiel 1909, Lám. 14)

the case of this piece, two rectangular areas are cut out of the lower cheeks. Caso (1938; 1950) published a mask, which he identified as representing Chalchiuhtlicue, which bears high on each cheek, just under the eyes, a large rectangular cut-out area. On the back is a relief carving of a goddess who displays both this rectangular area under the eye, divided into four fields, and a single broad stripe on the lower cheek. In the *Borgia* group of codices this symbol, whose fields are red, white, and black, is assigned variously to Xochipilli, the young flower-solar-fertility deity, to the intimately related Centeotl, the young maize god (Fig. 26), and, in one case at least (*Codex Fejérváry-Mayer*, Sheet 11), to a deity who is probably to be identified with the maize goddess. It is well represented on the famous Xochipilli-Macuilxochitl *xantil* collected by Seler in Teotitlan del Camino, Oaxaca (Seler 1904b, Pl. XLII), and on similar *xantiles* illustrated by Franco (1959, Lams. VIII, IX). From its position, high up on the cheeks, the inlay in the rectangular areas on this handsome mask was probably of this latter type rather than the parallel black stripe device.

Just above the hair line on our idol is a fillet, apparently a kind of broad strap, which bears seven representations of flowers, stylized in a standard fashion as five-petaled blossoms. According to Molina (1944, Pt. 1: 30 *verso*), the term *icpacxo-*

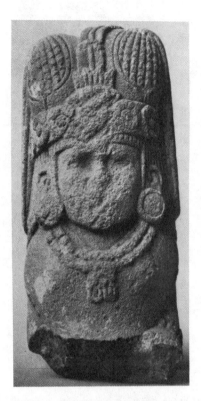
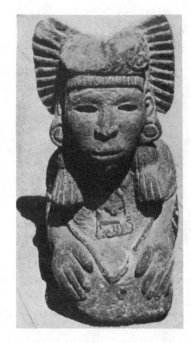

Figure 7. Fertility goddess with maize cobs in headdress. British Museum, London.—
Figure 8. Fertility Goddess. Museo de Historía y Arqueología, Toluca.

chitl ("*ycpacxuchitl*") was employed for a "corona de rosas o guirnalda," which would seem to aptly describe this headpiece (cf. Sahagún in Anderson and Dibble 1950-1961, Pt. II: 66). Such a decoration is not worn too frequently by the fertility goddesses. In the codices, a fairly close parallel can be cited in the case of the floral fillet which binds the hair, gathered up into two prominent tufts, on various female figures in the *Codex Borgia* (especially Sheets 58-60), which Seler (1904-1909, II: 182) identified as forms of Xochiquetzal, the female counterpart of Xochipilli, a goddess with important fertility and terrestrial associations (Fig. 23). Seler (1902-1903:216) identified the flowers as *izquixochitl*, "toasted maize flower" (*Bourreria huanita* Hemsley?), apparently on the strength of a statement in Sahagún (Anderson and Dibble 1950-1961, Pt. II: 66) that such a wreath adorned the impersonator of Tezcatlipoca during the Toxcatl ceremony.

On the stone idols, with the exception of the immediate group under consideration whose other members will be introduced below, this flower-studded fillet is rare. Seler (1902-1923, III: 425) illustrated a fertility goddess idol from the Cerro de Zapotitlan, near Castillo de Teayo, Veracruz, with a row of these stylized blossoms above the tall, rectangular *amacalli* headdress. In the Musée de l'Homme, Paris, is a fertility goddess idol (first illustrated in Hamy 1897, Pl. XV, No. 45) which displays a

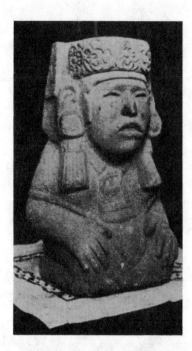 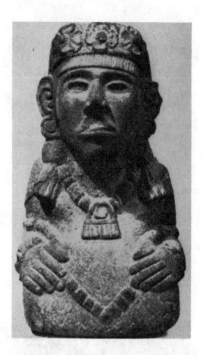

Figure 9. Fertility goddess (Chicomecoatl; "Seven Coatl," calendric name, carved on back). Palacios collection, 1935. (after Palacios 1935)—**Figure 10.** Fertility goddess. Museum of Primitive Art, New York. (Chicomecoatl; "Seven Coatl," calendric name, carved on top of head). (after Upjohn, Mahler, and Wingert 1958).

particularly good example of this floral fillet (also with seven blossoms, but hère six-petaled). Another example exists in the Berlin Museum für Völkerkunde, apparently still unpublished. A fertility goddess image in the Museo Nacional de Antropología, Mexico, wears an unusual fillet, apparently composed of overlapping feathers or leaves, which bears a single large blossom at the front (Caso 1953: Lam. V). A clay figurine has been illustrated by Preuss and Krickeberg, which wears this floral fillet (Fig. 24); the presence of the diagnostic two bunches of quetzal feathers identify it as Xochiquetzal, while the maize cob necklace, *cencozcatl,* provides a direct link to the maize goddess.

The fact that on our piece, and some of the others, seven blossoms are present is undoubtedly significant. "Seven Xochitl," Chicome Xochitl, was the *tonalpohualli* day dedicated to Xochiquetzal and a male counterpart deity. The latter was known by this calendric name; on this day, which fell every 260 days, a feast was held by the painters and weavers (whose patrons Xochiquetzal and Chicomexochitl were) (Sahagún in Anderson and Dibble 1950-1961, Pt. III: 35-36; Pts. V-VI: 7). Caso recently (1959:96) brought together various data concerning this *tonalpohualli* day; its connection with the solar-maize-earth deities, all preeminently expressing the fertility theme, is clear.

Rising from this floral headpiece is a pair of large, realistically represented maize cobs, each with its long tassel hanging down in back. Again, we are confronted with the *cemmaitl,* the double maize ear symbol, so diagnostic for the deities of this plant. Between the two maize cobs, although it is largely destroyed, a long feather ornament

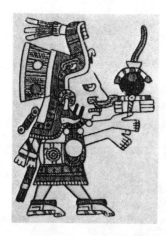

Figure 11. Chalchiuhtlicue. *Codex Borgia* 14 (after Seler).—Figure 12. Chalchiuhtlicue. *Codex Cospi* 6 (after Seler).

can be discerned, composed of a group of six short feathers, from which issue two medium feathers and one long feather. The presence of maize ears, either singly or in pairs, in the headdresses of fertility deities is frequently encountered in the codices. In the *Codex Borgia* group, the *Codex Borgia* itself (Fig. 25) and the *Codices Cospi* (Fig. 26), *Vaticanus B* (e.g., Sheet 33), and *Fejérváry-Mayer* (e.g., Sheet 3) all commonly display this feature in the headdress of Centeotl, the male maize deity. In the Aztec group, the *Codices Borbonicus, Telleriano-Remensis, Vaticanus A,* and the *Tonalamatl Aubin* show this same deity or his female counterpart with this feature (Figs. 27, 28, 29), plus the *Tovar Calendar* (Kubler and Gibson 1951, Pl. VII).

It is not as common on the stone images, but a few examples are known. Apart from the group to be considered below, it is encountered on an esthetically superior large idol in the Museo Nacional de Antropología, Mexico, supposedly from the neighborhood of Papantla, Veracruz (old Dehesa collection; illustrated variously, e.g, Palacios 1935, Fig. 47). Two stone plaques with relief carvings of fertility goddesses in rare front view poses, of unknown provenience but probably from the Valley of Mexico or its neighborhood (the first, now in the Brooklyn Museum, illustrated in Gondra 1846, Lám. 13, and Chavero 1887:589 [see Beyer 1921; Siegel 1953]; the second, in the Museo Nacional de Antropología, illustrated in Krickeberg 1960, Abb. 8 [it is erroneously identified with the Brooklyn Museum piece]), display, above their cord-band headdresses, the pair of maize ears, the *cemmaitl.* It is also worth mentioning that the maize ear(s) incorporated into the headdress of the deity of that plant was a feature of the iconography of other Mesoamerican cultures, including Monte Alban (Caso and Bernal 1952:18-19; Trimborn 1959, Tafel 16), Classic Lowland Maya (God E in the codices and on some sculptures), and Toltec-Maya at Chichen Itza (Seler 1909-1923, V: 317).

The plume device between the maize ears is another standard diagnostic of the fertility deities, both in the codices and in the sculptures. According to Sahagún (e.g., Paso y Troncoso 1905-1907, VI: 26; discussion in Seler 1902-1923, II: 459), it was called *quetzalmiahuayotl,* "quetzál feather-maize tassel." In the Valley of Mexico style codices it is usually (e.g., Fig. 18) represented by the jade, *chalchihuitl,* symbol

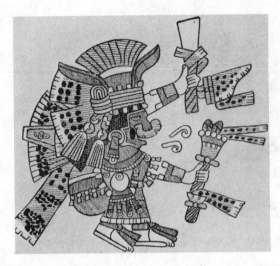

Figure 13. Chalchiuhtlicue. *Codex Borbonicus* 5 (after Seler).

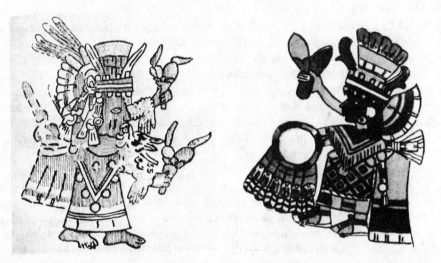

Figure 14. Fertility goddess (probably Chicomecoatl or variant). *Codex Borbonicus* 7 (after Seler,—**Figure 15.** Fertility goddess (probably Chicomecoatl or Xilonen). *Codex Borbonicus* 36.

at the base, two short yellow feathers, and two long green quetzal feathers. The examples on the sculptures tend to show a little more variety, especially in the total number of feathers in the device.

Our idol fragment can be closely compared with five others (Figs. 6-10), with which it forms a clear-cut group. These six images are so similar in general conception that, in spite of numerous differences in details, they were probably carved in the same area and about the same time. Since at least two of them seem to have come from the Toluca Basin (Figs. 8, 9, the latter specifically from Tenancingo), perhaps all of them originated in this area. This region, inhabited by Mazahua, Otomi, Matlat-

155

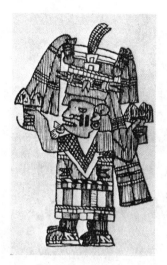

Figure 16. Chalchiuhtlicue. *Tonalamatl Aubin* 18 (after Seler).—Figure 17. Fertility goddess (probably Chicomecoatl). *Tonalamatl Aubin* 7 (after Beyer).

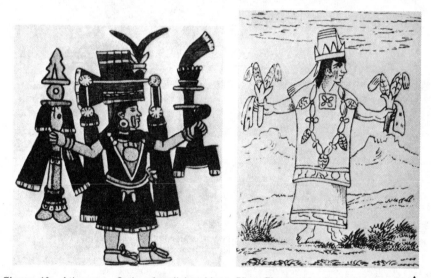

Figure 18. Atlacoaya. *Codex Magliabecchiano* 75r.—Figure 19. Chicomecoatl. Durán (Atlas," Trat, 2a, Lám. 9a).

zinca, Ocuilteca, and Nahua speakers at Contact, had been brought under the effective political control of Tenochtitlan by Axayacatl (1469-1481) and seems to have participated fully in the sculptural tradition of the Valley of Mexico during the last few decades before the Conquest. Apart from the near-identity of style, all of the group share the blossom-studded fillet and the necklace with the trapezoidal pendant. All but the British Museum piece (Fig. 7) bear the small tassels beneath the earspools. Three of the figures, however, lack the pair of maize cobs and the *quetzalmiahuayotl*

156

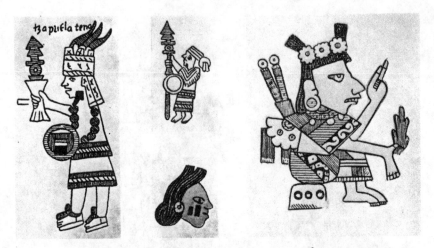

Figure 20. Zapotlantenan. Sahagún, *Primeros Memoriales* (Códice Matritense de Real Palacio, fol. 254r) (after Paso y Troncoso).—**Figure 21.** Chalchiuhtlicue? Sahagún, *Primeros Memoriales* (Códice Matritense del Real Palacio, fol. 254r) (after Paso y Troncoso).—**Figure 22.** Place-glyph, Cihuatlan (Place of Women).*Codex Mendoza*, 38r (after Peñafiel).—**Figure 23.** Goddess (version of Xochiquetzal?). *Codex Borgia* 59 (after Seler).

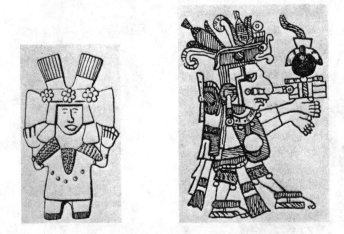

Figure 24. Clay figurine; probably Xochiquetzal. Museum für Völkerkunde, Berlin. (after Krickeberg).—**Figure 25.** Centeotl. *Codex Borgia* 14 (after Beyer).

in the headdress (Figs. 8, 9, 10). Two of these pieces, on the other hand, display an insignia lacking in the others, the pleated *amate* paper neckfan, the *amacuexpalli*[2], another important badge of the fertility deities in general. All but our figure wear fillets with only five blossoms, probably suggesting, therefore, "Five Xochitl," Macuilxochitl, the standard calendric name of the young flower-solar deity. Two of the group (Figs. 6, 9) have carved on their backs a calendric name, "Seven Coatl," the commonest name for the maize goddess. One (Fig. 10) has this same calendric name carved on the top of the head. Other stone idols which belong to this same group may well exist; perhaps the publication of this article will stimulate those who might know of them to bring them to the attention of Mesoamericanists.

Figure 26. Centeotl. *Codex Cospi* 4 (after Seler).—**Figure 27.** Centeotl. *Codex Telleriano-Remensis* 21r (after Seler).—**Figure 28.** Centeotl. *Codex Borbonicus* 19 (after Seler).—**Figure 29.** Centeotl. *Tonalamatl Aubin* 18 (after Seler).

Throughout the foregoing analysis, the frequency of insignia sharing and exchange among the fertility deities has been repeatedly emphasized. This pattern appears to have been another manifestation of what may have been a fundamental characteristic of Contact central Mexican religion: the cosmic, all-pervading divine power expressed through numerous individual deities and symbols, which, in turn, were grouped into various complexes embodying certain basic themes. Just how far this "supernaturalistic unification" had really proceeded in late pre-Hispanic central Mexico, however, has been the subject of considerable difference of opinion. Some of the earliest modern writers, such as Gallatin (1845:352), denied that any unifying principle could be discerned, seeing in Mexican religion only "a great number of unconnected gods, without apparent system or unity of design." On the other hand, as early as 1855 a leading pioneer European scholar of the subject believed he recognized traces of a "pantheistischen Monotheismus" (Müller 1847:474), while another student spoke a few years later of a Mexican "theism," citing the oft-quoted account in Alva Ixtlilxochitl of the building by the Tetzcoco ruler, Nezahualcoyotl (1431-1472), of a temple to the "unknown god" (Tylor 1874, II: 311). Both Müller and Tylor stressed the importance of the abstract concept, *teotl*, "divinity" or "divine power" (for a recent argument that this concept also involves the *mana* principle, see Hvidfeldt 1958), noting its particularly close association with the solar cult. The strongest early position in this direction was perhaps that of Squier (1851:47), who went so far as to declare his conviction that "all divinities of the Mexican, as of every other mythology, resolve themselves into the primeval God and Goddess."

Among recent students advocating the unitary position, Beyer (1910:116), in a brief discussion while analyzing a maize goddess idol collected by Humboldt, spoke of the fire deity, Xiuhtecuhtli, as a "pantheistischen Gottheit." More importantly, he expressed his opinion that the bulging pantheon of Mexican deities, in the conception of the initiated, really consisted of various manifestations of "des Einen." The most vigorous modern proponent of a view nearly identical to that of Squier is León-Portilla. In his *Filosofía Nahuatl* (1956; 1959a) and in various articles (e.g., 1959b) he has presented the evidence contained in some primary sources, above all a number of Sahaguntine Nahuatl texts, for the development by the leading religious thinkers, the *tlamatinime*, the "wise men," of a world view scheme featuring an all-pervading, sexually dualistic cosmic power embodied in the concept of the Ometeotl, "two-god," for which he has coined the term "omeyotization." His words (1956:185) closely echo those of Squier: ". . . la oscura complejidad del panteón nahuatl comienza a desvanecerse al descubrirse siempre bajo la máscara de las numerosas parejas de dioses, el rostro dual de Ometeotl." Other recent students (e.g., Seler 1900-1901:38-39; Spence

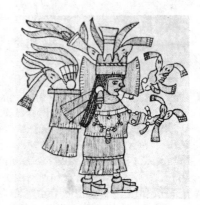

Figure 30. Impersonator of fertility goddess (probably Chicomecoatl) during Ochpaniztli ceremony. *Codex Borbonicus* 30 (after Seler).—**Figure 31.** Maize goddess (symbol of Tozoztontli ceremony). *Codex Vaticanus A* 43v (after Beyer).

1923:150; Soustelle n.d.:9-10; Caso 1953:18) feel that, although a quasi-pantheistic, unitary-dualistix concept of divine power may have been current among the most sophisticated members of the community, it represented a philosophical abstraction almost completely divorced from the living religion. Probably the average native Mexican tiller of the soil was as little concerned with this rarefied theological abstraction as have been the less instructed with such notions everywhere, preferring, more practically, to devote his major ritual attention to the active propitiation of the fertility deities.

One difficulty in resolving this question, apart from the inadequacy of the evidence, is the frequent problem of distinguishing between merely poetic, metaphorical expression in the texts and declarations of clearly conceived and deeply held beliefs. Certainly, as in all complex religions, there were different levels of conceptualization and understanding. The religious *weltanschauung* of the high priests of Tenochtitlan and Cholula, say, was hardly the same as that of the ordinary *macehual*. One fact is undeniable: whatever the degree to which a supernatural unification had been ideologically achieved, insignia sharing among related deities, creating various deity complexes, was characteristic of the iconographic, pictorial expression of the religious system which flourished in central Mexico in late pre-hispanic times. The idol fragment analyzed in this paper presents us with a typical case of this phenomenon.

As the author has stressed elsewhere (1958:593), careful analysis of symbol-decorated objects from pre-Hispanic Mesoamerica will always play a major role in the gaining of greater understanding into the ideological aspect of this area co-tradition. Not too vigorously cultivated in recent years, after the heyday of Seler and Beyer and their immediate followers, this branch of Mesoamericanist studies is at least as deserving of serious attention as the study of sequences of ceramic and other artifact

types, which has so preoccupied Mesoamerican archeologists during the past few decades. The results can be rewarding, for these symbol-strewn pieces often convey a rich amount of information concerning religious ideology, all, by definition, authentically pre-Hispanic. The battered stones of ancient Mexico frequently have much to say, and it is clearly one of the major tasks of the modern student, utilizing to the full the extensive body of materials now available, to induce them to speak.

Acknowledgements

The writer would like to express his sincere thanks to Mr. Everett McNear, the owner of the piece analyzed in the foregoing article, for providing the three photographs which illustrate it in various views and for information on its present condition. Profound thanks are also due the Museum für Völkerkunde, Berlin, for supplying the photograph of the piece illustrated in Figure 4 and permission to publish it, the Albright-Knox Art Gallery, Buffalo, New York, for the photograph of the idol illustrated in Figure 5 and permission to publish it, the British Museum for the photograph of the piece illustrated in Figure 7 and permission to publish it, and The Museum of Primitive Art, New York, for permission to publish the photograph of the piece illustrated in Figure 10.

Notes

[1]Paso y Troncoso (1898:136, 278) suggested that the name Chalchiuhcihuatl ("Jade [Precious] Woman"), one of Durán's terms for "la diossa de las mieses," be applied regularly to these hybrid figures.

[2]This common ornament has almost invariably been called (and the writer up to now has followed suit) *tlaquechpanyotl*, since it was first introduced as a technical term by Seler around the turn of the century, apparently relying on a passage in Sahagún's description of the Etzalqualiztli ceremony. The correct term, however, as Paso y Troncoso noted (1898:174; 278), appears to be that given. The writer hopes to demonstrate this in detail in another place.

Bibliography

Anderson, Arthur J.O. and Charles Dibble
 1950-61 *Florentine Codex. General History of the things of New Spain.* Fray Bernardino de Sahagún. Translated from the Aztec into English, with notes and illustrations, by . . . Santa Fe, New Mexico, School of American Research and Museum of New Mexico, Monographs of the School of American Research No. 14, parts II-VI, VIII-XI, XIII. Albuquerque.

Beyer, Hermann
 1910 "Das aztekische Götterbild Alexander von Humboldt's." In: *Wissenschaftliche Festschrift zur Enthüllung des von seiten S.M. Kaiser Wilhelm II, dem mexikanischen Volke zum Jubiläum seiner Unabhängigkeit gestifteten Humboldt-Denkmals:* 107-119. Mexico.

 1920 "Una pequeña colección de antigüedades mexicanas." *El Mexico Antiguo* I, 6: 159-197. Mexico.

1921 "El Huitzilopochtli de Gondra." *Revista de Revistas*, 577: 38-39. Mexico.

Caso, Alfonso
1938 "An Aztec Mask." *Mexico Speaks*, December: 65-66. Mexico.
1950 "Una máscara Azteca femenina." *México en el Arte* 9: 3-9. Mexico.
1953 "El Pueblo del sol. *Fondo de Cultura Económica*. Mexico.
1959 "Nombres calendáricos de los dioses." *El México Antiguo* 9: 77-100. Mexico.

Caso, Alfonso, and Ignacio Bernal
1952 *Urnas de Oaxaca*. Instituto Nacional de Antropología e Historia Memorias, II. Mexico.

Chavero, Alfredo
1887 *Historia antigua y de la conquista*. México a través de los siglos, I. Barcelona.

Codex Aubin-Goupil No. 20 (*Le culte rendu au tonatiuh* [*le soleil*])
1891 In: *Documents pour servir a l'Histoire du Mexico*. Catalogue raisonné de la collection de M.E. Goupil (Ancienne collection J.M.A. Aubin), Atlas, Pl. 20. Paris.

Codex Borbonicus
1899 *Codex Borbonicus*. Le manuscrit mexicain de la Bibliothèque du Palais Bourbon (Livre divinatoire et rituel figuré) . . . avec un commentaire explicatif par E.T. Hamy. Paris.

Codex Borgia
1898 *Il manoscritto Messicano Borgiano* . . . Facsimile edition published by the Duc de Loubat. Rome.

Codex Cospi (Bologna)
1898 *Codice Messicano di Bologna* . . . Facsimile edition published by the Duc de Loubat. Rome.

Codex Fejérváry-Mayer
1901 *Codex Fejérváry-Mayer* . . . Facsimile edition published by the Duc de Loubat. Paris.

Codex Laud
1961 *Códice Laud*. Introducción, selecion y notas por Carlos Martinez Marín. Instituto Nacional de Antropología e Historia, Serie Investigaciones, 5. Mexico.

Codex Magliabecchiano
1904 *Il Codice Magliabecchianus XIII, 3, della R. Biblioteca Nazionale de Firenze* . . . Facsimile edition published by the Duc de Loubat. Rome.

Codex Mendoza
1938 *Codex Mendoza*. The Mexican manuscript known as the Collection of Mendoza preserved in the Bodleian Library, Oxford. Facsimile edition edited by James Cooper Clark. London.

Codex Porfirio Díaz
1892 In: *Antiguedades Mexicanas*. Junta Colombina de México en el IV Centenario del Descubrimiento de América, Atlas, 12 Pls. Mexico.

Codex Telleriano-Remensis
1899 *Codex Telleriano-Remensis*. Le Manuscrit mexicain de Ch.-M. le Tellier, archevéque de Reims, a la Bibliothèque Nationale (Ms. Mexicain no. 385) . . . Facsimile edition published by the Duc de Loubat; commentary by E.T. Hamy. Paris.

Codex Vaticanus A (3738)
1900 *Il manoscritto Messicano Vaticano 3738 detto il Codice Rios* . . . Fascimile edition published by the Duc de Loubat; introduction by F. Ehrle. Rome.

Codex Vaticanus (3773)
1896 *Il manoscritto Messicano 3773*. Facsimile edition published by the Duc de Loubat. Rome.

Durán, Fray Diego
1952 *Historia de las Indias de Nueva España es islas de Tierra Firme*. 2 vols. and atlas. Editora Nacional. Mexico.

Franco, José Luis
 1959 "Representaciones de la mariposa en Mesoamerica." *El México Antiguo* 9 ; 195-244. Mexico.
Gallatin, Albert
 1845 *Notes on the semi-civilized nations of Mexico, Yucatan, and Central America.* Transactions of the American Ethnological Society 2: 1-352. New York.
Gondra, Isidro
 1846 *Explicación de las láminas pertenecientes á la historia antigua de México y a la de su conquista.* Vol. 3 of the Cumplido edition of Prescott's History of the Conquest of Mexico, Mexico, 1844-46. Mexico.
Hamy, E.T.
 1897 *Galerie Américaine du Musée d'Ethnographie du Trocadéro.* Ernest Leroux. Paris.
Hvidfeldt, Arild
 1958 *Teotl and Ixiptlatli; some central conceptions in ancient Mexican religion; with a general introduction on cult and myth.* Munksgaard. Copenhagen.
Krickeberg, Walter
 1960 "Xochipilli und Chalchiuhtlicue: zwei aztekische Steinfiguren in der völkerkundlichen Sammlung der Stadt Mannheim." *Baessler-Archiv*, N.S., 7, 1: 1-30. Berlin.
Kubler, George and Charles Gibson
 1951 *The Tovar Calendar.* Connecticut Academy of Arts and Sciences, Memoirs, XI, New Haven.
León-Portilla, Miguel
 1956 *La filosofía Náhuatl; estudiada en sus fuentes.* Ediciones especiales del Instituto Indigenista Interamericano. Mexico.
 1959a *La filosofía Náhuatla; estudiada en sus fuentes.* 2. ed. Universidad Nacional Autónoma de México, Instituto de Historia, Pub. 52 (Seminario de Cultura Náhuatl, Monografías, 1). Mexico.
 1959b "El concepto Náhuatl de la divinidad, según Hermann Beyer." *El México Antiguo* 9: 101-110. Mexico.
Molina, Fray Alonso de
 1944 *Vocabulario en lengua castellana y mexicana.* Facsimile edition of edition of 1571. Ediciones Cultura Hispánica. Madrid.
Müller, J.G.
 1855 *Geschichte der Amerikanischen Urreligionen.* Basel.
 1867 *Geschichte der Amerikanischen Urreligionen.* 2. ed. Berlin.
Museum of Modern Art, New York
 1940 *Twenty Centuries of Mexican Art.* New York.
Nicholson, H.B.
 1958 "An Aztec monument dedicated to Tezcatlipoca." *In:* Miscellanea *Paul Rivet: Octogenario, Dicata*, Pablo Martínez del Río, ed., Universidad Nacional Autonoma de México, Instituto de Historia, Publicaciones, Primera Serie, 50, I: 592-607. Mexico.
 1961 "An outstanding Aztec sculpture of the water goddess." *Masterkey* 35, 2: 44-55. Los Angeles.
Palacios, Enrique Juan
 1935 "Esculturas y relieves de Tenayuca." In: *Tenayuca.* Estudio arqueológico de la pirámide de este lugar, hecho por el Departamento de Monumentos de la Secretarío de Educación Pública: 265-280. Mexico.
Paso y Troncoso, Francisco del
 1898 Descripción, historia, y exposición del Códice Pictórico de los antiguos Náuas que se conserva en la Biblioteca de la Cámara de Diputados de Paris (antiguo Palais Bourbon)." *Tipografia de Salvador Landi.* Florence.

1905-07 *Historia general de las cosas de Nueva España por Fr. Bernadino de Sahagún;* edición parcial en facsímile de los Códices Matritenses en lengua mexicana que se custodian en las bibliotecas del Palacio Real y do la Real Academia de la Historia, 4 vols. (Vols. 6: 2-3, 7, 8). Fototipia de Hauser y Menet. (ed.). Madrid.

Peñafiel, Antonio

1885 *Nombres geográficos de México: catálogo alfabético de los nombres de lugar pertenecientes al idioma "Nahuatl"*; estudio jeroglifico de la Matricula de los Tributos del Códice Mendocino. Oficina Tip. de la Secretaría de Fomento, Mexico.

1909 "Ciudades coloniales y capitales de la República Mexicana;" Vol. 2, *Estado de Morelos.* Mexico.

Seler, Eduard

1900-01 *The Tonalamatl of the Aubin Collection . . .* Elucidated by Dr. Eduard Seler. Edinburgh University Press. Edinburgh.

1902-03 *Codex Vaticanus No. 3773 (Codex Vaticanus B) . . .* Elucidated by Dr. Eduard Seler. Edinburgh University Press. Edinburgh.

1902-23 *Gesammelte Abhandlungen zur Amerikanischen Sprach- und Altertumskunde.* 5 vols. Verlag Behrend und Co. Berlin.

1904a "The Mexican picture writings of Alexander von Humboldt in the Royal Library at Berlin." *Smithsonian Institution, Bureau of American Ethnology, Bulletin 28*: 123-229. Washington.

1904b "Wall paintings of Mitla: a Mexican picture writing in fresco." *Smithsonian Institution, Bureau of American Ethnology, Bulletin 28:* 243-324. Washington.

1904-09 *Codex Borgia . . .* Erläutert von Dr. Eduard Seler. Berlin.

Siegel, Flora

1953 "An Aztec relief in the Brooklyn Museum." *The Brooklyn Museum Bulletin 14,* 4: 8-14. New York.

Soustelle, Jacques

n.d. "Les religions du Mexique; première partie: la religion des Aztéques." In: *Histoire generale des religions,* Maxime Gorce and Raoul Mortier, eds., I: 183-188. Paris.

Spence, Lewis

1923 *The Gods of Mexico.* Frederick A. Stokes Co. New York.

Squier, E.G.

1851 *The Serpent Symbol.* New York.

Tonalamatl Aubin

See Seler 1900-01.

Trimborn, Hermann

1959 "Das alte Amerika."*Grosse Kulturen der Frühzeit,* Neue Folge. Kilpper. Stuttgart.

Tylor, Edward

1874 *Primitive Culture.* Boston.

Upjohn, Everard M., Jane G. Mahler and Paul S. Wingert

1958 *History of World Art.* 2. ed. New York.

Addenda:
An Aztec Stone Image
Of a Fertility Goddess

H.B. Nicholson

By coincidence, while the author's "An Aztec Stone Image of a Fertility Goddess" (*Baessler-Archiv* Bd. XI:9-30) was in press, another image which belongs to the general group therein discussed was published (Milkovich 1963:161). Due to the courtesy of Kester D. Jewell, Curator of the Pre-Columbian Section of the Worcester (Massachusetts) Art Museum, which owns the piece, side and rear view photographs plus various data on the image have been obtained. The following brief remarks concerning it are intended to supplement the article cited.

The Worcester Art Museum piece, of unknown provenience, most closely resembles the British Museum specimen illustrated in Figure 7 in the writer's article. The backs of both are sheered smooth, a feature restricted to these two members of the group. The configurations of the two maize cobs in the headdresses are nearly identical in both. The long hair streams over the shoulders in similar fashion. The representations of the *quetzalmiahuayotl* differ slightly in details. The *icpacxochitl* of the Worcester figure lacks the strap-like fillet worn by the other members of the group; the forms of the blossoms, however, are virtually identical to those of the British Museum specimen. Depending from the earspools are elements which are possibly very rudimentary versions of the tassels of the pieces illustrated, in the article, in Figures 1, 6, 8, 9, and 10—although they lack the striations present in these cases. A double necklace is worn, with a precious stone pendant, nearly identical to that of the British Museum figure, although in this case the strands are somewhat longer.

The most striking difference between the Worcester figure and the other members of the group is the cross-legged posture of the former. The lower portion of the British Museum figure is broken away. It may also have displayed the cross-legged posture, but this would seem doubtful. In the Worcester figure the hands rest heavily on the knees, with the point of the *quechquemitl* between. This latter garment is completely plain, bearing no border decoration of any kind, a very rare feature. The lower edge of the skirt, the *cueitl*, can be seen just above the ankle of the right leg. As

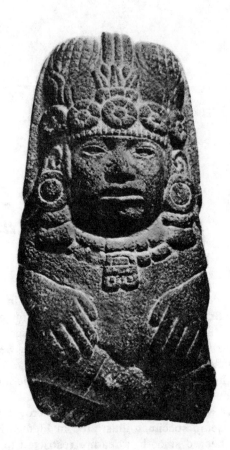

is usual with Aztec fertility goddess idols, the feet are bare. There are remnants of red pigment over the entire figure, including the plain back.

Of special interest are the two black parallel stripes on each cheek, in this case painted on rather than countersunk to contain inlays. The British Museum piece may have borne these stripes originally, but, if so, they have been completely eliminated by the extensive battering to which the facial zone was once subjected (probably the result of missionary zeal). These parallel cheek stripes, of course, link the piece closely to the McNear idol and the Berlin Museum für Völkerkunde specimen illustrated, in the article, in Figure 4, as well as various codex depictions referred to during the course of the discussion.

The cross-legged posture in Aztec idols is not too common but occurs occasionally. Perhaps the most famous single example is the Xochipilli idol of Tlalmanalco (e.g., Caso 1953: Lám. VIII); two striking Xipe idols, one reportedly from Texcoco (Dietschy 1945: Abb. 6), the other apparently from Tenancingo (Peterson 1959:Pl. 4), might also be cited in this connection. The cliff sculpture of Cerro de la Malinche, Acacingo, Tenancingo (Nicholson 1961:Fig. 10), represents a fertility goddess in a similar cross-legged pose. A very similar necklace and pendant are also worn by this figure. Significantly, it will be recalled that in the article it was stated that the idol of Figure 9 was supposedly from Tenancingo. The similarities between the Worcester Art Mu-

seum piece and the Acacingo-Tenancingo cliff carving would add further support to an hypothesis of a Toluca Basin provenience for the group as a whole.

Additional data have also become available concerning the color aspect of the piece. In the article, it was mentioned that it displayed "traces of gesso and color," which information was supplied by Mr. McNear. The latter, at the writer's request, kindly subjected it to a more thorough inspection and now reports that "The color remaining on the surface of the stone is a dark red . . . It seems to cover the entire surface of the head and headdress. I can find no other colors." Red was the standard color of the maize deities, although Chalchiuhtlicue was also often depicted with red face painting.

References Cited

Caso, Alfonso
 1953 *El pueblo del sol. Fondo de Cultura Económica.* Mexico.
Dietschy, Hans
 1945 *Führer duron das Museum für Völkerkunde, Basel: Alt-Mexiko.* Basel.
Milkovich, Michael
 1961 "Ancient Art in the Worcester Art Museum." *Archaeology* 16, 3: 154-161. Brattleboro, Vermont.
Nicholson, H.B.
 1963 "An Outstanding Aztec Sculpture of the Water Goddess." *Masterkey 35*, 2: 44-55. Los Angeles.
Peterson, Frederick
 1959 *Ancient Mexico: An Introduction to the Pre-Hispanic Cultures.* G.P. Putnam's Sons. New York.

The Identity of the Central Deity
On the Aztec Calendar Stone

Cecelia F. Klein

Of the extant artistic monuments created by the Aztecs of Pre-Columbian Mexico, the Aztec Calendar Stone is undoubtedly the most important (Fig. 1). The thirteen-and-a-half foot circular polychromed basalt relief has been used to illustrate Postclassic Mexican cosmological concepts and the nature of their manifestation in Postclassic visual art more often than any other single image of the period.[1] Discovered in 1790 lying face down in the Plaza Mayor of Mexico City (formerly the Aztec capital Tenochtitlán), and seen today in the Museo Nacional de Antropología in Mexico City, the Calendar Stone has, further, come to symbolize for the Mexican people the beauty and complexity of their Pre-Columbian heritage. Given its dual role as a national symbol and a key to scholarly understanding of Postclassic art and cosmology, it is critically important that the iconography of the Calendar Stone be fully comprehended.

The fundamental meaning of the Aztec Calendar Stone has been understood for some time. Scholars have typically accepted the interpretations offered by Eduard Seler and Hermann Beyer who are in essential agreement on the matter.[2] According to them, the Calendar Stone functioned as a graphic symbol of the Postclassic concept of cyclical time and space.[3] This theory is based on the form of the carving itself, which depicts a giant disk with pointed projections that in standard Postclassic iconography invariably represents the sun. The rim of the stone takes the form of two serpents meeting at tails and heads; they are typically identified as *Xiuhcoátls*, or Fire Serpents, mythological creatures who symbolize the twenty-four-hour course of the

*This article is a version of a paper presented to the Columbia University Seminar on Primitive and Pre-Columbian Art, 15 February 1974. It is based on a portion of my doctoral dissertation. I am particularly grateful to the Department of Art History and Archaeology, Columbia University for a 1968 Departmental Summer Travel Grant, which permitted me to pursue my dissertation research in Mexico, and to my dissertation adviser, Professor Douglas Fraser, for his direction, advice, and support.

N.B.: A bibliography of frequently cited sources will be found at the end of this article. All manuscripts and codices mentioned in the text can also be found in the bibliography.

sun through the daytime sky and the earth at night. An inner ring contains all twenty day-signs of the Aztec calendar.[4] In the center of the reliefs there appear the frontal, or *en face*, face and hands of what is certainly a deity; these are enframed by the six-lobed Postclassic graphic symbol for the word Ollin, which means "earth," "movement," or "earthquake." The Ollin sign is accompanied by four small circles that convert it into the date *naui ollin*, 4 Ollin, or "4 Earthquake." In each of the four angles of the Ollin sign there is an image that similarly refers to a specific date in the Aztec calendar.

In connection with this imagery Seler and Beyer point out that the Aztecs believed that the universe had passed through four cyclical epochs, each of which had had its own sun. Each of these epochs or "suns" had been violently destroyed at the end of a fifty-two-year cycle, or Aztec "century." The Aztecs themselves, on the eve of the Spanish Conquest in the early sixteenth century, were living in the fifth and last epoch or "sun" and believed that it too would be destroyed, thereby obliterating both man and his universe for all time. This present sun, whose name was *naui ollin*, (4 Ollin), was expected to be destroyed by earthquakes again at the end of an unspecified Aztec "century" of fifty-two years.[5] Since the date 4 Ollin appears on the Calendar Stone relief, and since the four dates located in the four angles of the Ollin sign are the exact dates of the destruction of the four previous "suns," Seler and Beyer safely conclude that the monument is a graphic symbol of the Aztec concept of the five mythological solar epochs and the end of the world.[6]

We know, however, that fear of the cataclysmic destruction of the fifth and final sun, *naui ollin*, led the Aztecs to hold elaborate vigils and rituals at the end of every fifty-two-year cycle, proceedings designed to stave off the disaster. These vigils took place around midnight when the appearance of a particular constellation and star at the center of the night sky guaranteed that the sun would rise as usual at the eastern horizon at dawn and that life would continue for at least another fifty-two years. The anticipated destruction of the sun was therefore apparently expected to take place at night, at which time it was believed to be dead and hidden in the underworld at the navel of the female earth goddess *Tlaltecuhtli* who systematically "devoured" it each day at sunset. Only proper ritual and sacrifice could insure that the sun would be "reborn" in the east in the morning to pursue its important travels across the sky.

The navel of the earth, moreover, was located at the center of the universe. The Aztecs divided both space and time into segments corresponding to the five world directions and arranged them in a cyclic sequence that ran east, north, west, south, and center. The east and north were associated with sunrise and noon, and thus the sky by day; the west, south, and center were associated with sunset and midnight, the night sky, the earth, and death. The south and center in particular were associated with the precise moment of midnight and the underworld; it was at this time and in these regions that all Postclassic cosmic cycles came to an end.[7] Accordingly, since each of the five mythological solar epochs referred to on the Aztec Calendar Stone were similarly assigned to a particular direction in the traditional sequence, the fifth and final sun, *naui ollin*, fell to the center. It is clear, therefore, that, in referring to the anticipation destruction of the fifth sun at the end of the entire Aztec spatio-temporal cycle, the Aztec Calendar Stone specifically alludes to midnight, the earth, death, and the center of the world.

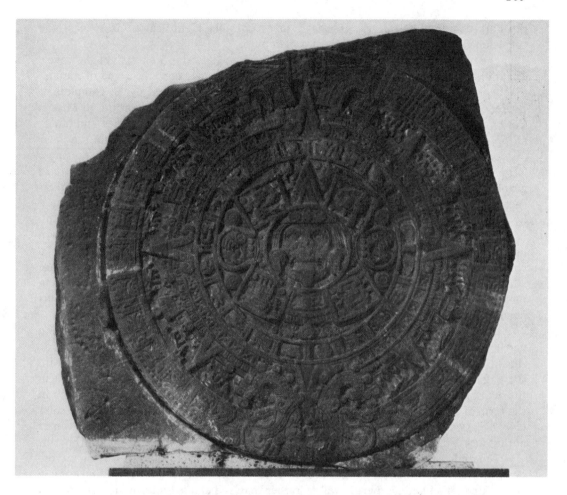

Figure 1. Aztec Calendar Stone. Mexico City, Museo Nacional de Antropología (photo: Museum).

In view of these additional implications, the identity of the deity represented *en face* at the very center of the Calendar Stone relief becomes increasingly problematic. Scholars have traditionally identified this deity as Tonatiuh, an Aztec sun god, an identification that on first analysis would seem appropriate within the context of the solar disk and references to the five mythological solar epochs. *Tonatiuh*, however, like all Aztec Deities, had specific functions and connotations, and these functions and connotations are in fact incompatible with the cosmological context of the stone. Tonatiuh was a god of the day sky, not of the night sky and the earth, and he was invariably associated with the world direction of the east in the Postclassic calendar and codices. Since death and destruction, like the earth and darkness, were associated with the world directions of west, south, and center in Postclassic cosmology, Tonatiuh's affiliation with the east dissociates him from these concepts as well. To identify the central deity of the Aztec Calendar Stone as Tonatiuh is therefore to locate a god of the east, and thus of the beginning of cosmic cycles, of daylight, of the sky and life itself, within a context of cosmic destruction and completion at midnight at

the dark center of the earth. In short, to accept this identification is to cast the consistency of the Postclassic mind into disrepute.

The deity represented at the center of the Aztec Calendar Stone is not, however, Tonatiuh. It is not a deity of light or the day sky of the east, nor is it a god of life and the beginning of cosmic cycles as opposed to one of death and cyclic completion. Evidence for this is both linguistic and literary as well as visual. According to Miguel Covarrubias's reconstruction drawing of the badly damaged and faded face and hands at the center of the monument (Fig. 2), the deity represented there within the solar disk originally had yellow hair, a jewel-tipped nose plug, circular dangling earrings, large teeth in an open mouth, and a long protruding tongue, which takes the standard graphic form of the flint knife used by Aztec priests to remove the hearts of their sacrificial victims. The deity wore a red fillet decorated with two jade rings separated by an abstract jewelled ornament at its center. The facial painting was divided into two horizontal zones, the lower half of which was red, the upper half of which was a lighter red or pink.[8] Two contiguous red bands, which may have read as either a single or double band, surrounded the outer edges of the eyes. The hands, which are still clearly clawed and which clutch human hearts, take the profile form of devouring monster heads. The absence of a body suggests that the god is viewed from above, his head upturned and hands upraised, thus hiding from view the body beneath them.

In the Postclassic codices, the sun god Tonatiuh also wears circular dangling earrings, a jewel-tipped nose bar, and a blond wig; his fillet is decorated with jade rings (Fig. 3). In the literature of the period, moreover, Tonatiuh was associated with the eagle, a bird sometimes depicted in the codices in conjunction with Tonatiuh in the act of grasping human hearts with its claws. The god frequently appears—both in the form of a full-length figure and as a disembodied head—in company with the solar disk; occasionally his head, unlike that of any other deity, is set directly in the center of that disk. At times his eyes are framed on three sides by a single red band (Fig. 4).

Tonatiuh never, however, appears with the monster-faced hands seen on the deity of the Aztec Calendar Stone, nor does he ever appear with a protruding tongue of any kind. His fillet is typically yellow rather than red and is typically decorated with at least three jade rings on each side and a central ornament that takes the form of the head of a bird. As a rule his eyes are not banded; when they are, a contiguous double band is never used. The god does appear frequently in the Aubin Tonalamatl' in his role of fourth of the thirteen Postclassic Mexican Lords of the Day, as a disembodied head set in the center of the solar disk and wearing not only a double (sometimes triple) eye-band, but a pink and red bi-zoned face painting as well (Fig. 5). Since the Aubin Tonalamatl image was one of the major bases for Beyer's original identification of the Calendar Stone deity as Tonatiuh, however, it is instructive that the identical markings appear in the same codex on the faces of the night sun gods *Xochipilli* and *Piltzintecuhtli* (Fig. 14).[9] Both double eye-bands and a bi-colored face painting are in fact occasionally found elsewhere on both Xochipilli and Piltzintecuhtli, while, with the single exception of the Mixteca-Pueblan Codex Borgia, 55 (Fig. 4), where Tonatiuh's face is painted in two shades of red, the day sun god's face is elsewhere either solid red or solid yellow. In other words, only single eye-bands, not double eye-bands, or a bi-zoned face painting, are characteristic of Tonatiuh.

Tonatiuh, moreover, never appears in the rare frontal, or *en face*, two-dimensional form adopted by the Calendar Stone deity. Even in the seemingly comparable

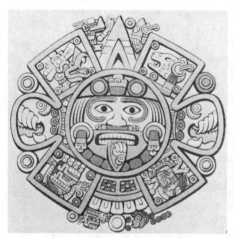

Figure 2. The central deity of the Aztec Calendar Stone, drawing by Miguel Covarrubias (from Caso, 1958, 32).

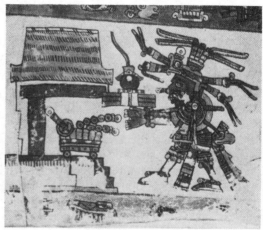

Figure 3. Tonatiuh, detail of Codex Borgia, fol. 23 (from Seler, 1963, III, 23).

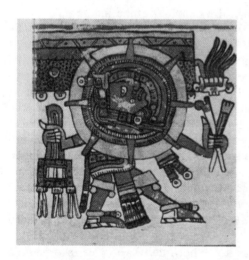

Figure 4. Tonatiuh, detail of Codex Borgia, fol. 55 (from Seler, 1963, III, 55).

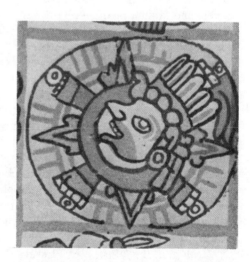

Figure 5. Tonatiuh, detail of Aubin *Tonalamatl*, fol. 9 (from Seler, 1900-01, facsimile, page 9).

Aubin Tonalamatl images the sun god is seen in profile view. Frontality, in fact, is always reserved in Postclassic two-dimensional imagery for those deities who are related to the female earth goddess Tlaltecuhtli who herself invariably appears two-dimensionally in *en face* form and who connotes earth, darkness, agricultural fertility, death, and the world directions of west, south, and center (Fig. 6).[10] Tlaltecuhtli is characterized visually by her dorsal "displayed" posture in which both arms and legs are bent and outspread in the traditional pose assumed by native Mexican women during childbirth.[11] Her head is typically upturned, as is better seen in a three-dimensional Aztec statue which represents her or her "sister" aspect *Coatlicue* (Fig. 7). Her monstrous face bears round, ringed, or banded eyes, an open mouth with sharp teeth, and a protruding tongue that often takes the form of a sacrificial flint knife. Her joints and extremities take the profile form of monstrous faces that frequently clutch human hearts. When she appears in two-dimensional form as Coatlicue, her frontal face, with its differentiated lower portion, its exposed teeth, its flint-knife tongue and its circular dangling earrings bears a striking resemblance to that of the deity of the Aztec Calendar Stone (Fig. 8).

Since only deities who shared Tlaltecuhtli's connotations of earth, death, darkness, and cyclic completion could adopt her frontal form and unique insignia, and since this form and many of these insignia appear in the Calendar Stone deity, but never on Tonatiuh, there can be little doubt that the former refers, not to Tonatiuh, but to a solar deity of the earth, night, fertility, death, and the western, southern, and/or central world directions. This assumption is supported by the fact that throughout Postclassic Mexico, round, ringed, and banded eyes, long tongues, flint knives, and human hearts—all encountered on the Calendar Stone image—symbolize death.[12] It is further supported by the fact that the Aztec land of the dead, *Mictlan*, was originally located in the south or center of the world, at the navel of the female earth monster herself where it was associated in the calendar with the hour of midnight.[13] Since the sun, like all celestial bodies, was believed to die and descend to the land of the dead each time it disappeared at the western horizon, it follows that a solar deity bearing the form and attributes of the female earth monster would represent the dead sun at night housed within her. We know, in fact, that the Aztecs believed that Tonatiuh, at the moment at which the sun disappears at the western horizon, was converted into another deity, a solar god of earth, death, and darkness, who passed through the underworld each night. This deity, who represented the dead sun at night in the body of the female earth monster, was variously known as *Xochipilli*, "Prince of Flowers," *Piltzintecuhtli*, "Lord of Princes," *Yoaltonatiuh*, "Night Sun," *Tlalchitonatiuh* or *Ollintonatiuh*, "Earth Sun," and *Yohualtecuhtli*, the "Lord of the Night."

Xochipilli, the "Prince of Flowers," was a southern deity who was incorporated into the Aztec pantheon in the course of military conquest (Fig. 9). He was the patron of music, dance, songs, and games and was affiliated with sexual pleasure, lust, fertility, and the sun. In an Aztec hymn addressed to him, the god refers to himself as "I, the maize"; he is linked here, as elsewhere, with the maize god *Cinteotl*.[14] Seler titles Xochipilli the "Lord of the South" and designates him as chief representative of that world direction.[15] Together with the moon goddess *Xochiquetzal* he ruled the mythical land of *Xochitlicacán*, the "Land of Flowers," which was located in the south. Since the land of the dead and the hour of midnight were associated with the

Figure 6. Tlaltecuhtli, relief on underside of an Aztec stone *cuauhxicalli*. Berlin, Museum fur Völkerkunde (photo: Museum).

Figure 7. "Coatlicue del Metro." Mexico City, Museo Nacional de Antropología (photo: Museum).

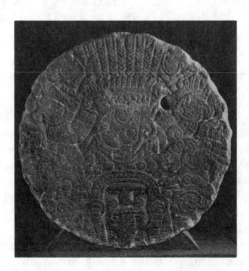

Figure 8. "Coatlicue," relief on underside of an Aztec stone statue. Mexico City, Museo Nacional de Antropología (photo: Museum).

south as well as with the center of the world, it follows that Xochipilli was a god of earth, darkness, and death. In the Aztec hymn addressed to him, Xochipilli is indeed described as one who sings *yoaltica*, "in the night."[16]

In most literary accounts Xochipilli was the husband or lover of the moon and vegetation goddess Xochiquetzal, but he is replaced in this role by one *Piltzintecuhtli* in the *Historia de los mexicanos por sus pinturas* and in an Aztec hymn addressed to Xochiquetzal.[17] In the codices, as in the commentaries and legends, Xochipilli in turn occasionally substitutes for Piltzintecuhtli and frequently appears with that god's insignia. According to the *Histoire du Mechique*, Piltzintecuhtli was Xochipilli's father.[18]

Xochipilli was intimately related to and even interchangeable with Piltzintecuhtli because Piltzintecuhtli was also a solar deity. Piltzintecuhtli is often described as "the young sun god" and wears—like Xochipilli—a number of solar insignia (Fig. 10). Although he appears as rattlebearer of the east in Codices Borgia 51, and Vaticanus B21, and faces the flint-knife god *Iztli* in that section of the Codex Fejervary-Mayer world direction chart (page 1) which corresponds to the east, Piltzintecuhtli is normally affiliated with the west. He appears in the Fejervary-Mayer world direction chart in his capacity as third of the nine Lords of the Night in which he was actually regent of the third Mexican day-sign *Calli* (House), which Seler describes as the "dark house of the earth, the west."[19] Piltzintecuhtli was reported to have fathered the maize god *Cinteotl* in the mythical land of Tamoanchan which also was located in the west.[20] According to an Aztec hymn addressed to the moon goddess Xochiquetzal, Piltzintecuhtli descended into the underworld in pursuit of her, his beloved; here he was believe to have intercourse with the moon.[21] Since the moon was believed to be hostile to the day sun, or Tonatiuh, Piltzintecuhtli can only have represented the sun at night.[22] The Mayan counterpart of the third day-sign Calli (House) ruled by Piltzintecuhtli was in fact Akbal, "Night," which among the Maya was ruled by the Jaguar God who represented the sun at night. The Aztec hymn sung every eight years at the festival celebrating the completion of the Venus-solar cycle clearly identifies the young sun god with night:

> See if Piltzintecuhtli resteth in the house of darkness, the house of night.
>
> O Piltzintli, Piltzintli, with yellow feathers are thou pasted over. On the ball court thou placest thyself, in the house of the night.[23]

There can be little doubt, therefore, that *Xochipilli-Piltzintecuhtli* was a solar deity who specifically represented the dead sun at night at the navel of the female earth monster. He is associated, accordingly, with the phenomenon of frontality in two-dimensional art, which signifies a relation to that goddess. Both Piltzintecuhtli and his Mayan counterpart, the Jaguar God, were associated with the number seven, and in Maya hieroglyphic writing the number seven was actually interchangeable with a conventionalized frontal face.[24] The Jaguar God often appears two-dimensionally in frontal form. Xochipilli himself ruled the twentieth and final Mexican day-sign *Xochitl* (Flower) whose Mayan counterpart was the *Ahau* glyph which also took the form of a frontal face (Fig. 11). J. Eric S. Thompson identifies the latter as the face of the sun and concludes that it is "almost certainly" that of the young sun god.[25] Moreover, since the Ahau glyph is always inverted when it appears in the Maya glyphs for east and sunrise, it would seem that its normal position refers to the sun in the underworld

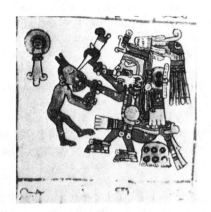

Figure 9. Xochipilli, detail of Co-
dex Borgia, fol. 16 (from Seler,
1963, III, 16).

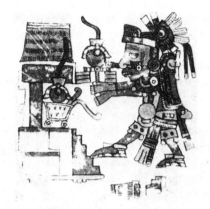

Figure 10. Piltzintecuhtli, detail
of Codex Borgia, fol. 14 (from
Seler, 1963, III, 14).

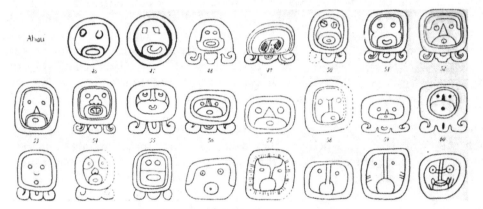

Figure 11. Maya Ahau glyphs, drawing (from Thompson, 1960,
fig. 10, Nos. 46-68).

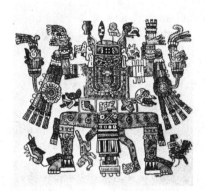

Figure 12. Xochipilli in deer dis-
guise, drawing, detail of Codex
Vaticanus 3773 (B), fol. 96 (from
Seler, 1963, II, fig. 116).

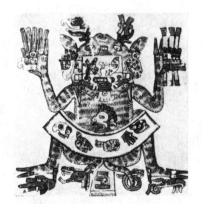

Figure 13. Xochipilli in deer di-
guise, detail of Codex Borgia, fol.
53 (from Seler, 1963, III, 53).

in the west, south, or center of the world. Its Mexican day-sign counterpart Xochitl always symbolized the south and, significantly, the hour of midnight as well.

Xochipilli-Piltzintecuhtli appears twice, moreover, in Codices Vaticanus B 96, and Borgia 53, in the full-lengh frontal displayed form of the female earth monster so closely related to the night sun (Figs. 12, 13). Here the god assumes the disguise of a deer, an act that surely refers to the Mexican legend that Piltzintecuhtli turned into a deer on the day 7 Xochitl (7 Flower), the day of the annual festival held in honor of his beloved, the moon goddess Xochiquetzal. Maya myths frequently tell how the young sun god dons a deer disguise in order to woo the moon.[26] Again, since only the night sun—never the day sun—was on intimate terms with the moon, these *en face* images of Xochipilli-Piltzintecuhtli in deer disguise can only refer to the sun at night.

Xochipilli-Piltzintecuhtli, a god of the night sun in the underworld, therefore shares with the central deity of the Aztec Calendar Stone the ability to be represented in two dimensions in the frontal form characteristic of the female earth monster Tlaltecuhtli. He further shares with the Calendar Stone deity the bi-zoned face painting: in the Aubin Tonalamatl his face is painted in two shades of red, and elsewhere it is often painted red on the bottom and yellow on the top (Fig. 14). Xochipilli-Piltzintecuhtli appears, moreoever, in Codex Borgia 14, 16, 28, and 57, as elsewhere, with double red bands surrounding the outer edges of his eyes (Fig. 9). The eye-bands reappear in Codex Borgia 39 on the disembodied face of an earth monster with upraised arms who has attributes of Xochipilli-Piltzintecuhtli (Fig. 15). Xochipilli often appears in the codices wearing a red rather than yellow fillet decorated with only one or two jade rings on each side. During the Aztec Xochilhuitl, or "Flower Feast," held in honor of Xochipilli, that god's impersonator carried an impaled human heart. These rather remarkable correspondences between the young sun god of night and the deity of the Aztec Calendar Stone certainly support the contention that the latter represents the night sun and further suggest that it may in fact represent, at least in part, the god Xochipilli-Piltzintecuhtli himself.

Human hearts, however, like long tongues and clawed hands and feet, were also characteristic of the *Tzitzimime*, the stellar souls of dead warriors who descended to the center of the earth at midnight during certain critical periods in the Aztec calendar. At the end of the fifth and final "sun," when the world was to be destroyed by earthquakes on the day 4 Ollin at the end of a fifty-two-year cycle, the Tzitzimime were expected to descend; at this time, it was believed, the sun itself upon dying would be converted into a Tzitzimime. The commentator of Codex Telleriano-Remensis lists a certain "Yoalaotecotli" among the ranks of these stellar demons and Thompson equates him with the god *Yohualtecuhtli*. "Lord of the Night," whom Seler identifies as the night sun in the underworld.[27] Sahagún reports that incense was not only offered four times a day to the day sun Tonatiuh, but five times each night as well to the sun god *iovaltecutli*, or "Lord of the Night."[28] Sahagún further identifies as Yohualtecuhtli the star known to us as Castor, which formed part of a constellation called Mamalhuaztli, the "Fire Drill Sticks." Although Sahagún reports that it was the sight of the Pleiades at the zenith of the midnight sky that signaled the beginning of another fifty-two-year cycle, he notes that *Mamalhuaztli*, was close to the Pleiades.[29] The two constellations were in fact closely associated with each other at the moment of the drilling of New Fire; so close, apparently, was this relationship that Alfonso Caso contends that it was the appearance of the star Yohualtecuhtli in the

Figure 14. Xochipilli, detail of
Aubin Tonalámatl, fol. 9 (from
Seler, 1900-01, facsimile page 9).

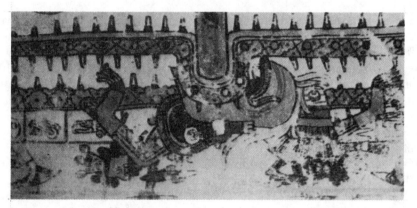

Figure 15. Earth Crocodile with attributes of Xochipilli, detail of
Codex Borgia, fol. 39 (from Seler, 1963, III, 39).

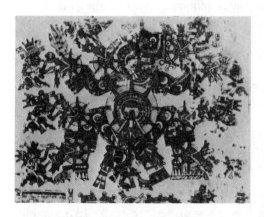

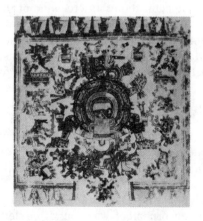

Figure 16. "Yohualtecuhtli," de-
tail of Codex Borgia, fol. 40 (from
Seler, 1963, III, 40).

Figure 17. "Yohualtecuhtli," de-
tail of Codex Borgia, fol. 40 (from
Seler, 1963, III, 40).

center of the midnight sky at the end of every fifty-two-year solar cycle that signaled a temporary reprieve from the cosmic cataclysm that the Aztecs believed awaited them.[30]

A god known as Yohualtecuhtli who represented the sun at night and the Tzitzimime was therefore apparently associated with the end of the fifty-two-year cycle. Sahagún, moreover, further links Yohualtecuhtli directly to the date 4 Ollin. In the course of his discussion of the Aztecs' worship of the sun, Sahagún passed from a discussion of Tonatiuh to the night sun Yohualtecuhtli and reports that: "It was said:/'The Lord of the Night, he of the sharp nose, hath unfolded, and we know not how his office will end.'/And his feast day came upon the day of the day-count called *naui ollin*, every two hundred and three days."[31]

According to Beyer, the Ollin sign was itself a symbol of the constellation Mamalhuaztli, the "Fire Drill Sticks."[32] In Codex Borbonicus 16, the date 4 Ollin is replaced by the "earth sun" deity *Tlalchitonatiuh* as co-patron of the sixteenth Aztec week. The dead sun at night at the center of the earth therefore shared his name and associations with the very stellar being who controlled the destiny of the Aztec nation.[33]

There are relatively few visual images of deities in Postclassic art that have been identified as Yohualtecuhtli, but it is significant that those that have been so indentified share a number of features with the Aztec Calendar Stone deity. Seler identifies as "Yohualtecuhtli, the solar god of the underworld" a large full-length figure on page 40 of Codex Borgia whose body is frontal and displayed (Fig. 16).[34] The god's profile head is upturned in the manner characteristic of the female earth monster and his eye is surrounded by a single red band on three sides. A giant sun disk forms the deity's torso; smaller sun disks, which take the form of anthropomorphic profile monster heads, adorn his joints and extremities. A comparable deity on page 43 of the same codex boasts the snout of a crocodile and a protruding tongue (Fig. 17). On page 35 of Codex Borgia, two full-length figures, again wearing single red eye-bands and crocodile costumes, are specifically identified by Krickeberg as the dead sun who nightly passes through the underworld.[35] The body of one is again frontal and displayed (Fig. 18). Seler understandably identifies the Borgia 35 figures with Cipactli, the earth crocodile of the east, but simultaneously concludes that they, like the Borgia 43 figure, represent lunar deities.[36] Since the moon was always affiliated with the female earth monster and the west, south, or center of the world—never with *Cipactli* or the east—the appearance here of crocodilian features must refer, like the frontal displayed form and anthropomorphic joints, not to Cipactli, but to Tlaltecuhtli and her association with darkness, death, and the earth.[37] Although Seler does not directly identify the Borgia 35 and 43 deities as Yohualtecuhtli may have represented the moon in the underworld as well as the night sun.

Confirmation of the identification of the Aztec Calendar Stone deity as *Yohualtecuhtli* comes from the writings of Sahagún. In speaking of the feast held on the day *naui ollin*, Sahagún reports: "And there was the image of that one [the sun] at a pyramid temple called *Quauxicalli*. There was erected his image, his image was designed as if it had the mask of a man [but] with [the sun's] rays streaming from it. His sun ornament was round, circled with feathers; surrounded with red spoonbill [feathers]."[38]

179

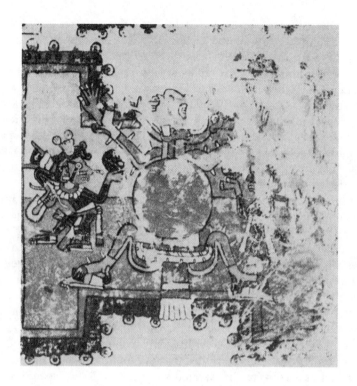

Figure 18. The Night Sun (?), detail of Codex Borgia, fol. 35 (from Seler, 1963, III, 35).

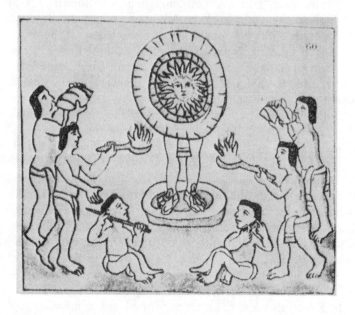

Figure 19. The Night Sun, drawing by native Aztec informants of Sahagún (from Sahagún, III, pl. 60).

In the matching illustration provided by Sahagún's native artists, the deity is depicted as a frontal face set in the center of a large circular sun disk (Fig. 19). Although the Aztec Calendar Stone lacks the red spoonbill feathers mentioned by Sahagún, Sahagún's illustration for obvious reasons has been frequently compared with that monument. Scholars have further assumed that Sahagún was specifically referring here to the day sun god Tonatiuh and have thus cited the accompanying illustration as proof that the Calendar Stone figure also represents that deity. Analysis of Sahagún's text reveals, however, that the passage referring to the frontal image of a solar deity immediately follows that discussing the Lord of the Night Yohualtecuhtli and his feast day *naui ollin*. The description of the solar image and the matching illustration therefore clearly refer to the sun in its nocturnal aspect.

In a number of Postclassic images, moreover, the Ollin sign, often in the context of the date 4 Ollin, is depicted with a single round half-closed eye at its center (Fig. 20). According to Seler, this eye symbolized the Tzitzimime, the setting sun, and the night.[39] The unique substitution in the Aztec Calendar Stone of a frontal face for the traditional eye within the Ollin symbol strongly suggests that the deity represented on the stone also represented the Tzitzimime, the setting sun, and the night. Throughout Mesoamerica the frontal face was and is conceptually equated with the eye; the Zinacantan Tzotzil word for "face" (*sat*), for example, is the same as that for "eyes," while the Zapotec *lao, loo* means "face," "eyes," and "frontside."[40]

Of the various Postclassic solar deities, only Yohualtecuhtli is listed as a Tzitzimime. Furthermore, since Seler concludes that the round eye at the center of the Ollin symbol functioned as a sign for the Nahuatl word for "night," *youalli*, it is probable that the substituted frontal face on the Aztec Calendar Stone served a related paralinguistic function. If this is the case, then the word for "night" may well even have appeared in the deity's name. Two solar deities include the Nahuatl word for "night" in their names—one is Yoaltonatiuh, the "Night Sun"; the second is his close relative Yohualtecuhtli, the great "Lord of the Night." The appearance of the Calendar Stone of attributes of Tonatiuh combined with attributes of the female earth monster and the nocturnal sun gods Xochipilli and Piltzintecuhtli in a solar context commonly reserved for the symbol for "night" therefore leaves little doubt that the deity represented there was a solar god of the night.

Yohualtecuhtli, however, represented not only the dead night sun in the underworld, but the "dead" planet Venus as well. Among the Mexicans, as among the Maya, the 584-day Venus cycle was divided into four phases, each of which corresponded to a specific world direction. The first phase was that of the Morning Star which appears at dawn in the east, the second was that of superior conjunction which was associated with the north, the third was that of the Evening Star which appears at dusk in the west, and the fourth was that of its disappearance in inferior conjunction in the south (or center) of the world. As was the case with all stars and planets, including the sun, Venus was believed to be "born" in the east as the Morning Star and, as the god *Xólotl*, the Evening Star, to "die" upon its descent to and disappearance at the western horizon. Upon entering the body of the female earth monster Tlaltecuhtli, Venus, like the sun, assumed that goddess's associations and insignia. Accordingly, the Evening Star of the west and the planet in inferior conjunction in the south or center of the world appear occasionally in Postclassic two-dimensional imagery in the frontal form of Tlaltecuhtli, with displayed limbs, upturned head,

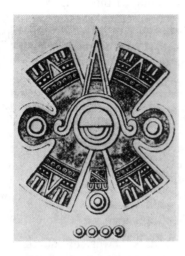

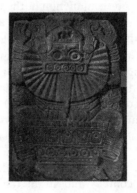

Figure 20. The date "4 Ollin" with single round eye, drawing (from Beyer, fig. 69).

Figure 21. Xólotl, Huastec stone relief from Tepetzintla, Veracruz. Mexico City, Museo Nacional de Antropología (photo: Museum).

Figure 22. The "Morning Star" deity and accompanying glyphs from Mausoleum III, Chichén Itzá, drawing (from Seler, 1960-61, v, figs. 241-43).

clawed hands and feet, round, ringed, or banded eyes, large teeth, and a protruding tongue (Fig. 21). Moreover, since the Venus cycle, like the solar cycles, began at dawn in the east and concluded at or around midnight in the south or center of the world, these *en face* images of the western and southern phases of the cycle must similarly refer to the conclusion of a cycle. The frontal so-called "Morning Star" reliefs seen on Mausoleum III at Chichén Itzá, which actually represents the Evening Star in inferior conjunction in the south or center of the world, are in fact accompanied by the date of the *completion* of a "Great Venus Cycle" consisting of 260 revolutions of that planet (Fig. 22).[41]

The Great Venus Cycle, however, simultaneously ended on the same day as a cycle of eight fifty-two-year solar "centuries." The 584-day Venus cycle also terminated on the same day as a 365-day solar cycle every eight years and further coincided with the completion of every other fifty-two-year cycle; in other words, the rituals carried out at the end of every other fifty-two-year cycle marked not only the completion of the major Aztec solar cycle but the completion of a 104-year Venus cycle as well. At this time, as at any time in which the sun and Venus simultaneously completed a cycle, the two celestial bodies were believed to engage in mortal nocturnal combat and ultimately to fuse in the dark bowels of the female earth monster. The hymn sung during the Aztec Atamalqualiztli festival held at the conclusion of the eight-year Venus-solar cycle tells of such a nocturnal contest between the young sun god of night, Piltzintecuhtli, and Xólotl, the god of the planet Venus as the Evening Star. This hymn opens, significantly, with an address to "the lord of the night."[42] One of the Maya names for Venus was *ah piz a'kab*, "Lord of the Night."

In pursuing his own interpretation of the Aztec Calendar Stone as a device for astronomical calculations, José Aviles-Solares proposed that the date 4 Ollin, when it is pierced by an arrow-like device such as penetrates it on the Calendar Stone, refers to the conclusion of the eight-year Venus, solar cycle.[43] Seler demonstrates that the Ollin sign was associated with the fifth and final period (as opposed to phase) of the planet Venus as well as with the fifth and final sun; in Codex Borgia 25, as Seler points out, it appears in this context as a symbol of the central world direction.[44] As the seventeenth of the twenty Aztec day-signs, moreover, Ollin was ruled by Xólotl, the Evening Star, who was actually associated in the Postclassic mind with the dead sun as it sank beneath the western horizon. The commentator of Codex Vaticanus B states that the date 4 Ollin was merely another name for Xólotl and the commentator of Codex Vaticanus A designates the day 4 Ollin as the day of the disappearance into the Red Sea of Quetzalcóatl, a historical personage later associated with Venus who was believed to have died and to have been later reborn in the eastern sky as the Morning Star.[45] In Codices Borgia and Vaticanus B, the date 4 Ollin co-ruled the sixteenth week of the calendar with Xólotl. Both the end of the fifty-two-year solar cycle and the critical date 4 Ollin were therefore associated with the planet Venus in its final phase as the Evening Star in inferior conjunction in the south or center of the world. It would seem likely that the Aztecs, who envisioned a cataclysmic destruction of the universe at the end of a fifty-two-year solar cycle, expected that destruction to occur at the simultaneous completion of a Venus cycle as well.

A number of related Postclassic images confirm the possibility that the frontal face at the center of the Aztec Calendar Stone refers to the god Yohualtecuhtli at the

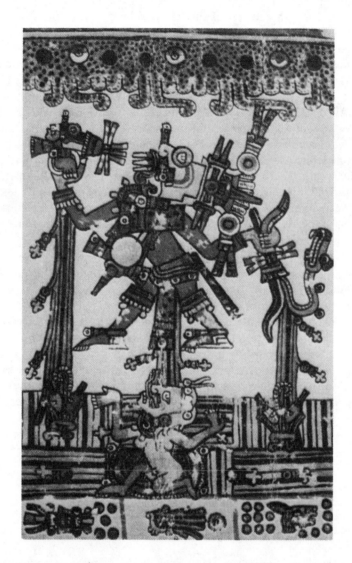

Figure 23. Tláloc with attributes of Xochipilli, detail of Codex
Borgia, fol. 28 (from Seler, 1963, III, 28).

end of a Venus as well as a solar cycle. In the center of page 28 of Codex Borgia, the rain god *Tláloc* appears in the guise of Xochipilli-Piltzintecuhtli, the night sun, as representative of the fifth and last of the Venus-solar periods (Fig. 23). He wears the red and yellow zoned face painting and the double red eye-bands characteristic of that god and similar to the insignia of the Calendar Stone deity. According to Seler, Tláloc as Xochipilli here represents the center of the world and the fusion of Venus with the sun.[46] The Maya equivalent of Xochipilli's calendrical name I Xochitl (I Flower) was I Ahau, or *hun ahpu*, the name of the Maya god of the dead planet Venus in the underworld. All of the Codex Borgia figures with frontal displayed bodies and red eye-bands are, moreover, located within that section of the codex that deals with the travels of Venus through the underworld. This includes the large figure on page 40 of that manuscript which Seler specifically identifies as Yohualtecuhtli (Fig. 16). This figure actually wears the conchshell earrings of the Venus god Quetzalcóatl and the paper leg bows frequently worn by the Evening Star deity Xólotl. In Codex Borbonicus 16, Xólotl appears opposite the earth sun deity Tlalchitonatiuh, as co-patron of the sixteenth week of the Aztec calendar, with double-banded eyes, a flint-knife tongue, and clawed hands and feet.

The deity depicted at the center of the Aztec Calendar Stone can, therefore, no longer be identified as the sun god Tonatiuh who represented the day sky and the east. Neither the literary nor the graphic evidence supports this view. Even Durán's report that the human sacrifice performed in honor of the sun on the day 4 Ollin was theoretically carried out at midday when the sun was at the center of the day sky, rather than at midnight, does not negate the thesis.[47] Since both the zenith and the nadir were regarded as part of the unifying central world direction, the two were often conceptually synonymous and, at times, even interchangeable.[48] In the version of the destruction of the second cosmogonic sun, 4-Ocelotl, "4 Tiger," presented in the *Anales de Cuauhtitlan*, the moment of death and darkness is actually reported to have occurred at noon rather than at midnight:

> Then it happened
> that the sky was crushed,
> the sun did not follow its course.
> When the sun arrived at midday,
> immediately it was night
> and when it became dark,
> tigers ate the people . . .[49]

Clearly, the spatial contiguity of zenith and nadir implied a temporal contiguity between noon and midnight as well. We know, in fact, that all beings temporarily located at the center of the sky were believed capable of descending directly to earth and to the crossroads at its center; among these were the stellar Tzitzimime alluded to on the Aztec Calendar Stone. That the same belief applied to the hour of noon and the sky by day is attested to by a contemporary Aztec story recorded by Madsen that tells of a man who hitched a ride with the sun at dawn; at noon the sun said to the man, "Here is where I leave you," and the man fell down into his own home below.[50]

The Aztec Calendar Stone image must therefore be regarded as a representation of the darkened sun and planet Venus at the center of the earth at the moment of cyclic destruction and completion in which they fused to create the hybrid deity

Yohualtecuhtli, the great Aztec "Lord of the Night." Since Yohualtecuhtli was a god of the earth, darkness, death, and the south and center of the world, his appearance here in a context of the end of the world at the center of the earth in the middle of the night is far more logical than would be that of Tonatiuh. More understandable, too, are the appearance of traits of the female earth monster and the rare utilization of the frontal form that always indicates cyclic completion in Postclassic Mexico. Recognition of the Aztec Calendar Stone deity as Yohualtecuhtli thus avoids the logical and cosmological discrepances involved in its identification as Tonatiuh and reveals a new level of beauty and profundity in the famous carving.

Oakland University

Notes

[1] Pre-Columbian Mexican history is traditionally divided into three major temporaral periods: the Preclassic (or Formative), the Classic, and the Postclassic. The latter roughly covers the years between A.D. 900 and 1521, the year of the Spanish Conquest. At the time of the Conquest, most of central Mexico was under the control of the Aztecs, a Nahuatl-speaking people who rose to power in the 14th century during what is known as the Late Postclassic period. The Aztec Calendar Stone was carved by these people to sit atop their major cermonial plaza where it presumably served in some way in the performance of Aztec rituals. The exact orientation and function of the monument have never been ascertained.

[2] E. Seler, *Disertaciónes*, trans. D. de Leon, Mexico City, M.M.S.S. del Museo Nacional, 1903, VI, If, and *Gesammelte Abhandlungen*, II, 796-99; Beyer. See also Caso, 1958, 33, for a more recent presentation of the same interpretation.

[3] Recent dissenting points of view are put forth by Aviles-Solares and R. Noriega, 221-242. While the two authors disagree in their identification of the various astronomical cycles and symbols represented, both conclude that the Aztec Calendar Stone was an astronomical calculating device used to compute time. Curiously, neither dissents from the traditional identification of the central figure challenged in this article.

[4] The Aztecs used two calendars that functioned independently but that ended on the same day every fifty-two years. The first, the *xíhuitl*, was an agricultural calendar based on the 365-day rotation of the earth around the sun. It was divided into eighteen months of twenty days each with an additional five days (*nemontemi*) at the end. The second, the *tonalpohualli*, was a divinatory calendar based on the meshing of an invariable series of twenty day-signs with a series of the numerals one through thirteen; each combination of day-sign and numeral could occur only once in 260 days. The 260-day cycle was divided into twenty periods, or "weeks," of thirteen days each. A larger cycle of fifty-two years, known as the *xiuhmolpilli*, always ended on a day that simultaneously concluded both a 365-day and a 260-day cycle. The *xiuhmolpilli* was itself divided into quarters and was of the greatest cosmic and ritual significance.

[5] Owing to the nature of the Aztec calendar, the solar year, and thus the fifty-two year cycle, could never have ended on the day 4 Ollin. It is therefore not clear how the Aztecs related their fear of the day 4 Ollin to the end of their fifty-two year "century." The date 4 Ollin would have occurred at least once every solar year, however, and events of that day may have been interpreted as prophesies or determinants of the fate of the sun at the end of the current fifty-two year cycle. The association of the day Ollin with the end of a fifty-two year cycle may also derive from the earlier use in many part of Mesoamerica of an Ehecatl-Mazatl-Malinalli-Ollin set of yearbearers. Such a system survived until the Conquest in parts of Oaxaca and Guerrero. If the names of the years, and hence the yearbearers themselves, were derived from the last day of the year, as Caso suggests, then the last day of the fifty-two year cycle would have always fallen on a day Ollin (see Caso, 1967, 128).

6The dates of destruction and hence the names of the five mythological suns cited on the Aztec Calendar Stone are those mentioned in the *Leyenda de los soles* and the *Historia de los mexicanos por sus pinturas*; other accounts give different names and/or sequences. Those seen on the Calendar Stone are: (1) 4 Ocelotl, "4 Tiger"; (2) 4 Ehecatl, "4 Wind"; (3) 4 Quiauhtl, "4 Rain"; (4) 4 Attl, "4 Water"; and (5) 4 Ollin, "4 Earthquake" or "4 Movement." For a translation of, and commentary on, the relevant passages in the *Leyenda de los soles*, see M. Leon-Portilla, *Aztec Thought and Culture*, trans. J.E. Davis, Norman, 1963, 37f. See also H. Nicholson, "Religion in Pre-Hispanic Central Mexico," *Handbook of Middle American Indians*, ed. R. Wauchope, X, 1971, 398-99.

7For a complete discussion and defense of this position, see Klein. I presented a brief summary of the argument at the conference on "Death and the Afterlife in Pre-Columbian America" held by the Dumbarton Oaks Center for Pre-Columbian Studies on 27 October 1973, in a paper titled "Postclassic Mexican Death Imagery as a Sign of Cyclic Completion," published in the proceedings, 1975.

The central world direction differed from the other four world directions in performing a transitional function. Since the Aztecs conceived of space, as well as time, in terms of recurring cycles, the end of one sequence automatically predicted, and even inaugurated, the beginning of the next. The central world direction, therefore, although typically associated with the end of a sequence, could also signify the beginning of a new one. For this reason it was often referred to as the "up and down" direction, a term based on the belief that the center of the universe extended vertically from the bottom of the earth to the top of the sky, thereby permitting easy access from one region to the other. In its temporal affiliations, as a result, it occasionally appears to have been more closely associated with the actual beginning of a cosmic cycle than with an ending. Such occurrences are rare, however; in the vast majority of instances, the center is clearly associated with the end of a cycle and hence with darkness, earth, and death. So strong was this association that the central world direction often appears to have been conceptually fused with the south and in many instances simply to have been left out of a sequence in favor of it.

8Covarrubias does not give his reasons for reconstructing the coloration of the Calendar Stone figure as he does, but his reconstruction is confirmed by that of Robert F. Sieck who actually examined the pigments remaining on the stone (see Noriega, opp. 64). Beyer, 20, reconstructs the deity's face as solid red, but admits to doing so "because Tonatiuh was painted this way in the codices of the central region" (author's translation).

9Beyer, 15.

10For a full defense of the thesis that frontality was reserved for deities associated with earth, death, darkness, and cyclic completion in two-dimensional Postclassic art, see my doctoral dissertation.

11Seler, 1900-01, 103.

12Thompson, 1960, 45, 173; E. Seler, "Explanation of the Wall Paintings of Mitla," in *Central American Antiquities, Calendar Systems, and History*, ed. C.P. Bowditch, *Bureau of American Ethnology Bulletin*, XXVIII, 1904, 323. The round, ringed, or banded eye was apparently roughly analogous to the closed eye, which also symbolized death. The closed eye is, however, relatively rare in Postclassic Mexican imagery and does not even appear on the major death deities Mictlantecuhtli and Micticacihuatl, whose eyes are round and/or ringed, but always open. For evidence that the ringed or banded eye in Postclassic Mexico was symbolically synonymous with closed eyes in Postclassic Maya art, see Klein, 206-217.

13Thompson, 1934, 222-25. Thompson argues here that the reported assignment of Mictlan to the north at the time of the Conquest represented either a very late development or a mistake on the part of the chroniclers themselves.

14Sahagún, III, 213.

15Seler, 1902-03, 139; see also Seler, 1960-61, II, 1097.

16Sahagún, III, 213.

17Seler, 1960-61, II, 1035.

18*Ibid*, IV, 60. See also Thompson, 1934, 223.

[19]Seler, 1901, 67.

[20]Seler, 1960-61, II, 1035.

[21]See J. Soustelle, *La pensée cosmologique des anciens Mexicains*, Paris, 1940, 40.

[22]There are a number of myths that reveal that the sun in the day sky was hostile to the moon; according to one, the sun's first act was to defend his mother, the earth, by cutting off the head of his sister, the moon, and putting his remaining siblings, the stars, to flight. According to Caso, 1958, 13, the sun was believed to reenact this victory every morning upon rising. In contrast, many Mexican and Maya legends make it clear that the dead sun in the underworld at night was in love with the moon, who is repeatedly identified as his wife or consort. See J.E.S. Thompson, "The Moon Goddess in Middle America," *Carnegie Institution of Washington, Contributions to American Archaeology*, V, Washington, D.C., 1939, 150.

[23]Sahagún, III, 212.

[24]J.E.S. Thompson, *A Catalogue of Maya Hieroglyphs*, Norman, 1962, 224.

[25]Thompson, 1960, 88.

[26]J.E.S. Thompson, *Maya History and Religion*, Norman, 1970, 364, 369-70.

[27]Thompson, 1934, 228-29; Seler, 1963, II, 28.

[28]Sahagún, III, 202.

[29]*Ibid.*, 60.

[30]Caso, 1958, 20. See also Krickeberg, 178-79. Caso, for reasons he does not cite, identifies the star Yohualtecuhtli with Aldebaran rather than Castor and states that it was observed in conjunction with either the Pleiades or Aries. E. Seler, in "The Venus Period in the Borgian Codex Group," in *Central American Antiquities, Calendar Systems, and History*, ed. C.P. Bowditch, *Bureau of American Ethnology Bulletin*, XXVIII, Washington, D.C., 1904, 356-57, also repudiates Sahagún's identification of Mamalhuaztli with Gemini and concludes that it may have been part of Aries.

[31]Sahagún, III, 202. This statement includes an error on Sahagún's part since, owing to the nature of the *tonalpohualli*, the day 4 Ollin could recur only once every 260 days.

[32]Beyer, 34.

[33]That a star in the center of the midnight sky should share the name and connotations of the dead sun simultaneously located at the center of the earth is understandable in view of the Postclassic belief that the underworld and its inhabitants nightly pass into, or are reflected in, the dark heavens. The stars were traditionally regarded as the "souls" of the dead in the underworld at the center of the earth and all nocturnal celestial bodies were affiliated with the earth, the underworld, and the western, southern, and central world directions. See Krickeberg, 130, and Klein, 33-34.

[34]Seler, 1963, II, 42.

[35]W. Krickeberg, "Das mittelamerikanische Ballspiel und Seine Religiose Symbolik," *Paideuma*, III, 1948, 141, 164.

[36]Seler, 1963, II, 28.

[37]Although Tlaltecuhtli was reportedly a toad, she was the female counterpart of the earth crocodile Cipactli and as such was closely related to and occasionally even confused with him. While the directional and temporal associations of the two were in direct opposition, both deities represented the earth. In two-dimensional Postclassic imagery, Tlaltecuhtli's frontal face often appears to be formed of two profile heads of Cipactli conjoined at the back or front. Tlaltecuhtli thus typically shares with Cipactli a missing lower jaw, sharp pointed teeth, a curled nose and curled eyebrow, and a flint knife projecting from the nose.

[38]Sahagún, III, 203.

[39]Seler, 1960-61, II, 723-24; Seler, 1900-01, 108.

[40]The Yucatec Maya word for "face" (*ich*) similarly means both "eye" and "front." Sahagún's catalogue of his Aztec informants' descriptions of the parts of the human body includes the following: "Face; that is to say, eye . . ." (Sahagún, II, 112).

[41]See Seler, 1960-61, I, 693-94, for an analysis of the Chichén Itzá reliefs. For a defense of the thesis that these reliefs, like all *en face* Postclassic two-dimensional images of Venus, refer to the planet in inferior conjunction in the south or center of the world at the end of a Venus cycle, see Klein, 89-91.

[42]Sahagún, III, 212-13. Seler, 1960-61, II, 1059, translates this as "he, the Lord of Midnight" (English translation mine). The passage equates this night lord with the word *xochitl* ("Flower") in two instances, thus providing further evidence that the god Xochipilli (Flower Prince), ruler of the day-sign Xóchitl (Flower), was at least an aspect or element of the deity known as the Lord of the Night:

> The flower of my heart lieth burst open,
> the lord of the night.
> She hath come, she hath come, our
> mother, the goddess Tlazolteotl.
> Cinteotl is born at Tamoanchan.
> the flowery place, on the day
> Ce xochitl.

[43]Aviles-Solares, 36-37; 41-49.

[44]Seler, 1963, I, 264. Seler also proposes here that the date 4 Ollin in Codex Borgia 28 represents the date of the disappearance of Venus as Morning Star into superior conjunction in the north. His arguments rest, however, on the faulty assumption that the Dresden Codex Venus tables begin with heliacal rising on the day 13 Kan, rather than on the day I Ahau, and on an erroneous assignment of the Acatl years to the north rather than to the east.

The five Venus periods were five consecutive Venus cycles of 594 days each which equalled exactly eight solar years. When the five Venus periods had recurred thirteen times, the final day coincided with both the end of the *tonalpohualli* and the fifty-two year cycle. This could happen only once every 104 solar years.

[45]See Caso, 1967, 197, for a list of the various associations of the date 4 Ollin mentioned in the codices and chronicles.

[46]Seler, 1963, I, 265.

[47]D. Duran, *The Aztecs: The History of the Indies of New Spain*, trans. D. Heyden and F. Horcasitas, Norman, 1964, 122.

[48]This probably explains why Seler, 1963, I, 166, associates Xochipilli, the "Lord of the South," with high noon, and may account, at least in part, for the apparent confusion at the time of the Conquest of north and south in regard to the location of the land of the dead (see note 13).

[49]M. Leon-Portilla, *Pre-Colombian Literatures of Mexico*, trans. G. Lobanov and M. Leon-Portilla, Norman, 1969, 36.

[50]W. Madsen, *The Virgin's Children: Life in an Aztec Village Today*, Austin, 1960, 128.

Bibliography

Aviles-Solares, J.
 1957 *Descifracion de la piedra del calendario*, Mexico City.

Beyer, H.
 1921 *El llamada "calendario azteca": Descripción e interpretación del cuauhxicalli de la "Casa de la Aguilas,"* Mexico City.

Caso, A.
 1958 *The Aztecs: People of the Sun*, trans. L. Dunham, Norman (first published 1954).

 1967 *Los calendarios prehispánicos*, Mexico City.

Duc de Loubat, ed.
 1900 *Codice Vaticano 3738(A) (Rios)*, Rome.
Hamy, E.T. ed.
 1899 *Codex Borbonico: Manscrit mexicain de la Bibliothèque du Palais Bourbon*, Paris.
 1899 *Codex Telleriano-Remensis: Manuscrit mexicain, Bibliothèque Nationale*, Paris.
de Jonghe, M.E. ed.
 1905 "Histoire du Mechique: Manuscrit francais inédit du XVIe siecle," *Journal de la Societe Américanistes*, n.s. 2, 1-41.
Klein, C.F.
 1972 "Frontality in Two-Dimensional Postclassic Mexican Art," Ph. D. diss., Columbia University, New York; to be published as *The Face of the Earth: Frontality in Two-Dimensional Mesoamerican Art*, New York, Garland Publishing (in press).
Krickeberg, W.
 1964 *Las antiguas culturas mexicanas*, 2nd ed., Mexico City.
Noriega, R.
 1959, "Sabiduria matemática, astronómica y cronológica," *Esplendor de Mexico antiquo*, ed., C.C. de Leonard, Mexico City.
Phillips, T., trans.
 1883 "Historia de los mexicanos por sus pinturas," *Proceedings of the American Philosophical Society*, XXI, 616-651.
de Sahagún, B.
 1950-71 *Florentine Codex: General History of the Things of New Spain*, trans. A.J.O. Anderson and C.E. Dibble, 13 vols., Santa Fe.
Seler, E.
 1900-01 *The Tonalámatl of the Aubin Collections: An Old Mexican Picture Manuscript in the Paris National Library*, Paris.
 1901 *Codex Féjervary Mayer: An Old Mexican Picture Manuscript in the Liverpool Free Public Museum*, Paris.
 1902-03 *Codex Vaticanus 3773 (B)*, 2 vols., London.
 1960-61 *Gesammelte Abhandlungen zur Amerikanischen Sprach und Alterhumskund*, 5 vols., Graz, (repr. of 1902-03 ed., Berlin).
 1963 *Commentarios al Codice Borgia*, 3 vols., Mexico City (1st ed., 1904).
Thompson, J.E.S.
 1934 "Sky Bearers, Colors and Directions in Maya and Mexican Religion," *Carnegie Institution of Washington, Publication 436*, Washington, D.C.
 1960 *Maya Hieroglyphic Writing: An Introduction*, 2nd ed., Norman.
Velasquez, P.F. ed.
 1945 "Leyenda de los Soles," in *Codice Chimalpopoco (Anales de Cuauhtitlán y Leyenda de los Soles)*, Mexico City.

The Ballcourt in Mesoamerica:
Its Architectural Development

Jacinto Quirarte

Introduction

This paper suggests possible origins, extensions and developmental sequences of specialized architectural forms, culled from an examination and analysis of plans and profiles of key ball courts, found throughout Mesoamerica.

All other variables—stone rings and markers, niches, decorations on walls and benches, superstructures, peripheral markers, stelae or other platforms—will not form a part of this study. Rather, a careful look at surface dimensions and proportions of the parallel ranges—their inner profiles as well as the spaces they define—will help us establish the essential components of the playing area. Changes and variations made to emphasize one or more surface of that basic area will enable us to chart the ball courts' development which, by extension, will help us place them into a spatial and temporal sequence.

Terminology and Classification

The alley or playing field of the ball court refers to the area defined by the two parallel mounds or ranges with specialized inner profiles. The rectangular playing field can be open at both ends or closed with low or high walls, which serve to define the end-fields. The latter has been aptly described as the capital I or the double T type of plan.

The portion adjacent to the playing field is the bench; its profile is made up of two surfaces: either battered or vertical face and a level or sloped top. The second component, but third surface, has usually been identified as the playing wall; this can be either vertical or sloped.

Since these terms are not always reliable and when applicable, difficult to isolate and identify within the profile, they will be retained only for descriptive purposes.

Further, they are difficult to use in classifying the different kinds of ball courts. Franz Blom[1] recognized this when he labeled the distinct parts ˙of the ball court structure with letters, starting from the top of the range and working downward to the

Reprinted by permission of Instituto Nacional de Antropología e Historia, Mexico.

playing field. Using the Great Chichen Itza Ball Court as an illustration, he labeled the two ranges A, the low terraces at the inner sides of the walls B for the top and C for the face, etc. Linton Satterthwaite[2] has done the opposite, by starting from the playing field and working upward to the top of the ranges, but has relied on descriptive terms for the various parts, rather than on letters.

Acosta and Moedano[3] used letters to classify the different types of ball courts found in Mesoamerica, relying mainly on the inner profiles of the twin ranges in setting up their system. These were placed in a specific category depending upon size and direction of the major and minor slopes, benches and playing walls.

Smith[4] based his classification of the Guatemala Highlands ball courts on profiles as well as on absence or presence of end fields and peripheral structures defining these areas in lieu of actual walls.

I would like to concentrate almost completely on profiles of structures found throughout Mesoamerica and classify them in the following manner:

Type one exhibits a major slope (surfaces one and two), and a) minor or b) major vertical plane (surface three); open ends or closed corner end-fields.

Type two exhibits a major slope (surface three), and a) minor slope or vertical plane combined with a sloped or level one (surface one and two) and b) with or without minor vertical plane (surface four), open ends or closed-corner end-fields.

Type three exhibits a major vertical plane (surface three) and minor slope horizontal plane (surfaces one and two). All types can have open ends or closed or open corner end fields; ground level or "sunken."

Types of Ball Courts

The Copán ball court[5] is the prime example of Type I: open ends and profiles comprised of vertical and sloping planes with the latter dominant. Surface 1 is battered in court I and in successive building periods becomes a vertical face. Surface 2 rises to an angle of 25 degrees and surface 3 measures one meter. The ratio of width to length of the playing field is 1 to 4 or 25 percent of the longitudinal extension of the playing area.

Type Ia courts still have open end-fields and three surface profiles with the second and third now dominant. The major slope angle is lowered; the loss in height is made up by emphasizing the vertical plane.

One of the most typical examples is found further north in Uxmal.[6] Surface 1 is battered, 2 has a slope angle of 8.5 degrees and 3 now measures 4 meters; the proportions of the playing field change, the wider alley now being 29.4 percent of the length.

Three surface profiles are continued in Type Ib courts. The same tendency to have a low major sloping area adjacent to playing field is retained, but further emphasized, with the vertical plane—surface 3—now playing a subordinate role.

Xochicalco[7] is the best example of this subtype. Surface 1 is battered; the 10 degree slope of surface 2 is in keeping with Type Ia courts, but is now almost twice as wide; surface 3 measures 2.5 meters. The court has closed end-fields. Dimensions of the playing field width remain within limits established in the Southern and Northern Maya Lowlands. However, the length is greater; thus giving a different ratio for the playing field: 1 to 5.7 or a width 17.5 percent of the length.

Type II Courts

The major slope is still an important part of the court profiles but its position has moved away from the playing field to surface 3. Surfaces 1 and 2 now become the narrow terraces or benches facing the playing field.

The outstanding example is the Monte Albán court.[8] Surface 1 is battered, 2 is level and longer than the ranges it defines; the major slope of surface 3 has an angle of 33 degrees; the court has closed end-fields and is "sunken." Proportions of the playing field change with the addition of the benches; width is marrower—1 to 5 ratio—or only 20 percent of the length.

Type IIa courts maintain similar proportions but to the three basic surfaces is added a fourth—a small vertical plane similar in size and direction to the Copán surface 3.

Piedras Negras R11 is a good example of this subtype. It has a gently curving profile instead of the sharply defined 2 surface bench. Surface 3 has a 36 degree slope; surface 4, actually a two-stepped vertical plane, measures approximately one meter. The playing field proportions are identical to Monte Albán: 1 to 5.14 or 19 percent.

Variants of the Piedras Negras R11 court are further developed in the Guatemala Highlands; a prime example is the early Chalchitan court.[10] Surface 1 is battered, 2 is wide and level, 3 has a 45 degree major slope and 4 is vertical. It has open end-fields and a ratio of 3.85 or a width of 26 percent of the playing field length.

Type IIb courts also have 4 surface profiles but dimensions and slope angles change. Xolchun[11] is typical. It has a narrower bench and a steeper slope—75 degrees for surface 3. The playing field ratio is 3.6 or width 28 percent of the length.

Type III and IV Courts

The major slope—initially made up of surfaces 1 and 2 and, with the addition of a narrow bench, surface 3—is abandoned in Type III and IV courts. The narrow benches are retained but the third surface is vertical and high.

The great court of Chichén Itzá[12] is the outstanding example of Type III: surface 1 is battered, 2 is level and very narrow, and 3 now measures approximately 7.5 meters. The ratio of width to length of the playing field is 1 to 3 or 33 percent.

Toluquilla and Ranas courts[13] fall outside the major classifications already made. Profile configuration is similar to Type IIb courts, but without surface 4. They are closer to Type III; however, surface 3 is very steep but not vertical. The seven courts found in these two sites exhibit the same profile: surface 1 is battered and high, 2 is level and narrow, and 3 has an 85 degree slope angle. Proportions of the playing field are not consistent. Ratios are anywhere between 3 and 6 or widths 16 percent to 33 percent of the length.

Developmental Sequences

The only courts assigned early Classic period dates of construction (300-600 A.D.) are Copán I[14] and Monte Albán[15]. However, dating of individual structures is hazardous when we realize that chronological sequences for entire cultures within the Mesoamerican context have not been firmly established.

Ceramic evidence, dated inscriptions as well as architectural sequences were used in assigning dates of construction to the three Copán courts, actually built one on top of the other over a 300-year period.[16] These can be assigned to the 5th, 6th, or 7th

centuries A.D. or 3rd, 4th or 5th, depending upon the correlation used in transcribing Maya dates into our own calendar. If the former alternative is taken, then the Monte Albán court would predate all known Maya courts.

Until these discrepancies in dating are more adequately resolved, we must rely on other sources for establishing precedence of types of specialized architectural forms.

That the ball game was based on the use of a rubber ball, which would point to the Gulf Coast area as a place of origin, would seem to take precedence away from the Oaxaca Valley. Even if this were not so, the great number of very similar Copan type courts found throughout Mesoamerica, would also support our looking toward the Motagua River area for origins of these architectural forms. Once we accept this as a point of departure, we find that our need for accurate dating is still most pressing. Unfortunately, these are not available. The two exceptions are Uxmal, with a date of 649 A.D. which has not been completely accepted,[17] and Piedras Negras K6 definitely dated after 662 A.D.[18] Most other dating has been necessarily vague and of a very general nature: courts have been assigned to the early and late Classic, Postclassic and Protohistoric times. We will have to follow this scheme.

Types I, Ia and Ib courts: Late Classic 600-900 A.D.

The Quiriguá court[19] is almost a replica of Copán III. The Asunción Mita and Guaytan courts,[20] although similar to the prototype, have lower surface 2 slope angles and closed end-fields, a feature that has been considered of Central Mexican origin. However, proportions and dimensions of profiles link these to other Maya lowland courts further west and north. Uaxactún B-V[21] of late Classic construction has dimensions and proportions of profile and playing field identical to Copán and Quiriguá. The great difference is the much lower surface 2: now 16°, representing a 10° drop. Piedras Negras court K6,[22] Tikal[23] and the Uxmal[24] court have almost identical profiles and proportions (3.2; 3.4); the Calakmul, Becan[25] and Chichén Itzá 3C10 or Red House court[26] maintain a similar ratio (3.7; 3.5 and 3.3). All surface 2 slope angles average 8.5 degrees. Courts in Peor es nada, Balakbal[27] and Chichén Itzá (3D4)[28] demonstrate the same general slope (9-14°), but proportions change due to wider alleys: an average of 2.5.

Thus we see that during the late classic, a coherence of parts and proportions of the ball court profiles and playing fields is maintained in the Peten, Rio Bec, Puuc and Chichén Itzá areas. The rich, uniform and sustained development of this type of court (Ia), leads me to favor some kind of contact between these cities and Xochicalco. The Xochicalco builders must have had knowledge of the courts being constructed in Piedras Negras (K6), Calakmul and Uxmal during the seventh and eighth centuries.

The Xochicalco and Tula relationship is obvious and most apparent in plan, profile and dimensions. But what of the early Chichén Itzá courts, which also bear some resemblance of the Tula court? Was it a combination of ideas and models, found in Xochicalco as well as in Chichén Itzá that determined the type of court that was built at a later date in Tula? All formal and available chronological evidence would seem to support this conclusion.

Other Copán variations are found, as before, outside the Southern Lowlands to the north in the Yucatán Peninsula (Coba)[29] and British Honduras (San José),[30] actually east of the Peten cities of Guatemala.

Dimensions and angles of profiles and plans are similar to the Copán type of courts. What distinguishes these is the addition of a narrow bench next to the playing field which technically would place them in the 4 surface profile Types II and IIa courts. In Cobá, this is so narrow that it could scarcely be called a bench. The proportions of width to length of the playing field also change drastically, now down to 13 percent or 1 to 7.7. In San José, the bench is a little wider but the playing field is so narrow that the ratio jumps to an incredible 1 to 17 or 6 percent.

Type II and IIa courts: Classic—300-900 A.D.

The early Monte Albán court built in the third century A.D., served as a nucleus for the court now visible. No data is available for the first court. Whether the prototype for the latest construction, also assigned to the early classic period, is to be found in the Maya area, is difficult to determine because of the conflicting dates for the structures in both regions. The only other early classic court in the Maya area is Copán I, which presents profiles and plans that bear no apparent relation to the Oaxaca court.

The courts in Yaxchilán[31] and Piedras Negras (R11)[32] are another matter. Monte Albán's major slope is in keeping with P.N. R11. However, the latter adds the fourth surface missing in Monte Albán. Because of the similar surface 1 and 2 configuration found in both sites, I would favor classifying P.N. R11 as a variant of the Monte Albán court. Another factor supporting this suggested sequence is the playing field proportion of 1 to 5 or 20 percent. This is not in keeping with widths of playing fields in the other Maya courts which are all consistently 25 percent or more of the length.

Yaxchilán courts I and II[33] represent as intermediate type which surprisingly was not taken up in other regions. Yaxchilán II, with a seven-degree slope for surface 2 is similar to subtype Ia and Ib courts; but, whereas all three represent an emphasis on a vertical surface 3, in Yaxchilán II this is yet another slope, causing it to have a saucer-like configuration as opposed to a more coherent balance of horizontal and vertical directions achieved in most other courts.

Yaxchilán I is similar to the Palenque court in profile; they differ in playing field proportions. Palenque[34] has a 1 to 8 ratio or 12.5 percent compared to a more normal 1 to 4 or 25 percent for Yaxchilán I.

In the Alta Verapaz or directly west of the Motagua River Valley sites in the Guatemala Highlands, the Chijolom and Chichén courts,[35] built also in the late Classic period, exhibit a variant of the four surface profile, whose prototype is to be found in Chalchitan.

900-1200 A.D.

The modified court or Chalchitan II[36] can be used as an example of the Post Classic period Type IIa courts. Its second phase construction is in keeping with the steeper angles of surface 3 for these courts.

There is now a wider variety of surface 3 slope angles. The only constant appears to be the open end-field plan. The Huil court[37] in the Quiché Department is typical. Surface 1 is now vertical, surface 2 has a gentle slope of 7 degrees, and surface 3 is a 55-degree slope. Almost a replica is the Oncap court[38] in the same vicinity. 1: vertical) 2: 6 degrees; 3: 60 degrees and a ratio of 5.1. Variations in the same area are

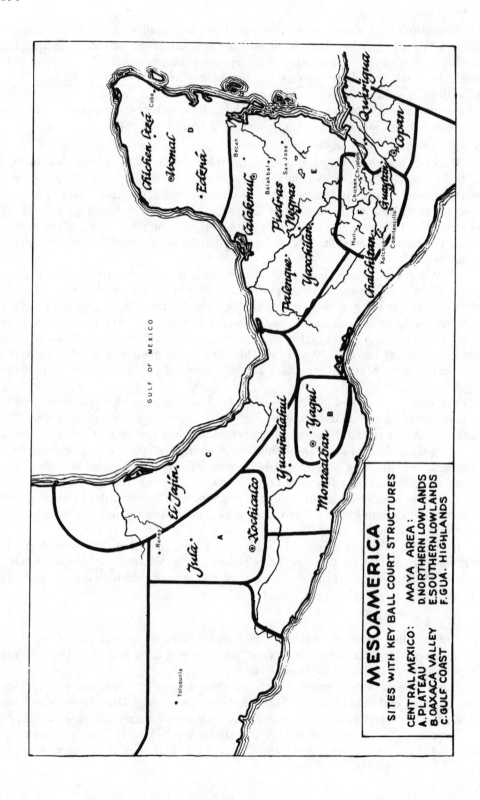

MESOAMERICA

SITES WITH KEY BALL COURT STRUCTURES

CENTRAL MEXICO: MAYA AREA:
A. PLATEAU D. NORTHERN LOWLANDS
B. OAXACA VALLEY E. SOUTHERN LOWLANDS
C. GULF COAST F. GUA. HIGHLANDS

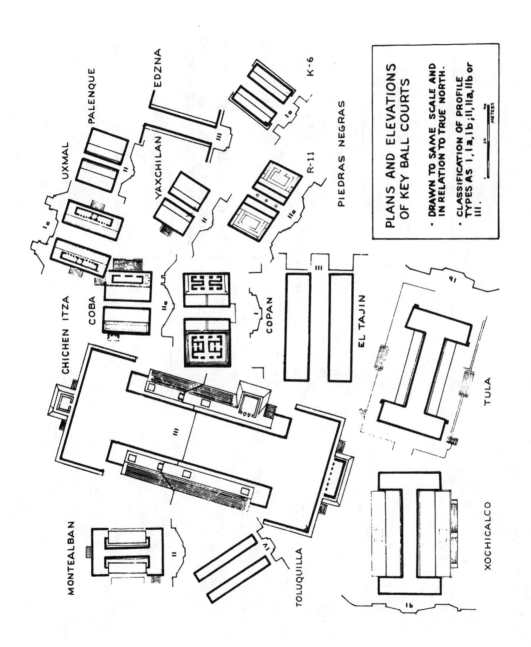

PLANS AND ELEVATIONS
OF KEY BALL COURTS

• DRAWN TO SAME SCALE AND
 IN RELATION TO TRUE NORTH.

• CLASSIFICATION OF PROFILE
 TYPES AS I, Ia, Ib; II, IIa, IIb or
 III.

198

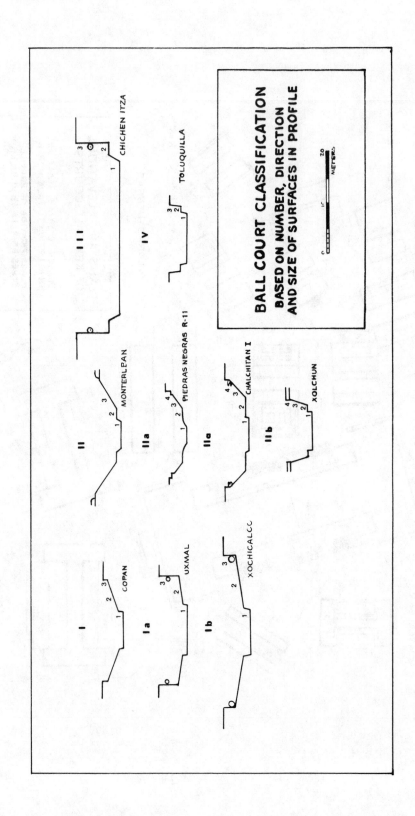

BALL COURT CLASSIFICATION
BASED ON NUMBER, DIRECTION
AND SIZE OF SURFACES IN PROFILE

Ball Court at Xochicalco

Ball Court at Monte Albán.

Ball Court at Chichén-Itzá.

Ball Court at Yagul.

Ball Court at El Tajín.

204

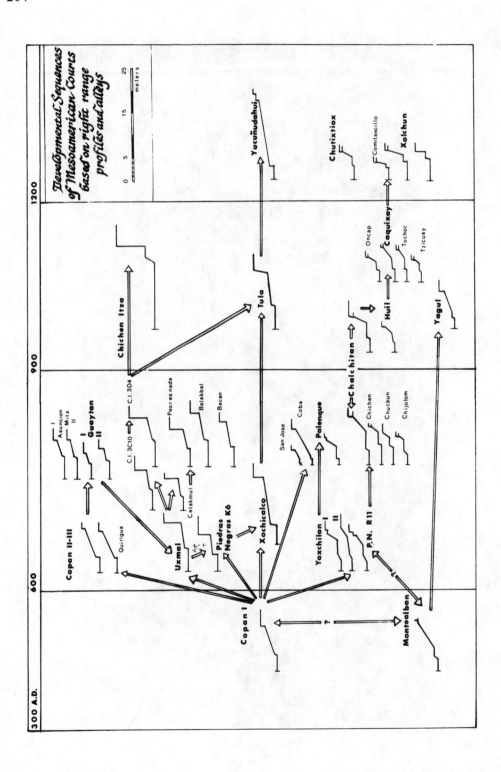

Developmental Sequences of Mesoamerican Courts based on right range profiles and valleys

APPENDIX

DIMENSIONS (meters) ANGLES, PROFILES and PLANS of the BALL COURTS.

TYPE OF COURT	SITE	STR.	1 ANG.	1 DIM.	2 ANG.	2 DIM.	3 ANG.	3 DIM.	4 ANG.	4 DIM.	PF DPTH	PF LGTH	PF RATIO	EZ DPTH	EZ LGTH	EZ HT	EZ WID	PLAN
I	COPÁN	I	75°	70	25°	7.00	90°	1.00			7.00	26.80	3.83					
	COPÁN	II	90°	80	25°	7.00	90°	1.00			7.00	26.80	3.83					
	COPÁN	III	90°	.80	25°	7.00	90°	1.00			7.20	28.45	4.06					
	QUIRIGUÁ		90°	.60	27°	6.50	90°	.75-1.00			5.80	24.00	4.00					
	ASUNCIÓN MITA	I	90°	.50	23°	3.60	90°	1.00			8.87	22.50	2.54	8.50	19.00	1.00	2.50	
	ASUNCIÓN MITA	II	90°	.40	17°	4.00	90°	.50			8.50	35.50	4.00	8.80	18.50	1.00	3.00	
	LA UNIÓN		90°	.50	25°	5.00	90°	?			7.00	25.00	3.57	8.50	18.50	1.00	2.00	
	SAN PEDRO PINULA		Princ. (destroyed without measurements)															
	GUAYTÁN	I	90°	50	17°	2.50	90°	1.00			7.00	25.00	3.57	5.00	13.00	?	?	
	GUAYTÁN	II	90°	50	12°	2.00	90°	1.00			7.00	19.00	2.71					
	UAXACTÚN	B V	90°	.60	16°	4.00	90°	1.00			8.00	20.00	2.5					
I a	UXMAL		80°	1.00	8.5°	5.60	90°	4.00			10.15	34.00	3.36					
	PIEDRAS NEGRAS	K 6	90°	1.18	6°-13°	4.50	90°	2.85			6.65	21.30	3.20					
	TIKAL		90°	40	8°	3.60	90°	1.70			3.20	13.70	4.30					
	PEOR ES NADA		90°	.80	10°	4.35	90°	3.00			8.50	21.00	2.47					
	CALAKMUL	XI	?	85	7.5°	4.00	90°	3.20			5.85	19.50	3.70					
	BALAKBAL	XI	90°	1.00	9.5°	6.00	90°	2.00			12.00	29.00	2.42					

APPENDIX (Continuation)

2

TYPE OF COURT	SITE	STR.	1 ANG.	1 DIM.	2 ANG.	2 DIM.	3 ANG.	3 DIM.	4 ANG.	4 DIM.	PF DPTH	PF LGTH	PF RATIO	EZ DPTH	EZ LGTH	EZ HT	EZ WID	EZ PLAN
I a	BECÁN	XI	90°	.90	9°	5.85	90°	MIN. 1.40			9.20	32.00	3.47					
	CHICHÉN-ITZÁ	3C10	70°	.81	8°	4.00	90°	3.00			9.00	21.00	3.33	13.00	24.00	1.50		
	CHICHÉN-ITZÁ	2D9	82°	.70	3°	1.57	90°	1.00			10.45	28.70	2.75	12.30 / 14.00	24.00 / 22.00			
	CHICHÉN-ITZÁ	3D4	68°	.63	14°	5.00	90°	4.00			10.70	29.00	2.71	14.00	36.00	1.00		
	CHICHÉN-ITZÁ	3E2	talud ?		talud			2.00			C.II.	C.3.3.	3.00	11.00 / 8.0C	28.00 / 28.00		2	
	CHICHÉN-ITZÁ	GROUP EXTRM EAST	talud ?	.75	?	?	?	?			II.	26.	2.36	16.00 / 17.00	43.00 muy / 49.00 bajo			
	ÁREA CHICHÉN-ITZÁ	GROUP CHULTUN	45°	1.40	0°	2.00	50°	2.60			7.00	26.	3.71	10.00 / 11.00	26.00 / 26.00			
	ÁREA CHICHÉN-ITZÁ	HOLTÚN	55°	.50	16°	1.20	talud ?	2.00			7.00	16.	2.29					
I b	XOCHICALCO		80°	1.40	10°	10.50	90°	2.50			9.00	51.00	5.66	10.00	35.00			
	TULA		80°	1.40	5°	7.25	80°	3.00			10.00	41.00	4.10	12.50	35.00	SUNKEN 2.5		
	YUCUÑUDAHUÍ		90°	1.00	7°	14.50	90°	1.00			6.00	44.00	7.30	12.00	26.00			
II	MONTE ALBAN		49°	1.00	0°	1.80	33°	6.50	?	1.00	5.00	26.00	5.20	7.00	C2200	SUNKEN 3.60		
	YAGUL	I	57°	.70	0°	1.50	26°	4.50	90°	?	6.00	25.00	4.16	9.00	28.50			
	YAGUL	II	66°	.70	0°	1.00	24°	5.85	90°	1.00	5.00	30.00	6.00	8.00	27.00			SAME
II a	SAN JOSÉ		90°	.10	0°	.75	27°	2.00	90°	90-1.00	1.00	17.00	17.00					
	COBÁ		90°	.10	0°	.35	31°	7.00	90°	1.00	3.50	27.00	7.71					
	PALENQUE		90°	.90	0°	2.50	58°	3.00			2.70	22.00	8.10					

APPENDIX (Continuation)

3

TYPE OF COURT	SITE	STR.	P1 ANG.	P1 DIM.	P2 ANG.	P2 DIM.	P3 ANG.	P3 DIM.	P4 ANG.	P4 DIM.	PF DPTH	PF LGTH	PF RATIO	EZ DPTH	EZ LGTH	EZ HT.	EZ WID	PLAN
IIa	YAXCHILÁN	I	28°	1.40	2°	3.00	58°	2.75	90°	.50	4.50	19.00	4.20					
	YAXCHILÁN	II	27°	1.00	7°	4.00	39°	2.40			5.00	18.00	3.60					
	PIEDRAS NEGRAS	R II	33°	.80	0°	2.50	36°	3.00	90°	1.00 / .50	3.50- / 4.30	18.00	5.14	1.1 / 17.0	27.1 PAVEMENT / 21.0 Wo WALL			
	CHALCHITÁN	I	74°	.75	0°	3.60	45°	4.60	90°	1.00	6.50	25.00	3.85					
	CHICHÉN	1-2	60°	.90	—	2.60	55°	1.80		.36	9.00	29.00	3.22					
	CHUCHÚN	1-2	65°	.80	0°	1.75	59°	2.00			7.50	25.00	3.33					
	CHIJOLOM	3-4	49°	1.00	0°	2.90	67°	1.25	86°	.50	4.20	17.50	4.17					
	MIXCO VIEJO		90°	.40	4°	1.25	65°	2.25	90°	.80	9.0	32.40	3.60	6.4	17.4	2.6	2+	
	HUIL	4-5	90°	.40	7°	2.00	55°	2.25	90°	.50	4.5	19.50	4.33					
	ONCAP	3-4	85°	.35-.40	5°-6°	2.40	60°	1.80	90°	.50	5.0	25.60	5.10					
	CAQUIXAY	5-6	90°	.50	1°-2°	2.25	38°	3.00	90°	.50	6.0	17.00	2.83					
	TUCHOC	5-6	90°	.50	0°	2.25	35°	2.50	90°	.50	6.0	17.25	2.89					
	TZICUAY	6-7	61°	.35	0°	1.50	55°	1.50	90°	.70	4.6	20.00	4.35					
	ZACULEU	22-23	73°	1.00	0°	1.40	45°	3.80	90°	.80	6.2	24.60	4.00	8.6 / 7.0	19.0 / 20.5	60		
	CHALCHITÁN II	23-24	74°	.75	0°	3.00	65°	3.50	77°	.90	6.5	25.00	3.85					
IIb	XOLCHÚN		87°	.80	0°	1.30	75°	3.75	90°	.70	7.7	27.40	3.56	5.	19			
	CHUTIXTIOX	16	62°	.50	0°	1.75	64°	2.50	90°	.55	6.0	25.00	4.17	6.5	18.6			

APPENDIX (Continuation)

4

TYPE OF COURT	SITE	STR.	1 ANG	1 DIM	2 ANG	2 DIM	3 ANG	3 DIM	4 ANG	4 DIM	PLAYING FIELD DPTH	PLAYING FIELD LGTH	PLAYING FIELD RATIO	PLAYING FIELD DPTH	END ZONES LGTH	END ZONES HT	END ZONES WID	SUNKEN	PLAN
II b	COMITANCILLO	4	90°	.60	0°	1.20	77°	2.10	90°	.50	5.9	20.20	3.42	5.5	14.10			1.00	(symbol)
	XOLPACOL	8	90°	.55	0°	1.80	74°	2.30	90°	.60	6 0	27.50	4.60	7.7 / 7.2	17 20		1.60		(symbol)
	CHUTINAMIT	H	70°	BALL COURT NEVER FINISHED, LACKS UPPER PORTIONS AND BENCHES.										2.4	9.20	1.70	1 40		(symbol)
	CHUTINAMIT	C	90°	.40	0°	1.80	72°	1.30	90°	1.00	7.00	24 75	3.54	2 8	14.70	1.60	1.00		(symbol)
	CHICHEN–ITZÁ	PRINC.	59°	1.40	0°	1.20	90°	7.5			15.2	48.00	3.15	12.4	32.8	2.00	1.10		(symbol)
III	EDZNÁ		90°	.90	0°	.80	90°	2.5			9.00	40.00	4.33						(symbol)
	EDZNÁ	ESTELA	54°		0°		90°	1.25											(symbol)
IV	TOLUQUILLA	D	82°	1.40	0°	1 00	85°	2.00			7.00	40.00	5.7						(symbol)
	TOLUQUILLA	L	82°	1.40	0°	1.00	85°	2.00			10.00	40.00	4 0						(symbol)
	RANAS	G	DIMENSIONS TAKEN FROM MARQUINA (1964d lam. 71). ALL THE BALL COURTS AT THIS SITE ARE DESIGNATED IN PLAN G.								14.85	36.30	2.44						SAME
	RANAS	G									13.20	46.20	3.50						SAME
	RANAS	G									10.00	36.30	3.60						SAME
	RANAS	G									13.20	33.00	2.50						SAME
	RANAS	G									9.90	36.30	3.66						SAME
OTHER	COTIO		ACCORDING TO A.L. SMITH (1961: p. 120) 52 OF THE BALL COURTS (closed end fields) WERE FOUND IN THE GUATEMALA HIGHLANDS.								9.50	33.00	3.47					1.50	(symbol)
	KAMINALJUYÚ	A									10.00	42.00	4.20					4 50	(symbol)
	KAMINALJUYÚ	B									16.00	44.00	2 75						(symbol)
	KAMINALJUYÚ	LOTHROP									45.00	110.00	2.44						(symbol)
	EL TAJÍN	SUR	THERE ARE 4 MORE BALL COURTS AT THIS SITE.								12.5	63.00	5.10						(symbol)
	EL TAJÍN										5.00	20.00	4.00						(symbol)

found in Caquixay and Tuchoc courts[39] also from the same period. Wider alleys brings the ratio down to 2.83 and 2.89 respectively and surface 3 slope of 38 degrees and 35 degrees.

Within the Oaxaca Area the Yagul court,[40] actually 2 phases of construction, duplicates the Monte Albán court; almost identical in dimensions and proportions.

1200-1500 A.D.

The Xolchun and Chutixtiox courts[41] are good examples of Type IIb, built in Protohistoric times.

The playing field dimensions are standardized and proportions average a 3.5 ratio (or 29 percent) of width to length. What changes drastically are the profile configurations already described for the Xolchun court. Surface 4 remains vertical and small throughout late classic, post classic and protohistoric times. Most of these courts also have enclosed end-fields, a double T outline.

The Yucuñudahui court,[42] similar to Xochicalco and Tula courts, represents the greatest changes yet made. Xochicalco,[43] has a 10-degree slope and a 1 to 5.66 ratio. Tula[44] has a slope of 5 degrees and a ratio of 1 to 4. Yucuñudahui maintains a similar slope angle (7 degrees) but the ratio is now 1 to 7.3—a very narrow playing field contrasted with the breadth of a slope—now twice as wide as those found in the other areas.

Type III and IV Courts: 600-1200 A.D.

A very similar type of court is found near the northern limits of Mesoamerica in the sites of Toluquilla and Ranas.[45]

Their similarity to courts found in El Tajín lead me to believe that closer contacts should be sought there. El Tajín[46] has six courts, most of which were definitely built during the Classic period. Dimensions, profiles and special emphasis placed on the vertical wall (surface 3) point to a possible influence reflected in Edzna[47] and later in the Great Chichén Itzá Court, built during the Post-Classic period.

Although the Chichén Itzá and Edzná courts are of the same type, a greater similarity is found in the inscribed ball court profile found in a stela from Edzná: battered surface 1, narrow and level surface 2 with a vertical surface 3.

Finally, I would like to re-emphasize that the Chichén Itzá court represents the terminal development of a Maya—*not* a Toltec-type of ball court, whose antecedents should be carefully sought in the Gulf Coast site of El Tajín.

Summary and Conclusions

1. Although not nearly enough systematic excavation and reconstruction has been carried out to firmly establish the precedence of one area over another, we can be fairly certain that the Mesoamerican archetypal ball court structure is found in Copán.

2. The basic configuration of the highly specialized ball court structures changed very little over a large area and for at least a millenium: two parallel ranges with open or closed end-fields. There is one known case of a double ball court structure—made up of three parallel ranges—recently found in the Chiapas site of Mal Paso.[48] It is a Type II court, probably built during the late Classic period. Structures 5d-78 through 81 in Tikal[49] represent yet another enlargement of the same order: a triple ball court.

3. The playing field proportions did not vary greatly from those established in Copán: 25 percent of width to length; in the Northern Lowlands, the wider alleys

made it 29 percent to 33 percent of the length. In Central Mexico, even with greater dimensions, the major longitudinal axis was long enough to make the width of the playing fields 20 percent of the length, the accepted norm.

4. Isolated departures were to be found in the far west (Palenque) and far north (Cobá) of the Maya area—all on the periphery of the major ball court building centers. The other exception, San José, is not geographically isolated, being east of the Peten; however, in spite of the importance of this area, there are surprisingly few examples of ball court structures: 3 in Tikal[50] and one in Uaxactún,[51] all of late Classic construction.

5. We found that the essential profile was made up of three surfaces in the Southern and Northern Maya Lowlands, and Central Mexico during the Classic Period and comprised of four surfaces in the Guatemala Highlands during the Late Classic, Post Classic and Protohistoric times.

Notes

Dimensions and slope angles used in the text have been taken from the sources given below. Whenever the author failed to give this information, readings were taken directly from the drawings of the plans, sections and elevations of the ball courts under discussion. Some accuracy has been lost in the process, but certainly not enough to affect the present study.

1. Blom, 1932, p. 490, figs. 5 and 6.
2. Satterthwaite, 1944, pps. 3-7.
3. Acosta and Moedano, 1946, p. 382.
4. Smith, 1961, pps. 100-125, figs. 8 and 9.
5. Stromsvik, 1952, pps. 189-198, figs. 2 and 5.
6. Ruz, 1958, pps. 639-640.
7. Marquina, 1964, lam. 289.
8. Acosta, 1965, p. 829; also Marquina, 1964, lam. 88.
9. Satterthwaite, 1944, pps. 8-29, figs. 1-5; 6a-9; 10.
10. Smith, 1955, p. 11.
11. Smith, 1955, fig. 58.
12. Marquina, 1964, p. 855, lam. 264; also Fernandez, 1925.
13. Marquina, 1964, p. 241, lam. 71.
14. Stromsvik, 1952, pps. 189, 198; also Borhegyi, 1960, p. 57.
15. Acosta, 1965, p. 829.
16. Stromsvik, 1952, pps. 189-198.
17. Ruz, 1958, p. 650.
18. Satterthwaite, 1944, pps. 37-8.
19. Stromsvik, 1952, p. 203.
20. Stromsvik, 1952, pps. 210-11.
21. Smith, 1950, p. 60, fig. 48c, d.
22. Satterthwaite, 1944, p. 41, figs. 17-19; p. 42, fig. 20.
23. Shook and Berlin, 1951, fig. 25.
24. Ruz, 1958, figs. 2bis, 7.
25. Ruppert and Dennison, 1948, pps. 21 and 61-2.
26. Ruppert, 1952, p. 49, fig. 33.
27. Ruppert and Dennison, 1948, pps. 66, 94.
28. Ruppert, 1952, p. 62, fig. 39.

29. Thompson, Pollock and Charlot, 1932, p. 47; also Blom, 1932, pps. 511-12 and Marquina, 1964, lam. 289.
30. Marquina, 1964, lam. 174.
31. Blom, 1932, fig. 36.
32. Satterthwaite, 1944, p. 26, fig. 6a.
33. Blom, 1932, fig. 37.
34. Ruz, 1952, pps. 30-33.
35. Smith, 1955, p. 57, figs. 35-36; pps. 61-62, fig. 134.
36. Smith, 1955, pps. 12-13, figs. 8, 56.
37. Smith, 1955, p. 29, fig. 80.
38. Smith, 1955, p. 29, fig. 81.
39. Smith, 1955, pps. 30-31, figs. 82, 83.
40. Wicke, 1957, figs. 30, 31.
41. Smith, 1955, p. 15, 19, figs. 58, 63.
42. Marquina, 1964, lam. 105.
43. Marquina, 1964, lam. 289.
44. Marquina, 1964, lam. 48.
45. Marquina, 1964, p. 241, lam. 71.
46. Garcia Payon, 1955.
47. Ruz, 1945, fig. III, 21, 22.
48. Matos Moctezuma, 1966, p. 36, fig. 9.
49. Coe, 1967, p. 90.
50. Coe, 1967, p. 50.
51. Smith, 1950, pps. 60-61, 74, fig. 98.

Bibliography

Acosta, J.R., and K. Moedano
 1946 "Los juegos de pelota," in *México Prehispánico*, Antologia de Esta Semana, Mexico, pp. 365-84.

Acosta, J.R.
 1965 "Preclassic and Classic Architecture of Oaxaca," in *Handbook of Middle American Indians*, Volume 3, Part 2, University of Texas Press, Austin, Texas, pp. 814-36.

Blom, F.
 1932 "The Maya Ball-Game Pok-ta-pok," *Middle American Research Institute,* Publications 4, Tulane University, New Orleans, Louisiana, pp. 485-530.

Borheygi, S.F.
 1960 "America's Ballgame," *Natural History,* LXIX, pp. 48-59.

Coe, W.
 Tikal.

Contreras, E.S.
 1965 "La zona arqueológica de Manzanilla, Puebla," in *Boletín* 21, Instituto Nacional de Antropología e Historia, México, Septiembre, pp. 363-73.

Fernandez, M.A.
 1925 El juego de pelota de Chichén Itzá," in *Anales del Museo Nacional de México*, IV, pp. 363-73.

Garcia Payon, J.
 1951 *La ciudad arqueológia de el Tajín,* Xalapa, Veracruz.

 1953 "El Tajín. Trabajos de conservacion realizados en 1951." Instituto Nacional de Antropología e Historia, *Anales*, V, Mexico, pp. 75-80.

212

1955 "Exploraciones en el Tajín, temporadas 1953-54." Instituto Nacional de Antropología e Historia, *Direccion de Monumentos Prehispánicos*, II.

1955 "Exploraciones en el Tajín," Instituto Nacional de Antropología e Historia, no. 2, *Informes*, Mexico.

Kubler, G.
1958 "The design of Space in Maya Architecture," in *Miscelanea Paul Rivet I, Mexico*, pp. 515-31.

Matos Moctezuma E.
1966 "Un juego de pelota en San Isidro, Chiapas," in *Boletín* 25, Instituto Nacional de Antropología e Historia, México, Septiembre, p. 36.

Marquina, I.
1964 *Arquitectura Prehispánica*, México.

Ruppert, K.
1952 *Chichén Itzá*, Architectural Notes and Plans. Carnegie Institution of Washington, Publication no. 595, Washington.

Ruppert, K. and J. Dennison
1943 *Archeological Reconnaissance in Campeche, Quintana Roo and Peten*, Carnegie Institution of Washington, Publication no. 543. Washington.

Ruz Lhuillier, A.
1945 *Campeche en la arqueología Maya*, Mexico.

1952 "Exploraciones en Palenque," *Anales* del Instituto Nacional de Antropología e Historia, V. no. 33, Mexico.

1958 "El juego de pelota de Uxmal," in *Miscelanea Paul Rivet*, I, Mexico, pp. 635-67.

Satterthwaite, L., Jr.
1944 *Piedras Negras Archaeology: architecture*, Part IV, no. 1: ball court terminology, University Museum, University of Pennsylvania, Philadelphia.

Shook, E. and H. Berlin
1951 "Investigaciones arqueológicas en las ruinas de Tikal," *Antropología e Historia de Guatemala*, III, no. 1.

Smith, A.L.
1955 *Archaeological reconnaissance in Central Guatemala*, Carnegie Institution of Washington, Publication no. 608, Washington.

Smith, A.L.
1961 "Types of Ball Courts in the Highlands of Guatemala," *Essays in Pre-Columbian Art and Archaeology*, Harvard University Press, Cambridge, Mass., pp. 100-25.

Smith, A.L.
1950 *Uaxactun, Guatemala*, Excavations of 1931-37, Carnegie Institution of Washington, Publication no. 588, Washington, D.C.

Stern, T.
1948 *The Rubber-ball game of the Americas*, American Ethnological Society, Monographs, no. 17, New York.

Stromsvik, G.
 The ball courts at Copan, with notes on courts at La Union, Quirigua, San Pedro Pinula, and Asuncion.

1952 *Mita*, Carnegie Institution of Washington, Publication no. 595, Contribution 55, Washington, D.C., 1952.

Wicke, C.R.
1957 "The ball court at Yagul, Oaxaca: a comparative study," in *Mesoamerican Notes*, 5, Mexico, pp. 37-78.

Thompson, J.E., H.E.D. Pollock and J. Charlot
1932 *A Preliminary Study of the Ruins of Coba, Quintana Roo, Mexico*, Carnegie Institution of Washington, March.

The Year Sign in Ancient Mexico:
A Hypothesis as to Its Origin and Meaning

Doris Heyden

Instituto Nacional de Antropologia e Historia, Mexico

The origin and development of the so-called *Year Sign,* also called the *Trapeze and Ray,* is examined here in different cultures in pre-Columbian America. An inquiry is made into its meaning and its possible origin, with emphasis on a little-known sculpture from Teotihuacán and similar representations in the later Aztec civilization. Although the written historical chronicles from the Colonial period (XVI-XVIII centuries) do not clarify the meaning of this symbol, its frequent representations in the painting, ceramics, sculpture, and architecture of many cultures allow the formation of a hypothesis that is meant to explain the important sign.

The Year Sign is usually described as an A joined to an O (Fig. 1), although at times the O takes a rectangular shape. It is found in the pictorial codices and on archeological monuments from the Mixtec region of Oaxaca, therefore it is often called the Mixtec Year Sign. It is frequently depicted in the mural painting, ceramics, and sculpture of Teotihuacán (Fig. 2), where its meaning is different from that of the Mixtec. The A-O symbol and its variants are also represented in the iconography of other sites in highland central Mexico of the Classic period (200-800 A.D.) and in early and late Postclassic times (900-1521 A.D.). If we go back in time to ca.500 B.C., we also see the symbol in Chavín, Peru.

The reference to Chavín comes from two ceramic vessels reproduced in the *Handbook of South American Indians* (Bennett 1946) (Fig. 3). The A joined to the O is clearly seen here. On one of the vessels, however, the O is open at one side and takes on the appearance of a jaguar's paw of the jaguar's fauces and fangs. The A-O or A-U symbol in Chavín may represent, then, the were-jaguar whose motifs are suggestive of Olmec iconography in Mexico (Fig. 4). In South America the jaguar has always been intimately associated with the shaman and represents an energetic principle, the natural life force (Reichel-Dolmatoff 1972). The were-jaguar and fire-serpent in ancient Mexico (Coe 1965, 1968) have been seen by Flannery and Marcus (1976) as the mythical ancestors of certain groups, in the way that other groups descended from caves or trees.

Reprinted from *Estudias de Cultural Maya,* Vol. 3, 1970.

The jaguar has also been associated with hills and the earth's fertility; furthermore, "the Sun created the jaguar to be his representative on earth" (Reichel-Dolmatoff 1972). Judging from these associations, a possible origin of the Year Sign in Chavín may be less surprising than appears at first glance. Porter (1953) has pointed out ceramic similarities between Mesoamerica and Peru during the Chavín horizon. According to Lathrap (1966), Mesoamerican influence in Peru may have begun with the introduction of maize through trade, at the same time that vigorous influences went north from South America. Badner (1972) has found motifs common to both Chavín and Teotihuacán, for example, currents of water containing "eyes".

A diffusion of symbols from South to Middle America may have accompanied the introduction of metallurgy into Mexico during some period in the pre-Columbian world. The jaguar-sun symbol, thus transplanted, would have retained some of its original meaning while acquiring others. The A as the Sun's ray seems to have maintained a certain permanence in the iconography, as can be seen in early Postclassic Mexican pictorial codices (Fig. 5) and in late Postclassic (Aztec) Sun stones (Fig. 6).

In Teotihuacán, the Year Sign appears in mural painting at Tepantitla, in the Palace of the Jaguars, at Zacuala, and on painted ceramics, where it forms part of the part of the headdress of the god of rain, thunder, and lightning. This headdress consists of a rectangular band surmounted by the *trapeze and ray* and a feather panache. Pasztory (1974) has made a study of the rain god in Teotihuacán where she designates as *Tlaloc A* the deity who often wears the Year Sign in his headdress and who carries a Tlaloc-form vessel in one hand, a serpentine staff (symbol of lightning) in the other (Figs. 7,8). Pasztory identifies Tlaloc A with the crocodile or *cipactli* (an earth-monster calendrical sign), with water and with earth. The Year Sign in the god's headdress relates him to the solar year and probably to the ritual cycle. With the end of the Classic period the Year Sign in Central Mexico seems to have lost its association with water and become a more abstract glyph, with specifically calendrical significance (Pasztory 1974).

Another interpretation of Tlaloc's headdress has been made by Clara Millon (1973). The Teotihuacán glyph she calls "tassel" consists of a tassel attached to a rectangle or panel similar to the A-O combination (Fig. 9). The symbol is seen in mural painting and on ceramics, worn by persons who also have attributes of Tlaloc. That this headdress is found on pottery and sculpture from Oaxaca, Tikal, Kaminaljuyú, and Copán, worn by Teotihuacán-type individuals who also bear arms, indicates that the insignia identifies Teotihuacán emissaries in foreign cities. C. Millon furthermore identifies members of the ruling group inside the Teotihuacán state by their use of this headdress.

The Year Sign in Teotihuacán is seen not only in mural painting and on pottery but also in sculpture and architecture. In Tetitla an architectural structure is represented in the frescoes whose form is similar to that of the stylized trapeze and ray (Fig. 10). Numerous merlons found in Teotihuacán, associated with clouds and water, have the form of a stepped fret, which can be said to be an extremely stylized trapeze and ray. Merlon-type vessel supports and even the combination of *talud* and *tablero* in architecture may be seen as the trapeze and ray in inverted position. The butterfly nose ornament, worn by water and vegetation gods, is another example of an abstract trapeze and ray (von Winning 1946) (Fig. 11).

A stylized Year Sign or trapeze and ray is the main motif on the relief-carved stone called by Caso (verbal communication) the representation of the New Fire ceremony and binding of the years at the end of the 52-year pre-Columbian "century" (Fig. 12). This stone was found at the foot of the original stairway of the Pyramid of the Sun and once must have formed part of the pyramid's facade. The so-called *New Fire Stone* is exhibited in the Teotihuacán Hall of the Museum of Anthropology in Mexico, although in inverted position. A twin stone is in one of the rooms of the residental zone below the Quetzal-Butterfly Palace at Teotihuacán. The symbol described above is seen here in abstract form with what seems to be a knotted cord in the center, but which may depict a twisted serpent often associated with water-vegetation gods. This multiple knot led Caso to speak of the binding of the years and the feathers in the background (which he interpreted as flames) as the New Fire. The motif as represented here survived into the Postclassic period, but first I will review the existence of the Year Sign in other regions of Mexico.

In Oaxaca the sign in sculpture and in the Mixtec pictorial manuscripts is the classical A-O (Figs. 1, 13). In Xochicalco, Morelos, the symbol was intimately associated with the calendar. The people of this site studied calendrics carefully and are said to have held a congress ca.650 A.D., with representatives from different parts of Mexico, to make calendar corrections (Piña Chan 1971). A study by Digby (1972) proposes that the Year Sign was a model for a sun dial (Fig. 14). Caso (1967) shows Year Signs or similar symbols from at least five different regions (Fig. 15). Recently various stelae were discovered in Chiapas that are very similar in design to Teotihuacán, including representations of Tlaloc and the Year Sign. Navarrete (1976) dates these stelae from the late Classic period and sees the style as emanating from Teotihuacán and passing through Chiapas—where a center on a trade route may have existed—on the way to Kaminaljuyú in Guatemala. The predominant figure on a stele from Campeche wears a Year Sign design on her earring, probably indicating her place on an upper rung of the hierarchy. In Uxmal a Tlaloc-like being wears Year Sign head and ear adornments (Fig. 16). The newly discovered late Classic murals at Cacaxtla, Tlaxcala, have been attributed to the Olmec-Xicalance (Diana and Danial Molina, verbal communication) and show strong Maya influence. In the battle scene the figures who seem to be the leading warriors wear the Year Sign headdress.

Probable Teotihuacán influence is found about eight centuries after the end of the Classic period on a sculpture of an Aztec deity from Castillo de Teayo, Veracruz, a Huaxtec-Aztec site, whose headdress bears great similarity to the *New Fire-Year Sign* stone from Teotihuacán (Fig. 17). The abstract Year Sign, in almost the same form as the Teotihuacan stone, is in the center of the headdress) the triple knot is in the same position as on the Teotihuacán relief. The "flames" are clearly represented as feathers on the Aztec stele. A new element is the presence of two serpents at the top. The figure who wears this headdress has characteristics of a goddess of vegetation. She emerges from the open maw of the Earth Monster; this signifies that she is a deity of sustenance, perhaps the representation of the Mother Goddess, the great provider.

The Museum of Anthropology in Mexico exhibits remains of all the ancient cultures of this country, among them the Aztec (1200-1521 A.D.) and the Huaxtec, more or less coeval. The Huaxtec is found in northern Veracruz and contributed much in a ritual sense in ancient times to the more powerful Aztec. A close similarity is seen in Aztec and Huaxtec sculpture of maize goddesses, in respect to the symbol I have

described. Some wear the Year Sign in the headdress while other have knots in this garment (Fig. 18). The superimposed sections that form the *merlon* or *trapeze* in the Teayo sculpture are seen as a four-part knot or bow (Fig. 18) or as ribbons (Fig. 19). Other sculptures wear cone-type protuberances as part of the adornment (Fig. 20). A new element typical of the Postclassic period is the representation of paper rosettes at each side of the headdress, with tassels pending from these.

The headdress of vegetation gods in Aztec times, especially the Mother Goddess and deities of maize, was called *meyotli* in the Colonial chronicles. This was derived from the word *tonameyotl* - sun's ray or brillance (Molina 1944). The meyotli headdress is seen in the Codex Borbonicus, a pictorial document which depicts gods and rites from Central Mexico in the Aztec period. The individual who represented the Mother Goddess, the skin of whose sacrificed impersonator was worn by a priest in the *Ochpaniztli* festival ,[1] wore not only the Year Sign-Meyotli headdress but also vegetables, fruits, and colored ribbons that symbolized maize of different colors (Fig. 21). The same figure appeared in the fiesta of the twelfth month, Teotl eco. Paper rosettes were worn at the sides of the headdress and the center knot or bow, seem in sculpture and earlier representations, had been substituted by two ribbons topped by a cone.

Now the cone, the paper rosette, and the knot made with various ribbons will be examined one by one in relation to associated elements and to other gods. The cone with crossed ribbons, similar in appearance to a stylized A-O, is usually associated with gods of fertility, especially those of sustenance, life and death, and fire. Maize gods and the Mother Goddess are included here, as well as the flayed gods. The priests in charge of the New Fire ceremony (Borbonicus 34) wore a headdress with the cone and paper rosettes (Fig. 22). A triangle similar to the meyotli forms part of the headdress. Other gods whose costume included the paper rosettes and cone with ribbons were the Lord of the Dead (*Mictlantecuhtli*) and *Itzlacoliuhqui*, one of the maize gods (Fig. 23). The Land of the Dead was, as I have mentioned, also the land of germination.

The four-part knot of various knotted ribbons formed part of the maize goddess's headdress, as seen above, and also adorned the flower in the meyotli-Year Sign headdress (Borbonicus 30). The same flower was carried at times by the fire priests (Fig. 22). In the same New Fire ceremony the torches carried by the fire priests were bound with four knotted ribbons. The Fire Serpent, insignia of the fire gods, also has the knotted ribbon ornament seen on the torches. The same ornament, here associated with fire, was also related to the Mother Goddess. In the Codex Vaticanus B she is seen giving birth to the symbol itself, while in the Borbonicus she brings forth a replica of herself, carrying a knotted cord, perhaps umbilical (Fig. 24). These ribbons, cords, and knots seem to have little to do with the Year Sign-meyotli headdress, yet they have in common the association with creator-fertility gods.

It is time to ask: what is the common denominator of the elements described that are found in different cultures and regions, especially in the Teotihuacán stele and the maize goddess sculptures? Is there a pattern of iconographic elements associated with the deities?

The Year Sign components and related elements have characteristics that overlap in various ways. The form of the symbol is the Fire Serpent, the *xiuhcoatl*, emblem of the fire god *Xiuhtechuhtli-Ixcozauhqui* (Fig. 25). Xiuhtecuhtli was the "mother and father of the gods" (Sahagún 1950, 1969), patron of sovereigns, and was the Lord of the

Year (Noguez 1971; Heyden 1972). The nose ornament that distinguished rulers and could be used exclusively by them was a stylized *xiuhcoatl*. Fire is the representative of power established since times immemorial since it is considered the oldest of the natural elements. Fire is the center of the earth, associated also with the jaguar, the world of the dead, and creation. Other elements discussed above have fire connections, such as the knotted ribbons and torches.

Summing up these iconographic elements, the Year Sign, as well as other motifs, is the symbol of fertility and sustenance. It forms part of the costume of maize goddesses and other agricultural deities. Knotted ribbons are seen not only on firebrands but on the headdress of fertility deities, and in relation to the Mother Goddess and the Lord of the Dead. Paper rosettes and ribbons or strips of paper are in the same category. Attributes of the different gods mentioned in reality point to similar characteristics: fire (Xiuhtecuhtli) and water (Tlaloc) were the great purifiers and intervened in rites of lustration or resurrection. Both water and fire were used in ceremonies for the dead, in bathing and cremation. Water gods were also gods of the underworld and of the earth's fertility. Tlaloc was "god of the earth" (*Costumbres de Nueva España* 1946; Sullivan 1972) and the "path under the earth" (Durán 1971).

The Year Sign, then, maintained its form with superficial changes over a long period of time but meaning was not always the same in different cultures. In its earliest manifestations the "proto-sign" probably was associated with the cosmos, the earth, the jaguar, and the shaman; the latter represented a social control through religion and ritual. In Teotihuacán the motif at the beginning may have symbolized fertility, water and fire, and sacred ancestors. In late Teotihuacán the sign was associated with the calendar and certain ruling groups. In the following period, the early Postclassic, its relationship was to the calendar and astronomy. These specialized meanings are represented in Xochicalco and in the Mixteca; both calendrics and astronomy at the same time signify social and political power of the priests who control these sciences. As a power symbol, it was worn by the Mayoid warriors portrayed in the Tlaxcala murals.

In the late Postclassic period, the time of the Aztec empire, the Year Sign or similar motifs again were related to agricultural fertility and its gods, especially the Mother Goddess. Perhaps in this sense it was influenced by the Huaxtec region, which had remained basically agricultural, while in the urbanized central highland the Year Sign was diagnostic of Fire gods and the Sun, and through these, with the highest ruling authorities.

The Teayo stele, whose headdress is almost identical to the Teotihuacán relief, depicts a maize and vegetation goddess emerging from the earth; the reverse side shows numerous water gods. Feathers surround the stylized Year Sign and in ancient chronicles feathers in this type of headdress symbolized corn stalks (Durán 1971). The maize goddess was one of the many aspects of the Mother Goddess, as was the goddess of water. Huaxtec influence was felt not only in Aztec sculpture of this type but in ritual. In the festival to the Mother Goddess her attendants were disguised as Huaxtecs. This agriculture-earth significance of the sign may have survived over the centuries and even millenia, while the element of social control, tribute, and war could have become associated with great centers little by little. One reason for the continuity of form would have been its representation of sacred ancestors and all they represented: prestige and justification of legitimacy in political and religious control.

In conclusion, the elements which form part of the Year Sign or motifs associated with it, as described in this paper, were associated with the Sun, fire, water, earth, fertility, certain deities, the concept of Mother-Father, ancestors, calendrics and astronomy, the ruling authorities and the sovereign. Although many changes took place from early cultures to late ones and from one region to another, basically the Year Sign symbolized the main elements of nature that are the "mother and father" of men and because of this, exercise control over those who dominate their growth and distribution. This idea includes the sun and the calendar, which regulate agricultural activities as well as political ones such as the investiture of the sovereign. The meanings of this symbol demonstrate the richness of pre-Columbian thought and iconography in only one example.

Note

1 Flaying was carried out in rites dedicated to the earth's fertility and to gods of sustenance. The Ochpaniztli festival was celebrated in honor of the Mother Goddess, "the heart of the earth" (Duran 1971:229).

Bibliography

Badner, Mino
1972 "A Possible Focus of Andean Artistic Influence in Mesoarmerica." *Studies in Pre-Columbian Art and Archaeology* No. 9. Dumbarton Oaks, Trustees for Harvard University, Washington D.C.

Bennett, Wendell C.
1946 "The Archaeology of the Central Andes." *Handbook of South American Indians.* Editor, Julian H. Steward. Vol. 2, *The Andean Civilizations:* 61-147. U.S. Government Printing Office, Smithsonian Institution, Washington D.C.

Caso, Alfonso
1967 *Los Calendarios Prehispánicos.* UNAM, Instituto de Investigaciones Históricas, Serie de Cultura Nahuatl 6. Mexico.

Codex Borbonicus
1974 *Codices Selecti,* Vol. XLIV. Study by Karl Anton Nowotny. Akademische Druck -u. Verlagsanstalt, Graz, Austria.

Codex Borgia
1976 Study by Karl Anton Nowotny and Jacqueline de Durand-Forest. Akademische Druck -u. Verlagsanstlatl, Graz, Austria.

Codex Nuttall
1902 Facsimile edition edited by the Peabody Museum, Harvard University. Text by Zelia Nuttall.

Coe, Michael D.
1965 *The Jaguar's Children.* Museum of Primitive Art, New York.
1968 *America's First Civilization: Discovering the Olmec.* American Heritage Publishing Co., Inc., in association with The Smithsonian Institution. D. van Nostrand Co., Inc., New York.
1945 *Costumbres, Enterramientos y Diversas Formas de Proceder de los Indios de Nueva España.* Edited by Federico Gomez de Orozco. *Tlalocan* II:1, Mexico.

Diaz Solis, Lucila
1968 *La Flor Calendarica de los Maya.* Merida, Yucatan.

 "Evidence in Mexican Glyphs and sculpture for a hitherto unrecognized
 astronomical instrument." *Atti del XL Congresso Internazionale Degli* Americanisti
Digby, Adrian
1972 "Evidence in Mexican Glyphs and sculpture for a hitherto unrecognized
 astronomical instrument." *Atti del XL Congresso Internazionale Degli American-
 isti:* Vol I. 433-442. Roma-Genova.

Durán, Diego.
1971 *Book of the Gods and Rites and The Ancient Calendar.* Translated and annotated by
 Fernando Horcasitas and Doris Heyden. The University of Oklahoma Press,
 Norman.

Flannery, Kent V. and Joyce Marcus
1976 "Formative Oaxaca and the Zapotec Cosmos." *American Scientist,* Vol. 64:
 374-383.

Furst, Jill Leslie
1977 "The Mixtec Tree-Birth Tradition in Myth, Codices and Minor Arts." University
 Seminar on Primitive and Pre-Columbian Art, Columbia University, New York.
 (Conference No. 55, March 25, 1977)

Heyden, Doris
1972 "Xiuhtecuhtli, Investidor de Soberanos." *Boletín INAH* Epoca II, No. 3:3-10.
 Mexico.

Kubler, George.
1967 *The iconography of the art of Teotihuacan.* Studies in Pre-Columbian Art and
 Archaeology No. 4. Dumbarton Oaks, Trustees for Harvard University, Washington
 D.C.

Lathrap, Donald W.
1966 "Relationships between Mesoamerica and the Andean Areas." *Handbook of
 Middle American Indians,* Vol. 4: 265-295. University of Texas Press, Austin.

Millon, Clara H.
1973 "Painting, Writing, and Polity in Teotihuacan, Mexico." *American Antiquity,* Vol.
 38, No. 3.

Molina, Fray Alonso de.
1944 *Vocabulario en Lengua Castellana y Mexicana, 1571.* Editorial Cultura Hispánica,
 Madrid.

Navarrette, Carlos
1976 "El complejo escultórico del Cerro Bernal, en la costa de Chiapas, Mexico." *Anales
 de Antropología,* Vol. XIII:23-45. UNAM, Instituto de Investigaciones Antro-
 pológicas. Mexico

Noguez, Javier
1971 *El Hueitlatoani y su Relación con el Complejo del Dios del Fuego Xiuhtecuhtli.*
 Thesis for *Licenciatura* in History, College of History, Philosophy and Letters,
 UNA, Mexico.

Paddock, John
1966 "Oaxaca in Ancient Mesoamerica." *Ancient Oaxaca,* Stanford University Press,
 California.

Pasztory, Esther
1971 *The Murals of Tepantitla, Teotihuacan.* Ph.D. dissertation, Columbia University,
 New York.

1974 *The Iconography of the Teotihuacan Tlalocs.* Studies in Pre-Columbian Art and
 Archaeology No. 15. Dumbarton Oaks, Trustees for Harvard University,
 Washington, D.C.

Piña Chan, Roman
1971 *A Guide to Mexican Archaeology.* Minutiae Mexicana, Mexico.

Porter, M. N.
 Tlatilco and the Pre-Classic Cultures of the New World. Viking Fund Publications in
 Anthropology No. 19.'

Reichel-Dolmatoff, Gerardo
1972 "The Feline Motif in Prehistoric San Agustin Sculpture." *The Cult of the Feline*,
 Elizabeth, P. Benson, editor. Dumbarton Oaks, Trustees for Harvard University,
 Washington D.C. pp. 51-64

Sahagún, Fray Bernardino de
1938 *Historia General de las Cosas de la Nueva España*. Introduction by W. Jiménez
 Moreno, notes by E. Seler. 5 vols. Antigua Libreria Robredo, Mexico.

Florentine Codex.
1950- *General History of the Things of New Spain*. Translated from the Aztec and
1969 annotated by Charles E. Dibble and Arthur J.O. Anderson. 12 volumes. School of
 American Research, Santa Fe, New Mexico.

Sejourne, Laurette
1966 *Arqueología de Teotihuacán: la Cerámica*. Fondo de Cultura Económica, Mexico.

Séjourné Laurette
1966a *Arquitectura y pintura en Teotihuacan*. Siglo Veintuno Editores, Mexico.

Seler, Eduard
1963 *Comentarios al Códice Borgia*. Translation from the German by Mariana Frenck. 3
 vols. Fondo de Cultura Económica, Mexico.

Sullivan, Thelma D.
1974 "Tlaloc: a new etymologial interpretation of the God's name and what it reveals of
 his essence and nature." *Atti del XL Congresso Internzionale degli Americanisti*,
 Vol. II:213-220. Roma-Genova,

von Winning, Hasзo
1947 "Representations of Temple Buildings as decorative patterns on Teotihuacan
 Pottery and Figurines." *Carnegie Institution of Washington, Notes on Middle
 American Archaeology and Ethnology*, No. 83:170-177.

1961 "Teotihuacan Symbols: the Reptile's Eye Glyph." *Ethnos* 26:121-166. Stockholm.

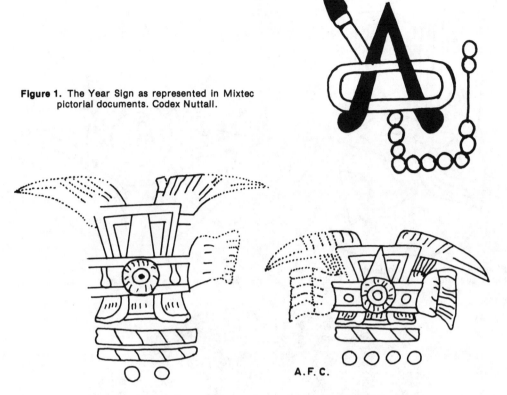

Figure 1. The Year Sign as represented in Mixtec pictorial documents. Codex Nuttall.

Figure 2. The Year Sign in *al fresco* decoration on conch shells from Teotihuacan. National Museum of Anthropology, Mexico. After Caso 1967.

Figure 3. Incised decoration on pottery from Chavin, Peru, suggestive of the Year Sign. The design on the right, if turned sidewise, resembles the fauces and fangs of the jaguar. After Bennett 1946.

222

a. f. c.

Figure 4. The mouth and fangs in Olmec iconography suggest the jaguar's fauces both in Olmec and Chavin art. After Coe 1968.

Figure 5. The sun's rays are seen as capital A's. Codex Nuttall.

Figure 6. The sun's rays as an A is also seen on the Aztec Sun Stone. Courtesy National Museum of Anthropology, Mexico.

Figure 7. This figure, possibly a Tlaloc impersonator, wears the Year Sign in his headdress. From the Atetelco murals at Teotihuacan. After Sejourne, 1966.

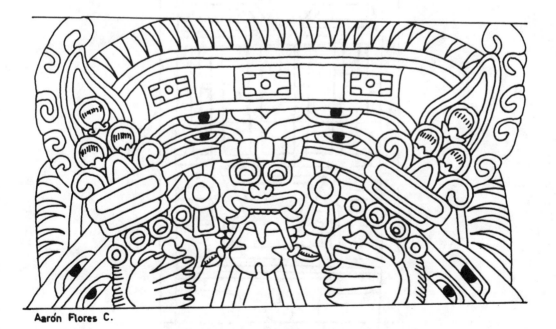

Aarón Flores C.

Figure 8a. The rain god Tlaloc as represented in Teotihuacan carries images of himself in the form of staffs or vessels, wearing Year Sign headdresses. After Pasztory 1974.

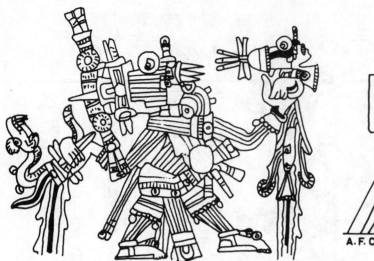

Figure 8b. Tlaloc, god of rain and lightning, whose head-dress forms a stylized Year Sign or trapeze-and-ray. Codex Borgia 27.

A.F.C.

Figure 9. "Tassel" glyph associated with the rain god and with certain power groups in Teotihuacan. After C. Millon 1973

Figure 10. Architectural motif whose form suggests the Year Sign or trapeze-and-ray as seen in Teotihuacan. From the mural painting at Tetitla, Teotihuacan.

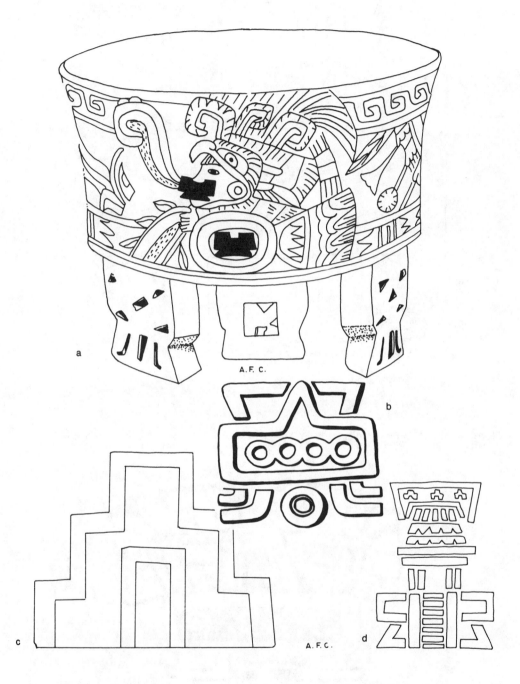

Figure 11. a. Painted vessel depicting two butterfly nose ornaments suggestive of the Year Sign form (Anahuacalli Museum, Mexico). b. Inverted ''merlon'' vessel support represented as a Year Sign. c. Architectural merlon. d. Teotihuacan temple whose *talud* and *tablero* (panel and sloped wall) suggest the sign in abstraction; merlons are also shown on the roof. After Sejourne 1966 and 1966a.

226

A.F.C.

Figure 12. The "New Fire-Binding of the Years" stele from Teotihuacan. The illustration is shown in inverted position in order to compare it with the Aztec Teayo sculpture (Fig. 17). Courtesy MNA, INAH.

Figure 13. Year Sign made of clay, from Atzompa, Oaxaca. Zapotec culture. Exhibited in the Oaxaca Hall, National Museum of Anthropology, Mexico. Courtesy INAH.

Figure 14. The Year Sign as the representation of a sun dial. Above: two depictions of the symbol and drawings of three dimensional models of the way they may have been used. Below: shadows caused by the course of the sun as the rays hit the O-A structure. After Digby 1972.

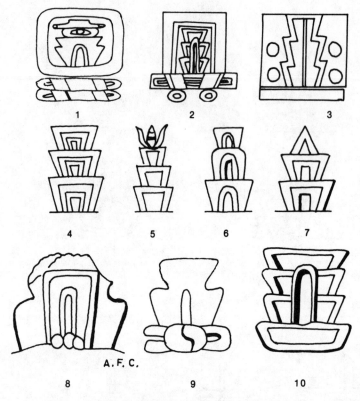

Figure 15. Glyphs in the form of the Year Sign: 1. stone carving from Xochicalco, Morelos, 2. stele from Rio Grande, Oaxaca, 3. Cerro de los Monos, Guerrero, 4, 7. tail of the Fire Serpent in Aztec sculpture, 5. Aztec, 6. *Codex Tonalamatl de Aubin*, 8, 9, 10. Acapulco, Guerrero. After Caso 1967.

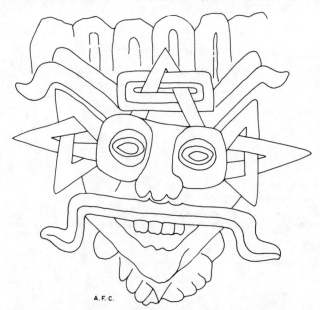

Figure 16. Deity, possibly rain god, whose headdress and ear ornaments have the Year Sign form. Provenience, the Sorcerer Pyramid, Uxmal, Yucatan. After Diaz Solis 1968.

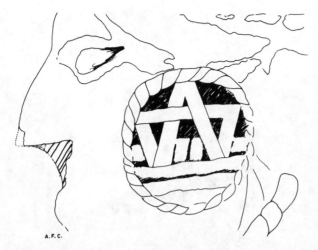

Figure 16a. The main figure on a Maya stele from Campeche wears a large ear plug adorned with the Year Sign. Courtesy MNA, INAH.

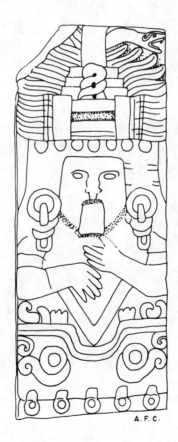

Figure 17. The headdress of the Aztec-Huaxtec vegetation deity from Castillo de Teayo bears great similarity to the Teotihuacan ''New Fire-Year Sign'' carved stone. Courtesy MNA, INAH.

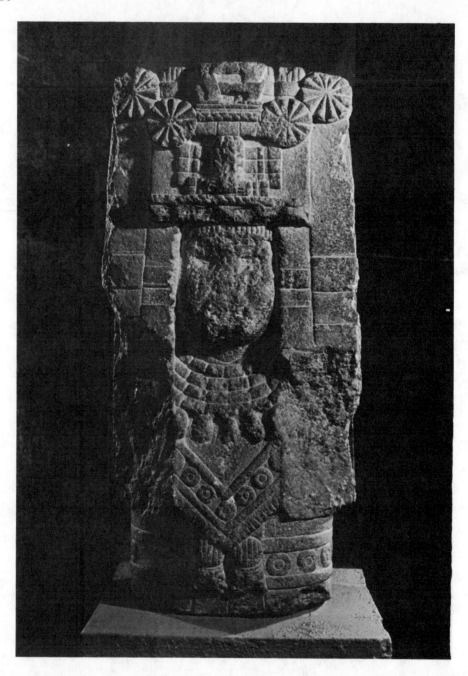

Figure 18.This Aztec maize goddess wears a Year Sign headdress with paper rosettes, bands, and knots. Courtesy National Museum of Anthropology, Mexico.

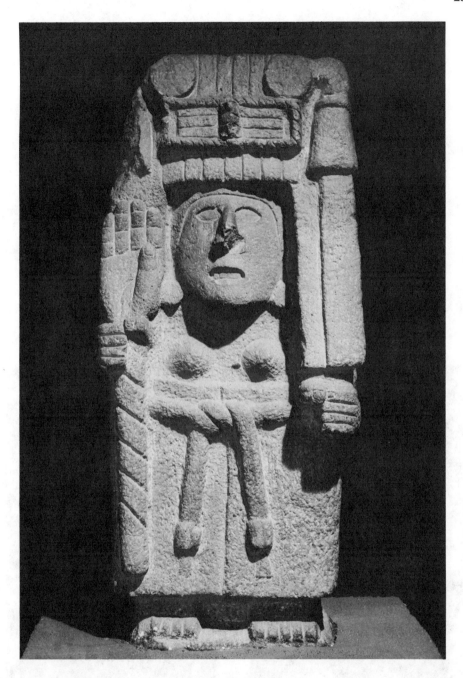

Figure 19. The protuberance in the center of the rectangle with bands or ribbons on the Aztec maize goddess's headdress is suggestive of the A-O in the Year Sign. Courtesy MNA, INAH.

232

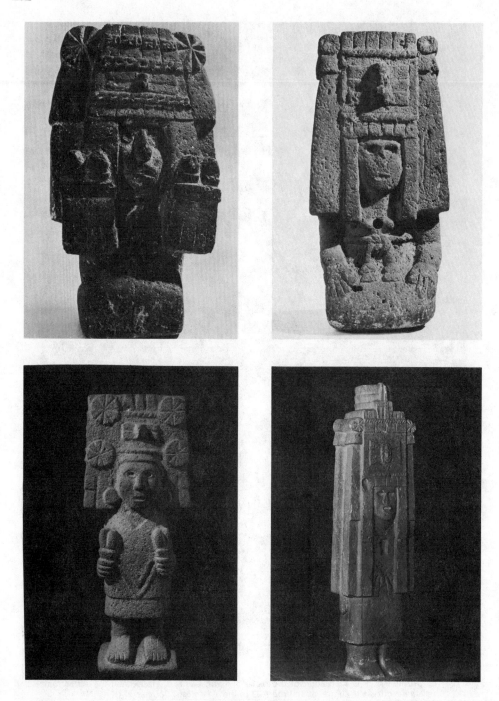

Figure 20. The squared headdress with bands and cone-like protuberance in the center, with rosettes and ribbons at the side, is characteristic of maize-vegetation deities, such as those seen in the Codex Borbonicus. Courtesy MNA, INAH.

A. F. C.

Figure 21. The *Meyotli*—Year Sign headdress was worn in Aztec ceremonies by impersonators of the Mother Goddess, who was basically a vegetation deity. The various elements that make up the headdress are shown on this page from the Codex Borbonicus, where the Ochpaniztli festival in honor of the Mother Goddess is portrayed. The central figure also wears a butterfly noseplug.

234

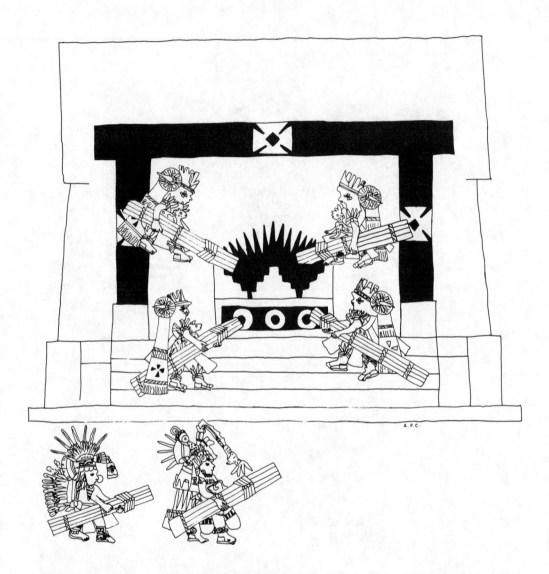

Figure 22. In the New Fire ceremony, celebrated every 52 years, the hearth is formed of merlons with pyramidal abstract Year Sign shape. The fire priests carry torches bound with ribbons and knots such as those seen on vegetation and fire deities, and wear in their headdress the cone and paper rosettes which also form part of the maize goddess's adornment, and of vegetation and death gods. Codex Borbonicus.

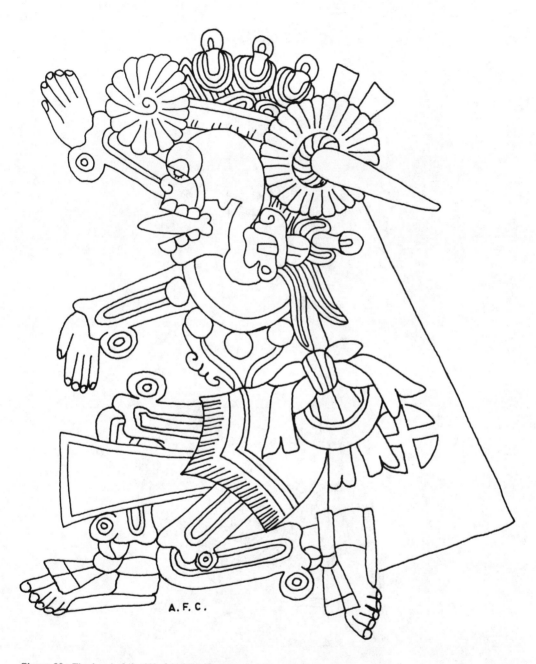

A. F. C.

Figure 23. The Lord of the World of the Dead wears ornaments similar to those used by vegetation deities. His reign is also the place of germination and creation, since life grows from death and germination takes place in darkness. Codex Borbonicus.

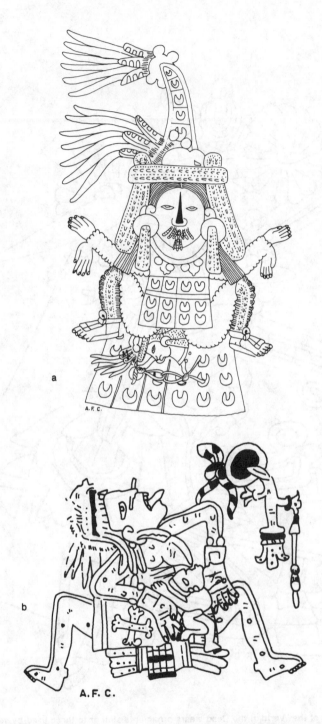

Figure 24. Tlasolteotl, one of the aspects of the Mother Goddess, is shown giving birth to an image of herself, in whose hands is the knotted (umbilical?) cord of creation and vegetation. Codex Borbonicus. b. In the Codex Vaticanus B the Mother Goddess gives birth to a creature associated with the ribbons and knots usually seen on the goddess's headdress.

Figure 25. The *xiuhcoatl*, Fire Serpent, was the insignia of Xiuhtecuhtli, god of fire and of the year, patron of Aztec rulers. The Fire Serpent has the form of the Year Sign and on this sculpture its base is the four-band symbol with knots, typical of vegetation deities. The god wears the sign in inverted position as a cape. Courtesy MNA, INAH.

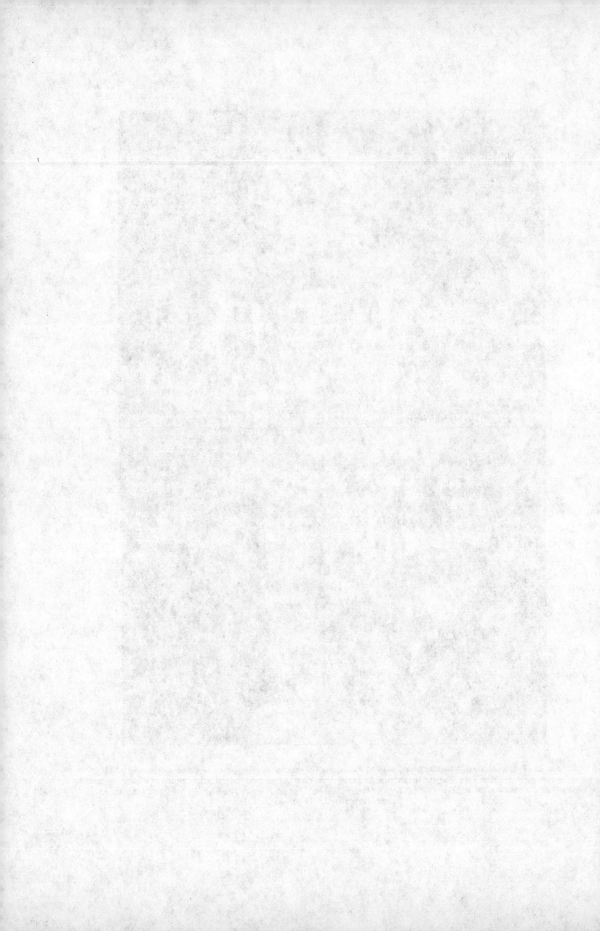

The Stone Sculpture of Costa Rica

Doris Stone

The importance of Costa Rica as a cultural meeting ground in pre-Columbian times cannot be underestimated. It is a crossroad area forming part of the great Central American isthmus which connects the northern and southern continents. Costa Rica exhibits outstanding and unique art forms which lend a character of their own apart from the cultural bonds linking it with the rest of Central America.

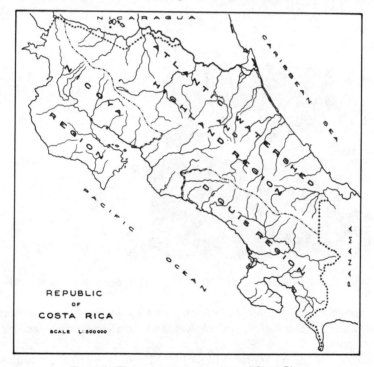

Figure 1. The archaeological regions of Costa Rica.

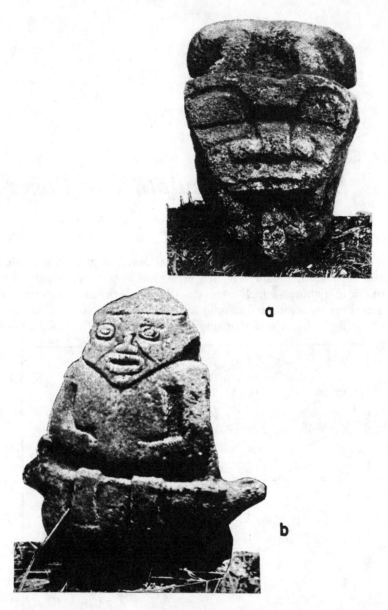

Figure 2. Stone figures, Nicoya Region. *a*, Feline-type head with alter-ego motif. *b*, Seated human figure.

One of the principal manifestations of Costa Rican pre-Columbian art is stone sculpture[1] which indicates highly technical and aesthetic traditions, probably of considerable time depth, and which suggests local developments. Cultural sequences are not known, but there are regional variations. These in part reflect influences from the South American lowlands and the Antilles, and Andean highlands, and various Mexican cultures.

In Costa Rica, there are three archaeological zones based primarily on art styles: the Nicoya Region; the Atlantic Watershed and Highland Region; and the Diquís

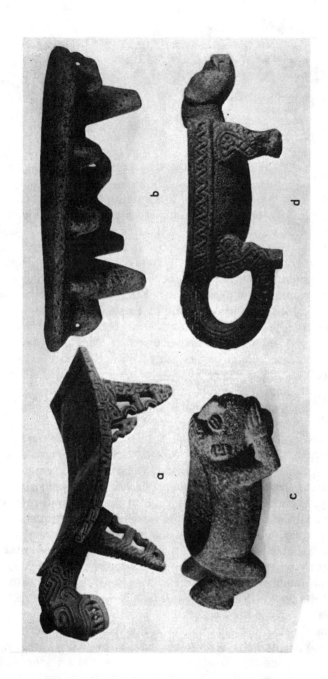

Figure 3. Grinding stones from Costa Rica. *a,* Rimless stone, Nicoya region. *b,* Grinding stone with stylized vestige of flying panel, Línea Vieja. *c,* Grinding stone in form of reclining figure, Línea Vieja. *d,* Jaguar-type raised-rim grinding stone, typical of Diquís Region but also extending into Atlantic Watershed and Highland Region.

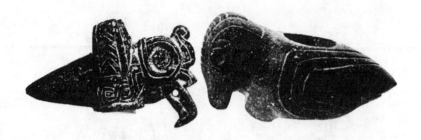

Figure 4. Stone mace heads, Nicoya Region.

Region (Fig. 1). The first two manifest basic similarities with the South American lowland and the Antilles as well as a penetration of Mesoamerican cultures strong in the Nicoya Region but barely appearing in that of the Atlantic Watershed and Highland. The art of these two areas is fundamentally realistic although some conventionalization is evident. The Atlantic Watershed in particular might be given credit for the development of folk art in stone work. The Diquis Region shows few connections with Mesoamerica but decided relationships with Andean South America. It is characterized by a highly stylized art with an emphasis on form.

The Nicoya Region. The only part of Costa Rica where large statues are found in any number is the Nicoya Region. More than one style is evident. At Los Palmares on the Pacific coast, figures of human beings seated on horizontal benches are known (Fig. 2,b). Facial features are in low relief and include flat nostrils on a narrow nose, thick oval lips and oval elongated eyes. Little attention is given to the limbs which seem inadequately thin in comparison to the massiveness of the figure as a whole. The low bench suggests the south.

There are two distinct types of monolithic statues both of which are also found in the republic of Nicaragua. In the area of Nacascola, "alter-ego" figures occur similar to those from Ometepe Island in Lake Nicaragua. These are representations of human beings with an animal or reptile on their heads or backs. Symbolically they portray the "other I" or the spiritual protector or associate of the person. These statues are massive frontal examples of sculpture. The artist was apparently satisfied to conform to the limits of the stone block without an attempt to interpret any movement or lifelike characteristics. Some scholars have attributed such figures to northern inspiration. The fundamental concept appears at Comitan, southwestern Mexico, and again in highland Guatemala and western Honduras. In Mesoamerica, the statues occur in greatest number in the area of Nicaragua already delimited. Lothrop has pointed out that these are probably early in the time scale as similar types have been found under certain altars at Copán, Honduras, and because they bear a stylistic resemblance to the Tuxtla Statuette.[2] At Los Palmares, Guanacaste, in the Nicoya Region, however, monolithic figures with feline type heads and alter-ego motifs are seen (Fig. 2, a). In both technique and conception they are reminiscent of statues from the Andean site of San Augustín, Colombia. It is not improbable that the alter-ego monuments of Costa Rica represent two different cultures: one of northern and one of southern inspiration.

Still another link with Nicaragua appears in monolithic statues which follow the form of a column. In Nicaragua, these are classified as "Chontales type" sculptures[3] and are found principally in the department of this name, and in Costa Rica, on the Nicoya Peninsula. They are carved in the round in low relief. Many of the Nicoya examples appear to wear masks and are covered with symbols suggesting tattoo or body painting.[4]

There is a small group of conventionalized male figures often cut in semi-round which occur in the Nicoya Region, but seem to extend from the Pacific coast of Panama through the Diquis Region of Costa Rica, and reappear in southern Honduras.[5] These images also stylistically recall San Agustín. A nubbin headdress, generally an accentuated spine, and always a peg base are characteristic. The arms are doubled upward on the chest and the legs bent in a seated upright position. The striking quality of these statuettes is that the body members and features mentioned are sharply delineated but the stone core serves a definite prominent place in the total concept.

Cylindrical stone seats with pinch-waists again connect in part the Nicoya Region with the Diquis.[6] These are decorated with textile and geometric designs or with a bird's head, the bill of which protrudes and is frequently sculptured in an open-work, lack-like pattern reminiscent of the slab-leg grinding stones for maize which will be examined later. A humorous touch is sometimes given to the whole through the conventionalization of the eyes and ears which are sculptured in high relief on the body proper. An occasional seat of this type is found on the Línea Vieja, Atlantic Watershed. The rarity of such specimens, however, is evidence that they were trade pieces in this latter region.

Distinctive of the Nicoya archaeological section, but found occasionally in the Línea Vieja and known in southwestern Nicaragua and the Comayagua area of Honduras, are three-legged rimless grinding stones. The grinding plate is the type associated with maize preparation. The legs are slab-shape and very often one end of the plate terminates in a protruding bird, animal or reptile head (Fig. 3, a). Geometrical motifs as a rule adorn the outer edge of the plate, the legs, and the neck of the projecting head. The open-work and almost gothic-like delicateness of these pieces emphasize the technical proficiency of the aboriginal artist with the material he had at hand. There are also tubular leg grinding stones usually decorated with low relief textile designs both as a border on the upper portion of the plate and covering the part underneath.[7] This latter adornment suggests a purely aesthetic purpose. In other words, when the stone was not in use, it was rested against the house wall, feet outward, and the decorative pattern afforded emotional pleasure to the casual observer. Raised-rim grinding stones associated with the rest of Costa Rica are likewise found in Nicoya.

Mace heads made of chalcedony, serpentine, granite, jadeite, diorite, etc., are distinctive of the Nicoya Region and the Reventazón Valley and La Unión de Guapiles on the Atlantic Watershed. These heads must have had a ceremonial significance although their effectiveness as a killing weapon cannot be denied if they were properly manipulated. Animals, reptiles, birds and human skulls are favorite subjects (Fig. 4). The bold clean interpretation cut with a maximum economy of line is characteristic. The skull motif is perhaps the result of Mexican influence, but the overall concept and execution of these mace heads remain without parallel in Mesoamerican art.

The Atlantic Watershed and Highland Region. Human figures ranging from 3½ cm. to 75 cm. high are common in this region and can be divided into distinct groups. The most stylized class consists of seated men usually called by the Misquito Indian name "sukia" signifying medicine man. These are portrayed in a pensive attitude or blowing a flute. Typical of this group, although not seen in all pieces, is a conventionalized spine showing a remarkable facility on the part of the aboriginal artist to accent vital features. "Sukia" figures are associated with the Atlantic Watershed and Highland Region, and appear occasionally in southern and southwestern Honduras, in western El Salvador, and in the Antilles.[8]

Characteristic of the Atlantic Watershed and Highland, however, is an artistic trend unfettered by conventions which gave rise to realistic and often humorous interpretations in stone and clay, a tendency rather uncommon in the Central American area. Stone images of human beings cut in the round and frequently giving the impression of portraits (Fig. 5) appear in most of this territory but seem to have a center of manufacture along the Línea Vieja and in the Reventazón Valley. These genre or portrait-like statues are notable for the non-frontal conception which is unusual in primitive art. It is probable that many stone figures serve as "penates" or household gods. Some, however, and in particular these individualistic statues could well have been representations of popular heroes, the beginning of a personalized interpretive style.

There are also stone figures which are on the whole more conventionalized although occasionally demonstrating individual characteristics. These include personages with ceremonial masks, for example, those usually attributed to the "alligator god" (although there are no alligators but only crocodiles in Costa Rica (Fig. 5, a)); men kneeling on one knee and rubbing their backs with a rectangular object; or men with a hand placed over the forehead by one eye as if acting as lookouts. A particularly numerous group of figures is composed of semi-conventionalized nude females sustaining their breasts (Fig. 6); men holding a trophy head and often an axe (Fig. 7); or men wearing a head on a rope hung around the neck. Some figures of this class were found at Retes, Irazú volcano, and belong to a fairly recent period as we shall see later. Lone heads of varied sizes similar in style compose another group.[9] The technique shown in the sculpture denotes a mastering of the material employed, a definite sense of design, and a remarkable ability to combine realistic form with a stylized attitude.

Historical documentation emphasizes the custom of human sacrifice every moon[10] without pointing out the method employed. There are many ceremonial objects which perhaps developed from this cult. The figures holding or carrying human heads make one division; the lone heads constitute another. Grinding stones and circular tables decorated around the rim with stylized human and occasionally animal heads, as well as individual human heads of stone compose still other groups. In fact, the continual appearance of this motif throughout the region suggests that the common way to meet religious demands was to offer a head in sacrifice. This is a South American trait as opposed to the Mexican or northern custom of cutting out and offering the heart.

Part of the ritual in connection with death rites whether by sacrifice or not, required chicha, a fermented drink made of tubers such as yuca (*Manihot utilissima* Pohl), tiquisque (*Xanthosoma violaceum* Schott), ñampi (*Dioscorea trifida* L.) and of

Figure 5. Stone Figures, Línea Vieja. *a,* Human figure with "alligator" mask. *b,* Prisoner with hands tied. *c,* Woman with parrot and vessel. *d,* Woman braiding hair.

Figure 6. Female figure sustaining breasts.　　　　**Figure 7.** Human figure holding trophy head.

the fruit of the pejibaye palm (*Guilielma gasipaes* Bailey).[11] These foodstuffs, which are South American in origin, need more water in their preparation than maize, and served not only for ceremonial purposes but also made up the basic diet of the majority of the aboriginal population of Costa Rica and the Caribbean coast of Central America as far as the Aguan River in Honduras. They were mashed on raised-rim grinding stones, as a rule four-legged, and the process employed was a side-to-side or rocker motion as compared to the forward-backward movement peculiar to the rimless grinding stones associated with maize and especially with northern and Mexican cultures.

The raised rim of the grinding stones, particularly the elaborately sculptured ones which were undoubtedly for ceremonial purposes, are usually adorned with human but sometimes with animal heads in relief (Fig. 8). These are often so stylized that they give the impression of a fluted or notched border. When this is the case, a less conventionalized head is seen on two sides of the mealing plate which may be oval but is as a rule rectangular in shape.

The characteristic mullers were stirrup-shaped to permit the rocking movement and at the same time protect the fingers from the raised edge of the grinding plate. Plain, short, horizontal and triangular ones are also seen. The stirrup-type and rectangular styles are generally decorated with naturalistic or geometric motifs which serve as handles.

In the Reventazón area and the western slopes of Irazú volcano, exquisitely sculptured raised-edged grinding stones with three legs and a flying panel appear (Fig. 9). Sometimes on the Línea Vieja as well as the actual Highlands or Meseta

Figure 8. Human heads adorning rim of grinding stone, Línea Vieja.

Figure 9. Grinding stone with flying panel, Reventazón area.

Figure 10. Offering table, Atlantean figures, Atlantic Watershed.

Figure 11. Pedestal-supported offering table.

Central, a stylized vestige of this panel is seen under the mealing plate (Fig. 3, b). The raised rim is frequently adorned with conventionalized heads, but it is the symbolism depicted in the supports and the panel and the technical manner of interpretation which place this type of grinding stone in a unique category.

The principal theme associated with the adornment refers to a large beaked bird fertilizing and creating man. This belief was prevalent in the Greater Antilles during the early conquest.[12] The representation of this myth is known in the Atlantic Watershed and Highland Region in clay[13] as well as in stone, offering non-written evidence to back the extension of Antillean and eastern South American culture traits into the Caribbean area of Central America. Some of these lithic interpretations are more elaborate than others and include varied mythical figures suggesting a hierarchy of divinities. Prominent among these, in addition to the bird with a large beak, are the monkey, the "alligator" god and the serpent. All have in common a solidness and logical sense of form which recalls the work of twentieth century Georges Braque. Outside of the Atlantic Watershed and Highland Region, similar grinding stones have been found in Veraguas, Panama.[14]

Reclining human figures on grinding stones, mortars, and pottery vessels are seen in the Atlantic Watershed and Highland Region. The decorative elements do not take away from the utility of the object but are ingeniously adopted to it. The head of a male figure protrudes from the artifact which rests on representations of bent arms and knees or these members project from a side of the vessel body (Fig. 3, c). In the above-mentioned region of Costa Rica, we have numerous examples of such figures. When of pottery, they are often combined with negative painting, a trait associated with the Andes.[15] We also have the same motif in clay from Peru with painted elements that might be inspired by negative painting. Considering that only one example, and this of clay without paint, is known from Oaxaca, Mexico,[16] we hold the motif of a reclining figure to be of southern relationship.

Stone bowls, pot stands and what may be offering tables appear in divers sizes and are characterized by Atlantean figures of men or animals. They are so skillfully sculptured that many offer a sense of movement, almost as a dance (Fig. 10). These too are common to Panamanian territory, for example, Chiriquí.

Other artifacts associated with the Atlantic Watershed and Highland Region of Costa Rica and found in lesser quantity in Chiriquí, Panama, but more crudely executed, are circular stone tables with a pedestal base. Made out of a single block, the support is frequently sculptured in an open-work pattern which suggests a basket-weave and lends a delicate aspect to what could be a massive, clumsy stand, or is open-cut in elongated slightly concave panels which indicate a dominance of design technique (Fig. 11). Human heads in high relief or animal figures adorn the outside margin of the border. Curiously, none of these tables show signs such as a smooth spot, a portion in the center, or anywhere on the surface which would denote use as a grinding stone. We are left free to suppose, therefore, that their purpose was purely ceremonial, most probably as offering tables upon which a head was placed. The ceremonial function for these tables is further suggested by the presence of a wooden replica in a cache of drums, tablets, staffs and idols, obviously for ritual use, from the slopes of Irazú volcano.[17] This is the only find as yet in Costa Rica with a carbon-14 date indicated, approximately A.D. 960. It is possible that the animal representations on these tablets might signify given clans as it is known that at least this region of

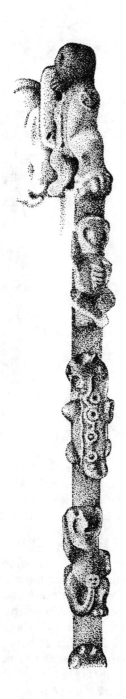 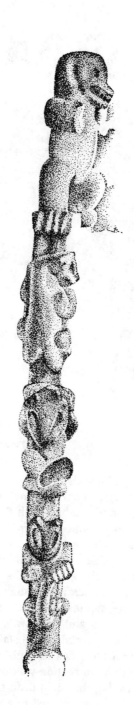

Figure 12. Side detail. **Figure 13.** Side detail.

Figures 12, 13, 14. Details of grave slab, Reventazón area.

250

Figure 14. Detail of upper front.

Costa Rica had a social organization based on matrilineal groups.[18] At the time of the Spanish arrival, each had one or more totemistic protectors. Raised-rim grinding stones and circular tables with the incised details of the decorative motifs painted in white are unique and come from a single cemetery at La Unión de Guapiles on the Línea Vieja.

Further evidence of totemic clans and of the technical and artistic skill of the aborigines are the stone slabs used as markers for graves. These graves were communal in character and generally utilized for secondary or bone burial, all persons related to the mother's side of the family being interred in the same place once the bones were clean and there was no flesh to putrify and contaminate the sepulcher. The grave was covered by the slab. The figures on the top of the slab are carved in the round and on the sides in high relief as to give the impression of being cut in the round. The bottom section was untouched as it was usually destined to be stuck into the earth leaving the sculptured area exposed. These slabs were located over the face of the grave or were placed in a slanting position to mark the opening.

Animal figures occasionally mixed with human ones formed the decorative motifs. The tendency to realism noted throughout the art of this region is combined here with a startling sense of design. There is also evidence of imagination and humor in the grouping of the figures (Figs. 12; 13; 14). Such slabs are confined to the

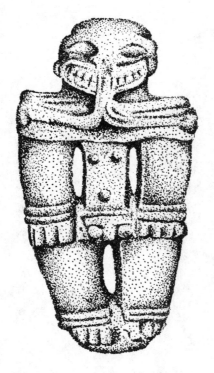

Figure 15. Flat slab figure, Diquis Region.

Atlantic Watershed and Highland Region and in particular to the Línea Vieja and Reventazón areas. Except for one specimen from Las Mercedes,[19] artistically these tomb indicators are unique in American archaeology. The sole exception noted is vaguely reminiscent of Quimbaya art. The uses of slabs, both decorated and plain, as grave markers is also known in the province of Manabí, Ecuador. The adornment on the Ecuadorian examples have geometric and conventionalized human motifs and are stylistically distinct from those of Costa Rica. Undecorated slabs serving the same function occur in the General Valley in the Diquis Region, and in Honduras, at Melchior in the Sula plain and on the Bay Islands.[20]

The Diquis Region. Abstract and conventionalized expression comes into its own in the Diquis Region. There seems to be a joy in form for the sake of form. Peculiar to this section are colossal stone spheres, some with a diameter of 2.15 meters. These balls are limited to the drainage of the Diquis or Rio Grande de Térraba and the largest are found in the river flood plain where boulders are practically non-existent and where in some cases cobblestone platforms had to be erected to maintain the spheres aloft in the alluvial soil. Many uses have been suggested for these balls, including the always present terms "ceremonial" and "calendrical." It is a fact, however, that in a number of instances these spheres have been found to mark the boundary of a graveyard. The technical dexterity required to fashion these stones and the engineering ability to transport them either before or after manufacture were remarkable achievements.

Figure 16. Figure with indicated depressions, Diquis Region.　　**Figure 17.** Figure cut in the round, Diquis Region.

There are varied kinds of lithic figures usually ranging in size from 25 cm. to 132 cm. high. The common characteristic is the peg base already described in the Nicoya Region, the function of which was to maintain the image erect by burying the peg in the earth. There are three Diquis types of statues. One is a human male, or occasionally a zoomorphic figure, cut from a flat slab of stone with arms and legs not freed from the body, the separative space being indicated by elongated rectangular openings (Fig. 15); another is hewn from a deeper block of stone with only the depressions indicated (Fig. 16); and a third is cut in the round (Fig. 17). In all types, details are cut in relief. There is little attention given to a neck and no realistic treatment of hands, feet or other features. The arms lie straight at the body side; flexed to the chest; crossed at the front or back; or meet at the breast. Fingers and toes are boldly delineated or are not even indicated. The eyes are outlined by one line or by a double-line rim. At times the sockets are hollowed, or there is a single horizontal line to denote the lids. The superciliary arch or what represents the forehead is connected with the nose. The mouth is cut almost rectangularly with or without vertically marked teeth. Feline-type teeth are occasionally seen (Fig. 17). The genital organs are often stylized in geometric form. Raised circular bumps probably signifying tattoo and "alligator" motifs around the shoulders and arms serve as decoration. Very rare examples show insect motifs recalling Quimbaya grasshoppers on the body. Occasionally hooded figures appear and frequently one or more serpents extend from the mouth of the image (Figs. 15; 17). Sometimes a staff is held in the hand, or a trophy head is worn suspended by a rope on the back or is seen on the front of the body.

Figure 18. Curly-tailed dog figure, Diquis Region.

There are only two specimens known to the writer which break away from the frontal aspect and have the head turned aside.[21] Stylistically the Diquis figures recall San Agustín and Los Barriles, Panama, statues. Their very form, the treatment of the features, details of adornment, and the position of the hands make one wonder if here in the southern Costa Rica area we do not have a flourishing highly stylized art developed from Andean inspiration.

Even many of the non-human figures point toward the south. Replicas of dogs resemble those associated with Coclé gold animals (Fig. 18). There are owls similar to those from San Agustín. On the whole, Diquis stone images are unique among the lithic interpretations seen in the greater portion of Central American territory.

The common grinding stone in this region is the raised-rim four-leg variety. The most usual kind is characterized by a projecting jaguar head at one extreme and a tail which is connected with one leg at the other (Fig. 3, d). The supports themselves take the form of animal legs, often with an indication of a slightly bent knee, and they, as well as the tail, raised rim and head, frequently are deeply incised with geometric patterns more often than not portraying jaguar spots. This type extends into the Atlantic Watershed and Highland Region.

CONCLUSIONS

The Nicoya and Atlantic Watershed and Highland regions indicate basic similarities which are essentially South American lowland. Throughout that of Nicoya, however, Mexican traits are common, while in the Atlantic Watershed and Highland, the Línea Vieja is the only area where Mexican elements occur in any number.

Andean South America plays an important part in Diquis lithic art. Manifestations of Diquis art appear in the regions of Nicoya and, in less degree, in the Atlantic Watershed and Highland.

The distinct cultural influences noted in Costa Rica gave rise to local art styles. Although extraterritorial extensions occur in each of the three archaeological regions, Nicoya, Atlantic Watershed and Highland, and Diquis, these regions individually demonstrate an artistic tradition confined chiefly to their respective borders. This sets one section apart from the other and places Costa Rica pre-Columbian art in a category of its own.

Notes

1. Jadeite will not be considered in this article as it is treated elsewhere in this volume.
2. Lothrop, 1921, p. 319.
3. Richardson, 1940, pp. 412-16.
4. See Stone, 1958a, Fig. 1, f.
5. Stone, 1948, pl. 28.
6. Stone, 1958a, Fig. 2, c-d.
7. Hartman, 1907, pl. X-XIII.
8. Stone, 1948, pl. 29, a-c.
9. Stone, 1958a, Fig. 4, a.
10. Fernández, 1886, t. V, p. 156.
11. Today maize and plantains are also used. See Stone, 1956, pp. 189-94.
12. Mártir de Angléria, 1944, dec. 1, lib. 9, cap. 5.
13. Balser, 1955.
14. Lothrop, 1950, Fig. 30, p. 29.
15. Stone, 1958a, pl. 1, a.
16. Caso, 1952, Fig. 477, p. 323.
17. Aguilar P., see e.g., the report of 1953; Stone, 1958a, p. 19.
18. Peralta, 1883, p. 71; Stone, in press.
19. Mason, 1945, pl. 34, Fig. B.
20. Stone, 1948, p. 181, pl. 32.
21. See e.g., Mason, 1945, pl. 56, Fig. C.

Bibliography

Aguilar, Carlos H.
 1953. *Retes un depósito arqueológico en las faldas del Irazú.* San José.
Balser, Carlos
 1955. "A fertility vase from the Old Line Costa Rica." *American Antiquity*, vol. 20, no. 4,
 pt. 1, pp. 384-87. Salt Lake City, Utah.
Bennett, Wendell C.
 1954. *Ancient arts of the Andes.* The Museum of Modern Art. New York.
Bushnell, G.H.S.
 1951. *The archaeology of the Santa Elena Peninsula in southwest Ecuador.* Cambridge.
Caso, Alfonso y Bernal, Ignacio
 1952. *Urnas de Oaxaca.* Mexico.
Enciso, Jorge
 1957. *Sellos del Antiguo México.* Mexico.
Fernández, Leon
 1881-1907 *Documentos para la Historia de Costa Rica.* San Jose, Paris, Barcelona.

Fernández de Oviedo y Valdés
 1851- *Historia general y natural de las Indias, Islas y Tierra-Firme del Mar Oceano, 4*
 55. *tomos. Madrid.*
Hartman, C.V.
 1907. "Archaeological researches on the Pacific coast of Costa Rica." Carnegie Museum,
 Memoirs, *vol. III, no. 1.* Pittsburgh.
Kelemen, Pal
 1943. *Medieval American Art,* 2 vols. New York.

Kidder, II, Alfred
 1944. "Archaeology of northwestern Venezuela." *Peabody Museum, Harvard University, Papers,* vol. XXVI, no. 1. Cambridge.
Lehmann, Walter, and Heinrich Doering
 1926. *Historia del arte del Antiguo Peru.* Barcelona.
Lothrop, S.K.
 1921. "The stone statues of Nicaragua." *American Anthropologist,* vol. 23, no. 3, July-Sept., pp. 311-19. Lancaster, Pennsylvania.
 1943. "Coclé; an archeological study of Central Panama. Part II." *Peabody Museum, Harvard University, Memoirs,* vol. VIII. Cambridge.
 1950. "Archaeology of Southern Veraguas, Panama;" with appendices by W.C. Root, Eleanor B. Adams, and Doris Stone. *Peabody Museum, Harvard University, Memoirs,* vol. IX, no. 3. Cambridge.
Mártir de Angléria, Pedro
 1944. *Décades del nuevo mundo.* Buenos Aires.
Mason, J. Alden
 1945. "Costa Rican stonework. The Minor C. Keith Collection." *American Museum of Natural History, Anthropological Papers,* vol. 39, pt. 3. New York.
Meggers, Betty J. and Clifford Evans
 1957. "Archaeological investigations at the mouth of the Amazon." *Bureau of American Ethnology, Bulletin 157.* Washington, D.C.
Peralta, Manuel Maria de
 1883. *Costa Rica, Nicaragua y Panamá en el siglo XVI.* Madrid, Paris.
Perez de Barradas, José
 1943. *Arqueología Agustiniana.* Bogotá.
Richardson, Francis
 1940. "Non-Maya monumental sculpture of Central America." *In: The Maya and Their Neighbors.* New York.
Saville, Marshall H.
 1910. "The antiquities of Manabi, Ecuador." *Contributions to South American Archeology, The George G. Heye Expedition,* vol. II. New York.
Stone, Doris
 1948. "The basic cultures of Central America." *Bureau of American Ethnology, Handbook of South American Indians,* vol. 4, pp. 169-93. Washington, D.C.
 1956. "Date of maize in Talamanca, Costa Rica; an hypothesis." *Journal de la Société des Américanistes,* n.s., t. XLV, pp. 189-94. Paris.
 1958. "The archaeology of Central and Southern Honduras." *Peabody Museum, Harvard University, Papers,* vol. XLIX, no. 3. Cambridge.
 1958a. *Introduction to the archaeology of Costa Rica.* Museo Nacional. San José.
 In Press. "The Talamancan Tribes of Costa Rica."

Torquemada, Fray Juan de
 1943. *Monarquia Indiana.* 3 tomos. Mexico.
Westheim, Paul
 1957. *Ideas fundamentales del arte prehispánico en México.* Fondo de Cultura Económica. Mexico.

Stylistic Affinities Between
The Quimbaya Gold Style
And a Little-Known Ceramic Style
Of the Middle Cauca Valley, Colombia

Karen Olsen Bruhns

The middle reaches of the Cauca Valley of Colombia, stretching from the area around the city of Antioquia in the north to near Buga in the south, have long been famous as the homeland of a number of impressive artifacts that have, for lack of a better name, been called Quimbaya. This name comes from that of a small tribe that inhabited a rather restricted area around the modern city of Manizales at the time of the Spanish Conquest. Whether any of the artifacts called Quimbaya were actually made by the Quimbayas themselves is a moot point. The Quimbayas were a rather small group, unrelated linguistically and somewhat different culturally, from the tribes around them.[1] The Quimbayas themselves said that they had migrated from the north, perhaps from the area around the Río Sinú, and had settled in the area in which the Spanish found them.[2] By Pedro de Cieza de León's calculations, the migration took place a very long time before the Conquest, although this point is open to question.[3] Because very little scientific excavation has been undertaken in the middle Cauca area, it is not known which of the many types of artifacts found in the region actually pertain to the historic Quimbaya. During museum research in Colombia in 1966 a series of separate ceramic styles was identified by the author.[4] Although the analysis of the ceramics was done on purely stylistic grounds, it was possible to check the analysis with the small amount of verifiable archaeological information available and to associate some other data, such as tomb type and non-ceramic artifacts, with the various groupings. In addition, there was some added corroboration of the ceramic groups from excavations in the closely related Calima culture area directly to the south. It is not known in what temporal relationship the various groups of pottery stand. However, since all of the remains overlap in geographic distribution, it is assumed that time differences must exist. One of the groups of ceramics so isolated corresponds to the style that Wendell Bennett called Brownware Incised.[5] This is a ware which he recognized as a distinct substyle, entirely different from the more common resist painted and appliqué and incision decorated vessels of the area. He noted that this style consists mainly of urn-like vessels, dark in color and with incised decoration. He further notes, ". . . One has a relief human figure on the side with

Reprinted from *Ñawpa Pacha*, Vol. 7-8, 1969. Published by the Institute of Andean Studies.

257

modeling quite superior to the general Quimbaya.'' On this point further research has borne Bennett out; the relief modeled decoration found on Brownware Incised vessels does not resemble that of the other ceramic styles of the middle Cauca at all. It does, however, show startling affinities with the style of metalwork, also featuring relief human figures (as well as figures in the full round), which is likewise called Quimbaya.

Bennett in 1942 had a total sample of the Brownware Incised style of only eighteen vessels.[6] In 1966, I managed to locate a sample roughly four times that size of urns alone, plus several related pieces of different shapes and an entire grave group from a tomb which had been recently found in an outlying barrio of Manizales. Although this tomb had been opened by workmen looking for treasure, they had brought at least part of its contents, including an urn and four large jars with their original contents, to the Museo Antropológico de Caldas, also in Manizales. In addition, they had given the secretary there some information about the type of tomb and its layout which she very kindly passed on to me. This sample was further extended by referring to published sources, although these were of secondary value, most of the published vessels having no provenience. The expanded sample, coupled with information from the Manizales grave group and bits of information from other sources, enabled me to make a fairly detailed analysis of the ceramic type, and also made it possible to associate one of the many tomb and burial types of the Cauca Valley with this style of objects. In addition, it has been possible to outline a general range of provenience for this style. None of the pieces with sure provenience comes from outside a rather restricted area in the departments of Caldas and El Quindío (Fig. 1).

The Brownware Incised style as represented in this extended sample is mainly a style of funerary urns; most of the vessels assignable to this style on stylistic grounds belong to this group.[7] The Manizales grave group, in addition to a funerary urn with cover, contains four large jars, also used as ash containers, a small bowl, and an olla of plain, undecorated ware. A number of other jars were observed in the Museo Antropológico de Caldas, the only collection studied containing a large number of vessels of apparent domestic use. These jars could belong to this group. The lack of elaborate decoration or fine finish on vessels which were not primarily of funerary use seems to explain why mostly urns are represented in museums and private collections. *Guaqueros*, who have done most of the burial excavations in the area, do not bother to collect vessels which are not handsomely decorated, for these do not have a ready market. Consequently, the sample represents only the (probably) relatively small percentage of pieces made expressly for funerary purposes.

As noted, the commonest shape represented in the Brownware Incised group is an urn. It is a semicylindrical vessel whose neck opening is of approximately the same diameter as its body. Most of these urns exhibit a slight bulbousness towards the bottom, giving a flowing line most pleasing to western eyes (Fig. 2). A few of the urns have pushed out protruberances on the lower quarter of the body instead of the bulbous swelling. The bottom is flattened, although not always precisely flat. The rim is always flat and ledge-like, thickened with a vertical edge (Fig. 3). A decorative molding encircles the body slightly below the rim of the vessel. This molding serves a functional as well as a decorative purpose, for the lids with which these urns were originally furnished often rested upon the molding, completely covering the decorated

rim. The urns vary widely in size. The largest one reported was over a meter and a half in height; the smallest are some 10 to 12 cm. tall, with an apparent average size of roughly 15 to 20 cm. All of the urns appear to have originally had lids, although often these have been mislaid in the process of moving the urns about or are catalogued separately as "bowls" or "basins." A number of urns with their original lids and a number of isolated lids were recorded. The lid usually has a rounded top, straight sides, and a thickened and flattened rim, much like that of the urn itself (Fig. 4).

A related shape, both in apparent function and in decoration, is an anthropomorphic urn (Fig. 5). All specimens examined represented females. In many cases the anthropomorphic decoration was more or less simply applied to the basic urn shape, although a number of pieces exhibit true modeling of the vessel. These vessels also have the flat, ledge-like rim, but lack the decorative molding. As none was seen which retained the lid, it is not known how the lid fitted on or if, indeed, it was of the same form as the lids of the other urns. The modeling and appliqué and incised decoration which these anthropomorphic urns bear is identical to that on the other urns, as is their color and finish, so there seems to be no doubt of their association with Brownware Incised pottery. The average height of the anthropomorphic urns appears to be about 20 cm.

The other vessels which can be attached to the Brownware Incised group are not numerous. The jars of the Manizales grave group are large (ca. 60 cm.), with a globular body and a tall, narrow neck, often with modeled decoration on the neck or at its base. The jars are not particularly well finished (at least in comparison to the urns) or elaborately decorated. A fair number of similar jars was seen, and it is likely that they also should be associated with the Brownware Incised group. Several small bowls and ollas were tentatively identified as also being Brownware Incised. With the exception of the examples from the Manizales grave group, these vessels can all only be provisionally associated with the more elaborate Brownware Incised ceramics. They are rather crudely made, and many show signs of use in the fire. These dishes were very likely the domestic ware of the people who made the urns. In addition, there are a few anthropomorphic or zoomorphic dishes which seem, on stylistic grounds, to belong to this group. No figurines in this style were identified.

All of the vessels seem to have been constructed by coiling, as is typical of the prehistoric ceramics of the middle Cauca Valley whatever their stylistic affiliation. The coils seem to have been built up from a flat pancake of clay which formed the bottom of the urn or jar. The coils were carefully smoothed on both the inside and outside of the vessel, although faint traces of them can be seen by holding the vessels against a strong light or felt by running the fingers lightly down the vessel, particularly on the interior. The moldings were evidently made of coils which were applied to the vessel and then cut and shaped. Relief decoration was likewise formed of coils or flat cut outs of clay applied and smoothed onto the vessel wall. The anthropomorphic urns and other vessels exhibit the same kind of construction.

Most of these vessels are more or less reduced in firing. Unlike other ceramic groups of the middle Cauca, this reduction seems to have been intentional, for practically all of the vessels exhibit an even, dark tone. A substantial number of vessels was lightly smoked, producing a black surface. The normal color is, however, a dark red brown, sometimes tending towards a chocolate brown. The paste is tannish

to greyish, with the smoked vessels having a dark gray paste. A few pieces, mainly jars and small utilitarian pieces, are oxidized. All pieces have a sand temper. A significant number has a micaceous sand temper; that of the other vessels is fairly evenly divided between quartz sand and quartz sand mixed with black obsidian particles.[8] The temper is moderate; perhaps 10 to 15 percent of the clay body.

All the urns, both plain and anthropomorphic, the dishes, and some of the jars were slipped and polished. More of the jars were merely smoothed and given a very low burnish, while other small vessels are only slightly smoothed. It appears that vessels made for funerary or ceremonial use were much better finished and elaborately decorated than those intended for domestic purposes.

The decoration of the urns follows certain very specific canons. The rim is always flat, projecting slightly beyond the vessel wall. The outer edge of the rim is almost invariably flat too, although the inner edge may slope imperceptibly into the interior wall (Fig. 3). The outer edge is often decorated with little incised ticks, punched circles, or excised triangular depressions, also small in size. Below the rim on the upper quarter of the body is a projecting molding upon which the lid usually rests. This molding was formed by pushing the vessel wall outwards while the clay was still damp and thickening the resulting bulge with an applied coil of clay, smoothed carefully so that the join is invisible. This molding may form a flattish shelf ticked to match the rim, or it may be cut and pulled to form vertical scallops or points (Fig. 2). On some vessels double rows of projecting scallops or flutes may be used as decoration. On a few of the plainer urns the molding is not decoratively shaped but is merely smoothed off to make a plain, projecting ridge. The body of the urn below the molding is then usually covered with vertical bands of incised decoration. At times a white paste was rubbed into the incisions, although this practice does not seem to have been general. The incision is very shallow and appears to have been scratched in when the vessel was quite dry. The vertical bands are most commonly filled with carelessly scratched V's and X's, sometimes forming a herringbone pattern. Filled bands usually alternated with the empty ones. If the molding is scalloped or notched the vertical stripes are usually matched up with these projections, the incised line forming the boundary of the decoration starting between the scallops or points. The regular placement of the stripes of ornament and the very scratchy, careless quality of the filler designs are typical of this ware. A few pieces are more elaborately decorated with modeling. On some pieces this modeling takes the form of modeled fluting on the body, the flatter areas between the flutes being filled with the usual scratchy designs. Other vessels have a second molding on the lower part of the body where the walls were pushed outwards to give the vessel its slightly bulbous shape. This second molding does not seem to have fulfilled any functional purpose. Other pieces decorated with modeling usually have applied heads located at regular intervals around the top molding. These faces are often flanked by slightly modeled upraised arms with incised hands, as if they were holding the lid which fitted onto the molding. A very few vessels have full figures placed around the vessels in low relief (Fig. 6). Both the full figures and the faces are in the same style. The faces are more or less triangular, with slanted slit eyes and a slit mouth incised in the clay. Both eyes and mouth have a raised edge; the eyes are often of the "coffee-bean" type. The nose is generally large and naturalistically formed. It seldom has an ornament, although some noses are pierced, and the former existence of a metal ornament is not impossible.[9] An appliqué

headband with incised detail, apparently representing some sort of plaiting or braiding, is placed across the forehead or at the top of the face. The arms, or in the case of whole figures, the entire body, are modeled in low relief, apparently by applying bits of clay of appropriate shapes to the vessel wall and smoothing and modeling them while in place. The body is usually in somewhat higher relief and shows more attention to detail than the limbs. Details are indicated by modeling, incision, and some punching. All figures seen were female, naked, but with arm and leg bands and ligatures. Individual pieces vary greatly in the quality of the modeling. Some are very schematic and stylized, while others are carefully modeled, especially on the face. The full-figure decorated urns generally display more care in modeling than the ones with only faces.

The urn lids are decorated in a similar manner. The vertical sides usually have simple scratched vertical lines or herringbones (Fig. 4). A few have fluted sides. One example had a modeled and scalloped rim like the scalloped molding seen on some urns. Similar scalloping or notching is seen on the band commonly applied as decoration around the necks of jars associated with Brownware Incised pottery. The jars may also have a little fluting or incised decoration on the neck in the style of the urns, although this practice seems uncommon. One jar from Manizales had the remains of dark red paint on the upper part of the neck. This was the only piece of Brownware Incised pottery observed which had any painted decoration.

The effigy urns seem to have been formed by coiling a vessel of the same shape as the non-anthropomorphic urns, modifying it slightly, and applying the effigy features to this modified shape. All the anthropomorphic urns seen represented females, apparently squatting or seated on a bench with the legs dangling.[10] The urn opening has the same rim shape and decoration as the non-anthropomorphic vessels. Usually the appliqué face is placed just below the rim. This face has the same shape and features as the faces on the non-effigy urns. It is cut out of a piece of thickish clay and stuck on with slip. The shoulders and thighs were formed by pushing the damp vessel wall outwards and are rather bulbous in appearance. The solid arms and lower legs were made of an applied roll of clay smoothed onto the vessel wall. The arms are shown bent at the elbows and with the forearms usually flanking the face. On one example, the shoulder and thigh were decorated with incised cross-hatching.[11] The breasts are indicated by applied pellets, and the navel is shown by a round, shallow indentation in the middle of the body, probably made with the end of a stick. Digits, bracelets, anklets, ligatures on the arms and legs, the crease at the bottom of the stomach, and the vulva are all represented by incised lines.

Two effigy dishes of the same style as the anthropomorphic urns were seen. One represents a female lying on her back with the dish opening in the center of her body. The thighs and shoulders are very bulbous, but the representation of the lower limbs is almost rudimentary. The bent arms of the female hold the dish opening. The other dish stands on a high annular base, a feature not observed on other Brownware Incised vessels. An applied triangular head, almost identical to that of the first dish and of the same style as the heads of the urns, is placed on one end of the vessel; at the other end a fish-like tail replaces the stylized limbs and incised genitals of the other dish. Two fins are modeled on either side of the vessel.[12]

Double vessels do not seem to be at all common in Brownware Incised pottery. Only one example was observed in the entire sample. This vessel consists of two very

small urns joined by a short piece of clay and standing on small tetrapod feet pushed out from the interior of the vessel.[13] The tetrapod feet are unusual too, although polypod and double vessels are known from other ceramic groups of the middle Cauca, as well as from many of the other ancient cultures of Colombia. This double urn is so small that, if it was a chinerary urn, it must have been intended for the remains of an infant or infants or, perhaps, for part of a body. Given the range of funerary practices in prehistoric times in the Cauca Valley, as well as the emphasis on cannibalism and trophy taking, either is a distinct possibility.

Archaeological information concerning the people who made the Brownware Incised pottery is almost entirely lacking. There are no occupation sites or non-ceramic artifacts that can be archaeologically associated with them. In at least one instance, in Manizales, they buried their cremated dead in a rectangular tomb of several chambers. The four jars and the one lidded urn from this tomb were all full of ashes and bits of charred bone. Lack of time and facilities made it impossible to have tests made to see if all this ash and bone was human. A rudimentary comparison with cremated remains from other ancient burials in Manizales demonstrates that, if these ashes were all human remains, each of the jars must contain the remains of more than one individual. Arango C. mentioned many times that multiple burial was extremely common in the tombs he looted, so it is quite possible that the Brownware Incised people also practiced multiple or retainer burial, cremating the bodies rather than interring them.[14] As has been mentioned, many of the urns are large enough to have contained multiple cremations or even secondary or primary burials.

Dating this pottery is difficult. It is not known how the Quimbaya themselves disposed of their dead, although there is some suggesttion that it was by burial.[15] If this was so, then the Brownware Incised pottery cannot belong to the historic Quimbaya. Because the places where these urns have been found often fall well within the known Quimbaya territory, it seems likely, then, that they predate the Quimbaya (Fig. 7). On the basis of current evidence, admittedly incomplete, this ceramic assemblage may date somewhat before 500 A.D. The resist painted pottery of the Quimbaya regions has much the same distribution as Brownware. This pottery is related, at least in its earlier phases, to that of the Calima culture directly to the south. There are, in fact, many Calima trade pieces found with the ones of "Quim-baya" manufacture. The Calima resist pottery is radiocarbon dated to somewhere between 800 and 1000 A.D.; later dates on the same style carry it through to at least 1300 A.D. and perhaps later.[16] If these dates are applicable also to the Quimbaya resist painted wares, this dating then leaves practically no time for the Brownware Incised style to have flourished and disappeared before the historic Quimbaya, with an unidentified style of ceramics and a different mode of disposal of the dead, came down from the north and occupied the same territory. Since there was another style of pottery in the "Quimbaya" area which is probably ancestral to the resist wares, the Brownware Incised style ought to date before 800 A.D. How much before this date is anybody's guess. Some time before 500 A.D. but perhaps after the turn of the millenium would be reasonable. This date corresponds to Root's guess dates of 400 to 700 A.D. for what he calls "Classic Quimbaya" in metal.[17] Any more secure dating will have to await scientific excavations in the middle Cauca Valley.

In addition to the several ceramic styles found in the middle Cauca Valley, there are a number of styles of metal artifacts. Because many of these objects are of gold or

gold alloys such as tumbaga, treasure hunting has been widespread in the Cauca Valley. It is to the treasure hunters that we owe the vast majority of collections of both ceramic and other artifacts as well as the almost total lack of any sort of provenience or other information about the cultures that produced these artifacts. Metal work, although better publicized in art books, is as little known as the pottery in many ways. Several descriptive works, mainly illustrated catalogues of collections, have been published on the goldwork of the Cauca Valley.[18] In addition there are illustrations and descriptions available for single pieces or for small groups of pieces in museum and private collections. However, no detailed analysis of Quimbaya goldwork considering stylistic features and archaeological matters which attempts a rigorous definition of the style has appeared. Pérez de Barradas in his monumental *Orfebreriá prehispánica de Colombia* has done some work in this direction, but to date there has been no intensive analysis of the goldwork nor any attempt to set up stylistic or cultural groupings except on the most superficial grounds of resemblance.[19] The problem is complicated by the fact that the major goldwork styles of Colombia all have much the same distribution. Thus goldwork called Tolima, Calima, Quimbaya, and Darien are actually found in most of the same areas. Because all the collections are derived from the work of professional or amateur treasure hunters, there are almost no archaeological data accompanying any of the metal work. The Quimbaya style is no exception. It is rather loosely recognized as being that style of goldwork which is found mainly in the Cauca Valley with the majority of the sites known being in the departments of Caldas, Risaralda, El Quindío, Valle, Tolima, and Antioquia (Fig. 7). It consists mainly of cast pieces of gold or tumbaga in contrast to, for example, the Calima style which is mainly sheet metal work. Most of the pieces called Quimbaya are flasks, anthropomorphic flasks or bottles, helmets, or small heads which apparently once formed parts of necklaces or clothing decoration. There are also a few unusual pieces such as spear throwers and trumpets. Although there is an abundance of smaller objects from the same area, these are not usually included in the Quimbaya style because of the difficulty of associating them stylistically with the other, more elaborate pieces. Ear and nose rings, nose pendants, metal plaques, and arm and leg bands are all very common finds in this geographic area. These ornaments are often of baser metal, but many examples of gold and silver are known. It is obvious, if only from anthropomorphic representations, that these pieces must correpond in some way to the culture which produced the Quimbaya pieces, but without archaeological associations it is impossible to say where and with what other materials they belong. There are also a number of pieces which are stylistically intermediate between some of the art styles; the Quimbaya style fades into both the Calima and Darien styles, with pieces showing features of both being fairly common. Whether the relationship is a regional or a temporal one is not known. For the purposes of stylistic comparison it has proved necessary to use just those pieces which most people familiar with Colombian antiquity would call Quimbaya; those which exhibit such congruity of peculiar traits that there is little doubt that they were all made by the same people within a fairly short period of time. No attempt has been made to utilize or analyze pieces which are closely related to the Quimbaya ones but seem to exhibit features belonging to other styles as well.

The two main collections used in this study were the collection of the Museo del Oro of the Banco de la República in Bogotá, as published by Pérez de Barradas, Carli,

and others, and the so-called "Tesoro de los Quimbayas," a single grave lot from a tomb in the *municipio* of Finlandia and now in the Museo de América in Madrid.[20] In addition many single pieces in North American and European collections that exhibit the distinctive set of traits that label them Quimbaya were used.

The technology of ancient Colombian metallurgy has been well studied; much better studied, in fact, than the objects as representatives of separate styles or the cultures to which they pertain.[21] Consequently, there is no need to describe the processes of manufacture in any detail. Most of the Quimbaya objects are cast, although hammering and repoussé work are known. Many objects are of pure gold, and many, perhaps more, are of tumbaga, a gold-copper alloy. *Mise en couleur* gilding was practiced, although seemingly to a lesser extent than in other Colombian metallurgical traditions. Most of the objects exhibit a high degree of finish. They have been smoothed and polished after casting, and any imperfections have been carefully repaired. This is in direct contrast to some other traditions, such as that of the Chibchas, whose metal pieces were left as rough as they came out of the mold.

Diagnostic of the Quimbaya style is the representation of serenely smiling human beings in a variety of quiescent poses. Most of these are figures in the round; usually the figures form a flask with a small neck in the top of the head.[22] Some figures are in relief, either on flasks of cast metal (Fig. 8) or on helmets or crowns of sheet gold in repoussé work. There are a number of pieces which represent the face only (Fig. 9); these may be small, as if they were intended to be strung as a necklace or sewn onto cloth, or they may be large enough to be separate ornaments. Both male and female figures are known, although there seems to be a slight preponderance of females. This preponderance, however, may simply be a function of the small sample. Both male and female representations have plump, softly rounded bodies with small hands and feet. Sexual differentiation is so slight in most figures that the only difference is in the genitals. Both sexes carry the same sorts of objects and wear much the same jewelry. The shoulders are commonly quite broad and square. An undeformed head has a broad, triangular face. Facial planes may be carefully modeled or quite stylized. There is a tendency towards more stylization or simplification in the small faces and on the repoussé figures. All figures have a simple headdress, usually a headband or some sort of plaiting that is tied around the forehead. It may occasionally be placed a little higher as if it were tied on like a hair ribbon. No hair is represented. Facial features are regular, although definitely stylized. A fairly long, narrow nose is common, usually with a nose ornament. These ornaments may be pendents of various shapes, or studs in the nostrils, or many small rings through the septum. The eyes are always shown closed or semi-closed. They are shown as long slits, either horizontal or slanting, with modeled edges giving an appearance of puffiness in some examples. The mouth is loosely closed, with slightly modeled lips; most of the figures seem to be smiling in a very restrained way. The total resemblance of the facial expression to certain East Indian depictions of the Buddha has often been remarked. One specimen, the so-called death mask in the British Museum, has an open mouth with filed teeth showing between the parted, smiling lips.[23] Sometimes there is a little incised or raised decoration on the face, perhaps depicting tatooes. Most of the figures have large, simply modeled ears with multiple earrings through the lobe and cartilage. Body details are very simple. All of the figures are naked except for their jewelry. Body and limb modeling is stylized and simplified, although remaining well within the

realm of "naturalism." All of the figures are plump. One example of a pregnant or obese female is known; there are no diseased or deformed individuals represented.[24] Jewelry usually consists of, in addition to the ear and nose rings, bracelets, anklets, and calf and sometimes upper arm ligatures. The ligatures and other limb ornaments are usually shown as made of some kind of braided or twined material similar to that of the headband. The necklaces or collars are rather stylized but seem to represent strings of beads of various shapes.[25] Some figures have small flasks hung about their necks on one of the strands of the necklace. These flasks are identical in shape to non-anthropomorphic metal flasks of the Quimbaya style. The scale is that of a real flask to a real human being. Some figures hold palm (?) branches or other small devices in one or both hands. Others hold small flasks or a flask and a spatula in their hands. This fact suggests some connection of the flasks with coca chewing.[26] That the makers of these little anthropoid containers intended some degree of realism in their representation is evident in the jewelry they wear, which is identical to real jewelry found in tombs of the middle Cauca Valley, and in the often very careful delineation of the plaiting or braiding of the headbands and body ornaments of the figures. It has not yet proved possible to identify the spiral ornaments held in the hands with any known artifacts from the area. This fact is not surprising, since the artifact inventory from the area is limited to what the treasure hunters think they can sell and to non-perishable items in general.

In addition to the various anthropomorphic representations, there are a number of nonrepresentational artifacts in this style. Their association with the Quimbaya style is certain, both on grounds of their representation on some of the little figures and because there is at least one instance of primary association with the figures (the Tesoro de los Quimbayas). Commonest among these artifacts are little flasks with narrow necks and lobed bodies. Some of these are identical in shape to flasks with relief figures on them. There are also little flasks similar to those held by the figures and objects of unknown use usually called lids or jar stands.[27] Some of the flasks have rings attached to them, presumably so they could be worn suspended around the neck as is seen on some of the figures. A few examples of "trumpets" and spear throwers are known. These objects often have anthropomorphic relief decoration in the same style as the flasks. This very limited set of artifacts completes the known inventory of Quimbaya metal objects. As has been mentioned, there are many small objects, such as bells and simple jewelry, both in precious metals and copper, that were found in the middle Cauca and probably pertain at least partly to the Quimbaya. To date, though, there are no reliable data to associate any of these unquestionably with the more elaborate metal work. What is even more unfortunate is that there is no archaeological information on any of the Quimbaya metal pieces except for an occasional vague provenience. The only grave group is the Tesoro de los Quimbayas, and even for this we have no reliable information on any of the other grave goods that may have been found with the gold. According to Arango, the major source for archaeological information for this area, most tombs contained, besides their gold and the bodies of the dead, many other artifacts.[28] There were usually ceramic pieces, weapons, and occasionally large items like canoes or furniture. Arango also mentions that textiles occasionally survived. Although Arango's descriptions of the artifacts are too vague to identify most of the ceramic or gold styles he found, he does give enough information to suggest that the position of the artifacts in the tomb was important in

terms of identifying principal personages buried and in terms of other practices. From Arango it becomes evident that multiple burial, retainer burial, and ossuaries were all common among the several aboriginal cultures of this area. Unfortunately, we have none of this sort of information for the Tesoro de los Quimbayas or for any of the other Quimbaya gold pieces.

The lack of archaeological information for this important style of metal objects means that the only way to arrive at any sort of information about other aspects of the culture of the people who made the metal work is to compare the metal objects stylistically with other artifacts having the same distribution in space. This approach was more or less impossible for a long time, because studies of other aspects of the ancient cultures of the middle Cauca Valley were even scarcer than studies of the metal working. My analysis of the ancient pottery of the middle Cauca Valley, while admittedly incomplete, indicated several things. The first was that the gold style called Quimbaya bore little resemblance to the more common ceramics also called Quimbaya, that is, the relatively abundant resist painted wares. Anthropomorphic representation is well developed in these ceramic traditions and is of a totally different style from that of the metal pieces. While it is not unknown for a people to have very different modes of representation in different media, it is uncommon for there to be no stylistic points of contact. Therefore, it seemed that, pending major evidence to the contrary, the Quimbaya gold style probably was not directly connected with the resist painted ware. Much the same situation pertained for the other major group of ceramics isolated. When comparing the gold style to the group of ceramics which, following Bennett, I have called Brownware Incised, however, the situation was very different. Allowing for the different properties of gold (or gold alloy) and clay, the similarities between the anthropomorphic decoration on the two classes of artifacts are too close to be accidental.

In comparing the gold with the ceramic artifacts the first thing one notices is that the shape categories appear to be mutually exclusive. This fact is not surprising, considering the different media and, apparently, the different functions of the artifacts. Some of the anthropomorphic gold and tumbaga flasks are occasionally, however, referred to in the literature as being cinerary vessels. Lacking references to the circumstances in which these articles were found, it is hard to say whether they were actually used as cinerary vessels or whether we are simply dealing with another terminological convention. Most of the Brownware Incised vessels appear to have functioned as cinerary or funerary urns. There are some correspondences, albeit very vague ones, in a tendency towards lobed decoration in both ceramic and metal vessels, but the main correspondences are, as I have said, in the anthropomorphic decoration, both in its style and in its placement on the vessels. When either the metal flasks or the clay urns are decorated with relief figures, these are placed in fairly low relief against the sides of the vessel. Usually the figures are placed singly between the projecting lobes (Fig. 6, 8). The flasks, being smaller, tend to have only two figures, while the larger and rounder urns may have four. The poses of these figures are the same: standing with the legs somewhat apart and the arms at the sides or bent at the elbow and held across the body. Some of the figures on the urns seem to be shown as if they were seated on a bench or stool with the legs hanging down, a common pose of the metal figures. In most cases the figures are naked females. Resemblances are somewhat less between the metal figures and the anthropomorphic

urns, perhaps because of the subordination of the body shape to function in the case of the urns. In the more stylized manifestations of the style the resemblances are more striking. There is an almost exact identity between the small detached heads of metal and the appliqué heads of clay that decorate some of the urns and form the heads of the anthropomorphic urns.

Comparisons in matters of detail are more effective than overall appearance. The shape of the head, particularly that of the detached or appliqué examples, is the same: more or less triangular, with rather little modeling of the facial planes except for the high cheek bones, which are often accentuated. The shape of the face is much the same on the relief figures as well. As there have been no figurines identified for the Brownware Incised style, it is impossible to compare the heads of figures in the round in clay and metal. However, the general shape of the face is the same in both. In all cases, the eyes are closed or only slightly open and are represented by a slit with raised edges. On the better modeled clay and metal examples, the eye treatment is modified a bit to show a rather swollen upper eyelid, as is found in some American and Mongolian groups today. The eyes are relatively long and may be slanted at an exaggerated angle, again particularly in the detached heads and appliqué faces. What seem to be representations of facial tatooing are found both in clay and in metal, though more elaborately executed in the latter medium. Although the clay and metal figures wear identical headdresses and limb ligatures, jewelry as such is found only on metal examples. This may be due to the difficulty of executing very fine details such as the jewelry in clay and to their fragility when fired. Elaborate ornaments in cast metal would be easier to form and less likely to break off. On the other hand, it is not impossible to do very fine work in clay nor is there any technological reason why the artist could not have rendered the simple, low relief necklace in clay. In any case, clay figures are somewhat simpler in execution than the metal ones, and this simplification is reflected in the amount of jewelry on the figures.

On all anthropomorphic representations the hands and feet are shown as being unnaturally small, and the individual fingers and toes are shown by an incised or indented line. The extremities of the clay figures were usually formed by smoothing off the end of the applied clay roll of the leg and incising the digits, but sometimes small feet were formed of separate pieces of clay and applied to the appropriate place. The hands and feet of the metal figures were cast separately and soldered on.

Body proportions in all the full figure representations are much the same. As has just been mentioned, the hands and feet are very small, perhaps corresponding to some local ideal of beauty. Limbs are of the "normal" length; the common New World convention of a relatively large head, thickset body, and short limbs is not very common in Quimbaya art. The shoulders of all figures are very broad and square; this, in fact, along with the tiny hands and feet, seems to be the most common and pronounced stylization of the style. Both limbs and body are plump with smooth, flowing surfaces. There is little or no difference in the representation of the breasts between male and female figures. However, on all figures, whether metal or clay (and including the anthropomorphic urns), the nipples are shown by a small pellet. This pellet was applied on the clay vessels, cast in one piece with the metal ones.

The same set of stylizations pertain for the lower body in both clay and metal. The navel is shown by a rather large, shallow, circular indentation. The line at the bottom of the abdomen is shown by an impressed or incised line. In the case of female

figures (there are no male figures in clay) the vulva is a broad, flat, triangular or trapezoidal area bisected by an incised vertical line.

It is particularly interesting that there should be so many correspondences of detail between the metal and clay representations. In most comparisons of one ancient art style with another (particularly if the cultures are widely separated in space) the comparison is done on the basis of overall resemblance or, at most, on the correspondence of one or two details. It seems, however, that the minor details of an art style often show the greatest conservatism and the greatest carryover between the different media. The Quimbaya gold style and the Brownware Incised pottery do not strike one immediately as being greatly similar, particularly because there is so much difference in color, texture, and size. In details of anthropomorphic decoration they are extremely similar, notwithstanding the differences of overall impression. The greater range of subject and the elaboration of representations in the metal work can, I believe, be laid to differences both in basic material and in function. If one compares the function of the metal figures with the supposed function of anthropomorphic pieces from other cultures of the middle Cauca Valley, the elaboration of the metal figures is not surprising. In these other ceramic styles the anthropomorphic figures (often flasks or jars) often have much more elaboration of detail than the anthropomorphic decoration on other pieces in the same ware. It is significant that there seem to be no figurines or figurine/flasks in the Brownware Incised style though these are prominent in most of the other ceramic styles of the area. If one assumes that the metal figures of the Quimbaya style take the place of the ceramic figures of other cultures, one perhaps can see some cultural reason for the greater elaboration of the metal figures as compared to the purely decorative anthropomorphic decoration in clay. It may also be pertinent that male figures are relatively common in other middle Cauca cultures in clay, while in the Quimbaya/Brownware Incised group they are found only in metal. In any case, the similarities between the style of human representation in the Brownware Incised ceramics and the Quimbaya gold style seem too numerous and pronounced to be due only to chance. Moreover, these similarities are much greater than those existing between either the metalwork or the ceramics and any now known art style of the middle Cauca Valley. There is the possibility that the similarities may be due to some temporal or trade connection and do not reflect different aspects of the culture of the same people. This is an objection which cannot be answered in the light of present information, and the possibility should be kept in mind. The much greater geographic range of the gold pieces can, I believe, be explained by the portability of the metal objects and their apparent wide appeal to foreign peoples. Finds of various styles of Colombian goldwork have been claimed for as far north as Honduras and Yucatan. Some of these finds may be Quimbaya or at least from the middle Cauca Valley.[29] Ceramics are not as portable and, in this case, where they seem to have been made for a specific, funerary purpose, there was probably little incentive to try to export them, since, considering the range of funeral customs at any one time in Colombia, the likelihood would be that most of the prospective customers would dispose of their dead in a different manner.

The problem of exact associations between the Quimbaya gold style and other cultural traits remains, however. Stylistic comparison, while valuable when there is no other evidence or for reasons of internal differentiation of process, can never give as convincing groupings as associations in the ground. What is really needed to clear up

269

the problems of the Quimbaya and their neighbors is for someone to start excavating in the area, to find living sites and, hopefully, some tombs missed by the *guaqueros*. It is only in this way that the questions of the associations of the various artifacts from the middle Cauca Valley will finally be answered for certain.

Notes

[1]Cieza de León, 1849, p. 375; Friede, 1963, ch. 1.

[2]Henao and Vélez, 1913.

[3]Cieza de León, 1945, p. 376.

[4]Bruhns, ms.

[5]Bennett, 1944, p. 76.

[6]Bennett, 1944, p. 77.

[7]The urns may have had other, non-funerary purposes. A large lidded urn, now in the museum of the Banco de la República in Manizales (collection of the heirs of Santiago Vélez Arango) was reportedly found filled with beans. Although this piece too was found in a tomb, it is quite possible that the urns were used for storage.

[8]Attempts to infer the provenience of vessels from their temper proved only partly successful. Almost all pieces with a temper of white quartz and black obsidian sand come from Manizales; other types of sand temper could not be so localized. However, no rigorous analysis of the tempering material was carried out, nor was any attempt made to locate ancient sources of sand or clay.

[9]Clay figures from other middle Cauca archaeological cultures occasionally have metal nose rings and other ornaments.

[10]A kneeling female is represented on one of the urns in the collection of the Museo Nacional in Bogotá. In this example, the legs are modeled separately and are hollow. However, the entire lower half of the vessel is reconstructed in plaster, and there is no way of telling if the reconstructed part shows the original form or represents modern artistic license.

[11]Museo Nacional catalogue no. 38-I-1088.

[12]The zoomorphic dish is illustrated in Nachtigall, 1961, p. 320.

[13]Nachtigall, 1961, p. 320.

[14]Arango C., 1924.

[15]Cieza de León, 1849, ch. XII.

[16]Bray, 1966 and personal communication.

[17]Root, 1961, pp. 254-255; cf. also Reichel-Dolmatoff, 1965, p. 45.

[18]e.g. Carli, 1957; Lavachéry, 1929, etc.

[19]Pérez de Barradas, 1954, 1958, 1966.

[20]This grave was opened in 1891. Its contents, or part of them, were given to the Queen of Spain in 1892. This collection has never been completely published. It is said to contain over 130 gold pieces including five gold figures, a helmet, and an incense burner.

[21]Bergsøe, 1937, 1938; Pérez de Barradas, 1954, 1958, 1966; Root, 1961.

[22]Anthropomorphic vessels of unknown use with an opening in the top of the head are characteristic of a number of middle Cauca cultures.

[23]This piece is illustrated in Pérez de Barradas, 1966, Fig. 11.

[24]Illustrated in Jouffroy, 1958, p. 91.

[25]Small stone and shell beads of various shapes, along with metal ones, are among the commonest archaeological finds from this area. Presumably some of them were originally strung into necklaces similar to those shown on the gold figures.

270

26Coca cultivation was widespread in Colombia at the time of the Spanish Conquest. Preservation of organic remains is very poor in Colombia in general and in the Cauca Valley in particular due to the humid climate. This fact, coupled with the lack of scientific excavation, has resulted in there being no actual remains of coca itself from this area. However, the paraphernalia used for coca chewing are very similar all over South America, and include besides something to hold the coca leaves, a small flask (of gourd or some other material) to hold the lime chewed with the coca and a spatula to remove the lime from the container. There seems to be no other use for this particular group of artifacts. Since the Spanish reported that the rich men or chiefs of the Cauca Valley used gold vessels to drink out of, there seems to be no reason to assume that they might not have used gold vessels to keep their lime in too, if they were rich enough. For coca use in Colombia cf. Uscátegui Mendoza, 1954.

27One figure, illustrated in Nachtigall, 1961, p. 541, has a lid on its head, the whole figure forming a lid. Also some gold figures hold flasks topped with stoppers very like these lids. It is not inconceivable that they actually were stoppers, either for some of the gold flasks or for flasks of perishable material.

28Arango C., 1924.

29Stone and Balser, 1965; Lothrop, 1952.

Bibliography

Arango C., Luís
 1924 "Recuerdos de la Guaquería en el Quindío." *Editorial de Cromos*, Luís Tamayo y Cía., Bogotá. (cover dated 1929)

Bennett, Wendell Clark
 1944 "Archaeological Regions of Colombia: A Ceramic Survey." Yale University *Publications in Anthropology*, no. 30. New Haven.

Bergsøe, Paul
 1937 "The Metallurgy and Technology of Gold and Platinum Among the Pre-Columbian Indians." *Ingeniorvidenskabelige Skrifter*. Nr. A 44. Copenhagen.
 1938 "The Gilding Process and the Metallurgy of Copper and Lead Among the Pre-Columbian Indians." *Ingeniorvidenskabelige Skrifter*, Nr. A 46. Copenhagen.

Bray, Warwick Michael
 1966 "Archaeology of the Middle Cauca Valley, Central Andes, Colombia." American Philosophical Society, *Yearbook* 1965, pp. 485-487. Philadelphia.

Bruhns, Karen Olsen
 ms. *Ancient Pottery of the Middle Cauca Valley, Colombia*. Ph.D. dissertation in Anthropology, University of California, Berkeley, 1967.

Carli, Enzo
 1957 *Pre-Conquest Goldsmiths' Work of Colombia in the Museo del Oro*, Bogotà [sic]. William Heinemann Ltd., London.

Friede, Juan
 1963 *Los Quimbayas bajo la Dominación Española; Estudio Documental* (1539-1810). Banco de la República, Bogotá.

Henao, José Tomás, and others
 1913 "Quimbayas y Pijaos." José Tomás Henao and Santiago Vélez; Rámon Correa and Emilio Robledo. *Boletín de Historia y Antigüedades*, año VIII, núm. 94, marzo, pp. 613-618. Bogotá.

Jouffroy, Alain
 1958 "Le Trésor des Quimbayas." *Connaissance des Arts*, no. 76, juin, pp. 88-93 and cover. Paris.

Lavachéry, Henri Alfred
 1929 "Les Arts Anciens d'Amérique au Musée Archéologique de Madrid." Editions *De Sikkel*, Anvers.

Lothrop, Samuel Kirkland
 1952 "Metals from the Cenote of Sacrifice, Chichen Itza, Yucatan." With sections by W.C. Root and Tatiana Proskouriakoff and an appendix by William Harvey. *Memoirs of the Peabody Museum of Archaeology and Ethnology*, Harvard University, vol. X, no. 2. Cambridge.

Nachtigall, Horst
 1961 *Indianerkunst der Nord-Anden; Beiträge zur ihrer Typologie*. Dietrich Reimer Verlag. Berlin.

Pérez de Barradas, José
 1954 *Orfebrería Prehispánica de Colombia; Estilo Calima. Obra Basada en el Estudio de las Colecciones del Museo del Oro del Banco de la República, Bogotá*. Madrid. 2 vols.

 1958 *Orfebrería Prehispánica de Colombia; Estilos Tolima y Muisca. Obra Basada en el Estudio de la Colecciones del Museo del Oro del Banco de la República, Bogotá*. Madrid. 2 vols.

 1966 *Orfebrería Prehispánica de Colombia; Estilos Quimbaya y Otros. Obra Basada en el Estudio de las Colecciones del Museo del Oro del Banco de la República, Bogotá*. Madrid. 2 vols.

Reichel-Dolmatoff, Gerardo
 1965 *Colombia. Ancient People and Places, 44*. Frederick A. Praeger, Publishers. New York.

Root, William Campbell
 1961 *"Pre-Colombian Metalwork of Colombia and its Neighbors." Essays in pre-Columbian Art and Archaeology*, by Samuel K. Lothrop and others, pp. 242-257. Harvard University Press. Cambridge.

Stone, Doris and Balser, Carlos
 1965 "Incised Slate Disks from the Atlantic Watershed of Costa Rica." *American Antiquity*, vol. 30, no. 3, January, pp. 310-329. Salt Lake City.

Uscátegui Mendoza, Néstor
 1954 "Contribución al Estudio de la Masticación de las Hojas de Coca." *Revista Colombiana de Antropología*, vol. III, pp. 208-289. Bogotá.

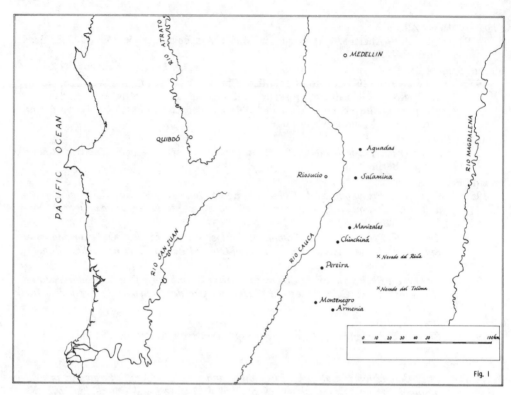

Fig. I

Figure 1. Map of western Colombia showing the municipios where Brownware Incised vessels have been found.

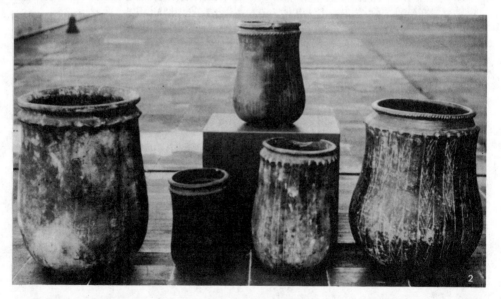

Figure 2. Group of Brownware Incised urns in the collection of the heirs of Santiago Vélez Arango, Banco de la República, Manizales.

Figure 5. Anthropomorphic Brownware Incised urn. Collection of Dr. Feliz Henao Toro, Manizales.

Figure 3. Silhouette of a Brownware Incised urn. Height 26.6 cm.

Figure 4. Lid from Brownware Incised urn. Height 12 cm., diameter 34 cm. Museo Antropológico de Caldas, Manizales.

274

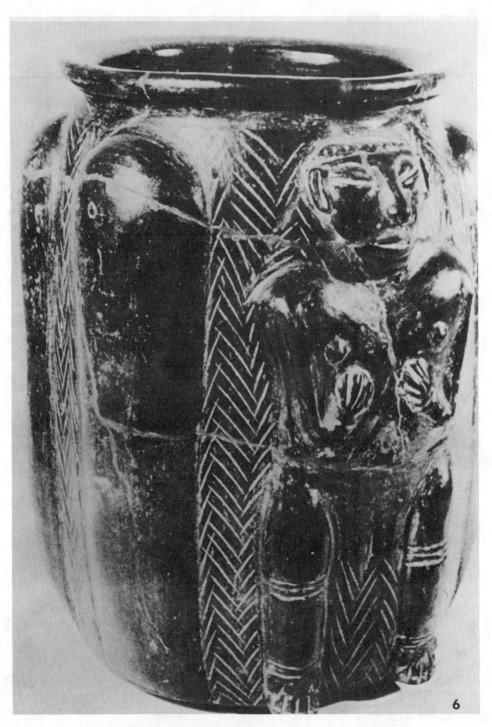

Figure 6. Brownware Incised urn with relief figures. Museo Nacional, Bogotá. Photograph courtesy of the Museum.

Costa Rica
Western Costa Rica (Stone and Balser, 1965)

Panama
Coclé

Colombia

Department of Antioquia
 Caucasia
 Antioquia
 Yarumal
 Pajarito (located on the border of the
 muncipios of Yarumal, Angostura
 and Campamento)
 Valdivia
 Medellín
 Jericó
 Caramanta
Department of Caldas
 Manizales
 Samarraya

Department of Riseralda
 Pereira
Department of Quindío
 Filandia
 Quimbaya
 Montenegro
 Armenia
Department of Valle
 Caicedonia
 Roldanillo
 Guásana
 Corinto

Figure 7. List of areas in which Quimbaya style gold ornaments have been found.

Figure 8. Tumbaga anthropomorphic phial. Photograph courtesy of the University Museum, University of Pennsylvania.

Figure 9. Yellow tumbaga mask (a miniature) in the Museo del Oro, Banco de la República, Bogotá. Photograph reproduced by permission of the Museum.

Pre-Ceramic Art From Huaca Prieta, Chicama Valley

Junius B. Bird

While excavating pre-ceramic debris at the Huaca Prieta in the Chicama Valley just north of Trujillo, two small carved gourds were found with a burial, a shallow, simple interment in the side of the community refuse dump.[1] Both were inside a woven cotton pouch which measured 12 by 21 cm. The gourds were so rotted that they were scarcely stronger than cigar ash and would have been abandoned except for the fact that they showed traces of carving. It required much painstaking work to harden the fragments and reconstruct the gourds for study.[2]

The results fully justified the effort, for these specimens were the only items of their kind encountered among the 10,770 gourd fragments and objects of gourd found in the same pit. Out of this total only thirteen pieces show any trace of decoration. Some pieces are crudely decorated by scratching away the outer surface or epidermis before the fruit was thoroughly dry, but the scratches in no instance form a recognizable design or pattern. Two fragments have fine incised line hatching. Five others show pyroengraving, but all are too incomplete to reveal the nature, quality, or extent of the design. None of the fragments show the careful cutting and combined use of fine and broad lines found on the two items from the burial. The lack of similar decorated pieces in the refuse suggests that the two containers were not made on the site but were importations.*

The more complete of the two, Figure 1, b and c, measures 6.5 cm. in diameter and is 4.5 cm. high; the other, Figure 1a, is slightly smaller. Both had lids cut from larger gourds, each with a yarn-whipped flange fitting inside the container opening.

The decoration of the better preserved gourd consists of four faces occupying equal segments of the surface, shown in flat projection in Figure 1b. Its lid, though simply marked, may have been so fitted that its markings coincided with the quadrant plan of the design below it.[3]

*Editors' Note: Donald Lathrap feels that the designs have their ultimate origins in Valdivia-Machalilla styles of coastal Ecuador (c.f. *Ancient Ecuador: Culture, Clay, and Creativity, 3000-300 B.C.* 1975:29).

Reprinted from *Ñawpa Pacha*, Vol. 1, 1963. Published by the Institute of Andean Studies.

The second gourd, Figure 1a, has a more complex theme, two human figures with their faces visible on opposite sides of the gourd, while their bodies and limbs are cleverly adapted to the small area across the bottom. It is, in fact, difficult to recognize the import of these lines on the original specimen, and they were not understood until Miguel Covarrubias showed me how they separate to form the two figures. Even he, however, could not interpret the lines in the remaining spaces on the sides. These are areas where cleaning was stopped, and in them the course and relationship of all the lines is not clear. The lid of this specimen bears an S-shaped incised figure with bird heads at each end. Although the adaptation to small areas may have modified the proportions of these heads, the shape of the beaks and the projections above them suggest the male condor.

The two containers have been shown to various artists and art historians who were asked for comments. All were in agreement on two significant points: that the work is not that of a beginner or someone experimenting in gourd carving, and that the character of the designs indicates a well established traditional art style. None could suggest a source or even a close parallel.* The burial, No. 99.1/903, with which these specimens were found did not differ in arrangement from others above and below it, except that it was the only one in which artifacts other than matting had been deliberately placed with the body.

The position of the burial indicates that it was contemporary with Excavation Layer O. It was located exactly two thirds of the distance down from the surface to the bottom in sloping strata which expand nearby to a present thickness of 13.7 m. As this large mound is and has been eroding for about 3,000 years, the original depth of refuse may well have been 3 m. greater. The whole mound consists of occupational debris resting on a flat surface, and all of it was deposited prior to the appearance of ceramics in this part of Peru.

The first C-14 measurements on samples from Huaca Prieta were made by the Chicago laboratory in 1950 using the solid carbon method.[4] The mean ages for the samples nearest to the burial (C-313 and C-316) suggest a date in the twenty fourth century B.C. for the burial. However, later measurements suggest that this date is too early. In 1955, the Lamont Laboratory ran two samples from the base of the deposit at Huaca Prieta using the newer carbon dioxide method (L-116A and L-116B).[5] Since publication of the results, the laboratory has corrected the age determinations by adding 200 years to each, because of the Suess effect. The earliest date which fits both of the revised Lamont measurements is 2125 B.C. The standard deviation figures for the earlier solid carbon dates are so large that these dates can be adjusted to the results of the Lamont measurements. If we accept 2125 B.C. as the most probable date for the beginning of the deposit at Huaca Prieta, the burial in question would be dated about 1950 B.C. Whatever the absolute date turns out to be, we have the positive evidence of stratigraphy that these carvings were made long before the appearance of pottery on this part of the coast.

Since the gourds were reconstructed, a study of the fabrics from the preceramic deposit has revealed far more patterning and design than we had previously expected. The commonest construction technique is twining with spaced wefts and exposed warps. Other pieces are woven, knotted, or looped. In the last two categories

*Editors' Note: cf. ed. note on pg. 277.

patterned examples are fairly common, but the techniques limit the design to structurally created diamonds variably spaced with bars or rows of small squares.

In the woven pieces patterning, except for stripes, is accomplished with warp floats. The most elaborate of these pieces, found above the level of the gourds, shows a bird figure, inverted and reversed in a repeat (Fig. 2). The design was reconstructed by using a microscope to determine the position of the floats and then plotting them on graph paper.

In the twined fabrics warp stripes are common, though only rarely is their presence indicated by surviving color differences. Structural patterning was done by warp manipulation, the warps being shifted or transposed laterally and from face to face in various ways. A few patterned pieces, while technically complex, apparently made no use of color. The decoration consists of structurally contrasting areas in simple geometric arrangements. In the remaining twined specimens the manipulation of the warp was for the control and distribution of color. These are the specimens pertinent to the present topic.

Recognition of the designs in pieces where color contrast was used is difficult because of loss of dyes, pigments and natural fiber shades. Only in rare instances do color contrasts survive. Where the color is gone, special photographic techniques can help, but in most cases one must work with a microscope and plot each and every warp yarn movement in order. In this way the original shifts of color position can be determined, and, if enough of the fabric survives, the pattern or figure can be reconstructed.

Some of the designs are purely geometric assemblages of small diamonds and lines to form bold chevrons and squares. Others are representations of people, birds, or animals. These designs are achieved by two basic systems. One, in which the design shown in Figure 3 is executed, is technically identical with the construction of certain Woodland twined bags of North America. In the other system the warp pairs are handled somewhat differently, giving more solid color areas and sharper color divisions. The use of the latter system has not survived into historic times anywhere, as far as I know.

Both methods have technical limitations which give specific characteristics to the designs. In the first method, if the vertical lines of a figure parallel the warp, the horizontal color divisions, running across the warp, are clear, sharp, and straight. Deviations from a continuous horizontal have to be stepped by at least the space between weft rows and are clearly visible. Verticals are inevitably slightly zigzag but can be shifted less abruptly than the horizontals. Diagonals with minimum angles away from the vertical, determined by the ratio of the warp-weft count, are jagged and become increasingly serrated as the angle increases.

The second method produces serrated lines for both verticals and horizontals but has straight diagonals along the angle of the warp shift movement. Any other diagonal shift will be stepped.

In both methods, curves could be indicated as a series of steps but would be effective only in larger figures than those encountered. All figures done in these techniques are markedly angular, and faces shown in front view could have a stylistic resemblance to those on the gourds.

The degree to which such structural factors affect an art style will be directly proportional to the frequency with which the medium is used. At the Huaca Prieta the

available media, in addition to textiles and gourds, include bark cloth, matting, basketry, wood, shell, bone, and stone. No decoration has been found executed in any of these materials, a situation which forces us to the conclusion that textiles were the major medium used in artistic expression. What is more, textiles were the major medium from the beginning of the occupation of the site. The complex techniques appear in the earliest levels and were already fully developed. Curiously, in the upper strata there is a suggestion of cultural, or at least artistic, degeneration. Production of the elaborate fabrics ceased completely, and there was no continuity of this form of expression into the later times.

What happened at Huaca Prieta need not have happened in other areas. Frédéric Engel has published a figured twined fabric from a pre-ceramic burial in the valley of Asia, about 660 km. south of the Huaca Prieta, which may date to late pre-ceramic times.[6] The design consists of large, angular double headed snakes. The construction of the Asia specimen is not exactly duplicated in the Huaca Prieta collection.

Perhaps more significant as a suggestion of continuity is the recurrence and distribution of the double headed snake theme. It appears in Figure 4 with crab appendages. Versions of the same motif are commonly executed in Paracas Cavernas (T-3) embroideries, double cloths and gauze weaves.[7]

Our sample of the other representations is too small to indicate preferences. I doubt that the use of the condor and of animal figures which might be cats has any more significance than the depiction of the crabs. The artists were representing the creatures they were familiar with, and if we find that their preference ran to the more impressive ones in each category, is that grounds for any but broad comparisons? What we should note is the absence of the type of emphasis on fangs which is so strongly apparent in the subsequent art of Chavín and wherever Chavín influence was felt.

This limited evidence suffices to extend the known antiquity of artistic expression in Peru and indicates at least some continuity with the work of later times. It shows that an angular, highly conventionalized style can be an outgrowth of technique and does not have to fit into any theoretical sequence of art forms starting with naturalistic treatment. There is as yet no basis for suggesting the origin or antecedents of this art style. As it is primarily a textile art, the chances of solving the question of its origins are exceedingly remote and will, in any case, involve an understanding of the rise and development of twined fabric technology in various parts of the world.[8]

Notes

[1]The excavations at Huaca Prieta were made for the American Museum of Natural History in 1946-47. For a general account of the site, see Bird, 1948.

[2]The initial field conservation was effected by slipping the gourd fragments from the pouch to wire screening and dipping them several times in a very dilute cellulose acetate, acetone and amyl acetate solution with no attempt at cleaning. Later each fragment was lined on its inner surface with bits of rice paper and, as contacts were established, the breaks also were covered. This procedure resulted eventually in the formation of a complete paper shell inside each specimen.

Next, over a period of weeks, very small amounts of the hardening solution were injected through the paper into the gourd material. Cleaning of the outer surface was left to the last and was the most delicate step, for the hardened dirt and dust had to be softened and removed without converting the gourds to a paste. In one case the work was completely successful; in the other it had to be stopped before all details were exposed.

[3]This gourd was illustrated by Covarrubias, 1954, fig. 2, p. 16.

[4]Bird, 1951.

[5]Kulp and others, 1952, p. 410; Broecker and others, 1956, p. 163.

[6]Engel, 1959, pl. 2.

[7]O'Neale, 1942.

[8]In using the illustrations to this paper it must be borne in mind that figs. 4, 5, 6 and 7 are plotted reproductions of yarn movements, laid out on graph paper at a warp-weft ratio of two to one. When this ratio differs radically from the warp-weft ratio of the specimen there is distortion. In fig. 6 the wing spread of the bird would be about one twelfth greater if the diagram were drawn in true proportion.

Bibliography

Bird, Junius Bouton
 1948 "Preceramic Cultures in Chicama and Virú." *Memoirs of the Society for American Archaeology*, no. 4, pp. 21-28. Menasha.
 1951 "South American Radiocarbon Dates." *Memoirs of the Society for American Archaeology*, no. 8, pp. 37-49. Salt Lake City.

Broecker, W.S., and others
 1956 "Lamont Natural Radiocarbon Measurements III." W.S. Broecker, J.L. Kulp, C.S. Tucek. *Science*, vol. 124, no. 3213, 27 July, pp. 154-165. Lancaster, Pa.

Covarrubias, Miguel
 1954 *The Eagle, the Jaguar, and the Serpent; Indian Art of the Americas. North America: Alaska, Canada, the United States.* Alfred A. Knopf. New York.

Engel, Frédéric
 1959 "Algunos datos con Referencia a los Sitios Precerámicos de la Costa Peruana." *Arqueológicas*, 3. Pueblo Libre.

Kulp, John Laurence, and others
 1952 "Lamont Natural Radiocarbon Measurements, II." J.L. Kulp, Lansing E. Tryon, Walter R. Eckelman, and William A. Snell. *Science*, vol. 116, no. 3016, October 17, pp. 409-414. Lancaster, Pa.

O'Neale, Lila Morris
 1942 "Textile Periods in Ancient Peru: II. Paracas Caverns and the Grand Necropolis." *University of California Publications in American Archaeology and Ethnology*, vol. 39, no. 2, pp. i-vi, 143-202. Berkeley and Los Angeles.

Key To Illustrations

Fig. 1 (Plate II), a, b, projections of the carved decoration on two small gourd containers and their lids. The solidly dark areas and heavy lines have been carved or excised; the finer lines incised or scratched. The two figures shown separately, upper left, interlock across the bottom of gourd a. Below, c is a side view of gourd b and d is a top view of the cover. The two gourds were found together at Huaca Prieta in Excavation 3, Layer O. Cat. No. 41.2/2555, 2554.

Fig. 2 (Plate III). Two bird figures created with a single faced, warp float, weave of two ply cotton yarn. Huaca Prieta, Excavation 3, Layer H_2I_2. Loom width of fabric, 10 cm. Cat. No. 41.2/1205.

Fig. 3 (Plate III). Two incomplete human figures from a twined construction fabric. The transposed warp technique of this specimen is the same as that used in some Woodland twined bags. Both figures lack heads, as that portion of the fabric is missing. Between the two, in a blue stripe, are an S-shaped figure with bird (?) heads at each end and a small bird seen in profile; both figures are in red. Huaca Prieta, Excavation 3, Layer F. Cat. No. 41.1/9613.

Fig. 4 (Plate IV). A double-headed figure with appended rock crabs, created in a twined fabric with a transposed warp technique. The shaded background indicates the extent of the surviving textile, beyond which all portions of the figure are reconstructed. Huaca Prieta, Excavation 3, Layer G. Original length perhaps 40.5 cm. Cat. No. 41.1/9826.

Fig. 5 (Plate IV). A plotting of the figures in a small, rectangular twined fabric of transposed warp technique. The area, measuring 18.3 x 28.7 cm., is divided into four separate units, the first containing two rock crabs, the other three of uncertain interpretation because sections are missing. Huaca Prieta, Excavation 3, Layer M. Cat. No. 41.2/1711.

Fig. 6 (Plate VI). Figure of a male condor with a snake in his stomach, from a transposed warp technique, twined fabric. As plotted, the height is exaggerated; the dimensions of the original figure are 17.2 x 10.5 cm. Huaca Prieta, Excavation 3, Layer K. Cat. No. 41.2/1501.

Fig. 7 (Plate V). Bird figures in twined, transposed warp construction from two specimens. Fig. 7a, incomplete stylization of the male condor in profile, repeated in a pattern stripe. Original length of figures, beak to tail, 18 cm. Color, blue against natural cotton. Huaca Prieta, Excavation 3, at juncture of the M and N layers. Cat. No. 41.2/1716. Fig. 7b, a reconstruction of a possible placing of the bird figures of 7a within the stripe area. Fig. 7c, succession of parrot-like bird figures, each 5.6 cm. long, within a pattern stripe. Huaca Prieta, Excavation 3, Layer M. Cat. No. 41.2/1695.

Plate II. Figure 1, carved gourds from Huaca Prieta. a,b, projections of the designs; c, side view of gourd shown in b; d, cover of same gourd. (See key to illustrations for explanation.)

284

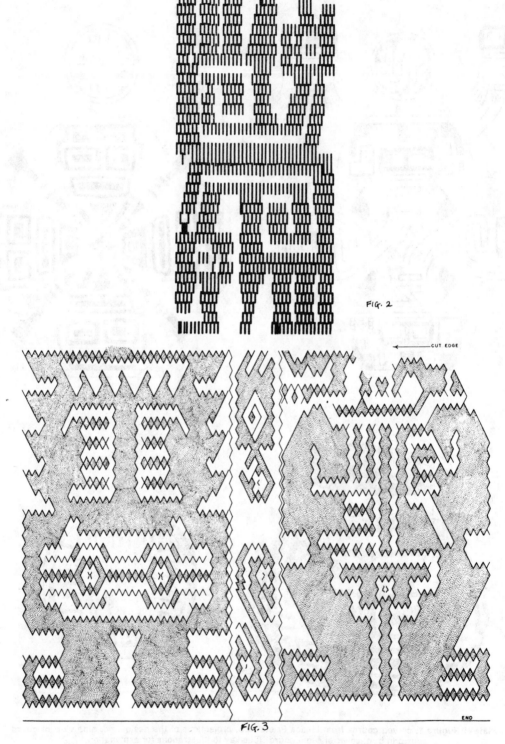

FIG. 2

← CUT EDGE

FIG. 3

END

Plate III. Figure 2, bird figures on woven textile from Huaca Prieta; **Figure
3,** human figures from twined fabric. (See key to illustrations.)

FIG. 4

FIG. 5

Plate IV. Figure 4, double headed figure with appended rock crabs from a twined fabric; **Figure 5,** rock crabs and unidentified design units from a twined fabric. (See key to illustrations.)

FIG 6

FIG. 7a

FIG. 7b

FIG. 7c

Plate V. Figure 6, figure of male condor with a fish in his stomach (height exaggerated); **Figure 7a,** incomplete bird figure design; **7b,** suggested reconstruction of 7a; **7c,** band of parrot-like birds, all from twined fabrics.

A Dated Sequence of Building
and Pottery at Las Haldas

Terence Grieder

Although Las Haldas has been long known as an important Preceramic and Early Horizon site, its history remains obscure. The later phases of its architectural history were somewhat clarified by the brief period of work described here, since changes in structural techniques were found which can be approximately dated by radiocarbon and related to developments in pottery. The architectural history has implications for the social history of the Chavín period on the coast and is indicative of relations with other areas.

The site lies directly on the Pacific shore about 30 km. south of the Casma Valley and 333 km. north of Lima. Las Haldas provides abundant evidence of its architectural history without excavation, since the three later periods of construction are largely visible on the surface. All structures visible on the surface were mapped using a transit, compass and tape (Fig. 1). The only constructions not mapped were a large number of superficial walls one stone high on the northwest flank of the site, a few small constructions which are probably small temple platforms east of the main part of the site, and the avenue 60 m. wide following the axis of the Main Group (Structures 1-6) inland toward the northeast for 2 km. in the direction of the Casma Valley. Four profiles were also measured (Figs. 2-4).[1]

Radiocarbon Determinations and Construction Periods

Although about a meter of preceramic debris covers the sterile sand throughout the site, our excavations revealed no evidence of preceramic construction. Frédéric Engel has informed me that subsequent excavation in what is labeled Structure 1 on the map did reveal a deeply buried preceramic structure. Engel had earlier published a radiocarbon age determination of 3800 ± 80 B.P., NZ-370-2 (1850 ± 80 B.C.) for perceramic culture with cotton at Las Haldas.[2]

All of the structures shown on the map lie on strata bearing ceramics and thus date from the Initial Period and the Early Horizon. Six excavations were made to study the architectural history and to relate it to the pottery.[3] Five other excavations which had

Reprinted from *Ñawpa Pacha*, Vol. 13, 1975. Published by the Institute of Andean Studies.

been made by previous visitors to the site were still open and they were also studied. Those excavations have been reported by Rosa Fung Pineda and by the University of Tokyo Expedition of 1958.[4]

The preceramic and ceramic levels join without any intervening layer throughout the site, which suggests that pottery was not developed by the local preceramic people, but was introduced already fully developed. The University of Tokyo expedition dated the initial ceramic levels at Las Haldas to 3850 ± 130 B.P., GaK-607 (1630 ± 130 B.C.) by a single radiocarbon measurement.[5] The plausibility of that date is increased by a measurement of 3430 ± 80 B.P., Tx-631 (1480 ± 80 B.C.) which we obtained from burned *Tillandsia* plants lying 1 m. above the floor dividing the ceramic from the precermaic levels in our Cut 1. *Tillandsia* are among the few plants which grow near the site today, which suggests that Las Haldas had a climate and vegetation 3500 years ago which were similar to those of today.

With the introduction of ceramics the record of building begins with walls of broken stone laid in mud motar and mud plaster floors. The mortar was not made of specially selected clay, but of the ordinary earth used to make adobes. The earliest construction we found consisted of a floor of hard yellow mud set directly on a preceramic deposit in Cut 1, with the lowest course of a double-faced wall set on top of the floor at one edge. That wall had been destroyed when a later building was put up, about 1480 B.C., more or less, judging by our radiocarbon sample. A meter of fill was put down over the original floor and a rectangular mud floor 4.70 m. wide was laid with a double-faced rubble-cored wall at each end. Cut 1 (Fig. 5) shows evidence of four campaigns of building and the beginning of the mounding up of the Main Group.

Preceding these constructions is a largely hypothetical period of preceramic building which ended about 1650 B.C. The known buildings which follow can be divided into three periods on the basis of changes in structural techniques. The periods can be roughly dated by radiocarbon assays: a period in which mud was used for mortar and floors from about 1650 to 900; a brief period, perhaps no more than ten years (900-890), during which a hard gray-white granular "concrete" was used for mortar and floors; a short period during which the site was abandoned, followed by a period during which single-faced free-standing walls were used for small structures on the surface, dated about 880 to 500 B.C.

Construction types based on loose rock fill sealed in mud and mud-mortared stone were used for the major part of the building which appears on the map. Two ash lenses gave radiocarbon determinates which bracket this phase. A sample taken by me from the base of the ash lens lying on the mud floor which seals the preceramic deposit under the Main Circle (Structure 6) gave a determination of 3140 ± 80 B.P., Tx-648 (1190 ± 80 B.C.). That would seem to date the beginning of the main period of building visible on the surface since the Main Circle is the focal point of the Main Group. Another ash lens is found on the surface in the stairway between Structures 4 and 5, evidently associated with the terminal period buildings on the surface in that area. (The stairway was not cleared, so its width was not recorded on the map.) The carbon sample from the base of the terminal period deposit gave an age determination of 2830 ± 70 B.P., Tx-632 (880 ± 70 B.C.). That is a plausible date for the beginning of the terminal period, and it may be taken as falling after the close of the short period in which concrete mortar was used, which ended building in the Main Group.

This date conflicts with recently published readings taken by the University of Tokyo expedition in 1969. Two samples from the stairway between Structures 4 and 5 gave readings of 3600 ± 95 B.P. (about 1650 B.C.) and 3150 ± 90 B.P. (about 1200 B.C.).[6] I cannot explain the discrepancy between these dates and those reported here. Although the dates remain insecure, the sequence of construction types is not in doubt and the midden is clearly posterior to the period of building in mud mortar.

The constructions in concrete mortar were left unfinished, one of them abandoned with the mason's stake and string still in place, which suggests a sudden and hasty departure (Fig. 9). Walls of the terminal period rest on a bed of sterile wind-blown sand which is variable in thickness, but averages about 10 cm. The sterile sand implies a period of abandonment prior to reoccupation of the site about 880 ± 70 B.C., a date based on an age determination run on carbon from fires of the terminal period. A long series of assays with results running from 780 B.C. to 410 B.C. has been taken from radiocarbon samples pertaining to the terminal period.[7]

Architectural Types

The periods during which mud mortar and concrete mortar were used, which I shall call here periods 2 and 3, show two characteristic types of building: the temple platform with courtyard and the sunken circle. Eighteen similar platform structures were mapped. The name "temple," which has become traditional, is used in the absence of any obvious utilitarian function. All of them, with the possible exception of Structure 1, appear to have been roofless platforms which orient between north and east. The stone-walled chamber atop Structure 1 may have had a roof, although there is no surviving evidence of it. A series of platforms or a stairway give access to the top platforms of all the temples. A rectangular courtyard as large as the total dimensions of the temple mound lies in front of the temple in the typical examples such as Structures 22 and 28. Structure 18, a small, irregular temple resting directly on the surface, may carry the type into the terminal period (or period 4), but that dating has not been proved. There is considerable variety in the details of these platforms and their forecourts, but there is enough consistency so that a type can be defined.

Some of the temple platforms are oriented toward sunken circles, of which there are two at Las Haldas: the Main Circle (Structure 6) and the West Circle (Structure 16). The Main Circle seems to be the focal point of the whole Main Group and at least one temple (Structure 15) is directed toward the West Circle. Structure 11 also was probably intended to point toward the West Circle since its stairway is angled toward the circle. The circles show no evidence of ever having had higher walls or roofs, and the only use of which we can be certain is that of holding a large fire, evident in the ash pile in the Main Circle. A small pit, possibly a fire pit, is found at the center of the West Circle, but there is no other evidence of the presence of fire in that circle. Both circles were built of broken stone laid in mud mortar.

Platform fill and the floors and walls which seal it underwent technical changes which show continuous development in architectural practices. If they could be dated and shown to be common practice they might serve to define phases or periods. The examples which follow are too few to do more than indicate trends.

Platform fill

Platform fill underwent labor-saving changes during Las Haldas' history. The early levels of building revealed by Cut 1 show the use of earth fill, which is dense and compact. In upper levels the fill changes to stone, which is loose and relatively unstable. No precise date can be assigned to this change, but the stone fill seems to have come into use after about 1190 B.C. on the radiocarbon time scale. There is no evidence of the way in which the earth fill was transported, but the stone fill was carried in nets or loose baskets made of knotted reeds, which were often cast into the fill with their loads. The reeds were probably not available locally; the nearest source now seems to be the Casma Valley.

It appears that the fill beneath Structure 1 may total about 40 m. in depth, of which at least the upper 4 m. are of loose broken rock. Our Cut 5, at the front of Structure 1, shows broken rock in reed nets as fill behind walls laid in concrete mortar, of the period about 900. A cut made by some earlier investigator into the southeast wing of Structure 2 reveals broken rock in nets in the upper 2 m. of fill, but a lower level of fill was made of smooth rounded beach boulders, also in reed nets. Waterworn stone was favored as a fill material by some preceramic builders, as at Rio Seco[8] and Kotosh[9], and it is found in the fill of the Moxeke temple in the Casma Valley. The waterworn stone layer was definitely laid by pottery-using people in Las Haldas, but it suggests the survival of an old tradition.

Floors

Mud floors were sometimes specially colored by the addition of pigment or perhaps by the choice of a strongly colored natural earth. The earliest floor in Cut 1, for example, was yellow. The mud floor of the sanctuary on top of Structure 1 was a strong earth red. Only traces of it exist now since it lay directly on the surface. The floors were irregular in thickness, averaging 2 or 3 cm., but the surfaces were smooth and they may have been polished originally.

A concrete floor was found in just one place, on the stairway in Structure 3. The usual technique for stair construction was followed there: a rough construction in stone with mortar and a thick surface of mortar applied as a finish. The stairway of Structure 21 was similarly constructed but presumably represents an earlier period, since mud was used for the mortar and the finish coat (Fig. 8). The concrete of the later period, which is harder than mud but not so hard as modern concrete, was given a white surface on the stairway in Structure 3.

No floors are known in buildings of the terminal period. Since the buildings are on the surface, weathering may have destroyed construction floors, or they may have used just the natural sand as floors.

Walls

Until the terminal period the double-faced wall was the common type of free-standing wall. Walls were set on the ground or on a floor without any foundation. Double-faced walls had a rubble core, and the stones were set in mortar. Most of the stones were laid perpendicular to the line of the wall to give the wall strength, and a fairly smooth surface was obtained. Single-faced walls, which are far more numerous, were used for revetments of building platforms. There is no evidence that any of the walls were ever plastered over, in contrast, for example, to the earlier structures at El Paraiso, Chuquitanta.[10] If a surfacing were used on might have found traces of it on

the mud-mortared façade wall of Structure 3, but it was definitely absent there (Fig. 10).

A variant wall type used during the period of mud mortar was built of natural basalt blocks quarried in the cliffs of the shore just northwest of the site. Blocks about one meter high were set upright, separated by a band of smaller broken stones. Structures 7 and 21 (Fig. 8) show this type of revetment. These are simple versions of the decorated revetment at Cerro Sechín, nearby in the Casma Valley, and might be compared with the wall of the Qalasasaya at Tiahuanaco.

We know that the builders of the period of concrete mortar used stakes and string to lay out their walls, since a stake and string were found still in place for the reconstruction of the front (northeast) stairway of Structure 1 (Fig. 9). The builders there were making a special effort to achieve a smooth surface, placing some stones longitudinally in the wall. An unusual feature is the construction of a double-faced wall, about a meter thick as usual, as a revetment flanking the stairway.

Structures 1, 2 and 3 are the only ones in which concrete was used, and the two largest constructions in which it is found were both left unfinished, those being a new front wall on Structure 3 (Fig. 10) and a new stairway and entrance to Structure 1 (Fig. 9). The stairway of Structure 1 was partly built, but its left end was no more than raw fill. Similarly, the flanking wall of the stairway had been completed to a length of about 2 m., but scarcely begun beyond that point. The new façade wall of Structure 3 had been built to about 1.30 to 1.50 m., less than half the height of the mud-mortared wall behind it, from which it was separated by a narrow gap of about 50 cm. These unfinished works mark the end of monumental construction at Las Haldas. The work appears to have been dropped suddenly and the site abandoned, as noted earlier.

It evidently remained unoccupied for only a short time to judge by the small amount of sand which accumulated over third-period buildings before the walls of the terminal period were laid. Walls of that period are usually just one stone deep, forming ragged lines in the sand. They look like the work of impoverished survivors occupying a famous ruin. They form small enclosures within Structures 3, 4 and 5. These small buildings are the only ones which look as if they might have been domestic. Since they show no evidence of having been semi-subterranean, they must have had higher walls and presumably roofs. Adobe and reed mats might have been used, but there is no trace of them today.

The Pottery

Two excavations, Cut 1 and Cut 3, produced significant samples of pottery. By far the larger sample, 1084 sherds, comes from Cut 3, which was undertaken in the hope of finding a stratified sample of ceramics. Cut 3 measured 1.5 x 3 m. and was located in the level area between Structures 20 and 26, about 80 m. southeast of the walls of Structure 3. Six natural levels were excavated before the preceramic layer was reached at 196 cm. depth. The pottery was classified in terms of twelve traits. I have been able to analyze only a part of the sample from Cut 1, 244 sherds from Levels 3, 4 and 5, but that analysis tends to confirm the conclusions suggested by Cut 3.

The mixing of early and late types in some levels can be accounted for by the fact that the soft sand of the site has been churned repeatedly by building projects. None of the levels in either cut was entirely sealed by floors, so an absolute segregation of the periods could not be expected. Such churning accounts, for example, for single

wide-necked bottle rim in the late Level 3 of Cut 1 and a single narrow-necked bottle rim in the earliest level of Cut 3. The general picture of the development of pottery types at Las Haldas emerges when one disregards those anomalies.

Table 1 summarizes the findings of Cut 3 with some comparative data from Cut 1 interpolated at the appropriate levels. The common vessel forms were neckless jars (called *ollas* here to distinguish them from cylindrical vessels listed as jars), globular bottles with restricted necks, and simple bowls with slightly flared, vertical or inward-curving walls. Round bases are the only ones found, no definable foot appearing on any vessel. The stirrup spout did not appear (Fig. 11).

Variations in the rims of ollas were particularly noted. The "fold-under" rim, in which the rim was smoothed by folding under the edge of the clay without working the folded part into the interior wall, appeared only in the deepest levels. Rims in which the folded part had been well incorporated into the inner surface, which we call "round rim," were common in all but the surface level, but were most common in Level 5 of Cut 3. The most highly worked rim form, in which the rim was smoothed and given a very sharply defined bevel on the lip of the olla, appeared in every level. The largest number was in Level 4, but the percentages were highest in the two levels nearest the surface, and on the surface it was the only olla rim found. That Las Haldas pottery developed toward more perfect finishing is implied by these findings.

The jar form runs throughout the sequence, but was most common in the middle levels. Its form shows no obvious changes, the rim being slightly rounded with well defined corners where it meets the inner and outer surfaces in all levels.

The vessel form which shows the most dramatic change is the globular bottle, which (despite the appearance of one narrow neck in Level 6) appears to have developed from wide-necked in the earlier periods to narrow-necked in the later. This development is confirmed in Cut 1, (again despite one wide neck in Level 3). The deepest ceramic level of Cut 1 held two wide-necked bottle fragments, and narrow-necked bottles appeared in higher levels. The change halved the width of the neck, from a range of 6 to 10 cm. diameter down to 4 to 4.5 cm. The narrow-necked bottle is a standard Chavín form. The gap in the bottles in Levels 3 and 4 of Cut 3 makes it appear that one type went completely out of use before a new type came into use. To refer to a development from one form to the other implies that they are connected in the sense that they fulfilled the same need, but all that we can be sure of is that these similiar forms were not in contemporary use.

The decorative techniques found most commonly at Las Haldas are punching, which may be confined to zones bordered by incised lines (i.e., "zoned punching"); incising, in which category I have included lines of all widths; and painting with red and metallic black, which has the appearance of graphite. Incising and the combination of incising with punching were popular in the earlier periods, to be slowly superseded by painting, which was absent in the lowest level and came in as an addition to zoned punch designs. In the surface level the two paint colors appeared separated from each other for the first time, on vessels which were solid red or solid black. The trend from plastic decoration of the surface toward a polished colored surface is quite definite.

Figurines were represented in Cut 3 by just one fragment, but four fragments of figurines were found in Cut 1 in the same late level (III) which held narrow-necked bottles. All of the fragments show the same type: solid bodies with upraised arms, legs

separated by a groove, fingers and toes indicated by grooves or notches, eyes marked by an incision, and long incised lines to show hair down the back. No clothing or ornament is shown. Although none is complete, they appear to have been about 10 cm. tall. The type is so far known only locally.

Conclusions

Las Haldas is of interest because it was inhabited for such a long time, and during periods which have been plausibly dated by eight radiocarbon assays. Earlier interest has centered principally on the preceramic and initial ceramic periods.[11] There has been a tendency to consider the temples at Las Haldas examples of the architecture of the Initial Period; Lanning, for example, puts them in a group dated between 2000 and 1500 B.C.[12] But there is probably little on the surface which dates before 1200, and likewise only the meager terminal remains which date after 900. The discussion here centers on the period from 1200 to 900, which falls within the Early Horizon or Chavin period.

We cannot follow Gordon Willey's advice of many years ago to study only the "representational aspect of the Chavin style, the feline motif and its combinations," [13] for those are too rare at Las Haldas. There is no stone sculpture at the site and only one potsherd definitely shows a Chavín feline. That sherd, from Cut 2, has the distinctive lower lip and corner of the mouth of a grimacing feline with fangs from a thick blackware effigy vessel or hollow figurine. It is technically at home at Las Haldas and reassures us that there is indeed a Chavín component in the site, but it makes it clear that we must seek the manifestation of the style in things other than representations.

Since we studied only the architecture and the forms and decorative techniques of the pottery, we can only point out the widely shared features of those arts, widely shared features being the basis of the Chavín "horizon style."

The most interesting architectural features are the sunken circles. Donald Thompson has informed me that other examples are known in the Fortaleza and Huarmey valleys and excavations at Chavín de Huántar in 1972 brought to light a similar, but more elaborate, example. [14] The Chavín de Huántar circle has four stairways, rather than the two of both Las Haldas circles, and stone reliefs ornament the walls, rather than the plain stonework of Las Haldas.* How old the Main Circle at Las Haldas was when the fire burned on its floor about 1190 (\pm80) is unknown, but only one floor lies beneath the ash. The semi-subterranean circular plaza is an early or middle Chavín structural type. I suspect that deeper excavations at other Chavín-related sites, particularly in the Casma Valley, would produce more examples of the type.

*In this [article] I gave the erroneous information that the recently discovered circular plaza at Chavín de Huántar has four stairways, citing Federico Kauffman Doig's *Manual de arqueologia peruana* (1973, p. 186). Information received from Richard L. Burger, who is conducting studies in the region of Chavin de Huantar, is that the circular plaza has only two stairways.

In 1963 Kauffman correctly predicted the discovery of a sunken plaza east of the Old Temple, showing it in his diagram as a rectangular plaza with four stairways (Kauffman Doig, 1973, pp. 182-183). Perhaps this preconception led to the description of four stairways when the predicted plaza actually came to light.

If the circular plaza had had four stairways it would have been a unique example. With two stairways it is another example of a type known in the Huarmey and Fortaleza valleys as well as at Las Haldas, a type which helps define a period in the history of Chavín style architecture. The superior construction and decoration of the example at Chavín de Huántar as shown in the photographs published by Kauffman Doig (1973, p. 186) reemphasize the premier position of that site in the Chavín culture.

Terence Grieder, January 18, 1977

Although three fairly distinct ceramic styles can be defined, there are strong elements of continuity between them. The earliest is characterized by wide-necked bottles, neckless ollas with fold-under or round rims and garlands of zoned punching around the shoulder, and bowls with punched designs which sometimes show post-fire red paint preserved in the punch marks. These elements can be found in practically all the very early pottery of the north and central coasts and the adjacent highlands, notably at Chavín de Huántar and Kotosh, although the Las Haldas pottery appears to be simpler and less fine than the best early pottery of those two sites. I think 1630-1190 might date the style, those dates being taken from the radiocarbon assays and being intended to stand only as round numbers. This style accompanies the early mud-mortared buildings which began the ceremonial center, but it probably antedates most of the construction visible on the surface.

The middle style is characterized by textured surfaces made by incision, punching and modeling, often with fired red and metallic black paint. Olla rims were round or beginning to be beveled. Vertical-walled jars with round bases were a popular form, and the narrow-necked bottle completely replaced the wide-necked form. Figurines were made during one phase of this period; 1190-900 may be taken as a general dating. Although the pottery of Pallka published by Tello is richer in variety of forms and decorations, notably in the presence of stirrup-spout bottles and flat-based forms, it certainly manifests the same general style.[15] The presence at Pallka of elements found in the earlier Las Haldas style, such as wide-necked bottles,[16] shows the same continuity found at Las Haldas. Filleting and other relief additions are found in both of the earlier periods at Las Haldas and those features are also found at Pallka. The Cahuacucho and Gualano phases from the Casma Valley, defined by Collier, may represent the same kind of continuity, despite the absence of decorated pieces in the former.[17] This middle period of Las Haldas pottery accompanies the constructions visible on the surface which form the great temple complex, and may be considered a middle Chavín manifestation.

The third style, which I believe accompanied the terminal occupation and should date about 880-500 B.C., shows a continuity of vessel forms but a new preference for sharply beveled rims on ollas and polished bottles painted in one color, either red or metallic black. Collier's Patazca Phase from the Casma Valley,[18] for which he accepted a date of 342 ± 80 B.C. based on a radiocarbon measurement on a sample taken from a wooden lintel at Chankillo, sounds like a similar style.[19] This later style at Las Haldas is a late Chavín style. Although there is a consistent local tradition, which the churning of the deposits tends to exaggerate, the changes in the forms and decorations of the pottery show that the site was occupied for a long time.

The continuity of the cultural material in the excavations is interrupted by just two definite breaks, one at the meeting of the ceramic and preceramic levels, which appears to document the meeting of two groups of people with separate technical traditions, and the hiatus of about 900-880. The hiatus ended the building of large ceremonial structures at the site, but the continuity of ceramic types through the surface levels indicates a reoccupation of the site by people carrying on the earlier traditions in a later style. Human agents, rather than a natural disaster, seem to have caused the hiatus, for there is no evidence of widespread destruction or deposits indicative of flood or earthquake. Although the returning inhabitants represented a late

Chavín culture, they left no remains rivalling late Chavín art and architecture at other centers. Perhaps the decline of Las Haldas holds clues to the cultural processes which led to the eventual decline even of Chavín de Huántar.

October 10, 1974
revised June 6, 1975

Notes

[1] This work was done under my direction from October 31 to November 11, 1967. It was sponsored by the Instituto de Agricultura Precolombina of the Universidad Agraria, directed by Dr. Frederic Engel, for whose support and assistance I am grateful. Participants were Bernardino Ojeda, archaeologist; Apolonio Lino, foreman; Isaac Peralta and Crisostomo Ayala, laborers, and Mario Linares, cook. All excavated materials were deposited in the Instituto de Agricultura Precolombina in Lima.

[2] Engel, 1966, p. 82.

[3] The six excavations were as follows:

Cut 1 lay 16 m. southwest of the lower (northeast) corner of Structure 4, outside the courtyard and abutting the wall. Ojeda supervised the work and recorded the results. The cut measured 9 x 3 m. and ended in sterile sand at 5 m. depth.

Cut 2 was the clearing of slumped soil and sand from the stairway of Structure 21. Maximum depth was 90 cm. The deposit was removed in two artificial levels. The upper 20 cm. contained sherds, textile fragments of cotton, and a lump of red pigment. The lower level, 10 to 70 cm. thick, contained fewer sherds but of the same types as above, and a fragment of anthracite mirror.

Cut 3 was located about 80 m. southeast of Cut 1; it measured 1.5 x 3 m. The pottery is analyzed in the text and is the only material from these excavations for which an analysis has been completed. Preceramic levels were sampled down to sterile sand, but cotton string was the only artifact recovered.

Cut 4 revealed the reconstruction of the facade wall of Structure 3 facing into the courtyard of Structure 4. The cut was 1 m. wide and ended at the floor of the courtyard.

Cut 5 was the clearing of slump to expose the stairway of Structure 1 and revealed the unfinished construction of the stairway. Additional stairs must exist, but they were not sought. This cut was refilled to protect the ancient stake and string which were found in place.

Cut 6 was on the interior, against the east wall, of the sanctuary of Structure 1. It revealed the original mud floor directly on the surface, and the cut was terminated in loose rock fill at 3.5 m. depth. Whatever earlier structures may exist in that area are covered by a thick layer of loose rock fill, sometimes in loose reed nets. The excavation was refilled.

[4] Fung Pineda, 1972; Tokyo Daigaku, 1960. The earlier excavations which were evident in 1967 consisted of (1) a trench to sterile soil across the Main Circle (Structure 6) made by Rosa Fung Pineda; our radiocarbon sample Tx-648 was taken from this cut; (2) a trench to floor level across the midden in the stairway between Structures 4 and 5; our radiocarbon sample Tx-632 was taken from the base of this midden; (3) a cut into the top of the eastern flanking platform of Structure 2; (4) a shallow test pit measuring 1 x 1 m. in the courtyard of Structure 6 outside the Main Circle; (5) a shallow 1 x 1 m. test pit in the center of Structure 7.

[5] Tokyo Daigaku, 1960, p. 518.

[6] Matsuzawa, 1974.

[7] Seven radiocarbon samples have been taken from deposits of the terminal period: Tx-1011, taken by me, at 2730 ± 70 B.P. (780 ± 70 B.C.); GaK-606, taken by the University of Tokyo (Tokyo Daigaku, 1960, p. 518), at 2680 ± 150 B.P. (730 ± 150 B.C.); NZ-211, taken on the surface by Engel (Engel, 1966, p. 88; Fergusson and Rafter, 1959, pp. 232-233), at 2500 ± 100

B.P. (550 ± 100 B.C.); and four samples taken by the University of Tokyo in 1969 and published by Matsuzawa (1974): Pit 1/no. 3 at 2690 ± 150 B.P. (740 ± 150 B.C.); LH-Bex, Layer 9 at 2590 ± 80 B.P. (640 ± 80 B.C.); Trench D, Layer 4 at 2520 ± 60 B.P. (570 ± 60 B.C.); and Trench A, Layer 2, upper part, at 2360 ± 90 B.P. (410 ± 90 B.C.). All of these readings seem reasonable for the terminal occupation.

[8] Lanning, 1967, p. 70

[9] Izumi and Sono, 1963, p. 67.

[10] Engel, 1967, p. 49.

[11] For example, Lanning, 1967.

[12] Lanning, 1967, p. 189.

[13] Willey, 1951, p. 134.

[14] Kauffman Doig, 1973, p. 186.

[15] Tello, 1956, pp. 36-46

[16] Tello, 1956, figs. 9j, 14a.

[17] Collier, 1962

[18] Collier, 1962.

[19] But Edward Lanning, who has examined both Casma and Las Haldas sherds, writes me (May 25, 1968) that none of the Casma styles is present at Las Haldas.

Bibliography

Collier, Donald
1962 "Archaeological investigations in the Casma Valley, Peru." Akten des 34. *Internationalen Amerikanistenkongresses* (Wien, 18. bis 25. Juli 1960), pp. 411-417. Verlag Ferdinand Berger, Horn-Wien.

Engel, Frederic
1966 *Geografía humana prehistórica y agricultura precolombina de la Quebrada de Chilca.* Tomo I, informe preliminar. Universidad Agraria, Lima.

1967 "Le complexe précéramique d'El Paraiso (Pérou)." *Journal de la Société des Américanistes,* n.s., tome LV-1, 1966, pp. 43-96. Paris.

1970 *Las lomas de Iguanil y el complejo de Haldas.* Universidad Nacional Agraria, Lima.

Fergusson, G.J., and Rafter, Thomas Athol
1959 "New Zealand 14 C age measurements - 4." *New Zealand Journal of Geology and Geophysics,* vol. 2, no. 1, February, pp. 208-241. Wellington.

Fung Pineda, Rosa
1972 "Las Aldas: su ubicacion dentro del proceso histórico del Perú antigo." *Dédalo,* ano V, nos. 9-10, junho-dezembro, 1969. Sao Paulo.

Izumi, Seiichi, and Sono, Toshihiko
1963 *Andes 2; excavations at Kotosh, Peru, 1960.* Kadokawa Publishing Co., Tokyo.

Kauffman Doig, Federico
1973 *Manual de arqueología peruana.* Quinta edición. Ediciones PEISA, Lima.

Lanning, Edward Putnam
1967 *Peru before the Incas.* A Spectrum Book, Prentice-Hall, Inc., Englewood Cliffs, New Jersey.

Matsuzawa, Tsugio
1974 "Excavations at Las Haldas, on the coast of central Peru." The Proceedings of the Department of Humanities, College of General Education, University of Tokyo, vol. 59. *Series of Cultural Anthropology* no. 2, pp. 3-44. Tokyo [Text in Japanese, pp. 3-20) English summary, pp. 21-24.]

Tello, Julio César
 1956 *Arqueología del Valle de Casma; culturas: Chavín, Santa o Huaylas, Yunga y
 sub-Chimú.* Informe de los trabajos de la Expedicion Arqueológica al Marañon de
 1937. Publicación Antropológica del Archivo Julio C Tello, de la Universidad
 Nacional Mayor de San Marcos, vol. I, Editorial San Marcos, Lima.

Tokyo Daigaku
 1960 *Andes; the report of the University of Tokyo Scientific Expedition to the Andes in
 1958.* Bijitsu Shuppan sha, Tokyo.

Willey, Gordon Randolph
 1951 "The Chavín problem: a review and critique." *Southwestern Journal of
 Anthropology,* vol. 7, no. 2, summer, pp. 103-144. Albuquerque.

TABLE 1

Summary of Ceramic Development

Trait									
Cut 1 Level			3		4			5	
Cut 3 Level	1	2		3		4	5		6
Depth in cm.	0-35	35-55	--	55-82	--	82-117	117-154	--	154-196
Total sherds	24	97	189	109	42	165	426	--	263
Plain body sherds	15	79	128	91	--	140	367	--	241
Olla, fold-under rim	0	0	0	0	--	0	1	4	3
Olla, round rim	0	5	16	8	17	9	38	5	7
		(5%)		(7.2%)		(5.4%)	(8.8%)		(2.6%)
Olla, beveled rim	2	5	3	3	7	7	3	--	3
	(8%)	(5%)		(2.7%)		(4.2%)	(0.7%)		(1.1%)
Jar rims	0	1	1	1	2	4	3	--	1
Bottle, wide neck	0	0	1	0	--	0	2	2	1
Bottle, narrow neck	1	2	3	0	2	0	0	--	1
Red and graphite paint	1 red 1 graph.	2	1	5	5	3	2	--	0
Punched	0	1	1	0	1	2	7	2	0
Zoned punch	0	0	3	1	6	0	4	--	4
Incised (no punch)	0	1	1	1	2	1	1	--	2
Figurine	0	1	2	0	0	0	0	0	0

Percentages given are based on the number of sherds in that level.

Sherds in Cut 3, Levels 3, 4 and 5 which have both red and graphite paint and punching or zoned punching have been counted in both categories.
In Cut 3, Level 3 one of the five painted sherds had zoned punching.
In Cut 3, Level 4 one of the three painted sherds was also punched.
In Cut 3, Level 5 both of the painted sherds also had zoned punching.

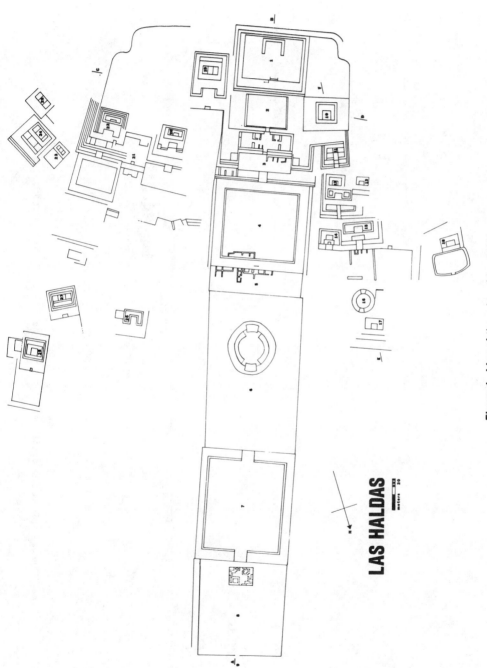

Figure 1. Map of the ruins of Las Haldas.

LAS HALDAS

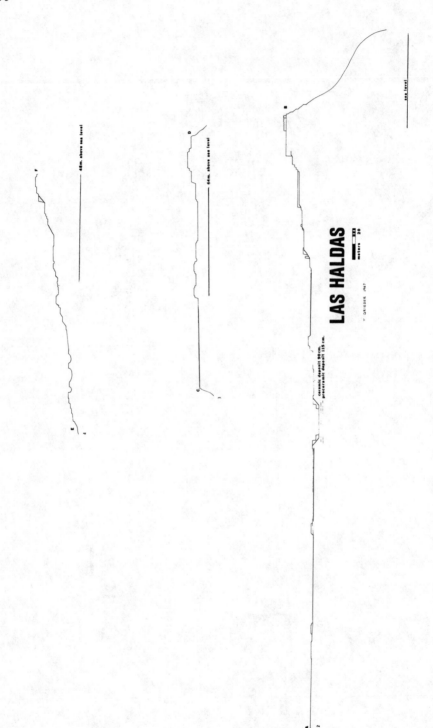

Figures 2-4. Three profiles of the elevation of the ruins. Each profile fits the map (fig. 1) between the letters which identify the profile.

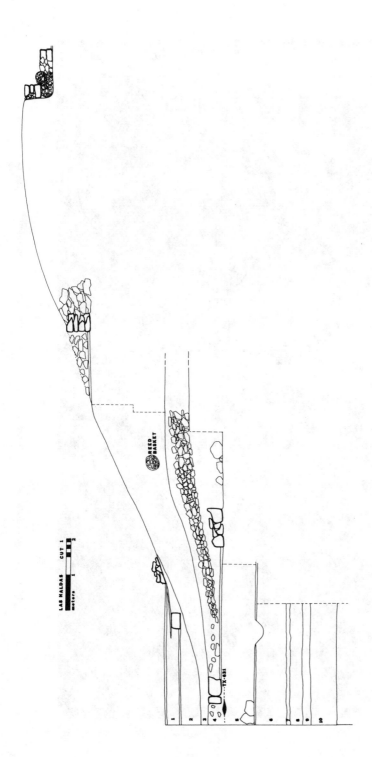

Figure 5. Longitudinal section of Cut 1, excavated by Bernardino Ojeda, after his drawing. Previously published in Engel, 1970, fig. 4. Key: Level 1-5 are ceramic and 6-10 are pre-ceramic. Level 1, superficial walls, yellow mud floor with stone marking the position of a wall, and windblown sand. Level 2, windblown sand. Level 3, sand and a reed basket containing rock fill. Level 4, sand and a layer of stone fill, and a hard mud floor with walls at both ends. Level 5, lowest level containing ceramics, sandy soil above a yellow mud floor with a pit through the floor (radiocarbon sample Tx-631 from burned *Tillandsia* leaves gave a reading equating to 1480 B.C. + 80). Level 6, highest pre-ceramic level, ashy soil. Level 7, shell. Level 8, ashy soil. Level 9, brown soil. Level 10, ashy soil ending in sterile sand.

302

Figure 6. View of the site from Structure 1 toward the north-northeast showing Structures 1-8.

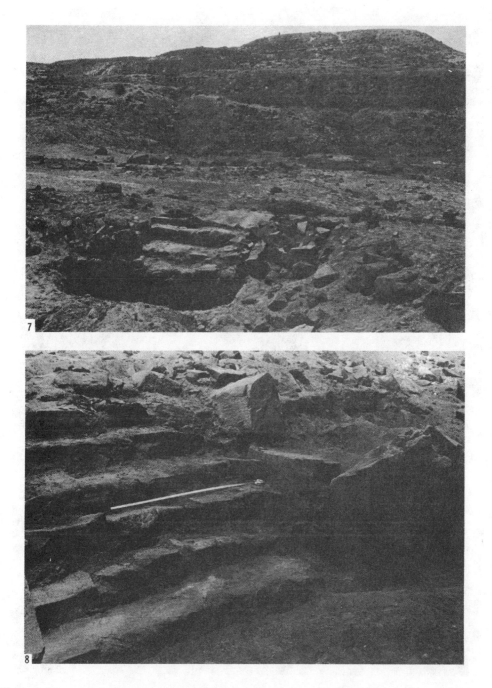

Figure 7. View of the Main Group (Structures 1-3) from the West Circle (Structure 16), looking south;
Figure 8. Structure 21, revealed by Cut 2, a stairway of stone laid in mud mortar flanked by walls of vertical slabs separated by smaller stones; the tape shows 1 m.

Figure 9. Cut 5, showing the unfinished reconstruction of the stairway onto Structure 1 using concrete mortar. The mason's stake and string remain in the corner (lower left center). The stairs on the right were left incomplete; on the stair is a reed net for fill stones (right center). The tape shows 1 m.

Figure 10. Cut 4, showing the earlier mud-mortared facade wall of Structure 3 at the top and the later con-
crete-mortared wall under construction in front. The tape shows 1 m.

Figure 11. Summary of the ceramic forms from Cut 3, by level.

Form and Meaning in Chavín Art

John Howland Rowe

To the observer who sees it for the first time, Chavín art is as puzzling as an undeciphered script. The designs are so complex that it requires close attention even to see the details, which usually turn out to be minor figures having no very obvious relationship to the main subject. We can, of course, ignore representational meaning and appreciate Chavín designs as abstract patterns, but it is obvious that they were more than abstract patterns to the artists who made them. Let us attempt a decipherment which, in proportion to its success, will enable us to see Chavín art as its makers intended it to be seen.[1]

There are two indispensable conditions for this kind of decipherment. The first is to pay close attention to context, asking always where and in what combinations design elements or complete designs are used. The second condition is to be able to sort the monuments according to date. It is not necessary to know their dates in years, but we do need to be able to tell, in any comparison, whether two pieces are contemporary or not, and if not, which is the earlier. The failure of previous attempts to understand Chavín art can be traced in part to the fact that they did not fulfill these conditions. To avoid old difficulties in the present inquiry, it will be convenient to begin by talking about place and time.

Place and Time

Chavín is the modern name of a small town located in a fertile valley on the northeastern slope of the main range of the Peruvian Andes at an altitude of 3,135 meters (about 10,200 feet). Just outside this town, which is also called Chavín de Huántar and San Pedro de Chavín, are the ruins of a great temple which is one of the most remarkable surviving monuments of American antiquity. The temple is a masonry structure and was originally richly ornamented with stone sculpture and with reliefs modeled in clay plaster and painted. The settlement associated with this temple apparently occupied the whole area where the town of Chavín now stands and some of the fields around it as well. Since the ancient name of the temple and its associated settlement is not known, the name of the modern town is generally used to designate them.

It was the stone sculpture at Chavín which first attracted the attention of explorers, and this sculpture became the basis for defining the Chavín style. When we

say that an object from some other part of the country is decorated in the Chavín style we mean that it is in substantially the same style as the sculpture at Chavín.[2] The Chavín style was used not only for monumental sculpture but also for small carvings in stone, bone and shell, for modeled and incised pottery, and for decorating textiles and repoussé gold ornaments. There are naturally some variations in the designs which are attributable to the choice of materials and to considerations of scale.

The site of Qotus ("Kotosh") near Huánuco marks at present the southern limit of discoveries of objects in the Chavín style in the sierra. The central sierra is so poorly explored, however, that future explorations may very well extend the area of Chavín occupation. To the north and west the Chavín style has been traced over a distance of about 400 kilometers. On the coast, objects in the Chavín style have been found as far south as Ica and as far north as Chiclayo.

The site of Chavín is not the only one with an imposing temple in the Chavín style. Two more are known in the sierra, one at La Copa ("Kuntur Wasi"), west of Cajamarca, and the other at Pacopampa near the northern edge of known Chavín territory. On the coast there is a great temple at Garagay, 7 km. north of Lima, the plan of which is very similar to that of Chavín, and other famous shrines at Mojeque and Pallca in the Casma Valley and at Cerro Blanco in the valley of Nepeña. In the present state of our knowledge we cannot say that Chavín was the ultimate center of origin of the Chavín style, although the style presumably originated somewhere in the area of its distribution. The available evidence suggests, however, that Chavín became an important center for the distribution of ideas of religious art.

At the same time that the Chavín style dominated the art of northern Peru a different style, called Paracas from the place where it was first recognized, was flourishing to the south of it. The Paracas style, with many local variations, has been found along the coast from Cañete in the north to Yauca in the south, and in the sierra near Ayacucho. Its full extent has not yet been traced. The Paracas style had close relations with Chavín, although it had many distinctive characteristics. No Paracas stone sculpture is known, but Chavín influence is evident in designs on pottery vessels, pyroengraved gourds, and textiles.

Dates in years for the decorative styles of ancient Peru are based on radiocarbon measurements. None of the results of measurements made on samples supposedly having Chavín style associations inspires much confidence, but the determinations made on earlier and later materials indicate the general order of antiquity of the Chavín style. On the basis of this kind of evidence it now appears that the Chavín style flourished between about 1200 and about 300 B.C. Its origins have not yet been found and may go back considerably further.

Constant change is apparently a universal characteristic of art styles, and it is not surprising to find that there were substantial changes in Chavín art in the nine hundred years or so of its existence. By determining the order of these changes we can establish a scale which will enable us to determine which monuments are earlier and which are later. Much research remains to be done on this problem, but the general outlines of the sequence are already apparent.

Our best evidence for the order of changes in the Chavín style is derived from a study of the Chavín influences reflected in the Paracas style pottery of the Ica Valley. The development of the Paracas tradition in Ica was the subject of an important study made by Lawrence E. Dawson and Dorothy Menzel of the University of California at

Berkeley in 1959 and 1960.[3] These investigators were able to distinguish ten successive phases in the Ica variant of the Paracas style. This variant they call Ocucaje, after a section of the Ica Valley in which remains of this type are abundant, so that the phases of the sequence are designated "Ocucaje 1," "Ocucaje 2," and so on. The influence of the Chavín style is strong from Ocucaje 1 to Ocucaje 8, chiefly in the most elaborate pieces. Dorothy Menzel made the crucial observation that the Chavín influence in the Ocucaje sequence is not uniform; the Chavín features vary from one phase to another in a very consistent fashion, and features which are restricted to certain phases at Ica are found only on certain Chavín monuments. The order of changes in the Chavín influences in the Ocucaje sequence can be expected to reflect at least approximately the order of changes in Chavín art.

Among the features of Chavín origin present in the Ocucaje sequence which have proved most useful in establishing time differences in Chavín art we may mention a decorative point at the corner of the mouth which appears at Ica first in Ocucaje 4, earlier Chavín influenced mouths having simple rounded or square corners. The mouth with this point should therefore be a relatively late feature at Chavín. Another useful feature is the treatment of twisted geometric figures. The curvilinear guilloche occurs early in the Ocucaje sequence, while the angular twined fret occurs only very late and can be shown to have developed out of the guilloche. Decorative curls acquire longer and longer stems. There is an interesting tendency to accommodate the design to a framework of parallel bands like the spaces on lined paper, with a consequent replacement of curved lines by straight ones.

Using these features and a few others which occur in the Ocucaje sequence as guides, it has been possible to arrange the stone sculpture from Chavín in a consistent order which also makes sense in terms of other features not found on Ica pottery, or occurring there under circumstances which do not permit placement in time. Features of this sort which occur only in a relatively late context in Chavín art are eyes with angular eyebrows, the presence of a central fang on profile faces, triangular teeth in the mouths of principal faces, small snake heads in which the mouth is a continuation of the eyebrow line instead of being drawn separately, and the extension of lip and teeth over the profile of the face.

While I was working at Chavín in 1961 it occurred to me that it might be possible to derive some independent evidence for the relative age of Chavín sculpture from the relationship of individual pieces of sculpture to successive phases in the construction of the temple. The inquiry turned out to be more valuable for establishing context than for finding evidence of time differences, but the results have some value for both purposes.

Largely because of vandalism beginning in the Colonial period and lasting until the early years of the present century, most of the sculpture at Chavín has been removed from its original position. Much has been destroyed, and much is preserved only in battered fragments used as building stone in the village church and in private houses. There are, however, a few fragments remaining in or near their original locations which enable us to visualize how sculpture was used in the construction of the temple.

The temple consists of a number of rectangular structures up to 12 meters in height which appear to be platforms of solid masonry designed to support shrines built on top of them (Fig. 2). These rectangular structures are not solid, however, but

are honeycombed with interior passages and small rooms, roofed with large slabs of stone and connected with each other and with the open air by an effective system of ventilating ducts. There are traces of painted plaster on the walls of these passages, and in one of the rooms three of the slabs forming the ceiling have traces of low relief carving, now badly damaged. Most of the roofing slabs were not carved, however.

The outside walls of the temple fabric were adorned with a row of human and animal heads, carved in the round, which projected from the facade. These heads were provided with stone tenons, rectangular in section, which fitted into sockets provided in the masonry. Above the row of heads was a projecting cornice of flat slabs with squared edges. The under side of this cornice, and in places the outer edge as well, was decorated with figures carved in low relief. Only one slab of this cornice is now in place, but others were found at the foot of the wall, presumably not far from where they had fallen. A number of rectangular stone slabs have been found, each with one side well finished and carved with a figure in relief with a frame around it. These slabs were apparently designed to be set in walls, but none has been found in its original position.

One of the interior passages leads to a great image which was evidently a cult object of major importance, one of the few cult objects of ancient Peruvian religion which can still be seen in its original setting (Fig. 5). It is a shaft of white granite, some 4.53 meters long, set upright in a gallery crossing. The stone has been carved in low relief to represent a figure in human form with the right hand raised. The scale of this Great Image and its setting in a dark passage give it an awe-inspiring quality which can be felt even by a present day unbeliever, but which photographs and drawings fail to communicate.

The Great Image, infelicitously called "the Lanzón" in the earlier literature, was probably the principal cult object of the original temple at Chavín, for it stands close to the central axis of the oldest part of the temple structure. The original temple seems to have been a U-shaped structure consisting of a main building and two wings enclosing three sides of a rectangular court, the open side being on the east. The whole structure occupied an area of some 116.30 by 72.60 meters (Fig. 2).

Subsequently the temple was enlarged several times and its center shifted. The two principal additions affected only the south wing, enlarging it until it formed a solid rectangular structure 70.80 by 72.60 meters in plan. The enlarged south wing was then treated as the main building of the temple; a new and larger court was laid out in front of it with flanking buildings on the north and south sides, again providing a U-shaped arrangement open to the east. The east front of the new main building, facing the court, was provided with a monumental portal, the south half of which was constructed of white granite and the north half of black limestone. We can call it the Black and White Portal (Figs. 3 and 4).

The expansion of the south wing of the old temple until it became the main building of the new one probably reflected an increase in the importance of a deity which had originally been worshipped in the old south wing, an increase no doubt accompanied by a decline in the prestige of the deity of the Great Image. The original image of the deity of the south wing has not been found, probably because it was destroyed centuries ago. As we shall see, there may be a later representation of it, however.

We cannot use the sequence of additions to the old south wing to establish the order in which the cornices and tenon heads of this part of the structure were carved,

because there is evidence suggesting that older sculptures were reused when a new addition was built, and that damaged slabs in the older parts of the temple were replaced long after the original date of construction. The evidence is stylistic; some of the cornice blocks found by the walls of the second major addition are almost identical in style with the earliest ones from the old south wing, while the most advanced style cornice slab in the whole temple was found near a much earlier one at the foot of the wall of the old south wing.

The sculptures associated with the Black and White Portal, however, do have some value in establishing a sequence of style changes in Chavín art. The Portal sculptures consist of two cylindrical columns, each carved with a single large figure in flat relief, and a short cornice decorated with a frieze of standing birds, also in relief (Figs. 8, 9, 15, 16).[4] The columns supported the lintel of the entrance, and the cornice must have rested on top of the lintel. The close structural relationship of these carved members, the dimensions of which indicate that all were cut for the positions they occupied in the Portal, suggests that they were all carved at the time the Portal was built. This inference is supported by the fact that the style of all three is virtually identical. We can therefore treat the Portal sculptures as a stylistic and chronological unit for purposes of comparison. From its position the Portal cannot be earlier than the construction of the second addition to the south wing, and it may be later; its sculptures, therefore, should represent a relatively late phase in the sequence of Chavín carvings. The evidence of Chavín influence at Ica also suggests a relatively late date for the style of the Black and White Portal, so there is no conflict in the evidence.

The evidence now available is sufficient to suggest only the general outlines of a chronology for the Chavín style, a chronology much less detailed than the sequence we have for the contemporary Paracas style from Ica. For the present we can distinguish only four phases of Chavín art based on stylistic differences in the sculptures at Chavín itself; we can label these phases AB, C, D, and EF for convenience of reference. The use of the double letters, AB and EF, for the first and last of these phases will serve to remind us that it should be possible to subdivide them when a little more evidence is available.*

The anchor point in this sequence is Phase D, for which the sculptures of the Black and White Portal serve as a standard of comparison. There are many other pieces of sculpture at Chavín which can be assigned to this phase because of their stylistic similarity to the Portal reliefs. Chavín Phase D should be at least in part contemporary with the fourth and fifth phases of the Paracas sequence at Ica. For Phase C at Chavín the standard of comparison is the most elaborate single monument of Chavín art, the so-called "Tello Obelisk" (Figs. 6 and 7).[5] Only a few other fragments of sculpture can be assigned to this phase. Phase AB includes all examples of Chavín art which are judged to be earlier than the "Tello Obelisk," while EF includes all those which are later than the Black and White Portal. Among the monuments assigned to AB by these criteria are the cornice blocks from the main structure of the new temple which are decorated with representations of eagles or

*Editors'Note: In 1974, Peter Roe published an extension of this chronology entitled *A Further Exploration Of The Rowe Chavín Seriation And Its Implications For North Central Coast Chronology*. Dumbarton Oaks Studies in Pre-Columbian Art and Archeology, no. 13. Washington, D.C.

hawks (Figs. 11-13), except for one, mentioned earlier, which belongs in Phase D (Fig. 14)[6]. The Great Image in the old temple (Fig. 5) can be assigned to Phase AB also, although it is possible that some of the details on this figure were added later. Phase EF includes the famous Raimondi Stone (Fig. 10) and a number of other reliefs, mostly fragments.[7]

Turning to monuments from other sites and pieces without provenience, we can assign the temple reliefs at Cerro Blanco in Nepeña to Phase C, and the lintel found at La Copa to EF.[8] The superb jaguar mortar in the University Museum in Philadelphia, the provenience of which is unknown, is a Phase AB piece, while Phase C is again represented by a carved bone spoon from the Huaura Valley.[9]

Not all examples of Chavín art can be assigned to their proper phase in our present state of knowledge; only ones which happen to have some features which we can recognize as significant for chronology can be placed in the sequence. Naturally, the more complex and elaborate a Chavín design is the more likely it is to contain features which we can use for dating. The simple pieces are more likely to be difficult to handle. Nevertheless, for purposes of understanding Chavín art it is not necessary to be able to place every piece. What we need is enough of a sequence so that we can see what kinds of changes took place in the style, and that much is now available.

Convention and Figurative Expression

Chavín art is basically representational, but its representational meaning is obscured by the conventions which govern the Chavín style and, in many cases, by the fact that representational details are not expressed literally but in a figurative or metaphorical fashion. These matters need to be explained before we can ask what Chavín artists were trying to represent.

The most important conventions affecting the understanding of representation in Chavín art are symmetry, repetition, modular width, and the reduction of figures to a combination of straight lines, simple curves, and scrolls. Except for the tenon heads at Chavín, some figures modeled in clay at Mojeque, and a few stone mortars, conceived in the round, the task Chavín artists set themselves was to produce a linear design on a surface which was either flat or treated as if it were flat. The conventions must be seen in this context.

The symmetry of Chavín designs is generally bilateral with relation to a vertical axis. There are a few Chavín designs both halves of which are exactly alike, but more commonly there is some difference; for example, the head of a figure may be shown on the main axis but in profile, or a full-face figure may hold different objects in his hands. It seems to be the balance of the design which is most important. Individual figures shown entirely in profile are not symmetrical, but there was a tendency to put figures facing one another so as to achieve symmetric balance by grouping instead of within each figure.

The repetition of details or even whole figures in rows is very characteristic of Chavín design and gives it a certain rhythm. When details are repeated they are as nearly identical as space will permit, while when whole figures are repeated the repetition need not be so mechanical. For example, the cornice of the Black and White Portal is ornamented with a frieze of standing birds (cf. Figs. 15 and 16). The birds are represented in profile and all face the center line of the Portal, the two middle ones standing beak to beak. All the birds are about the same general size and shape, but in details they vary by pairs. There are two alike, then two more, alike but

different from the first pair, and so on. Repetition of details became increasingly common in later Chavín art, and details came to be multiplied for the purpose of repetition without much regard for the requirements of the representation.

Modular width is an expression which Lawrence E. Dawson has suggested to designate a convention which is common to a number of art styles in ancient Peru. By the convention of modular width a design is composed of a series of bands of approximately equal width, and nonlinear features, such as eyes and noses, are accommodated to the modular framework as well. In Chavín art the bands tend to be adjacent and parallel, so that sections of a design look as though they had been drawn to follow parallel ruled guide lines, like the lines on ruled paper, a convention also found in the Paracas style, as we noted earlier. The accommodation of designs to modular banding became increasingly strict in late Chavín art, the curved lines of earlier designs being replaced in Phase EF by straight ones which interrupted the banding less. In earlier Chavín designs several different modular widths might be used for different parts of the design, thus providing variety; band width is more standard in the later phases.

The reduction of figures to a combination of straight lines, simple curves, and scrolls led to the representation of anatomical features as more or less geometric figures. The pelage markings of jaguars, for example, are represented as quatrefoils or cinquefoils and crosses. These figures are reasonable approximations of the shape of jaguar markings in nature, though of course no natural jaguar marking would have the sharp corners and straight sides of the cross the Chavín artists used to represent it. It would be easy to mistake such geometric figures for abstract elements used simply to embellish empty spaces if we had to interpret them on the basis of a single example. Comparing many pieces, however, we find these particular figures occurring repeatedly on cats, while they are absent on representations of birds, snakes, and people. It is this kind of consistency in context which enables us to decide between alternate possible interpretations in ancient art. A similar argument based on the observation of context in many examples enables us to conclude that small scrolls or curls were common conventions for hair and for the down on birds. Eyes may be represented by circles, ovals, lens shaped figures, or rectangles, and some intermediate forms are also found.

It is the figurative treatment of representations in Chavín art which has caused the most difficulty to modern observers. The question of why figurative expression was used in Chavín art is one which we can consider more profitably after we understand how it was used.

The type of figurative elaboration which is characteristic of Chavín art is one with which we are more familiar in literary contexts; it is a series of visual comparisons often suggested by substitution. To give a literary example, if we say of a woman that "her hair is like snakes," we are making a direct comparison (simile). If we speak of "her snaky hair" we are making an implied comparison (metaphor). We can go even further, however, and simply refer to "her nest of snakes," without using the word hair at all, and in this case we are making a comparison by substitution. In order to understand our expression the hearer or reader must either· share with us the knowledge that hair is commonly compared to snakes or infer our meaning from the context. Comparison by substitution was an especially fashionable device in Old Norse court poetry, and it was given the name "kenning" by the thirteenth century Icelandic

scholar Snorri Sturluson (1178-1241). This term, which implies that some knowledge or thought was required to understand the allusion intended, is appropriate and applies equally well to the comparisons by substitution in Chavín art.

Figurative expressions, of course, lose their force as they become familiar and commonplace, and they may end by being no more than synonyms for the literal statement. In order to maintain the figurative character of the discourse, fading figures need to be strengthened by elaboration or replaced by new ones. The weakening to which popular figurative expressions are subject thus provides a motivation for changes.

In Old Norse court poetry kenning became the chief basis on which verse was judged. The poets responded to this development in taste by devising ever more complex and far fetched kennings as well as increasing the frequency with which they used these figures. The elaboration of kennings was of two kinds, the kenning of kennings and the introduction of kennings which depended on a reference to a story which the hearers were assumed to know.

Both kinds of elaboration can be illustrated from the celebrated "Head-ransom" poem composed by Egil Skallagrímssonar in honor of Eric Bloodax, king of Northumbria, about the middle of the tenth century. An example of the kenning of kennings can be found in the fifth verse of Egil's poem where, in speaking of a battle, the poet says:

> The seal's field roared in wrath under the banners;
> There in blood it weltered about.[10]

"The seal's field" is a common kenning for the sea which would have been recognized immediately by Egil's audience. The sea, in turn, is a kenning for the attacking force, sweeping forward against the king's battle line as the sea sweeps in to break in confusion on the rocks. Neither the attacking force nor the sea to which it is being compared is mentioned directly in this figure. In another place in the same poem Egil refers to poetry as "Odin's mead," using a kenning which involves a reference to a story, in this case the old Norse legend of the origin of poetry, not told in this poem.

The same kind of development in the direction of increasing figurative complexity which we have described for Old Norse poetry took place also in Chavín art. Kennings became more numerous and more far fetched, and we can identify cases of the kenning of kennings. We cannot identify kennings referring to stories in any specific way, because the literary tradition is lost, but no doubt some of the figures which are difficult to interpret as simple visual comparisons are in fact kennings of this type.

The way in which kennings and other comparisons were used in Chavín art can be seen most clearly in earlier pieces in which the comparisons are still relatively simple. Let us examine a few of the more common comparisons.

A projecting appendage to the body may be compared to a tongue and hence shown issuing from the mouth of an extra face which is inserted in the body for the purpose. The tongue comparison is applied to the tail and feet of cat figures, the legs and feet of human figures, and the tail, wings, and feet of birds. Since an extended tongue would cover the lower jaw, the faces used in this comparison are agnathic; that is, the lower jaw is not shown. The extra faces may be represented either in front view or in profile. Sometimes, when a front view face would seem to be called for, we find instead two profile faces, drawn nose to nose, combining symmetry with repetition.

The same bodily appendages which are compared to tongues may be compared simultaneously to necks and provided with a face at or near the end in consequence. A long appendage, such as a tail, may have an agnathic face part way down its length from which the rest of the appendage issues as a tongue.

Smaller bodily appendages are usually compared to snakes, and in this case they usually issue directly from the body or from a simple ring in the earlier style. The hair and whiskers of cats are represented as snakes, and sometimes the ears as well. In bird representations the down on the head and the alula at the front of the wing may be shown in this way. Individual feathers usually end in faces, but it is not always clear whether they were thought of as representing snakes or simply as necks with a head at the end, snake heads not being always clearly distinguishable from other heads. On many of the tenon heads which represent human beings the hair is shown as snakes, and sometimes the long wrinkles of the face as well.

Another common kenning is the use of greatly elongated mouths, best described as continuous mouth bands, to mark the major structural lines of the body. In the earlier examples of Chavín sculpture this device is used only to mark the main axis of the body, the axis of the backbone, in representations of birds with the wings spread, and the continuous band has no eyes or nose associated with it. In later Chavín art the continuous mouth band was used more freely; for example, to mark the bony axis of bird's wings and the axis of the tail, and there is often a nose and an eye associated with it. The comparison intended by the continuous mouth band seems to be one between the strong but flexible structure of a chain of bones and the lines of teeth set in a pair of jaws.

The commonest figurative device in all of Chavín art is one in which the mouth of almost any kind of creature may be represented as the mouth of a snarling cat, with the teeth bared and long pointed canines overlapping the lips. The cat the artists had in mind was probably the jaguar, legendary throughout tropical America for its courage and strength, because most of the complete cat figures shown in Chavín art have jaguar pelage markings. The cat mouth appears not only in its natural context, in representations of cats, but also as the mouth of human figures, of snakes, and, most incongruously, of birds. Birds shown with the head in profile, in fact, often have not only a jaguar mouth but a complete cat face with nose and forehead marking, the bird's beak and cere being attached to the profile like an ill-fitting mask. All faces used to establish the kennings of tongues and necks have cat mouths, and the continuous mouth band is a cat mouth also, as indicated by the presence of long canines. The cat mouth is not universal in Chavín art, however; there are some representations of human beings which do not have it. It is interesting that these human figures also lack kennings entirely. Small snake heads used as kennings for hair or down also lack the cat mouth, although larger snake heads have it.

The logic behind the figurative use of the cat mouth in Chavín art is obscure. It is hard to see the cat mouth as a direct comparison, but on the other hand it has a very intimate association with the use of kennings, being used in all faces which establish kennings except for the small snake heads. Perhaps the most reasonable of several possible alternative explanations is that the cat mouth is used to distinguish divine and mythological beings from ordinary creatures of the world of nature, with the implication of a comparison between the power of the jaguar and supernatural power. If so, the cat mouth can be considered a kind of kenning also, although it differs from the others in that it involves a comparison of quality; it becomes an allegorical figure.

The solution we have proposed for the problem of interpreting the significance of the cat mouth in Chavín art is supported by the further consideration that there are some suggestions from the archaeological context of the art that it is associated with religious ritual. All of the sculpture at Chavín with known provenience which uses the cat mouth figuratively is temple sculpture, and the clay reliefs at Cerro Blanco in Nepeña have similar associations. One of the few lots of smaller objects in the Chavín style which has been found in some kind of association is a hoard of gold from the Hacienda Almendral, near Chongoyape, most of which is now in the Museum of the American Indian in New York.[11] The lot includes four crowns with elaborate designs, eleven ear spools and a pair of tweezers, an assemblage most reasonably interpreted as ritual paraphernalia. Both at Chavín and in the Chongoyape crowns the more prominent the main figure in a design is the more kennings (i.e., the more cat mouths) it has associated with it. Perhaps the use of kennings was even proportional to the supernatural importance of the figure involved.

The kennings we have discussed so far involve a single face for each kenning, and the faces themselves are treated more or less naturalistically. There is one comparison which involves a purely imaginative elaboration of figurative faces, however. Any long narrow feature such as a girdle or the body of a snake may be compared to a chair of connected profile faces; the girdle of the Great Image is a good example (Fig. 5). The faces in the chain have two interesting peculiarities. In the first place, they are what we can call "dual faces"; that is, each mouth has an eye and a nose on each side of it, so that the mouth may be seen as shared by two faces, each upside down with respect to the other. In the second place, the faces are joined to one another by the device of a continuous lip band which runs from one mouth to the next across the profiles of the faces.

The chain of faces was subject to further elaboration as the Chavín style developed. In later phases the part of the continuous lip band connecting different mouths across the profile of the face was interpreted as the lip of an agnathic mouth at right angles to the original ones, and it was supplied with the appropriate teeth. There was also some tendency to run the lip and teeth of single faces up over the profile, probably by analogy with the faces in the chains.

As early as Phase AB we find front view agnathic faces provided with a pointed tooth in the center as well as the usual canines on each side. The central tooth is a pure product of the imagination which can be based on no observation of nature and represents simply the triumph of Chavín ideas of symmetry over the symmetry of nature. The idea later spread to other contexts. In Phase C the central tooth appears on profile faces with lower jaws, and this usage becomes standard in Phase D. The central tooth projects downward from the upper jaw and rests against the lower lip.

Although the Chavín style is predominantly representational, as we have already noted, it does include a few abstract and purely decorative elements. On the Great Image, for example, a two-strand guilloche appears on the back and under the feet of the principal figure. In the latest phase of Chavín art an angular twined fret was developed out of the rounded guilloche, although guilloches also continued to be made. Another late development was the use of three-strand guilloches and twined frets as well as two-strand ones.

As early as Phase C the guilloche acquired a representational meaning in some cases, being used to represent the twined bodies of two snakes. The difference is, of

course, that such guilloches end in snake heads. Later the holes where the strands cross were supplied with eye pupils. Both of these developments represent reinterpretations of abstract shapes as representations, a type of reinterpretation made earlier by the fact that Chavín artists were accustomed to using geometric figures as representations of features of nature.

Abstract elements are, on the whole, commoner in the later sculpture from Chavín than in the earlier, and commoner on pottery than in sculpture. Some of them seem to be derived from earlier representational figures which came to be used out of context and were sufficiently ambiguous as figures so that their representational meaning was easily lost or ignored. For example, a simple figure like an S lying sideways is very common in later Chavín pottery and occurs also in later sculpture. It appears to be derived from a representation of an eyebrow with a curled end which is common in the earlier sculpture. An intermediate form appears on the bodies of the Phase AB cat figures which ornament the cornice on the southwest corner of the temple at Chavín (Fig. 17). Here the S figure has a round eye in each end, and neither eye is in context as the eye of a face. The case of the S figure is, of course, the converse of that of the guilloche.

It should ultimately be possible to write a kind of grammar of Chavín art which would provide a complete explanation of the conventions and kennings of even the most complex of the later designs. The observations offered here fall far short of such a grammar, but they should be sufficient to enable the reader to make intelligent observations of his own when he looks at Chavín designs, and that is the purpose of the present survey.

Representational Meaning

Once we are able to recognize the elements in Chavín designs which are figurative or which represent purely decorative elaboration we can look behind such elements for the underlying representational meaning of the figures. For the most part, each figure is a separate problem; most Chavín compositions consist of a single principal figure which stands or acts alone, although it may have smaller subsidiary figures associated with it. The subsidiary figures are arranged according to the dictates of symmetry, however, and the arrangement does not necessarily reflect any narrative meaning.

When one learns to see through the figurative elaboration of Chavín designs, a surprising proportion of them turn out to be representations of natural bird, animal, and human forms. Since most of these forms are supplied with cat mouths and other kennings, they are presumably the forms of supernatural beings, but the point is that they are seldom monstrous forms. Beings which are part human and part animal in form do occur in Chavín art, as we shall see, but they are much less common than is generally supposed.

The commonest natural forms represented in Chavín art are birds which can be identified as eagles and hawks. The recognizable features which permit this identification are the strong raptorial feet, the short, sharply hooked beak with a prominent cere over it containing the bird's nostril, and the fact that the birds are always shown with down or feathers on the head and sometimes under the chin as well. Hawks are distinguished by having a decorative line on the face curving back from the base of the eye, a convention for the cheek marking of natural hawks; eagles lack this marking. Contrary to widespread belief, there are no representations of condors in

Chavín art. The figures which have been mistaken for condors are figures of eagles or hawks. The error originated in a misinterpretation of the Chavín convention for the cere with a nostril in it; this convention is a simple scroll at the top of the beak, and it was mistaken for a representation of the peculiar caruncle which projects above the beak of the male condor. Condors have no feathers on their heads, however, and do not have raptorial feet.[12]

Representations of cats are not particularly abundant in Chavín art and are virtually restricted to Phases AB and C. In most cases there is no question that the cat represented is a jaguar, the identification being given by conventionalized jaguar markings. On the cornice slab preserved at the southwest corner of the new temple at Chavín, however, there are two figures of cats, without the standard jaguar markings, which may be intended to represent pumas (Fig. 17).

Representations of other animals are very rare as principal figures in Chavín compositions. At Chavín itself, there are two snakes on the same cornice slab with the "pumas," and one representation of a monkey, one of a bat, and one which may possibly be intended for a viscacha, these last three being on flat relief slabs originally set into a wall.[13] Representations of crabs are fairly common on the coast but have not been found in the sierra.[14] Fish occur only as secondary figures, but they are quite common in that context. It is interesting that there are no representations of food animals, such as the deer, guanaco, and guinea pig, and none of several other animals which are common subjects in other Peruvian art styles, such as the fox, the lizard, and the frog. Plants and vegetable products are rarely shown in Chavín art and then only as secondary figures.

The sculptured animal figures at the Chavín temple occur in three contexts, on cornices, on rectangular relief slabs made to be set in a wall, and in the form of tenon heads. In all three cases they serve as architectural decoration and are not given such emphasis that there is any reason to think that they may have served as cult figures. The eagles and jaguars which predominate on the cornices may have been thought of as supernatural beings which served the gods, but they were clearly not deities themselves. The other animals less commonly shown are perhaps figures from mythology.

There are a few representations of men from the Chavín area which have no figurative elaboration of any kind. They are all on fairly small slabs and may also have served as architectural decoration. The most interesting one shows a man carrying a spear thrower and three darts in his left hand and a trophy head in his right (Fig. 20). Perhaps a quarter of the tenon heads from the temple at Chavín represent human heads shown without kennings; there are also some which have natural mouths but hair and facial wrinkles kenned as snakes.[15]

Figures with a human or animal form depicted with elaborate kennings are the ones most likely to represent deities or important mythological beings, and our confidence that they do is increased by the contexts in which such figures occur.

There is only one animal figure which is represented in Chavín art in such a way as to suggest that it might be a deity or important mythological figure, and that is the alligator, or more properly cayman, which is represented on the so-called "Tello Obelisk" (Fig. 6) and in two other sculptures, a granite frieze found at the foot of the Monumental Stairway at Chavín (Fig. 19) and a relief from Yauya (Fig. 18). In all three cases the caymans are shown with elaborate kennings, and in two of them

accompanied by subsidiary figures. The "Tello Obelisk" is a rectangular shaft, carved on all four sides, and is more likely to have been a cult object than a simple piece of architectural decoration. The caymans are represented with fish tails, but this mythical detail may be no more than a misunderstanding on the part of artists who were not personally familiar with their subjects, caymans occurring only at a much lower altitude.

The Great Image in the interior of the old temple at Chavín certainly served as a cult object, and the principal figure shown on it can be taken to represent a deity. This figure (Fig. 5) is human in form, apart from a moderate amount of figurative elaboration. The deity of the Great Image is represented standing, with his left arm at his side and his right arm raised. The hands are open and hold nothing. He wears ear pendants, a necklace, and apparently a tunic and girdle. His hair is kenned as snakes and his girdle as a chain of faces.

The most peculiar feature of this figure is the mouth, which is very large, has the corners turned up, and is provided with upper canines only. Ordinary human figures have mouths of more modest proportions, the corners of which are either straight or turned down, while the ordinary figurative cat mouth has both upper and lower canines. The peculiar features of the mouth of the Great Image are paralleled in three tenon heads belonging to an early phase of the Chavín style.[16] In the tenon heads, however, the mouth is agnathic and has no teeth in it, while the mouth of the Great Image does have teeth, together with a lower lip and a lower jaw. The teeth and lower lip seem out of context here, and on close observation it can be seen that they do not fit. The artist's conception of the deity he was representing may have demanded this incongruous combination, but it is also possible that the figure was first carved with a toothless agnathic mouth and then the teeth and lower jaw added.

A later representation of the same deity has also been found at Chavín on a beautifully finished relief slab found in a corner of the small patio in front of the Black and White Portal (Fig. 21). The identification is based primarily on the mouth, which is large and has upturned corners, large backswept upper canines and no lower ones. This figure also has ear pendants which look as though they were copied from those of the Great Image. The figure on the relief slab holds a large spiral shell in the right hand and what appears to be a *Spondylus* shell in the left.[17] Shells such as these were common offerings in ancient Peru in many periods, and those which the deity holds very likely represent the offerings he expected from his worshippers. This cheerful deity deserves a name, and I propose to call him the Smiling God.

We were able to identify the Smiling God as a deity because the Great Image, which represents him, is clearly a cult object. There are some other figures represented in the temple at Chavín which occur in such contexts that we can recognize them as lesser supernatural beings; these are the figures represented on the columns which flank the doorway in the Black and White Portal (Figs. 8 and 9). These columns are working architectural members and hence unlikely to have served as cult objects. Each column is ornamented with one great figure in low relief, and each figure has the body, legs, and arms of a man, but the head, wings, and claws of a bird of prey. The bird attributes of the figure on the south column are those of an eagle, while the figure on the north column has the cheek markings of a hawk. The figures are standing, and each holds what is apparently a sword club across his body. Both figures are represented with elaborate kennings, those of the eagle figure being

somewhat the more elaborate of the two. The position of the columns suggests that these figures represent supernatural beings stationed to guard the entrance to the temple, "angels" in the original sense of the word; that is, supernatural messengers and attendants of the gods.

The guardian angels of the Black and White Portal were specifically the attendants of the god who was worshipped in the new temple, presumably the same one who had been worshipped in the south wing of the old temple. As we remarked earlier, his cult image has not been found, but it possible to argue that we have other representations of him. There are two parts to the argument, the first involving the Raimondi Stone and the second a gold plaque in the Museo Rafael Larco Herrera in Lima.

The Raimondi Stone is a beautifully finished granite slab carved with a figure in relief which is so elaborated with kennings as to suggest that it represents a deity (Fig. 10). It was found in the ruins of the temple of Chavín about 1840, but no record of the precise location was made; it has been exhibited in Lima since 1874.[18] The slab is 198 cm. long and 74 cm. wide, making it the largest relief slab showing a single figure which has been found at Chavín. The deity represented on it is a being of human form standing in full face position and holding a vertical staff in each hand. He is not the Smiling God, because he has a mouth with turned down corners and is provided with both upper and lower canines. Furthermore, he lacks ear pendants, although this feature is not necessarily as significant as the mouth treatment and the position holding two staffs. Let us call him the Staff God. The Raimondi Stone was meant to be set vertically, no doubt in a wall. The figure of the deity takes up only the lower third of its total height, the rest of the length of the stone being filled with extraordinarily elaborate figurative treatment of the Staff God's hair in which a common late kenning, hair compared to a tongue coming out of a mouth, is multiplied by repetition to fill the space. The figure of the god could not be elongated to fill the slab, because to do so would violate accepted canons of proportion of the human body, and the multiplication of hair kennings was an ingenious solution to the artist's problem of making the representation of the god fit the stone.

The Raimondi Stone is carved with the same care and has the same unusually fine finish as the relief slab from the terrace setback which represents the Smiling God. The relation between the latter slab and the Great Image seems to be that the slab, which is later in style than the cult image, serves the purpose of providing a representation of the Smiling God out in the open on a wall of the temple where worshippers who would not be admitted to the inner sanctum where the original image was could see it. The first part of my argument is that the Raimondi Stone is an analogue of the slab representating the Smiling God and thus a representation of another image worshipped in the interior of the temple. Since the Raimondi Stone is the larger of the two slabs and the kennings on it are more elaborate, it should represent a deity which, at the late period when the Raimondi Stone was carved, was more important than the Smiling God. The deity of the new temple was the one at Chavín who became more important than the Smiling God, so the Staff God should be the deity of the new temple.

The gold plaque in the Rafael Larco Herrera Museum which figures in the second part of the argument lacks provenience but is in a pure and relatively late Chavín style (Fig. 23). It represents a figure which, from its pose and treatment of the mouth, we can recognize as the Staff God of the Raimondi Stone without the elaborated figurative

treatment of the hair. To right and left of the Staff God are abbreviated figures of attendant angels which combine human and bird attributes like the angels on the columns at Chavín. The combination on the plaque suggests that the angels shown on the columns are specifically attendants of the Staff God. If so, the Staff God belonged in the temple behind them.

The Staff God was clearly more than just a local divinity at Chavín, for we find him represented also in gold on one of the crowns from the Almendral hoard at Chongoyape and on two pieces found in the territory of the Paracas style, at Ica. One of the pieces from Ica is a painted textile in the collection of Michael D. Coe in New Haven,* and the other is a ritual gourd cup, in the Paracas style but under heavy Chavín influence, in the collection of Paul Truel in Ocucaje (Fig. 22).[19] In later Andean religion gods who were worshipped so widely were nature gods, all others being of local or regional importance. If, as seems likely, this fundamental distinction was an old one in Peru, the Staff God was probably a nature god. His association with eagles and hawks in the temple at Chavín suggests that he was a sky god, but that is as far as our archaeological evidence will take us. Perhaps he was a god of Thunder, like the Inca deity Illapa, who was pictured as a man holding a club in one hand and a sling in the other. There is no particular reason to think that he was a creator god.[20]

The Staff God is the only deity of Chavín religion whom we can recognize on the basis of present evidence as having more than local importance. The other gods we have been able to identify, the Smiling God and the cayman deity, are not known outside of the area around Chavín. An image found at La Copa perhaps represents another local deity of this type.[21] It should be remembered, however, that the evidence we have is still very fragmentary, and that future work may bring to light many other Chavín gods, some of whom may prove to be as widely popular as the Staff God.

We have now discussed the representational meaning of most of the complete figures which appear in Chavín art. There are also many abbreviated figures, the meaning of which is much less clear, particularly on pottery and gold ornaments. These abbreviated figures include human, cat, bird, and snake heads or simply generalized agnathic faces, and individual features out of context, such as eyes, hands, feathers, jaguar markings, and dotted circles which represent snake markings. We can usually recognize a bird head as a bird head, for example, when we find it on a Cupisnique bottle from the north coast, but we cannot yet tell whether the abbreviated figure is purely decorative or whether it is intended to convey also some religious meaning.

In spite of the problems that remain, we are now in a position to look at Chavín art with some understanding as well as to appreciate its purely aesthetic value. It is a religious art, but it is also a highly intellectual one, produced for people who were willing to have their minds challenged as well as their emotions. For us who approach Chavín art without knowing the language, the religious ideas, or the mythology of the men who made it, the problem of understanding what they meant to say is indeed comparable to the problem of deciphering an unknown script.

The Sequel

The Chavín style came to an end about 300 B.C., but we know little as yet about

*Editors' Note: Now in Dumbarton Oaks, Washington, D.C.

the attendant circumstances. Perhaps its spread had been associated with military conquest and the central power collapsed, or perhaps a movement for religious reform developed and brought with it a simpler style. Perhaps the style itself simply became more and more abstract, so that the old rules disintegrated. At any rate, come to an end it did, and there followed a period characterized by the development of many distinctive local styles in the area which the Chavín style had once dominated. The Chavín style must have left some sort of a tradition, however, as Roman art left a tradition in the Middle Ages, because we find both imitations and derivatives of it in later times. Imitations of Chavín style are particularly prominent in the pottery style of Moche, while deities in the pose of the Staff God are found in the Middle Horizon religious art of Huari and Tiahuanaco.

The Moche style flourished on the coast between Pacasmayo and Nepeña, an important part of the old Chavín area, between about A.D. 1 and A.D. 850. The finest Moche pottery was naturalistically modeled or painted with lively narrative scenes executed in dark red on a cream background. Some of the scenes are clearly derived from myths, and a prominent figure in them is a personage with a human head but a jaguar mouth. His exploits remain to be studied in detail, but he appears in contexts which suggest that he may have been a culture hero.[22]

The shapes of the finer vessels in the Moche style and its emphasis on naturalistic modeling appear to represent a deliberate revival of the corresponding features of the Cupisnique style, the local variety of the Chavín style of pottery. This revival followed a period of some centuries during which the pottery of this area was quite different. In the third phase of the Moche style there are also a number of vessels which are decorated with remarkably faithful imitations of Chavín incised designs.[23]* There is no question about the date and associations of these pieces, for several of them have been found in graves with ordinary Moche style pottery, and they display some characteristic Moche features mixed with the revived Chavín ones.

The Huari and Tiahuanaco styles of the Middle Horizon flourished about A.D. 580 to 930, the first in Peru and the second in northern Bolivia and neighboring areas. The two styles display variants of a common tradition of religious art the immediate origins of which are obscure. The Huari and Tiahuanaco styles have as one of their most prominent deity subjects a full face figure of human form holding two staffs, like the Staff God of Chavín. In fact, it seems likely that all deities in these styles were depicted in the Staff God pose. In the Huari style, but not at Tiahuanaco, deity figures have a jaguar mouth.[24] In both styles deities may be accompanied by attendant angels, sometimes with the heads of hawks.[25] These resemblances to Chavín are of a different sort from those of Moche, however; they represent a transmission of particular religious conventions. There are no known Huari or Tiahuanaco pieces which show an attempt to imitate the actual Chavín manner, like the attempt made by the Moche potters. One way or another, however, it is evident that Chavín art and Chavín religion cast a long shadow in ancient Peru.

*Editors' Note: See Rowe 1971, "The Influence of Chavín Art on Later Styles." *Dumbarton Oaks Conference on Chavín*. Elizabeth P. Benson, ed. Washington, D.C.

Notes

[1]This study is a revision, written in 1967, of a paper originally written for a publication of the Museum of Primitive Art of New York (Rowe, 1962). The illustrations provided are a different selection from those which appeared with the 1962 version, and a selection which I believe is more appropriate to the text. Except as specifically acknowledged in the text, the ideas and interpretations presented here are my own and are based on direct examination of the original evidence.

My research on Chavín art was supported in part by a grant from the National Science Foundation. This study incorporates also data gathered on a trip to Peru in 1961, the expenses of which were met by grants from the American Philosophical Society and the University of California. Further data were gathered on another trip made in 1963 under the auspices of the University of California. It is a pleasure to acknowledge the hospitality and generous guidance provided by the Archaeological Commissioner at the ruins of Chavín, Marino Gonzáles Moreno, whose skillful and meticulously documented excavations, beginning in 1954, have thrown a flood of new light on Chavín architecture and sculpture. This study is dedicated to him in respect and admiration. I am also very grateful to Drs. Manuel Chávez Ballón and Jorge C. Muelle for information regarding their research at Chavín and to Toribio Mejía Xesspe and Julio Espejo Núñez for putting the Tello collections at the National Museum of Anthropology and Archaeology at my disposal.

The unsigned drawings are the work of the following illustrators: Zenon Pohorecky (Figs. 10, 11, 15, 16); Janet C. Smith (Figs. 6, 7, 8, 9, 12, 18); and Robert Berner (Figs. 1, 14, 17, 19).

[2]This definition follows the one proposed by Gordon R. Willey in 1951 (p. 109). Willey's paper is a valuable guide to the earlier literature on Chavín and the Chavín style. The most important subsequent contribution to the subject is J.C. Tello's report on Chavín, written between 1940 and 1946 but not published until 1960. It includes a catalogue of the Chavín sculpture known before 1945.

[3]Menzel and others, 1964.

[4]See also Rowe, 1962, Figs. 1, 3, 9, 10. The columns were found fallen and have been set up one step below their original position and further apart.

[5]For other illustrations of this monument see Rowe, 1962, Fig. 6; Tello, 1923, Fig. 72 and Plate I; Tello, 1960, Fig. 31. It is now in Lima, where I made a rubbing of it in 1961 which was the basis of the drawing presented here.

[6]See also Bennett, 1942, Fig. 3; Tello, 1943, Plate XXII; Valcárcel, 1957, Figs. 6 and 7; Tello, 1960, Figs. 36, 64, 66-67.

[7]Tello, 1960, Fig. 69 (Bennett, 1942, Fig. 24), and Tello, 1960, Figs. 60 and 70. The piece illustrated by Tello, 1960, Fig. 53, from the ruins of Qotus ("Gotush") on the opposite bank of the Mosna River, probably belongs to this phase. The piece illustrated by Tello, 1960, Fig. 52, is another fragment of the same monument as that shown in Fig. 53, or of another one very much like it.

[8]For Cerro Blanco, Nepeña, see Means, 1934, pp. 100-105; Tello, 1943, Plate XIIIa (a reconstruction). I have cited the lintel from La Copa on the basis of a drawing published by Carrión Cachot, 1948, Fig. 17.

[9]For the mortar, see Rowe, 1962, Fig. 33; for the spoon, Lothrop, 1951, Fig. 74d.

[10]Text from Gordon, 1957, pp. 112-114; my translation.

[11]Lothrop, 1941, pp. 251-258.

[12]This argument is an extension of one published by Yacovleff, 1932. The identification of the birds at Chavín as condors was first made by J.C. Tello in 1923.

[13]There is a good photograph of the snakes in Izumi, 1958, p. 7, top. For illustrations of the bat and the "viscacha" see Rowe, 1962, Figs. 12 and 13. It was Marino Gonzáles who suggested the possibility that the last might be a viscacha. The lack of detail makes a positive identification of this animal particularly difficult.

[14]Kroeber, 1944, Fig. 5A, from Supe, is the clearest example.

15For reliefs of human figures, see Tello, 1960, pp. 245-250; for tenon heads see his pp. 259-263 and 268-283. Compare also Rowe, 1962, Fig. 5.

16Tello, 1960, Figs. 90-92.

17The identification of the object in the left hand of the deity was suggested by Junius B. Bird. I had thought previously that it might represent a bunch of flowers, but this interpretation is most improbable, since there are only two "stems" corresponding to three "flowers." This representation of a *Spondylus* shell is unique in known Chavín art, and unique representations are always the most difficult ones to identify in so conventionalized a style.* Spiral shells are more common; there is another one with a face on the "Tello Obelisk," Fig. 7, A-21, for example.

18Polo, 1899, p. 195.

19See also Tello, 1959, Figs. 31 and 33. The textile from the Coe collection is published in Rowe, 1962, Fig. 29.

20On the late origin of Creator worship among the Incas, see Rowe, 1960.

21Carrión Cachot, 1948, Plate XX.

22For examples, see Schmidt, 1929, pp. 160-168, 176-177, 202 and 204.

23Kroeber, 1926, Figs. 3 and 4, are pieces from Moche III burials.

24Kelemen, 1943, Vol. II, Plate 165.

25Posnansky, 1945, Vol. I, Plates XLV-L.

*Editors' Note: Rowe has since identified a *Spondylus* shell carving on a ceiling slab from the Vigas Gallery at Chavín (see Lumbreras y Amat 1965-1966 "Informe Preliminar Sobre Las Galerías Interiores De Chavín." *Revista del Museo Nacional*, vol. 33-34: Lamina XIa, Lima. In addition, the senior editor has identified two anthropomorphized *Spondylus* shells on Chavín textiles from Ica. Finally, a zoomorphized *Spondylus* appears on the Tello Obelisk (Rowe Fig. 7, A2).

Bibliography

Ayres, Fred D.
 1961 "Rubbings from Chavín de Huántar, Peru." *American Antiquity*, vol. 27, no. 2, October, pp. 238-245. Salt Lake City.

Bennett, Wendell Clark
 1942 "Chavín Stone Carving." *Yale Anthropological Studies*, vol. III. New Haven.

 1944 "The North Highlands of Peru; Excavations in the Callejón de Huaylas and at Chavín de Huántar." *Anthropological Papers of the American Museum of Natural History*, vol. 39, part 1. New York.

 1954 *Ancient Arts of the Andes*. The Museum of Modern Art. New York.

Buse, Hermann
 1957 *Huaras-Chavín*. Juan Mejía Baca and P.L. Villanueva, Editores. Lima.

Carrión Cachot, Rebeca
 1948 "La Cultura Chavín; dos Nuevas Colonias: Kuntur Wasi y Ancón." *Revista del Museo Nacional de Antropología y Arqueología*, vol. II, no. 1, primer semestre, pp. 99-172. Lima.

Engel, Frédéric
 1956 "Curayacu—a Chavinoid Site." *Archaeology*, vol. 9, no. 2, June, pp. 98-105. Brattleboro.

Gordon, Eric Valentine
 1957 *An Introduction to Old Norse*. Second edition, revised by A.R. Taylor. At the Clarendon Press, Oxford.

Izumi, Yasuichi
 1958 "Andesu no iseki." *Mizue*, no. 22, Winter quarter, Supplement. Tokyo.

Kelemen, Pál
 1943 *Medieval American Art; A Survey in Two Volumes.* The Macmillan Co., New York.

Kinzl, Hans, and Erwin Schneider
 1950 *Cordillera Blanca (Perú)*. Universitäts-Verlag Wagner, Innsbruck.
Kroeber, Alfred Louis
 1926 "Archaeological Explorations in Peru. Part I: Ancient Pottery from Trujillo." *Field Museum of Natural History, Anthropology, Memoirs*, vol. II, no. 1. Chicago.
 1944 *Peruvian Archaeology in 1942*. Viking Fund Publications in Anthropology, number four. New York.
Lothrop, Samuel Kirkland
 1941 "Gold Ornaments of Chavín Style from Chongoyape, Peru." *American Antiquity*, vol. VI, no. 3, January, pp. 250-262. Menasha.
 1951 "Gold Artifacts of Chavín Style." *American Antiquity*, vol. XVI, no. 3, January, pp. 226-240. Menasha.
Means, Philip Ainsworth
 1934 "Des Commentaires sur l'Architecture Ancienne de la Côte Péruvienne." *Bulletin de la Société des Américanistes de Belgique*, no. 14, aout, pp. 75-110. Bruxelles.
Menzel, Dorothy, and others
 1964 "The Paracas Pottery of Ica; a Study in Style and Time," by Dorothy Menzel, John H. Rowe, and Lawrence E. Dawson. University of California Publications in *American Archaeology and Ethnology*, vol. 50. Berkeley and Los Angeles.
Polo, José Toribio
 1899 "La Piedra de Chavín." *Boletín de la Sociedad Geográphica de Lima*, año IX, tomo IX, nos. 4-6, 30 de septiembre, pp. 192-231; nos. 7-9, 31 de diciembre, pp. 262-290. Lima.
Posnansky, Arthur
 1945 *Tihuanacu, la Cuna del Hombre Americano; Tihuanacu, the Cradle of American Man*. I-II. J.J. Augustin, Publisher. New York.
Rowe, John Howland
 1960 "The Origins of Creator Worship Among the Incas." *Culture in History; Essays in Honor of Paul Radin*, edited by Stanley Diamond, pp. 408-429. Published for Brandeis University by Columbia University Press. New York.
 1962 *Chavín Art; An Inquiry Into Its Form and Meaning*. The Museum of Primitive Art. New York.
Schmidt, Max
 1929 *Kunst und Kultur von Peru*. Im Propyläen-Verlag zu Berlin.
Tello, Julio César
 1923 "Wira Kocha." *Inca*, vol. I, no. 1, enero-marzo, pp. 93-320; no. 3, julio-septiembre, pp. 583-606. Lima.
 1943 "Discovery of the Chavín Culture in Peru." *American Antiquity*, vol. IX, no. 1, July, pp. 135-160. Menasha.
 1959 *Paracas. Primera parte*. Publicación del Proyecto 8b del Programa 1941-42 de The Institute of Andean Research de New York. Empresa Gráfica T. Scheuch S.A. Lima.
 1960 "Chavín; Cultura Matriz de la Civilización Andina." Primera Parte. Publicación *Antropológica del Archivo* "Julio C. Tello" de la Universidad Nacional Mayor de San Marcos, vol. II. Lima.
Valcárcel, Luis Eduardo
 1957 "Nuevos Descubrimientos Arqueológicos en el Perú: Chavín." *Cuadernos Americanos*, año XVI, vol. XCIII, no. 3, mayo-junio, pp. 180-184. México.
Willey, Gordon Randolph
 1951 "The Chavín Problem: A Review and Critique." *Southwestern Journal of Anthropology*, vol. 7, no. 2, Summer, pp. 103-144. Albuquerque.
Yacovleff, Eugenio
 1932 "Las Falcónidas en el Arte y en las Creencias de los Antiguos Peruanos." *Revista del Museo Nacional*, tomo I, no. 1, pp. 33-111. Lima.

326

Figure 1. Location of some archaeological sites of the Chavín and Paracas cultures. White circles, Chavín sites; black circles, Paracas sites.

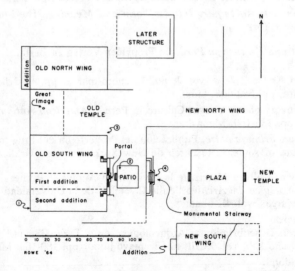

Figure 2. Plan of the ruins of the temple of Chavín, surveyed in 1963 by J.H. Rowe and Marino Gonzáles Moreno. The numbers indicate the places where some of the sculptures were found: 1, the cornice ornamented with felines and serpents, fig. 17; 2, the relief of the Smiling God, fig. 21; 3, the cornice ornamented with an eagle discovered in 1919, fig. 12, and fragments of other similar cornices discovered in 1958, fig. 13; 4, relief ornamented with caymans, fig. 19.

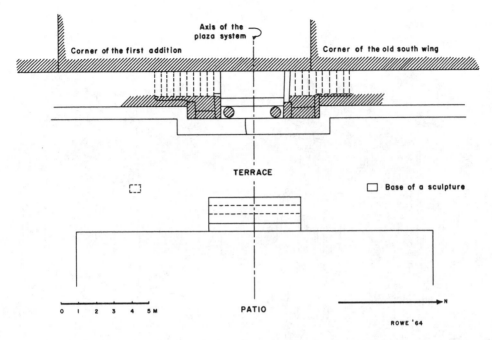

Figure. 3. Plan of the Black and White Portal. The dashed lines indicate details reconstructed in the drawing.

Figure 5. Side view of the Great Image, based on a photograph made by Abraham Guillén. Phase AB.

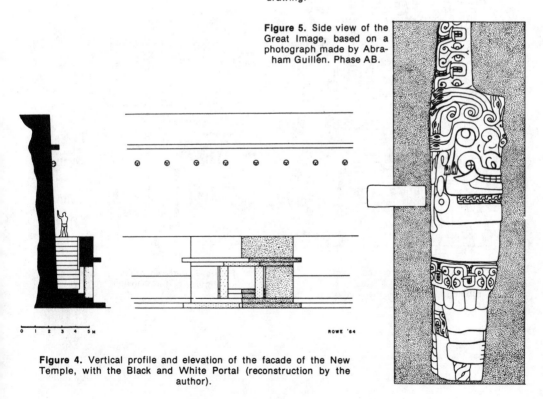

Figure 4. Vertical profile and elevation of the facade of the New Temple, with the Black and White Portal (reconstruction by the author).

328

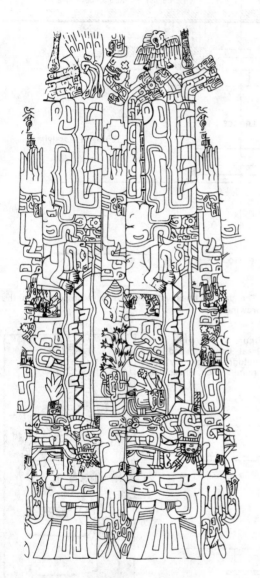

Figure 6. Roll-out of the reliefs on the ''Tello Obelisk'' based on rubbings made by the author. Phase C.

Figure 7. Reference key to the figures on the ''Obelisk.''

329

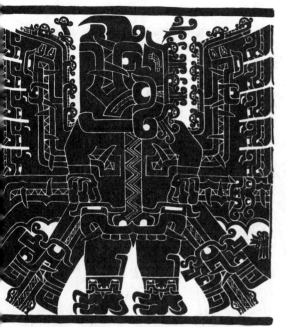

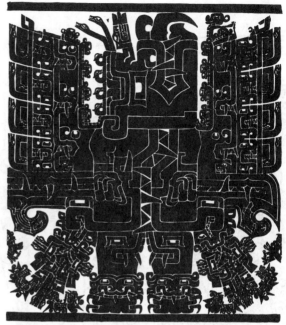

Figure 8. Roll-out and reconstruction of the guardian angel figure from the north column of the Black and White Portal. This angel has the facial markings of a hawk. The drawing is based on a rubbing by Fred D. Ayres (Rowe, 1962, fig. 10) and on rubbings and drawings by the author. Phase D.

Figure 9. Roll-out and reconstruction of the guardian angel of the south column of the Black and White Portal, with the face of an eagle. The drawing is based on a rubbing by Fred D. Ayres (Rowe, 1962, fig. 10) and on rubbings and drawings by the author. Phase D.

Figure 10. The Raimondi Stone, ornamented with a representation of the Staff God. The drawing is based on a photograph taken by Abraham Guillén and on a squeeze made by Max Uhle. Phase EF.

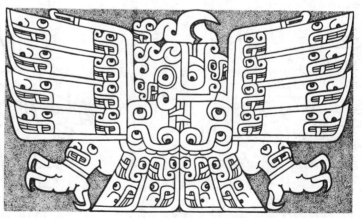

Figure 11. Early style eagle reconstructed on the basis of fragments of a cornice found near the southeast corner of the New Temple (second addition). Another fragment with the same figure was found in front of the east face of the old south wing. Phase AB.

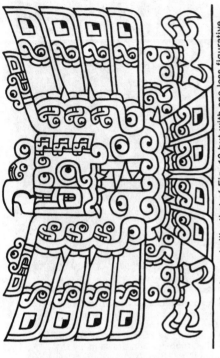

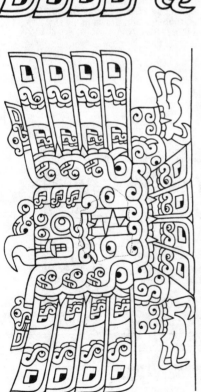

Figure 13. An eagle like that of Fig. 12 but with one less figurative element in the wings. Reconstruction on the basis of fragments of a cornice discovered in 1958 near the place marked 3 on the plan (Fig. 2). Probably a contemporary with Fig. 12.

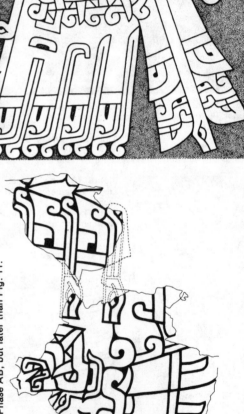

Figure 15. Profile hawk from the cornice of the Black and White Portal. Phase D.

Figure 12. Eagle represented on a cornice found in 1919 at the place marked 3 on the plan (Fig. 2), reconstructed on the basis of what remains of the original and of a plaster cast in the Museo Nacional de Antropología y Arqueología, Lima. The body of the eagle, destroyed in the original (dashed outline), has been reconstructed to agree with the fragments of similar eagles found in 1958 (see Fig. 13). Phase AB, but later than Fig. 11.

Figure 14. Fragment of an eagle of a late style from a cornice stone found at the northeast corner of the old south wing of the temple of Chavín. Phase D.

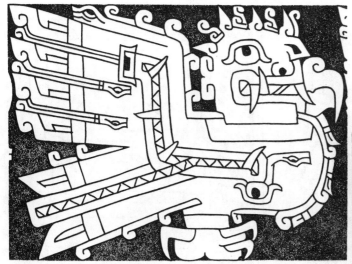

Figure 16. Profile eagle from the cornice of the Black and White Portal. Phase D.

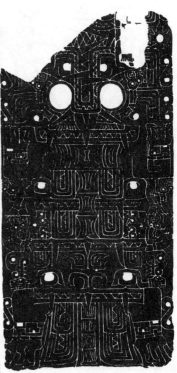

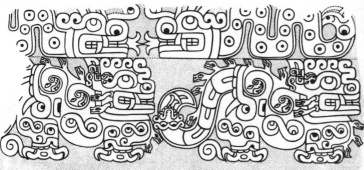

Figure 17. Felines and serpents from the cornice at the southwest corner of the New Temple (no. 1, fig. 2), drawn on the basis of a rubbing made by the author. The felines are on the under side of the cornice and the serpents on its edge. Phase AB.

Figure 18. Roll-out of the figures of a relief found in Yauya. The figures are an almost complete mythical cayman and part of the nose of a second one. The drawing is based on a rubbing made by Fred D. Ayres (Rowe, 1962, fig. 31).

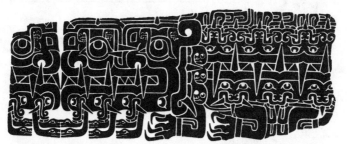

Figure 19. Reconstruction of the figures ornamenting two fragments of a granite lintel found in 1962 at the foot of the Monumental Stairway (no. 4, fig. 2). Two profile caymans are represented. The reconstruction is based on two rubbings and a photograph of the original.

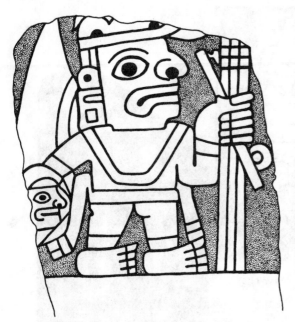

Figure 20. Figure of a warrior which formed part of a frieze of similar figures. The drawing is based on a rubbing made by the author.

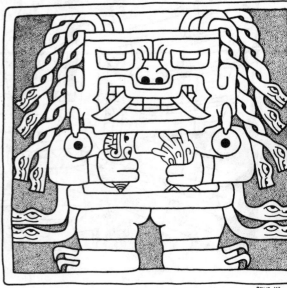

Figure 21. Representation of the Smiling God from a slab found in the patio of the New Temple (no. 2, fig. 2). The drawing is based on a rubbing made by the author. Phase D.

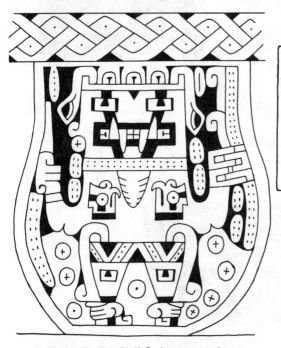

Figure 22. The Staff God represented on a pyroengraved gourd found in a Paracas tomb in the Ica Valley. The gourd is in the Paul Truel Collection. Drawing by L.E. Dawson and the author.

Figure 23. The Staff God represented on a gold plaque without provenience in the Museo Arqueológico "Rafael Larco Herrera," Lima. The inlays which decorated the original are missing. Drawing on the basis of a photograph in the Museum of Modern Art, New York (Rowe, 1962, fig. 27).

Gifts of the Cayman:
Some Thoughts on the
Subsistence Basis of Chavín

Donald W. Lathrap

Introduction

About a third of the essays in this volume* address themselves to the problem of the origin and spread of efficient agricultural systems. This unity of theme was not in any way encouraged by the editor, it just happened; but the popularity of this subject with our authors is certainly an indication that the field of study, so aptly designated by Carl O. Sauer as "Agricultural Origins and Dispersals," is now a fashionable one, and one in which much exciting work is being accomplished.

I wish to enter a cautionary note about certain ideas which are still widespread today, and which in many instances are accepted as axioms or articles of faith by those studying agricultural origins. There is a strong tendency to equate agricultural origins with the appearance of seed crops in the relatively arid regions of the world, at least regions with a marked dry season; and to treat the appearance of agriculture as a response to or at least a concomitant with the progressive desiccation of various areas of the world which started at the end of the Pleistocene.

It is true that in many areas of the world recent research has pushed the beginnings of seed crop agriculture back to near the Pleistocene-Holocene boundary and it is also true that the localized patterns of readjustment now demonstrated for many of the more arid regions fit a general model that people were in fact responding to the disappearance of game resources and the shrinking of zones of useful vegetation. None of these data, however, have a negative bearing on the hypothesis which Sauer so neatly formulated in his elegant little book *Agricultural Origins and Dispersals* (1952). Sauer argued that an effective adaptation to the riverine zone of the moist tropical forest, in Southeast Asia and in South America, is very old, and that within this adaption to the resources of the riverine flood plains there was considerable experimentation which tended to increase the availability of certain important plants. Some of these incipient cultigens were propagated by seed, but in a number of

*Editors' Note: This article originally appeared in *Variation in Anthropology* and it is to that work that this sentence refers.

Reprinted from *Variation in Anthropology*, 1971, by permission of the Illinois Archaeological Survey.

instances the most important crops were early brought under a regime of vegetative reproduction. Sauer has argued that this pattern of horticulture or incipient root crop agriculture is very old on the flood plains of the tropical forests; indeed he claims that it is older than the seed crop pattern in the semiarid zones of the Middle East or Mesoamerica.

It will always be infinitely easier to obtain direct evidence of seed crop agriculture in semiarid to arid regions than to extract evidence of root crop agriculture from the moist tropics. Those interested in studying the emergence of agricultural systems in the rain-forest zones must rely on various kinds of indirect evidence and must make the most of those rare instances in which actual plant remains are preserved. The task if formidable but is perhaps not as hopeless as indicated by Mangelsdorf's malignant review of Sauer's book:

> A theory almost completely lacking in factual basis may still be stimulating and pro- vocative and may be especially useful if it can be subjected to critical tests which would prove it wrong. I can think of no such tests to apply to Sauer's theory. His two principal hearths occur in regions where few archaeological remains have so far been found and where the climate almost precludes the long-time preservation of herbaceous cultigens. Practically all of his conclusions, although unsupported by evidence, are still virtually im- possible to disprove. Indeed if one sought, as an exercise in imagination, to design a completely untestable theory of agricultural origins and dispersals, it would be difficult to improve upon this one. In creating such a theory, the author has at least demonstrated that there are still huge gaps in our knowledge of man's history (Mangelsdorf 1953:90).

Since Mangelsdorf published the above comments, the work of Reichel-Dolmatoff on the flood plain of the Río Sinú and elsewhere in the moist tropics of Colombia (Reichel-Dolmatoff, G. and A. 1956; Reichel-Dolmatoff 1965), and my work on the early ceramic cultures of the Upper Amazon have more than tripled previous esti- mates as to the time depth of large, sedentary agricultural societies in these areas of South America (Lathrap 1962, 1970, 1971; compare with Meggers and Evans 1957:589 -90). More recently the work of Solheim (1969) and his students, especially Gorman (1969), is yielding indications that Sauer's picture of Southeast Asia as a very early hearth of cultural innovation will be validated in a detailed and specific way.

The single-minded way in which most students of the problem of agricultural origins have focused on seed crops and semiarid areas has strongly affected the kinds of explanatory models which they have proposed. The extensive and subtle deforma- tions in thinking which have resulted from this restricted field of vision offer an epistemological problem worthy of extended treatment. Such a study is beyond the scope of the present paper. It is easy to show, however, the way in which this particular emphasis, when combined with an insistence that desiccated plant remains and human feces are the only kinds of data worth considering, can mold specific programs of research.

Agriculture and the Rise of Civilization in Peru

Recently MacNeish has embarked on an ambitious research project in Highland Peru "concerned with the origin of agriculture and the relationship of this phenome- non to development of village life and ultimately to civilization" (MacNeish 1969:1). MacNeish has chosen to center his research around Ayacucho, because of the

availability of dry caves, the ecological diversity, and the presumed presence of copious plant remains.

One might argue that there are other regions of Peru which are more significant to our understanding of the *appearance* of civilization in the Central Andes. A full understanding of agricultural development and even social evolution in the Ayacucho Basin should shed considerable light on why Huari was to become the most important political and religious center in Peru around A.D. 450-800. It is doubtful if this developmental sequence will greatly increase our understanding as to why most of the distinguishing characteristics of civilization appeared some 500 kilometers to the north at Chavín de Huántar around 1200 B.C. While Chavín de Huántar was exerting religious and possibly political domination over much of Peru (Patterson 1971), the Ayacucho Basin was of marginal importance and continued as a cultural backwater for another 1500 years. I would suggest that any attempt to understand the civilizing effects of agriculture in the Central Andes must ultimately face up to the problem of the agricultural basis of Chavín de Huántar and the state that it ruled.

MacNeish initially considered the possibility of working around Chavín or in the adjacent section of the Marañón Valley but rejected it because, "both areas lacked the ecological diversity and dry caves we were looking for" (MacNeish 1969:3). Perhaps a research design so totally predicated on the existence of dry caves is inadequate to the solution of the problems which MacNeish raised.

The massive ceremonial center of Chavín de Huántar is located on a western tributary of the upper Marañón, the major headwaters of the Amazon River. The valley in which it is situated, the Callejón de Conchucos, comes down from the eastern slope of the Cordillera Blanca, the highest section of the Peruvian Andes. The ruin itself is at an elevation of more than 3,000 meters above sea level, but the Marañón offered then as it does now an open avenue of communication leading down to the moist tropical forests of the Amazon Basin.

There are other major ceremonial centers in the Central Andes which predate the construction of Chavín de Huántar by a considerable margin. Such ruins as Chuquitanta (Engel 1966) at the mouth of the Lurín River, La Florida in the lower Rimac Valley (Patterson and Moseley 1968:118-19), Haldas to the south of the Casma Valley on the coast (Ishida et al 1960:191-197; Fung 1967), and Kotosh (Izumi and Sono 1963; Izumi 1971) in the Huánuco Basin on the eastern slope of the Andes are now securely dated to the second or even third millennium B.C. The nature and significance of these sites have been well summarized by Lanning (1967:57-95). In none of these sites, however, do we find a sophisticated and iconographically complex art style in the service of the local cult, and in none of these sites do we find evidence of a network of influence and pilgrimage extending over much of the Central Andes.

As Willey (1962:7) and others have pointed out, Chavín bears the same kind of developmental relationship with the later civilizations of the Central Andes that Olmec has with the later civilizations of Mesoamerica. Both appear suddenly without known antecedents; both represent a huge jump in organizational complexity over earlier societies known in the area. This complexity is manifest in iconographic elaboration, stylistic development, and engineering and technological competence. Most of the later styles of the Central Andes can be derived from Chavín by a series of gradual progressive modifications, a fact first noted by Tello (1961), just as most of the later art styles of Mesoamerica can be so derived from Olmec, as first perceived by

Covarrubias (1957; Stirling 1968). Both Chavín and Olmec appear to have exerted a profound "civilizing" effect on all of the later societies in their respective areas of influence, an effect which penetrated all domains of culture.

The major centers of Olmec culture were in a tropical forest riverine environment, with the major agricultural efforts probably focused on the natural levees of the rivers (Coe 1969:9). Recent work has demonstrated that the inhabitants of these centers were dependent on fish and aquatic reptiles to a very high degree (Coe 1968:59-60). Such an early dependence on fish protein is a crucial feature of Sauer's model.

Though located in a high, glaciated valley, Chavín de Huántar presents an art style suggesting a very different ecological niche. Almost all of the creatures depicted in Chavín art are native to the riverine flood plains of the Amazon Basin (Lathrap 1971).

Though the inhabitants of Chavín de Huántar were so inconsiderate as to leave neither plant remains nor feces in dry caves, where they would be readily available to the archaeologist, they did leave certain "hard" evidence as to their attitudes toward the plant world and especially toward the domain of cultigens. Such evidence deserves careful scrutiny!

The Obelisk Tello

I intend to use as my point of departure two statements on which there is agreement by all who have studied the Chavín Horizon with some care: 1) The carved granite shaft usually referred to as "El Obelisco" or the Obelisk Tello is the most richly conceived and elaborately executed of all extant examples of Chavín art (Rowe 1962:12); 2) All indications are that the Obelisk Tello served as an idol and was a direct representation of and surrogate for a deity.

The step-like notch at the top of the Obelisk Tello is shared by the "Lanzon" or "Great Image," the only Chavín cult object to remain *in situ* (Lumbreras 1971:Fig. 3A,B). As Rowe says, "The 'Tello Obelisk' is a rectangular shaft, carved on all four sides, and is more likely to have been a cult object than a simple piece of architectural decoration" (1967:83). The same notch is characteristic of a whole group of large stone idols from the north end of the Titicaca Basin and of Qaluyu or Pucara culture (Chavez, S. and K. 1970). In all early Central Andean contexts such a notch is probably a definitive indication that a particular carved stone served as an idol.

The artistic pre-eminence of this particular idol suggests a comparable pre-eminence among the gods of the Chavín pantheon for the deity it represents; and as we will presently see, there is internal evidence for such a position in the hierarchy. It is the nature and function of this particular deity which will occupy us for the rest of this paper.

Tello has published the most complete description of the Obelisk Tello and has also given an adequate account of its history (1961:177-8). For the purposes of this paper it is necessary only to reiterate that the idol certainly comes from the central group of temple structures at Chavín, but that its original position within that architectural complex cannot be determined. It is the type specimen of Phase C in Rowe's chronology of Chavín art (1962:12), and thus belongs to the earlier half of the span of Chavín artistic development, but toward the end of the earlier half. A date between 800-1000 B.C. is in line with available evidence.

The design of the Obelisk Tello consists of two representations of a mythical being. The head, body, and tail of each of the pair appears on one of the broad sides

of the rectangular prisms while the legs, genitalia, and other affixed elements appear on the narrower sides. The beasts are pointed upward with head toward the top of the shaft and the tail at the very bottom of the shaft.

Two published versions of the design are useful. The drawing by Pablo Garrera Mendoza (Tello 1961:Fig. 31) is beautifully rendered and at a sufficiently large scale so that the various elements of the design are readily perceived. The version published by Rowe is more meticulously accurate (1967:Fig. 6), but at so minute a scale as to be almost illegible without magnification. Consistently I have consulted both of these versions in preparing the following comments and illustrattions; and I would advise this procedure for anyone who wishes to check on all details of the argument.

The density and complexity of the design on the Obelisk Tello makes it difficult to factor out the important constituent elements, even when one confronts the original at Museo Nacional in Pueblo Libre, Lima. For this reason I decided to illustrate only those segments of the design which are of particular importance to the discussion. Ideally a photograph of the plant representations to be treated might provide the best basis for identification. I had hoped to take a series of such photos when I visited Peru during the summer of 1970, but at that time the Obelisk was sheathed in glass to protect it from the hands of tourists. As a substitute for photographs I have had pairs of drawings prepared, one after Tello's illustration (1961:Fig. 31) and the other after Rowe's (1967:Fig. 6). Only details perceived both by Rowe's artist and Tello's will be used to identify the plants.

We must now face squarely the very difficult problem of meaning in religious art. I would like to propose a tripartite division in this domain.

A first level of meaning in religious art might be designated as formal. The brilliant dissection of Northwest Coast Art presented by Franz Boas (1951:183-298) stands as the definitive example of this level. The realm of discourse is the stigmata which permit one to tell man from beast from deity and to distinguish the various species of animal. The formal rules for organizing these clues into total designs must also be treated in a grammar which permits an infinite number of unambiguous formulations.

A second level of "meaning," as the term is applied to religious art, might be called mythic. Any visual expression of a religious system may depict the key incident of the myth or myth cycle which validates the religious system, and the key actor or actors in these myths. This observation holds for almost all religious art in the Western tradition, from Egypt and Sumer to modern times. It is especially true of Medieval Christian art. The justly famous slate sculpture of the Bear mother as executed by the Haida carver, Skaowskeay (Inverarity 1950:Pl. 194), is the prime example of this level in Northwest Coast art, where the first level of meaning is far more fully implemented. It is always easier to go from the myth to the concrete artistic expression than from a fossilized concrete expression to a full reconstitution of the myth; nonetheless a full reconstitution of fossilized myths is of greatest interest to the anthropologist studying cultural evolution. Such a reconstitution is the aim of this paper.

A third level of meaning in religious art might be called structural. The number and ordering of iconographic elements in a particular concrete expression of a religious system may also reflect the organization of the functioning social units of a society

or of the contrasting units in various other domains of culture. Likewise such features may map the whole cosmos. Insofar as a Gĕ village plan (Nimuendaju 1946:37) or an Atoni house (Cunningham 1964:67) can be considered religious art they are prime examples of this level of meaning. The paper which R. Tom Zuidema presented at the 1969 Conference on Chavín held by the Dumbarton Oaks, unfortunately still not published, represented an all-out attempt to derive this structural level of meaning from Chavín art.

The following discussion of the meaning of the Obelisk Tello relies heavily both on Rowe's interpretation of meaning in Chavín art and on the more complex formulations of Tello. With regard to specific details, these statements of "meaning" are occasionally in disagreement, but with regard to the broader picture they are complementary rather than contradictory. Rowe's view is firmly rooted in level one with only timid and fleeting forays into the mythic or structural meaning of Chavín art. Tello, on the other hand, is far more interested in the mythic functions of the god depicted on the Obelisk Tello than in the stigmata which bound his person from other entities (1961:78-86). Tello was not unaware of the formal details and grammatical complexities which so intrigue Rowe, but he treats them far less systematically.

For the purposes of this present investigation, the less rigorous but more adventurous approach of Tello had more value.

It is of considerable historical interest to mark the date of composition of Tello's commentary. The readily available version of Tello's analysis of the Obelisk Tello bears the publication date of 1961, but as Tello indicates, the relevant section of his monograph was first published in *Wira-cocha* in 1923 (Tello 1961:178). My friend Toribio Mejía Xesspe, who has long functioned as Tello literary executor, told me (personal communication, 1970) that the actual composition date was probably 1919-20. Even in 1919 Tello's thinking was remarkably resonant with such advanced writings on myth and iconography as Reichel-Dolmatoff's *Desana* (1968).

As we have seen, there is complete agreement between Tello and Rowe that the Obelisk Tello is an idol and that the entity twice depicted on its surface is a deity. Tello described this entity as a cat (jaguar), but with such an elaborate discussion of the monstrous elements which go to make up the being that it would be fairer to Tello's intent to call the entity a cat-dragon. Rowe described the entity as a deified cayman, and in this instance I feel that he is absolutely correct (Rowe 1962:18).

Elsewhere I have discussed at considerable length my reasons for agreeing with Rowe that the primary essence of the creature twice represented on the Obelisk Tello is that of a cayman (Lathrap n.d.). Here it seems necessary only to reiterate that the conventions of showing a full upper tooth row, even when the creature's mouth is shut, is not arbitrary but realistic. When a cayman's mouth is shut the upper tooth row is fully exposed and the teeth of the lower jaw are completely hidden. This is not true of the crocodile which exhibits a lot of both tooth rows even when his mouth is closed.

Most caymans are relatively small animals, and the only form of sufficient size and ferocity to be an appropriate model for this deity is the black cayman, the form designated by Gilmore as *Caiman niger* (1950:405-6), but now more correctly designated *Melanosuchus niger*. This huge creature is not afraid to attack man, and has a range restricted to the flood plains of the largest rivers in the Amazon system (Reichel-Dolmatoff, personal communication, 1971).

Rowe has made much of the agnathic trait in Chavín mouth depictions (1962:17). It might be hazarded that this cliché started out as an illustration of the constantly visible upper tooth row of the cayman. Rowe has also argued convincingly that the "Lanzon," the great idol still *in situ* in the oldest section of the Chavín de Huántar temple, was originally furnished with an "agnathic" mouth which was later recarved to a normal "jaguar" mouth (Rowe 1962:19). This conversation of cayman attributes into jaguar attributes might be interpreted as a gradual downgrading of the reptilian deity on the part of people long separated from the habitat of its prototype.

In both of the cayman depictions on the Obelisk Tello and in both of the cayman depictions on the Yauya stella (Rowe 1962:Fig. 31; Espejo 1964) the creature is portrayed with a fish tail. Rowe makes the rather bland assumption that this affixing of a fish tail to a cayman is fortuitous: "this mythical detail may be no more than a misunderstanding on the part of the artists who were not personally familiar with their subjects, caymans occurring only at the much lower altitude" (1961:19). Since Rowe agrees that the being on the stelae is "The Great Cayman," that is to say a deity rather than any cayman in any tropical forest lagoon, the trip that the artist would have taken to verify the nature of the Great Cayman's tail could not have been by raft down the Marañón and out through the Pongo de Manseriche into the Amazon Basin; rather it would have been a trip on a brew of *Banisteriopsis* or on *Piptadenia* snuff off through several layers of the universe.

I would prefer to think that this association of fish parts with "The Great Cayman" was deliberate and highly meaningful. I would take this patterned association to signify that most basic and primary function of "The Great Cayman" is as master of the fish. The recent monograph of Reichel-Dolmatoff, *Desana* (1968), contains a full discussion of the concept, "master of." Levi-Strauss has also noted the extremely wide temporal and spatial distribution in South America of the myth concerning the master of the fish (1967). The Yuaya stela in which the caymans are exuding a multitude of fish and nothing else might be taken as an affirmation that the primary function of the Great Cayman is indeed as "Master of the Fish."

While Rowe is satisfied with identifying the creature twice represented on the Obelisk Tello both as a deity and a cayman (1962:18), Tello goes on to ponder on the functions of the deity and to note the fact that the deity appears with different attributes in the two representations. His suggestion that two aspects or manifestations of the same basic deity, "dos aspectos diversos de una sola divinidad" (1961:185), are represented offers the key to a more detailed and complete interpretation of the design. To facilitate a discussion of the differing attributes of these two aspects of "The Great Cayman," I will make use of the handy atlas of the design which has been provided by Rowe (1967:Fig. 7). The aspect which Tello designates as I, Rowe designates as B, while the aspect which Tello designates as II, Rowe designates as A. For the sake of consistency I will follow Rowe's terminology throughout.

The most obvious interpretation of the duality indicated by the two aspects of "The Great Cayman" is that A is masculine and B is feminine. Such an interpretation seems especially plausible since A is provided with an element, A-24 (Fig. 4) which I will insist is a penis, while B has a very different kind of design in the genital area (B-24), one which Tello interprets as a pod with two seeds in it (1961:183). Without rejecting that a male/female opposition is implied, I will still maintain that there is a more basic significance to the two aspects of the Great Cayman.

Tello, using a complicated and ingenious argument maintains that Cayman A is the bringer of rain and green vegetation and is thus a kind of scaly Persephone, while Cayman B is heat, drought, the fall, and the harvest of seed crops (1961:185). Without disagreeing with Tello's interpretation I will again maintain that this is not the primary dichotomy involved.

I believe that the Cayman designated A is the deity of the water and underworld and that Cayman B is the deity of the sky. We have already noted the marked inset at the top of the granite shaft. This notch restricts the space available in the uppermost segment of the idol. All of this constricted area lies above the snout of the two caymans and it is in this region that the two representations show their greatest divergence. Following Tello's lead I would argue that the contrasting elements appearing in this segment of the design can be taken as affixes modifying the basic nature of the cayman deity. In the uppermost position above the snout of Cayman A (A-2) there is an entity which Tello correctly identifies as a mollusc. His suggestion that the mollusc involved is a *Strombus* (1961:182) would seem to be a lapse of memory or a slip of the tongue. The mollusc is clearly a bivalve and shows exactly the same conventions of representation as the shell which Bird and Rowe have correctly identified as a *Spondylus* (Rowe 1962:19, Fig. 11). The signifier of Cayman A is clearly the mythical *Spondylus* since it is provided with a jaguar mouth and three snake appendages. Immediately behind the elbow of Cayman A's front leg, there is another large deified mollusc. In this case, it is a univalve that is clearly indicated and the identification with the genus *Strombus* is justified (Rowe A-21). Again exactly the same conventions are observed as in another representation which Rowe has definitively identified as a conch shell (Rowe 1962:19). I contend that these two modifiers indicate that Cayman A is "The Great Cayman of the Water and the Underworld."

In the uppermost position above the snout of Cayman B there is a beautifully rendered bird (Rowe B-2). Tello identifies this with the condor (1961:182), but here I again agree with Rowe that Tello in in error. Elsewhere I have argued at length that the most basic bird in Chavín iconography can be identified down to the species level as the great monkey-eating eagle, *Harpia harpyja* (Lathrap 1971). It was a curious oversight that I neglected to mention the eagle depiction on the Obelisk Tello since the specific features unique to the harpy eagle are more realistically rendered here than anywhere else in Chavín art. Immediately in front of the front claws of Cayman B and immediately below its chin there is another harpy eagle (B-10), which is much compressed both laterally and vertically, but still shows the diagnostic features. I believe that these two modifiers definitely indentify Cayman B as the Great Cayman of the Sky or Air.

At this point the skeptical reader should question the meaning of the obvious fish (B-3) which is placed immediately in front of Cayman B's mouth and immediately below the harpy eagle. I would contend that even when the Great Cayman is transformed into a sky deity, his association with fish and water is so basic that it needs reiteration.

More puzzling is the interpretation of the beautifully depicted jaguar which is placed in the same register as the limbs of Cayman A but which overlaps considerably onto design elements clearly associated with Cayman B. The conventions of this jaguar representation are almost identical with those on the famous University of Pennsylvania mortar (Rowe 1962:Fig. 33). My original impulse was to associate the

jaguar with Cayman A, the god of water and the underworld, an interpretation which is congruent with at least certain other mythical associations of the jaguar (Thompson 1970:293); but both Tello and Rowe construe it to be part of Cayman B. A second thought might be that the ambiguous positioning of the jaguar is deliberate on the part of the artist and should be read as "mediates between" sky and water. I will argue that there is further evidence that would assign the jaguar a consistent role of mediator or messenger.

I have no original suggestions as to the meaning of the element labeled by Rowe as A-1, but its relationship to the two discrete cayman depictions is also ambiguous.

I would suggest, then, that the Obelisk Tello represents a standard sort of trinity, with the whole standing for "The Great Cayman" as Creator and Master of the Fish; and with the two discrete depictions standing for a sky deity and a deity of the water and underworld respectively. According to my colleague, Dr. Luis Millones, this opposition of an extremely powerful sky god to an extremely powerful god of water and the underworld is consonant with the beliefs of the modern highland Quechua (personal communication, 1970). The modern Shipibo, a large Tropical Forest group living along the Ucayali in Eastern Peru (Lathrap 1970), likewise feel the necessity of an even-handed propitiation of two powerful deities, one in the depths of the water and the other in the sky (James Loriot 1964, personal communication).

None of the above discussion of the two aspects of The Great Cayman represented on the Obelisk Tello is as clear-cut and obvious as the observation of Tello that both aspects are performing the same role. Both appear on this monument as the bearers of useful cultivated plants. Again the forcefulness of Tello's conclusion cannot be improved upon when he states that the principal attribute of both aspects: "es otorgar a los humanos los frutos alimenticios; por eso lleva en sus garras dichos frutos. En su primer aspecto, lleva los frutos dentro de su cuerpo, y en su genital la semilla que debe reproducirlos" (Tello 1961:185). This is the only one of the interpretations of the Obelisk Tello which is crucial to the present argument. The identification of the cultigens brought by the two aspects of The Great Cayman thus becomes of more than passing interest, since they were clearly considered of paramount importance by the artists and priests who planned the Obelisk Tello.·

Except for Tello's brilliant discussion, plant representations in Chavín art have not received the attention they deserved. Rowe passes off the whole matter in a single sentence: "Plants and vegetable products are rarely shown in Chavín art and only as secondary figures" (1962:18). This statement neglects the prominence of a motif which Herman Amat has identified as coca leaf (personal communication 1970) which appears both at Chavín de Huántar and on one of the South Coast textiles illustrated by Rowe (1962:Fig. 29). Though not available to Rowe, a more recently discovered lot of South Coast painted and tie-dyed wall hangings show a wide array of plants which cry out for a detailed ethnobotanical interpretation.* Most seriously Rowe's statement allows him to side-step the several meticulous plant representations on the Obelisk Tello.

*Editors' Note: An iconographical analysis of these textiles is now available: Cordy-Collins, Alana, 1976. *An Iconographic Study of Chavín Textiles from the South Coast of Peru: The Discovery of a Pre-Columbian Catechism.* Doctoral Dissertation, Institute of Archaeology, University of California, Los Angeles.

Cayman B, whom I have suggested is the Sky God, brings with him two clear-cut representations of plants. One of these plants extrudes from the nasal area of a jaguar-headed serpent. The serpent's body is truncated and coiled in the vertical plane, reposing comfortably in the angle between the vertebral column and the pelvis of Great Cayman B. As is frequently the case in Chavín art, the vertebral column takes the form of an elongated tooth row while the ilium is in this instance indicated by a subsidiary cayman head.

I originally identified this plant (Fig. 1) as cotton, concentrating my attention only on the element furthest to the upper left which I took to be a partially matured cotton boll. In making that identification I glossed over the two leaf representations—not at all like cotton leaves, which are markedly five-lobed—and the full-blown flower, which is distinctly unlike the spectacular five-petaled bloom of the cotton. The cotton flower is typically malvacaen, very similar to a hollyhock or hibiscus blossom. I ignored completely the element immediately in front of the jaguar's mouth, yet the drawings of Tello and Rowe are in complete agreement about the precise characteristics of this element.

Dr. Barbara Pickersgill (personal communication 1971) has taken me to task for not looking first to the very specific and peculiar object in front of the jaguar's mouth. Once this is identified, as it must be, with the matured and dried fruit of *Lagenaria siceraria*, the bottle gourd, all other problems disappear; the leaves and the distinction between male and female flowers are remarkably accurate for that species. Particularly well observed is the long, jagged calyx of the closed flower in the upper left. The gourd on the Obelisk Tello should be compared with the actual archaeological specimens of gourd, net floats excavated by Bird at Huaca Prieta (Bird 1948:Fig. 10), or even better yet with the bird house which Audubon furnished for his painting of the purple martins (Audubon 1937:Pl. 22). Also early European depictions of *Lagenaria* are very similar to the Chavín carving in all of their features (Bailey 1937:3). The care with which the Chavín artists singled out the essential features of the bottle gourd and depicted them shows that there was nothing casual or accidental about the way in which they viewed and drew the vegetable world.

The other plant extrudes from a cat head which is being dragged along by the claws of Cayman B's hind foot (Fig. 2). In view of the shape of the four fruit and of the calyxes which contain them, the plant must be *aji*. The conformation of the leaves is equally indicative of the genus *Capsicum*, as is the typically solanaceous flower. Barbara Pickersgill in a personal communication (1971) feels that the depiction is sufficiently precise to permit identification down to the species level (see also Pickersgill 1969)! There can be no doubt but that one of the cultivated *ajis* is intended. This was also Tello's conclusion (1961:184).

It is interesting, and perhaps significant, that the two plants associated with the sky Cayman (also Tello's Fall and Seed Cayman) are classically seed crops propagated by seed and with their valuable portions produced well above the ground.

Again there are two clear and detailed plant representations associated with Cayman A, deity of the water and the underworld. The smaller and less interesting of the two projects from the top of an isolated jaguar head which in turn rests on the ilium of Cayman A (Fig. 3 of this paper, Rowe A-19, 20). As in Cayman B, the ilium is represented by a subsidiary cayman head. The plant appears only as a clump of six leaves. I find the total configuration of the plant completely compatible with the

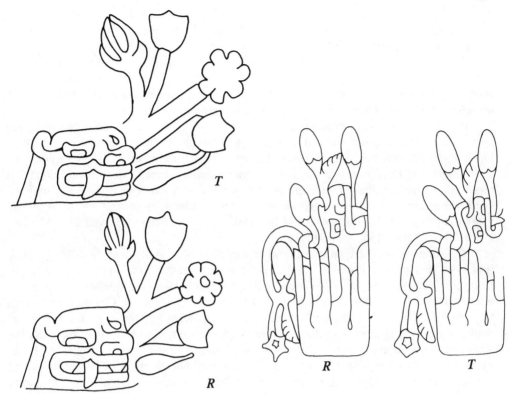

Figure 1. Depiction of bottle gourd vine with male and female flowers and mature gourd associated with the Great Cayman of the Sky on the Obelisk Tello. After Tello 1961 (T) and Rowe 1967 (R).

Figure 2. Picture of *aji*, *Capsicum*, plant with flower and four mature fruit, associated with the Great Cayman of the Sky on the Obelisk Tello. After Rowe 1967 (R) and Tello 1961 (T).

Figure 3. Picture of Achira plant associated with the Great Cayman of the Water on the Obelisk Tello. After Tello 1961 (T) and Rowe 1967 (R).

Figure 4. The penis of the Great Cayman of the Water and the Underworld exuding a manioc bush. After Tello 1961 (T) and Rowe 1967 (R).

above-ground portion of achira, *Canna edulis* (Leon 1964:Fig. 4), and am willing to accept that identification. Others might want to argue that maize is indicated, but I would suggest that the total configuration is too compact and squat, and that the spatial relationship among the several leaves is not at all suggestive of a maize plant. Since this plant representation offers the smallest number of distinctive features, its identification must of necessity be the most tentative.

It is the second plant brought by the Great Cayman of the Water which deserves the most extended discussion. It projects as a tongue from the mouth of a jaguar-headed serpent which in turn projects from the lower abdomen of Great Cayman A. That the jaguar-headed serpent is the Cayman's penis, seems clear beyond doubt. It takes but a brief familiarity with the mythology of South America to discover that the symbolic interchangeability between snakes and penes is a conceit which is by no means confined to the Viennese middle class (compare Goldman 1963:257; Murphy 1958:125-6; Huxley 1957:149-50).

The plant is depicted in considerable detail. It is a multi-branched, leggy bush (Fig. 4 of this paper, Rowe A-23, 24). At the ends of the long branches are large, fleshy, palmate leaves, usually shown with five individual pointed lobes. The spindly branches are furnished with eyes, depicted in one of the standard Chavín conventions for eyes. This plant could only be manioc. The general appearance of a cultivated manioc bush is indicated in Figure 5. Here the leaves are slightly droopy from the hot afternoon sun. Figure 6 shows a close-up of a manioc branch which should go far to explain why the Chavín artist felt free to make a symbolic merging of human eyes and manioc eyes. The reader might also examine a Moche pot depicting a clump of manioc tubers and the attached stalk with its "eyes" (Fig. 7).

The critical reader might wish to object at this point that I am playing fast and loose with the categories of colloquial English. The fact that English designates the scar left by a fallen leaf, from which a new plant may be slipped (vegetatively propagated), as an eye, may have no bearing on the symbolic or lexical associations of Chavín priests and artists. That this merging of categories is not confined to English and is in fact operative in extant Peruvian ethnic groups can be shown by reference to a myth from the North Highlands. I am again indebted to my colleague, Dr. Luis Millones, for this Spanish version of the myth.

> Una vez la yuca, la papa y el puma eran grandes amigos. Les gustaba bailar, cantar, ir a fiestas y engañar a las chicas. Eran *jircas* pero se habían mezclado tanto con la gente que ya lo tenían olvidado. Un día, luego de una borrachera, se quedaron dormidos en el *ojo* de una montana. Entonces los *jircas* hablaron entre ellos y los condenaron a llevar ojos en el cuerpo por toda su vida. Avergonzados la yuca y el pluma (PREGUNTA: No sería jaguar? RESPUESTA: Qué más da! Igual tienen manchas cuando nacen) se fueron a vivir a la selva y las papas se quedaron para ser comida de los pobres. (INFORMANTE: Severiano Cuspi Guzman, natural de Pachapaque [Río China] Ancash, 1970).

Two explanatory notes are in order. The term *jirca* refers to a localized, usually malevolent, spirit, the kind of entity which would be designated *wamali* in the more southerly dialects of Quechua. *Ojo de una montaña* should be rendered as spring or fountain. The fact that jaguars, puma cubs, potatoes, and manioc (yuca) all have "eyes" shows the strength of this pattern of association on a cross-linguistic basis. Many other interesting points could be developed from this myth, but for the moment I only wish to show that the Peruvian Indian believes that manioc has "eyes."

Figure 5. The five-lobed, palmate leaves of a manioc bush. Imariacocha, 1970.

Figure 6. The "eyes" on the stalk of a manioc bush, Imariacocha, 1970.

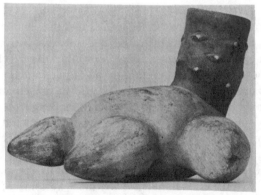

Figure 7. Moche pot in the form of manioc tubers and attached stalk with well defined "eyes." Collection of the Field Museum of Natural History, Chicago. Photograph courtesy of the Division of Photography of the Field Museum.

The skeptical reader may also wonder why the eyes are put on sideways rather than horizontally as they should be in a fully realistic rendering. Here I can only argue, along with Rowe, that the aesthetic of Chavín art favored a maximum use of parallel and nearly parallel lines and a partial avoidance of lines intersecting at right angles (Rowe 1962:14).

It is also worthwhile to raise the question as to why the artist felt compelled to illustrate the eyes, when the depiction is definitvely recognizable as manioc even without these anthropomorphized affixes; in fact it would be somewhat more "realistic" as a gestalt without them. Tello, though he failed to make the identification of the plant as manioc, did identify the "eyes" as "yemas," scars from which further sprouting could take place (1961:183). It is worth emphasizing that all of the races of *Manihot* are cultivated by means of vegetative propagation. One or more segments of manioc stock are placed in a mounded "hill" of loose earth so that two or three eyes are below the level of the earth and two or three eyes are above. The roots then grow from the eyes below ground and the stalks from the eyes above ground. Tello argues brilliantly and vehemently that a basic theme of the Obelisk Tello is fecundity and the processes of propagation; and the fact that the artist focused the viewer's attention on the "eyes" of the manioc fits beautifully with Tello's interpretations.

One further area of Cayman A deserves close attention. As in the case of Cayman B, the claws of the hind foot drag along a subsidiary jaguar head. Along the top of this head (Rowe A-35) are three objects which Tello has identified as "X-ray" illustrations of peanut pods (Tello 1961:184). I find this identification totally compatible with my own thinking, but doubt that its probability is at as high a level as some of the other identifications we have been making.

Exuding from the nose and mouth of this jaguar are three objects which Tello identifies without hesitation as a clump of manioc tubers (Fig. 8; Tello 1961:184). I find this interpretation completely convincing and the manioc plant on the Obelisk should be perceived by visually combining its two segments which are separated by about a half meter of cayman leg and cayman penis. It is worth emphasizing at this point that though the plants are the gifts of the Cayman, in each instance they emerge from a jaguar's nose and mouth, confirming the mediating role of the jaguar suggested earlier.

Of all of the plant identifications discussed, I feel that manioc is by far the most secure. All parts of the plant are illustrated and the distinctive characteristics are depicted with considerable care and realism. Certainly the "Tello" depiction is far more faithful than the design scratched into a Sajara-patac phase vessel from the site of Kotosh (Fig. 9; Izumi and Sono 1963:Pl. 57, B1) in the Huánuco Basin. Yet this identification as manioc has been accepted without challenge.

Both because of the care with which the plant is depicted and because of its placement within the total design, I must argue that manioc is the most important cultigen depicted on the Obelisk Tello. For those brought up in the Judeo-Christian Tradition, the tip of the penis may be difficult to accept as the most sacred and awful location on a deity. On the other hand, the mythical systems of a number of South American groups, especially Tropical Forest groups (Goldman 1963:30, 190-201, especially 192, 199; Huxley 1957:144), make very clear the tight symbolic association between sexual potency, life force, and agricultural productivity. In this sense it is instructive to compare the design of the Obelisk Tello with that justly famous segment

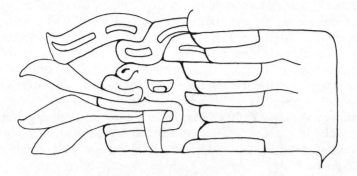

Figure 8. The hind foot of the Great Cayman of the Water and Underworld dragging along a jaguar head exuding manioc tubers and objects which Tello has identified as peanuts. After Tello 1961.

Figure 9. Manioc bush and tubers incised on a Kotosh Sajara-patac vessel. After Izumi and Sono 1963: Plate 57.

of the mural on the Sistine Chapel in which God confers *elan vital* to Adam through the tip of his right index finger. One must applaud the firmer grasp of biological reality shown by the Chavín artist. If we had the text of the myth which the Obelisk illustrates, one line surely ought to read, "Manioc is the semen of the Great Cayman." Indeed just this equivalence between manioc flour and divine semen is recorded by Reichel-Dolmatoff for the Desana (1968:35), and by Huxley for the Urubú (1957:159).

In its totality, then, the Obelisk Tello can be viewed as a huge, granitic doxology, in which the Deity is thanked for the agricultural blessing which made the current state of civilization possible. Of the four or five blessings listed in this stone hymn, manioc is the greatest.

I am not arguing that the congeries of plants represented on the Obelisk Tello is an accurate and quantitative statement as to the caloric intake of the population which was supporting the ceremonial center of Chavín de Huántar at the time the Obelisk Tello was carved. I suspect that if we had an adequate sample of the feces of this population, it would show a far wider range of fare than is displayed on the great monument; I also suspect that cultigens more resistant to cold than those shown on the Obelisk would make up a large, possibly predominant, part of the fecal content. We might expect that the plants on the monument had the same relation to the daily diet of the people as our own Thanksgiving Feast has to our daily intake of hamburgers and hot dogs. The monument, then, is less a manual for day-to-day nutrition than a celebration of the prior agricultural system which allowed the Chavín elite to achieve its current dominance. As such it points to an earlier state of agricultural development in a very different geographical setting. Along with all of the species of animal represented in Chavín art, the cultigens represented on the Obelisk Tello point to a setting in the moist tropics on the flood plains of the Amazon Basin.

Acknowledgements

I wish to thank my wife, Joan W. Lathrap, for her comments and editorial assistance. All drawings except Figure 8 are by Mrs. Doris Hazard. Figures 5, 6 and 8 are the work of the author.

Bibliography

Audubon, John James
1937 *The Birds of America.* MacMillan Co. New York.

Bailey, L.H.
1937 *The Garden of Gourds.* MacMillan Co. New York.

Bird, Junius B.
1948 "Preceramic Cultures in Chicama and Viru." A Reappraisal of Peruvian Archaeology. Wendell Bennett ed., *Memoirs of the Society for American Archaeology,* No. 4, pp. 21-28. Menasha.

Boas, Franz
1951 *Primitive Art.* Capital Publishing Co. New York.

Chávez, Sergio J., and Karen L. Mohr Chávez
1970 "Newly Discovered Monoliths from the Highlands of Puno, Peru." *Expedition,* Vol. 12, No. 4, pp. 25-39. Philadelphia.

Coe, Michael D.
 1968 "San Lorenzo and the Olmec Civilization." *Dumbarton Oaks Conference on the Olmec,* Elizabeth P. Benson, ed., pp. 41-71, Dumbarton Oaks Research Library. Washington, D.C.
 1969 "Photogrammetry and the Ecology of Olmec Civilization." Paper read at Working Conference on Aerial Photography and Anthropology, Cambridge, Massachusetts, 10-12 May.

Covarrubias, Miguel
 1957 *Indian Art of Mexico and Central America.* Alfred A. Knopf. New York.

Cunningham, Clark E.
 1964 "Order in the Atoni House." *Bijdragen: Tot de Taal-, Land-en Volkenkande.* Deel 120 le Aflevering. Anthropologica VI, pp. 34-68. S-Granenhage.

Engel, Frédéric
 1966 "Le Complexe Précéramique d'el Paraiso (Pérou)." *Journal de la Société des Américanistes.* Tome LV, No. 1, pp. 43-95. Paris.

Espejo Nuñez, Julio
 1964 "Sobre un Neuvo Fragmento de la 'Estela de Yauya' ." *Boletín del Museo Nacional de Antropología y Arqueología.* Año 1, No. 1, p. 2. Pueblo Libre, Lima.

Fung Pineda, Rosa
 1967 *Las Aldas: Su Ubicacion dentro del Proceso Historico del Perú Antiguo.* Tesis, Doctora en Letras, Universidad de San Marcos. Lima.

Gilmore, Raymond M.
 1960 "Fauna and Ethnozoology of South America." Handbook of South American Indians, Vol. 6, Physical Anthropology, Linguistics and Cultural Geography of South American Indians, Julian H. Steward, ed., pp. 345-464. *Bureau of American Ethnology, Bulletin* 143. Washington, D.C.

Goldman, Irving
 1963 "The Cubeo." *Illinois Studies in Anthropology*, No. 2. Urbana.

Gorman, Chester F.
 1969 "Hoabinhian: a Pebble-Tool Complex with Early Plant Associations in Southeast Asia." *Science*, Vol. 163: 671-673. Washington, D.C.

Huxley, Francis
 1957 *Affable Savages.* The Viking Press. New York.

Inverarity, Robert Bruce
 1950 *Art of the Northwest Coast Indians.* University of California Press, Berkeley.

Ishida, Eiichiro, and others
 1960 *Andes I, The Report of the University of Tokyo Scientific Expedition to the Andes in 1958.* Tokyo.

Izumi, Seiichi
 1971 "The Development of the Formative Culture in the Ceja de Montaña: A Viewpoint Based on the Materials from the Kotosh Site." *Dumbarton Oaks Conference on Chavín,* Elizabeth P. Benson, ed., pp. 49-72. Dumbarton Oaks Research Library, Washington, D.C.

Izumi, Seiichi and Toshihiko Sono
 1963 *Andes 2, Excavations at Kotosh, Peru, 1960.* Tokyo.

Lanning, Edward P.
 1967 *Peru Before the Incas.* Prentice-Hall, Inc. Englewood Cliffs.

Lathrap, Donald W.
 1962 "Yarinacocha: Stratigraphic Excavations in the Peruvian Montaña." Doctoral dissertation, Harvard University, Cambridge.
 1970 *The Upper Amazon.* Thames and Hudson. London.
 1971 "The Tropical Forest and the Cultural Context of Chavín," *Dumbarton Oaks Conference on Chavín,* Elizabeth Benson, ed., pp. 73-100. Dumbarton Oaks Research Library. Washington, D.C.

n.d. "Complex Iconographic Features Shared by Olmec and Chavín and Some Specu-
 lations on Their Possible Significance." Paper read July 31, 1971 at Primer
 Simposio de Correlaciones Antropológicas Andino-Mesoamericano. Salinas (To be
 published in the Proceedings of the Symposium.)

León, Jorge
1964 "Plantas Alimenticias Andinas." *Boletin Tecnico*, No. 6. Instituto Interameri-
 cano de Ciencias Agricolas Zona Andina. Lima.

Lévi-Strauss, Claude
1967 "The Serpent with Fish inside His Body." *Structural Anthropology*, pp. 264-
 268. Doubleday and Co. New York.

Lumbreras, Luís Guillermo
1971 "Towards a Re-evaluation of Chavín." *Dumbarton Oaks Conference on Chavín*,
 Elizabeth P. Benson, ed., pp. 1-28. Dumbarton Oaks Research Library. Wash-
 ington, D.C.

MacNeish, Richard S.
1969 *First Annual Report of the Ayacucho Archaeological-Botanical Project*. Phillips
 Academy. Andover.

Mangelsdorf, Paul C.
1953 Review of "Agricultural Origins and Dispersals," by Carl O. Sauer. *American
 Antiquity*, Vol. 19, No. 1, pp. 86-90. Menasha.

Meggers, B.J. and Clifford Evans
1957 "Archaeological Investigations at the Mouth of the Amazon." *Bureau of Ameri-
 can Ethnology, Bulletin* 167. Washington, D.C.

Murphy, Robert F.
1958 "Mundurucú Religion." *University of California Publications in American Arche-
 ology and Ethnology*, No. 49, No. 1. University of California Press, Berkeley.

Nimuendajú, Curt
1946 "The Eastern Timbira." *University of California Publications in American Ar-
 chaeology and Ethnology*, Vol. 41. University of California Press, Berkeley.

Patterson, Thomas C.
1971 "Chavín: An Interpretation of Its Spread and Influence." *Dumbarton Oaks
 Conference on Chavín*, Elizabeth P. Benson, ed., pp. 29-48. Dumbarton Oaks Re-
 search Library, Washington, D.C.

Patterson, Thomas Carl, and Michael Edward Moseley
1968 "Late Preceramic and Early Ceramic Cultures of the Central Coast of Peru."
 Ñawpa Pacha 6, pp. 115-134. Berkeley.

Pickersgill, Barbara
1969 "The Archaeological Record of Chili Peppers (*Capsicum spp.*) and the Sequence
 of Plant Domestication in Peru." *American Antiquity*, Vol. 34, No. 1, pp. 54-61.
 Salt Lake City.

Reichel-Dolamatoff, Gerardo
1965 *Colombia*. Thames and Hudson. London.
1968 *Desana*. Universidad de los Andes. Bogotá.

Reichel-Dolmatoff, Gerardo and Alicia Reichel-Dolmatoff
1956 "Momil: Excavaciones en el Sinú." *Revista Colombiana de Antropológia*. Vol. V.
 pp. 109-333. Bogotá.

Rowe, John H.
1962 *Chavín Art: An Inquiry into its Form and Meaning*. The Museum of Primitive Art.
 New York.
1967 "Form and Meaning in Chavín Art." *Peruvian Archaeology: Selected Read-
 ings*, John H. Rowe and Dorothy Menzel, eds., pp. 72-103. Peek Publications.
 Palo Alto.

Sauer, Carl O.
 1952 *Agricultural Origins and Dispersals.* The American Geographical Society. New York.

Solheim, Wilhelm G., II
 1970 "Reworking Southeast Asian Prehistory." *Social Science Institute Reprint* No. 34, University of Hawaii. Reprinted from *Paideuma*, Vol. 15: 125-139.

Stirling, Matthew W.
 1968 "Early History of the Olmec Problem." *Dumbarton Oaks Conference on the Olmec*, Elizabeth P. Benson, ed., pp. 1-8. Dumbarton Oaks Research Library. Washington, D.C.

Tello, Julio C.
 1961 *Chavín: Cultura Matriz de la Civilización Andina, Primera Parte,* Toribio Mejía Xesspe, ed. Universidad de San Marcos. Lima.

Thompson, J. Eric S.
 1970 *Maya History and Religion.* University of Oklahoma Press. Norman.

Willey, Gordon R.
 1962 "The Early Great Styles and the Rise of the Pre-Columbian Civilizations." *American Anthropologist*, Vol. 64, No. 1, pp. 1-14. Menasha.

Chavín Art:
Its Shamanic/Hallucinogenic Origins

Alana Cordy-Collins

> *In the earliest religions the sacred and the aesthetic were fused . . . and the fusion of the two was ritual.*
>
> *Ralph Ross*

Chavín culture is recognized as the first expression of high civilization in the Andean area. The earliest known evidence of Chavín civilization appears in Peru around 1500-1200 B.C., and this is far from an insipient stage. Although the culture's developmental locus is uncertain, Donald Lathrap's 1973 study indicates that the tropical forest may have been the Chavín homeland. Whatever the center was, it did not contain Chavín civilization past 1200 B.C.; and within 100 years Chavín culture diffused to the Peruvian coast and highlands (Willey 1971:117), from the Lambayeque and Jequetepeque Valleys in the north to the Palpa Valley in the south and inland to the Callejón de Huaylas (Figure 1).

The diffusion was rapid and thus suggests that some powerful motivational factors were operative. Religion was undoubtedly one of these. Three and a half millenia after the beginnings of Chavín civilization it is still impossible to miss the overtly religious character which pervades Chavín art.

Chavín art is a highly contrived style that is at once baroque, sensuous, and allegorical. The religio-stylistic complexities of Chavín art can be almost overpowering, but I am convinced a combined examination of the art and the religion will be most enlightening: by examining the one we can better understand the other.

While we have been able to appreciate a Chavín religious aesthetic generally, there remains a need to isolate that specific religious experience which inspired and unified Chavín art.

John Rowe has demonstrated that at least two deities were worshiped by the Chavín, each during a distinct period. The "Smiling God" was the earlier of the two and was eventually reduced in stature by a new deity, the "Staff God" (Rowe

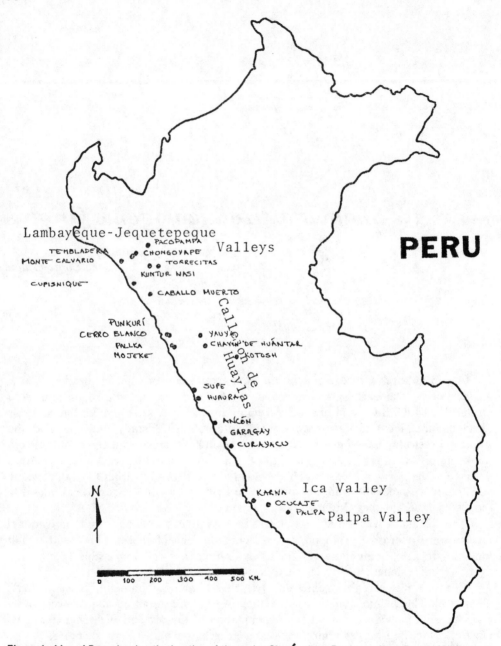

Figure 1. Map of Peru showing the location of the major Chavín sites. Re-drawn from Rowe 1962:figure 2.

1962;1967). I have proposed elsewhere (Cordy-Collins 1976:268-274) that a second era of Chavín cultural diffusion came about as a direct result of the growing importance of the Staff God and his cult of practitioners. By extension, it is reasonable to assume that the initial Chavín diaspora resulted from a similar religious motivation. Perhaps it

was a product of the Smiling God cult, as intimated by Lathrap (1973:96-103). Yet concommitant with the changes in Chavín religion, there is a tremendous continuity evident.

We may investigate this continuity on quite different levels: the first level is the internal basis for continuity and the source from which the religion developed; whereas, the second level of investigation concerns the external manifestations of the religion and the artistic themes themselves as well as the vehicles which served to carry and diffuse the themes. While we can see a certain amount of the latter in the archaeological record, what can be said of the former, the basis of Chavín religion?

Weston La Barre has argued convincingly that the origin and the basis for all religion is shamanism brought about by individual visionaries' *ecstatic* experiences (1972). Although glossed over by Mircea Eliade in his magnum opus on shamanism (1964), it now appears that hallucinogenic plants were largely responsible for the ecstatic state of the shaman (La Barre 1972:270).

In the light of these contentions, it is important to examine a stonecarving recently excavated at the Chavín type site, Chavín de Huántar (Figure 2). The carving

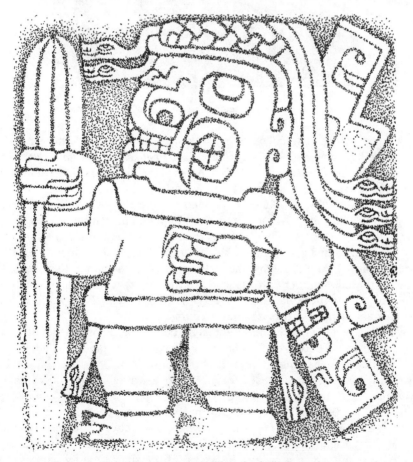

Figure 2. Supernatural human holding the hallucinogenic cactus, San Pedro. Chavín de Huántar.

Figure 3. San Pedro cactus in bloom. R. McClelland photo.

depicts a supernatural human carrying an object in his right hand which we can identify as the hallucinogenic San Pedro cactus (*Trichocereus pachanoi*) used today by modern shamans in Peru (Sharon 1972). As evident in Figure 3, actual San Pedro cactus is ribbed while that in Figure 2 appears flat. However, the stone carver was working in an essentially two-dimensional medium and therefore indicated the ribs by carving grooves. But, above all, it is important to point out that the cactus thus carved has four ribs, and four-ribbed San Pedro is thought to be extremely rare and potent in modern Peruvian shamanism (Sharon 1972:120). No actual four-ribbed San Pedro has ever been recorded, and it seems likely that it is more symbolic than real. Douglas Sharon feels that the number four associated with the cactus has connotations with the four world directions (personal communication). The division of the world into cardinal quadrants is an intrinsic part of shamanic complexes.

The stonecarving is not the only representation of San Pedro cactus in Chavín art, but it is the earliest. There are four phases of Chavín development, labeled AB, C, D, and EF, and the stonecarving is from the first phase, AB.

Are we to presume then, based upon the identification of the object held as San Pedro cactus, that the figure holding it is a shaman? While we cannot say with complete certainty that he is, such an interpretation is suggested by the fact that the figure is depicted with animal fangs and claws. Universally, shamans have the ability to assume the form of their animal familiars. Peter Furst has ably shown that in tropical forest South America today, the avatar of the shaman is the jaguar (1968), an animal not only suggested by the fangs and claws of the San Pedro carrying figure,

but by the proximity of a row of carved jaguars immediately below the supernatural human (Figures 4 and 5). Furst stresses that modern belief has it that while the shaman is at all times a jaguar, he only manifests feline form during his ecstatic state (*ibid.*), a state which can be brought about by the ingestion of an hallucinogenic substance, in this case San Pedro cactus.

Figure 4. Carved blocks in the circular plaza, Chavín de Huántar. San Pedro carrying figure in the upper row, rt., jaguars in the lower row.

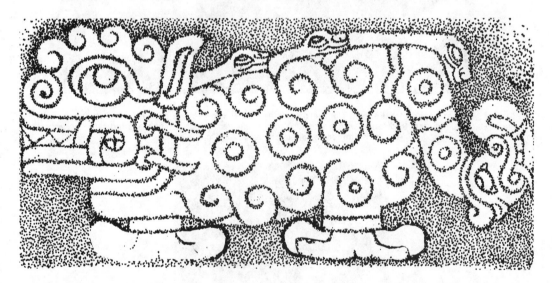

Figure 5. Jaguar from lower row of blocks. Circular plaza, Chavín de Huántar.

The second instance of San Pedro cactus in Chavín art is on a textile which dates to Phase D (Figures 6 and 7). There are five partial representations of the cactus, three of which seem to have four ribs, and one is directly associated with a spotted feline reminiscent of the spotted jaguars at Chavín de Huántar (Figure 7). The feline-San Pedro relationship is found again on the Tembladera variant of Chavín pottery from the north coast (Figures 8, 9, Sharon 1972:Figure 21, and possibly Anton 1972:Figure 13). A deer is associated with the cactus on a second north coast Chavín pottery variant, Chongoyape (Figure 10). The deer figures in modern Peruvian shamanism where it symbolizes "swiftness and elusiveness" and is called upon by

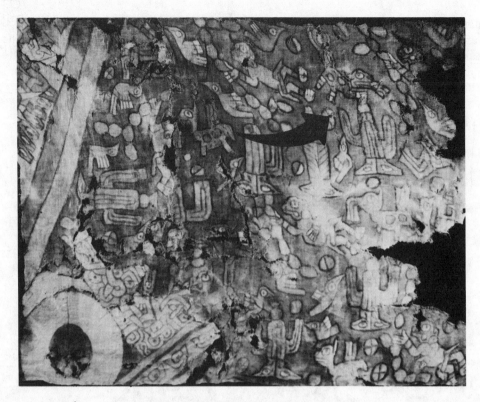

Figure 6. Chavín painted textile from Carhua displaying San Pedro cacti, a partial Staff God (upper left), deer or llamas, and a spotted feline with a foot touching a San Pedro cactus bloom (as indicated by arrow). Lapiner-Emmerich collection. A. Cordy-Collins photo.

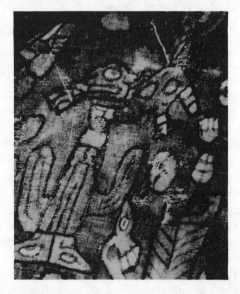

Figure 7. Detail from upper right of the textile in Figure 6 showing the spotted feline and San Pedro cactus. A Cordy-Collins photo.

Figure 8. Chavín stirrup spout bottle decorated with a jaguar flanked by San Pedro cactus. Peruvian north coast. C.B. Donnan photo.

Figure 9. Chavín stirrup spout bottle decorated with a jaguar on one side and San Pedro cactus on the other. The cactus is barely visible over the top of the bottle's chamber (see arrows). Private collection. R.X. Reichert photo.

Figure 10. Chavín bottle with a deer and San Pedro cactus. Private collection. Photo courtesy D. McClelland.

the shaman to detect attacking spirits and to exorcise them during possession, all in a ceremony where a San Pedro brew is imbibed (Sharon and Donnan 1974:55). The spotted animal appearing in association with the feline and San Pedro cactus on the textile in Figure 6 may also be a deer.

The cited representations of San Pedro cactus were produced during quite distinct periods of Chavín history. The stonecarving in Figure 2 dates to Phase AB, while the textile in Figure 6 was produced during Phase D. The pottery examples have not been assigned to specific phases, but are probably late in the Chavín sequence (Sawyer 1968:20,22). In addition the examples were found in widely separated areas of Peru: The stonecarving is from Chavín de Huántar in the Callejón de Huaylas, the textile is from Carhua (Karwa) in the Ica Valley on the south coast (although it may have been manufactured in the north), and the pottery is from the Lambayeque-Jequetepeque Valleys of the north coast. It is my belief that textiles were used during Chavín times for the transfer of ideas, specifically religious ones, to far flung areas of Peru from Chavín de Huántar and, thus, served as a type of catechism (Cordy-Collins 1976:272-273; ms.a). If, as I have tried to show in this paper, the basis of Chavín religion—and, hence, the art—was shamanism incorporating the hallucinogenic San Pedro cactus, then it is easy to see why and how representations of San Pedro appeared outside Chavín de Huántar and in various media.

Chavín civilization collapsed inexplicably around 300 B.C., but vestiges of it continued in Paracas and Nasca art on the south coast and in Moche art on the north coast. And it can hardly be accidental that representations of San Pedro cactus also appear in these art styles (Sharon 1974:Figures 6, 7). It seems that through the medium of San Pedro cactus was transmitted the religious message from Chavín civilization. In essence, the medium was the message (Sharon and Cordy-Collins n.d.).

In summary, what we seem to have is a religious art grown out of a basic hunter-gatherer shamanism that solidified sometime in the third millenium B.C., perhaps in the tropical forest, into a cult with religious practitioners. It seems quite probable that proselytes from this cult were responsible for the rapid intrusion of Chavín culture into Peru around 1200 B.C. Lathrap has made a good case for the earliest Chavín deity having been derived from the powerful cayman *Melanosuchus niger* (1973:95). La Barre points out that religion's early gods are First Shamans, apotheosized and for a time represented predominately in animal form—that of their animal familiars—and only later assumed a primarily anthropomorphic form (1972). Lathrap's argument that the Chavín cayman on the Tello Obelisk (page 358, Figure 6) and the Smiling God on the Lanzón (page 357, Figure 5) represent the same deity—one essentially animal, the other essentially human—takes on added weight when viewed in the light of La Barre's remarks. We know that the Smiling God was eventually supplanted by the Staff God during Phase D (Rowe 1962; 1967), the time of the proposed second diaspora of Chavín cultists (Cordy-Collins 1976:272). The Staff God probably reflects the culmination of a shift in the economic orientation of Chavín civilization from the tropical forest cultivators to highland agriculturalists; the Staff God is so designated because he bears a staff in each hand—quite possibly a digging stick initially and later a symbol of authority.

In support of this contention we find the Tello Obelisk cayman (Smiling God) associated with tropical forest cultigens (Lathrap 1973) and the Staff God associated

with cotton, a dry land crop (Cordy-Collins 1976:77, 106, Figures 51, 69a-69d; ms.b). The Staff God is also associated with birds, spirit familiars of shamans to whom is ascribed the role of rain bringers (La Barre 1972:268). Rowe has suggested that the Staff God is a weather god, possibly of thunder (1962:20; 1967:86), a role quite appropriate to an agricultural deity.

Therefore, the picture that emerges is of a religion changing under varying geographic and economic stimuli, but retaining its shamanic origins as a nucleus and the use of an hallucinogen as a means to transcendence. The art, in turn, served to transmit this message.

When, for whatever reasons, the hierarchial Chavín religious superstructure collapsed, the shamanic nucleus remained and was transmitted to later cultures. They, in their turn, collapsed, but the shamanic nucleus remains still.

Bibliography

Anton, Ferdinand

 1972 *The Art of Ancient Peru.* G.P. Putnam's Sons. New York.

Cordy-Collins, Alana

 1976 *An Iconographic Study of Chavín Textiles from the South Coast of Peru: The Discovery of a Pre-Columbian Catechism.* Doctoral Dissertation. Institute of Archaeology. University of California, Los Angeles.

 ms.a *The Chavín Textiles of Ica: Vehicles for Early Horizon Idea Transmission.* Paper presented at the 39th meeting of the Society for American Archaeology. May 3-5, 1974. Washington, D.C.

 ms.b *Cotton and the Staff God: Analysis of an Ancient Peruvian Textile.* Paper presented at the Junius B. Bird Pre-Columbian Textile Conference, 1973. Washington, D.C. (In press.)

Eliade, Mircea

 1964 *Shamanism: Archaic Techniques of Ecstacy.* Willard R. Trask, translator. Bollingen Series LXXVI. Princeton University Press. New York.

Furst, Peter T.

 1968 "The Olmec Were-Jaguar Motif in the Light of Ethnographic Reality." *Dumbarton Oaks Conference on the Olmec.* Elizabeth P. Benson, editor. Dumbarton Oaks Research Library. Washington, D.C.

La Barre, Weston

 1972 "Hallucinogens and the Shamanic Origins of Religion." *Flesh of the Gods: The Ritual Use of Hallucinogens.* Peter T. Furst, editor. Praeger Publishers. New York.

Lathrap, Donald W.

 1973 "Gifts of the Cayman: Some Thoughts on the Subsistence Basis of Chavín." *Variation in Anthropology.* Lathrap and Douglas, editors. Illinois Archaeological Survey. Urbana.

Rowe, John Howland

 1962 *Chavín Art: An Inquiry into Its Form and Meaning.* The Museum of Primitive Art. New York.

1967 "Form and Meaning in Chavín Art." *Peruvian Archaeology: Selected Readings.* John H. Rowe and Dorothy Menzel, editors. Peek Publications. Palo Alto.

Sawyer, Alan R.

1968 *Mastercraftsmen of Ancient Peru.* The Solomon R. Guggenheim Foundation. New York.

Sharon, Douglas

1972 "The San Pedro Cactus in Peruvian Folk Healing." *Flesh of the Gods: The Ritual Use of Hallucinogens.* Peter T. Furst, editor. Praeger Publishers. New York.

1974 *The Symbol System of a North Peruvian Shaman.* Doctoral Dissertation. Department of Anthropology, University of California, Los Angeles.

Sharon, Douglas and Alana Cordy-Collins

n.d. *North Peruvian Shamanism: Is the Medium the Message?* Paper presented at the 16th Annual Meeting of the Institute of Andean Studies. January 9-10, 1976. Berkeley.

Sharon, Douglas and Christopher B. Donnan

1974 "Shamanism in Moche Iconography." *Ethnoarchaeology.* Christopher B. Donnan and C. William Clewlow, Jr., editors. Monograph IV. Archaeological survey. Institute of Archaeology. University of California, Los Angeles.

Willey, Gordon R.

1971 *An Introduction to American Archaeology, vol. II: South America.* Prentice-Hall, Inc. Englewood Cliffs, New Jersey.

Paracas and Nazca Iconography

Alan R. Sawyer

Preface

This study was prepared and submitted to the editors of *ESSAYS IN PRE-COLUMBIAN ART AND ARCHAEOLOGY* by Samuel K. Lothrop and Others late in 1959. A few minor editorial changes were allowed before its publication by Harvard University Press in the fall of 1961. In this reprint the text appears exactly as it did in the Harvard edition. Acknowledgements and illustration credits, omitted by the Harvard University Press, are included. I have resisted the temptation to rewrite certain sections of the manuscript in the light of information which has subsequently become available. This new data has not changed my basic conclusions though it does help to clarify a few points. Some of the most significant developments are briefly mentioned below.

Our picture of the Paracas culture in the Ica Valley has been somewhat altered in the last three years by the appearance of an ever increasing number of ceramics and other materials derived from the clandestine digging of local huaqueros. Of special interest are the materials from the Callango area of the Southern part of the Ica Valley, many of which are distinctly Chavinoid, a few so strongly so as to lead some experts to speculate that they could be imports from the North Coast. The regrettable flourish of illegal activity points up the urgent need for thorough scientific archaeological field work in the area before all important sites are hopelessly scrambled by eager treasure seekers.

Dr. Frédéric Engel of Lima, with various field assistants, has been conducting a series of excavations on the Paracas Peninsula since about 1958. In 1960 he showed me the results of an excavation at Cabeza Larga which involved an extremely complex stratigraphy spanning most of the known Paracas sequence. The results of this and other important excavations by Engel remain to be published. They are certain to greatly supplement our knowledge of the Paracas cultural sequence in the Pisco Valley. Among those ceramics from Cabeza Larga shown me were a large number of incised and polychrome painted Cavernas wares which, like those found by Engel at Tambo Colorado ("Early Sites in the Pisco Valley of Peru: Tambo Colorado." *AMERICAN ANTIQUITY*, Vol. 23, No. 1, July 1957, pp. 34-45) are strongly related to

wares found in the Upper Ica Valley of Peru (best known by material from the site of Juan Pablo, Teojate).

In 1957 through early 1960 Mejía Xesspe of Peru's National Museum conducted a series of Paracas grave excavations in the Ica and Río Grande de Nazca Valleys. Viewing these finds at the National Museum I found of special interest a small group of ceramics from the Palpa Valley demonstrating a regional style related to certain potteries found in Callango in the Ica Valley. These finds also remain to be published.

In the summer of 1960, I made a stratigraphic cut at a site on the Hacienda Cordero Alto in the Upper Ica Valley in conjunction with the Ica Regional Museum. Further excavations in the area are desirable before a final report is published. Preliminary findings indicate an abrupt introduction of the "Necropolis" style of Period III with a strong continuance of the local incised Cavernas style. Considerable inter-action between the two traditions is evident as is a gradual and smooth transition from Period IV to Nazca A. All of the Cahuachi Proto-Nazca and "Early Nazca" ceramic types reported by Strong (1957) are present. The regional variations are closer to Cahuachi types than to corresponding wares found on the Paracas Peninsula.

No clarification has as yet been found of the source of the naturalistic design tradition characteristic of Period IV. A small number of embroidered textile fragments I found in stratigraphic association with Period III ceramic types indicate the possibility that this naturalistic tradition was introduced with the "Necropolis" tradition. If this is so, my Periods III and IV may have to be judged at least partially contemporary, with III manifesting the inter-reaction between Cavernas and Necropolis traditions and IV the dominance of the Necropolis naturalistic iconography. The possibility of the existence of another as yet unidentified source for this tradition which is the direct precursor of Nazca A cannot, at this writing, be ruled out. I hope it will be possible to conduct further excavations in an attempt to clarify this and other problems in the not too distant future.

A detailed seriation of ceramic types in the private collections at Ocucaje and elsewhere in Peru has been made by Mr. Lawrence Dawson and Dr. Dorothy Menzel of Berkeley. This study has resulted in their designating ten periods of Paracas style for the Ica Valley which they name Ocucaje 1 through Ocucaje 10.* I question the wisdom of selecting Ocucaje as a term for all Ica Valley variants of Paracas ceramics since many Ica types are not found in this important zone. It can be shown that there are at least three distinct regional variations of Paracas style within the Ica Valley: the Upper Ica (Teojate), Central Ica (Ocucaje) and Lower Ica (Callango). Varying according to periods, the contrast in style between these three areas is often greater than between one of them and a style found in the adjacent Pisco Valley to the north or at sites in the Río Grande de Nazca drainage to the south.

July 1962

Acknowledgements

When I was asked to write this paper I was the Curator of Primitive Art at The Art Institute of Chicago. The concepts I advance were largely developed during my eight years of work and study at that institution, not only with its splendid ancient

*Editors' Note: See: Menzel, Dorothy, John H. Rowe, and Lawrence E. Dawson, 1964, *The Paracas Pottery of Ica, A Study In Style and Time*. University of California Publications in American Archaeology and Ethnology, Volume 50. University of California Press. Berkeley and Los Angeles.

Peruvian holdings, but with other collections in this country and Peru as well. The Art Institute's famed Gaffron Collection has furnished most of the examples of Nazca motifs used here. A large number of Paracas designs was drawn from the Nathan Cummings Collection of Paracas ceramics, which was first made available to me at the Art Institute and later lent to The Textile Museum. A third major source of illustrative material is the collection of The Textile Museum which includes a most comprehensive group of Paracas textiles and a large number of grave lots with associated textiles, ceramics, and other materials from the sites of Ocucaje (the latter group shared with the American Museum of Natural History).

I am greatly indebted to Mr. Nathan Cummings, not only for making his important Paracas collection available to me, but for his financial assistance which made much of my research here and at the Art Institute possible and which has underwritten the cost of the preparation of this paper.

The rollout drawings for Figures 6 through 12 were rendered, with few exceptions, by Miss Grace Brennan of The Art Institute of Chicago and Mrs. Olive Abel, formerly with The Textile Museum. Miss Brennan executed all the Nazca motifs other than Figure 9i and Figure 12g. These were drawn by Mrs. Abel who is also responsible for the Paracas examples, except for Figure 6f, Figure 9a, b, and d, and Figure 10c (by the author). Figure 10a was furnished by the American Museum of Natural History and Figures 10d and e are after Yacovleff (1932a).

Paracas textiles and Nazca ceramics are two of the most widely acclaimed art forms of ancient Peru, yet many aspects of the history and development of the cultures that produced them remain relatively obscure. The reason for this phenomenon lies mainly in the fact that most of the Paracas and Nazca materials in the world's museums were excavated without the benefit of scientific observations. Archaeologists, seeking data with which to reconstruct the complex cultural history of the South Coast of Peru, have been greatly hampered by the scrambled and incomplete evidence of thoroughly looted sites. In spite of these limitations, the broad outline of most of the history of these two remarkable cultures has been reconstructed and archaeologists working in the field during the past few years and at the time of this writing will undoubtedly give us an understanding of many of the unsolved problems which remain. Meanwhile, it would seem profitable to turn our attention to the abundant, though largely undocumented, materials which are available in order to re-evaluate what can be learned from the objects themselves in the light of what is now known.

In this paper I will attempt to identify and trace the evolution of a number of important iconographic elements which are found throughout significant portions of the Paracas-Nazca stylistic sequence. In so doing I hope to be able to demonstrate visually some of the major trends in the early cultural history of the South Coast of Peru. My approach seeks to apply art historical principles while fully utilizing archaeological findings. Some of the principles I feel are particularly applicable to studies of archaeological material I outline below.

Art is always an expression of the time and place in which it is produced. The evolution of its style and content varies in direct relation to changes in the cultural environment. Ancient peoples were almost universally dominated by religion which furnished and controlled the symbolism of their art. Design vocabularies tended to remain relatively constant, while modes of representation evolved gradually from the simple toward the more complex. This complexity sometimes manifested itself in a trend toward greater realism, at other times toward increasingly abstract symbolism.

Any abrupt change in either iconographic content or stylization usually indicates the altering of religious concepts and practices by outside influence. The mingling of two distinct artistic traditions, each with its own religious symbolism and technical processes, usually produced a proliferation of motifs and experimentation with techniques before the culture settled down to a new and homogeneous style. When a people were conquered by an invader the traditional local style tended to disappear. The degree of domination is shown by the extent to which native traditions were allowed to survive. All of these principles may be discerned in the long sequence of stylistic evolution which began with the earliest known phases of Paracas and ended with the introduction of dominant Highland influence at the close of the Nazca Period.

In any chronological ordering of archaeological material it is, of course, important to make careful note of changes of forms and techniques as well as iconography. While these factors have been taken into consideration in the interpretations advanced in this paper, their detailed discussion must wait for a publication of larger scope.

Iconographic studies have been used in one form or another by many researchers in the field of ancient Peruvian art. The most notable studies of Nazca ceramic designs were published by Seler and Yacovleff.[1] Similar illuminating studies on the iconography of Paracas textiles have been made by Tello and Carrión Cachot and others of the National Museums of Peru.[2] This paper will limit itself primarily to ceramic design, since that offers the most complete documentation of style. Textiles, which are preserved only when conditions are ideal, will be cited when they help to clarify the ceramic sequence.

The Paracas Culture

In 1925, the late Julio C. Tello and Samuel K. Lothrop explored archaeological sites on the Paracas Peninsula in the Pisco Valley that were to give the Paracas culture its name. In subsequent excavations Tello observed that the materials found represented two distinct cultural traditions. The group he named "Cavernas" included incised and post-fire-painted ceramics and poorly preserved textiles with geometric designs. In certain of the ceramic designs of this group he recognized affinities with the early widespread Chavín culture. A second group of materials which he named "Necropolis" consisted of relatively undecorated ceramics and richly embroidered textiles. Some were geometric and others comparatively naturalistic in their design conventions. The naturalistic style he recognized as being closely related in iconography to early Nazca ceramics. Recent findings have verified both of the basic cultural relationships Tello recognized, but his terminology has been a source of much confusion. The term "Cavernas" has unfortunately come to be applied to incised and post-fire-painted ceramics of all Paracas phases, while the term "Necropolis" has continued to include two apparently distinct stylistic groups of materials.

Evidence of various aspects of the Paracas culture has been discovered throughout a wide area of the South Coast of Peru which includes the Cañete, Chincha, Pisco and Ica Valleys and the Valleys of the Río Grande and its tributaries the Palpa, Ingenio and Nazca, etc. (Fig. 1). Among the Paracas sites now known, the one which shows the most complete sequence of styles leading from earliest Paracas to Nazca is Ocucaje. Ocucaje is located in the Central Ica Valley. It furnishes the principal basis for the stylistic periods of Paracas outlined here. For comparative purposes, I shall also describe another Paracas style found at a site in the upper reaches of the Ica Valley known as Juan Pablo and referred to locally as "Pampa de Teojate."

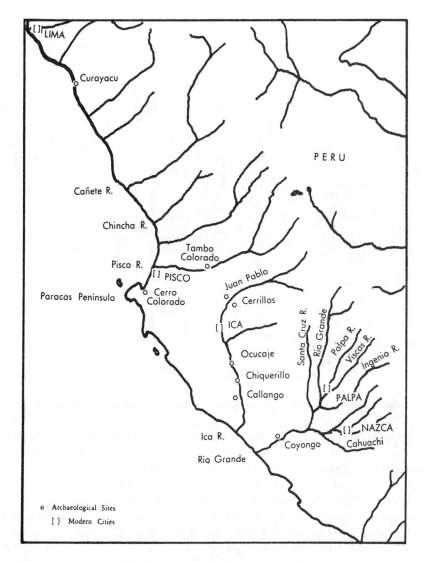

Figure 1. Map of the south coast of Peru.

Paracas-Nazca Chronology

Figure 2 shows the time distribution of the selected iconographic elements discussed in this paper. Dashed lines indicate Juan Pablo, solid lines Ocucaje. (Dotted where motif is secondary.) Double lines signify motifs which are of primary import-ance to our discussion. Let us first briefly examine the context and character of the periods designated.

Period I

The earliest positively identified cultural level of Southern Peru directly related to our problem is a strongly Chavinoid phase recently isolated by Dr. Dwight Wallace at a stratified site, in the upper Ica Valley, called Cerrillos. He found it underlying levels

KEY CULTURE	STYLISTIC PERIODS		FOX	CONDOR	FALCON	FELINE	HUMAN	DOUBLE HEADED SERPENT	TROPHY HEAD	MONKEY	GOLD ORNAMENTS	KILLER WHALE	VEGETABLES & FRUITS	BIRDS AND ANIMALS	FISH AND FISHERMEN	SCROLL AND LANCET
		MOTIF														
PARACAS	I FORMATIVE (Chavinoid)		?													
	II EARLY		‖	⋮	‖	‖	‖									
	III MIDDLE		?‖	⋮	‖	‖	‖									
	IV LATE		‖		‖	‖	‖	‖	‖		‖					
NAZCA	"A" EARLY NAZCA															
	"X" TRANSITIONAL		⋮											⋮	⋮	
	"B" LATE NAZCA		⋮											⋮	⋮	
	Y1 DECADENT															
	Y2 NAZCA-HUARI Y3		} Not Covered													

Figure 2. Time distribution of iconographic motifs in Paracas and Nazca periods.

which correspond closely to what the author designates as Paracas II at Juan Pablo, located nearby.[3] Ceramics similar to Cerrillos Chavinoid have been found at Juan Pablo and are strongly in evidence at Ocucaje,[4] at a small site south of Ocucaje called Chiquerillo, and at Callango in the southern part of the Valley.

The iconography of this phase shares many motifs with Chavinoid cultures of the North Coast and Highlands of Peru. The most conspicuous among these is a feline mask with prominent fangs which overlap the lips (Fig. 4, a, b and c), a human face usually with a distinctive rectangular eye pattern and a double-headed serpent.[5] The condor may well be present since it is an important Chavinoid element elsewhere* and is found in Paracas II. Two other important motifs occur which are not generally identified as belonging to the Chavinoid vocabulary. They are the fox and the falcon.

The decorative techniques used on Paracas Chavinoid ceramics are incised lines and post-fired resinous paints. These techniques were used both separately and in combination. Incising is a widespread Chavinoid trait. The origin of the post-fired, resinous-paint technique is not yet known. It remains characteristic of Ocucaje and other Central and Southern Ica Valley sites throughout the four Paracas Periods. The post-fire, carbon black, negative decoration commonly associated with subsequent Paracas phases has also been found with pieces having Chavinoid traits, though on the North Coast of Peru the technique appears definitely after the Chavín horizon. The

*Editor's Note: The condor as a Chavinoid element is refuted by Rowe in his article in this volume.

double-spout-and-bridge bottle makes its earliest known appearance on the South Coast in Period I with one spout always blind and in the form of a human head, a modeled bird, or bird-head which usually contains a whistle.[6] This distinctive type of vessel bears a striking resemblance to a bottle form of the Salinar culture which is again post-Chavín on the North Coast.[7] On the other hand, the "corn-popper" and other characteristic Chavinoid ceramic shapes appear in this Paracas phase.[8]

The Paracas Ceramics of Juan Pablo

Considerable new evidence has come to light since Dawson published his temporary classification of Paracas ceramics in 1958.[9] The Chavinoid phase had not then been identified and it now appears probable that the Juan Pablo style was contemporary with that of Ocucaje throughout all four Paracas Periods, although earlier publications[10] have classified all Juan Pablo ceramics as "Early Paracas."

Juan Pablo iconography is derived from its Chavinoid phase with perhaps a strong admixture of local traditions. Its principal motifs are the feline, fox and falcon, two or three stylized birds, and a few geometric motifs. The Chavinoid double-spout bottle with one blind spout continues throughout all periods, the blind spout appearing in the form of a head of either a bird, falcon, fox, or human being. The iconography remains constant while the style grows increasingly complex throughout Periods II and III. In Period IV the Chavinoid tradition becomes decadent and the style undergoes extreme simplification while acquiring a few new late Paracas motifs such as the winged forehead ornament.[11] An evidence of relations with other groups at this time is the presence of Paracas IV trade pieces from Ocucaje.

Juan Pablo post-fired pigments appear for the most part to have been mixed with a gum which is soluble in water.[12] The binder in the paint has now deteriorated leaving the pigments in powdery form. In some cases they have disappeared altogether. The gum-based paint evidently was easier to handle than the thick resinous paint used at Ocucaje,[13] enabling the Juan Pablo craftsmen to execute more complex color patterns and finer detail.

Period II

Period II is characterized by the development of related local styles based on the Chavinoid traditions. At Ocucaje, the iconography relates closely to Paracas Chavinoid, but with a different emphasis from that found at Juan Pablo.[14] The fox and falcon are minor motifs, with the feline, human being, double-headed snake, condor and various geometric motifs appearing most frequently. Full figure elements are usually shown against a yellow background with widely scattered space fillers. Double-spout and bridge bottles often have bowl bases bearing geometric patterns and a falcon head appears as a modeled decoration on one and sometimes both of the spouts, which are left open at the top. Toward the end of the period falcon heads are often lacking, making the bottles directly comparable in form to those of the Nazca Period. Yellow remains as the usual background color but space fillers are seldom used.

Period III

The Third Period of Paracas marks the introduction of a strong, new, outside influence which greatly changed the iconography and style of Ocucaje ceramics. It does not seem to have had any effect at Juan Pablo which continues the Chavinoid tradition. The source of the influence may be a culture found by Edward Lanning and

Dwight Wallace in the Cañete, Chincha and Pisco Valleys. They call it "Topara" and equate it with "Necropolis" ceramics and the geometricized style of embroidered textiles found by Tello at Paracas.[15] It is evident that the Necropolis tradition co-existed and interacted with the Chavinoid tradition throughout Periods III and IV. Necropolis ceramics are largely undecorated, but the influence of their forms and techniques can be clearly seen in Ocucaje late period incised wares.

The iconography of Period III textiles consists mainly of feline, monkey and human trophy-head cult deities, double-headed serpents and birds. Design elements are made up of lines of vertical, horizontal and diagonal direction. Outlines are often embellished with sawtooth edges. Small figures, trophy heads and triangular obsidian knife motifs are found pendant to bodies and tails and are used as space fillers (see Fig. 3 top). Ocucaje ceramic designs of Period III retain some of the iconographic elements of Period II while giving a major role to the new trophy-head cult symbolism. The textile motifs are translated rather freely into ceramic equivalents which are rendered in flowing and zigzag lines against comparatively uncluttered backgrounds. (See Fig. 6, k.) Double-spout bottles are subglobular in form and are decorated on the upper half only. Blind spouts occur in the form of human and feline heads.

The custom of collecting trophy heads appears to have been of paramount importance in the intrusive Necropolis culture. Both the practice and the deity symbols connected with it can be traced throughout the remaining Paracas Period and the entire Nazca sequence. The origin of this cultural trait is obscure. It does not seem to have played a part in Chavín horizon religion but evidence of it crops up in widely scattered ancient cultures such as Mochica [Moche][16] and Pucara.[17] Another notable new feature of the Paracas design is the presence of the monkey as an important iconographic motif.

Period IV

The Fourth Period of Paracas is characterized by naturalistic style conventions, an amazingly rich and varied textile iconography, and a highly diversified ceramic typology. Most significant is the presence of a profusion of new animal, bird, fish and fishermen, vegetable and fruit motifs together with monkey and human agricultural fertility deities. Almost all Period III iconographic elements are present translated into the new style (compare Fig. 3, top and bottom). The trophy-head cult is still strong and appears with the important additions of the killer whale and falcon to its pantheon of deities. Gold forehead and whisker ornaments, which are later so diagnostic of Nazca ceramic iconography, first appear at this time. The whisker ornament is often worn by monkey deities but seldom by human figures, which suggests that its origin is from the monkey.[18] Felines in Period IV are seldom shown with whisker ornaments.

Many Paracas textiles in existence are rendered in styles falling between the geometric and naturalistic extremes of Periods III and IV. They may represent transitional phases in a continuous development but seem more likely to be products of an inter-action between two cultures. The two traditions are known to co-exist[19] and the contrast appears too great to be explained by simple evolution. Therefore, it seems probable that Period IV Paracas culture was the result of contact with another group having strongly naturalistic art conventions and an agricultural fertility cult. The author would not be surprised if the source of this new influence in Period IV is found to be the Río Grande drainage area. There is scant evidence to support or

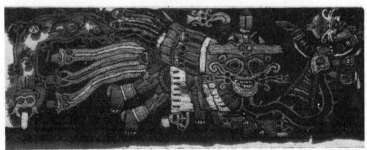

Figure 3. Paracas textiles, Periods III and IV.

disprove such speculation though Strong's proto-Nazca finds at Cahuachi, and the existence of numerous Necropolis-like textiles from the area,[20] would fit into such a picture.

Few textiles with naturalistic style embroidery have been found at Ocucaje. However, the effect of the new iconography can be clearly seen on its post-fire, resin-painted pottery. Naturalistic killer whales, birds, monkeys, felines, foxes, and other animals are found on well-fired, thin-wall ceramics. The trophy-head cult motifs continued from Period III are rendered in greatly simplified and more naturalistic outline.

It seems rather unlikely that Ocucaje was a major center for the development of the Nazca style, but a considerable number of transitional ceramics are found there. They represent a number of technically experimental types ranging from the "classic" Necropolis cream-slipped spout-and-bridge-to-head modeled forms, with incisions and sometimes resin paint, to a fully developed, incised, polychrome slip style which has only to lose its incised lines to become Early Nazca. Ceramic design motifs are almost always less complex than their textile equivalents, a factor which must have contributed considerably to the trend of simplification in iconography and representation before the beginning of the Early Nazca Period.

Nazca Ceramic Style

Kroeber has divided the Nazca stylistic sequence into periods A, X, B and Y (1, 2 and 3).[21] These designations are correlated in Figure 2 with the generalized terms "Early," "Transitional," "Late," "Decadent" and "Nazca Huari."[22] Since the primary purpose of this paper is to demonstrate the continuity of Paracas and Nazca iconography, I have traced designs only as far as the end of the Late Nazca Period (Kroeber's B). Beyond that point we would become involved in a whole new series of problems dealing with the influence of the Highland Huari culture.

The transition from Paracas to Early Nazca is characterized by a shift from weaving to ceramics as the medium for the conveyance of what is essentially the same iconography. Realistic representations of religious motifs in textiles seem to disappear shortly after the polychrome slip technique of ceramic decoration was mastered. The iconography which had undergone extreme simplification in the Paracas IV Period trended gradually toward greater stylization and complexity throughout Early Nazca. At first ceramic motifs were rendered with much the same conventions as had been used in embroidered Necropolis textiles. Anthropomorphic and animal deities along with many naturalistic birds, animals, fish, reptiles, vegetables and fruits were set against simple backgrounds. As the Nazca craftsmen developed increased proficiency in the ceramic arts, vessel shapes became more precise and varied, and designs exhibited a more formal stylization which was the natural outgrowth of the technique of drawing on pottery. At the same time, Nazca religious beliefs and practices gradually modified and we see an increased emphasis on representations of trophy-head and fertility cult deities, together with a lessening frequency of natural elements.

In the transitional period between Early and Late Nazca a great change took place in both iconography and style. This was brought about by a new cultural influence whose most characteristic design element I shall refer to as the "scroll and lancet." This new element appears as an appendage to highly stylized versions of traditional Early Nazca deities which become increasingly symbolic and are often abstracted by the breaking up and rearrangement of their component parts. Two new iconographic elements appear which, although they have Early Nazca precedents, are distinctly different in form. They are familiarly referred to by some Peruvianists as the "horrible bird" and "bloody mouth." The former is a stylized condor which carries a trophy head in its beak,[23] while the latter is a highly stylized version of the killer whale head.

Late Nazca ceramics are immediately identifiable by the proliferation of scroll-and lancet motifs which greatly alter the appearance of the design elements. The style is as different from Early Nazca as Mochica [Moche] is from Chimu and just as

deserving of a name of its own. Tello called it "Chanca," a term rejected by archeologists for valid reasons.[24] Perhaps, once the source of the influence which formed the new style has been determined, a better nomenclature can be worked out. Ceramics in the Late Nazca or related styles are found throughout a wide area of the Highlands as well as the Coast. In the Nazca area the change of culture seems to be a result of the introduction of new religious concepts rather than the forceful conquests by outsiders. Neither the quantity nor the quality of Nazca art is affected. One interesting phenomenon in Late Nazca is the reappearance of religious iconography in textile design which is related to that of the ceramics.

The Origin of Feline Motifs

Survival was the primary concern of ancient and primitive societies. The gods to whom they appealed for protection against the elemental forces and human enemies which threatened them were often visualized as possessing attributes of the most formidable animals they knew. In the Central Andean region the Highland puma and Lowland jaguar were the largest and strongest animals. Therefore, it is not surprising that they became the most widespread deity symbols among ancient cultures of the area. The Chavín culture of Northern Peru was probably the earliest to possess a highly organized religion centering around a feline deity.[25] This religion and its symbols was apparently spread by movement of groups of people from the Northern area to other parts of Peru, including the South Coast, where felines were relatively unknown. Neither the puma nor the jaguar, or even the small ocelot, was native to the area.[26] The persistence of the feline motif throughout the Four Paracas Periods can only be explained by a strong continuance of Chavinoid beliefs and symbols sustained by the reintroduction of the feline as an important element in Period III.

Feline Mask Motifs—Period I

The most characteristic Chavinoid motif of the Paracas I Period is a feline mask. The variety of its stylization seems to indicate that the Period was of fairly long duration. The most Chavinoid, and therefore apparently earliest style, is shown on a bottle from Chiquerillo (Fig. 4, a and b). The mask is rendered in broad, curvilinear incised lines and painted with red, orange, yellow, cream and black resinous post-fire paint. Its stylization is closely comparable to many Northern Chavinoid renderings of the same motif such as the gold plaque in the Bliss Collection and the Simkhovich gorget.[27] Another example from Chiquerillo is rendered in what appears to be in later style (Fig. 4, c), perhaps the result of the mingling of the Chavinoid with the as yet unidentified local culture. The mask is now enclosed in a compact outline of three bands. The nose is in relief and the eyes, prominent fangs and other elements are drawn in a curvilinear, but less flamboyant manner. A reed-stamped circle appears in the center of the forehead of the example shown. For comparative purposes with later renderings it should be noted that in the Chavinoid Period the diameter of these circles varies from 3/8 to 1/2 inch and larger. The resinous paints are not well preserved on the specimen shown but traces indicate that the colors used were red, yellow ocher, cream, orange brown and olive green.

The feline mask motif is found at Ocucaje in Period I but is rare in Period II at that site. At Juan Pablo it continues as a major motif throughout Periods II, III and IV. Its evolution is demonstrated by a series of six examples (Fig. 4, d-i).

Figure 4. Paracas bottles, Chiquerillo and Juan Pablo.

Period II—Juan Pablo

The feline mask motifs found on Juan Pablo bottles of Period II resemble those of the Chavinoid Period, but are usually wider in proportion and more geometric and complex in design. The prominent fangs do not overlap the lip. The mask is usually enclosed by a double band which follows the ear form and is separated from the blind spout by a space as it was in Period I (d). At other times the ears of the mask partially surround the base of the spout (e). Noses are in relief and reed-stamped circles, when they occur, range from 5/16 to 3/8 inch in diameter. Unconnected lines often end in a punched dot and dots are sometimes found within the reed-stamped circles (a

Chavinoid trait). One or more geometricized Chavinoid rectangular eye patterns are generally found in the chin area and arm and paw or whisker motifs appear at each end of the mouth. Juan Pablo bottles of this Period are usually larger than in Period I. The ware is thinner and reduction fired, varying from black to yellow-brown color. Some orange-brown oxidation ware occurs decorated with negative spots. The gum-based post-fire paint used included red, orange, yellow, yellow green, cream, white and black. What may have originally been a resin-based olive-green paint is sometimes found (as on the outer border and line below the nose of d).[28]

Period III—Juan Pablo

In Period III Juan Pablo bottles are wider and lower in proportion than those of Period II (f and g). The feline mask motif is more complex and bordered by a simplified outline which often eliminates the profile of the ears. The latter are now represented only by a rectangular or, less frequently, triangular loop at the end of the brow element (a feature often present in Period II in addition to the outlined ear). The forehead area is more elaborate in Period III with many reed-stamped circles which average about 1/4 inch in diameter. Noses are seldom in relief; mouths extend to each side of the mask and fangs are less prominent. A geometric design such as a step, "Z", or "S" repeat occupies the area below the mouth. Punch dots are still found at the end of lines and are also used as a geometric design element (as in g). A broad band of geomeric designs sometimes borders the mask passing over the top of the vessel between the spouts. Juan Pablo ceramics of Period III are sometimes reduction fired (f) but are more often oxidized with a negative spot decoration (g). Pigments seem to be exclusively gum-based with a preference shown for red, orange, yellow, white, brown, black and light green.

Period IV—Juan Pablo

Ceramics of the Fourth Period at Juan Pablo are usually less well made than those of the earlier periods. Bottle forms are subglobular (h), lenticular (i) or muffin-shaped with bowl bases. The ware is heavy and ranges from black through gray and brown. To my knowledge, no negative-decorated bottles occur. A preference is shown for shades of pink, orange, red and white gum-based paints with minor accents of black and brown. A resin-based dark green is found which is sometimes broken down into a whitish powder containing green flecks visible under magnification. The feline masks are wide with the mouths low, eliminating the decorated chin area. Mouths are sometimes shortened and lack canine teeth (see Fig. 6, e and g). Ears are triangular and forehead areas elaborate. Reed-stamped circles vary from 3/16 to 1/8 inch in diameter. Noses are never in relief. Bands of geometric decor across the top continue and sometimes the entire top of the vessel is covered with incised motifs and post-fire paint.

The last survival of Chavinoid-Cavernas traditions is shown in Figure 4, i. Here the mask has a double row of teeth instead of the usual one, and misplaced canines appear in the eyebrow area. This bottle was found in grave association with a bowl decorated with a forehead ornament motif similar to those found at Ocucaje in this Period.

The Feline Figure Motif

The author has seen very few full feline figure motifs on Period I ceramics. The stylization of these closely resembles the North Coast Chavín feline. The motif is

OCUCAJE	JUAN PABLO	NAZCA
No trace	No trace	White
Cream	White	Cream
Yellow	Cream	Tan
Tan	Yellow	Light Orange
Olive-Green	Light Orange	Orange
Gray	Orange	Light Mauve
Light green	Tan	Dark Mauve
Dark Green	Olive	Light Grey
Brown	Brown	Dark Grey
Red	Red	Brown
Black	Black	Dark Brown
		Indian Red
		Black

Figure 5. Color key.

Figure 6. Paracas feline motifs, Juan Pablo and Ocucaje.

found at Juan Pablo, Ocucaje, Callango and other sites in Period II though its character and frequency varies. At Ocucaje the feline figure is always found on double-spout bottles while at Callango it occurs on both bottles and bowls. At Juan Pablo feline masks are found on both bowls and bottles while the feline figure motif is limited to the bowls.

The Feline Figure Motif—Juan Pablo

The Juan Pablo Period II, III and IV feline motif appears as a full-faced mask alongside a somewhat abstract profile body. Typical versions are illustrated in Figure 6, a, c and d. The mask b is a Period III variant. In Period IV simplified versions of the mask alone (e and g) are more common than figures. It will be noted that the trends in the development of the Juan Pahlo style are the same as we traced in our discussion of the feline mask motif. The motif becomes increasingly complex up until Period IV, during which it becomes somewhat degenerate and simplified. Reed-stamped circles, when present, show a steady decrease in size and incised lines run from broad in Period I to extremely fine in IV. The feline head (f) is taken from a rare modeled figure belonging to Period III and is included for comparison with the fox head shown in Figure 9.

The Feline Figure Motif—Ocucaje

Three characteristic variants of Ocucaje feline figures in Period II are shown in Figure 6, h, i and j. The prominent canine teeth of h mark it as the earliest, a conclusion borne out by the fact that it occurs in a gave lot of 14 ceramics, all of which have distinct Chavinoid traits. The stylization of i is more characteristic of Period II with its shortened mouth without fangs. (This trait does not appear at Juan Pablo until Period IV.) It is also more typical in that it occurs on a bottle with a bowl base decorated with geometric designs and with a modeled falcon head on the spout. Variant j is taken from a double-spout bottle without a bowl base. Its simplicity indicates that it belongs to the last part of Period II.

In Period III, at Ocucaje, feline figures acquire simplified head outlines and jagged edges to body and tail which reflect the influence of geometric style Necropolis textiles. Of the two variants shown, k (which is taken from a large jar) is the most conservative, being a translation of the Cavernas feline element into Period III conventions. Variant l appears on a bottle with a blind spout in the form of the modeled human head above an incised figure holding an obsidian knife in one hand and a trophy head in another. The association of this feline figure with the trophy-head cult is also shown by the obsidian knife appended to its head, the protruding tongue and feline or serpent-headed tail.

Three versions of the feline motif as it appears at Ocucaje in Period IV incised and resin-painted ceramics are shown in Figure 6, m, n and o. The example m is taken from the side of a rattle-based bowl having a simplified version of the Period III trophy-head deity on its interior surface. Variant n has also been taken from an interior-incised bowl, a form which in this Period is found bearing many naturalistic animals and birds and which is a forerunner of the Early Nazca interior-decorated bowl. The stylization of n retains some of the conventions of Period III such as the protruding tongue and the rectangular pelt markings (compare k) but like m lacks the serrated border to body and tail. The final example (o) is typical of renderings of the feline element in the last part of Period IV. It is taken from a straight-sided,

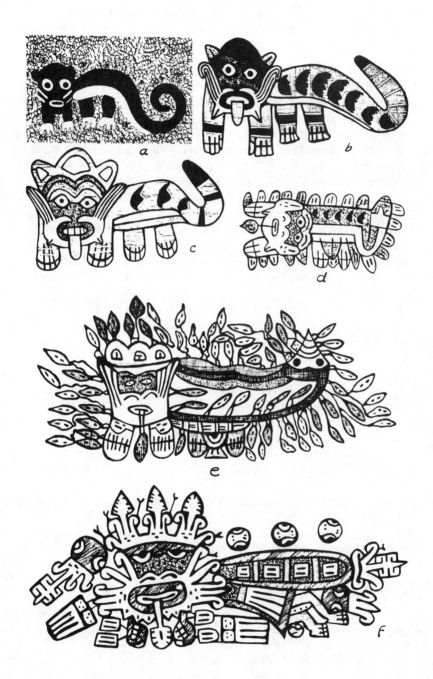

Figure 7. Nazca feline motifs.

round-based, thin-ware bowl. The smooth flowing line in which the feline is rendered relates it closely to the Early Nazca style. It should be noted that the conventions of frontal face and profile figure which were established by the end of Period I, remain unchanged throughout the entire Paracas-Nazca sequence.

The Feline Motif in Nazca Ceramics

It has been customary to refer to all Nazca figure motifs having a whisker "face mask" as being feline deities. While this is logical in view of the widespread use of feline deity symbols in ancient Peru, there is, as we have already seen, a possibility that the whisker element originated in the Necropolis Period as a monkey attribute (see Fig. 3, bottom). Usually such face ornaments show the whiskers standing out to the side of the face. In the most feline of Nazca motifs (Fig. 7) they stand straight up, a characteristic that may be worth noting. With religious traditions stressing feline symbols, it would have been logical for the Nazca to deify the most catlike animal they knew. This was the otter (*lutra felina*) commonly called the "gato de agua" (water cat) or "tigerillo" (little tiger). It is still to be seen frequently along the rivers and irrigation ditches of the South Coast valleys and it would have been natural for the ancient inhabitants to have regarded it as possessing a beneficent spirit toward agriculture. The whiskers of the otter slant back toward its ears, whereas the cat whiskers do not.[29]

A representation of the "gato de agua" from a very early Nazca bowl is shown in Figure 7, a. It will be noted that it differs from the feline deities mainly in the fact that it lacks crescent-shaped markings. It is possible these markings represent an ocelot attribute. This animal is native to the eastern jungle valleys of Peru and may have been imported in Necropolis times for ritual purposes. Evidence favoring this view is found in Necropolis textiles in which monkey-like agricultural deities carry ocelots in their arms.[30] The "gato de agua" is found frequently in Necropolis textiles. The Nazca appear to have combined the attributes of the imported feline symbol and familiar catlike otter in visualizing a deity which would insure the fertility of their crops. For those interested in this problem, Valcárcel has published an illuminating study with many illustrations.[31] He shows one very early modeled representation of the "gato de agua" which has both the crescent-shaped ocelot markings and a row of stylized beans down its side indicating its connection with agricultural concepts.

The feline agricultural deity motif appears as an important item in the Nazca iconography. Its evolution is demonstrated by the selected examples shown in Figure 7. The Nazca stylization of the feline motif follows the conventions of Period IV Paracas textiles in which the frontal view of the forelegs is added to the frontal face and profile body. In Paracas ceramics only two legs are shown. Early Nazca variants, such as b and c, are often shown with pepinos or other fruits or vegetables. In the Transitional Period (d) the figure is abstracted and tablike conventionalized pepino symbols are attached to the body and tongue.

The "scroll-and-lancet" motifs which are often present in Transitional Period designs are not associated with feline fertility deities in the first part of the Late Nazca Period (e). It appears that this late Nazca element was associated with the trophy-head cult and that the forked barbedlike attachments which occur at the loop of the scroll element represent trophy hair. These can be see in f attached to the headdress and tail ornaments which in this version appear to represent sprouting plant forms. The interpretation of the "barb" as trophy hair is something that would require a full

Figure 8. Paracas fox motifs.

Figure 9. Paracas and Nazca fox motifs.

page of illustrations to demonstrate. Space does not permit its full explanation here but those familiar with Nazca ceramics may note the trend of simplification in trophy-head representations throughout the later part of Early Nazca and the Transitional Period. In many instances during the latter period the trophy head is eliminated, leaving only the locks of hair which become increasingly stylized until in the Late Nazca they are represented by the small, forked black symbols. The element has been interpreted as a cactus thorn, yet this would seem to be unwarranted in view of its constant association with deity symbols of the trophy-head cult. Its presence with the agricultural fertility cult symbol in Figure 7, f is evidence that in Late Nazca it was believed that the collecting of trophy heads contributed to the assurance of success for crops. Note that in the late version f the figure is anthropomorphic and no longer has the "gato de agua" type whiskers, but the generalized type associated with other Nazca deities.

The Fox Motif

The fox (*dusicyon*) is today, and probably was in ancient times, the largest land animal native to the South Coast of Peru. Therefore, it would have been one of the most logical deity symbols of peoples living in the area. The fox is sometimes represented in North Coast Chavinoid styles such as Cupisnique,[32] but nowhere with the frequency and evident importance that it enjoys in Juan Pablo, the most distinctively regional of Ica Valley Paracas styles. Its prominence suggests that it may have been an important local symbol before the introduction of the Chavinoid feline deity in Period I.

Variants of the earliest Paracas ceramic design that may be interpreted as a fox are shown in figure 8, a and b, taken from Period I bowls from Juan Pablo and Chiquerillo. The motif has also been found at Ocucaje and Cerro Colorado.[33] It would be tempting to identify this element as a feline head in profile, citing Chavinoid precedents. The importance of the fox on the south coast made it necessary, however, to differentiate between the two animal representations. Primitive artists almost invariably represent things from their most easily identifiable aspect; thus cat heads are shown frontally, while the fox with its longer snout can be most readily identified from the side. The interpretation of the Period I motif as a fox is also based on its relationship to later versions which can be more easily identified as this animal. A rare, modeled version of a fox head of Period II from the site of Callango is shown in Figure 9, a. Note the similarity of this version to Figure 8, a with its long mouth and snout and the treatment of the eye and brow elements. Figure 9, b shows the fox head as it appears as a Period III Juan Pablo blind spout. Note the body of the fox incised on the front of the vessel.

At the beginning of Period II at Juan Pablo (Figure 8, c) the head of the fox in incised designs is a simplified and more geometric version of a and b with a highly stylized body element added. Later in this Period the full figure is shown (d). In Period III the profile fox figure occurs with many variations as represented by e and f. In Period IV it appears as a much elongated and somewhat abstracted element as in g, or when modified by influence of the new naturalistic style, a more simplified representation as in h and i. Note the similarity of i to the Ocucaje Period IV variant shown in j (the latter taken from an incised resin-painted rattle-based bowl). It is interesting to note that in both i and j, the ears and eyes are shown in front view, whereas the body and mouth are in profile. Any such radical altering of the

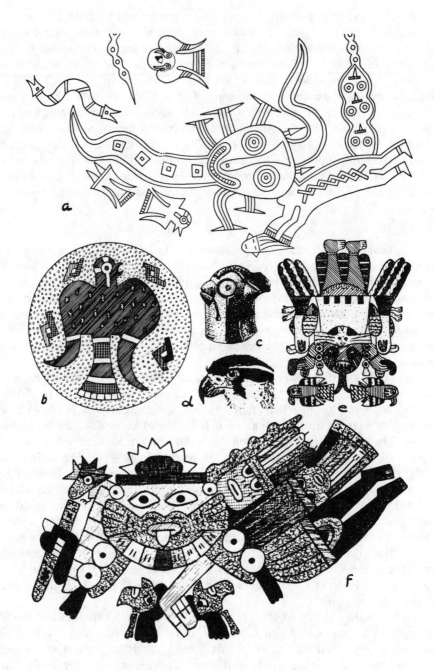

Figure 10. Paracas and Nazca falcon motifs.

long-established style conventions of Juan Pablo is most logically explained by the introduction of outside influence.

The fox motif is not seen frequently in Ocucaje ceramics and we may therefore assume that it did not play an important role in religious symbolism of that site. A rare example from Period I is shown in Figure 9, c, which is rather closely related to the Chavinoid face variants shown in Figure 8, a and b, and the Juan Pablo II version shown in Figure 8, d. The element was re-introduced at Ocucaje in Period IV. A blind-spout, modeled fox head taken from a Period IV Necropolis style bottle with heavy cream slip applied along the ridge of the nose is shown in Figure 9, d. The vessel from which this detail is drawn is typical of the experimental forms occurring in Period IV which combine incised lines with slip in a development of the proto-Nazca style.

The fox was not a particularly important symbol in Nazca iconography. It is found occasionally in all periods but does not become radically altered in Late Nazca as do more important iconographic elements. The trend of its stylistic development may be seen in Figure 9, a-j. The early Nazca Period is represented by e, f, and g during which the fox gradually becomes more stylized. The front view of ears is kept as it was in Paracas Period IV ceramic versions (Fig. 8, i and j), but the eye and figure with four rather than two legs are shown in profile in keeping with Late Paracas textile conventions. In the Nazca Transitional Period the fox is not greatly changed (h) although the variant i may be a fox conformed to the new style. However, in Late Nazca the fox occurs very rarely and when it does is little altered from its Early Nazca form (j).

The Falcon Motif

The falcon (*falco fermoralis*) is native of the Coast of Peru, while the large condor ranges both Highlands and Coast. Both birds feature in South Coast iconography, but the falcon was, like the fox, of particular importance to the Paracas peoples. An excellent study of the falcon and other birds of prey as they appear in ancient Peruvian art has been published by Eugenio Yacovleff.[34] A head detail of his drawing of the falcon is reproduced in Figure 10, d. It will be noted that the distinctive markings below the eyes are faithfully rendered in the modeled, blind-spout falcon head from Period II at Juan Pablo which is shown in c of the same figure. The ears of this motif are rather difficult to explain; they are found as an attribute of the falcon in all periods at Juan Pablo, but disappear in Periods III and IV at Ocucaje, as may be seen in a and b. The ear as an attribute of the falcon may have been brought to the South Coast by the Chavinoid culture of Period I. Again we may note the strong resemblance to the Post-Chavín Salinar versions as illustrated by Larco-Hoyle.[35] Two of the four representations he illustrates have ears and are identified by him as owls, yet they have the distinctive falcon trait of a protuberance around the nostril at the top of the beak which is not shared by owls. The latter feature is also shown on an eared falcon in the form of a Cupisnique stone mortar, illustrated by Larco-Hoyle.[36] Therefore, it would appear that the falcon symbol may have been given ears as an owl (or more likely puma) attribute in North Coast Chavinoid iconography and that the tradition was brought to the South Coast where it was continued. A strong resemblance in modeling of the falcon head to that of Salinar versions may be seen in the Chavinoid Period I example from Chiquerillo illustrated in Figure 4, j. The head of this example contains a whistle and the vessel itself is of a peculiar form closely

Figure 11. Nazca falcon trophy-head deity.

resembling a vessel of the North Coast Gallinazo culture which is said by Larco-Hoyle to represent a balsa raft.[37] It would be interesting to know whether the blind-spout head on the Gallinazo vessel also contains a whistle. Whatever the origin of this unusual ritual vessel with whistle spout, it continues to occur infrequently in Juan Pablo Periods II and III (Figure 4, k and l).

By far the most frequent representation of the falcon in Juan Pablo ceramics is on a blind-spout bottle form shown in m, n and o of Figure 4; m and n belong to Period II and show the outspread wings of the falcon, with the breast and tail represented by conventionalized, rectangular, Chavinoid eye patterns which appear below the shoulder area which is decorated with reed-stamped circles. In Period III the breast and tail ornaments are usually much more elaborate, as in o, and by Period IV all or part of the top of the vessel is covered with designs.

In Period IV ceramics at Ocucaje the falcon sometimes appears in association with deities of the trophy-head cult as it does in Figure 10, a, taken from an incised drawing without paint, on a large jar. Concurrently the falcon is also found alone as a realistic element on ceramics (b), but in Necropolis Period IV textiles it is associated with, or lends attributes to, a large number of trophy-head cult deities. Among these are winged warrior figures holding trophy heads, and anthropomorphic deities with falcon wings and tails which also hold trophy heads. An interesting example of the latter as illustrated by Cachot and others[38] is shown in e. In some Necropolis versions of this winged trophy-head deity, the head appears with whiskers of the "gato de agua" type similar to that of the feline agricultural deity we previously discussed.[39]

In Early Nazca ceramic iconography both the winged warrior (f) and winged trophy-head deity are important elements. The latter is characterized by falcon wings and tail and a "gato de agua" type head with its tongue sticking out to a trophy head held in the hands (Figure 11, a). The falcon attributes of this figure continue throughout Early Nazca but disappear along with naturalistic renderings of the falcon in Late Nazca ceramics. A typical Late Nazca version of this motif is shown in Figure 11, b. Space does not permit tracing each stage of its evolution. It is sufficient to point out that the gradual changes in its form follow much the same pattern as is illustrated in the evolution of other motifs such as the killer whale to which we will now turn our attention.

The Killer-Whale Motif

The killer-whale motif which makes its first appearance in the Paracas IV Period remains as an important symbol of the trophy-head cult throughout the entire sequence of the Nazca style. Since it is always easily identifiable, it offers an outstanding demonstration of Nazca stylistic evolution. Yacovleff[40] published a very careful and detailed study of this motif. In arranging the elements from their naturalistic to their most abstracted versions, he came very close to putting them in chronological order even though that does not appear to have been his objective. In Figure 12 of this paper we see ten typical killer-whale variants which show the broad outline of the stylistic change through the Necropolis and Early, Transitional and Late Nazca Periods.

Figure 12, a and b show two versions of the killer-whale motif taken from Paracas IV ceramics at Ocucaje: a from an interior negative-decorated bowl, and b from a thin-walled incised and post-fire resin-painted cup. It will be noted that in both versions the killer whale is shown with a human arm, though it does not carry a trophy

388

Figure 12. The killer-whale motif.

head, as is often the case in Period IV textiles[41] and Nazca ceramics. A very Early Nazca rendering of the killer whale is shown in c. Three other typical versions (d, e and f) show the gradual increased stylization of the motif throughout the Early Nazca Period. The Transitional Period is represented by g in which the symbol becomes anthropomorphic and a "scroll" element appears between the fins. Also characteristic of this Period is a frontal mask of the anthropomorphized killer whale, previously referred to as "bloody mouth."[42] In Late Nazca versions, the head of the killer-whale figure resembles this transitional motif (i).

The extremes of Late Nazca stylization are shown in h and j, while i is a more typical Late Nazca representation. Although we have not attempted to trace Nazca motifs beyond the end of the Late Nazca Period, the killer whale may be found in the Decadent phase of Nazca in the form of further simplifications of the symbolic version j. It will be noted that although the killer-whale motif is usually shown with trophy heads in Early Nazca, the element is represented only by small "barb" trophy hair appendages in Late Nazca.

The killer-whale motif offers a clear demonstration of the manner in which the Nazca style grew out of the Paracas IV Period. Its evolution is typical of Nazca motifs in that it became progressively more stylized and symbolic with its only abrupt change of conventions occurring in the Transitional Period. Without having studied intermediate steps, it would be hard indeed for one to believe that the symbolic element j was descendant from the Necropolis motif a. The identification and evolution of nearly all Nazca motifs can be accomplished through similar examination of their gradual changes in style.

Notes

1. Seler, 1923, vol. 4, pp. 169-338. Yacovleff, 1931, vol. 1, no. 1, pp. 25-35; 1932a and 1932b.
2. Tello, 1929; 1959. Carrión Cachot, 1931, vol. 1, no. 1, pp. 37-86; 1948, vol. II, no. 1, pp. 99-172, and 1949.
3. Conclusions based on description and sketches furnished the author by Dr. Wallace.
4. See Kroeber, 1944, pl. 13, B, C, E, F, and G; pl. 14, F; and pl. 15, A, H, I, and J.
5. *Ibid.*, pl. 15, A (Human Face) and pl. 13, F (Double-headed Serpent).
6. Figure 3, a-b. An unusual Chavinoid form (j) containing a whistle is found in Periods II and III at Juan Pablo (k and l).
7. See Larco-Hoyle, 1944, photos pp. 5, 9, and 11.
8. The author has seen specimens from Callango and Juan Pablo which are unquestionably Chavinoid. "Corn Poppers" are fairly common at Juan Pablo in Periods II and III. Period I stirrup spout bottles are also found at Callango.
9. Privately circulated in mimeograph form by John H. Rowe in 1957, and published in 1958 by *Revista del Museo Regional de Ica.*
10. Strong, 1957.
11. This ornament is best known in its gold form. It has been found fashioned from leather and decorated with feathers and may have been made of other materials as well. See Sawyer, 1960.
12. Alternative suggestions have been made. Pablo Soldi proposes the prickly pear cactus fruit juice, a substance used today by Indians to prepare a whitewash like paint. Robert Sonin favors Algarrobo gum.
13. Sonin believes that the binder in resinous paint may have been obtained from the "Pepper Tree" (*Schinus molle*)

14. The "Cavernas" ceramics at the National Museum in Lima are a mixture of excavated material from the Paracas Peninsula and pieces from other sites. All four Periods appear to be well represented. Unfortunately, little has been published concerning the provenience or grave association of this group.

15. Excerpt of letter of Dwight Wallace's to author dated July 30, 1959: ". . . The sherds and pots from the Necropolis site itself and from Cabeza Larga fit perfectly among the sherd types of the first two Topara phases. . . . Lanning got textiles with his Topara Phase I sherds. They are identical in technique to the geometricized textile designs from Necropolis, although the motifs are not exactly identical. Unfortunately, we have no good association of Phase 2 ceramics and textiles. But I am almost positive that the fancy embroideries go mainly with this Phase."

16. The arms and armor of defeated warriors seem to have been the principal trophies taken by the Mochica. Trophy heads are, however, sometimes shown. See Kutscher, pls. 25, B, 53, 65, B, etc.

17, See Kroeber, 1944, p. 41, E.

18. According to Dr. Charles Handley, Associate Curator of Mammals at the Smithsonian, monkeys depicted in Necropolis textiles appear to be of the *cibus* variety—a type common in the valley jungles of Eastern Peru. This monkey has bushy white whiskers and brows. See Sawyer, 1960.

19. Examples of both were found in mummy 49 from Cerro Colorado opened in 1949 at the American Museum of Natural History.

20. Strong, *op. cit.* The Art Institute of Chicago has an interesting group of embroidered and needle knit textiles said to have come from Coyungo in the Río Grande Valley which are Necropolis-Proto Nazca in style.

21. Kroeber, 1956.

22. A much more detailed seriation of the Nazca ceramic style has been made by Lawrence Dawson who designates nine periods. Though the results of his excellent study have not been published, his terms are used by many Peruvianists. His first period corresponds to our Late Paracas IV; periods 2, 3 and 4 to Kroeber's A, 5 parallels X, 6 equals B, and 7, 8 and 9 cover Y 1, 2, and 3.

23. See Kroeber, 1956, *op. cit.* pl. 44, a and b.

24. See Kroeber, 1944, *op. cit.* p. 29.

25. Feline, condor and serpent designs have been found by Junius Bird in textiles from Huaca Prieta dating about 2000 B.C. This is about 1000 years prior to the probable full development of Chavín. The Huaca Prieta culture, however, gives little evidence of any elaborate ceremonial cult such as dominated the Chavín.

26. According to Dr. Charles Handley of the Smithsonian cited in note 18.

27. See Lothrop, 1951, Figs. 71 and 72.

28. This paint has broken down to a granular whitish powder containing lumps of dark green, visible under magnification (gum based paints become powdery rather than granular). By comparison with deteriorated resin paints on Ocucaje ceramics it is evident that Period I and a few Period II and IV paints used at Juan Pablo were resinous.

29. The prominent whiskers of the otter are clearly shown in Mochica modeled versions. See Larco-Hoyle, 1938, t. I, Fig. 68.

30. Bird and Bellinger, 1954, pls. LXXIX, LXXXI and LXXXII.

31. Valcárcel, 1932.

32. Larco Hoyle, 1945, p. 8.

33. Tello, 1959, *op. cit.*, pl. 7, A and B and Fig. 7.

34. See note 1.

35. See Larco Hoyle, 1944, *op. cit.* pp. 6 (*top*), 7 (*top left*) and 10 (*top left*).

36. See Larco Hoyle, 1945, *op. cit.* p. 6 (*top left*).

37. Larco Hoyle, 1945, p. 5 (*top right*).

38. Carrión Cachot, 1949, pl. XI, j; also see Yacovleff, 1932a, *op. cit.*, Fig. 7, j.

39. Bird and Bellinger, 1954, *op. cit.* pls. XVI, XVIII and XIX.

40. See Yacovleff, 1932b (note 1).

41. See Carrión Cachot, 1949, *op. cit.* pl. VIII.

42. See Kroeber, 1956, *op. cit.*, pl. 39, d.

Bibliography

Bird, Junius, and Bellinger, Louisa
1954. "Paracas fabrics and Nazca needleword, 3rd century B.C.—3rd century A.D." *The Textile Museum, Catalogue raisonné.* Washington, D.C.

Carrión Cachot, Rebeca
1931. "La indumentaria en la antigua cultura de Paracas," vol. 1, no. 1. *Wira Kocha*, pp. 37-86. Lima.
1948. "La cultura Chavín, dos nuevas colonias: Kuntur Wasi y Ancón." *Revista del Museo Nacional de Antropología y Arqueología*, vol. II, no. I, pp. 99-172.
1949. *Paracas:cultural elements.* Corporación Nacional de Turismo. Lima.

Dawson, Lawrence E.
1958. See Rowe, John H.

D'Harcourt, Raoul
1948. "Un tapis brodé de Paracas, Pérou. *Journal de la Société des Américanistes*, n.s., t. XXXVII, pp. 241-57. Paris.

Gayton, A.H., and Kroeber, A.L.
1927. "The Uhle pottery collections from Nazca." *Publications in American Archaeology and Ethnology, University of California*, vol. 24, no. 1. Berkeley.

Kroeber, A.L.
1924. "The Uhle pottery collections from Ica" (with William Duncan Strong). *Publications in American Archaeology and Ethnology, University of California*, vol. 21, no. 3. Berkeley.
1930. "Textile periods in ancient Peru" (with Lila M. O'Neale). *Publications in American Archaeology and Ethnology, University of California*, vol. 28, no. 2, pp. 23-56. Berkeley.
1944. *Peruvian archaeology in 1942.* Viking Fund, Publications in Anthropology, no. 4, New York.
1953. "Paracas Cavernas and Chavín." *Publications in American Archaeology and Ethnology, University of California*, vol. 40, no. 88. Berkeley.
1956. "Toward definition of the Nazca style." *Publications in American Archaeology and Ethnology, University of California*, vol. 43, no. 4. Berkeley.

Kutscher, Gerdt
1954. *Nordperuanische Keramic; figürlich verzierte Gefässe der Früh-Chimu.* Berlin.

Larco Hoyle, Rafael
1938. *Los Mochicas.* T.I. Lima, Peru.
1944. *Cultura salinar; síntesis monográfica.* Trujillo, Peru.
1945. *La cultura Virú.* Trujillo, Peru.
1945. *Los Cupisniques.* Trujillo, Peru.

Lothrop, Samuel K.
1951. "Gold artifacts of Chavín style." *American Antiquity*, vol. 16, no. 3, January. Menasha.

O'Neale, Lila M.
1930. "Textile periods in ancient Peru" (with A.L. Kroeber). *Publications in American Archaeology and Ethnology, University of California*, vol. 28, no. 2, pp. 25-26. Berkeley.
1937. "Archaeological explorations in Peru, Part III: textiles of the Early Nazca Period." *Field Museum of Natural History, Anthropology Memoirs*, vol. 2, pp. 110-218 (no. 3), pls. 32-68.
1942. "Textile periods in ancient Peru: II Paracas Cavernas and the grand Necropolis." *Publications in American Archaeology and Ethnology, University of California*, vol. 39, no. 2, pp. 143-202. Berkeley.

Rowe, John H.
 1958. "La serición cronológica de la cerámica de Paracas elaborado por Lawrence E. Dawson. *Revista del Museo Regional de Ica*, año IX, no. 10. Ica, Peru.

Sawyer, Alan R.
 1960. "Paracas-Necropolis headdress and face ornaments." *Textile Museum Workshop Note,* no. 21.

Seler, Eduard
 1923. "Die buntbemalten gefässe von Nasca." In: *Gesammelte Abhandlungen,* vol. 4, pp. 169-338. Berlin.

Soldi, Eduard

Soldi, Pablo
 1956. *Chavín en Ica.* Privately printed. Ica, Peru.

Strong, William Duncan
 1952. La expedición Ica-Ocucaje-Nazca." *Revista del Museo Regional de Ica*, año 4, no. 5, pp. 7-11. Ica, Peru.
 1954. "Recent archaeological discoveries in south coastal Peru." *New York Academy of Sciences, Transactions*, series 2, vol. 16, no. 4, pp. 215-18. New York.
 1955. "The origin of Nazca culture." *Philadelphia Anthropological Society, Bulletin,* vol. 8, no. 2, pp. 1-2. Philadelphia.
 1957. "Paracas, Nazca, and Tiahuanacoid cultural relationships in south coastal Peru." *American Antiquity,* vol. XXII, no. 4, pt. 2. *Society of American Archaeology Memoirs*, no. 13. Salt Lake City, Utah.

Tello, Julio C.
 1929. *Antiguo Perú: primera Época.* Comisión Organizadora del Segundo Congreso Sudamericano de Turismo. Lima.
 1959. *Paracas; primera parte.* (Publicación del Proyecto 8b del Programa 1941-42 de The Institute of Andean Research de New York). Lima, Peru.

Uhle, Max
 1914. "The Nazca pottery of ancient Peru." *Davenport Academy of Sciences, Proceedings,* vol. 13, pp. 1-16. Davenport, Iowa.

Valcárcel, Luis E.
 1932. "El gato de agua, sus representaciones en Pukara y Naska." *Revista del Museo Nacional*, vol. 1, no. 2. Lima.

Willey, G.R.
 1951. "The Chavín problem: a review and critique." *Southwestern Journal of Anthropology,* vol. 6, no. 2, pp. 103-44. Albuquerque.

Yacovleff, Eugenio
 1931. "El vencejo (Cypselus) en el arte decorativo de Nasca." *Wira Kocha*, vol. 1, no. 1, pp. 25-35. Lima.
 1932a. "Las falconidas en el arte y en las creencias de los antiguos peruanos." *Museo Nacional, Revista*, vol. 1, no. 1, pp. 33-111. Lima.
 1932b. "Arte antiguo peruano, la deidad primitiva de los Nasca." *Revista del Museo Nacional*, vol. 1, no. 2. Lima.

Pre-Columbian Ceramics: The Problem of Partial Counterfeits

Raphael X. Reichert

Researchers of pre-Columbian ceramics are continually faced with the possibility that a specimen may be counterfeit. This problem has been created by the large demand for pre-Columbian art and the subsequent high prices that fine pieces can demand.

The concern of this paper is a special type of fraudulent vessel—the partial counterfeit. This category is broad and may include vessels created or altered by individuals whose sole purpose was to increase the price of an object as well as specimens which have been restored by museum personnel. It is certainly not appropriate to include all museum restoration work under the heading of counterfeit. I believe, however, that use of the pejorative term (partial counterfeit) is justifiable since there are numerous instances in which museums exhibit restored specimens and fail to indicate the areas which have been created by modern hands. There are presumably many reasons for this practice. Some institutions favor displaying objects with a minimum amount of accompanying written material; others, rightly or wrongly, may assume that there is no need for such information since many viewers would simply not be interested. A few museums may feel that the status of their collections would be undermined if they indicated all instances of extensive restoration. Whatever the reason for failing to identify restored specimens, the deception remains, and I maintain that it is appropriate to refer to such specimens as counterfeit.

In addition to the apparently numerous reasons for counterfeiting, the degree to which a vessel may be illegitimate is also broad. At one end of the spectrum are vessels which have had small portions of surface repainted or minor modeled features recreated. At the other extreme are instances in which a fragment of an authentic vessel is used as a point of departure from which an entire vessel is constructed. Examples from both ends of the scale will be examined in this paper.

Specialists examining pre-Columbian vessels may make remarks such as, "I don't think the head belongs with that body" or, "The clay looks fine but the finish doesn't," when referring to a piece they suspect is partially counterfeit. The factors influencing their opinions are complex. The specialist can generally point to specific

features which are incompatible with the piece in question; often, however, he or she will simply indicate that this or that element simply does not "feel" right. Although general works on counterfeiting have been written by Ekholm (1964) and Peterson (1953), no one has concentrated on a single style and spelled out those criteria which together produce an incorrect "feel."

Even a brief examination of broad survey publications will make the reader aware of the great stylistic diversity within pre-Columbian art. Clearly, each style will have distinctive criteria by which pieces will be judged legitimate or otherwise. This study will focus on a single pre-Columbian ceramic tradition, the Peruvian style known as Recuay which has been the subject of my research since 1971.[1] In working with the style I have assembled a photographic archive representing over 850 specimens, approximately one half of which have been examined first hand. This discussion will concentrate on those partially counterfeit vessels which have become "legitimized" because of their having been illustrated in the literature. It is imperative that these specimens be singled out so that they will not be deemed genuine by future investigators. That these vessels were initially chosen as representative of the Recuay style is indicative of how limited our understanding of the style has been.

The Recuay Style

The first large body of Recuay ceramics assembled in modern times was part of the Macedo collection, which was formed in 1874 (Hamy 1882:70) by Don Agustín Icaza (Macedo 1881:V) and later purchased by the Peruvian doctor, José Mariano Macedo. In 1881, Macedo took the collection to Paris, France where it was exhibited. Macedo's exhibit catalog became the first published source to recognize Recuay as a distinct style (Rowe 1959:4). Later, his collection became part of the holdings of the Museum für Völkerkunde in Berlin, Germany. Because of its early formation, the Macedo collection may, with some precautions, serve as a touchstone to which other vessels may be compared.

Despite this early awareness of the style, it has received scant attention in the literature, generally being dealt with as something peripheral to another subject. There are two basic reasons for this situation. In the first place, as is the case with most Peruvian ceramic styles, the vast majority of vessels have been excavated by *huaqueros* or graverobbers, and thus have little associated data recorded for them. Secondly, with the exception of the Macedo collection, Recuay vessels are widely scattered in collections throughout the world making analysis of the style difficult. In order to view all *known* examples of Recuay vessels one would have to visit a total of 68 sources in South America, Europe, and the United States.

Recuay ceramics were produced in northern Peru from approximately 200 B.C. to A.D. 600. The present dating of the style is imprecise and is based mainly on stylistic analogy and limited stratigraphic evidence. The style is best known from the Callejón de Huaylas, an intermontane valley in the department of Ancash, but has also been reported to the east, in the upper Marañón River area, and to the west in coastal valleys ranging from the Pacasmayo to the Casma.

The Recuay style exhibits great variety; more than 20 separate shape categories have been identified to date. These forms range from simple bowls to elaborate effigy vessels of humans and animals. Despite the large amounts of sculptured elements often included on their vessels, the Recuay potters consistently produced specimens of

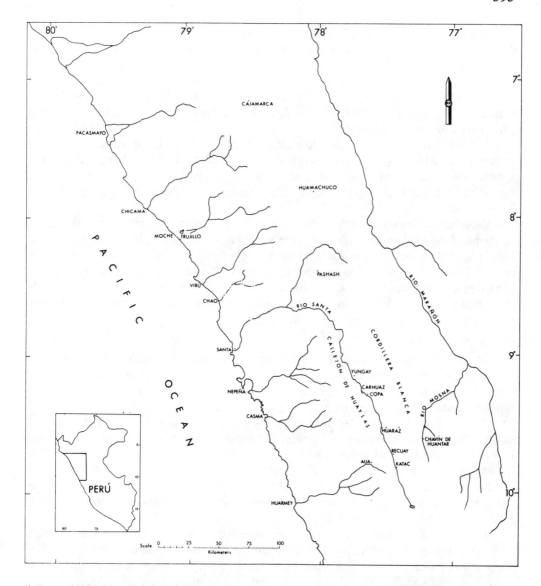

light weight. Not only are chamber walls very thin, but the sculptured figures are, with the exception of a few very small ones, always hollow. The most common surface finish used in the style is what is termed three-color resist. Since this finish is important to the following discussion, it is appropriate to explain it in detail.

Three-color resist began with a light surface, often a light orange or buff slip (liquid clay), sometimes a white kaolin slip. In some instances the vessel body would be made of kaolin but more often the vessel would simply be slipped with kaolin, possibly indicating that the supply of this clay was limited. A red slip was then applied over this light surface. Red was used to outline registers and also to color broad areas, generally the faces of modeled male figures. After firing, the vessel received the resist decoration. This involved the application of a resist material such

as clay slip or wax to effectively mask that portion of the vessel which was to become the design. The entire surface is thought to have then been painted with an organic liquid which would carbonize when held over a flame. When the resist material was removed, a design was revealed in the color of the vessel chamber surrounded by zones of fugitive black pigment. The term fugitive refers to the relatively fragile nature of the organic black material which tends to fade through time and, presumably, exposure to ground water.

The resist technique was used to execute a wide variety of geometric motifs such as step-frets, triangles, dots, and parallel bands. In terms of other Peruvian ceramic styles, however, the special character of Recuay resist was its use for detailed figurative designs such as profile cat-like creatures, birds, serpents, and frontal human faces.

Certain motifs and themes maintain a general consistency throughout the style. In terms of details, however, an extreme variation is permitted or perhaps dictated. This is best illustrated on vessels in which a single figurative motif is repeated, but in no such instance is it rendered exactly the same in all its depictions.[2] There are a few instances in which vessels appear to have been produced as deliberate pairs; but it is clear that the potter did not attempt to produce precise duplicates, a feat certainly well within the capabilities of the Recuay artist.

Counterfeit Painted Surfaces

The most common type of Recuay forgery consists of the repainting of surfaces whose resist designs have faded. To date, forgers do not seem to have attempted to reproduce the precise resist techniques of the Recuay potter. Invariably they will repaint a faded resist design using a positive technique.

This practice is illustrated by a recently published (Lapiner 1976:173, Pl. 409) vessel (Pls. 1-4) which represents a common Recuay type. Forty-six such vessels are known. The type has a globular chamber, a constricted neck, and a flat disc rim which is connected to the chamber by a flat bridge. Beneath the rim is a modeled human head wearing a headdress and earspools. Two tiny feet extend from beneath the garment edge. Flanking the human are two felines with two-dimensional painted bodies from which project modeled heads.

The features described above are consistent with other Recuay vessels of this type. The problem lies with the painted design on the vessel chamber. Originally, the surface was finished in typical Recuay three-color resist. The resist remains intact in a number of zones on the vessel but is best preserved on most of the strap handle (Pl. 3) and on the vessel neck (Pl. 4). Apparently the designs on the front and sides of the chamber had faded because these have now been repainted using a positive technique. It is likely that the front of this vessel was originally decorated with a central panel of figurative Recuay designs, probably similar to those on the vessel neck (Pl. 4), and flanked by panels of diagonal cross-hatching, some of which has survived (see arrows, Pl. 1). Although employing different designs, the composition was probably similar to the vessel illustrated in Plate 5, faded to a condition similar to the vessel in Plate 6, and was then repainted with its present surface.

Plates 3 and 4 reveal the crisply executed resist designs which are a hallmark of many Recuay vessels and which stand in sharp contrast to the forged, positive designs on the vessel front (Pl. 1). Not only is the technique of the front panel inaccurate, but

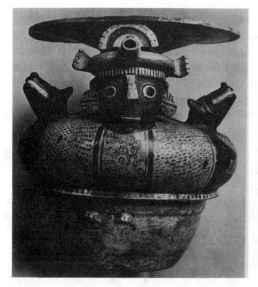

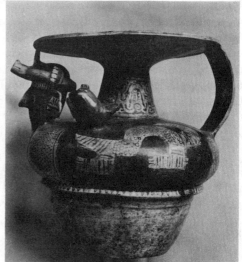

Plate 1. Private collection. Height 22.3 cm. (8¾ in.)

Plate 2.

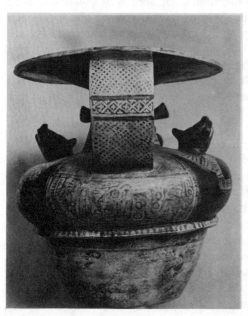

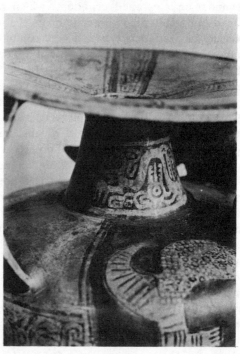

Plate 3.

Plate 4.

the style of the animal depicted is, even taking the considerable variation permitted in Recuay into consideration, totally alien to the tradition. The line drawing is meant to represent a type of creature commonly depicted on Recuay surfaces whose precise identification is undetermined. Some of the variation of this animal is exhibited in

Plates 5 and 7. The creature's most consistent attributes include the following: it is always depicted in profile, its head is a circle or concentric circles, and it has a muzzle filled with teeth. It may or may not have a crest extending from its head and an elaborate tail. Considerable variation occurs in the treatment of the torso and, when depicted, the crest. The specific features of the fraudulent drawing which are most obviously incorrect include: the calligraphic, tendril-like crest; the double triangle on the head; the double outline for head, muzzle, and tongue; and the squared-off treatment of the feet.

Counterfeit Modeling

Since many Recuay modeled features are small and somewhat delicate, breakage and subsequent repair or renewal is not uncommon. One such reworked vessel is in the National Museum of Anthropology and Archaeology in Lima, Peru (Pls. 8, 9). The piece, hereafter referred to as the Lima vessel, is a modeled human and llama, and has been frequently illustrated (e.g. Tello 1929:95, Fig. 57; Bennett 1946:107, Fig. 8b; Kubler 1962:Pl. 128b; Pelloni 1970:Junio).

Forty-four vessels of this kind were examined for this study. The authentic type (Pls. 10,11) is described as follows: a modeled human wearing an elaborate head-dress, earspools, and garment, stands next to a modeled llama. The human torso is a cylinder or telescoped cylinders, which represent separate garments. A decorative band commonly runs vertically down the garment front. Although the figure wears a variety of headdress types, a very common element associated with them is a large fan-shaped slab projecting vertically. Earspools are less varied; the most common type is decorated with a dot surrounded by a ring of dots. Legs, when visible, are straight cylinders or gently tapering cones with slab feet. Arms and hands are only present when the figure is holding something. Generally the human holds a lead line which runs through a hole pierced in the llama's ear or passes around the animal's neck. Additional objects held by the human may include a shield-like object, a panpipe, a staff, or a number of objects of uncertain identity.

The llama, which is most often smaller, but in a few instances may be the same height or taller than the human, is rendered in a consistent manner. Its torso is a sausage form with an orifice rimmed by a flaring collar located above the hindquarters. The head has few details and is characterized by rounded, often pierced, ears and an elongated muzzle. The legs are similar to those of the human and are always straight cylinders with simple slab feet or long tapering cones without feet. Llama legs are either vertical or angle slightly away from the longitudinal axis of the body. In every authentic example they are straight; in no instance is there an attempt at naturalistic modeling of llama legs, and knee joints are never articulated.

The painted decoration on Recuay llamas is very limited and generally consists of a bichrome treatment which divides the body into broad bands of color. Figurative designs rarely occur on llamas, but when they do, they are confined to a band around the neck which consists solely of geometric elements, steps or frets. The flaring collar of the vessel mouth is never decorated.

The Lima vessel portrays an animal with legs which depart from the prototype described above and which indicate reconstruction. Uncharacteristically, the legs are rendered in a naturalistic manner (cf. Bates 1964:93). This is particularly true of the rear legs. Instead of a simple straight cylinder or cone, the thighs angle back from the

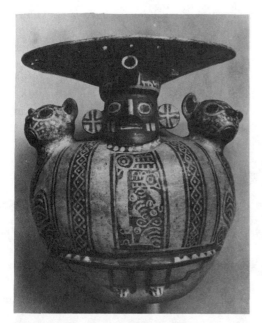

Plate 5. Private collection. Height 20.4 cm. (8 in.).

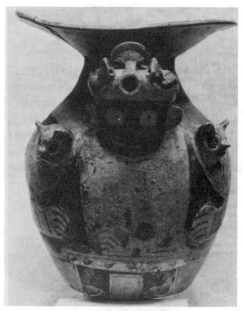

Plate 6. Museo Nacional de Antropologia y Arqueologia, Lima, #1/1366. Height 19.1 cm. (7½ in.)

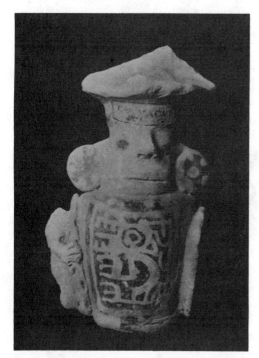

Plate 7. Museum für Völkerkunde, Berlin. VA31215. Height 21.5 cm. (8½ in.) Photo courtesy Christopher Donnan.

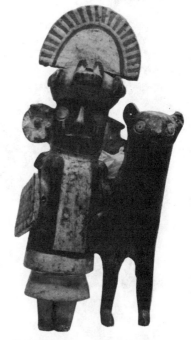

Plate 8. Museo Nacional de Antropologia y Arquelogia, Lima #1/1901. Height 21.0 cm. (8¼ in.)

hindquarters and join near-vertical calves at clearly defined knees. There is considerable variation in the girth of the limbs. In addition to the legs, the animal's short blunt muzzle is atypical. Beyond the features which can be discerned from the photos, other aspects of the vessel which require first-hand inspection, indicate reconstruction. These include the heavy weight of the llama, probably due to the use of plaster in its reconstruction, and the coarseness of its finish in comparison to the surface of the human, which appears to be authentic. Finally, the painted triangles and circles on the llama's back, as well as the designs on the rim of the vessel mouth, have never been found on other specimens of this type.

Although there are no obvious technical or stylistic features of the human to indicate that it has suffered reconstruction or repainting, a word of caution is perhaps

Plate 9.

Plate 10. Museo Larco Herrera, Lima. Height 23.8 cm. (9-3/8 in.)

Plate 11.

in order. Specifically, I refer to the thin headdress crest which appears to be in pristine condition. Based on the above evidence, it is apparent that the vessel had been sufficiently damaged to require reconstruction of the llama, and it is therefore not unlikely that the crest may also have required restoration. There are numerous examples of such headdresses with broken or missing crests (e.g., Anton 1962:Pl. 17; Bennett 1944:Pl. 2H; Lapiner 1976: 180#439; Larco 1963:n.p.; Schmidt 1929:239, bot. lt.; Seler 1893:Pl. 45, cent. rt., cent. lt.).

A fragment of a vessel similar to the Lima piece is in the Museum für Völkerkunde, Berlin (Pl. 7) and suggests what may have been the condition of the Lima vessel prior to the addition of its newly created features.

A Conundrum

Although a first hand examination of the two specimens discussed above confirmed that they had indeed been modified, in both instances their new additions deviated so greatly from Recuay artistic and technical norms that they could be easily identified from the published photos. Identification of suspected reconstruction is not always so simple. A rather spectacular jar (Pl. 12) published by Kidder (1964:82), Lothrop (1964:179), and Larco (1966:127,Fig. 79) illustrates some of the complexities involved in identifying possible counterfeits. The vessel is in the Larco Herrera Museum in Lima and will be hereafter referred to as the Larco jar.

The Larco jar is a fairly common Recuay type of which there are 88 specimens known and which is characterized by a flat bottomed, hemispherical chamber with a

number of small modeled figures on the jar top. A principal male figure is generally depicted in a central position and larger than the accompanying figures. The Larco jar is the sole example within this type which has four large standing males holding a blanket or canopy over the modeled group.

The published photographs of the Larco jar have always shown it from virtually the same angle, a slightly oblique frontal view; the rear or sides have never been published. The description which follows derives from a personal, although brief, examination of the vessel made in 1971. Since I was only permitted to take two photographs of the jar, I am, unfortunately, unable to present detailed views of the specimen.[3]

The first suggestion that the Larco jar might be reconstructed came as the vessel was being lifted in preparation for photographing it. Despite the relative bulk of the jar, I was unprepared for its extreme weight. I had lifted a large number of Recuay vessels and never encountered one of such weight. This exceptional feature immediately suggested that the vessel had been reconstructed, probably using plaster.

The figures on top of this vessel consist of a principal male, seated in the center, and surrounded by five small females each holding a bowl, and four extremely large, standing males, each with his arms raised high and grasping the corner of what is presumably a textile serving as a canopy over the entire composition. The females are identified by their cowl head coverings and are stylistically consistent with other such figures occurring on numerous Recuay vessels. One female, who has a spout protruding from the back of her head, faces the central figure; the remaining females are positioned around the chamber top, each facing to the outside, *away* from the central figure. Although there is considerable variation in the details of placement and individual accouterments of the small attendant figures on Recuay vessels, there is one feature which, with the exception of this vessel, is consistent: attendant females on multiple-figure vessels always face either the central figure or in the same direction as he does.

Compared to all other Recuay figurative representations, almost everything about the standing male figures is atypical. In the first place, although examples of canopies over modeled figures are known (cf. Larco 1965:106; Schmidt 1929:237), in no other instance are humans employed as atlantean or caryatid figures. In addition to their supportive function, the size of these figures is atypical. Scale was consistently used as a means of indicating status in the Recuay style. In every known example except this one, when an elaborately attired principal figure is accompanied by human attendants, the attendants are never larger than the principal. The only attendant figures which may exceed the size of the central male are animals, some of which may be supernatural.

In addition to the gross aspects of the male attendants, their details are unusual. Each figure wears a short sleeved, tubular garment decorated with resist dots and edged with triangles. The garments extend to the waist only. Two of the figures are depicted with exposed penises. Garments with flaring edges are common in the Recuay style (Pl. 8), but in every other instance they extend well below the knee. Depictions of sexual activity occur in the style (cf. Larco 1965:84), however, they are not common, and actual representations of genitalia are rare. Although there is one instance in which the genitals of female attendants are displayed (Disselhoff 1966:

119), in no instance other than the Larco jar are the sex organs of male attendants depicted.

The heads of these attendant males also have some unique features. Both the eyes and mouths of the figures are represented by applique elements, rings for the eyes, ovals for the mouths. It may be noted that there are three types of eyes represented on the vessel: the incised and painted ovals of the central male, the pierced slots of the female attendants, and the applique rings of the males. Combinations of the first two eye types are common on Recuay multiple-figure vessels. The painted or incised and painted type is used for the central male, and the pierced slot type is used for the small attendant females. However, when applique eyes are used, they occur on *all* figures in the composition (cf. Seler 1893:Pl. 43, bot. rt., bot. lt.).

Finally, the figures are unusual because of the treatment of their hair or headdresses (Pl. 13). Striated clay slabs extend from a lump at the back of the head and curve outward and forward meeting at a point above the forehead. I know of no counterparts for such hair or headgear within the style.

In the preceding paragraphs I have discussed a number of features of the Larco jar which are either unique or inconsistent with practices revealed on other Recuay vessels. Taken by themselves, these features would perhaps cast suspicion on the vessel. The weight of the specimen and the many unique features of the male attendants could suggest that they are fraudulent. There is no reason to question the authenticity of the central figure or the female attendants. The problem with condemning the male attendants as frauds lies in their finish. As far as I was able to determine, the decoration on these figures as well as the canopy is authentic resist. If

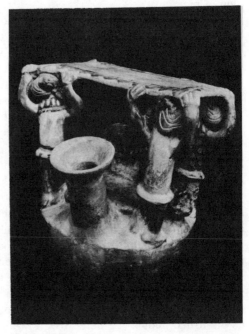

Plate 12. Museo Larco Herrera, Lima. Height 22.9 cm. (9 in.)

Plate 13.

it is true that forgers have yet to produce resist decoration, then this would suggest to me that the male attendants are authentic although indeed unique.

The vessel's extreme weight, the rough texture at the rear of the chamber, and the visible signs of repaired cracks on the figures clearly reveal that some repair and reconstruction have taken place. From the admittedly meager evidence, it would seem to me that there are two ways to view the Larco jar. At best, all the figures are authentic, were found broken from a vessel top and were reconstructed upon an at least partially rebuilt chamber. Or, a forger, capable of producing resist designs, began with some legitimate fragments, the central male and the attendant females, and constructed an elaborate composition around them.

Although I am unwilling at this point to pass a definitive judgment on the Larco jar, I nevertheless feel that there is sufficient evidence to warn against acceptance of the specimen at face value.

Conclusions

In the above discussion several criteria were employed in assaying Recuay vessels. Unfortunately, not all of these criteria will prove of equal use to the non-specialist. Most helpful, perhaps, is the area of vessel finish. Since, as we have seen, forgers will repaint faded resist areas using a positive technique, the ability to discern resist decoration is essential in evaluating Recuay resist ware. Such a skill is not difficult to acquire and may be obtained by reviewing the excellent discussion of resist technique diagnostics provided by Shephard (1968:208). This capability, coupled with a study of published authentic Recuay vessels, will enable the viewer to recognize areas on vessels in which the resist has been replaced by positive application of pigment.

In terms of weight, unless an individual can actually lift a vessel, this criterion will prove useless. Even the opportunity to handle a piece will not, at this point, be much more helpful. The best that can be said in the latter situation is that if a piece feels light, in spite of large size or abundance of modeled features, then it should not be suspected of having been reconstructed with plaster. To deal with the issue of vessel weight objectively, it will be necessary to actually weigh specimens of known authenticity and determine mean weights for various Recuay vessel types. The weights of suspect vessels may then be compared to these means.

The application of style criteria in judging a vessel requires familiarity with a large body of Recuay specimens.[4] Because of its early formation, presumably before the style was being counterfeited, the Macedo collection is well suited for comparative purposes. Unfortunately, the collection is poorly published. Macedo pieces may be found scattered throughout the literature but the largest numbers are in Seler (1893) and Schmidt (1929). Both Seler and Schmidt, however, may prove to be more frustrating than helpful because of the poor photographic quality of the former and the incomplete photo coverage of the latter.

It is appropriate at this point to warn the reader that at least one of the Macedo pieces has undergone reconstruction while in Berlin. Specifically, I refer to a modeled feline with a bird on its head. The bird's beak has never appeared the same in any of its published photos (cf. Seler 1893:Pl. 45, bot., 2nd from lt.; Schmidt 1929:231, rt.; Lehmann 1931:n.p.; Hartmann 1955:Pl. 128).

Finally, it is important to remain aware of the great variation inherent in the

Recuay style. Although excessive deviation from *known* Recuay canons may arouse suspicion, it will not always serve to invalidate a specimen. As an example, consider a sherd recently illustrated by Proulx (1973:Pl. 4F). The fragment is a Recuay modeled human head with teeth represented by an indented design. Not only are teeth rarely depicted on Recuay humans, but the style of the figure's dentition is unique within the sample. Here, an unquestionably authentic piece (as far as I am aware, no one would find profit in making sherds) stands dramatically apart from all earlier known pieces.

There are numerous individuals who have dedicated years to the study of various pre-Columbian art styles. It is these specialists who are most capable of verifying specimens within their area of expertise. It is hoped that this paper, focusing as it has on a relatively obscure ceramic style, will stimulate others to compile similar lists of suspect specimens accompanied by specific criteria used to judge them.

Notes

1. Field research was made possible by a grant from the UCLA Art Council and the support of Christopher B. Donnan. I am grateful to the following people for providing valuable comments on early drafts of this paper: Uta LaJeunesse, James Kus, Alana Cordy-Collins, and Deborah Jenkins.

 Finally, the paper owes its completion to the patience and encouragement of my wife, Judy.

2. This feature was pointed out by two of my graduate students, William Miles and Nora Sherrill, within the context of an art history seminar at California State University, Fresno.

3. My customary procedure in documenting Recuay vessels is to inspect the interiors using an extremely thin flashlight. Areas of reconstruction can often be discovered in this way. I was unable to conduct this examination with the Larco jar.

4. The Recuay photographic archive, currently at the Department of Art, California State University, Fresno, functions as a research tool. Any persons or institutions possessing Recuay specimens which they may wish documented using the comparative materials of the archive are invited to send complete photographs of their specimens to the author in care of the above department, Fresno, California, 93740. The photos will become part of the archive which is presently employed in graduate seminars. The owner of the vessel will receive a comprehensive analysis of the specimen based on the largest data base for the Recuay style in existence.

Bibliography

Anton, Ferdinand
 1962 *Alt-Peru und seine Kunst.* E.A. Seamann Verlag, Leipzig.

Bates, Marston
 1964 *The Land and Wildlife of South America.* Time Incorporated, New York.

Bennett, Wendell C.
 1944 *The North Highlands of Peru, Excavations in the Callejón de Huaylas and at Chavín de Huántar,* Anthropological Papers of the American Museum of Natural History, XXXIX, Part 1. New York.

1946 "The Archaeology of the Central Andes," *Handbook of South American Indians*, VII, Julian H. Steward, ed., Smithsonian Institution Bureau of American Ethnology, Bulletin 143. Washington, D.C.

Disselhoff, H.D.
1966 *Alltag im alten Peru*. Callwey, Munich.

Ekholm, Gordon F.
1964 "The Problem of Fakes in Pre-Columbian Art," *Curator*, VII, 1.

Hamy, E.T.
1882 "Les Collections péruviennes du docteur Macedo," *Revue d'Ethnographie*, I, January-February, pp. 68-71.

Hartmann, Horst
1955 *Peruanische Keramik aus vorkolumbischer Zeit*. Schloss Celle, A. Madsack and Co., Hanover.

Kidder, Alfred
 "Rediscovering America," *Horizon*, VI, 3 (Summer 1964), pp. 73-93.

Kubler, George
1962 *The Art and Architecture of Ancient America*. Penguin Books, Baltimore.

Lapiner, Alan
1976 *Pre-Columbian Art of South America*. Abrams, New York.

Larco Hoyle, Rafael
1963 *La Cultura Santa*. Lima.

1965 *Checan*. Nagel, Geneva.

1966 *Peru*. World Publishing Company, Cleveland & New York.

Lehmann, Walter
1931 *Altamericanische Kunst*. Staatlichen Museen, Berlin.

Lothrop, S.K.
1964 *Treasures of Ancient America*. World Publishing Co., Cleveland and New York.

Macedo, Jose M.
1881 *Catalogue d'objets archéologiques du Pérou de l'ancien empire des Incas*, Paris, Imprimerie hispano-américaine.

Pelloni, Gertrud
1970 Peruano-Suiza Insurance Company Calendar. Lima.

Peterson, Fred
1953 "Faces That are Really False," *Natural History Magazine*, April, pp. 176-180.

Proulx, Donald A.
1973 *Archaeological Investigations in the Nepeña Valley, Peru*, Research Report No. 13. Department of Anthropology, University of Massachusetts, Amherst, July.

Rowe, John H.
1959 "Cuadro Cronológico de Exploraciones y Descubrimientos en la Arqueología Peruana, 1863-1955," *Arqueologicas IV*. Instituto de Investigaciones Antropologicas, Ica.

Schmidt, Max
1929 *Kunst und Kultur von Peru*. Propyläen-Verlag, Berlin.

Seler, E.
1893 *Peruanische Alterthümer*. Berlin.

Shephard, Anna O.
1968 *Ceramics for the Archaeologist*. Carnegie Institution of Washington.

Tello, Julio C.
1929 *Antiguo Peru. Primera Epoca*. Lima.

The Thematic Approach
to Moche Iconography

Christopher B. Donnan

One of the most remarkable art styles of pre-Columbian America was that produced by the Moche Kingdom, which flourished on the north coast of Peru between 100 B.C. and A.D. 700. Although the Moche people had no writing system, they left a vivid artistic record of their activities and the objects in their environment. Their art illustrates their dress and house fashions, implements, supernatural beings, and a multitude of activities, such as warfare, ceremonies, and hunting. Although Moche art gives the impression of having an almost infinite variety of subject matter, analysis of a large sample of it indicates that it is limited to the representation of a very small number of basic themes. This paper demonstrates the nature of these basic themes and the advantages of working with Moche art in terms of them. A single basic theme from Moche art is identified and then analyzed in detail.

To illustrate what is meant by a basic theme, it is perhaps best to make an analogy to Christian art. If a large sample of Christian art were examined, a number of basic themes would become apparent because of the frequency with which they are depicted. Among these basic themes would be the birth of Christ, the Last Supper, and the Crucifixion. By carefully studying numerous representations of one of these basic themes, it would be possible to identify a specific set of symbolic elements that are characteristic of it. With the birth of Christ, for example, the symbolic elements include certain individuals (the infant, the virgin, Joseph, wise men, innkeeper) and objects (manger, inn, barnyard animals, star). There are also certain activities that are traditional for each character. Since most of these activities relate to the birth of the Christ child, we might refer to the various depictions of this event as examples of the Nativity Theme.

Although the symbolic elements that characterize the Nativity Theme are standard, there is a great deal of variation in the way they are combined in different

I would like to express my appreciation to Donna McClelland and Alana Cordy-Collins for their advice and encouragement in factoring out the Presentation Theme in Moche Art; and to Patrick Finnerty, Donna McClelland, Susan Einstein, and Junius Bird for their help with the illustrations.

Reprinted from the *Journal of Latin American Lore*, Vol. 1, No. 2, 1975.

representations. In some of the representations, only one of the symbolic elements is shown—perhaps only the Christ child, or the star, or the manger. More often, artists will choose a combination of elements. Thus we have numerous representations of the virgin and child, or the virgin, child, and Joseph. Others combine the child, manger, and star in a single representation, or wise men, star, and child. The possible combinations are almost infinite. It should be noted, however, that the complete inventory of symbolic elements is rarely found together in a single representation.

A detailed analysis of Moche art illustrates its similarity to Christian art in consisting of a limited number of basic themes. One of these basic themes involves the presentation of a goblet to a major figure, and thus it can be referred to as the Presentation Theme. The contents of the goblet are not known, but there is reason to suspect that they may, at least in part, be human blood that is taken from prisoners who are normally shown in the same scene. To understand the nature of this theme, it is best to examine a depiction of it that includes a large number of its symbolic elements. An excellent example is the fineline drawing shown in Figure 1. To facilitate identification of the symbolic elements of this representation when comparing them with others, each is identified with a letter.

A. A rayed figure, who can be recognized by the rays emanating from his head and shoulders, his large size relative to the other figures in the scene, and the fact that he is being presented with a goblet by a figure holding a disc. He also consistently wears a conical helmet with a crescent-shaped ornament at its peak, a backflap, and a short shirt and skirt.

B. A figure holding a disc in one hand and a goblet in the other. He normally is shown presenting a goblet to A. He is always part bird and part human and wears either a conical helmet, as shown in this representation, or a headdress similar to that worn by D in this scene.

C. A figure holding a goblet in one hand appears to be covering the goblet with a gourd plate (upside down) held in the other hand. He has a diagnostic set of clothing which makes him recognizable wherever he is depicted. This includes the long shirt and headdress with tassel ornaments hanging in front and behind. (In this instance the artist, for lack of space, has drawn the forward tassel on top of the headdress rather than in front of it [see Fig. 2]). From the shoulders of the figure hang long sashlike objects that terminate in serpent heads. In some representations this figure holds the disc in one hand while presenting a goblet with the other.

D. A figure recognizable because of certain details of his clothing—primarily the scarflike objects hanging from his shoulders, which have serrated upper edges, and the other sashlike objects with a series of discs at the border. The figure also wears an elaborate nose ornament and a very characteristic headdress. The front of the headdress has a half circle of sheet metal with an animal face, possibly feline, embossed near its center. This half circle is flanked by two curved objects which are possibly also of sheet metal. At the back of the headdress is a tuft of feathers (for a three-dimensional representation of this headdress, see Fig. 9).

E. A human figure in the process of drawing blood from a bound, nude prisoner.

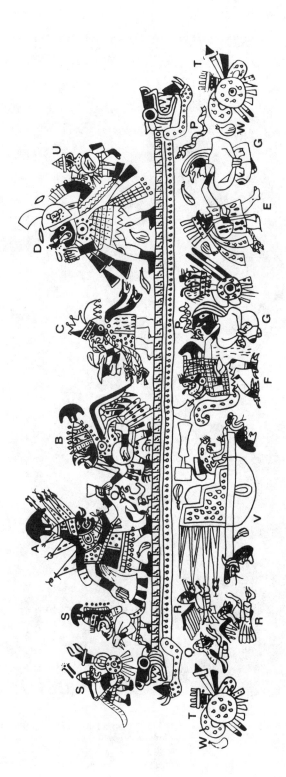

Figure 1. Fineline drawing of the Presentation Theme derived from a stirrup spout bottle (see Fig. 2). After Kutscher 1955:24-25.

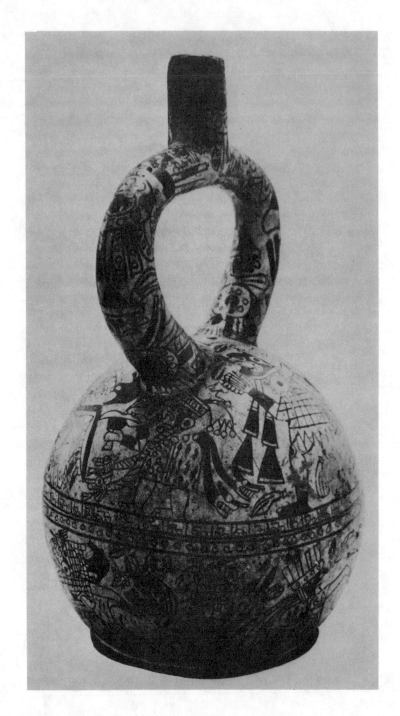

Figure 2. Stirrup spout bottle with fineline drawing of the Presentation Theme (see Fig. 1). Courtesy of Museum für Völkerkunde, Munich.

F. An anthropomorphized feline figure in the process of drawing blood from a bound, nude prisoner. Sometimes this figure is fully feline, with no noticeable human attributes.

G. A bound, nude prisoner from whom blood is being drawn.

These seven, then, are most of the major figures involved in the Presentation Theme. Other major figures not shown in this representation will be added from other depictions discussed below. In addition to the major figures, the following minor figures and objects are customarily included:

O. A dog near the rayed figure (A).

P. A serpent.

Q. An anthropomorphized fox warrior.

R. An anthropomorphized bird warrior.

S. An anthropomorphized feline warrior.

T. A club and shield.

U. An anthropomorphized club and shield, frequently shown holding a goblet.

V. A litter. In some representations, a throne is represented instead of a litter.

W. An ulluchu fruit.

Another example of the Presentation Theme is a low relief design from the chamber of a ceramic dipper (Fig. 3). In this case the limited area available for the design may well have been a factor in the artist's decision to simplify the Presentation Theme by using fewer figures. He has nevertheless included the primary figure (A) in the upper left-hand corner, complete with the rays emanating from his head and shoulders. Facing him, and presenting him with a goblet, is the anthropomorphized bird figure (B) who, in this case, is wearing the headdress typically worn by D. Immediately below the figure with the disc is the bound, nude prisoner (G) being held by a feline (F). In this instance the feline has no obvious human attributes. To the left is the anthropomorphized bird warrior (R), seen here as a rather significant figure in contrast with the way he was shown in the scene discussed above. The artist has also included two serpents (P) and a club and shield (T) next to the prisoner and an anthropomorphized club and shield (U) on the left of the scene.

Still another example of the Presentation Theme is seen in a fineline drawing from the chamber of a stirrup spout bottle (Fig. 4). Here again there is a slightly different arrangement of the symbolic elements, but the theme is clearly recognizable. On the left can be seen the bound prisoner (G) who is having his blood taken by the captor. In this instance the captor is neither a human figure nor feline, but rather an anthropomorphized bat, clearly identifiable because of the form of the ear and the large curved thumbnail on the upper part of the wing. Other examples of the Presentation Theme include similar bat figures, and these suggest that he is an individual whose function and overall import is equal to that of the feline and human figures who are in charge of the prisoners. He can thus be added to the inventory of major figures and given the letter designation H. The primary individuals in Figure 4 are the two in the center. The one on the left (C) is clearly the same individual as C in Figure 1. He has the same headdress and clothing, but in this instance he carries the disc and presents the goblet, a role usually played by the anthropomorphized bird figure (B). Moreover, in this case the goblet is presented to a seated individual (D)

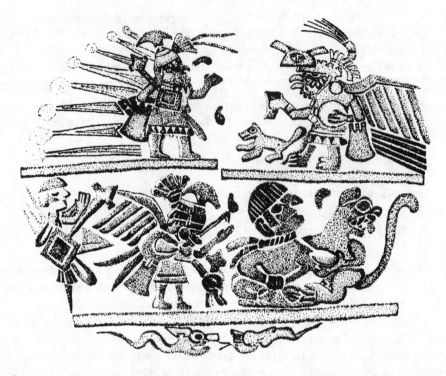

Figure 3. Low relief representation of the Presentation Theme derived from a dipper. Landmann Collection, New York (drawing by D. McClelland).

who is identical with D in Figure 1. Thus, although the role played by these two is distinct from the previous examples, they are easily identifiable because of their clothing and are appropriate to the basic inventory of major figures that characterize the Presentation Theme.

On the right in Figure 4 is an anthropomorphized feline (S), the counterpart of S in Figure 1. The clubs (T) are the counterpart to the usual club and shield, and the anthropomorphized club (U) in the hands of the seated individual may well be the counterpart to the anthropomorphized club and shield that are regularly a part of the Presentation Theme.

Figure 5 provides still another version of the Presentation Theme. The placement of the figures is somewhat distinct from the other versions, although the basic activities of taking blood from a bound prisoner and presentation of a goblet are clear. The characters are also easily identified by analogy with the other versions. The same letter designations have been added to facilitate comparison. The only new figures in this version of the Presentation Theme are the anthropomorphized Muscovy duck (X), who should perhaps be added to the list of minor figures, and the captor (I), who in this case has neither bat nor feline attributes, but rather is an anthropomorphized bird.

With this basic inventory of characters and an awareness of the activities that are inherent in the Presentation Theme, let us now turn our attention to a Moche mural from the wall of a temple at the site of Pañamarca (Fig. 6). This is the most famous of

all Moche murals because of its complexity and excellent state of preservation. Nevertheless, it is obviously only a part of what originally must have been a much larger mural. The activity shown in this mural has generally been interpreted as a procession, with the figure at the left having the major role and importance (Bonavia 1959). It is now possible to identify this mural as a representation of the Presentation Theme. Each of the figures shown on the preserved section can be identified on the basis of the other representations described above. The anthropomorphized bat (H) and feline (F) appear to have taken blood from the bound prisoners (G) behind them, and are in procession toward the central activity of the mural. A human captor (E) still stands beside one of the prisoners. Beneath the prisoners and in front of the anthropomorphized feline are serpents (P), and on the far right is the standard club and shield design (T). One additional feature not previously noted in examples of the Presentation Theme is the large thick-rimmed open bowl with what appear to be three goblets inside (Z).

By comparing what remains of the Pañamarca mural with the examples of the Presentation Theme described above, it is possible to reconstruct what the complete mural may have been, since the basic symbolic elements are somewhat predictable. The large figure on the left of the preserved section is identifiable as Figure C on the basis of his costume. He holds a goblet in one hand, but is not holding a disc in the other. Instead, he was probably holding a gourd in that hand, just as in Figure 1. Since the presentation of a goblet to the major figure is normally done by someone holding a disc, this large figure in the preserved section was probably not one of the primary figures on the mural, but rather was standing to one side of the primary figures. On the basis of Figure 1, it seems likely that in front of C in Figure 7 was an anthropomorphized bird figure (B) presenting a goblet to the rayed figure (A). In reconstructing the original form of this mural, I have chosen to represent this bird figure wearing the headdress usually worn by D. He could, alternatively, wear a conical helmet with a crescent-shaped ornament. A dog (O) would have been appropriately placed between the two major figures. Further to the left any number of figures and objects may have been depicted, since these secondary features are numerous, and various combinations can occur. The set shown in this reconstruction is quite plausible. It consists of anthropomorphized feline warriors (S), an anthropomorphized fox warrior (Q), an anthropomorphized Muscovy duck (X), a bird warrior (R), an ulluchu fruit (W), and another serpent (P). Based on the tendency toward bilateral symmetry found in Moche art, it also seems plausible that there was an enlarged club and shield design on the far left of the mural (T) to balance the one we know existed on the far right. One final element that was quite possibly shown on the mural was the anthropomophized club and shield (U). I have chosen to place it to the right of the large bird figure holding the disc. Of course, this suggested reconstruction of the original mural is hypothetical, but it does seem reasonable on the basis of the other examples of the Presentation Theme discussed above.

It can be seen, therefore, that the identification of a major theme of Moche art and thorough analysis of the symbolic elements of that theme provide a certain potential for prediction in working with the art. As a result, it becomes possible in some instances to reconstruct the missing portions of a fragmentary depiction. Of even greater importance, however, is the fact that the identification of a basic theme allows for the identification of some representations of figures which would otherwise

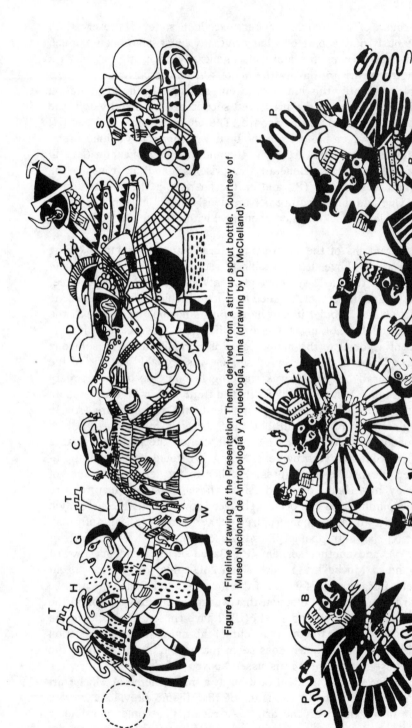

Figure 4. Fineline drawing of the Presentation Theme derived from a stirrup spout bottle. Courtesy of Museo Nacional de Antropología y Arqueología, Lima (drawing by D. McClelland).

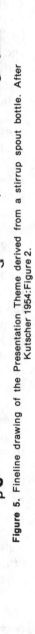

Figure 5. Fineline drawing of the Presentation Theme derived from a stirrup spout bottle. After Kutscher 1954:Figure 2.

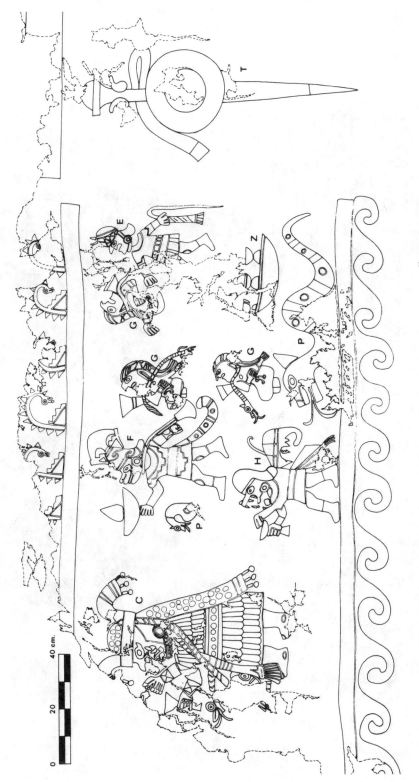

Figure 6. Mural representation of the Presentation Theme from the site of Pañamarca (drawing by P. Finnerty).

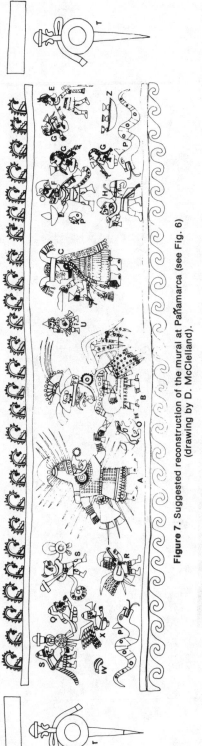

Figure 7. Suggested reconstruction of the mural at Pañamarca (see Fig. 6) (drawing by D. McClelland).

Figure 8. Modeled representation of the prisoner with a feline captor. Two views. Courtesy of Peabody Museum, Harvard University (photo by S. Einstein).

Figure 9. Modeled representation of B holding a disc. Courtesy of the Art Institute of Chicago.

418

Figure 10. Copper rattle with incised representations of figures from the Presentation Theme. Courtesy of the American Museum of Natural History, New York (drawing by P. Finnerty).

be impossible to interpret accurately. For example, modeled representations of bound prisoners held by felines (Fig. 8) can be identified as one of the elements of the Presentation Theme, where they are often shown in identical form (see Fig. 3). Similarly, the single figure of an anthropomorphized bird (Fig. 9) takes on a special meaning when, because of his characteristic clothing and the fact that he is holding a disc, it is possible to identify him as B in the Presentation Theme.

In 1961 a large cache of Moche copper objects was acquired by the American Museum of Natural History, including several large copper goblets identical with those used in the Presentation Theme and a number of copper rattles with long narrow handles (Fig. 10). The form of the rattles is similar to that of the object above the front part of the litter (V) in Figure 1. The upper portion of one of these rattles has a design incised on each of the four sides and on the top (Fig. 10). Each design is distinct, but taken as a group they clearly relate to the Presentation Theme. On the top of the rattle is A wearing his typical headdress (a conical helmet with a crescent-shaped ornament), short shirt with kilt, backflap, and rays emanating from his head and shoulders. On one side of the rattle is a figure holding a tumi knife, apparently the counterpart of E, who is generally shown holding or drawing blood from a bound, nude prisoner. The next side of the rattle shows the bound, nude prisoner. That he is tied to a rack and that human heads are associated with the rack itself are somewhat unusual. On the other hand, similar human heads can be seen hanging from the litter in Figure 1. The representation of the prisoner on the rattle is not sufficiently detailed to determine whether or not the figure is nude, although other Moche representations of figures in this position suggest that he is. A third side of the rattle shows a figure holding a goblet in one hand and apparently a gourd lid in the other. It is likely that this is a representation of B, although the headdress is unusual in not having a clearly defined half circle in front similar to that in Figure 10. All other aspects of the figure are appropriate, however, including the three featherlike objects on the back which can be seen as counterparts of the wings on B. The fourth side of the rattle depicts an anthropomorphized bird warrior—a clear counterpart to R in the Presentation Theme. The form of this rattle and its incised designs, as well as the form of the goblets found in the same cache of copper objects, thus can be directly associated with the Presentation Theme. It seems likely that these objects were used in the ceremony in which the various figures in the Presentation Theme are actively engaged.

Identification of the Presentation Theme allows us to better understand a great many examples of Moche Art which would otherwise have little meaning beyond their obvious features. It also demonstrates the way Moche artists chose to represent a given theme by illustrating one of its symbolic units alone or illustrating two or more of them together in various combinations. Realizing that the artist could and frequently did represent a complex theme by showing only one of its symbolic elements, present-day researchers should be encouraged to go beyond a simple explanation of a given piece and to search for a basic theme to which it belongs.

Bibliography

Bonavia, Duccio
 1959 *Una Pintura Mural de Pañamarca, Valle de Nepeña.* Arqueológicas, 5. Lima: Museo Nacional de Antropología y Arqueología.

Donnan, Christopher B.
 1972 "Moche-Huari Murals from Northern Peru." *Archaeology*, 25:2, 85-95.

Kutscher, Gerdt
 1954 *Nordperuanische Keramik.* Berlin: Casa Colitora, Gebr. Mann.
 1955 *Arte Antiguo de la Costa Norte del Perú.* Berlin: Gebr. Mann.

The Moon Is a Boat!: A Study in Iconographic Methodology

Alana Cordy-Collins

Iconography is an extremely fascinating subfield within the discipline of art history because it allows the researcher, far removed in space and time from the artist's epoch, to gain insights into the minds and mores of ancient man by recognizing and perhaps understanding his symbol systems. Moreoever, iconographic decipherment need not be difficult if one adheres to the three step approach suggested by Panofsky (1962:3-17). However, one must recognize that the three steps are exactly that, and they must be taken one at a time and in order.

Panofsky's first step is the description of the design motif thoroughly in *objective* terms. His second step is the complete analysis of the motif just described. One needs to determine what the motif is. This is accomplished by assembling as large a sample of the motif as possible in order to identify the patterns the motif follows and its variety. One needs to look for relationships between the motifs under study and others. Panofsky's third and final step is the interpretation, or deciding *what the motif means*.

This third step is hazardous because meanings of things change through time and space. Obviously, iconographic interpretations are best drawn from information written at the time the motif was in use. However, this is not always possible. For example, step three is particularly tricky when dealing with Pre-Columbian iconography, especially of the Andean area of South America. Andean cultures left no written records prior to the Spanish Conquest of 1532 because the native inhabitants had no writing system. Furthermore, the Spanish chronicles or ethnohistories of the Colonial Period are far from complete. If we rely on these ethnohistories or, worse, modern ethnographies to interpret Andean iconographic motifs, we run the risk of disjunction[1] or of descendants having forgotten what a motif originally represented.

Thus, Panofsky's third step is admittedly hazardous and should be approached with caution. Many times the situation is such that an iconographical interpretation cannot be offered at all—at least with present resources. It is no wonder that iconographers fantasize of discovering *the crucial source* tucked away, forgotten, in some dusty archive!

421

Yet raising our level of understanding of iconography even to the second step can be rewarding, because we *can* see and appreciate the way the ancient artist organized his material. One particularly enticing art style is Moche.[2] Moche (sometimes called Mochica) culture flourished on the north coast of Peru from the first through the eighth centuries A.D. Although represented by several media, it is in the ceramic art of Moche where one finds an immediate fascination. Moche ceramics are usually of extremely fine craftsmanship, and the designs are executed in a robust, fluid, and highly competent manner. In addition the motifs seem easy to identify. One can usually discern felines, birds, lizards, etc., as well as various individuals: e.g., warriors, nobles, and deformed persons. However, this apparent ease of identification can be hazardous and misleading. Many researchers have fallen into the trap of identifying a Moche motif on the basis of what it looked like to them. This, of course, violates a basic tenet of iconographic decipherment: describe and interpret separately.

The following analysis demonstrates the importance of separation of Panofsky's three steps and will serve as an example of iconographic methodology.

In Danièlle Lavallée's study of Moche ceramics (1970:106-109) she describes a motif as a man in a crescent moon (Figures 1-7). In coming to her conclusion concerning this motif, Lavallée has merged the three steps of iconographical research (description, analysis, and interpretation). The resulting judgment, as it turns out, is invalid; i.e., identification of a crescent *shape* as a "crescent moon."

It can be extremely misleading to identify a motif based on one's own cultural experience. Certainly the crescent shape does remind *us* of a crescent moon, but there is no cultural basis whatsoever for believing that the Moche artist intended nor that the Moche citizen perceived the shape as a crescent *moon*. In fact, the Moche artist intended the crescent shape to represent something quite different.

The sample of bottles in this study with the man-in-the-crescent motif is limited to seven examples. Nevertheless, these must suffice as an accurate representation of the motif because they are the only examples of the motif in a total sample of over seven thousand Moche ceramics.[3]

In order to arrive at an understanding of this motif, each example must be described in some detail; but since the designs in Figures 1 through 5 are very similar to one another they can be described as a group. In each case the same design appears on both sides of the bottle. Each example shows a man kneeling in a crescent. He is shown in profile, and his arm is stretched forward over some object. His face is dark with the exceptions of the eye, nose, and mouth. His mouth is fanged (an attribute generally accepted to be an indicator of the supernatural or divine) in Figures 1 through 3. He wears a cross-hatched costume, belted in Figures 1, 2, and 5, a dotted headband with truncated appendages, a segmented attachment or train, and a large ear disc. Situated between the train and the body is a dotted stripe (probably another item of clothing such as a cape). The crescent is in a position horizontal to the base of the bottle and the viewer. Furthermore, it is composed of two parts: a dark area underneath the man and the light crescent which extends beyond the dark area to culminate in pointed tips. Finally, zoomorphized lines radiate about the crescent and the man.

Figure 6 is nearly identical except that the man's headdress lacks a train, no cross-hatching appears on his costume, and no dark inner area can be discerned

Figure 1. Phase Vb stirrup spout bottle with a man-in-the-crescent motif. Museo de America, #214. Madrid, Spain. C.B. Donnan photo.

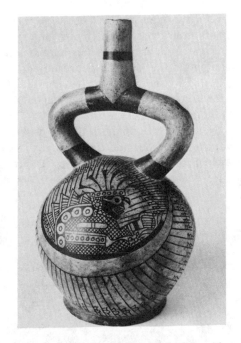

Figure 2. Phase Vb stirrup spout bottle with a man-in-the-crescent motif. Museo Amano. Lima, Peru. Photo courtesy the Museo Amano.

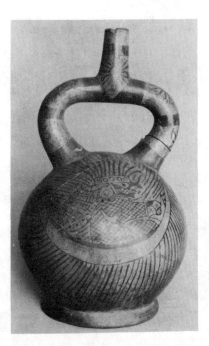

Figure 3. Phase Vb stirrup spout bottle with a man-in-the-crescent motif. Museo Preistorico Etnografico Luigi Pignorini, #37344. Rome, Italy. C.B. Donnan photo.

424

between the man and the crescent. (This piece is aberrant too in that the design appears in low relief and on only one side of the vessel.)

Figure 7 is also extremely similar to the previous illustrations, with the following exceptions: the man is represented only by his head, and his body is merely suggested by the cross-hatched bundle. Moreover, the radiant lines are not zoomorphized, and no dark inner area appears between the "body" (cross-hatched bundle) and the light crescent.

Now that the analysis of the design motif is complete, next it is necessary to organize the bottles and their designs in a systematic, chronological order. The bottles on which the designs in Figures 1 through 7 appear[4] are known as stirrup spout bottles because the handle shape resembles a stirrup. Moche stirrup spout bottles

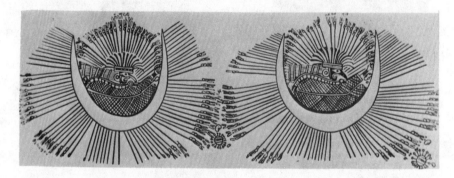

Figure 4. The man-in-the-crescent motif from both sides of a Phase Vb (?) ceramic vessel. The vessel's shape is unknown. Museo Rafael Larco Herrera (?) Lima, Peru. Re-drawn from Larco 1943:figure 3.

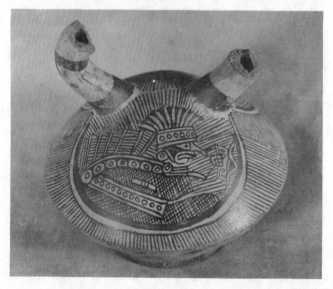

Figure 5. Phase Vd stirrup spout bottle with a man-in-the-crescent motif. Museo Nacional de Antropología y Arqueología. Lima, Peru. C.B. Donnan photo.

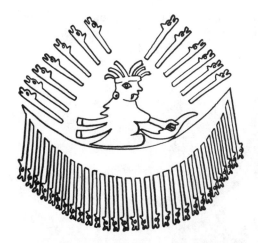

Figure 6a. Roll-out drawing from the bottle in Figure 6b. Re-drawn from Lavallee 1970:Pl. 84.

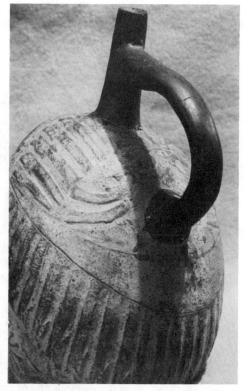

Figure 6b. Phase V (b?) spout and handle bottle with a low relief man-in-the-crescent motif. The Art Institute. Chicago, Illinois. C.B. Donnan photo.

have been seriated[5] into a five phase chronology which is based on changes in the form of the spout. We need not be concerned here with the first four phases because all seven of the man-in-the-crescent motifs appear on Phase V bottles.

Unpublished research in recent years has resulted in the further seriation of stirrup spout bottles of Phase V into four subdivisions. For convenience here these subdivisions are called Phases Va, Vb, Vc, and Vd. In Phase Va the bottle shape is somewhat elongated, in Phase Vb the bottle chamber attains a more spherical shape, by Phase Vc the bottles begin to exhibit a slight bulge around the equator of the chamber, and in Phase Vd the stirrup spout bottle is compressed at the poles, resulting in extreme equatorial bulging. Thus, a chronological evolution has been established to which we can correlate the evolution of the man-in-the-crescent motif (Figure 8).

In addition to changes in chamber shape of the Phase V Moche bottle, subtle alterations are also evident in the shape of the spouts (Figure 8). Classic Phase V spouts are shorter than the preceding ones of Phase IV and also taper inward at the lip. However, by Phase Vc the spouts no longer taper inward, but straighten and even begin to flare perceptibly at the lip (Cordy-Collins ms.:28,35).

Yet other changes are discernible in the fine line painting. The bodies of kneeling figures become increasingly abstracted, finally resembling a U laid on its side (a lazy U) (Donna McClelland, personal communication), as in Figure 4.

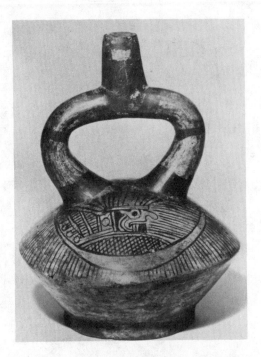

Figure 7. Phase Vd stirrup spout bottle with a man-in-the-crescent motif. The spout appears to be an improper restoration. Musée de l'Homme, #78-1-42. Paris, France. Photo courtesy the Musée de l'Homme.

Figure 8. Diagram showing stirrup spout bottle sub-shapes of Phase V.

These changes indicate another evolution, an evolution in painting style, which makes it possible to trace painted motifs through a definite sequence that, like the evolutions in chamber and spout, enables the researcher multiple corroboration of any hypothesis related to chronological change.

With these established sequences of changes in mind, the researcher can now easily place six of the seven examples of the man-in-the-crescent motif in chronological order.

The earliest examples of the motif in this sequence are represented on the bottles in Figures 1 and 2 because in these instances the posture of the kneeling man does not approximate the lazy U shape. Moreover, the bottle chambers are spherical, and the spout is relatively short and inward tapering. Therefore, these bottles were probably produced during Phase Vb.

The motif on the bottle in Figure 3 seems to be only slightly later, probably transitional between Phases Vb and Vc. The man's posture is more compressed and approaches a lazy U shape. Nonetheless, the bottle chamber is spherical, but the inward tapering spout is beginning to straighten near the lip.

Because the bottle shape of the Figure 4 is unknown, the only criterion we can use to date this piece is the kneeling figure's body posture. Because of its extreme compression, this motif may be tentatively assigned to Phase Vc.

The stirrup spout bottle illustrated in Figure 5 is assignable to Phase Vd on the basis of the pronounced equatorial bulge of the chamber and the compressed form of the man. Although the spout is missing, it is likely that the spout would have been one with a slightly outward tapering lip.

The placement of the bottle of Figure 6 within Phase V is uncertain because of three factors: the bottle's shape is irregular, the stirrup and spout may well have been restored, and the design in question is executed in low relief instead of fine line painting. Even so, because of general body posture, it is very likely that this motif was executed during Phase Vb.

The example of Figure 7 falls easily into Phase Vd because of the extreme compression of the vessel's chamber and the reduction of the man-in-the-crescent to only the upper half of a lazy U form. However, according to our criteria, the bottle's spout should be taller and not so tapered. It should be mentioned with regard to this abnormality that it is likely that this spout is a restoration.

Having objectively described the seven examples of the man-in-the-crescent motif and the bottles upon which it appears (Panofsky's first step), next is the analysis of the motif (Panofsky's second step). At this point, the analysis is best conducted by comparing the motif with others similar to it. In the aforementioned total sample of over seven thousand Moche ceramic vessels, the crescent man with all his accoutrements was found to appear in two other contexts. He appears as a subsidiary personage in a series of five bottles showing a burial scene (Donnan and McClelland, ms.) where he differs slightly in that he is shown standing rather than kneeling.

The other instance in which the crescent man appears is in a series of seven bottles depicting a tule boat.[6] In the tule boat scenes he is also in a kneeling position, but alternates with another man in a tule boat who holds a paddle on the opposite side of the bottle.[7] Obviously, the closer comparison is with the tule boatman, rather than with the burial scene person, because of the former's kneeling posture. In addition, in most cases, the kneeling boatman also has his arm extended with the hand over some object on the deck.

The tule boat motif has been examined in detail elsewhere and appears to constitute a specific theme which spans all five phases of Moche art (Cordy-Collins 1972). Even so, only during Phase V does the boatman appear consistently dressed in the same costume as the man-in-the-crescent. For purposes of comparing these two motifs it is necessary to arrange the seven tule boat bottles in chronological order.

The tule boat motif of Figure 9 belongs to Phase Va because the shape of the chamber is elongated, and spout still resembles the very tall, straight-sided spouts of Phase IV. In addition, the boatman's posture has not yet been reduced to a lazy U shape into which kneeling figures evolve.

There are only two criteria remaining by which to determine the temporal placement of the bottle's motif in Figure 10. Neither the stirrup nor the spout of this bottle is original, as can be seen by the crude join at the chamber. Yet, judging by the globular chamber and the upright position of the boatman, this piece seems to date to Phase Vb.[8] The bottle of Figure 11 also dates to Phase Vb because of the spherical chamber, short inward tapering spout, and the upright boatman.[9]

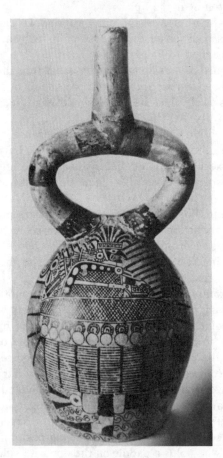

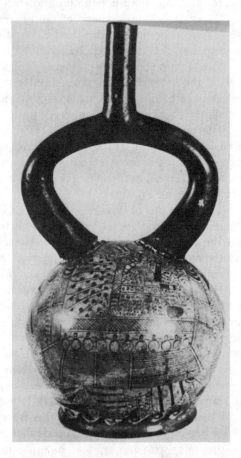

Figure 9. Phase Va stirrup spout bottle with a tule boat motif. After Leicht 1944: figure 8.

Figure 10. Phase Vb stirrup spout bottle with a tule boat motif. Both the stirrup and spout are incorrect Phase IV restorations. Museo de América. Madrid, Spain. Photo courtesy Alan C. Lapiner.

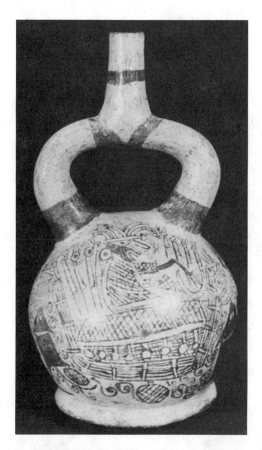

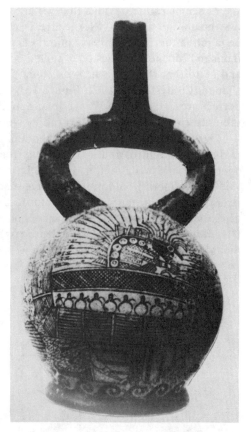

Figure 11. Phase Vb stirrup spout bottle with a tule boat motif. Museum of Cultural History, #X70-811. University of California, Los Angeles. C.B. Donnan photo.

Figure 12. Phase Vb stirrup spout bottle with a tule boat motif. The spout is an incorrect Phase IV restoration. Staatliches Museum für Völkerkunde. Munich, West Germany. C.B. Donnan photo.

The example of Figure 12 appears to best fit as a transition piece between Phases Vb and Vc. It exhibits the spherical chamber (with an incorrect Phase IV spout replacement), but the boatman's posture is slightly compressed. The bottle of Figure 13 is probably contemporary with that of Figure 12 because, again, the chamber is fully round with an original inward tapering spout, and the boatman is also somewhat compressed.

A slight equatorial chamber bulge plus a spout which tends to straighten toward the lip suggest that the Figure 14 bottle and design belong to Phase Vc. Unfortunately, the only published side of the bottle exhibits the paddler rather than the kneeling boatman; but, even so, body compression is more evident in this figure than in any earlier ones of the paddler (Cordy-Collins 1972:48).

The figure 15 example also belongs to Phase Vc. The bottle shape is slightly compressed, as is the preceding example, the spout is beginning to taper slightly, and the boatman is radically compressed into a lazy U shape.

One final item of comparison is the zoomorphic lines which radiate around the crescent and the man kneeling in it. These same sort of zoomorphized lines radiate around the boatman and the tule boat.

It seems rather obvious that we are dealing with the same individual, both in the tule boats and in the crescent. He is consistently shown in the same costume and engaged in the same activity; and, because nowhere else in the total sample of seven thousand Moche ceramics does such a correlation occur, we may venture a bit further and state that the crescent *represents* the tule boat. Actual tule boats *are* crescent-shaped (Cordy-Collins 1972: Figure 1b), and tule boats painted during Phase III are a perfect crescent shape (Wasserman-San Blas 1938: frontispiece), and the position of the crescent (i.e., horizontal to the viewer) is just the same as the tule boat.

We have seen an increasing tendency toward simplication of motifs with regard to the human figure, and it is certainly reasonable to assume that a similar trend was operative with other motifs. Here it is important to mention that simplification of a well-known motif would probably have made no difference to those Moche people who understood the meaning of the motif. Donnan (Article 33) has pointed out that Christian iconography offers an analogous situation to the Moche. We may represent the Christ Child in a crib, or the Three Wise Men, or a star over a manger, and even though none of these representations is the complete Nativity Scene, we all know that

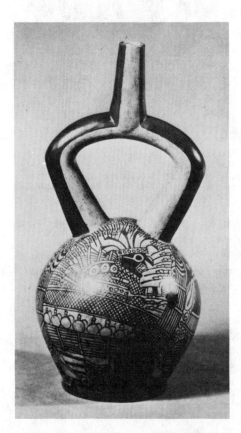

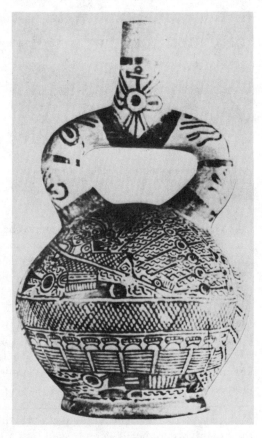

Figure 13. Phase Vb stirrup spout bottle with a tule boat motif. Private collection. Photo courtesy Alan C. Lapiner.

Figure 14. Phase Vc stirrup spout bottle with a tule boat motif. After Della Santa n.d.:front cover.

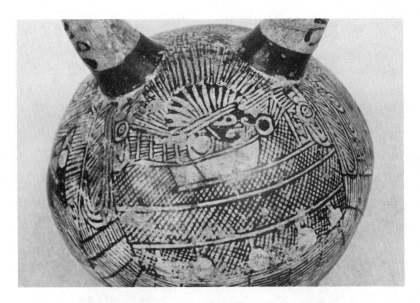

Figure 15a. Detail of Figure 15b showing the figure on the opposite side of the bottle. C.B. Donnan photo.

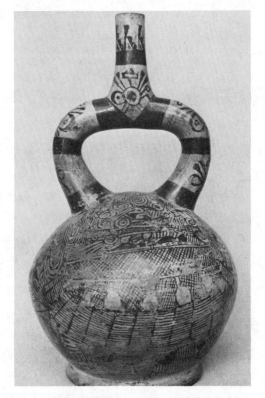

Figure 15b. Phase Vc stirrup spout bottle with a tule boat motif. Ganoza collection. Trujillo, Peru. B.C. Donnan photo.

432

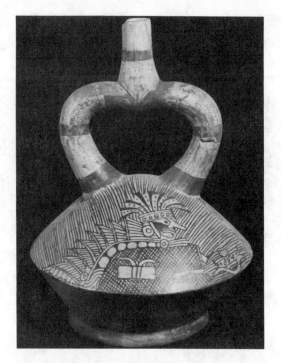

Figure 16. Phase Vd stirrup spout bottle. Linden-Museum für Völkerkunde, #93386. Stuttgart, West Germany. C.B. Donnan photo.

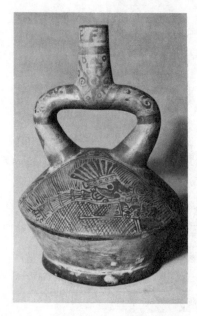

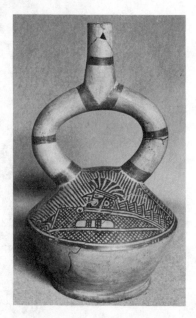

Figure 17. Phase Vd stirrup spout bottle. Museum Rietburgzürich. Zürich, Switzerland. C.B. Donnan photo.

Figure 18. Phase Vd stirrup spout bottle. Museo de Trujillo, #8819. Trujillo, Peru. C.B. Donnan photo.

the Nativity Scene is what is intended. Each of these three representations is an abbreviation or shorthand method of showing a complex scene familiar to everyone within our own culture. There is every indication that a similar situation existed in the Moche culture.

With regard to Moche, it should be pointed out that the crescents do not replace the tule boats in a chronolgical sense. In fact, the seriations show that the two types of depictions are contemporary. This contemporaneity is underscored by the discovery that at least four of the bottles were painted by the same artist: two of the tule boat designs and the other two of the crescent. These four pieces (Figures 1, 2, 12, and 13) all show essentially similar renditions of the kneeling man: the elongated sweep of the eye corner, a pincer-shaped mouth, the peculiar nose shape with its flat underside and hooked top, as well as its placement in relation to the eye. Also, the shape and position of the hand are the same in each case, as is the manner of painting clothing. All are too alike to be the result of coincidence, yet all vary too much to have been done with a stencil.

In order to conclude this analysis, three more Moche stirrup spout bottle designs must be examined. All three are assignable to Phase Vd because of the extreme equatorial bulge and straighter spout with its slight outflare. It is immediately apparent that the kneeling man on each bottle is the tule boatman, Figures 16, 17, and 18. However, in none of these three instances is either a tule boat or crescent shown. We may view this as another step in the trend toward reduction of the tule boat theme to a shorthand, in this case by eliminating a direct reference to the tule boat or crescent.

However, while it is true that neither a tule boat nor a crescent is painted on the vessel, it is *not* true that the tule boat/crescent idea has been omitted.

We noted previously that this particular vessel shape with the exaggerated equatorial bulge occurs only during Phase Vd. There are several known examples of the shape with various motifs. Yet here, in Figures 16, 17, and 18, what the artists have done is to employ a standard vessel shape in a very ingenious manner. In these instances the vessel design is related to vessel shape as never before. The artists have used the unadorned, sloping lower half of the bottle chamber *to represent* the crescent-shaped tule boat, a very subtle refinement—and a refinement that can mislead the unwary.

Thus, this brief implementation of Panofsky's second step demonstrates how iconographic research, if carefully done, can result in important insights into an ancient culture's symbol system. A careful, objective examination of a large sample has resulted in a concept far different from the obvious: The "moon" is a *boat*! Such methodology results in a more accurate estimation of what the artist intended, and that estimation enables the researcher to be more accurate with Panofsky's third step, interpretation. Furthermore, we have isolated a segment of stylistic change; we can see the evolution of design into symbol. We see the beginning of idea codification, which is the first step toward the written word.

Notes

[1]Cultural disjunction occurs when a new people move into an area, adopt a motif developed in that area, but fail to adopt the meaning and, instead, substitute their own.

[2]See also Articles 27 and 29 (Donnan's & McClelland's.)

[3]These seven thousand Moche ceramics are located in the photographic records of the Archive of Moche Art at the University of California, Los Angeles.

[4]The bottle shape of Figure 4 is unknown.

[5]Seriation is a method of relative dating based on the concept that style changes gradually, but consistently through time.

[6]A tule boat is a native Peruvian fishing craft made of *totora* reeds. Its use is now restricted to a 150 mile stretch of the Peruvian north coast, but in Colonial times it had a wider distribution. This type of craft is represented in several ancient Peruvian coastal art styles, and there seems to be little doubt that it was widely used before the Conquest.

[7]It is unfortunate that two of the seven bottles have been incompletely published, showing only one side. In one case, Figure 9, the kneeling figure appears, while in the other case, Figure 14, the paddling figure appears. Thus, it seems likely that the two types of boatmen alternate from side to side on these vessels also.

[8]This aberrant type of figure is discussed fully in Cordy-Collins 1972:48.

[9]This design graphically demonstrates that not *all* Moche artists were mastercraftsmen!

Bibliography

Cordy-Collins, Alana

 1972 *The Tule Boat Theme in Moche Art: A Problem in Ancient Peruvian Iconography.* Master's Thesis. Institute of Archaeology. University of California, Los Angeles.

 ms. Revised Master's Thesis.

Della Santa, E.

 n.d. *La Collection de Vases Mochicas des Musees Royaux d'Art et d'Histoire.* Willy Godenne. Bruxelles.

Donnan, Christopher B.

 1975 "The Thematic Approach to Moche Iconography." *Journal of Latin American Lore.* Latin American Center. University of California, Los Angeles.

Donnan, Christopher B. and Donna McClelland

 ms. "The Burial Theme in Moche Art."

Larco Hoyle, Rafael

 1943 "La Escritura Peruana sobre Palleres." *Revista Geografica Americana*, año XI, no. 22. Noviembre y Diciembre 1943: 277-292. Buenos Aires.

Lavallée, Danièlle

 1970 *Les Representationes Animales dans le Céramique Mochica.* Université de Paris, Mémoires de l'Institut d'Ethnologie, IV. Institut d'Ethnologie. Musée de l'Homme. Paris.

Leicht, Hermann

 1944 *Indiansche Kunst und Kultur. Ein Jahrtausend im Reiche der Chimu.* Orell Füssli Verlag. Zürich.

Panofsky, Erwin

 1962 *Studies in Iconology: Humanistic Themes in the Art of the Renaissance.* Harper & Row. New York.

Wasserman-San Blas, B.J.

 1938 *Cerámicas del antiguo Perú de la colección Wasserman-San Blas.* Buenos Aires.

The Ulluchu:
A Moche Symbolic Fruit

Donna D. McClelland

Between 100 B.C. and A.D. 700 the north coast of Peru was governed by the Moche Kingdom following the breakdown of the pan-Peruvian Chavín influence. The Moche culture created a sophisticated art style in which the Moche artists skillfully employed a variety of materials. Ceramic vessels were a major expression of the art. Some of the vessels were decorated with extremely complex fineline drawings. These fineline drawings are the focus of iconographic research at U.C.L.A. in the Moche Archive, an extensive collection of photographs and drawings of Moche art which has been developed under the direction of Dr. Christopher Donnan to study the art. This paper represents one aspect of the ongoing iconographic research of the fineline drawings.

In the course of our research with Moche iconography, it became apparent that there are many distinctive objects and designs that are secondary in importance to the major figures in a scene. Among these secondary items or background elements are birds, fish, clubs and shields, dotted irregular shapes, waves, and plants. Since the background elements are not likely to be without meaning, it was decided that an investigation of these would be worthwhile to our iconographic research. A preliminary study demonstrated that some of the background elements function as geographic identifiers. Still others occur in such a diversity of settings that we may assume they were not geographic identifiers, but rather were used to impute some meaning or quality, perhaps sacred or magical, associated with the supernatural realm. This paper describes the most enigmatic of these. It is a grooved, comma-shaped fruit with an enlarged calyx (Fig. 1). Larco (1938:94) referred to the plant as the *ulluchu*, and that name will be used for convenience in this paper. By focusing on this one seemingly simple decorative or background element, and tracing its distribution in the large sample of art contained in the Moche Archive, it is possible to demonstrate how the study of a simple secondary element can contribute to a greater understanding of Moche art and culture.

435

Figure 1a. Museo Arqueológico Rafael Larco Her-
rera, Lima.

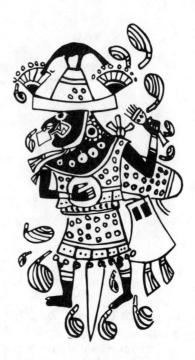

Figure 1b. Private Collection, Trujillo.

Fruit on Plant

Headdress Design

Belt Design

Background Elements

Figure 2. Range of Variability in the Depiction of
the Ulluchu.

The Ulluchu as a Symbolic Plant

It appears that the *ulluchu* fruit carries a symbolic meaning in Moche art to which magical qualities may have been attributed. There is ethnographic evidence that the people on the north coast of Peru today have plants to which they attribute "magical" properties. The plants are commonly associated with *curanderismo*, or folk healing, as reported by Sharon (1972:167). The "magic" plants are differentiated from strictly medicinal plants and are gathered at sacred lagoons in the Andes. In addition, Gillen (1945:126-127) describes the use of plants by a *curandero*, a folk healer, in the modern Moche community. Historical evidence also suggests ceremonial or ritual use of plants. One of the early chroniclers, Father Pablo Joseph de Arriaga (1968:34), describes the use of corn in divination. Therefore, ethnographic and historical evidence reflects the symbolic quality of plants in pre-Columbian cultures.

Identification

The Moche Archive was searched for all *ulluchu* representations. These included those in three-dimensional modeled form, two-dimensional fineline drawing, and bas-relief forms on ceramic vessels as well as those found on wall murals, textiles, and metal objects. Included in these were many stylistic variations of the *ulluchu*, as well as numerous background elements that were not readily identifiable. Therefore, a study was initiated to determine the range of variation in the depiction of the *ulluchu*. Fineline drawings of the *ulluchu* were compiled (Fig. 2), and these were then compared with modeled *ulluchus* (Fig. 1). This indicated that the primary diagnostic feature in the identification of the fruit is the comma-shape. Secondary diagnostic features are an exaggerated round calyx and lines on the body corresponding to the grooves on the modeled fruits. In some cases the spatial orientation of the fruit aids in identification. When the plant is shown in fineline drawings, the leaves are boomerang shaped, and the plant exhibits a splayed symmetry which is unique within the Moche sample of plants (Fig. 3). The fruit hangs from the plant by its smaller pointed end. Although the sample includes *ulluchu* depictions which can be attributed to Phases II, III, IV, and V, it was not possible to recognize variations in depiction that correlate with changes through time.

Several botanists were consulted to obtain a botanical identification of the plant, which might lead to information about any special physical characteristics of the fruit or its physiographic zone. The botanists had to base their analyses on the Moche representations of the plant, because no archeological remains of the *ulluchu* have yet been reported. Although botanical characteristics of the fruit and plant are clearly shown in the depictions, they have not yet led to its precise botanical identification. Nonetheless, they do eliminate the possibility of identifying the *ulluchu* as *pepino* (*Solanum muricatum*) or *aji* (*Capsicum*), since the *ulluchi* fruit is suspended from the plant by its smaller pointed end, whereas these two are suspended by the large end. We cannot derive the *ulluchu*'s ecological zone from the art, as the fruit-laden plant is not found in scenes with other plants. In the South American botanical literature there is a plant with a similarly spelled name, *Ullucus tuberosus* (Leon 1964:15), but the description and drawings of this tuber differed greatly from the Moche depictions of the *ulluchu*.

The *ulluchu* does have some resemblance to a gourd, and gourds are known to have been used by the Moche people as rattles and as lime containers for coca

438

Figure 3. After Larco 1938:figure 58.

Figure 4. Private Collection, New York.

Figure 5. Courtesy of the Metropolitan Museum of Art, New York.

chewing. When all modeled rattles in the Moche Archive which might represent gourds were examined, only one rattle out of a sample of twenty-five was shaped like *ulluchus*. Similarly, Moche depictions of lime gourds do not have the *ulluchu's* diagnostic lines and comma-shape.

It is not altogether clear from the Moche depictions whether the plant is a tree, shrub, or vine. A tree or large shrub is suggested in Figure 4, where monkeys and humans appear to be in the branches picking the fruit. Alternatively, it could be viewed as a vine shown from above, with its branches growing along the surface of the ground. Such a representation would be perfectly consistent with Moche rules of perspective (Donnan in press)*. If this is the case, then those vessels which seem to show monkeys and humans in the branches must be explained as a combination of the top view of the vine and with a profile view of the figures.

The plant was identified by Larco (1939:94-98) as the *ulluchu*.[1] He said it was a yellow edible fruit that he found in the sierras. He reported that the peoples of the sierras and along the coast, especially in the Viru and Moche Valleys, believe that the fruit must be picked silently or the fruit turns bitter and becomes inedible. Earlier, Larco (1938:12a) labeled a drawing of the plant (Fig. 3), *Phaeolus Sp.*, a bean (Towle 1961:55). However, the leaves of the *Phaseolus* do not resemble the *ulluchu* leaf depictions.

Alan Sawyer (1968:46) once identified the fruit as:

the narcotic fruit of the ullucho tree, which grows in the highlands.

In recent personal communication, however, he stated that he had received his information from personal communication with Larco and:

At this point I would not feel that I had adequate evidence to call the Ullucho "narcotic."

The actual size of the *ulluchu* is difficult to determine from the art, primarily because the Moche artists did not consistently scale their depictions to natural proportions. An object in a scene may be enlarged to promote easy identification or reduced to provide enough space for other components of the scene. The double *ulluchus* worn in the headdress and those that are being held in the hand would indicate by comparison to a human figure that the *ulluchus* might be from four to six inches long. However, this size must be viewed cautiously. The actual headdress being depicted (Fig. 5) may contain artificial *ulluchus* which are larger than the real-life variety and *ulluchus* being held in the hand may be enlarged for identification or symbolic purposes.

While in Peru for two weeks in September of 1972, I shopped in the native markets in Trujillo and Cajamarca trying to locate an *ulluchu*. I asked local villagers if they knew of a fruit or plant by the name of *ulluchu* or *ullucho*. In Cajamarca I asked a vendor of magic items and medicinal plants the same questions. None seemed to know of a plant by that name. Thus, I concluded that (1) the plant is either uncommon or nonexistent in these areas today, (2) the superstition surrounding the fruit prevents it from being discussed with outsiders, or (3) the plant has a different common name in the Trujillo or Cajamarca areas than that reported by Larco.

*Editors' Note: This work is now published (1976).

Figure 6. Museo Nacional de Antropología
y Arquelogía, Lima.

Figure 7. Private Collection, Trujillo.

Sample Description

There are 112 Moche specimens in the sample on which the *ulluchu* is depicted. These include 106 ceramic vessels, two textiles, one gold object, one copper object, and two wall murals. In addition, there are approximately 125 vessels on which the *ulluchu* appears only as a belt design. Since the *ulluchu* has two usages, i.e., as a background element and as a decorative element on clothing, the sample is divided into these two categories.

Background Elements

This category contains forty-five representations including forty-one ceramic vessels, two textiles, and two murals. Forty-two of the specimens depict the *ulluchu* fruit as a background element in a scene and occasionally as a hand held object. Included in this category are three ceramic vessels which illustrate the fruit-laden plant. The *ulluchu* is depicted as a background element in at least sixteen different types of scenes (Figs. 6-8). A number of hypotheses about the usage and meaning of the *ulluchu* as a background element were tested in an attempt to define its distribution and significance.

It was hypothesized that the *ulluchu* was a geographic indicator. A set of plants, animals, and geological formations sharing a common ecological zone may be used on a vessel by the Moche artist to create a naturalistic setting for the activities that occur there. There are sets of background elements representing the desert, fresh water marshes, lomas (belts of vegetation which derive their moisture from fog), ocean, and mountains. Plants constitute a large part of each set, and they tend to be mutually exclusive. The *ulluchu* plant was not found in an ecological identifiable scene. However, since the fruit is found in association with ocean, desert, and lomas settings, it seems clear that its appearance in the background of a scene does not convey geographic meaning.

It was also thought that the *ulluchu* might derive its meaning from the activity in the scenes in which it appears. However, since the activities are so diverse, it would appear appropriate for *ulluchus* to be added to the background of any scene. Furthermore, a given complex scene may be depicted many times throughout the Moche artistic media, but the specific details may or may not be repeated in all depictions of the same scene. Consequently, a given complex scene may be shown with or without *ulluchus* in the background. Since the *ulluchus* may be included or omitted from a given complex scene, it would seem that the inclusion or omission of the *ulluchu* does not change the activity within the scene. Rather, it contains its own symbology which it adds to that scene. An examination of five vessels showing the same burial scene is interesting. Whereas the *ulluchu* is clearly depicted many times in the background on two of the vessels, it is not represented on the other three vessels. However, one of the latter has it prominently displayed on the spout under the modeled monkeys (Fig. 9).

It was hypothesized that the *ulluchu* might serve as an identifier of a particular figure. However, in scenes involving humans or anthropomorphized animals, it was found that the *ulluchu* may appear beside only one figure, beside more than one figure, or be unrelated to any figures in the scene. Further, it was not obvious why one human or anthropomorphized animal in a scene was selected to have an *ulluchu* placed beside him. Supernatural figures, i.e., figures with fanged mouths, may have

Figure 8. After Larco 1938: Lamina XXIII.

Figure 9. Photo courtesy of Musée de l'Homme, Paris.

one or more *ulluchus* hovering about them; however, if one supernatural figure in a scene has an *ulluchu* near him, then every supernatural figure in that scene has an *ulluchu* near him (Fig. 10). Of the 42 representations which contain *ulluchus* as background elements, 33 are associated with supernatural figures, one is associated with a mythical animal (conch shell monster), and only eight are associated with human figures. Therefore, it would seem that the *ulluchu* does not serve as an identifier of any particular figure.

The spatial orientation of the fruit in the background of a scene appears completely random. This suggests that the position of the fruit in the background does not impart additional meaning.

Since lima beans and *ulluchus* may be found together as background elements, it was hypothesized that they might relate the same meaning to a scene (Fig. 8). Therefore, the distribution and roles of beans and *ulluchus* were compared to test this. It was found that beans, like *ulluchus*, appear in a variety of ecological zones. The bean is depicted as food in serving containers, but the *ulluchu* is not. Like the *ulluchu*, the bean is utilized as a decorative element; however, the *ulluchu* is much more extensively used. The bean is not a component of a headdress like the *ulluchu*. Unlike the bean, which frequently occurs as an anthropomorphized warrior or is metamorphized into a runner, there are no examples of anthropomorphized or meta-morphized *ulluchus*. Beans and *ulluchus* may be found together in the background of a scene. Even though the sample of Moche bean depictions is much larger than that of *ulluchus*, the bean serves as a background element in only three types of scenes while the *ulluchu* is found in at least sixteen. Although beans and *ulluchus* may share a few similar roles, the comparison shows that they each have roles which they do not share with the other, and each has a separate distribution which only occasionally overlaps with the other. Therefore, it would seem that they have different, though perhaps related symbolic meanings.

Decorative Elements

The second category consists of those representations which utilize the *ulluchu* as a decorative element. There are 61 specimens which show the *ulluchu* as a decorative element on belts, warrior's backflaps, tweezers, and headdresses. These include 60 ceramic vessels and one copper object.

Belts

The *ulluchu* is depicted as a design element in fineline drawing on belts (Fig. 11). The Range of Variability Chart (Fig. 2) pictorially summarizes the depictions of *ulluchus* on belts and shows clearly how the *ulluchu* design develops from a realistic form into an abstracted form—the comma-shape—for the belt design. The *ulluchu* design always maintains the hanging position of the fruit on the plant. Belts are most commonly worn by human or anthropomorphized warriors and runners. Depictions of the *ulluchu* as a belt design are more numerous than all other representations of *ulluchus* combined. *Ulluchu* motifs are more prevalent than any other Moche belt design. Approximately fifty per cent of the belts are decorated with *ulluchus*. Because of the limited range of Moche belt designs, the very frequent use of the *ulluchu* would seem to have considerable significance. There are also examples of painted scenes where the *ulluchu* is drawn on the belt as a design as well as appearing in the background of the scene (Fig. 12).

Figure 10. After Larco 1948:76.

Figure 11. Courtesy of the British Museum, London.

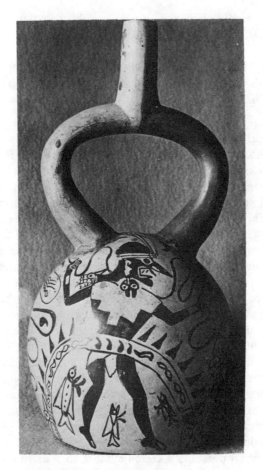

Figure 12. Trujillo Museum, Trujillo.

Figure 13. After Kutscher 1954:11.

Backflaps

Three pottery vessels show the *ulluchu* on the backflap which hangs from the waist of warriors. Two of these depict warriors in fineline scenes (Fig. 13). The other vessel is a modeled warrior figure who has five backflaps hanging from his waist (Fig. 14). Two of the five backflaps have modeled *ulluchus* at the top. The copper object, a tweezer which rattles, might be included here, as it is shaped similarly to the backflaps and has the modeled *ulluchus* at the top as a decorative element.

Headdress

There is a group of forty-six vessels which shows figures wearing headdresses adorned with two *ulluchus* (Figs. 5, 15) and occasionally with four *ulluchus* (Fig. 16). Forty-three vessels are modeled human figures and the other three are fineline renderings of supernatural figures wearing the same headdress. The *ulluchus* (or models of *ulluchus*) seem to be components of this headdress rather than painted or woven design motifs. As a part of the headdress, *ulluchus* are sometimes decorated with geometric designs. The homogeneity within this group of figures wearing double *ulluchus* in their headdresses is easily discerned. The figures are associated with a limited set of variables. These figures either wear bangled earrings (Figs. 5, 15), sit next to a figure wearing bangled earrings, hold an animal in their arms (Fig. 16), wear bags (Figs. 5, 15), or hold a lime gourd. A given figure may have only one of these variables or as many as three of them. Since holding a lime gourd and an animal are mutually exclusive, all five variables could not occur on any one figure.

In this sample of double *ulluchu* headdresses, six of the forty-three vessels are double figures. One or both figures wear double *ulluchu* headdresses. We may be viewing a double-double, i.e., a double fruit and double figures or twins. Arriaga (1968:21,30-31) wrote that the natives called double fruits or fruits that grew together, *chuchus*, and said that they considered them sacred objects. As sacred items, the *chuchus* were considered appropriate ritual offerings (Arriaga 1968:129). Figure 1 is a modeled representation of two *ulluchu* fruits surmounted by a stirrup spout. Perhaps this double fruit vessel represents a sacred symbol such as that described by Arriaga. There is also archeological evidence that pairing of objects was significant in the Moche culture.

There is an interesting association between people wearing bangled earrings, the *ulluchu*, and the long strings of *espingo* seeds. The strings of *espingo* seeds are used today on the north coast of Peru in shamanic curing (Sharon and Donnan 1974:53). People wearing bangled earrings hold the long strings in a characteristic position (Fig. 17). When they wear the double *ulluchu* headdress, they hold strings of *ulluchus* instead of *espingos* (Fig. 18). While the people wearing bangled earrings may wear the *ulluchu* in their headdress, the *ulluchus* are not found in the background of a scene associated with them.

In contrast to the many vessels which have the *ulluchu* depicted in fineline on the belt, there are only two vessels in the Moche Archive which show it in fineline on the headband of a headdress. Both vessels are so similar that they were probably made from the same mold. They represent a clothed monkey with his arms and legs wrapped around a jar (Fig. 19). The monkey may be anthropomorphized, but it is not clear whether he has any human features other than the clothing. Similar monkey vessels may be found with a geometric design on the headband or with an undecorated headband.

Figure 14. Courtesy of the British Museum, London.

Figure 15. After Kutscher 1954:8-9.

448

Figure 16. Private collection, Trujillo. Photo by
Margaret Hoyt.

Figure 17. Courtesy of Cambridge Museum of
Archaeology and Ethnography.

The *ulluchu* is frequently found with the monkey. In fact, the monkey is the only natural animal that is associated with the *ulluchu* except for the animals that are being held by figures wearing double *ulluchu* headdresses. Monkeys are found with other fruits. There is iconographic evidence that monkeys were tethered and kept as pets. In Figure 3 we may be seeing a monkey assisting human figures in the collection of the fruit. On an erotic vessel in the Rafael Larco Herrera Museum a monkey with a bag around his neck sits in the branches of the plant and collects the fruit. Beneath the plant is a copulating supernatural male and female. Why did the Moche artist juxtapose the supernatural sexual behavior with the monkey collecting the fruit? What meaning does the fruit collection bring to this scene? This is the only time that the complete plant including the fruit is found in association with other activity.

Conclusions

The importance of magic plants in the Peruvian cultural tradition is indicated by historical documents and by ethnographic studies of folk healing. It seems likely that the *ulluchu* was one of these plants. While it is not known if the *ulluchu* is narcotic, the fruit may be a magic symbol without actually possessing psychotropic properties. Alternatively, we may be viewing a mythical plant. Since Moche artists depicted several mythical animals such as the conch shell monster and "moon" animal, it seems reasonable that they may have also conjured up a plant for which there was no direct botanical model, and assigned to it a special meaning. The *ulluchu* has not been botanically identified to my satisfaction, although there are valid criteria for eliminating it as a gourd, bean, *pepino*, or *aji*. Of course, if the *ulluchu* was a mythical plant, then a botanical identification would not be possible.

It was shown that the *ulluchu* plays various roles in Moche iconography. As a background element it does not serve as a geographical indicator nor as an identifier of a particular supernatural being; however, a definite patterning emerged in the distribution of the *ulluchu* which demonstrates that it was more than a simple background filler element. For example, if one supernatural figure in a scene has an *ulluchu*, then each supernatural figure in that scene must also have one.

The following factors support the significance of the *ulluchu* plant and/or its fruit:

1. It is very common in Moche art, both in the actual number of scenes in which it appears, and in the variety of media including textiles, metal, and murals as well as ceramics.
2. It is the most common Moche belt design.
3. It has a strong association with the supernatural realm.
4. It is worn as a headdress adornment by people who are associated with lime gourds, bags, bangled earrings, and quadrupeds.
5. It is substituted for *espingos* on long strings.
6. It has a strong association with monkeys.
7. It is the only fruit which is shown being picked from the plant.
8. It is one of the few plants which appears in several physiographic zones.

Trying to relate the multiplicity of activities that the *ulluchu* is associated with will not necessarily provide a definition of its meaning. A given complex scene may be shown with or without *ulluchus* in the background. Since the *ulluchu* may be included or omitted from a given complex scene, it would seem that its inclusion or omission does not change the major activity within the scene. Rather, the *ulluchu* contains its

Figure 18. After Montell 1929:97.

Figure 19. Courtesy of the Museum für Völker-
kunde, Munich.

own symbology which it adds to a scene. It is possible that it had several meanings depending upon its usage. For example, the meaning that the *ulluchu* headdress brings to its wearer, or the activity of its wearer, may vary from its meaning when used as a background element. This possibility is supported by the fact that *ulluchu* headdresses and background *ulluchus* do not occur together. Alternatively, background *ulluchus* may derive their meaning from the rituals in which *ulluchu* headdresses are worn.

Based on current studies, Donnan (in press)* proposed that all Moche art is a form of ritual expression and that higher levels of meaning should be considered for even simple modeled representations. The *ulluchu* study supports this proposal. If the *ulluchu* serves as a magic symbol, this symbology would be implicit whether it is represented alone, or as a part of a complex scene. On the basis of historical evidence, the modeled double *ulluchu* vessel may display the sacred quality of double fruits.

This paper demonstrates a new approach to the study of Moche iconography. Whereas previous iconographic studies concentrated on major figures or themes depicted in the art, it is now feasible, with the large organized sample of the Moche Archive, to study the concomitant details of background and design motifs. The *ulluchu* was selected for study, and its distribution was traced throughout the more than 7,000 specimens in the Moche Archive. The data show that its distribution is non-random, and that it has various usages which display definite patterns. By defining and relating the distribution and associations of secondary features like the *ulluchu*, the analysis of major figures or activities will be greatly facilitated, even if the study is unable to define the specific meaning and identification of the secondary feature. Since background elements bring additional information to a scene, they should no longer be viewed as simple filler, and we must conclude that studies of background elements are extremely important to understnding and interpreting Moche iconography.

*Editors' Note: c.f. note on p. 439

Notes

[1]Larco used two spellings, *ulluchu* and *ullucho*; however, *ulluchu* is used in this paper.

Bibliography

Arriaga, Pablo Joseph de
 1968 *The Extirpation of Idolatry in Peru*. Lexington, Kentucky.

Donnan, Christopher B.
 1972 "Moche-Huari Murals from Northern Peru." *Archaeology*, vol. 25, no. 2:85-95.

 1976 *A Study of Moche Iconography*. Latin American Studies Series of the Latin American Center, University of California Los Angeles.

Gillen, John
 1945 *Moche. A Peruvian Coastal Community*. Smithsonian Institution, Institute of Social Anthropology Publication 3, Washington.

452

Kutscher, Gerdt
 1955 *Ancient Art of the Peruvian North Coast*. Berlin.
Larco Hoyle, R.
 1938-39 *Los Mochicas*, 2 vols. Lima.
 1948 *Cronologı́ca Arqueologı́ca del Norte del Perú*. Buenos Aires.
Leon, Jorge
 1964 *Plantas Alimenticias Andinas*. Instituto Interamericano de Ciencias Agricolos
 Zona Andina, Boletin Tecnico 6, Lima.
Montell, Gosta
 1929 *Dress and Ornaments in Ancient Peru*. Oxford.
Sharon, Douglas
 1972 *Curandero Phenomenology: The Symbol System of a North Peruvian Folk Healer*.
 M.A. Thesis. University of California Los Angeles.
Sharon, Douglas and Christopher Donnan
 1974 "Shamanism in Moche Iconography." *Ethnoarchaeology*. Donnan and Clewlow
 (eds.), Monograph IV, Archaeological Survey, Institute of Archaeology, University
 of California Los Angeles.
Towle, Margaret A.
 1961 *The Ethnobotany of Pre-Columbian Peru*. Chicago.

Peruvian Textile Fragment From The Beginning of the Middle Horizon

Abstract

A large textile fragment which is closely related to Huari-Tiahuanaco ponchos in loom technology contains iconography indicating a considerably earlier date than that usually assigned to the ponchos. The textile, which is reportedly from a site between Pisco and Ica, was not a poncho, but probably a ceremonial cloth or wall hanging.

The central motif is a frontal Tiahuanacoid deity face. It is flanked by large winged felines on each side, other secondary mythological animals, and a repeated scene of two human figures engaged in a ritual fire creation. The textile is closely related stylistically to pottery from Conchopata which marks the beginning of the Middle Horizon, but has some features which tend to be more closely related to the style of Tiahuanaco, Bolivia. The textile is helpful in evaluating Bennett's 1934 proposal of art style transfer by textiles, as well as possibly throwing new light on the Tiahuanaco religion. The paper also stresses the importance of textile analysis as a research tool in the understanding of the weaving-oriented ancient Peruvian cultures.

Introduction

It is the purpose of this paper to record and review an unusual textile fragment (Fig. 1) which may be of assistance in understanding the origins of the Middle Horizon in the Andean culture series, and to note some characteristics of textiles in contrast to other artifact types as conveyors of cultural change.

Our artifact for analysis is a tapestry fragment almost a meter long by 25 centimeters, with two irregular edges and two edges remaining as formed in the original weaving. The provenience of the textile is reportedly between Pisco and Ica in Southern Peru.

The weaving bears an immediate resemblance to the interlocking tapestry of the Middle Horizon ponchos which have been analyzed by Sawyer (1963), and others.

Structurally, the textile seems identical with these Huari ponchos which are in museums and collections throughout the world. The warp is of natural light brown cotton, with a count of about 40 to the inch. The weft, which has a count of about 90

Reprinted from the *Textile Museum Journal*, Vol. 3, No. 1, 1970. Copyrighted by the Textile Museum, Washington, D.C.; reprinted with their permission.

454

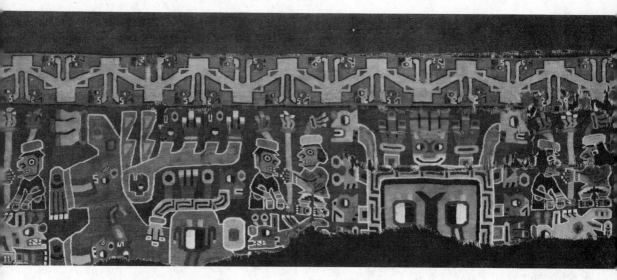

Figure 1. The entire Peruvian tapestry fragment after mounting. (Textile Museum 1972. 27.)

threads to the inch, is of dyed wool—probably alpaca. The warp is two-ply, with each element Z spun, and the combination S plied. The weft is also two-ply, with the individual elements Z and the doubling S. The weaving is standard tapestry weaving, with interlocking of the wefts at all color changes; but also, curiously, with vertical columns of weft interlock occurring within solid background areas, apparently indicating division of the textile into seven work panels.

Of the two original edges still existing, one is a weft, or side, selvage with the designs extending to the very edge of the textile, and the other, a warp selvage, is formed by a chaining of the warp loops. Huari ponchos characteristically have one warp selvage of chained warp loops and the other with warp ends cut and worked back in. (Sawyer, 1963).

The *colors* of the textile include black, brown, and white which are generally used for figurative definition, with six colors—red and pink, yellow and ochre, and green and a light bluish-green—used as both background and as fill-in. However, the textile creates the overall impression of consisting of three colors—red, yellow and green—a point which will be of considerable interest later in our interpretation.

By inference from the symmetry of the design, the textile appears to have been 105 centimeters wide, which is wider than most Peruvian weaving (O'Neale 1930 and 1937), but only one-half as wide as the most typical of Huari textiles which are woven to form one-half of a poncho shirt and are around 2 meters in weft dimension. The orientation of the figures on this particular specimen appears to rule out its use as half of a poncho. However, there are evidences of it having been joined to another textile along the chained warp selvage (Fig. 2-A). Supporting this analysis is a technically related textile in the Textile Museum (Fig. 3). Though its design is quite different and its weft width is more than double that of our specimen, it is joined to a piece of plain cloth bearing small embroidered panels along its edges and was most certainly a wall hanging or mantle rather than a portion of a poncho shirt. Bird has estimated that

455

Figure 2-A. Detail showing one of several remnants of binding indicating attachment to a second textile.

Figure 2-B. Detail showing threads which at one time bound the folded fragment into the form of a band.

Figure 3. Woolen tapestry panel attached to cotton cloth with embroidered emblems. Nazca-Huari. 3' 3¼'' x 12' 10¾''. Textile Museum 91.281.

Figure 4-A

Figure 4-B

Figures 4-A and 4-B. The Peruvian textile fragment as a rolled or folded band.

95% of all Peruvian textiles were used as clothing; nevertheless, instances of wall hangings and ceremonial cloths are not uncommon.

Two aspects of *the condition* of the textile under discussion suggest something of its history. First, the colors are brightest and textile preservation best along the irregular bottom edge. Close examination of this edge reveals deliberate tearing prior to burial rather than deterioration. This tear occurs through the center of the face of the full-face deity.

A second set of aspects also is suggestive of the original disposition of the textile. Throughout the fragment, on a regular basis, are bits of threads, crudely sewn into the fragment (Fig. 2-B). Checking the patterns of these thread bits indicates that matching would occur when the textile was rolled up or folded. This conclusion is strongly confirmed by the wear which has occurred at the folded edges. When this folding is accomplished in such a fashion that all thread bits are lined up, only a kind of decorative band is left visible. This strongly suggests that the burial condition of the textile was as this sewn together band or belt, with the main figurative body of the textile thus obliterated both by tearing and by rolling under and sewing up (Fig. 4a and b).

The composition of the textile design consists of a top band of a continuous stepped meandr with pairs of attached falcon heads reversing direction across the width of the textile, with seven compositional groupings below in accordance with the seven postulated work panels (Fig. 5). Panels 1, 3, 5 and presumably the missing panel 7 are nearly identical, except for reversals, and depict two human figures with a small mythological animal below. Panel 2 and 6 are also nearly identical except for color changes and design reversals, and each depicts a large mythological being combining bird, feline, and human attributes. The central panel, number 4, depicts a large frontal deity face with headdress appendages, five types of which are still present in the fragment.[1] A possible reconstruction of the entire original textile is illustrated (Fig. 6). The reconstruction is based upon the assumption of symmetry in the design layout and upon the supposition that the appendages of the central face motif were repeated in reverse order on the missing lower half.

Since there are no reliable provenience or associated artifacts to help us in identifying the cultural placement of the textile, we must proceed with a comparative analysis based upon this internal evidence of composition, color, iconography, and technique. This comparison can be made with other textiles, but also with other artifacts.

Figure 5. Diagram of the 7 apparent work panels. (WJC)

Ceramic Comparison

We identify the Middle Horizon in ancient Peru as an intelligible cultural unit on the basis of artifacts found throughout Peru which show a stylistic relationship to the culture of Bolivian Tiahuanaco. Menzel (1964, 1968), Lumbreras (1959, 1969), and others, through stratigraphic and stylistic analysis, have detected a time sequence for ceramic art styles during this period. The most thorough chronology available for the Middle Horizon is that developed by Menzel on the basis of ceramic art styles. The longevity and quantity of ceramic sherds make the selection of such an artifact obvious, but the limitations of such single artifact analysis must be borne in mind.

A single example can illustrate. A review of the relationship of the Huari culture of the Middle Horizon with the Inca culture, on the basis of single artifact analysis reveals the hazard. Textile analysis indicates a strong continuity, especially in the weaving technology, but also in the woven art styles, with the late Huari seeming to be almost co-terminal with the Inca designs (Bird, in conversation 1970). *In situ* stone carving analysis reveals a strong continuity between the two cultures, with Huari functioning as a most influential model for Inca stone carving. A direct comparison of ceramic decorative styles, however, would indicate a nearly total loss of cultural connection between the Middle and Late Horizons. With the primary exception of the Kero shape (Rowe, 1956), the broad bulk of Inca pottery seems entirely alien to anything created during the Middle Horizon. In this instance though, we have many other sources of information to keep us from being exclusively influenced by the ceramic analysis.

Obviously, different artifacts reveal different facets of cultural change, and may especially reveal different time scales of cultural change. The three artifacts mentioned above—stone carving, fancy textiles and decorated ceramics—have many obvious differences as indices. The cultural sequences of the Middle Horizon as defined by changes in stone carving styles would indeed be few in number. Ceramic sequences may be the most sensitive index of the time record which is available to us. The short life of pottery as such helps dispose of old art styles, and makes the ceramic arts most sensitive to fashion.

Fancy textiles during this period may well have been characteristically a more tradition-carrying art form than ceramics, since their production generally required far more human effort than pottery, and they may well have lasted longer. Some Peruvian textiles show repeated repairs. So each artifact series may be its own kind of culture clock, telling its own kind of time.

The manifestation of the Huari ceramic sequence for Ica, the provenience area of this textile, has been developed by Menzel (1964), Lyon (1966) and Pezzia (1968). In general, these sequences begin with the clearest and most complete ceramic representation of Tiahuanaco motifs to be found in the area under study. In this case, that would represent the offering deposit at Pacheco in Epoch I. Although no complete report on Pacheco is available, Tiahuanacoid representations on available Pacheco pottery include a great emphasis on agricultural representations which are not found in the ceramics or stone work from the Bolivian site.

Following the Pacheco offering in the Ica ceramic sequence is a style of pottery almost identical with wares found at Huari and other important ceremonial centers such as Pachacamac. This Ica-Pachacamac material is still further removed from Tiahuanaco iconographic style and content.

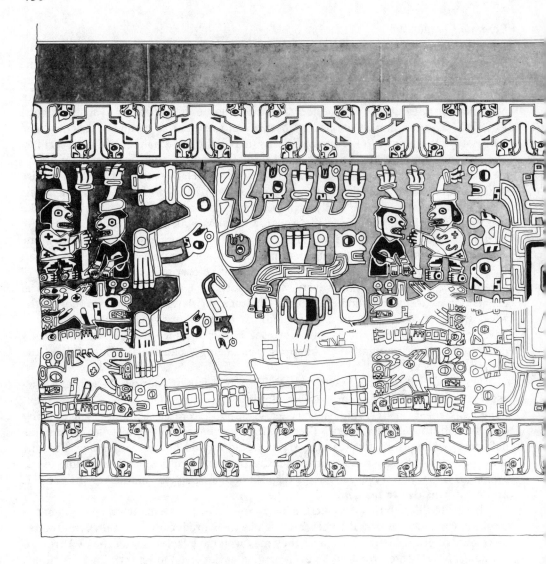

Figure 6. Reconstruction drawing of the entire
Peruvian Textile. (WJC)

A review of the early Middle Horizon sequence in the Ayacucho valley, geograph-
ically close to the alleged provenience of the textile under discussion, suggests the
Conchopata pottery of Epoch I for comparison, an offering deposit rather than a
burial. These pottery fragments contain several Tiahuanacoid type figures, including a
profile winged figure illustrated in reconstructed form by Menzel (1964), a frontal
deity with crossed fangs, and also horizontally oriented staff-carrying figures which
seem closely related to the similar figures in the textile (Fig. 7). Much of the detailed
drawing of headdress appendages on the pottery is also comparable. In the textile,
each leg joint is marked by a central band terminated by a feline head at the joint, as
they are commonly in Tiahuanaco stone carving; however, limb joints are only rarely

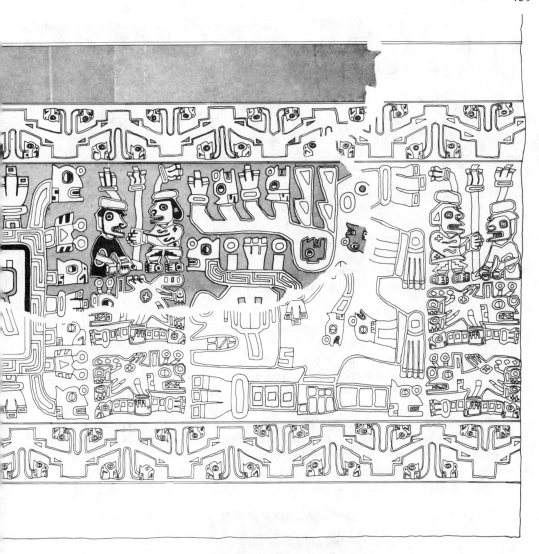

so animated in Conchopata pottery, according to Menzel (see Note 4). Crossed fangs, drawn like the letter ''N'' in the textile figures, occur commonly in Epoch I figures from Peru, but only very rarely in figures from Tiahuanaco (Schmidt, 1929, p. 359, p. 456, Ubbelohde-Doering, 1954, p. 121).

A review of the colors of the textile is also highly instructive in the matter of possible relationships. The textile colors are well preserved with the predominant color scheme, as noted before, red, yellow and green. If iconographic details of ceramics and textiles show continuity, then one would expect color schemes to do so also. Red and yellow are common ceramic colors, but green is rare indeed. There are a few recorded examples of the use of ''green'' in Tiahuanaco ceramics (Bennett, 1934), but none recorded from the Peruvian Middle Horizon. Of particular interest, however, are reports by the French mission to the site of Tiahuanaco in the year 1903

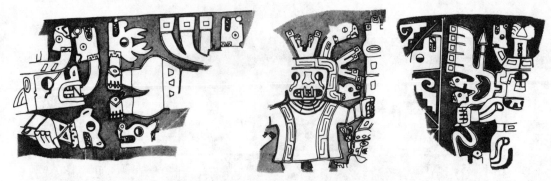

Figure 7. Sherds of decorated ceramics from the offering pottery found at Conchopata. Museo Nacional de Antropología y Arqueología, Lima, Peru. (WJC)

(Kubler, 1962), of painted stone sculpture. In several instances when stone sculpture was freshly unearthed, it was revealed that the stone had been brightly painted.[2] Predominant colors were recorded as red, yellow, and green (Croqui-Montfort, 1903).[3] This would seem to coincide with the color scheme of the textile.

Compositional Analysis

A comparison of the *design composition* of this textile with that artifact bearing the closest technological relationship, the Huari poncho (Sawyer, 1963), reveals strangely enough, few similarities in the matter of composition. Huari style ponchos always have the vertical direction of all represented figures coincident with the direction of the weft. Smaller Middle Horizon representational textiles of tapestry weave, such as headbands, consistently also have this coincidence. In the textile under discussion, the axis of composition is coincident with the warps. Also, the vertically-banded repeated motif nature of Huari poncho composition as analyzed by Sawyer (1963), is not present. The design composition though, is similar to many published examples of decorated pottery from the site of Tiahuanaco in Bolivia (Fig. 8). The top band of the textile, a continuous meander with attached falcon heads,

Figure 8. Decorated pottery from the site of Tiahuanaco in Bolivia. Textile Museum Collection.

closely parallels the Tiahuanaco art tradition shown in the ceramic illustrated and which is also frequently found on the major stone sculptures.

Both the textile and the Tiahuanaco pottery have mythological feline figures drawn in a rounded representational style arrayed beneath a meander band. Unfortunately, there are no known textiles of proven Tiahuanaco provenience for comparative analysis.

Tiahuanaco stone carving bears strong textile-like design qualities (Bennett, 1934) and shows closely related compositional characteristics. Compositionally like the textile, the "Sun Gate" has a full-face deity centrally located (however with staffs), many mythological figures on either side, and a stepped meander band with falcon heads, horizontal in the composition but below the other figures.

A minor carved stone lintel from the site of Tiahuanaco is also of very special interest (Fig. 9, after Posnansky, 1945, Fig. 140a). This lintel has a symmetrical composition of horizontally aligned, staff-bearing figures, which have crossed fang teeth. The unique characteristics of this stone fragment were noted by Rowe and Menzel.[4]

The iconographic analysis of the individual figures represented is both the most fascinating and the most frustrating of our analytic directions. Most of the deep cultural content of ancient Peru is mute to us, and yet there is a vast record of obviously highly expressive and exact art left for our review.

The full-face deity represented in the center of the textile (Fig. 10) has an array of appendages attached to his head band which may explain his attributes. The absence of the full figure holding staffs, it could be argued, makes him closer to the essential symbolic representation of the sun or the moon. The large winged felines on either side appear to fly toward this central deity. The split eyes of these felines stare directly toward the crossed eyes of the central figure. The eye markings of the central and secondary figures and the split eyes of all of these figures indicate "eye contact" amongst the mythological figures of this pantheon. The eyes of the human figures are carefully distinguished from these eyes of the deities. All of the small faces are vigorously lively and expressive. These realistic characteristics stand in great contrast to the later abstraction of Huari textile art.

Each of the repeated small panels 1, 3, 5 and 7 contains a pair of related human figures above a flying staff-bearing feline. The human figures are simplified but quite explicitly detailed. A pole is held between the two outstretched hands of the green-shirted figure. The seated, black-shirted figure holds firmly in both hands a short, horizontal object which seems to be related to the bottom of the pole. The pole has the motif of the falcon tail feathers attached to its upper end, as do the hats of the human figures. In both instances, these tail feather motifs appear to wave, whereas the

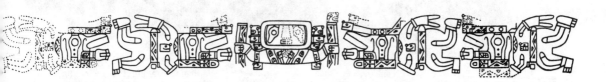

Figure 9. Carved stone lintel from the site of Tiahuanaco, Bolivia (Posnansky, 1945).

462

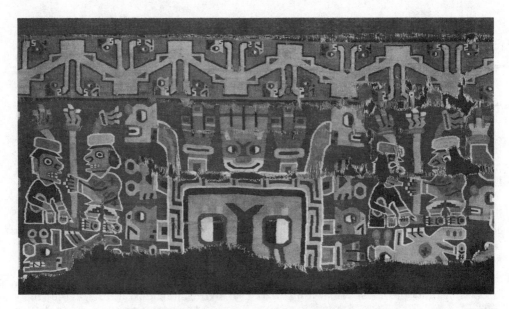

Figure 10. The full-face deity in the center of the textile.

comparable motifs attached to the mythological figures in the same textile are rigid and formal.

The drawing style of the human figures has a close counterpart in Tiahuanaco ceramics (Fig. 11). Seated figures are represented with protruding lips and articulate dentures. They wear similar hats and hat plumes. The green-shirted figure could be interpreted as a hunchback, which was, as Ponce-Sangines (1969) has recently pointed out, a traditional figure of Tiahuanaco mythological art.

Figure 12. "Wapisiana making fire by drilling," Vol. III 1948, Plate 117, ff, p. 826, John Gillin's "Tribes of the Guianas" Handbook of South American Indians, J.H. Steward, Ed.

Figure 11. Tiahuanaco sherd. Alan R. Sawyer Collection.

In spite of the clarity of the scene, interpretation of the activity cannot be entirely certain. In alternative interpretations the pole could be seen as a dancing stave, as a pounding stave or digging stick in an agricultural scene, or—in the interpretation which seems most probable—as a ritual fire scene, with one figure twirling the ceremonial-sized fire drill while the other holds the hearth stick. There appears to be no other known representation of this scene in Peruvian art, but there are references to ritual fire creation during Inca times (Rowe, 1946). Also, there are many references in ethnographic literature to fire creation amongst the native non-Spanish people of South America (Fig. 12). All such references indicate that the oldest known or traditional method of fire creation was by fire drill, and much of the native mythology is concerned with the event. One distant tribe reports (Metraux, 1944) the use of 8 foot or 9 foot long (2.8m) fire drills, which assures us of the workability of the fire drill interpretation. Because of the Incan claim of Tiahuanacan cultural ancestry, we should consider seriously that the entire scene could represent a ceremonial event which is ancestral to the Inca Raimi ceremony which occurred at the summer solstice. Garcilaso described the event as involving "lion" and "condor" garment array, and a sacrificial burning. Fresh fire was created for this sun ceremony either by reflection or by rubbing sticks together. His detailed description[5] would seem to indicate quite possible derivation of the Inca ceremony from that portrayed on the textile.

As a general *conclusion*, it would seem clear that on several points the textile is stylistically closer to Tiahuanaco than to any known Peruvian textile or ceramic style. The absence of any comparable stylistic material from the Ica area and the reused condition in the burial suggests a non-local origin. There are at least two possible explanations. The first would be that the textile is, in fact, an imported piece, having been actually designed and woven in Tiahuanaco, Bolivia, and carried to the coast via Huari marking the beginning of the Middle Horizon in a way which has been previously suggested by Bennett on the basis of other evidence.[6] The second would be that the textile was woven in highland Peru by a local group which was so strongly connected to Tiahuanaco that the work is, for us, indistinguishable from what must have been the weaving tradition of that culture. This group may well have been the one that also created the offering ceramics of Conchopata.

There are also two possible approaches to the subject of the time of its creation. The textile could indeed be earlier than any of the known ceramics of Epoch I of the Middle Horizon. Stylistic analysis would seem to indicate that it was. This would clearly support the priority of textiles as art style carriers as Bennett suggested and it would also indicate the possibility of the movement from Tiahuanaco into Peru occurring at least as early on the coast as in the highlands.[7]

However, another explanation might be as follows: the textile was roughly contemporary with either Conchopata or Pacheco ceramics; and the textile iconographic forms, which may be closer to Tiahuanaco than are those of the ceramics, are simply more complete and traditional statements than was customary on pottery. In that case, the question of the date of the textile cannot be determined by a comparison with ceramic sequences.

It should be noted that the shirts portrayed on the human figures do not resemble known Middle Horizon ponchos. Not only do they seem to have sleeves, but they also display iconographic symbols, namely the square cross, the s-volute and the circle, whose origins are as pelt markings in the Early Horizon.

There are, however, certain points which do emerge with some certainty from the evidence. Clearly, a mythological-religious scene is being conveyed in a very early artifact of the Middle Horizon, implying that the movement was a deeply religious one, as has been suggested (Menzel, 1968) at least in its earliest phases.

The mythological scene conveyed associates fire, birds, and felines in a way which seems to relate the Huari-Tiahuanaco religious tradition with that of the Incas and continues to survive in the primitive mythology of all South America.

But there is also something to learn about method. Certainly where textiles are preserved from textile-oriented cultures such as ancient Peru, wherever possible their sequences should be at least developed in parallel with ceramic sequences.[8] Although most of the Peruvian textiles stored in the world's museums have little certain provenience information, they do have the advantage of possible Carbon-14 dating. Hence, the creation of another culture clock, based on style and time of textiles, can be of major importance in helping us to understand the content and sequence of the ancient Peruvian civilizations.

Notes

[1]Max Uhle (1903) recorded a large painted textile with Tiahuanacoid characteristics, having as a central figure a full-face deity with staffs. This textile, from Pachacamac, would appear to be the only other published full-face Tiahuanacoid deity on a Peruvian textile.

[2]This would accord with de Molina's remark concerning Tiahuanaco, that, ". . . on these edifices were painted many dresses of Indians." (Markham, 1873).

[3]The white outlining of all the major figures below the meander is found in other Middle Horizon textiles as well as in ceramics and, in fact, might be the identifying factor in a stylistic grouping; however, this outlining is also obviously closely related to Tiahuanaco stone carving.

[4]Personal communication with Dorothy Menzel (1970). Menzel has contributed many ideas and suggestions to this paper, though the author alone is responsible for the conclusions.

[5]"Raimi . . . was the greatest feast of the heavenly body . . . the sun . . . the curacas came to the ceremony in their finest array with garments and headdresses. . . . Others who claimed to descend from a lion appeared . . . wearing the skin of this animal on their backs and on their heads . . . its head. . . . Others still, came, got up . . . with the great wings of the bird called condor, which they considered to be their original ancestor. Others wore masks that gave them horrible faces. Raimi was preceded by very strict fasting that lasted three days . . . On the feast day . . . a ceremony to the sun."

Then the description of the sacrificed animals, which ". . . were burned until nothing remained of them but ashes." The fire used for this sacrifice had to be fresh or, as they said, given to them by hand of the sun. And Garcilaso describes creating fire by metal mirror directly from the sun. He adds though: "If the sky was gray, on the eve of the sacrifice, the fire was lighted by means of two little sticks . . ." (Garcilaso de la Vega, 1961)

[6]Wendell C. Bennett, 1934, page 488: "Since the coast textiles show very close Tiahuanaco affiliates, it is possible to suggest that the Tiahuanaco style was largely carried to the coast through the medium of textiles, the designs of which were utilized for decorative elements on the existing coastal pottery shapes."

[7]It is fascinating to note that Inca mythology tells of the brothers Ymaymana Viracocha and Topaco Viracocha who left their Bolivian homeland, spreading the religion northward, with one taking the highland route and one taking the lowland route, visiting the people, and teaching agriculture along the way. (DeMolina, in Markham, 1873, page 7)

[8]Anna H. Gayton, 1961: "Because textiles could serve many purposes, were sizable, flexible, colorful, and transportable, their capacities as symbol-bearers and eye-pleasers were

more versatile than those of ceramics or any other medium in the restricted technological stage in which the Andean area remained up to the Spanish conquest.

The head start, so to say, which textiles had over ceramic, metal and mural decoration may have established a lasting priority for the textile art as the primary means of visual communication.''

Bibliography

Bennett, Wendell C.
1934 "Excavations at Tiahuanaco," *Anthropological Papers of the Museum of Natural History,* Vol. XXXIV, Part III, pp. 359-494. New York.
1946 "The Archaeology of the Central Andes" in *Handbook of South American Indians,* Vol. II, pp. 61-147. Bureau of American Ethnology, Bulletin 143, Washington, D.C.

Bird, Junius B.
1964 "Textile Designing and Samplers in Peru" in *Essays in Pre-Columbian Art and Archaeology,* S.K. Lothrop and others, pp. 299-316. Harvard University Press, Cambridge, Mass.

Croqui-Montfort, Le Comte, G. de
1904 "Fouilles de la Mission Scientifique Française à Tiahuanaco," Internationler Amerikanisten-Kongress Vierzehnte, Tagung. Zweite Halfte, Stuttgart. Verlag von W. Kohlhammer (1906), pp. 531-550.

Garcilaso de la Vega
1723 *Comentarios reales.* Madrid. Edited by Alain Gheerbrant, 1961, New York.

Gayton, Anna H.
1961 "The Cultural Significance of Peruvian Textiles: Production, Function, Aesthetics," *Kroeber Anthropological Society Papers,* No. 25, pp. 11-128.

Kubler, George
1962 *The Art and Architecture of Ancient America,* Penguin Books, Baltimore, Maryland (p. 309).

Lumbreras, Luis G.
1959 Esquema Arqueologico de la Sierra Central del Peru, *Revista del Museo Nacional,* Tomo XXVIII, 1959, Lima, Peru.
1969 *Antiguo Peru,* Moncloa-Campodonico, Lima, Peru.

Lyon, Patricia J.
1966 "Innovation through Archaism; the Origins of the Ica Pottery Style," *Ñawpa Pacha,* No. 4, pp. 31-62. Berkeley, California.

Menzel, Dorothy
1964 "Style and Time in the Middle Horizon," *Ñawpa Pacha,* No. 2, pp. 1-106. Berkeley, California.
1968 "New Data on the Huari Empire in Middle Horizon Epoch 2A," *Ñawpa Pacha,* No. 6, pp. 47-114. Berkeley, California.

Metraux, Alfred
1944 "The Botocudo" in *Handbook of South American Indians,* Vol. 1, pp. 531-540 (537). Bureau of American Ethnology, Bulletin 143, Washington, D.C.

Molina, Christoval de
ca. 1580 "The Fables and Rites of the Incas" in *The Rites and Laws of the Incas,* translated and edited by Clements R. Markham, Hakluyt Society, 1873. p. 7.

O'Neale, Lila M. and A.L. Kroeber
 1930 "Textile Periods in Ancient Peru, University of California Publications in *American Archaeology and Ethnology*, Vol. 28, No. 2, pp. 623-56, Berkeley, California.

O'Neale, Lila M.
 1937 "Wide Loom Fabrics of the Early Nazca Period" in *Essays in Anthropology Presented to A.L. Kroeber*, pp. 215-28, Berkeley, California.

Pezzia-Aaereto, Alejandro
 1968 *Ica y el Peru Precolombino*, Tomo I, Arqueologia de la Provincia de Ica, Ica, Peru.

Ponce-Sangines, Carlos
 1969 *Tunupa y Ekako,* Estudio Arquelogico Acerca de las Efigies Precolómbinas de Dorso Adunco. Academia Nacional de Ciencias de Bolivia, Publicación No. 19, La Paz, Bolivia.

Posnansky, Arturo
 1945 *Tihuanacu,* Vols. I and II.
 1957 *Tihuanacu,* Vols. III and IV, Ministerio de Educacion, La Paz, Bolivia.

Rowe, John H.
 1946 "Inca Culture at the Time of the Spanish Conquest" in *Handbook of South American Indians,* Vol. II, pp. 183-330.

 1956 "Archaeological Explorations in Southern Peru, 1954-55," *American Antiquity*, Vol. XXII, No. 2, pp. 135-151.

Rowe, John H., Donald Collier and G.R. Willey
 1950 "Reconnaissance Notes on the Site of Huari, near Ayacucho, Peru," *American Antiquity*, Vol. XVI No. 2, October, pp. 120-137, Salt Lake City.

Sawyer, Alan R.
 1963 *Tiahuanaco Tapestry Design*, Museum of Primitive Art, Studies, No. 3, New York.

Schmidt, Max
 1929 *Kunst und Kultur von Peru*—Impropylaen—Berlin, 1929.

Uhle, Max
 1903 *Pachacamac*, University of Pennsylvania, Philadelphia.

Ubbelohde-Doering, Heinrich
 1954 *The Art of Ancient Peru*, Praeger, New York.

The Arapa and Thunderbolt Stelae:
A Case of Stylistic Identity
With Implications for Pucara Influences
In the Area of Tiahuanaco

Sergio Jorge Chávez

Archaeologists have long been aware of the striking stylistic similarities between the Arapa stela (see Fig. 1, upper portion) from the District of Arapa, Province of Azángaro in the Department of Puno, Peru, and a like piece of several fragments called the "Thunderbolt" by Posnansky, from Tiahuanaco, Bolivia (see Fig. 1, lower portion). I shall demonstrate that the two pieces are definitely from a single stela, most probably originating from the Pucara culture region in Peru, and providing us with a case of stylistic identity between the pieces of stone sculpture from the two ends of Lake Titicaca.[1] Questions regarding time and direction of transportation of one fragment are posed.

Description and History

The stepped stela from Arapa is of pinkish-white fine-textured quartzite or quartzitic sandstone, with dimensions as follows:

Overall height of broken stela	347 cm.
Width	77.5 to 78 cm.
Thickness	24 cm.

It has a rectangular cross section, and is carved in low relief of 1 cm., or slightly less, on the two opposite broad faces only. Three and one-half design panels are carved on each face and there is a narrower, smaller decorated area filling the uppermost part near the step or notch. On one face, the upper narrow area contains two small frogs or toads, while the opposite face has two curled "snakes"; for ease of reference I shall refer to the former face as face A and the latter as face B.

Kidder briefly summarized the history of the Arapa stela[2] from the time Antonio Raimondi first noted it as a door lintel in the church there,[3] to Uhle's photograph of it there when it was still a single piece,[4] its mention by Palacios,[5] and Kidder's own photographs of both faces and his description of it when it was in two pieces inside the door of the new Arapa church. He also described the site itself where he found no artifacts from the Pucara culture.[6] It is notable that when Uhle photographed the stela

Reprinted from *Ñawpa Pacha*, Vol. 13, 1975. Published by the Institute of Andean Studies.

(what I designate as face B), it was in a single piece as a lintel, but when Kidder photographed it the stela was in two pieces, as one can observe it now outside the church, the larger piece on the left and the smaller on the right (see Figs. 2 and 3). Mary B. Kidder, Dr. Kidder's wife who accompanied him to Arapa on June 24, 1939, writing about the Arapa stela states,

> Most unfortunately, when Dr. Pardo [Dr. Luis A. Pardo, then Director of the Archaeological Institute of Cuzco] journeyed down to see it he ordered it cut in two to be moved to the museum in Puno before he troubled to find out that he couldn't possibly move it anyway.[7]

According to several informants in Arapa, whom I questioned concerning the stela's location prior to its incorporation as a lintel in the church, the stela came from Islapuncu or Island Passage, an area just southeast of the village. While Kidder did not locate Pucara style ceramics in either the village or the surrounding area, another informant told me of pottery containing abundant mica ("gold") found in Trapiche, located some distance behind the church. In any case, as Kidder pointed out, the Pucara occupation in or near Arapa needs to be precisely located. Kidder was also shown a slab with a standing human figure in high relief[8] which was in the Islapuncu area, but today is located outside the church door on the right. This slab, with a human figure holding a trophy head in each hand, possesses Pucara elements and may represent the only other evidence of Pucara occupation in the Arapa region, although in 1973, in a house in Arapa, I located a broken monolith (referred to here as Arapa 3),[9] to be described below, which somewhat resembles the Arapa stela, and in 1974 I recorded a previously unknown and recently discovered complete Pucara statue from Villa de Betanzos near Arapa.

In reassessing the comparisons of this Arapa stela with the Bolivian "Thunderbolt" or stone sculpture No. 40 of Bennett,[10] I realized that the two pieces form a single, large stela. Uhle first pointed out the similarities between the two,[11] and others have done so since,[12] particularly Kidder who concluded, "The two are not only similar, but so nearly identical, as far as comparison is possible, as to suggest very strongly that they were the work of the same individual or group of artists,"[13] but the incompleteness of available illustrations apparently allowed no further conclusions.

In 1945 Posnansky illustrated the Bolivian piece, but with omissions and errors and with no scale or measurements. Referring to the Thunderbolt stela, Posnansky says,

> We came to know it in a small museum established by Colonel Ríos Ponce, meritorious and exceptional resident of Tihuanacu, in the plaza of the modern village. About the year 1903 [1904 in the parallel Spanish version of this text], we took on a large plate, the photograph of which we are publishing in Fig. 152a [should be Fig. 152].
>
> * * * * * *
>
> When we first saw this archaeological piece it was placed horizontally with the back against the wall of the room where the worthy Colonel Ríos Ponce kept it. The Museo Tihuanacu was then dismantled after his death and Don M.C. Ballivián saved some of the things for the Museo of La Paz of that time. However, this interesting block had disappeared and for many years no one knew anything about it. Recently, only a few years ago, we were informed by certain

"llockallas" of Tihuanacu that something very valuable was "shut up" in the "tambo" of the village. We went there, along with the Director of the Museum, and indeed, in a room from which they had removed the doors, closed up the entrance with bricks and plastered the outside in order to hide the location of the old door—after having "unlocked" this place—we found, cast on the floor and broken into pieces, the famous piece that we had been able to photograph about 1903: another vandalic act of the regrettable greed of the iconoclasts of the present day who surely, since this was the "custom," suspected that the piece contained gold and therefore destroyed it completely. We had the largest piece of the "stelle" brought out and we immediately noticed that on the back part it had sculpturing as interesting or even more interesting than those in front. Figure 153a [should be Fig. 153] shows the rest of the famous piece and Fig. 153b [should be Fig. 153a] the little that it was possible to reconstruct in the schematic drawing.[14]

Apparently when Posnansky originally photographed the stela, he did not realize there was carving on the opposite face; it was only when the piece had been broken and moved that he became aware of the other face, and the new photo shows only a fragment rather than the complete opposite face. Posnansky felt the stela had originally been set in the ground because of the pedestal base and that is "probably formed a part of a shrine to the thunderbolt and the tempest, the carriers of the fertilizing rain."[15] Further, when Posnansky compared the Bolivian stela fragment to the two stelae from Hatuncolla, he misleadingly stated he was providing schematic drawings of the latter, when in reality he reproduced only one face of one of them (his Fig. 154b). The other drawing he labels as a "stele from Hatun-Kolla" (his Fig. 154b), is actually part of face B of the Arapa stela from which he has omitted the step form at the top and instead placed vertical lines reconstructing it as though it continued upward. He also reconstructs the lowest panel of the Arapa stela without noting that the Bolivian fragment itself completes this panel. His Figure 154c shows the broken upper portion of face A of the Arapa stela, upside down, again omitting the step form. All of these drawings have been a source of error and confusion for others.

Uhle provides additional information on the provenience of the Bolivian piece:

> In the excavations of the "Palacio" to the west of the Stonehenge [Qalasasaya] was found in years past, almost superficially, a pillar (Fig. 9) carved with ornaments in the shape of volutes and zigzags, different from the usual ones in the ruins. We now know many more pillars from the Lake Titicaca Basin carved in a similar manner, like one from Arapa (Fig. 13), another from Caminaca (still in its place), and two from Hatuncolla (Fig. 14), now in the museum of Lima.[16]

Uhle may be referring to the excavations made by Georges Courty in Tiahuanaco in 1903 when he found the "Palacio," now referred to as Putuni by Ponce (east of Kheri-qala and west of the Qalasasaya) as well as other structures,[17] apparently just before Posnansky photographed the Thunderbolt piece.[18]

Uhle's illustration of the Bolivian piece shows the same face as does Posnansky's 1903 photograph, but it is longitudinally obstructed, apparently by a stone covering the other horizontal portion (if one views his photo upsidedown this becomes clear); so again, the illustration is incomplete. It may be that Uhle photographed the piece while it was in the museum of Colonel Ríos Ponce to which Posnansky refers.

Today the Bolivian portion is in the Tiahuanaco Museum, in six pieces as can be seen in Fig. 4b, and as I observed during my visit there on August 17, 1973 (Fig. 4a).

Since no measurements had ever been published, it was not until 1973 that I was able to obtain the dimensions of the Thunderbolt to support the other evidence which pointed to the match between it and the Arapa stela. The complete dimensions are exactly the same:

Width	78 cm.
Thickness	24 cm.

The length is 2.28 m., making the total original height of the stela 5.75 m., one of the tallest stone stelae ever reported from Peru, and belonging to the Pucara style.

Combining the Arapa and Thunderbolt pieces, there is a total of five rectangular design panels on each face of the *complete* stela (Fig. 1), a smaller narrow area at the top near the step, and an uncarved portion at the base to be set into the ground. In addition to the dimensions, evidence that the two pieces fit together can be seen in the order of the design panels on each face. The order of the five designs on face A is exactly the reverse of those on face B, so that the panels on each face, numbered 1-5 from top to bottom, show the following combinations (see Fig. 1):

	Face A	Face B
Panel	1	5
	2	4
	3	3
	4	2
	5	1

Only when the Arapa and Thunderbolt fragments are joined is this design arrangement apparent. The location of the break with respect to the design panels in both the Arapa and the Bolivian pieces coincides very neatly, and in 1973 the outlines of the broken parts were matched.

Furthermore, the material of both pieces is the same, a banded quartzite. The width and location of the bands, parallel to the broad faces, exactly coincide (compare bands of Figs. 3a and 4a). Small samples have been taken from both the Arapa and the Thunderbolt pieces for neutron activation analysis, already arranged at the University of Michigan laboratory,[19] in order to demonstrate that the stone came from a single source and to permit future determination of the quarry or stone source from which the material for the stela came. With this problem in mind, it was discovered that the façade of the Arapa church today is constructed of what appears to be the same fine-textured, banded quartzite including some of a pinkish color. Informants said that this stone comes from a nearby source on a hill called Mumu to the west of and overlooking Arapa. On a return trip in the summer of 1974 the Mumu hill was explored and samples of quartzite were obtained for future neutron activation analysis.

Stylistic Comparisons

The Arapa-Thunderbolt stela belongs to the Pucara style as shown by the multiplicity of similarities to other stelae from the Pucara culture area, including one from Hatuncolla and the Pucara plaza stela, as has been pointed out by other authors, as well as to the Arapa 3 stela (Fig. 12, to be discussed) and new finds from Yapura.[20] Pucara style elements which link the Arapa-Thunderbolt stela with other

Pucara stone sculpture of the northern Lake Titicaca region include: the frog/toad motif, the checkered-cross motif, the curled "tadpole" or "snake" with trapezoidal head having long volute appendages, relief rings, step designs, the double "jagged-S" element, and the general form with a step in one upper corner.

The closest similarity within the Pucara style lies with face A of the Pucara plaza stela (Fig. 5a).[21] The uppermost panel on face A of the Pucara plaza stela best compares to face A panel 1 and face B panel 5 of the Arapa-Thunderbolt stela; this double jagged-S motif also appears on two additional lower panels on face A of the Pucara stela. The use and positioning of the stepped corner elements on the lower panels of this same face are similar to those on the Arapa-Thunderbolt stela face A panel 1, face B panel 5, and panel 3 of both faces, including the framing of eared "serpents," though the elements themselves differ in some respects. Also, the relief rings as corner elements on face A of the Pucara stela are similar to the rings on face A panel 5 and face B panel 1 of the Arapa-Thunderbolt stela, although the former are within stepped frames while the latter are not. Checkered crosses contained in four square elements on face B of the Pucara plaza stela (Fig. 5b) compare to the checkered-cross motifs on the Arapa-Thunderbolt stela faces A and B panels 2 and 4 of both faces. In addition, the outline of the top of the Pucara plaza stela resembles the heads of the trapezoidal-headed motifs with volute appendages on the Arapa-Thunderbolt stela face A panels 3 and 4, face B panels 2 and 3. Detailed comparisons were made by Kidder, and he states, "The total impression in comparing the two stones is one of close technical equivalence (the reliefs are done as though by the same carver) and common conceptual motivation."[22] The trapezoidal-headed animals with volute appendages behind the heads on the Arapa-Thunderbolt stela face A panels 3 and 4, and face B panels 2 and 3 constitute a motif which links this stela with monoliths of what Karen Chávez and I have called the Asiruni substyle,[23] some of which also have trapezoidal-shaped animal heads with coiled appendages behind the head.[24]

The Pucara plaza stela comparison permits the Arapa-Thunderbolt stela also to be compared with a seated, headless anthropomorphic figure of magnetite in the University Museum, Philadelphia, of unknown provenience (catalogued as coming from "Tiahuanaco, Peru") described and illustrated by Kidder[25] (Fig. 6, pls. VI and VII). Kidder shows similarities between this figure and monoliths, including the Pucara plaza stela, the Arapa stela, and one Hatuncolla stela, from the Pucara region where he believes the statuette was originally made. He also compares it to the Pokotía statues from Bolivia,[26] and it can be further compared to the Bern statuette collected by Johann Jakob von Tschudi at Tiahuanaco.[27]

Two small "lightning stones" can also be compared to the Arapa-Thunderbolt stela and the Pucara plaza stela. One of these small stones comes from the southern margin of Lake Titicaca[28] (Fig. 7). Posnansky indicated that the Indians said this stone was to prevent lightning from striking the house. The rollout (Fig. 7d) shows two mirror image figures, each composed of three connecting serpent forms, on opposite sides of the stone with a checkered cross on the top between them. This motif with three connecting serpents resembles elements on panel 3 of faces A and B of the Arapa-Thunderbolt stela, but most closely compares to the top panel of face B of the Pucara plaza stela (Fig. 5b). The latter panel has a design very similar to the lightning stone elements with mirror image serpent figures disposed opposite one

another, although on the Pucara plaza stela a relief ring replaces the checkered cross found on the lightning stone.

The other small lightning stone (Fig. 8) which comes from Escoma, Omasuyu, Bolivia, was given to the Ethnographic Museum in Berlin by Max Uhle,[29] and has not been illustrated since Uhle's publication. Uhle separated this specimen, along with others, from typical Tiahuanaco style sculpture. The piece is similar in size and style to the one just described. Assuming the opposite side of the stone to have the same motif of three connecting serpents, in mirror image to those on the side shown and separated from them by the cross on top, then the two lightning stones are very similar, suggestive of being a pair. The same comparisons to the Arapa-Thunderbolt and Pucara plaza stelae can be made for this stone as were made for the one described above. The triangular-headed, eared serpents and the checkered-cross motif of the lightning stones are to be found in the Yaya-Mama style,[30] but these elements continue into Pucara style sculpture; it is the arrangement of the motifs that make the lightning stones resemble the Pucara style more than the Yaya-Mama style.

Two fragments were found in 1967 in the village of Yapura near Capachica and have been reported by Margaret A. Hoyt.[31] As a result of hearing about the stela from Hoyt, Karen Chávez, three students, and I visited the site on August 15, 1973, at which time we uncovered the buried portions, made rubbings, and obtained additional information.[32] On the Yapura fragments,[33] the intricate style of elements, both curvilinear and rectilinear, disposed with the same kind of symmetry within rectangular panels on two broad faces of a stela form, is similar to the Arapa-Thunderbolt stela, and may represent a "common conceptual motivation," to use Kidder's phrase. Although similar elements are found on the Arapa-Thunderbolt stela and the Yapura fragments, they are combined differently on the two. Similar motifs include relief rings; trapezoidal-headed animals; the jagged-S element; and frogs/toads and coiled serpents situated in the center of panels. However, the jagged-S element on the Yapura pieces is single, not double, and more elongated than the oval to round ones on the Arapa-Thunderbolt stela; the Yapura serpents are double-headed and central panel motifs are unframed. Also, the larger Yapura fragment indicates no reversal in the order of panels on opposite faces, as is found on the Arapa-Thunderbolt stela; the Yapura panels lack corner motifs; and the Yapura trapezoidal-headed animals have unique squared eyes and possess legs.

Specifically, the designs in the complete panel on the south face of the larger Yapura fragment and the nearly complete panel on the north face of the same fragment, are extremely similar to those on face A panel 5 and face B panel 1 of the Arapa-Thunderbolt stela (see Fig. 1). The elements in the middle of the sides and top and bottom of the Arapa-Thunderbolt design panels may be compared to the bodies of the trapezoidal-headed animals on the Yapura panels, especially the versions shown on the sides of the panel on the north face where the bodies are split. These split, double-triangular elements on the Arapa-Thunderbolt stela are oriented in the same way as the animal bodies on the Yapura fragment, inward on the top and bottom of the panel, and outward on the sides. On both monuments the similar elements are joined by a continuous, twisting band interrupted by zigzags of which there are two on the Arapa-Thunderbolt piece, and one set on the Yapura fragments. A similar comparison can be made with face A panel 1 and face B panel 5 of the Arapa-Thunderbolt stela, although in these panels the twisting bands are double and not

continuous, since the split, double-triangular elements have here been completely divided and are represented by two unconnected zigzags from which the twisting bands issue. These panels, in turn, can be compared with panels on face A of the Pucara plaza stela (Fig. 5a).

Furthermore, there are similarities between face A panel 2 and face B panel 4 of the Arapa-Thunderbolt stela and the incomplete panels on the larger Yapura fragment. Both have stepped rectilinear motifs, and the split, double-triangular elements on the Arapa-Thunderbolt piece are paralleled by similar elements in the same position on the Yapura panel. In the incomplete Yapura panels there are apparently only two animals facing in opposite directions away from the center of each panel, while on the Arapa-Thunderbolt stela there are no animal heads. Only on panels 3 and 4 of face A and 2 and 3 of face B of the Arapa-Thunderbolt stela are there actually large animal heads (with coiled appendages behind the head). On panel 3 of both faces all four animals face outward from the center of the panel and have bodies consisting of a solid trapezoidal element attached to a hollow rectangle; the two animal heads of panel 4 of face A and panel 2 of face B also face outward from the center, but have bodies composed of divided stepped elements. On panel 3 of both faces the long curved appendages emanating from the four corner elements and from the central diamond are not continuous, but end in animal heads with small zigzags on one side of the band behind each such head. It can be suggested that on panels 1 and 5 of faces A and B respectively, the zigzagging of the continuous curvilinear bands represents the overlapping or joining of the animals which are separated on panel 3.

The Arapa-Thunderbolt monolith may also be compared to one of the Hatuncolla stelae,[34] but not to the other.[35] This first Hatuncolla stela (Fig. 13) shares the following characteristics with the Arapa-Thunderbolt piece: motifs in panels which include checkered crosses; frogs/toads; nested, multiple-step designs; and corner elements. It differs from the Arapa-Thunderbolt stela, however, in that panels are not in reverse order on opposite faces and all four faces are decorated.

Further comparisons can be made with the Arapa 3 monolith, recorded on August 5, 1973, described and illustrated here for the first time (Fig. 12). This quartzite block was located in the house of Luis Abarca Sotomayor in Arapa and has been in the possession of his family from his grandparents' time. Although its original provenience is unknown, the owner said it probably came from Arapa. The block has low relief carving on one face only; the other three faces and the flat bottom surface are polished. The uppermost part of the stone is broken, so that the total height is unknown. The monolith could have been a panel or one of a series of panels, although it lacks the framing margins of the stelae already mentioned. The element which most closely compares to one on the Arapa-Thunderbolt stela is the step motif with coiled serpent appendages terminating in triangular heads. Panel 3 on faces A and B of the Arapa-Thunderbolt stela has half of such a stepped element in each of the four corners of the panel from each of which emanates a coiled serpent appendage ending in a trapezoidal head. The stepped elements, however, are not solid, and the scroll appendages emanate from what appears to be the top of the step (had the element been complete) rather than from the bottom. The animal on the Arapa 3 block has an unusual triangular head which tapers to a kind of snout, and the circular eyes consist of two concentric grooves, the outer groove of the eye on the right overlapping that on the left. The front legs of the animal are in the same position as those of the trapezoidal-headed animal on the incomplete panels of the larger Yapura fragment.[36]

Original Location and Subsequent Movement

The question now arises as to the original location of the complete Arapa-Thunderbolt stela; the direction of movement, from north to south or south to north, of one of its portions; and the time such movement of one of the pieces may have occurred. Insofar as the direction of movement is concerned, while present evidence is incomplete, it is my belief that the Arapa-Thunderbolt stela was originally erected in or near Arapa in Pucara times, roughly during the first century B.C.; later it was broken in two and the basal portion was transported to Tiahuanaco, a straight-line distance of 220 km.[37]

The most convincing evidence that the Arapa-Thunderbolt stela came originally from Puno is the fact that the Pucara substyle to which it belongs has so far been found only around the northern Lake Titicaca Basin, as demonstrated by the comparisons we have made with the Pucara plaza stela, one of the Hatuncolla stelae, and the Yapura fragments, as well as with the Arapa 3 monolith. These stelae combine a distinctive composition, technique, and stylization of elements, and form a separate group within the Pucara style. The home of this substyle, then, appears to be in Puno. While other Pucara style sculpture has been found on the southern end of the lake in Bolivia, no examples of this particular substyle occur there. In fact, in Bennett's classification of Tiahuanaco stone sculpture, the Thunderbolt piece and only this piece is placed in his Style 8, Geometric Patterns.[38]

The report of village residents giving the original position of the Arapa stela as always having been in the Islapuncu even before its use as the church lintel, would be important testimony in support of my case; but while this account may be true, it is also possibly unreliable. More convincing, however, is the material (quartzite) from which the stela is made. This material is apparently present near the town of Arapa, as indicated by the banded quartzite church façade and the account that the quartzite used in the façade comes from the hill Mumu. The results of petrographic and neutron activation analyses should settle this point.

Arguments concerning the time of transportation will differ depending on the assumed direction of transport, though some considerations are applicable to either case. Following my hypothesized direction of movement from Puno to the south, there is evidence to support the possibility that the transportation of the basal portion to Bolivia was made prior to the European conquest, perhaps in early post-Pucara or in Tiahuanaco times, and conceivably indicating a pattern of reuse of earlier stone sculpture as religious symbols or cult objects.[39]

The best evidence for pre-conquest transport of the Thunderbolt stone lies in its having been found in the Palacio, a Tiahuanaco construction, as reported by Uhle in 1912. Transportation of the piece from Arapa in post-conquest times does not seem reasonable in view of the fact that many pieces could easily have been obtained at the site of Tiahuanaco itself with much less effort, for whatever reasons those people might have needed such a stone: for decorative purposes, curiosity pieces, or use as building material. This kind of reasoning could also apply against an argument for the Bolivia to Arapa direction of transportation. Furthermore, anyone having brought the piece at the cost of so much effort over such a distance would surely not have abandoned it in the ruins of the Palacio. In addition, transportation in Colonial times is unlikely, since we would expect destruction of such monoliths by Spanish conquerors in order to do away with early "pagan" images, and not purposeful trans-

portation and reuse of them, though there may have been exceptions. The Arapa piece was, however, used in the Catholic church there for practical reasons, having an appropriate and ready made form for a lintel.

In support of my suggestion that there existed a pattern of reuse of earlier stone sculpture by later inhabitants, the case of the Semi-subterranean Temple at Tiahuanaco presents a documented instance. In Bennett's 1932 excavations in the Temple, within his Pit VII, he found Stela 15 associated with Stela 10;[40] the two were aligned side by side as if they had been erected upright one next to the other. Bennett placed Stela 15 (his Style 3) into Group III stylistic group which probably corresponded to Decadent Tiahuanaco times, and Stela 10 into Group II corresponding to Classic Tiahuanaco times.[41] He dated the Semi-subterranean Temple as late, with earlier materials being brought together, reused.

Ponce, however, dates the Temple as well as Stela 1 to his Epoch III; Stela 10 is assigned to Epoch IV. Ponce believes that Stela 10 was placed in the Epoch III Temple during Epoch IV, when Stela 15 was moved slightly to one side in order to do so.[42] Given this interpretation, we find that during Epoch IV times reuse, or continued use, of an earlier style stone sculpture in the patio of the Temple itself occurred, suggesting the importance and perhaps veneration of these stone representations. If we can assume this practice was acceptable in Classic Tiahuanaco times (Epoch IV), then we could argue that the Classic Tiahuanaco people were responsible for the reuse of the Thunderbolt stone dating from Pucara times and coming from the site of Arapa. That is to say, it may have been that Classic Tiahuanaco religious functionaries brought or had brought this Arapa fragment to Tiahuanaco as a venerated object to be incorporated into the Palacio, reflecting perhaps their concern with identifying with their past.

There are various problems which arise from this explanation, however, and further work is needed to prove or disprove any of the possibilities mentioned here. There is the problem, for example, of why only the basal portion, a piece which has almost more uncarved than carved area, was moved. Possibly it was intended to bring the upper part later. One might postulate a concept of the base representing the "root" to be "grown" again in its new location, but there is no way to verify such a conjecture. Reuse of Stela 15, belonging to a style we have suggested is pre-Pucara,[43] does not necessarily mean that the Classic Tiahuanaco people would reuse a Pucara style stela in the same manner. Another problem is the date of the Palacio itself; is this structure of Epoch IV date? Why would only the Arapa stela, and not others, be selected, or was it? Was the site of Arapa unoccupied at the time? Are there indications of Tiahuanaco presence near Arapa (although numerous reasons could be given for Tiahuanaco presence in the area)? Tiahuanaco pottery has been found at least as far north as Juliaca,[44] and in 1973 we recorded Tiahuanaco pottery from the vicinity of Taraco, about 28 km. by land from Arapa and to the northeast of Juliaca. A fragment of a Classic Tiahuanaco stone head in the Puno Museum[45] would appear to be a unique case of the occurrence of Tiahuanaco stone sculpture at the northern end of the lake.

Another reason for the presence of the fragment in Bolivia might be that the Pucara people from Arapa, or their descendants, moved to the site of Tiahuanaco and carried the Thunderbolt fragment with them for some reason. These individuals would have had to have considerable influence in order for their stela fragment to be used in

the Palacio, unless they themselves constructed the Palacio. There is no evidence to support any of these suggestions. Could Pucara immigrants to Tiahuanaco have been missionaries, or what remained of them? Could Pucara sculpture have been brought as models for imitation? Are there undiscovered Pucara or Pucara-like occupations at Tiahuanaco? Pucara or Pucara-like sculpture at or near Tiahuanaco could be indicative of Pucara occupations there, although it is not certain that any Pucara pottery has yet been found at Tiahuanaco itself.[46] Could there have been a local Pucara-like occupation having distinct pottery, for example, but producing Pucara style stone sculpture?

The most likely means of moving the piece would appear to be a combination of water transport by balsa rafts and land travel. Departing from Arapa at the northwestern end of Lake Arapa and following this lake to Lagunas Chacamarca and Titihue into the northwestern end of Lake Titicaca, with perhaps a few short overland hauls, the piece could have been brought across Lake Titcaca to the southern shore where it could have been taken to Tiahuanaco via the Río Tiwanaku.

Pucara Related Sculpture from the Southern Titicaca Basin

Keeping the Arapa-Thunderbolt stela in mind, one must review the other sculpture which is Pucara or Pucara-like in style from Tiahuanaco or other sites at the southern end of the lake. I do not know if the presence of these other Pucara style monoliths can also be explained as representing a pattern of reuse, but it is a possibility to be tested on the grounds presented here for the Arapa-Thunderbolt case. Examples of Pucara-like sculpture from Tiahuanaco include the two kneeling statues at the door of the church of Tiahuanaco.[47] Ponce says that these belong to Epoch IV or Classic Tiahuanaco,[48] but the elements on the headbands (Fig. 9)[49] make the statues similar, as Uhle also noted, to the Pucara style statue from Azángaro[50] which is now in the Puno Museum and to others having upside-down front-view animal heads on twisted or undulating headbands. These two statues from the Tiahuanaco church are most similar to two blocky, kneeling or squatting statues from Taraco, one of which has a headband element similar to that described above while the other has one hand over the chest and the other at the knee.[51]

Four sculptures from Pokotía, just to the south of Tiahuanaco, share Pucara style elements, and include the two kneeling "women," a seated "man," and the "Flute Player."[52] Ponce place the first two of the Pokotía statues in his Epoch IV,[53] but elements such as the headband (similar to those on the statues from the church in Tiahuanaco as shown in Fig. 9), breechclout with side flaps, representation of ribs and navel, two "snake-braids" curling up to the shoulders,[54] and overall realism are very Pucara-like. The third statue[55] also relates to Pucara style sculpture in being blocky, in the position of the hands, the presence of a cap under the hat, and representation of the navel. This piece is most like one of the headless statues reported by Núñez del Prado from Waraq'oyoq Q'asa, Chumbivilcas, Cuzco,[56] in its similar seated position, position of arms on chest, and relief ring in the navel position. The similarities of the "Flute Player" to other Pucara style sculpture are even greater than those of the other three Pokotía statues, especially when compared to a statue now in the Pucara museum (Fig. 14).[57] The similarities include: the neck fringe, wrist bands, cap under the hat, detailed face motifs on the hat,[58] the general facial features, and an object emanating from the mouth. In the Pucara example this object is an anthropomorphic figure upside down with the head held in the two hands at the chest (perhaps being eaten). The similar object held in the Pokotía statue's hand is not a flute, as the name

implies, nor any other musical instrument as suggested by Ponce,[59] but is an anthropomorphic figure which has hairlike braids on the sides of its head, and arms bent at the elbows with hands just under the stomach. This observation was confirmed during my visit to Bolivia in 1973.

The Bern statuette bought at Tiahuanaco by Tschudi in 1858,[60] and the seated and hunchbacked statues from the Island of Titicaca,[61] have some Pucara elements; but, as Ponce notes, hunchback statues have never been found among sculpture from Pucara.[62] The iconographic elements of the Bern statuette, however, are Pucara ones. The Pucara style statuette of uncertain provenience illustrated by Kidder is very much like the Bern statuette, but is not hunchbacked (Fig. 6).[63] A new statuette from Taraco recorded by us in 1973 appears to be Pucara in style and has the suggestion of a hunchback representation.

There are other monoliths from Bolivia which resemble Pucara style stone sculpture but are not sufficiently well documented to be used in this argument and present a subject for a separate article. In some cases, photographs of such possible Pucara style pieces have been published but do not show sufficient details, such as incised motifs, which characterize the Pucara style. It is necessary, therefore, to examine the pieces themselves instead of relying on the published versions. Other possible Pucara style monoliths in Bolivia include a human statue with breechclout and ribs now in the Museo Nacional de Arqueología in La Paz, two pieces with frogs/toads having tails,[64] and one interesting stepped slab in the Museum at Tiahuaaco.[65] This last, unpublished piece was identified by me during my visit to Tiahuanaco in 1973, and appears to be the first case of the occurrence of a Pucara style stepped stela in Bolivia; previously only statues and unstepped pieces have been described. This stepped slab is red sandstone and has relief carving on one face, of a zoomorphic figure with an oval, undecorated head, two arms bent upward, and does not show the lower portion of the animal's body.

Conclusion

The question of why two pieces of stone sculpture, coming from widely separated localities at both ends of Lake Titicaca, are stylistically very similar has been resolved by showing that the pieces belong to a single stela. Other problems are raised, however, regarding the direction and time of transport of one or both of the pieces. I have suggested possible answers to these, but more work is needed.

But beyond the academic value of this unusual case of stylistic identity, it should also make us realize that present political boundaries (Peru and Bolivia) may create barriers to the pursuit of knowledge of altiplano archaeology. What we need is closer collaboration between "Peruvianists" and "Bolivianists" in coordinating all of the data for the purpose of reconstructing prehistoric altiplano events and societies, reinforcing a contact already made during Pucara and even pre-Pucara times.

Acknowledgements

The research upon which this paper was based was partially funded by a Senate Research and Creative Endeavor Grant and by a Faculty Achievement Award from Central Michigan University, both granted to Karen L. Mohr Chávez, with myself as assistant. I wish to express my special thanks to: Karen L. Mohr Chávez for her support, suggestions, advice, and exchange of ideas in different stages of the preparation of this work; John H. Rowe for providing me with slides of the Thunder-

bolt stela and for his comments and suggestions; Margaret A. Hoyt for generously providing me with slides and information she recorded for the Yapura fragments and for her additional comments; Manuel Chávez Ballón for his support as a member of the then Patronato Departamental de Arqueología del Cuzco; Maks Portugal Zamora, Max Portugal Ortiz and Carlos Ponce Sanginés with whom I exchanged ideas on the Arapa-Thunderbolt case; and Patricia J. Lyon for editorial assistance.

<div align="right">

May 31, 1971
revised September 27, 1975

</div>

Notes

[1]This paper, as part of a larger work which also included Chávez and Chávez, 1976, was presented in the symposium entitled "Analysis and Interpretation of Form and Style of the Precolumbian Art of the Andean Region," during the 36th Annual Meeting of the Society for American Archaeology held at Norman, Oklahoma, May 6, 1971.

[2]A. Kidder, 1943, p. 19.

[3]Raimondi, 1874-1913, vol. 1, p. 175; 1940, p. 132.

[4]Uhle, 1912, Fig. 13.

[5]Palacios R., 1935, p. 236.

[6]A. Kidder, 1943, pl. VI, 1 and 2 *passim*. Larco Hoyle (1963, p. 47, Fig. 73) also illustrated the stela, but said it was from "Sarapa," not Arapa; his photo, like Uhle's, shows it (face B) when it was a lintel in the church, though his photo is upside down with respect to the true orientation of the stela. See also Ponce Sanginés, 1957, p. 132, Fig. 27a (from Kidder's illustration); Lehmann (1943, pp. 141-142) mentions the Arapa stela along with one from Hatuncolla, then compares the frog motif on the latter to one on a Bolivian piece (possibly the Thunderbolt?) and to one of the unknown provenience in Munich.

[7]M. Kidder, 1942, p. 187; see, however, Palacios R. (1935, p. 236) in which much the same story is told but with a "coronel Ponce" blamed for the breakage.

[8]A. Kidder, 1943, pl. VI, 7.

[9]Arapa 3 is the catalog number given to this third monolith from Arapa by S. and K. Chávez. Arapa 1 is our catalog number for the Arapa stela, subject of this paper, and more widely known in the literature as the Arapa stela; Arapa 2 is our catalog number for the slab which Kidder described and illustrated (A. Kidder, 1943, pp. 35-36 and pl. VI, 7).

[10]Bennett, 1934, p. 463.

[11]Uhle, 1912, pp. 477-478.

[12]Posnansky, 1945, vol. II, p. 230.

[13]A. Kidder, 1943, p. 33.

[14]Posnansky, 1945, vol. II, pp. 228-229.

[15]Posnansky, 1945, vol. II, p. 228.

[16]Uhle, 1912, pp. 477-478, my translation.

[17]Bennett, 1934, p. 367.

[18]Courty was a geologist on the French Créqui-Montfort and Sénéschal de la Grange expedition and excavated at Tiahuanaco between September 3 and December 15, 1903 (Créqui-Montfort, 1906, p. 532). Ponce states that while Posnansky returned to Bolivia from Europe in September of 1903, he likely went to Tiahuanaco for the first time after May, 1904 (Ponce Sanginés, 1969b, p. 24). By the time Posnansky went to Tiahuanaco the Thunderbolt had already been discovered and taken to the museum of Colonel Ríos Ponce where Posnansky first

saw and photographed it. While the Thunderbolt may have been found by Courty, the report of the excavations published by Créqui-Montfort does not mention it. Posnansky characterizes the work of Courty as destructive and lacking in careful excavation techniques (Posnansky, 1945, vol. I, pp. 64-65). The Thunderbolt may have been overlooked by Courty or found later by local inhabitants.

[19]Dr. Adon A. Gordus, personal communication.

[20]Hoyt, 1976.

[21]This stela was first published by Tello (1929, Figs. 1-5 and 106). Tello's drawings are not accurate, though his Fig. 105, showing what I designate as face A, is more accurate than his Fig. 106, my face B. Photographs of the two faces have been published as follows: Valcárcel (1935, Fig. 10) shows face B; Muelle (1936, p. 5) shows face B; Bennett (1938, p. 178) shows face A; Valcárcel (1938, Fig. 6) shows face B; Schaedel (1948, p. 71) shows face A; Cossío del Pomar (1949, photograph on third page following p. 48) shows face A; Bennett and Bird (1960, Fig. 16) show face B; Harth-Terré (1960, pp. 246, 248) shows faces A and B, but cut; Mason (1968, pl. 18B) shows face A. For other references see Espejo Núñez (1971).

[22]A. Kidder, 1943, p. 34.

[23]We suggest the name Asiruni, or "with snake" in Aymara (from A. Kidder, 1943, p. 10), for a Pucara substyle having serpents, especially eared, or other reptilian fauna, with or without face or body details, often associated with relief rings, on stelae and slabs (for example, see Chávez and Chávez, 1970, pp. 25, 28-30, 35-36; Valcárcel, 1932, Fig. 1; Franco Inojosa, 1940, *passim*; A. Kidder, 1943, pl. IV, 1-6, pl VII, 1, 8-9; Portugal Zamora, 1961, Figs. 2, 3; Franco Inojosa and González, 1936, drawing no. 4). Some elements of the Asiruni substyle are shared with the Yaya-Mama style (Chávez and Chávez, 1976), but elements of the Asiruni substyle relate more closely and in greater detail to those of the Pucara style. In addition, the geographic distribution of the Asiruni substyle and of the Pucara style are closely congruent; both occur around Lake Titicaca and at sites considerably inland from the lake especially to the north as far as the Department of Cuzco, while the Yaya-Mama style is found around the lake, especially in the south. The Asiruni substyle will be defined more completely in a separate article in preparation, which will include ethnohistorical references as well as examples from both Peru and Bolivia.

[24]Valcárcel, 1935, Fig. 7; A. Kidder, 1943, pl. VII, 9.

[25]A. Kidder, 1965. The caption of the illustration indicates the height of the statuette to be 29¼ inches, while the text states it to be 8 inches; the latter was confirmed to be correct.

[26]Posnansky, 1945, vol. II, Figs. 91-94.

[27]Rowe, 1958.

[28]Posnansky, 1958, pl. LXXV.A.a. and p. 124.

[29]Uhle, 1912, p. 478, Fig. 15.

[30]Chávez and Chávez, 1976.

[31]Hoyt, 1976. Hoyt furnished me with details of the discovery and generously provided me with slides she took of the pieces.

[32]Karen Chávez and I think the two Yapura fragments probably came from a single stela since the dimensions of both pieces are so much alike (width, thickness, and dimensions of design panels), the stone material is the same, and the execution and designs of both are so closely similar. The curvilinear panels of the smaller fragment could be a continuation of the pattern of alternating curvilinear and rectilinear panels found on the larger piece but with a connecting segment(s) missing. The higher relief portion of the smaller fragment indicates another piece is missing as well; this high relief conceivably is a frog/toad and could be the very top of the stela.

[33]Hoyt, 1976, Figs. 2-7.

[34]Squier, 1877, pp. 385-386; Uhle, 1912, Fig. 14; A. Kidder, 1943, pl. VII, 10.

[35]Uhle, 1912, Fig. 14; A. Kidder, 1943, pl. VII, 11.

[36]Hoyt, 1976, Figs. 4, 6.

[37]Rowe (personal communication), however, has suggested an alternative possibility for the direction and time of transportation, namely that the top portion was brought to Arapa from Tiahuanaco in post-conquest times to use as the church lintel. There is a third logical alternative: that the Arapa-Thunderbolt stela was originally erected neither in Arapa nor in Tiahuanaco, but at some other location from which both pieces were later transported.

[38]Bennett, 1934, p. 473. The only exception to the southern occurrence of the substyle might be the two lightning stones mentioned previously, though they are distinct from stelae in form and size and are easily portable.

[39]Cases of indigenous reuse of earlier stone sculpture in the altiplano of Peru and Bolivia have been documented within the last two centuries, as in the case of the Bern statuette known around 1858 as "the god of thieves" by the Indians of Tiahuanaco who showed "to it the same reverence they did to any of the saints of the church" (Rowe, 1958, p. 260). Another case documents the same kind of veneration of an ancient stone statue (known as Awicha Anselma) during the 1967 drought in Puçara, Peru (Flores Ochoa, 1971).

[40]The numbers given to these stelae are designations in the cataloguing system of the Centro de Investigaciones Arqueológicas de Tiwanaku. Stela 15 was named the "Barbada" by Wendell C. Bennett and was his stone sculpture No. 24. Stela 10 is Bennett's stone sculpture No. 2.

[41]Bennett, 1934, p. 474.

[42]Ponce Sanginés, 1964, p. 68.

[43]Chávez and Chávez, 1976.

[44]Rowe, 1956, p. 144.

[45]A. Kidder, 1943, p. VII, 5. According to the Puno Museum register it was obtained by the Puno Concejo in 1920 from Mrs. Epifania Zevillaños de Palao, and was found at her house in the city of Puno while putting in foundations.

[46]On p. 56 of his 1944 report, Rowe made a positive identification of a single sherd from Level 9 of Bennett's Pit V at Tiahuanaco as "Pucara Polychrome." The sherd in question was a small one with a stepped design in red and black, the color being outlined by incision. In a later publication, Rowe discussed this identification and concluded that Bennett's sherd might belong to a local style related to Pucara rather than to the Pucara style proper (Rowe, 1963, pp. 7-8). In 1968, Rowe had an opportunity to see the Qalasasaya style pottery from Ponce Sanginés' excavations at Tiahuanaco on exhibit in the site museum there, and he realized that Bennett's sherd might belong to the Qalasasaya style rather than to the Pucara one. He subsequently stated to several people that no Pucara style pottery had been found at Tiahuanaco, a statement he now regrets, since there is a perfectly good possibility that Bennett's sherd is indeed Pucara, as Rowe thought when he first saw it in 1941. (Note added by J.H. Rowe.)

[47]Posnansky, 1945, vol. I, pl. XIII c-e, pl. XIVa. See also Rowe's comments, 1963, p. 8.

[48]Ponce Sanginés, 1969a, p. 20.

[49]Uhle, 1912, Figs. 10-12.

[50]Uhle, 1912, Fig. 8 and p. 478.

[51]A. Kidder, 1943, pl. III.

[52]Posnansky, 1945, vol. II, Figs. 91-93, 93a, 94-96; Ibarra Grasso, 1965, p. 121; Ponce Sanginés, 1969a, Fig. 19.

[53]Ponce Sanginés, 1969a, p. 20.

[54]The curled "snake-braids" are similar to three Pucara style pieces, one from Wara-q'oyoq Q'asa,, Chumbivilcas, Cuzco (Rowe, 1958, p. 259), the Bern statuette purchased in Tiahuanaco (Rowe, 1958, p. 261), and one now in the University Museum, Philadelphia, of uncertain provenience (A. Kidder, 1965, pp. 22-23; see my Fig. 6).

[55]Posnansky, 1945, vol. II, Fig. 95.

[56]Núñez del Prado Béjar, 1972, lám. XVII, Fig. 4.

[57]According to Mr. Emilio Ramos Carrión, his son found this piece in 1969 in one of the stone enclosures at Pucara.

[58]Fig. 14, on the upper right of the headband, a face motif occurs (Fig. 10) comparable to the one on the headband of the "Flute Player" (Fig. 11). This face motif appears on both Pucara sculpture and pottery, and continues to be present on some Classic Tiahuanaco sculpture, as was noted by Kidder (A. Kidder, 1943, p. 36), such as on the finger joints of Stela 8 or the Ponce Stela (Burland, 1970, p. 111). The motif also occurs on the back of the legs on one of the Wakullani statues (Posnansky, 1945, vol. II, Fig. 98, right).

[59]Ponce Sanginés, 1969a, p. 37. He refers to Fig. 6 in his discussion, but should refer to Fig. 19.

[60]Rowe, 1958, pp. 260-261.

[61]Ponce Sanginés, 1969a, pp. 21-22, 33, pls. 13, 14, 15, 18, 20 and possibly 16, 17.

[62]Ponce Sanginés, 1969a, p. 20.

[63]A. Kidder, 1965, pp. 22-23.

[64]Bennett, 1934, p. 472; Posnansky, 1945, vol. I, pl. XIVb.

[65]These last three stelae belong to the Asiruni substyle; see note 23. There appears to be a greater concentration of this substyle in the northern Lake Titicaca Basin, however.

Bibliography

Bennett, Wendell Clark
 1934 "Excavations at Tiahuanaco." *Anthropological Papers of the American Museum of Natural History,* vol. XXXIV, part III. New York.
 1938 "Summary of Archaeological Work in the Americas; I. South America" [Part I]. *Bulletin of the Pan American Union,* vol LXXII, no. 3, March, pp. 171-180. Washington.

Bennett, Wendell Clark, and Junius Bouton Bird
 1960 *Andean Culture History.* Second and revised edition. American Museum of Natural History, Handbook Series, no. 15. New York.

Burland, Cottie
 1970 *The People of the Ancient Americas.* Paul Hamlyn, London, New York, Sydney, Toronto.

Chávez, Sergio Jorge and Karen Lynne Mohr Chávez
 1970 "Newly Discovered Monoliths from the Highlands of Puno, Peru." *Expedition,* vol. 12, no. 4, summer, pp. 25-39. Philadelphia.
 1976 "A Carved Stela from Taraco, Puno, Peru, and the Definition of an Early Style of Stone Sculpture from the Altiplano of Peru and Bolivia. *Ñawpa Pacha* 13, 1975, pp. 45-83. Berkeley.

Cossío del Pomar, Felipe
 1949 *Arte del Perú Precolombino.* Fondo de Cultura Económica, México-Buenos Aires.

Créqui-Montfort, Georges, Marquis de
 1906 "Fouilles de la Mission Scientifique Française a Tiahuanaco. Ses Recherches Archéologiques et Ethnographiques en Bolivie, au Chili et dans la République Argentine." Internationaler Amerikanisten-Kongress. *Vierzehnte Tagung,* Stuttgart 1904. Zweite Hälfte, pp. 531-550. Verlag von W. Kohlhammer, Stuttgart.

Espejo Núñez, Julio
 1971 "Fuentes para el Estudio de la Cultura Pucara." *Boletín del Seminario de Arqueología,* no. 9, enero, febrero, marzo, pp. 78-83. Lima.

Flores Ochoa, Jorge Aníbal
 1971 "La wak'a Awicha Anselma." *Allpanchis Phuturinga; Orakesajj Achukaniwa* , vol. III, pp. 68-78 and photograph facing p. 96. Cuzco.

Franco Inojosa, José María
 1940 "Inventario de los Especímenes Existentes en el Museo Arqueológica de la Municipalidad de Pucara (Provincia de Lampa)." *Revista del Museo Nacional*, tomo IX, no. 1, I semestre, pp. 137-142. Lima.

Franco Inojosa, José María, and González, Alejandro
 1936 "Exploraciones Arqueológicas en el Perú." Departamento de Puno. *Revista del Museo Nacional*, tomo V, no. 2, II semestre, pp. 157-183. Lima.

Harth-Terré, Emilio
 1960 "Un Mapa Regional en Litoescultura; Examen Estético de la Estela de Pucara." *Revista Universitaria*, año XLIX, segundo semestre, no. 119, pp. 239-258. Cuzco.

Hoyt, Margaret Ann
 1976 "Two New Pucara Style Stela Fragments from Yapura, Near Capachica, Puno, Peru." *Ñawpa Pacha* 13, 1975, pp. 27-34. Berkeley.

Ibarra Grasso, Dick Edgar
 1965 "Prehistoria de Bolivia." *Enciclopedia Boliviana*, Editorial "Los Amigos del Libro," La Paz - Cochabamba.

Kidder, Alfred II
 1943 "Some Early Sites in the Northern Lake Titicaca Basin. Expeditions to Southern Peru." Peabody Museum, Harvard University, Report No. 1. *Papers of the Peabody Museum of American Archaeology and Ethnology*, Harvard University, vol. XXVII, no. 1. Cambridge.

 1965 "Two Stone Figures from the Andes; Question: What Part?" *Expedition*, vol. 7, no. 4, summer, pp. 20-25. Philadelphia.

Kidder, Mary Barbour
 1942 *No Limits but the Sky*. The Journal of an Archaeologist's Wife in Peru. Harvard University Press, Cambridge.

Larco Hoyle, Rafael
 1963 *Las Épocas Peruanas*. Santiago Valverde, S.A., Lima.

Lehmann, Walter
 1943 *Historia del Arte del Antiguo Perú*. Tihuanacu, Selección de Gustavo Adolfo Otero, pp. 139-142. Emecé Editores, S.A., Buenos Aires.

Mason, John Alden
 1968 *The Ancient Civilizations of Perú*. Pelican Books A395, Penguin Books, Baltimore.

Muelle, Jorge Clemente
 1936 "Muestras de Arte Antiguo del Perú, un Criterio Para Estudiar el Arte Peruano." *Publicaciones del Museo Nacional de Lima*. Guías y Folletos de Difusión Popular, no. 2. Lima. [author given as J.C.M.]

Núñez del Prado Béjar, Juan Víctor
 1972 "Dos Nuevas Estatuas de Estilo Pucara Halladas en Chumbivilcas, Perú." *Ñawpa Pacha 9*, 1971, pp. 23-32. Berkeley.

Palacios R., Julián
 1935 "Puno Arqueológico." *Revista del Museo Nacional*, tomo III, no. 3, 1934, pp. 235-240. Lima.

Ponce Sanginés, Carlos
 1957 "Una Piedra Esculpida de Chiripa." *Arqueología Boliviana* (Primera Mesa Redonda), publicación dirigida por Carlos Ponce Sanginés, pp. 119-138. Biblioteca Paceña - Alcaldía Municipal. La Paz.

 1964 "Descripción Sumaria del Templete Semisubterráneo de Tiwanaku." *Centro de Investigaciones Arqueológicas en Tiwanaku*, Publicación no. 2. Tiwanaku.

1969a "Tunupa y Ekako; Estudio Arqueológico acerca de las Efigies Precolombinas de Dorso Adunco. Con la Colaboración de Gregorio Cordero Miranda." *Academia Nacional de Ciencias de Bolivia,* Publicación no. 19. La Paz.

1969b "Descripción Sumaria del Templete Semisubterráneo de Tiwanaku. Tercera Edición, Revisada." *Academia Nacional de Ciencias de Bolivia,* Publicación no. 20. La Paz.

Portugal Zamora, Maks
1961 Nuevos Hallazgos Arqueológicos en la Zona Noroeste del Lago Titicaca. *Khana, Revista Municipal de Arte y Letras,* año VIII, vol. I, no. 35. La Paz.

Posnansky, Arthur
1945 *Tihuanacu; la Cuna del Hombre Americano. Tihuanacu; the Cradle of American Man.* Vols. I and II. J.J. Augustin Publisher, New York.

1958 *Tihuanacu; la Cuna del Hombre Americano. Tihuanacu; the Cradle of American Man.* Vols. III and IV. Ministerio de Educación, La Paz.

Raimondi, Antonio
1874- *El Perú.* Imprenta del Estado (Except vol. 4, published by Librería e Imprenta
1913 Gil), Lima. 6 vols.

Rowe, John Howland
1944 "An Introduction to the Archaeology of Cuzco. Expeditions to Southern Peru," Peabody Museum, Harvard University, Harvard University Report no. 2, *Papers of the Peabody Museum of American Archaeology and Ethnology,* Harvard University, vol. XXVII, no. 2. Cambridge.

1956 "Archaeological Explorations in Southern Peru, 1954-1955;" Preliminary Report of the Fourth University of California Archaeological Expedition to Peru. *American Antiquity,* vol. XXII, no. 2, October, pp. 135-151. Salt Lake City.

1958 "The Adventures of Two Pucara Statues." *Archaeology,* vol. 11, no. 4, December, pp. 255-261. Brattleboro.

1963 "Urban Settlements in Ancient Peru." *Ñawpa Pacha 1,* pp. 1-7. Berkeley.

Schaedel, Richard Paul
1948 "Monolithic Sculpture of the Southern Andes." *Archaeology,* vol. 1, no. 2 (2), June, pp. 66-73. Cambridge, Massachusetts.

Squier, Ephraim George
1877 *Peru; Incidents of Travel and Exploration in the Land of the Incas.* Harper & Brothers, Publishers, New York.

Tello, Julio César
1929 *Antiguo Perú; Primera Época.* Editado por la Comisión Organizadora del Segundo Congreso Sudamericano de Turismo. Lima.

Uhle, Max
1912 "Posnansky—Guía General Ilustrada para la Investigación de los Monumentos Prehistóricos de Tihuanacú é Islas del Sol y la Luna, etc.—La Paz 1911." *Revista Chilena de Historia y Geografía,* año II, tomo II, segundo trimestre, no. 6, pp. 467-479, Santiago de Chile.

Valcárcel, Luis Eduardo
1932 "El Gato de Agua; Sus Representaciones en Pukara y Naska." *Revista del Museo Nacional,* [tomo I], no. 2, pp. 3-27. Lima.

1935 "Litoesculturas y cerámica de Pukara." *Revista del Museo Nacional,* tomo IV, no. 1, I semestre, pp. 25-28. Lima.

1938 "New Links in the Record of Ancient Peruvian Culture. The Latest Archaeological Discoveries in Peru." Publications of the National Museum of Lima, *Discovery Series,* no. 1, pp. 21-26. Lima.

Key to Illustrations

Unless otherwise noted, all drawings are by the author.

Plate I. Figure 1. Arapa-Thunderbolt stela. Reconstructed dimensions: length 575 cm., maximum width 78 cm., thickness 24 cm. Composite drawing based on A. Kidder, 1943, pl. VI, 1 and 2; Posnansky, 1945, vol. II, Figs. 152, 152a, 153, 153a; and slides of the Thunderbolt provided by J.H. Rowe. The center of panel 3 on face B has been left blank because wear made it impossible to distinguish the figure represented (see Fig. 3a).

Plate V. Figure 5. Stela now in the Pucara Museum. Length above ground approximately 240 cm., drawn from rubbings.

Plates VI-VII. Figure 6. Statuette probably from the northern Lake Titicaca Basin, now in The University Museum of the University of Pennsylvania, Philadelphia. Broken height 8 inches, thickness 4½ inches. Photographs courtesy University of Pennsylvania Museum.

Plate VIII. Figure 7a-c. Height approximately 15 cm., drawn from Posnansky, 1958, pl. LXXV.A.a. Fig. 7 d is top view rollout drawing of stone in Figs. 7a-c.

Figure 8. Height approximately 13.3 cm., width approximately 12.4 cm., drawn by Catherine T. Brandel from Uhle, 1912, Fig. 15.

Figure 9. Drawn from Uhle, 1912, Figs. 10-12.

Plate IX. Figure 12. Maximum width at base 41 cm., maximum width at broken top 43.5 cm., maximum thickness 31 cm., maximum height (broken) 41 cm. Light chalking was used to emphasize outlines.

Plate X. Figure 13. Erected in the Museo Nacional de Antropología y Arqueología, Lima, Peru. Red sandstone.

Figure 14. Chalk was used to highlight prominent grooving.

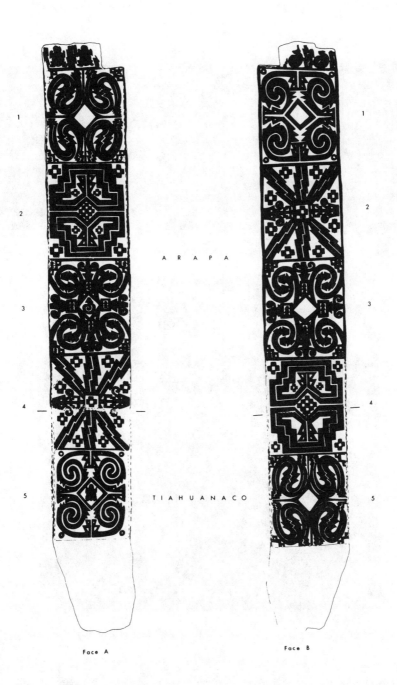

Face A Face B

Plate I. Figure 1. Stela from Arapa, Peru (top) matched with the Thunderbolt stone from Tiahuanaco, Bolivia (bottom). See Key to Illustrations.

486

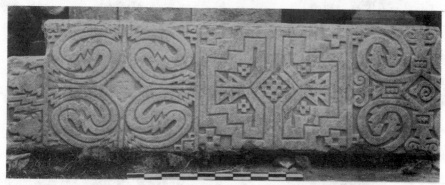

2a

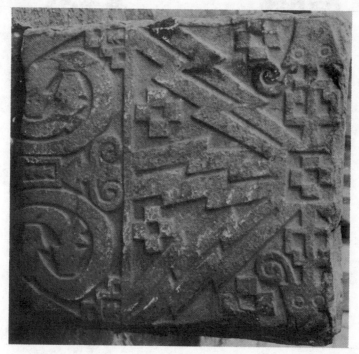

2b

Plate II. Figure 2. Stela from Arapa, Peru, outside the Arapa church, face A; Figure 2a, larger fragment, panels 1, 2, and part of 3; Figure 2b, smaller fragment, part of panels 3 and 4.

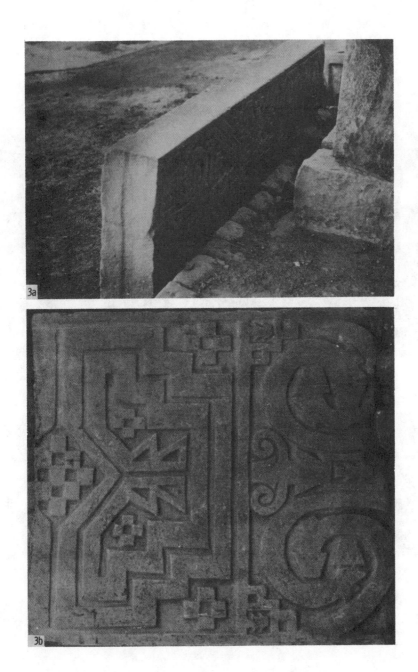

Plate III. Figure 3. Stela from Arapa, Peru, outside the Arapa church, face B.; Figure 3a, larger fragment showing banding of the quartzite; Figure 3b, smaller fragment part of panels 3 and 4.

4 a

4 b

Plate IV. Figure 4. The Thunderbolt stela from Tiahuanaco, Bolivia, 228 cm. long; Figure 4a, face A, panel 5 and part of panel 4, note banding of quartzite; Figure 4b, face B, from left: undecorated base, panel 5, and part of panel 4 (photograph courtesy of J.H. Rowe).

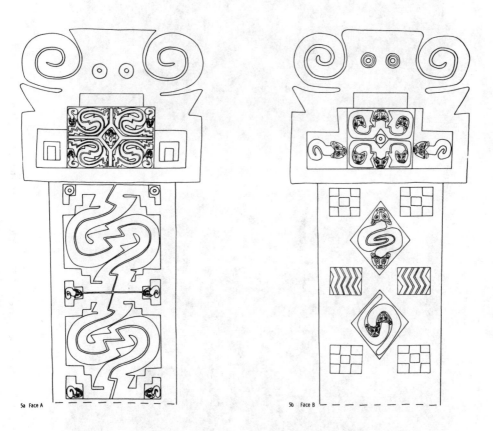

5a Face A

5b Face B

Plate V. Figure 5. Pucara plaza stela. See Key to Illustrations.

490

Plate VI. Figure 6. Pucara style statuette. Photographs courtesy of The University Museum of the University of Pennsylvania, Philadelphia. See Key to Illustrations.

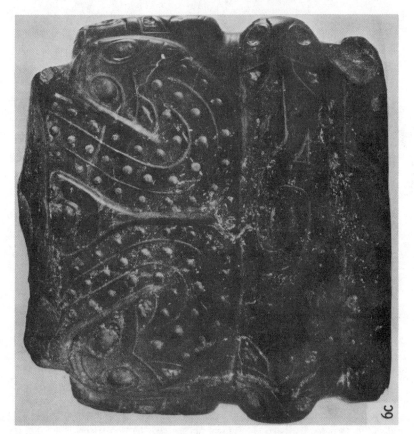

Plate VII. Figure 6. Pucara style statuette. Photographs courtesy of The University Museum of the University of Pennsylvania, Philadelphia. See Key to Illustrations.

492

Plate VIII. Figure 7. Lightning stone from southern margin of Lake Titicaca; **Figure 8.** Lightning stone from Escoma, Omasuyu; **Figure 9.** Motifs from the headbands of the two kneeling statues in front of the church at Tiahuanaco; **Figure 10.** Face motif from headband of Pucara statue in Figure 14; **Figure 11.** Face motif from headband of the "Flute Player" from Pokotia, Bolivia. See Key to Illustrations.

Plate IX. Figure 12. Arapa 3 monolith. See Key to Illustrations.

494

13

14

Plate X. Figure 13. Stela from Hatuncolla, Peru, approximately 180 cm. high; **Figure 14.** Pucara style statue in the Pucara Museum, 55 cm. high. See Key to Illustrations.

The Burr Frieze;
A Rediscovery At Chan Chan

Margaret A. Hoyt and Michael E. Moseley

The north coast of Peru is an area rich in pre-Conquest friezes, and within this region, the site most famous for decorated walls is Chan Chan, the ancient capital of the Kingdom of Chimor. This site in the Moche Valley has long attracted attention because of its size and complexity and its many elaborate friezes. The latter were a source of interest for early travelers and remain a tourist attraction today. The adobe wall decorations at Chan Chan have suffered periodic obliteration by heavy rains that fall at long-separated intervals on the otherwise arid coast; the last of these storms was in 1925. Although each downpour partially or totally destroyed the friezes exposed at the time, the site has never lacked decorated walls exposed for admiration, since three-hundred years of continuous grave-robbing and treasure-hunting have assured a continuing exposure of new friezes. It is possible that, in the period following the 1925 rain, the number of exposed friezes at Chan Chan has dropped considerably, due to governmental efforts to curtail looting.

In the course of archaeological investigations conducted at the site by the Chan Chan-Moche Valley Project in the summer of 1969, a portion of a very elaborate adobe frieze was uncovered by Samuel H. Burr, a member of the Project crew.[1] The frieze is located in the Velarde *ciudadela,* on the western side of the site, and decorated the side of a series of ramps on a structure which will be described subsequently. The section uncovered consists of a series of horizontal decorative bands depicting fish, crustaceans, ornithomorphic and anthropomorphic figures (Fig. 1). The frieze is of particular significance because some of the motifs used resemble decorative elements on Chimú pottery and thus can be correlated with the Chimú ceramic sequence. This fact makes it possible to place the Burr Frieze in temporal and stylistic context, and analysis of the panel carries important implications for the later history of the occupation of Chan Chan.

Initially this frieze was thought to be a heretofore unknown wall decoration, but information provided by Dr. Francisco Iriarte Brenner, and further investigation in the library of the Archaeological Museum of the National University of Trujillo

Reprinted from *Ñawpa Pacha*, Vol. 7-8, 1969. Published by the Institute of Andean Studies.

proved it to be a previously unexposed section of an extensive panel which had been uncovered much earlier by the then Prefect of the area, Don Carlos Aureo Velarde. As Prefect of the Department of La Libertad, Velarde, who was an avid antiquarian and treasure-hunter, commanded sufficient resources to loot extensively at Chan Chan. Sometime between 1904 and 1908 he uncovered most of this frieze in the compound which now bears his name.[2] The panel was never described or analyzed in any detail, but it was photographed several times after the conclusion of Velarde's excavations.[3] After the frieze was destroyed by the heavy rains of 1925, these photographs were thought to be the only surviving record of this elaborate construction.

The frieze decorated at least two of the exterior walls of a rectangular adobe brick platform, which was the principal structure of a semi-isolated walled complex of courts, corridors and small rooms. As is typical of much of the monumental architecture at Chan Chan, the platform was a product of multiple stages of building. In the course of his looting, Velarde broke through several walls and exposed most of the interior of the structure. Systematic examination of these cuts revealed four major construction stages. During the first two, the building was a walled structure with internal open rooms, corridors, and walls with friezes, an example of which may be seen on the checkered wall visible in the background of Ubbelohde-Doering's Plate 152b and Wright's photograph on page 27. In the following stage, all but the eastern end of the structure was filled in, and this modification created a solid platform measuring 23.6 meters (north-south) by 28.9 meters (east-west). Two ramps running along and incorporated into the south face provided access to the summit; one of these ramps sloped up from the western corner of the platform, and the other ascended from the eastern corner of the area of this second ramp that Burr discovered the new section of the frieze. Originally the frieze covered the south and east faces of the platform; the north side was undecorated, and it remains unclear whether or not the west side was also decorated with a frieze. During the fourth and final construction stage, the platform was enlarged to 28.4 meters (north-south) by 43.6 meters (east-west); this expansion was made by adding fill, principally along the south and east faces; thus the frieze was covered and protected until it was exposed by Velarde.

The Prefect had cut away the fourth-stage fill and uncovered the panel along the entire east face of the platform, as well as in the area of the western ramp along the south face of the structure, but he did not clear in the immediate area of the eastern ramp. In the fill remaining against the south side of the platform, Burr opened a narrow trench (2.5 by 1.5 meters) against the face of the east ramp, thereby exposing a segment of frieze 2 meters long, 1.5 meters high at the west end, and 1.1 meters high at the east end. This trapezoidal shape was due to the down-slope (west to east) of the ramp surface along the top of the panel, and a slight rise from west to east in the plastered floor running along the base of the section.

Design Layout

For convenience of description, the section of the frieze exposed by Burr has been arbitrarily divided into nine bands. Numbering from the top down, bands one, three, five and seven are plain raised strips of undecorated plaster. Bands two and six are rows of catfish with circular cane-stamped eyes and body spots. Band four contains a row of standing or running birds wearing crescent headdresses and carrying spears; small fish are used as space fillers between the heads and feet of the avian figures.

Bands eight and nine are two parallel, approximately horizontal rows of repeated complex design blocks. These blocks have been numbered from right to left; band eight contains two blocks, and band nine has three (Fig. 2). The basic design block consists of a principal anthropomorphic figure surmounted by a W-shaped serpentine belt with square end blocks. This principal figure is a small flying man who wears a crescent headdress that is connected at the top to the underside of the serpentine belt; these figures have triangular appliqué noses that protrude beyond the rest of the frieze, and each figure carries a short rod or staff in one hand. It is possible that the whole serpentine belt and attendant figures may be intended as part of the paraphernalia of the central figure, since they all sprout from his head. Within the serpentine belt are catfish in the end blocks and diagonal portions of the belt, crabs in the lower and upper angles, and small fish occasionally interspersed as filler elements between the crabs and catfish. Above each end block is a small flying anthropomorphic figure wearing a long trailing hat and carrying an upward-pointing spear; these figures face inward toward the central rise of the serpentine. Sitting in each of the two dips of the W-shaped belt is a small, squatting human figure who carries an upward-pointing spear and also faces inward. On top of the central rise of the serpentine is a facing pair of avian figures wearing crescent headdresses and carrying down-pointing spears. Between these and the square ends of the belt, small birds are used as space fillers; the number and form of these birds varies from one design block to another, depending on the space available. Between the rising ends of each pair of serpentines in the same horizontal band appears a multi-legged crustacean with pincers, probably a shrimp or crayfish.

The frieze layout was influenced by the shape of the wall space to be decorated. Where Burr excavated, the converging slopes of the ramp floor and the floor at the base of the panel produced a trapezoidal surface that necessitated some modifications in the basic design block. Diminishing space at the eastern end of the panel left insufficient room for the principal figure to be placed beneath the serpentine of block one, band nine, and consequently the artisans substituted a duck for the flying man. At the other end of the section, with the expansion of space available for decoration because of the increasing divergence between ramp and floor, the artisans began to add a third row of motif blocks at the base of the frieze, as may be seen by the offset between block three in band nine and the two serpentine fragments to the left of it. Early photographs of the platform as excavated by Velarde indicate that where the friezed wall reached its greatest height, there were four horizontal bands of design blocks.[4]

In terms of layout, the Burr Frieze shares several general similarities with other decorated walls at Chan Chan and other sites in the vicinity. If the design blocks of bands eight and nine are interpreted as the principal decorative elements of the frieze, bands one through seven would constitute a border for the panel. These first seven bands not only edged the top of the panel, but were also used vertically at the corners of the frieze-decorated portion of the east wall; there was no comparable border at the base of the frieze.[5] Similar use of a three-sided border to frame rows of repeated complex design blocks appears in a frieze in the Gran Chimú ciudadela at Chan Chan.[6] Such a border was also used in the Uhle compound to edge diagonal motif bands.[7] Another three-sided border is present at the Huaca El Dragón, a platform several kilometers north of Chan Chan; there, however, it did not frame a

panel but separated individual design blocks of large size.[8] Although the present sample of friezes is relatively small, this sort of border may prove to have been a frequent element in Chimú decorated walls.

Another common usage is that of continuous bands of a single repeated motif, usually a fish or bird. This seems to have been a basic canon of Chimú design and is represented in bands two, four and six of the Burr Frieze, and in most of the other ornamented walls at Chan Chan. The bands are not always horizontal; they may be diagonal, as in the Uhle compound at Chan Chan;[9] or stepped, as in the Tschudi compound at the site, or may join ends in a diamond shape, as at the Huaca Esmeralda.[10] Similar bands of repeated single figures were also used frequently to decorate Chimú ceramics.

Construction Techniques

The Burr Frieze was the product of a complex set of construction techniques involving excision, incision, cane-stamping, appliqué and the use of two distinct plaster surfaces. The first step in making the frieze was to plaster the adobe brick platform face to produce a smooth surface. After this surface had dried, and had been remoistened, or perhaps before it had dried completely, a second layer of plaster 2 cm. thick was applied and smoothed. While the second coat was still damp enough to work with, the frieze motifs were fashioned by excising the damp plaster between them, down to the level of the first plastered face. A narrow, sharp chisel was used, and bit-marks may be seen on the first plaster surface where it appears between the motifs. Where design elements are widely spaced, there was apparently little diffculty in excising the unwanted material down to the base plaster. However, in areas of greater density of motifs, the cuts sometimes tapered and did not reach the base plaster because the space between motifs was too narrow to permit complete excision.

The use of two levels of plaster had two advantages. First, it was undoubtedly easier to work with a damp coat of plaster than to attempt to carve hard adobe. By using a moist layer, sharp angles and smooth surfaces could be produced. Second, by excising to the primary plaster layer, the artisans were assured that the resulting frieze motifs would be of uniform elevation. Maintaining a standard depth of relief would have been much more difficult if carving a single layer of plaster or if simple modeling had been used.

Once the frieze motifs had been outlined by excision, such details as eyes, mouth, fins and body markings were added by incision or by cane-stamped circles. The appliqué noses used on the principal figures in the motif blocks of bands eight and nine were small triangular wedges of clay, added to the second plastered surface, between the incised eyes of the figures.

It is possible that some of the smaller motifs, such as the catfish in bands two and six or filler elements in bands eight and nine, may have been simple plaster cutouts applied to the base surface where excision left large open spaces. A certain amount of evidence for this suggestion is provided by the fact that one catfish, on a large segment of fallen frieze from the fill cleared away in exposing the panel, broke away neatly from its background to reveal that it had been outlined with a faint incised dotted line, possibly to indicate placement of the figure. This technique may have been used in cases where an artisan made such a large mistake in excising around a figure that it was more efficient to remove the whole ruined figure down to the

primary plaster and to replace it with a cut-out equivalent. However, the method would have been difficult and time-consuming, and it would probably have been used for a very small portion of the frieze at most. It does not appear that a template was used for cutting out the catfish and other small motifs in an attempt to make them uniform, as they vary in body proportions, thickness of fins and other shape features.

Because the frieze had to be completely excised while the second plaster layer was still workable, it was presumably constructed in sections. A segment of wall would be plastered from top to bottom, the frieze executed, and then a new, contiguous segment of wall would be plastered. Within each section, the frieze was constructed by working from the top downward, since bands one through seven are relatively uniform along the whole panel, while bands eight and nine are not fully symmetrical and sometimes appear to reflect spatial miscalculations on the part of the artisans. Block two in band nine is squeezed vertically, and part of the serpentine is cut off by the floor. Block one in the same band lacks even more of the serpentine, and a duck has been substituted for the principal figure because of insufficient space. Similar crowding and possible miscalculation at the base of the frieze is apparent in early photos of other sections of the panel.

It seems probable that the motif blocks in bands eight and nine were executed by different artisans, apparently following some sort of basic plan which left them free to improvise somewhat with minor details of the decoration. The basic design would have included the serpentine belt, its catfish and crabs, the principal anthropomorphic figure, and all of the larger avian and human representations, as well as the shrimp or crayfish between the motif blocks. This master-plan technique would account for the differences between the blocks in minor details and in small space-filling elements, such as birds and fish.

In terms of construction techniques, specifically the use of excision and two layers of plaster, the Burr Frieze has counterparts at Chan Chan in the ciudadelas of Rivero, Tschudi and Gran Chimú, and in the Uhle compounds.

Motifs

The Burr Frieze uses only curvilinear motifs; the panel includes no geometric or rectilinear figures, although such motifs are relatively common in other friezes at Chan Chan. It has been suggested that the latter derive from textile motifs and perhaps differ culturally and temporally from curvilinear design elements. However, both types of motif can appear on a single frieze, as in the ciudadelas of Gran Chimú[11] and Rivero at Chan Chan, and both types of motif can ornament the same structure, as in the Tschudi ciudadela. These associations indicate that curvilinear and geometric motifs must be considered at least partly contemporaneous.

Although many of the motifs of the Burr Frieze have counterparts on other friezes at Chan Chan and in the vicinity and on smaller objects from the north coast, the whole complex of motifs is not repeated elsewhere. Correspondences between the zoomorphic and anthropomorphic figures of the Burr Frieze and similar figures elsewhere will be noted in the course of describing the individual frieze motifs.

Fish

Two types of fish are depicted on the frieze, and the most frequent of these is the catfish, known locally as *bagre* and in the highlands as *suche* (Fig. 3). From the depiction on the frieze, it is not possible to determine whether these are marine cat-

fish, of which there are four genera off the Peruvian coast, including *Galeichthys,*[12] or river catfish of the genus *Pygidium.*[13] These fish appear in bands two and six, and within the serpentine belts in bands eight and nine. The figure is portrayed in a dorsal view, and is represented with curling whiskers, a triangular head, projecting fins, and a triangular tail. Slight differences in the execution of the catfish in different parts of the panel may indicate the work of at least two artisans. The catfish in bands two, six and eight have cane-stamped circles indicating eyes and body spots, usually with only two or three circles used for body decoration. However, in band nine, the fish frequently have almond-shaped eyes or irregularly-drawn circular eyes instead of neatly-stamped circles. Variation is also evident in blocks two and three of band nine, where some figures have as many as seven stamped or drawn circles for body decoration.

To date the only other known depictions of catfish in Peru come from Pucara stone sculpture of the southern sierra, Inca painted plates,[14] Inca textiles of the central coast,[15] Moche ceramics,[16] and Chimú Inca ceramics (Fig. 4). Catfish strictly comparable to those of the frieze are rare in Chimú Inca pottery; more common is a spadeheaded fish, resembling the catfish in body outline, but lacking their curling whiskers.

The second kind of fish appearing on the frieze is smaller than the catfish; it is depicted from a lateral perspective, has a blunt nose, usually a single long dorsal fin, one or two central fins, and a triangular tail; a back-pointing triangle is frequently incised on the body, possibly to indicate a pectoral fin (see Fig. 5). These figures occur in band four, as space-fillers between the spear-carrying birds, and within the serpentines in bands eight and nine. The frequency with which they appear in bands eight and nine and the details of their depiction are variable and were apparently left to the discretion of the individual artisan executing each motif block. In band eight, block one contains two of these fish, and block two has four, while in band nine, the incomplete block one contains one such fish, block two none, and block three has two. In terms of specific details, such as the number of fins, placement of the mouth, and the presence of an incised pectoral fin, there is also considerable variation from one figure to the next.

This type of fish is a relatively common design element on Chimú Inca pottery, usually depicted in low relief on press-molded blackware, like the catfish, but occasionally appearing as a painted design on oxidized ware. Similar fish occur in a continuous stepped band on the side of a building in the Tschudi ciudadela, and also in the diamond-shaped figures at Huaca Esmeralda.

Crustaceans

Crabs and shrimp are used as motifs in bands eight and nine. Within each serpentine are three crabs, occupying the central high point and the two low points of each belt. Viewed dorsally, these crustaceans have oval bodies, upward-pointing eye stems and pincers, and four downward-pointing posterior legs (see Fig. 5). Although the figures are basically similar, some minor variation occurs. Some crabs have cane-stamped circles on the eye stems, and two specimens in block three of band nine have circular stamps on their pincers. In block two of band eight, the crabs in the lower parts of the serpentine belt are misshapen, either because of exigencies of space or from carelessness in their execution.

On the north coast crabs were employed as ceramic motifs on Moche pottery, and in at least the last half of the Chimú sequence, from about 1,000 A.D. until the Spanish conquest. On the south coast, the motif appears on Inca-influenced pottery from the Ica Valley. Crabs do not appear on any other friezes that have been uncovered to date.

The second type of crustacean that appears is a shrimp or crayfish; it is unclear whether these figures represent a river species or a marine form.[17] They occur in bands eight and nine, in the area between the ends of adjacent serpentines. They are depicted dorsally, and are represented with multiple lateral legs, anterior pincers, and short antennae (see Fig. 5). Variation exists in the amount of incised body detail and the number of legs that different specimens have. The fact that these crustaceans were given six, eight or twelve lateral legs may reflect some confusion on the part of different artisans as to how many appendages shrimp or crayfish actually have. Representations of the motif were also affected by spatial exigencies. In the lower left end of the panel, between block three of band nine and the initial block of what would have been band ten, a crustacean was bent sideways and squeezed into a smaller space than was usually allowed. Just below this figure is another shrimp or crayfish that was truncated by the floor. A catfish was substituted for a crustacean between blocks one and two of band nine, presumably because of lack of space.

Like the crab, the shrimp or crayfish motif is found on Moche ceramics and on Chimú pottery from at least the last half of the ceramic sequence. No other representations on friezes are yet known.

Ornithomorphic Figures

Two types of avian figures appear on the panel. The first consists of three varieties of small birds used as space fillers in bands eight and nine: type a, a long-beaked bird with long legs, large feet and a humped back (see Fig. 9); type b, a figure with a long beak, protruding breast, spread tail and long legs; type c, a stylized bird with excised triangles in the wing and tail areas and without legs or feet (see Fig. 5). All three types are represented in profile and all have eyes indicated by cane-stamped circles or incised ovals. There are four examples of type a: two in block one of band eight, one in block two of the same band, and one in block one of band nine. Type b is represented by one specimen in the right side of block two in band nine. Three examples of the type c bird are present on this section of the frieze; two in block two of band eight and one in block two of band nine. All of these birds appear to have been used as space-fillers, since the placement of them is not consistent in the different design blocks; some are squeezed or positioned at angles, according to the amount of space available.

All three types of small bird motifs have similarities to figures on Chimú ceramics dating from the phase immediately before the Inca conquest of the north coast, and from the Chimú Inca phase. That is, similar pottery motifs appear about 1200 or 1300 A.D. and last until about 1532. Figures similar to the type c birds appear at Chan Chan on a frieze in the Tschudi ciudadela.

The second group of ornithomorphic figures consists of two varieties of larger spear-carrying birds which seem to be two versions of the same figure; they appear running or standing in band four, and seated in facing pairs above the central rise of the design block serpentines in bands eight and nine. Each wears a crescent

headdress and has a long beak (usually with an excised triangle or an incised line indicating the beak opening), an ear or earspool protruding behind the head, a three-pronged tail, some indication of a pointed wing protruding behind the body, a three-toed foot-like appendage, a three-digit hand-like appendage that holds a spear, and a round or oval incised eye. The running figures in band four carry a spear pointing backwards over their shoulders (Fig. 6). The pose of these bird figures is similar to that of spear-carrying birds on a frieze in the Uhle compound at Chan Chan.[18] There are also counterparts on Chimú ceramic pieces that date between 1200 or 1300 A.D. and the time of the Spanish conquest.[19] Schmidt illustrates the head of a wooden staff, said to be from Trujillo, which bears a carved representation of two spear-carrying birds wearing crescent headdresses and a "moon creature" without a headdress.[20] The crescent headdresses of the birds on the frieze and on the staff bear some resemblance to those of representations of the "moon creature" that appear on Chimú ceramics from the last two pre-conquest phases. The "moon creature" is an animal representation that first appeared on Recuay pottery, and that continued, with variations, to be used into the Colonial Period; in the last phases of the Chimú sequence, it began to be depicted wearing a crescent headdress, which seems to have had mythical or divine connotations for north coast peoples at that time.[21]

The facing pairs of ornithomorphic figures in bands eight and nine are similar to the band four birds, except that they are seated and carry their spears pointing downward (Fig. 7). As with the running birds, some variation in depiction occurs, chiefly in that figures have the beak opening represented by an excised triangle, and others by a straight or curving incised line; also there are differences in the depiction of the wing. The only resemblance between these figures and any Chimú ceramic motif is a similarity to the crescent headdresses of the "moon creatures" mentioned with reference to the avian figures in band four. In terms of their profile position and the spear held in front of the body, these figures have a general similarity to the Angel A and Angel B staff bearing figures of the Middle Horizon styles.[22]

Anthropomorphic figures

Three types of anthropomorphic figures appear on the frieze, all in bands eight and nine. The first type is a flying spear-bearer that occurs immediately above the end blocks of each serpentine; this individual is in an extended prone position and faces inward toward the center of the serpentine. Each of these figures wears a long headdress, part of which trails backward above the extended body and a small portion of which projects forward over the face. Their faces are prognathous, with the mouth and an oval eye delineated by incision, and a single round ear or earspool at the rear of the head; both legs extend out behind the body, and an arm and hand reach forward to carry a spear in a vertical position, pointing upward (Fig. 8). In some cases, the spear shaft extends down beside the end block of the serpentine, and in others it ends at the upper edge of the end block. Although there are minor variations in depiction, all of these figures are relatively similar. The major exception is the example on the right side of block one of band eight, which faces outward instead of in toward the center of the serpentine.

This motif has no close counterpart on other local friezes or in the Chimú ceramic style. There are some slight similarities between its position and that of the flying Huari style figures, Angel C and Angel D.[23]

The second type of supporting anthropomorphic figure is a small being seated in the low points of each serpentine. These are depicted from the side, face inward toward the center of the serpentine, and wear forward-drooping headgear (see Fig. 5). The face has a pointed nose, incised oval eye and mouth, and an ear or earspool projecting behind the head. Each figure has one leg flexed under or in front of him, and has one arm and hand extended forward to hold a spear vertically, point upward. These beings are generally similar, although some are more compressed or elongated than others, depending on the available space within the serpentine curve.

This figure has no similarity to any known from Chimú ceramics. The pointed caps worn by these figures have some resemblance to the headgear worn by the homunculus figures, motives IV and V from the Huaca El Dragón frieze.24 The motif more closely resembles small anthropomorphic figures on a shell-inlaid wooden plaque, probably part of a litter, which was recently excavated at Huaca Tacaynamo, near the Huaca El Dragón.

The anthropomorphic figures beneath the centers of the design block serpentines are considered the principal figures of the frieze for several reasons. The manner in which the crescent headdress of each of these figures is joined to the underside of the accompanying serpentine suggests that the whole motif block may have been intended as an ornament or appendage of this central figure. This impression is augmented by the fact that the projecting appliqué noses of these figures distinguish them from all other representations on the panel. Also, these figures tend to be larger than most of the other motifs on the panel.

The body of this principal figure is depicted in profile, while the head is viewed face-on; the mouth and oval eyes are indicated by incision, and the nose is an appliqué triangle; on each side of the head is a round ear or earspool. The figures are depicted with three limbs visible: an arm with a three-fingered hand extends in front of the body and grasps a short staff or rod; two legs, or possibly an arm and a leg, project on the opposite side of the body and touch the inner side of the serpentine (Fig. 9). If these two limbs represent legs, as seems most probable, the position of these figures is analogous to that of the smaller anthropomorphic figures above the end blocks of the serpentine. The principal figures exhibit considerable variation. Those in band eight fly with their heads toward the right, while those in band nine have their heads toward the left. The major differences probably represent artisans' modifications because of problems of space available. The two examples in band eight are alike in size and form. However, the figures in band nine are smaller and vary in their proportions; the block three personage is compressed into a shorter space than that of block two, and the block one example has been replaced by a duck.

The crescent headdresses of these principal figures are similar to that of the "moon creature" and to those of a series of anthropomorphic deity figures that appear on Chimú ceramics from the beginning of the Late Intermediate Period until the Chimú Inca phase or the Colonial phase. Their flying position, like that of the flying spear-bearers above the end blocks of the serpentines, has faint similarities to that of Huari style motifs, Angel C and Angel D.25

The closest counterpart of these principal figures, and indeed of the Burr Frieze as a whole, is found in the engraved design on a silver bowl illustrated by Baessler, said to be from Trujillo.26 The design band on this bowl represents a continuous serpentine double line with seated human or avian figures in the low points of the

serpentine; flying anthropomorphic figures wearing crescent headdresses and carry-
ing short staffs, and also smaller prognathous animal figures wearing crescent
headdresses, both under the high points of the serpentine; and small bird, serpent,
human, monkey and circular figures used as space-fillers throughout the band. The
general similarity between this design and that of the motif blocks of the Burr Frieze
is obvious, as are the differences in detail. Since no data exist on the associations of
the bowl, it is not possible to assign it to any time period.

Interpretation

The motifs of the Burr Frieze are largely realistic representations; crustaceans,
fish and the small birds are depicted in a recognizable form. The anthropomorphic
figures are clearly human and are not endowed with animal characteristics; the
crescent headdress of the principal figures is the only attribute that can definitely be
considered to have had mythical connotations. The larger avian figures are recogni-
zably bird shapes, but with the addition of a mythical attribute in the crescent
headdress, and of non-avian characteristics in their spears and possible earspools.
This realism contrasts with some of the other known friezes in the Moche Valley.
Elsewhere the motifs are frequently modified to such a point that the animal or figure
depicted is difficult to recognize. This effect is most apparent at the Huaca El Dragón,
where anthropomorphic and zoomorphic elements are so modified that they can
probably be interpreted as mythical beings.

It is possible that the Burr Frieze had mythical connotations for its makers.
Evidence from the Chimú ceramic sequence seems to indicate that the crescent
headdress in Chimú contexts was worn only by deities and supernatural characters,
not by mere humans. If the serpentine band above the principal figures is considered
as an elaboration of or appendage to the crescent headdresses of these personages, it
may indicate a superhuman status. If the analogies between the positions of several of
the Burr Frieze motifs and those of the Huari-style Angel figures, which initially
appeared only in sacred contexts, are correct, additional support is given to the idea of
a mythical significance for the Burr Frieze. The fact that so many of the frieze motifs
depict water dwellers may indicate that the principal personage is intended to be
some sort of marine or river deity, and as such his position might be interpreted as
swimming rather than flying. Perhaps the spear-bearing figures above the serpentine
may be interpreted as guardians of the deity or as representations of predators on the
water creatures.

Implications

The Burr Frieze is unique in several respects. First, it is composed of a large
number of differing motifs, and there are few other friezes of similar complexity.
Second, many of these motifs can be related to phases of the Chimú ceramic
sequence. The most definite connections are with the Chimú Inca phase and with the
phase just prior to the Inca conquest of Chan Chan; thus the similarities are to pottery
design elements thought to date from 1200 or 1300 A.D. to about 1532. One motif in
particular, that of the catfish, seems to be limited to ceramics of the Chimú Inca
phase; the other types of water dwellers do occur on pre-Inca Chimú pottery, but
catfish do not reappear as a ceramic motif until Inca influence reaches the north coast.
The reappearance of the catfish on north coast ceramics at this time may perhaps be
considered as a reaction by Chimú potters to seeing catfish depicted on Cuzco Inca

plates. By extrapolation from the ceramic sequence, the frieze may date to the period immediately before the Inca conquest of the Kingdom of Chimor, or, more probably, it may have been constructed in the period of Inca rule that began sometime between 1462 and 1470.[27] Because this is the first frieze for which a date can be suggested, it is not possible to say whether there was any continuity in marine motifs on friezes constructed on the north coast between the Middle Horizon and the Late Horizon; other than the catfish, the only marine motif that occurs on other friezes is a fish like the second type of fish depicted on the Burr frieze. The sample of complex friezes from the area is still limited, and future excavations may uncover other friezes that can be assigned to earlier Chimú phases because of correlations with ceramic motifs.*

*Author's Note: Subsequent to the writing of this article, four years of archaeological investigation at Chan Chan failed to produce evidence of an Inca presence at the city, and its abandonment seems to have been brought about by the Inca conquest. Thus, while the catfish motif of the Burr Frieze may be an Inca-derived element, it apparently entered the Chimú stylistic vocabulary prior to the physical subjugation of the Moche Valley.

M.E. Moseley

Editors' Note: Both authors agreed to omit the final two paragraphs of the *Implications* as they appeared in the original publication. It was felt these last paragraphs placed undue stress on the possibilities of Inca influence.

Notes

1. The authors' research has been generously supported by Grant No. 742 from the National Geographic Society and by GS-2472 from the National Science Foundation, as well as by Ford Foundation Training Grants awarded to the University of California at Los Angeles and to Harvard University. Additional support was provided by the Center for Latin American Studies at the University of California, Berkeley.

For information and special assistance, thanks are due Dr. Francisco Iriarte Brenner, Dr. José Zevallos Quiñones, and the staff of the Chan Chan-Moche Valley Project.

2. Anonymous, 1956, p. 2; Rivadeneira, 1935, p. 29.

3. The best examples of these photographs are published in Ubbelohde-Doering, 1967, p. 152-153; Wright, 1908, pp. 27-29. See Holstein, 1927, p. 46, for photographs of the portion of the frieze uncovered by Velarde, before and after the 1925 rain. After the Burr Frieze had been drawn and photographed, it was reburied to prevent damage by possible rain and vandalism.

4. Wright, 1908, pp. 27-29.

5. Wright, 1908, pp. 28-29.

6. Squier, 1877, pp. 137-138; Wright, 1908, p. 30.

7. Bushnell, 1957, Fig. 52.

8. Schaedel, 1966.

9. Bushnell, 1957, Figs. 52, 53.

10. Horkheimer, 1944, Fig. 68.

11. Squier, 1877, p. 137.

12. Schweigger, 1914, pp. 238-239.

13. Koepcke and Koepcke, 1968, p. 21.

14. Carrión Cachot, 1955, Lám. XIII.
15. Arturo Jimenez Borja, personal communication.
16. Larco Hoyle, 1938, pp. 103, 126-127.
17. Larco Hoyle, 1938, pp. 110, 113.
18. Mason, 1957, Pl. 4.
19. Fuhrmann, 1922a, Pl. 7.
20. Schmidt, 1929, Fig. 423-3.
21. Fuhrmann, 1922b, Pl. 83.
22. Menzel, 1964, p. 20.
23. Menzel, 1964, pp. 20-21.
24. Schaedel, 1966, p. 408.
25. Menzel, 1964, pp. 20-21.
26. Baessler, 1902-03, vol. 4, Pl. 162, Figs. 440, 441.
27. Rowe, 1948, p. 40.

Bibliography

Anonymous
 1956. "El problema de la conservación de las decoraciones murales prehistóricas." *Chimor*, año IV, no. 1, noviembre, pp. 1-8, Trujillo.

Baessler, Arthur
 1902-03 *Ancient Peruvian Art.* A. Asher & Co., Berlin; Dodd, Mead & Co., New York. 4 vols.

Bushnell, Geoffrey Hext Sutherland
 1957. *Peru. Ancient Peoples and Places.* Frederick A. Praeger, Publisher, New York.

Carrión Cachot, Rebeca
 1955. "El culto al agua en el antiguo Perú." *Revista del Museo Nacional de Antropología y Arqueología*, vol. II, no. 2, primer semestre, pp. 50-140. Lima.

Fuhrmann, Ernst
 1922a. "Reich der Inka." *Kulturen der Erde*; Material zur Kultur- und Kunstgeschichte aller Volker. Band I. Folkwang-Verlag G.M.B.H. Hagen i. W.
 1922b. "Peru II." *Kulturen der Erde;* Material zur Kultur- und Kunstgeschichte aller Volker. Band II. Folkwang-Verlag G.M.B.H. Hagen i. W. und Darmstadt.

Holstein, Otto
 1927. "Chan-Chan; capital of the great Chimu." *Geographical Review,* vol. XVII, no. 1, January, pp. 36-61. New York.

Horkheimer, Hans
 1944. *Vistas arqueológicas del noroeste del Perú.* Librería e Imprenta Moreno, Trujillo.

Koepcke, Hans Wilhelm and María Koepcke
 1968. *Division ecológica de la costa peruana.* Segunda edición. Facultad de Pesquería, Universidad Agraria, La Molina, Boletín de Extensión, no. 11. Lima.

Larco Hoyle, Rafael
 1938. *Los mochicas.* Tomo I. Casa Editora "La Crónica" y "Variedades," S.A. Ltda., Lima.

Mason, John Alden
 1957. *The ancient civilizations of Peru.* Pelican Books A 395, Penguin Books, Inc., Baltimore.

Menzel, Dorothy
 1964. "Style and time in the Middle Horizon." *Ñawpa Pacha* 2, pp. 1-106. Berkeley.

Rivadeneira, Ricardo
 1935. *Las ruinas preincaicas de Chanchán.* (de la síntesis monográfica de la cuidad de Chanchán.) Universidad de La Libertad. Trujillo.

Rowe, John Howland
 1948. "The kingdom of Chimor." *Acta Americana,* vol. VI, núms. 1-2, enero-junio, pp. 26-59. Mexico.

Schaedel, Richard Paul
 1966. "The Huaca El Dragón." *Journal de la Société des Américanistes*, tome LV-2, pp. 384-496. Paris.

Schmidt, Max
 1929. *Kunst und Kultur von Peru.* Propylaen-Verlag, Berlin.

Schweigger, Erwin
 1964. *El litoral peruano.* Segunda edición. Editado por la Facultad de Oceanographía Pesquería de la Universidad Nacional Federico Villarreal. Lima.

Squier, Ephraim George
 1877. *Peru; incidents of travel and exploration in the land of the Incas.* Harper & Brothers, Publishers, New York.

Ubbelohde-Doering, Heinrich
 1967. *On the royal highways of the Inca.* Frederick A. Praeger, Publishers, New York.

Wright, Marie Robinson
 1908. *The old and the new Peru; a story of the ancient inheritance and the modern growth and enterprise of a great nation.* George Barrie & Sons, Philadelphia.

508

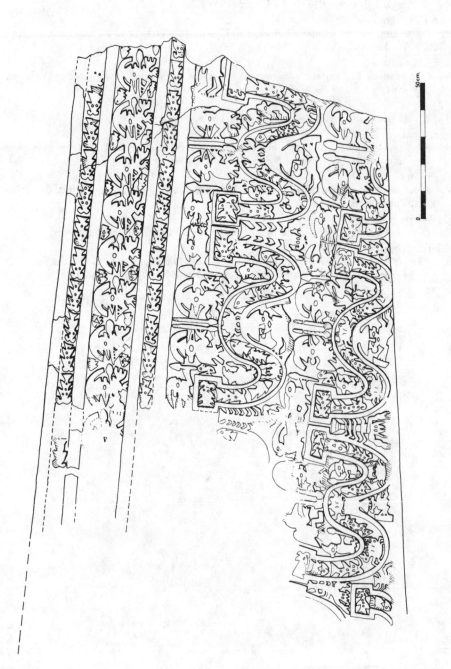

Figure 1. Drawing of the Burr Frieze.

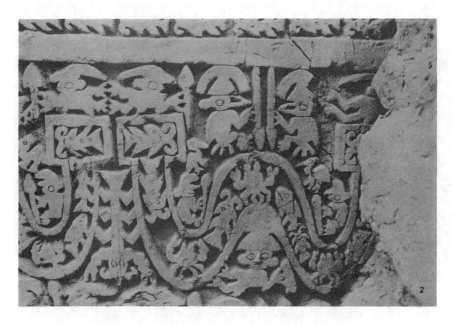

Figure 2. Detail of block one of band eight of the Burr Frieze.

Figure 3. Catfish from band two.

510

Figure 4. Blackware Chimú Inca double-chambered vessel, said to be from Pacasmayo. Height to top of spout, 15.8 cm. Peabody Museum of Archaeology and Ethnology, Harvard University, no. 54799, purchased by S.S. Bucklin in about 1876.

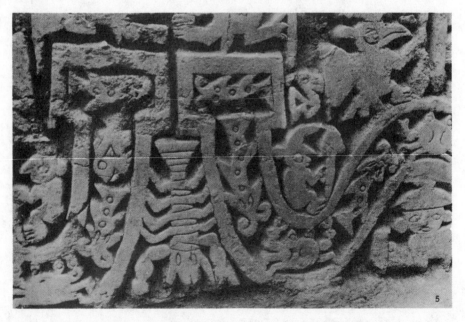

Figure 5. Detail of end sections of blocks two and three of band nine of the Burr Frieze containing shrimp, crab, two kinds of fish, the type c bird, and small seated spear-carrying men.

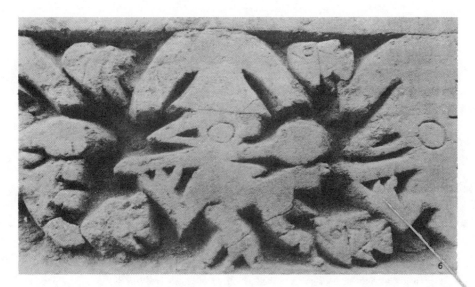

Figure 6. Spear-carrying birds from band four.

Figure 7. Seated spear-carrying birds from block one of band eight.

Figure 8. Flying spear bearers from the end blocks of blocks one and two of band eight.

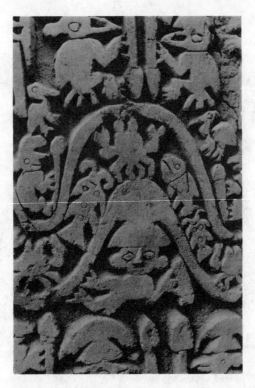

Figure 9. The principal figure from block one of band eight; small type a birds are also shown.

An Ancient Peruvian
Architectural Model

Christopher B. Donnan

Several decades ago a unique wooden architectural model became part of the collection of the Museum für Völkerkunde in Stuttgart (museum number 69169). Although the only provenience data for the specimen was "Gravefind, Ancient Peru," its characteristic style of inlay and wood carving suggests that it was associated with the Chimu culture which flourished on the north coast of Peru between 900 and 1500 A.D. Due to recent archaeological investigation of the remains of Chimu architecture it is now possible to relate this model to specific Chimu constructions and to identify many of the architectural features which it illustrates.

The model measures 65.5 centimeters in length, 32.5 centimeters in width (excluding the ramp), and 22 centimeters in height (Figs. 1 and 2). It consists of four large pieces of wood. One forms the front half of the structure including the front and center walls, the elevated platform, and the ramp. Another, which forms the three walls defining the back part of the structure, is attached to the first by means of wooden dowels and lashings of cotton thread. Two other pieces of wood form the pillars, which are socketed with a wide, shallow dowel into the floor of the elevated platform and cemented in place with a black pitch-like substance.

Inlay of shell and metal provides decoration on many surfaces of the model. A face has been inlaid into the upper part of the ramp. This consists of two circular white shell eyes, and a trapezoidal nose and mouth of orange shell. Just above the ramp face is a rectangular piece of inlay which may represent a forehead or headdress ornament for the face on the ramp. Between the pillars and the side walls are what may be interpreted as two additional inlaid faces. Each consists of a pair of circular shell eyes and a rectangular nose.

Each of the pillars has seven circular shell inlays—six on the vertical face of the upper portion and one on top (Fig. 3). Along the vertical front of the elevated platform are additional circular shell inlays. There are ten on the right side of the ramp and nine on the left side. Finally, there is a decorative frieze on the upper part of the walls. This consists of a repeated step motif with a continuous horizontal band above

Reprinted from *The Masterkey*, Vol. 49, No. 1, 1975. Published by the Southwest Museum, Los Angeles

Figure 1. Front view of wooden architectural model.

(Fig. 4). Although most of the inlay forming this decorative frieze is missing, enough is preserved to indicate that it originally consisted of alternating shell and metal step motifs. The horizontal band was exclusively of metal. All of the interior walls were decorated in this fashion, except for the back side of the center wall. The exterior walls lack any sign of decoration.

There are several indications that the model was originally larger and more complex than it appears today. Holes along the front edge of the side walls and adjacent parts of the floor suggest that these areas may have been extended forward by having additional pieces of wood doweled to them. Furthermore, sewing grooves on the top of the back wall and diagonal holes drilled into the top of the center wall suggest that something may have been attached here also—possibly roofing materials. Finally, there are six small wooden pegs (approximately 0.4 centimeters in diameter) set into the floor of the elevated platform, between the two pillars and the center wall. These are in a row and evenly spaced about 8.5 centimeters apart. They

Figure 2. Top view of wooden architectural model.

Figure 3. Detail of inlay on a carved pillar.

might have served to support another structural element of the model itself, or a row of figures which originally were standing in front of the center wall.

In the past six years an archaeological expedition jointly sponsored by the National Geographic Society and the Peabody Museum of Harvard University has been conducting an extensive investigation of the site of Chan Chan. This site, which

Figure 4. Detail of inlay from wall frieze.

516

Figure 5. Aerial view of a portion of Chan Chan showing the Rivero (foreground) and Tschudi (background) ciudadelas. (Courtesy of Harvard University.)

is located near the modern city of Trujillo, is known historically to have been the capital of the Chimu empire. The Chimu were an extremely important political power which dominated northern Peru for several centuries before finally being conquered by the Inca about 50 years prior to the Spanish arrival. The Chimu are well known for their large urban settlements which are still preserved in the arid climate of the Peruvian coast.

Chan Chan is the largest Chimu settlement, covering an area of more than six square miles (Fig. 5). The site is characterized by large rectangular enclosures, called *ciudadelas*, which contain internal subdivisions laid out in a planned and regular fashion. The walls and buildings at Chan Chan are made of sundried mud bricks laid in a mud mortar. Plaster was added to the exterior surfaces and often elaborated with low relief designs. Although the upper portions of the walls exhibit varying degrees of erosion it is still possible to reconstruct many details of the layout and construction by careful examination of the remaining walls, and by limited excavation in certain areas of the site. The current project has produced a series of detailed maps of this ancient site, as well as a variety of reports on different aspects of its construction, function and history.

While there is no construction at the site of Chan Chan which exactly duplicates the wooden architectural model, its components are all present at structures within the site. The closest analogies lie with the rear sections of the entry courts in the first and second sections of the *ciudadelas* (Fig. 6). The correspondences are the central ramp giving access to an elevated platform, the friezing of the vertical front of the platform with circular elements, the pillars flanking a restricted doorway, and the fact that the doorway opens into a narrow structure. It should be noted, however, that while this narrow structure is an enclosed room on the wooden model, at the site of Chan Chan it is generally found to be a narrow hallway. Other similarities between this model and the structures at Chan Chan include the relationship between the thickness and height of the walls, characteristic thinning of the walls toward the top, and the narrow, vertical-sided doorway which is characteristic of Chimu architecture.

Circular pillars, like those flanking the doorway on the wooden model, have been found at Chan Chan. They were made by wrapping bundles of canes with grass ropes and then plastering the exterior surface with mud. Some of these pillars had the canes bundled around posts of *algarrobo* wood. Either type of construction would have been ideal for producing pillars of the form shown in the wooden model.

The friezing along the upper walls of the wooden model is of particular interest in reconstructing some details of Chimu architecture that are not preserved in the ruins that exist today. Because the upper part of the walls is usually destroyed it is only when we find a frieze on the lower part that we know that a frieze existed. When the lower part is plain it has generally been assumed that the entire wall was plain. This model indicates that such an assumption is not necessarily valid, and that many of the walls which are plain in their lower sections may originally have been elaborately decorated at a higher level.

Most of the entry courts at Chan Chan have three elevated platforms—one along the back wall with a central ramp, as shown in the model, and one along each of the two lateral walls that form the sides of the court. These lateral platforms are usually a little lower than the back platform. As mentioned above, holes in the front edge of the model indicate that there were originally pieces extending forward on each side. The

Figure 6. Map of the Rivero ciudadela, showing the entry courts in the first and second sections, and the ramps with elevated platforms (Courtesy of Harvard University, Moche Valley-Chan Chan Project).

pattern of holes suggests that these pieces may well have formed extensions of the side walls, with a platform along the lower portion of each wall.

The location, layout, and size of the entry courts in the *ciudadelas* at Chan Chan suggest that they were used for gatherings of people. These gatherings could either have been audiences where an individual of high status would appear on the central elevated platform and speak or perform a ceremonial function, or the large courtyard could have been used as a reception/staging area for people who had business with the governmental bureaucracy. Limited excavation in a few of these entry courts suggests that there may have been a kitchen area immediately adjacent to one side. These have been seen as evidence for feasting by people within the entry court—possibly on ceremonial occasions.

It is interesting to speculate about the function that the wooden architectural model played in Chimu culture. One possibility is that it served as an architect's model, from which its full size counterpart was built. Given the formal layout of the major construction at Chan Chan, it is apparent that the structures were well designed in advance and built according to careful plans. Lacking paper, it is quite possible that Chimu architects relied on small models for working out the designs of their buildings.

It is known that Inca architects used clay models to design their public buildings, and some stone models may also have been employed for this purpose (Garcilaso 1723: pt. 1, bk. 2, ch. 16; Pardo 1936). There is, however, no mention in the early

Spanish accounts of wooden architectural models, nor have any others yet been reported in museum collections.

An alternative interpretation for the Chimu model is that it was built as a miniature copy of already completed architecture. The motivation for making such a miniature is difficult to reconstruct on the basis of our present evidence, although it may have been meant as a plaything for children, or as the property of an adult. Miniature representations of ceremonial activity—rendered in intricately worked silver—have been found in elaborate Chimu tombs, thus demonstrating that miniature representations were considered appropriate tomb contents.

Clearly, what is needed in order to further understand this unique specimen is the reporting of similar objects, hopefully with precise archaeological provenience, and continued efforts to relate the models to specific portions of Chimu architecture that remain in the vast ruins of their ancient cities.

Acknowledgements: I would like to express my sincere appreciation to Dr. M. Edward Moseley and Mr. John Topic of Harvard University for kindly providing information derived from the Moche Valley-Chan Chan Project.

Bibliography

Garcilaso de la Vega
 1723 *Primera parte de los Commentarios reales* . . . 2nd edition. Madrid.
Pardo, Luis A.
 1936 Maquetas arquitectónicas en el antiquo Perú. *Revista del Instituto Arqueologico del Cuzco*. Peru.